AMERICAN
ART
GALLERIES

THE ILLUSTRATED GUIDE
TO THEIR ART AND ARTISTS

LES KRANTZ

AMERICAN ART GALLERIES

THE ILLUSTRATED GUIDE TO THEIR ART AND ARTISTS

Les Krantz
Editor & Publisher

Paul Hertz
Managing Editor

Facts On File Publications
New York, New York ● Oxford, England

Special Acknowledgement: The Publisher wishes to thank Managing Editor Paul Hertz for his many contributions, and thoughtful input.

AMERICAN ART GALLERIES
THE ILLUSTRATED GUIDE TO THEIR ART AND ARTISTS

CORRESPONDENCE regarding editorial material should be addressed to: The Krantz Company Publishers, Inc., 2210 N. Burling, Chicago IL 60614

Library of Congress Cataloging in Publication Data

Main entry under title:

American art galleries.

 1. Art Galleries, Commercial—United States—Directories. I. Krantz, Les.
N510.A48 1985 708.13 84-18750
ISBN 0-8160-0089-1
ISBN 0-8160-0090-5 (pbk.)

Printed in the United States of America
10 9 8 7 6 5 4 3 2 1

Contents

Foreword

Since 1950 the United States has come to be regarded as the world center of the visual arts. Subsequently, thousands of art galleries of all quality levels have emerged across the nation. This volume surveys a selective, yet large group of them—slightly more than 1,000.

Our selections were not random. We have tried to eliminate the frame shops, the stock-poster galleries and the "art stores," many of which purport to be "art galleries." Our definition of gallery is important to understanding *American Art Galleries*. We define art galleries as publicly accessible spaces which both exhibit and sell original art. A museum gallery, therefore, may or may not be included, depending on whether the art is for sale or simply exhibited to the public. Among contemporary galleries, we have strived to review primarily those which exhibit new and emerging art styles. We have also reviewed a very large number of the important period galleries which specialize in art of historical significance from America, and everywhere on the globe.

Our research netted galleries in all 50 states. In our ten years of writing and publishing on this subject, we feel familiar enough with the field to insure the reader of our confidence that most galleries which meet the above criteria are included in the pages that follow.

ALABAMA

FAIRHOPE

Whiting Art Center 401 Oak St., Fairhope, AL 36532
1 (205) 928-2228; Tue-Sat: 10-12, 2-4 Sun: 2-5;
dir: James L. Whitehead

The Whiting Art Center devotes its exhibition
space to works by local and regional artists.

MOBILE

Boland-Bethea Gallery 212 St. Francis St., Mobile,
2 AL 36602 (205) 432-6952; dir: Lois Eastman

The Boland-Bethea Gallery exhibits contemporary American painting, graphics and sculpture,
with emphasis on local and regional artists.
The gallery has presented works by Kurtis
Thomas, Knox Wilkenson, Arthello Beck, T. De
Jong, Jan Dorer, Derald Eastman, L. Hoffman,
Jo Myer, Maria Spias, William Street, Arie Van
Selm and Inge Wright.

MONTGOMERY

Green Garden Gallery 611 Lawrence St., Montgom-
3 ery, AL 36104 (205) 262-0775; dir: Allan
Swafford

The gallery features works by local and regional
painters.
Among the artists whose work has been
shown are Mollye Daughtery, Joyce Wesley
Estes, John Foust, Barbara Gallagher, Eve Perry
and Beau Redmond.
Other artists include Dwayne Alford, Edward Carlos, Ann Copeland, Marilyn Head, Judith Krause, John Lapsley, Frank Loeb, John
McDonald, J. Sabel, Takako, John Wagnon,
C.B. Whitehead and Sharon Yavis.

ALASKA

ANCHORAGE

Artique, Ltd. 314 G. St. & 470 E. Benson, Anchor-
4 age, AK 99501 (907) 277-1663; Mon-Sat: 10-6;
owner/dir: Jean Shadrach & Tennys Owens

Artique shows contemporary Alaskan paintings
and works by visiting artists.
Alaskan artists featured by the gallery include
Byron Birdsell and Fred Machetanz, chronicler
of early days in Alaska. Other Alaskan artists are
Rie Munoz, John Pitcher, Jean Shadrach, Susan
Ellis, Jon Van Zyle and Dale DeArmond. Their
work frequently deals with the landscape, wildlife and people of Alaskan, as well as the legends that have sprung up in this vast land. Jamie
Wyeth has exhibited realistic paintings as a visiting artist. The wildlife paintings of noted ornithologist Roger Tory Peterson and Canadian
painter Robert Bateman have also been shown,
as well as Northwest artist Bill Reese's horse-and-wagon and Mexican street scenes.
Larry Avhakana, a sculptor, tells legends of
his Eskimo heritage through his work. Chuna-Yupih, a Native American of Alaska, interprets
local birds, animals and folklore in his work.

Stephan Fine Arts 600 W. 6th Ave. 440 W. 3rd Ave.
5 & Capt. Cook Hotel/9th Ave & K St., Anchor-
age, AK 99501 (907) 278-9555; daily: 10-6;
owner: Pat & Pam Stephan dir: Dawn Kelly

Stephan Fine arts features international and Alaskan artwork, specializing in original graphics,
oils, acrylics, watercolors, ivory and soapstone
sculpture. The gallery publishes editions of Alaskan art.
Artists exhibited include Ernest Robertson,
well-known for his oil paintings of Alaska, and
Charles Gause, an Alaskan watercolorist. The
gallery also shows work by Leroy Nieman, Norman Rockwell and Aldo Luongo in Alaska.

KETCHIKAN

The Gathering #28 Creek St., Ketchikan, AK 99901
6 (907) 225-5987; Mon-Sat: 10-5:30; owner/dir:
Kathleen Johnson Kuhn

The Gathering specializes in contemporary
Alaskan art. The gallery features painting,
prints, pottery, sculpture, jewelry and Alaska
native art, which includes carving, jewelry, basketry, masks and ivory. Artists from the Pacific
Northwest area are also featured. The Gathering
provides a showcase for Alaska's more contemporary artists as well as for traditional Alaskan
artists.
Outstanding Alaskan artists include Larry Avhakana, Jim Schoppert, Kathy Donahey, Marianne Wieland, Keith Appel, Dale DeArmond
and Fred Machetanz. Local artists include Elizabeth Rose, Norman Campbell, Mattie Walters
and George Estrella. Representatives of Alaska
native art are David Boxley, Freda Diesing,
Robert Davidson, Linda Auernhammer, Steve
Brown, Jack Hudson and a variety of Eskimo
artists. The gallery has recently shown works by
Linda Larsen and Kes Woodward.
Artists from outside the Alaska region include
Suellan Ross, Yvonne Davis, Randy Rutherford,
Craig Zweiffel, Judith Starbuck, Sutton Hoo and
Judith Gumm.

ARIZONA

PHOENIX

Ianuzzi Gallery 2650 E. Camelback Rd. Phoenix, AZ
7 85016 (602) 956-4522; open evenings except
Sun; owner/dir: Mara Ianuzzi

The Ianuzzi Gallery features important international artists, with an strong accent on sculpture.
Conrad Marca-Relli, Fernando Botero and
Laddie John Dill are among the painters featured
in the gallery. Sculptor George Rickey was one
of the first to experiment with kinetic art. Sculptor Kenneth Snelson developed open structures
based on tension and compression members—
structures called "tensegrities" by inventor
Buckminster Fuller. Harry Bertoia, known for
his architectural and sonic sculpture, usually
worked with abstract organic motifs in various
metals welded over a metal framework. The
gallery also carries work by German graphic artist, painter and sculptor Paul Wunderlich, known
for his meticulous draftsmanship and surreal
imagery.
Other artists exhibited include Bill Kane, Lyman Kipp, Deborah Remington, and Jack Zajac,

as well as Fred Borcherdt, an Arizona sculptor working with forged iron and natural boulders, and Bob Boss, a Tucson painter.

Thompson Gallery 815 N. Central, Phoenix, AZ
8 85004 (602) 258-4412; Mon-Fri: 9-5 Sat: 9-12

Located in downtown Phoenix, the gallery typically exhibits over 400 paintings, graphics, and sculptures by nationally and internationally recognized artists.

Gallery artists include Charles Campbell, a Phoenix artist whose oils have a jewel-like quality. Ina Mae Moore is a watercolorist who paints in a loosely traditional fashion. Phoenix artist Shirley Murray is a strong colorist with a broad brush, impressionist technique.

George Procok is a New York artist who paints Western scenes and landscapes, working in a traditional style in acrylics on paper.

The gallery frequently has available fine old works as well as contemporary art.

Gallery Three 3819 N. Third St., Phoenix, AZ 85012
9 (602) 277-9540; Mon-Fri: 8:30-5:30; owner: Shirley Manoukian

Opened in 1969 in the developing Uptown section of downtown Phoenix, Gallery Three shows contemporary art. There is a substantial collection of original graphics and posters, in addition to the painting and sculpture. Among the works featured are large, layered-canvas landscapes by Lewis Wilson; watercolors and hand-colored etchings and lithographs by Harold Mason; pen-and-ink drawings by Ralph Gus Kniffin; and hand-loomed fiber pieces by Carol Colburn. Large-scale photographs by Larry Olson also are displayed.

Other works on view include processed paper works by Karen Poulson, pastels and watercolors by Bill Lundquist, watercolor and ink landscapes by Michael Scaerba, acrylic on canvas landscapes by Helen Seller, and canvases by Hank Spirek. In addition, Gallery Three displays a collection of African artifacts.

West Side Gallery 4411 N. 19th Ave., Phoenix, AZ
10 85015 (602) 265-8940; Mon-Sat: 10-5; dir: Gary Zodrow

This modern, spacious gallery offers a wide variety of art in many styles—traditional, impressionistic, abstract, and decorative. Watercolors, oils, acrylics, and mixed-media works may be seen.

Among the works on display are embossed etchings in Southwestern motifs by Norma Andraud, watercolors of Southwestern subjects by Douglas P. Bennion, watercolors of landscapes and wildlife by Gary Davis, abstract watercolors by Betty Braig, watercolors of Southwestern landscapes by Ann McEachron, and floral watercolors by Jacqueline Schulz.

The gallery also shows the Western oils of Alan Alexander, Southwestern landscapes in oil and watercolors by Howard King and Zoltan Szabo, watercolors and acrylics by Robert Oliver, and traditional large landscapes by Frank Wagner.

Wood, bronze and alabaster sculpture is also displayed.

SCOTTSDALE

Bishop Gallery 7164 Main St., Scottsdale, AZ 85251
11 (602) 949-9062; Mon-Sat: 10-5 May 20-Oct 1: closed; owner: W.P. Bishop

The gallery handles contemporary sculpture and two-dimensional work, as well as a wide range of antiques.

Sculpture is represented by the works of Kenn Bunn and George Carlson. Bunn creates beautiful, anatomically correct bronzes of animals, particularly African animals. Carlson has had a one-person show at the Smithsonian Institution. His Tarahumara bronzes capture the way of life of a tribe of Indians in Mexico before the government ran a highway through their village.

The gallery's leading painters are Neil Jacob, Len Chmiel, John Zahourek, Ray Patterson and Amy Sidrane. Jacob is known for his figurative work documenting the costumes and physiognomy of Indian tribes, and recently has also painted African tribes. Chmiel is an acclaimed landscape artist working in oil. He paints throughout the United States as well as in foreign countries, and recently painted and drew in China.

The gallery also handles the work of rising young artists, including oils and pastels of remote villages by Will Caldwell, landscape and wildlife watercolors by Sam Venn, surrealist layered paintings by W.P. Hill, and graphic work by Sheridan Oman and Gene Kloss. Well-known illustrator Judy Graese is represented by wood engravings and watercolors.

The gallery has a fine selection of baskets from Botswana and Kwazulu. Bishop's antique collection contains American country, English, Continental, Oriental, African and Oceanic items.

Suzanne Brown Gallery 7160 Main St., Scottsdale,
12 AZ 85251 (602) 945-8475; Mon-Sat: 9:30-5:30 Thu eve 7-9 during season; owner/dir: Suzanne Brown

For over 20 years, the Suzanne Brown gallery has represented contemporary artists of the West and the nation. Among the more prominent artists shown are Veloy Vigil, Ed Mell, and Wilma Parker.

The gallery also exhibits intense Indian images by Clifford Beck, soft pueblo batiks by Katalin Ehling, contemporary cowboy images by Howard Post, whimsical portrayals of desert animals by Anne Coe, dramatic landscapes by Carl Douhie, and watercolors depicting the Tucson area by Barbara Smith. Other artists represented include Los Angeles artist Richard Bunkall, Aleutian artist Alvin Amason, and Texas artists John Hogan and Daryl Howard.

Marilyn Butler Fine Art 7157 Main St., Scottsdale,
13 AZ 85251 (602) 994-9550; Mon-Sat: 10-5; owner/dir: Marilyn Butler

Opened in 1978, the gallery features a select number of contemporary artists whose work has emerged since the 1960s and achieved a worthy influence in the mainstream of contemporary American art.

Fritz Scholder, Roy DeForest and Judy Chicago are among the best-known of the artists exhibited. Scholder's style, in which he admits the influence of Francis Bacon, has aroused considerable controversy for his Expressionistic

rendering of Indians, at odds with traditional imagery. Scholder is known for his paintings, sculpture, monotypes, and prints. Roy DeForest's painting blends classical art history and personal experiences into a crazy-quilt of images—dogs, cows, people, furniture, etc—slippery-sliding over the picture plane. Judy Chicago has become known as a feminist artist. Her tough-sounding last name was adopted as a humorously defiant gesture towards the art world; some of her first work was based on techniques of spray-painting adopted from the avowedly masculine pursuit of customizing cars. Her more recent work, such as *The Dinner Party,* is based on the recuperation of women's history, and employs ceramics, weaving and documentation to produce a large-scale, unified work.

Jaune Quick-To-See Smith paints landscapes that reflect her French-Cree and Shoshone heritage, growing up on the Flathead Reservation. Emmi Whitehorse paints "standing ruins" that recall her Navajo childhood and the landscape of the Southwest. Christopher Pelley and Mark McDowell work in oil, depicting common objects on uncommon fields.

Joan Cawley Gallery 7137 Main St., Scottsdale, AZ
14 85251 (602) 947-3548; owner: Joan Cawley dir: Ann Quackenbush

With locations in Wichita, Kansas and Scottsdale, the Joan Cawley Gallery specializes in contemporary Southwestern and Mexican art. The Gallery exhibits acrylics, watercolors, original lithographs, serigraphs, and etchings, as well as unnumbered print editions and poster art by the artists shown at the gallery.

Artists exhibited include R.C. Gorman, Rufino Tamayo, Francisco Zuniga, Amado Pena, Jr., Mary Ann Ginter, Michael Atkinson, Veloy Vigil and Charles Jeffress. Recent shows include an R.C. Gorman book signing and graphics show, and a Mary Ann Ginter exhibit of acrylics on linen. Works by noted Mexican sculptor Francisco Zuniga have also been shown, as well as watercolors and serigraphs by Michael Atkinson.

In addition, the gallery carries *champleve* jewelry by Ursula Duba.

Fagen-Petersen Fine Art 7077 Main St., Scottsdale,
15 AZ 85251 (602) 941-0089; Mon-Sat: 10-10 Sun: by appt; dir: C. Fagen

Fagen-Petersen specializes in the work of young, undiscovered artists, as well as some established figures. Their work ranges from traditional oils to contemporary and postmodernist pieces.

The gallery exhibits the work of Bruno Zapan, who lives in Majorca, producing thick impasto oils and silkscreen prints. Two prominent painters of the Southwest, James Rome and Dagne, are also featured. Rome's works on paper depict stylized Indian iconography and versions of Indian legends and mythology. Dagne's nude portraits are shown, and the gallery plans to exhibit her bronzes. Kirk Hughey, a protege of Fritz Scholder, shows contemporary Southwest impressionist paintings with a strong gestural facture.

Among the new artists the gallery has assembled, some from its Newspaper Artists Exhibition, are: Gregg Singley, Elizabeth Carson Manley and Ray Jacobsen, Southwestern water-

colors; Lee Seebach, impressionist oil painting; Kee Rash, photorealist painting; Patti Valdez, finely detailed etchings; Antonio Grass, silkscreen prints on Aztec themes; and Nessa Gale, contemporary sculpture in marble, bronze and wood.

The gallery has a private collection of Mexican masters such as Rufino Tamayo, Silva-Santamaria, and Ana Maria Pecanins, and plans to exhibit work by Chicano (Mexican-American) artists from the MARS Gallery (Movimiento Artistico del Rio Salado).

Golden West Galleries 7130 Main St., Scottsdale, AZ
16 85251 (602) 941-5164; Mon-Sat: 10-5; owner/dir: Barney Goldberg

Featuring fine 19th and 20th century American Western and Southwestern art, the gallery carries painting and sculpture by many of the master artists of the region. The gallery specializes in wholesaling to the trade.

Charles M. Russell, Frederic Remington, William R. Leigh and Henry Farny are among the prominently featured Western masters. Southwestern masters include the Taos Founders, specifically E.I. Couse, Joseph Henry Sharp, Oscar Berninghaus, Oscar Blumenschein, Martin Hennings, Walter Ufer and Kenneth Adams. Important 19th century landscape artists such as Albert Bierstadt and Thomas Moran are included in the gallery's roster. Bronze sculptures by Carl Kauba (1865-1922) and Alexander Phiminster Proctor (1862-1950) are offered, along with works by the living sculptor Harry Jackson. Also available are paintings by Russian-born artists Nicolai Fechin and Leon Gaspard, and *Saturday Evening Post* cover illustrators Norman Rockwell and John Falter.

Several works by Gerard Curtis Delano, best known for his paintings of Navajo Country, are shown in the gallery; also, numerous paintings by Grace Carpenter Hudson, who portrayed California's Pomo Indians, and their children in particular, with great sensitivity.

Recently the gallery has been handling such American Impressionists as Edward Potthast, Childe Hassam, Willard Metcalf, Theodore Robinson, and California plein air painters Edgar Paine and Hanson Duvall Puthuff.

Hand & Spirit Crafts Gallery 4222 N. Marshall Way,
17 Scottsdale, AZ 85251 (602) 949-1262; Tue-Sat: 10:30-5; owner/dir: Joanne Rapp & Star Sacks

Hand and Spirit shows contemporary fine crafts, with topical shows including traditional crafts. While leading American craft artists in all media are represented, the gallery consistently shows ceramics, fiber, wood and jewelry.

Ceramists include Claude Conover, James Lovera, Wayne Higby, Andrea Gill, Peter Shire, Bennett Bean and Jean Otis. Fiber artists shown are Janet Taylor, Richard Landis and Diane Iter.

Ed Moulthrop, George Nakashima, Bob Stockdale, Garry Bennett and David Lory are woodworkers whose carvings are regularly exhibited. The gallery also displays the jewelry of Ronald Hayes Pearson, James Meyer, Clare Yares, Ann Young and Peggy Simmons. Anne Flaten Pixley, Glenn Brill and Jody Klein all work in handmade paper.

"The Mirror" is the part of the gallery that

displays wearable art. Designers include Judy Corbet, Susan Neal, Ellen Hauptli, Anahisa Hedstrom, Asiatica (Fifi White and Elizabeth Wilson), and Puri Sharifi. Trunk showings are scheduled on a regular basis.

Elaine Horwitch Galleries 4211 N. Marshall Way,
18 Scottsdale, AZ 85251 (602) 945-0791; Mon-Sat: 9:30-5:30; owner: Elaine Horwitch dir: James Ratliff

The focus of the gallery is on contemporary Southwestern art, including painting, drawing, graphics, and sculpture. Contemporary art by nationally recognized artists is also exhibited.

Nationally recognized artists include Paul Jenkins, a second generation Abstract Expressionist whose style, similar in technique to the work of Morris Louis, Helen Frankenthaler and Sam Francis, evolved from washes and splashes of thinned paint. Works are also shown by Abstract Expressionist Ida Kohlmeyer, whose painting presents a complex "alphabet" of painterly signs, and Abstract Illusionist James Havard, whose painterly brushstrokes, smears and planes of color appear to float above the surface of the painting by a curious application of trompe-l'oeil technique. Realists exhibited include Tom Palmore, photorealist David Kessler, Southwest "pop" artist John Fincher, and Southwest photorealist Bill Schenck. Merrill Mahaffey paints landscape, while Beth Ames Swartz uses mixed-media in a Neo-Expressionist style.

Other artists include Masoud Yasami, illusionist painting; Brian Blount, chalk and torn paper; Harry Fonseca, Indian folklore genre paintings; Tom Golya, "power sticks"; Carol Sherwood, ceramics; Judy Rhymes, watercolors; Rudy Fernandez and Suzanne Klotz-Reilly, mixed media shelf pieces and sculpture.

Leslie Levy Gallery 7141 Main St., Scottsdale, AZ
19 85251 (602) 947-0937; Summer: Tue-Sat: 10-5 Oct-Apr: Mon-Sat: 10-5 & Thu eve: 7-9; owner/dir: Leslie Levy

The Leslie Levy Gallery has a reputation as one of Arizona's leading contemporary galleries. The gallery exhibits many contemporary American artists, with an emphasis on new realism, such as photorealism.

James Harrill paints the land and architecture of the Southwest and the equally strongly-lit land and architecture of Greece, revealing the effects of light on white-washed adobe. John Bayalis, Jr., paints photorealist still lifes in watercolor; while Steve Hanks does precise romantic watercolors and pencil drawings of women. Other artists shown are Eileen Bryce, Allen Garns, David Hare, Hilary Heyman, Patricia Hunter, John Kleber, Eugene Norton, Robert Parkison, Kirk Pederson, Brian Quinn, Jesse Silver, D.G. Smith, Harold Joe Waldrum and Gregory West.

During the winter season, shows change every three weeks and the gallery remains open Thursday evenings for the traditional Scottsdale "Art Walk".

Main Trail Gallery 7169 Main St., Scottsdale, AZ
20 85251 (602) 949-9312; Mon-Sat: 9-5 Jun-Sep: closed Mon; owner/dir: Dick Flood III

With locations in Scottsdale and Jackson, WY, the gallery specializes in masters of the Old West

and significant contemporaries, both in bronze sculpture and in paintings. Also on display are antique baskets, pottery and objects from the Northwest Coast.

Featured artists include Grant Speed, Daro Flood, Dennis Smith, Richard Greeves, James Reynolds, Gary Kapp, Jeffrey Lunge, Nat Youngblood, Robert Knudson, Charles M. Russell, Ace Powell, Joe DeYoung, Bill Schenck, Earle Heikka, Donald "Putt" Putman, Stella Shutiva, Sandy Scott, John Houser, Jon Lightfoot and Ross Stefan.

Mammen Gallery II 4151 N. Marshall Way, Scotts-
21 dale, AZ 85251 (602) 949-5311; Jun-Sep: Tue-Sat: 10-5 Oct-May: Mon-Sat: 9:30-5:30 Thu eve: 7-9; owner/dir: Betty Mammen

Mammen Gallery II features contemporary, traditional, and Western art. The media represented include oils, watercolor, batik, bronze and marble.

The gallery presents in Arizona the work of nationally known sculptor Jasper D'Ambrosi, who creates classical and intricately detailed Western bronzes. There is a strong emphasis on watercolor, with works shown by artists De-Loyht-Arendt, Roland Lee, Larry Weston, Gloria Gemmill, Jinni Thomas and "Del" Decil.

Vat-dyed batiks by Philomena Clarke are featured. Her work is known for strong design and balanced color. Historical Western scenes by Dave Flitner also may be seen, along with large-scale landscapes. Oil paintings of Western ranch scenes by Dwayne Brech are realistically accurate in detail. Nationally known Indian artist Carol Theroux paints realistic dancers and children in acrylics.

Martin Gallery 7257 First Ave., Scottsdale, AZ 85251
22 (602) 947-3406; Mon-Sat: 9:30-5 Summers: closed Mon

Established in 1966, the Martin Gallery is one of Scottsdale's oldest and best-known fine art galleries. The gallery offers contemporary paintings, sculpture, pottery and graphics, with an emphasis on original art of the Southwest.

Artists long exhibited by the gallery include Len Agrella, Eyvind Earle, Ron Faner, Charles Frizzell, Robert Hamilton, Starr Johnson, Judith Kettunen, Harold Lyon, Ana Maria Pecanins, and Robert Watson.

The gallery's collection also includes graphics by international artists such as Salvador Dali, Guillermo Silva Santamaria, Kaiko Moti, and Diana Hansen. Limited edition prints by Ray Harm, Charles Frace, Charles Harper, Jim Harrison, Joe Beeler, Gordon Snidow, Bill Owen, and Fred Fellows are on display in the large print gallery.

The May Gallery 7149 Main St., Scottsdale, AZ
23 85251 (602) 941-2370; Mon-Sat: 9:30-5:30; Jun-Sep: closed

Specializing in American realism, the gallery concen-trates on Western landscapes and depictions of figures from the Old West—pioneer settlers, cowboys, Indians, and trappers. Generally, the artist's rendition idealizes these subjects.

The paintings of Roy Kerswill dominate the gallery. Kerswill has made the mountain man his central subject for many years. Other artists

highlighted include Fritz White, winner of the Gold Medal for Sculpture at the 1983 Cowboy Artists of America exhibition; Greg McHuron, who paints watercolors and oils; Gerry Metz, popular young painter of mixed-media historical scenes; and Bob Abbett, an outdoor painter who depicts hunting, fishing and rodeos.

The gallery shows work by Dick Dahlquist, a Colorado painter who paints the mountain man; by John Leone, who formerly illustrated Western novels and made a transition to easel painting; and by his wife Martha Leone, who does naive paintings with skillful design and draftsmanship.

The May Gallery also features the paintings of Olaf Wieghorst, active from 1920 through the 1970s, whose work makes the transition from early styles of Western painting to contemporary Western art.

Missal Gallery 7134 Main St., Scottsdale, AZ 85251
24 (602) 946-9612; Mon-Sat: 10-5; owners/dir: Pegge & Joshua Missal

The Missal Gallery opened in Scottsdale in 1976, after operating in Farmington, CT, for 6 years. The gallery moved to a new, larger space in August 1983 and now is located on "Gallery Row" in Scottsdale.

The gallery features oils by American artists dating from 1850 to World War II, including works of the American Landscape School. It also offers paintings by post-Impressionist French artists and British Victorian painters. Original prints are available by such major artists as Durer, Rembrandt, Goya, Whistler, Picasso, Miro, Chagall, Rouault, Renoir, Toulouse-Lautrec, and Vasarely.

A section of the gallery is devoted to paintings and drawings by Stephen Missal, a Scottsdale artist. Missal's oils range from fantasy and surrealism to character-study portraits.

The gallery does not have shows, but instead maintains a fine permanent collection of paintings and original prints.

Montgomery-Taylor 7100 Main St., Scottsdale, AZ
25 85251 (602) 945-0111; Mon-Sat: 10-5:30; owner: Ron Watkins dir: Claude D. Peters

The gallery specializes in 18th, 19th, and early 20th century European painting, as well as some American painting.

Artists whose work is available include Richard Redgrave, Nicholas J. Rosenboom, James Webb, P.C. Dammer-son, S.R. Percy, Sam Boogh, H.J.Y. King, T.B. Hardy, Edward Duncan, F. Maillaud, Thomas Sidney Cooper, Montague Dawson, William MacDuff, A.D. DeBriansky and many more 19th century watercolorists.

The gallery also handles the work of marine painter Charles Vickrey.

O'Briens Art Emporium, Inc. 7122 Stetson Dr.,
26 Scottsdale, AZ 85251 (602) 945-1082; Nov-May: Mon-Sat: 10-5 Jun-Oct: Tue-Sat: 10-5 owner: Mr. & Mrs. William Dickerson

O'Briens was established in 1855 in Chicago. The gallery presents artists from Canada and the United States who work in oils, watercolor and sculpture. The emphasis is on a representational style.

Although much of the work shown has a Southwestern feeling, florals, seascapes, and still lifes can also be found. The work of R. Brownell McGrew has long been featured. McGrew is considered by some to be the "dean" of painters who concentrate on American Indians as subjects. His paintings and drawings revel in the powerful contrasts of light and the weathered human features of the Southwest. The paintings of Clarence McGrath may also be admired. McGrath travels widely and has painted the peoples of Guatemala, Tibet and Africa. Other painters include Kang Cho, William E. Sharer and Mark Daily.

Sculpture is represented at the gallery by the works of Glenna Goodacre, George Lundeen, Gerald Balciar, Estelle Austin, Ann Larose, Dora Perry and Hollis Williford. The whimsical wash and pen-and-ink drawings of Jean Ekman Adams are also exhibited.

Lovena Ohl Gallery 7373 Scottsdale Mall, Suite One,
27 Scottsdale, AZ 85251 (602) 945-8212; Mon-Sat: 9:30-5:30; owner: Lovena Ohl dir: William Faust

Specializing in prehistoric, historic and contemporary Indian arts and crafts, the Lovena Ohl Gallery shows work by leading Native American artists of the Southwest. Works shown include jewelry, rugs, pottery, sculpture, and paintings. Sand paintings, a traditional artform made with colored sand and gravel and used in healing rituals, and kachinas, doll-like images of spiritual helpmates, are also on display.

Indian artists include Charles Loloma, "The Grand Master", a Hopi jeweler internationally known for his use of lapis, coral, turquoise and other stones with gold and silver. Larry Golosh, jeweler, is noted for his contemporary designs and eccentric placement of stones. Navajo jeweler Harvey Begay combines traditional designs with contemporary influences. The internationally collected polychromed vessels of Blue Corn, a San Idelfonso Pueblo potter, are inspired in ancient motifs of the Sikyakti potters. Grace Medicine Flower's pottery is decorated with intricately incised *sgraffito* designs, a technique which is more recent than the earliest black-on-white or polychrome painting. Robert Redbird paints the visions and beliefs of the Kiowa.

The Lovena Ohl Foundation helps young Indian artists to grow and mature in their chosen field while preserving their culture. Recipients include David Johns, a Navajo painter of portraits and abstracts using traditional and contemporary designs, and James Little, a Navajo jeweler who creates legends of his people in gold and silver. Donations to the Foundation are tax deductible.

Bob Parks Gallery, Inc. 7072 5th Ave., Scottsdale,
28 AZ 85251 (602) 946-6100; Mon-Sat: 10-5; owner: Bob Parks dir: Elizabeth Hain

The gallery specializes in the Western bronze sculptures of Bob Parks, and displays paintings by many Western contemporary artists such as Harland Young, Stephen Juharos and Bill Neal.

The sculptures of Bob Parks are some of the finest bronzes in the Western art field today. His pieces are charged with action, lifelike, yet with a personal touch. Bob's most notable piece is probably the "Gene Autry" bronze, which has been placed in the Cowboy Hall of Fame in Oklahoma City.

Peacock Galleries, Ltd. 7173 Main St., Scottsdale,
29 AZ 85251 (602) 941-2278; Mon-Sat: 10-6; dir:
Anne Morrow

The Peacock Gallery specializes in contemporary
American Impressionism. The artists exhibited
work in oil, acrylic, watercolor and bronze.

American landscapes, florals, still life and
figure painting are rendered by artists Richard
Earl Thompson, Claire Ruby, Jane Shuss, Mary
Betzenderfer, Buck McCain, Tom Lynch, Paul
Abram, Jr., Anders Gisson, Ray Vinella and
Edward Norton Ward. Bronzes of varied subjects
including ballet, wildlife and animal subjects,
and the human figure are sculpted by Sparkle
Fuller Anderson, Gary Price, J.L. Searle, B.J.
Martin and Mansel Ocheltree.

In addition to original works, the gallery
also carries a collection of signed and numbered
limited edition prints and posters by well-known
American artists. These include Frank McCar-
thy, James Bama, Robert Bateman, Maynard
Reese, John Clymer, James Reynolds, Gordon
Snidow, Claire Ruby and Tom Lynch.

C.G. Rein Galleries 4235 N. Marshall Way, Scotts-
30 dale, AZ 85251 (602) 941-0900; Mon-Sat:
10-5:30; owner: C.G. Rein dir: Jane Josephson

With locations in Denver, Houston, Santa Fe,
Minneapolis and Edina, MN, in addition to this
one in Scottsdale, C.G. Rein Galleries offers a
large and very diverse inventory of works in all
media by American, Mexican, European and
Oriental artists. The collection is eclectic, rang-
ing from abstract to figurative works by contem-
porary artists as well as 19th century masters.
C.G. Rein also handles a large and flexible leas-
ing program.

The emphasis is on contemporary American
art, especially stressing works by regional Ameri-
can artists. Controversial contemporary South-
western Indian artist John Nieto dramatically
limns his silhouetted images with bright color.
Landscape expressionist Paul Shapiro is well-
known for his vivid palette. Sharokh Rezvani
works in intaglio, monotypes and paper. Ann
Taylor is famed for her "sky" paintings—large,
freely flowing areas of paint on canvas that imply
accelerating movement. Darrell Hill places im-
ages in absurd situations that have psychological
undertones, and Genevieve Reckling paints arid
landscapes in a contemporary realist style.

Sculptors at Rein are: Paul Granlund, realistic
bronzes of the human figure; James McCain, an
artist skilled in handling unusual varieties of
wood; Bruce Wynne, who interprets Indian lore
in alabaster; and Eichengreen/Gensburg, sisters
who work together to produce highly polished
bronze abstracts.

The gallery also has extensive holdings in
modern American Western masters, such as Olaf
Wieghorst, Laverne Nelson Black, Albert Bier-
stadt and Gordon Phillips, as well as modern
Mexican masters such as Rufino Tamayo, Fran-
cisco Zuniga, Carlos Merida and Diego Rivera.

Savage Gallery 7112 Main St., Scottsdale, AZ 85251
31 (602) 945-7114; Mon-Sat: 10-5; owner: J.N.
Savage dir: Don Bell

Savage Galleries features paintings and sculpture
in a traditional realist style, usually depicting
Western and Southwestern scenes and life.

Among the artists featured, Bill Hughes is
known for his dramatic use of light and shadow
in grand panoramic landscapes; sculptor Ken
Payne portrays historical ranch and rodeo scenes
from the life of the Western cowboy; painter Gil
Dicicco records the moods of Southwestern land-
scape with a painterly touch; while Manes Lich-
tenberg brings to the gallery sun-drenched scenes
of Mediterranean towns in France, painted in
oils. Oil painters Robert Winter and George Dee
Smith portray Western subjects. Scott Jennings
and Patrick Woodman paint Arizona and New
Mexico landscape in oils and acrylics.

Watercolors by Edith and John Massey, Lee
Rommel and Betty Saarni are also available, as
well as bronzes by sculptor Jim Knox.

Gallery 10 7045 E. Third Ave., Scottsdale, AZ 85251
32 (602) 994-0405; Mon-Sat 10-5 and by appt; dir:
Lee Cohen

One of the prominent centers in the United States
for fine art by Native Americans, Gallery 10 has
a showroom in New York and its headquarters in
Scottsdale. The gallery specializes in historic and
contemporary textiles, prehistoric, historic and
contemporary pottery, historic basketry and ka-
chinas, artifacts, historic and contemporary jew-
elry. The oldest works are of the Anasazi, the
"alien ancient ones" in the Athapaskan tongue
of the Navajo, who wandered into and settled the
Southwest long after the complex Anasazi cul-
ture had vanished.

Contemporary potters such as the late Maria
Martinez led a revival of the ancient culture
among the Hopi and Pueblo Indians. Her work is
shown at the gallery , along with the polished
blackware of Margaret Tafoya and the work of
Nancy Youngblood Cutler, Jody Fowell, and Al
Qoyawayma.

Featured weavers are Philomena Yazzi, Ra-
mona Sakiestewa and Sadie Curtis. Contempo-
rary jewelry by Charles Loloma and kachina
carver Von Monongya are set alongside basketry
from the Yokuts, Apache, Panamint and Pomo
Indians.

The gallery displays the paintings of magic
and ceremony of the Plains Indians created by
superrealist Paul Pletka. Photography of the tra-
ditional ways of life is shown by Jerry Jacka.
The early Native American subjects of Fritz
Scholder are also exhibited.

Trailside Galleries 7330 Scottsdale Mall, Scottsdale,
33 AZ 85251 (602) 945-7751; Mon-Sat: 9:30-5:30;
owner/dir: Ted Mollring & Christine Mollring

There are four locations of Trailside Galleries:
Jackson Hole, WY, Phoenix International Air-
port, the Four Seasons Hotel in Houston, and the
gallery in Scottsdale. Trailside presents art from
the classic era of Western painting and contem-
porary Western sculpture and painting.

Works are available by Frederic Remington
and C.M. Russell, the most exemplary Western
painters of the robustious pioneer days. Unlike
the anthropological work of earlier observers
such as George Catlin, Seth Eastman or Alfred
J. Miller, Russell and Remington portray an era
which senses it own end, and views its world
with a certain raw nostalgia. The Taos Foun-
ders, also extensively featured in the gallery,
carried on this tradition into the 20th century.

George Carlson, *Mane of Wind,* 23 x 28, bronze, Bishop Gallery (Scottsdale, AZ).

Ed Moulthrop, *Turned Wooden Globes,* Hand and The Spirit Crafts Gallery (Scottsdale, AZ).

Contemporary sculptors and painters of Western subjects shown at the gallery include Joe Beeler, John Clymer, Robert Duncan, Fred Fellows, Bill Nebeker, and Bill Owen, all members of the Cowboy Artists of America. Also exhibited are wildlife artists Kent Ullberg, Sherry Sander, John Seerey-Lester and Nancy Glazier, as well as Rod Goebel, Walt Gonske and Robert Daughters, all of whom are important American landscape impressionists.

The Trailside inventory also includes an extensive collection of traditional and contemporary Indian jewelry and weaving.

Udinotti Gallery 4215 N. Marshall Way, Scottsdale,
34 AZ 85251 (602) 946-7056; Tue-Sat: 10-5 owner/dir: Agnese Udinotti

The gallery mainly represents the work of Agnese Udinotti, whose images evolve in welded steel sculpture, oil painting and pencil drawing. Occasional exhibitions of other artists are held.

All of the work refers to the human form, and the images are based on psychological and sociological statements about contemporary man. Udinotti's work in steel represents masses of anonymous miniaturized people. Her painting and drawing take an "x-ray" look at the individual human.

Work by figurative artists Rudy Turk and Carole Foster Blake is more whimsical and humorous in tone. The gallery also exhibits work by Kansas artist Jim Pruner and Texas artist Steve Crain.

A collection of primitive art from New Guinea is on view as well. All the objects in the collection have been used ceremonially.

The Gallery Wall 7051 Fifth Ave., Scottsdale, AZ
35 85251 (602) 990-9110; Mon-Sat: 9-5 Oct-May: Thu eve: 7-9; owner/dir: Sandy & Glenn Green

With locations in Phoenix, Santa Fe and Scottsdale, the Gallery Wall has ample resources for its specialty, exhibiting contemporary Southwestern art, particularly work by Native Americans.

Native American sculptor Allan Houser is often thought of as a "sculptor's sculptor". He works in Carrara marble, Indiana limestone, Colorado alabaster, and African wonderstone. A balance between form and void—positive and negative space—is a hallmark of his bronzes. He excels in simple forms that convey a universal sense of serenity and dignity.

Dan Namingha is a Hopi-Tewa painter who works in a variety of media, including acrylic on canvas, oil, pastel, and lithography. Most of his subject matter is inspired by his Hopi heritage, but his work are contemporary in design and execution.

Both artists have been featured in Germany in a traveling exhibit of their work. The tour has recently been extended to include Eastern European countries.

Yares Gallery 3625 Bishop Lane, Scottsdale, AZ
36 85251 (602) 947- 3251; Mon-Sat: 10-5 Jul-Aug: closed; owner: Riva Yares dir: Douglas Webster

The Yares Gallery carries modern and contemporary paintings, sculpture and drawings by established masters and recognized artists.

The New York School of the 50s is well represented with works by abstract painters Paul

Brach, Friedel Dzubas, Esteban Vicente and Hans Hofmann. European artists in the Dada and Surrealist tradition are well represented, with works usually available by Max Ernst, Jean Tinguely, Yves Klein and Gunther Uecker. Other artists whose work is available are California ceramic sculptor Robert Arneson, distinguished American colorist Milton Avery, Constructivist Ilya Bolotowsky, painterly realist Byron Browne, and Chilean surrealist Roberto Matta. Phillipine-born painter Alfonso Ossorio is known for his exuberant jeweled mosaics of shells, feathers, and other found objects. The work of Color Field painter Jules Olitski has evolved from stained canvases to speckled, sprayed textures and finally to dense impastos of baked-on paint.

One may also see works by Fletcher Benton, James G. Davis, Sorel Etrog, Dorothy Fratt, John Henry, Luis Jimenez, James McGarrell, Fox Joy McGrew, Ray Parker, Jerry Peart, Paul Reed, Richard Saba, Frank Anthony Smith, Kenji Umeda, Jim Wade and others.

SEDONA

El Prado Galleries, Inc. Box 1849, Sedona, AZ
37 86336 (602) 282-7390; Mon-Sat: 10-5 Scottsdale: Sun: 12-5; prop: Don H. & Elyse Pierson

El Prado Galleries , Inc., embraces five different Southwestern galleries in Sedona, Phoenix and Santa Fe, all specialized in traditional, Western, impressionistic and contemporary art and a wide range of sculpture.

Award-winning impressionists shown at the gallery include: Terrence Hick, Ted Goerschner, and Keith Lindberg. Western artists are James Reynolds, Joe Beeler, and R.S. Riddick. Members of the Taos and Santa Fe Schools whose work is available at the gallery include Eanger Irving Couse, Fremont Ellis, and Peter Hurd. Southwestern artists exhibited are Fran, Hal and Kristin Larsen, David Chethlahe Paladin, and Mary Ann Nibbelink. The gallery also exhibits "Polages" by Austine Wood.

There are "people" sculptures by Naida Seibel; mixed media flower sculptures by museum sculptor Norman Neal Deaton; batiks by John Soulliere and Anna Balentine; and wildlife paintings in tempera by Geoff Mowery. New talent exhibited includes James Darum, Tom DeDecker, Pat Skiba, D.W. Pinkham, Richard Schiele and Ted Smuskiewicz.

Elaine Horwitch Galleries Schneblay Hill Rd. &
38 Hwy. 179; Sedona, AZ 86336 (602) 282-6290; Mon-Fri: 9:30-5:30; owner: Elaine Horwitch dir: James Ratliff

See listing for Scottsdale, AZ.

Husberg Fine Arts Gallery 556 So. Hwy. 179, Se-
39 dona, AZ 86336 (602) 282-7489; Mon-Sat: 10-5 Sun: 12-5 Jun-Aug: closed Sun

Opened in 1968, the gallery features contemporary Western, wildlife, and landscape paintings. There also is a selection of impressionistic and fantasy paintings.

The works of well-known Western artists are shown at the gallery. Frank McCarthy paints Western subjects featuring the Plains and Southwestern Indians. Arnold Friberg, illustrator of the Mormon Bible, paints vigorous renditions of

Western landscapes and Indian subjects. Super-realist Don Crowley specializes in Indian and Western subjects and still lifes. Ray Swanson is noted for his paintings of Indian life, with an emphasis on Indians of the Southwest.

The gallery also has presented the works of a group of impressionistic painters, including Alan Maley's views of France at the turn of the century, and works by Runcy, who specializes in Indian portraiture. Kent Wallace is a younger impressionist who paints contemporary American subjects.

Sculpture is also featured in the gallery's exhibits, including bronzes and wood carvings by J.N. Muir, Eillen Conn, Ken Ottinger, and Kevin McCarthy.

The gallery also features fantasy artists, among them Michael Hague, noted illustrator of children's books.

The gallery holds an annual exhibition every February at the Arizona Biltmore Hotel. Further details can be obtained by writing the gallery.

Masters Gallery of Fine Art, Inc. 431 Hwy. 179,
40 Sedona, AZ 86336 (602) 282-2226; daily: 10-5

Opened in early 1983, the Masters Gallery exhibits a varied selection from all art genres.

The gallery shows original art, lithos and etchings by Salvador Dali, Marc Chagall, Joan Miro, Pablo Picasso, and Alexander Calder along with works by Leroy Nieman, Kaiko Moti, Alvar, Reine, and Noyer.

Among the artists presented by the gallery are Delmary, who paints dazzling seascapes in the old Flemish style; Irv Burkee and John Davidson, multi-media works; Robin Cockburn, woodcarvings; Tess Nelson, drawings on scratchboard; Carlo Wahlbeck, paper sculpture; Dyan Nelson, soft/fabric sculpture; Fred Schimer, pottery; and Dick Canby, photography.

The gallery displays sculptures by Reagan Word, Jean Franck, Stan Johnson, Bonnie Burkee, Robert Refvem and Elizabeth Guarisco. Wall sculpture in resin-acrylic by Joe Pavsek and large-scale bas relief woodcarvings by David Fischel grace the walls of the two-story gallery.

Among the artists represented in oil, acrylic, watercolor and gouache are Stephen Juharos, Fred Oman, Betty Billups, Jim Lewis, Kelly Daniel, Alix Thayer, Don Schairer, Evelyn Embry, Tom Ward, Rita Joyce, Gwen Taylor, Gayle Kiveat, Patricia Andre, George (Jorge) Lane, Stephen Missal, Lucille Ferra, Sam Palmieri and Delmer Joakum.

The gallery also holds tours and seminars for students from elementary school age through college.

El Mundo Magico Gallery Box 186, Sedona, AZ
41 86336 (602) 282-3762 Mon-Sat: 9:30-5 Sun: 10:30-5

El Mundo Magico Gallery is one of the oldest galleries in Tlaquepaque Village, Sedona. The gallery features 52 artists, who work in handcrafted furniture, bronze sculpture, batik, watercolor, oil painting, and silkscreen.

Jerry Dollar's woodcarvings give the viewer the impression that he has just walked into a haven of real birds. Dollar carves detailed feathers on even his smallest pieces. The sandpaintings of C. Hodges are geometric studies of

Indian baskets, rugs, kachinas, potsherds, and pictographs. "Pauli", a Sedona artist, is famous for her stylized Indian design pottery in antiqued cracked glaze, with feather and yarn decorations. Airbrush artist Jerry Gadamus creates realistic wildlife and landscapes.

The gallery also displays three-tier tables made out of native Arizona juniper wood by artist Don Swanson; Indian and Western bronzes by Jerry Anderson and Fred Hill; "Huisinga" paintings that create landscape impressions in thick alla prima paint; and small bronzes decorated with handmade turquoise bracelets, necklaces, earrings and concho belts, made by Leona and Ray Tidd.

During the summer and fall artists work on the gallery premises, demonstrating their skills to the public.

TUCSON

El Presidio Gallery 201 N. Court Ave., Tucson, AZ
42 85701 (602) 884-7379; Mon-Sat: 10-5; owner: H. Rentschler

El Presidio Gallery features Western subjects in both traditional realism and modern stylization, but non-Western subjects are also included in the varied inventory. Also on display is an extensive collection of American paintings from the early 1900s. All painting media and some prints are shown.

Traditional Western painting is exemplified by the works of Chuck Pabst, Olaf Palm and Leighton Fossum, who paint landscapes and Western subjects. Also prominent in the gallery are paintings by Richard Kozlow, who combines landscape painting with abstract technique. The gallery also shows paintings and lithographs of Indian subjects in earthy Southwest colors by Jon Lightfoot.

Social commentary characterizes the paintings of Gil Boduc and Marcia Gaiter. Stainless steel and wooden figurative sculptures by Charles Ulrich are dynamic, visionary pieces. The gallery also shows photorealist painting by Francisco Rodriguez-Maruca, landscapes and figurative paintings by Nancy Fuller, and watercolors and prints by noted Blackfeet artist King Kuka.

Sanders Galleries 6420 N. Campbell, Tucson, AZ
43 85718 (602) 299-1763; Mon-Sat: 10-5

Sanders Galleries shows works by nationally known artists, specializing in traditional Western and contemporary Southwestern art. Only original art is shown, with a concentration in oil paintings, bronzes, and alabaster sculpture.

A sense of Western Americana is seen in the oils of Buck McCain, Ron Stewart, Doug Ricks, Jim Norton, Richard Iams, and Kimbal Warren. Tony Schibley's soft oil pastels and Loren Willis's very contemporary oils depict the traditions of Southwestern Indian tribes.

Sculptors include Jaramillo and Gordon Van Wert, who work in alabaster, sculpting images of Indian reservations and Spanish culture. The gallery shows bronze sculpture by Russell Bowers, Dan Bates, Fred Fellows, Bill Klesert, Al Micale, Buck McCain, Mansel Ocheltree, Gary Price, and Bob Scriber.

Settlers West Galleries 6420 N. Campbell, Tucson,
44 AZ 85718 (602) 299-2607; Mon-Sat: 10-5; owner: Stuart Johnson dir: Sandy Clendennen

The Settlers West Gallery specializes in Western and wildlife paintings of past masters and contemporary painters.

Artists include Howard Terpning, Kenneth Riley, Duane Bryers, Tom Hillana, James Reynolds, Frank Hagel, Nick Wilson, Joe Halko, Bob Kuhn, Morris Rippel, Jack Lestrade, Harley Brown, Paul Strisik, William Acheff, R.M. Stubbs, John Scott, Joe Buhler, Valoy Eaton and Tom Sander.

ARKANSAS

FORT SMITH

Moulton Galleries Brunwick Place, Suite B, 101 N.
45 10th St., Fort Smith, AR 72913 (501) 783-5351; owner/dir: Bettye Moulton

Contemporary painters of the Midsouth and Southwest (Arkansas, Oklahoma, Texas, New Mexico and Kansas) are showcased at the Moulton Galleries, which also exhibits work by California and New York artists. Styles range from representational to abstract.

The gallery shows several artists who have received various distinctions for their work in pastels, including Emily Guthrie Smith, Jill Bush and Judy Pelt. The gallery also features the watercolors of Tony Van Hasselt, member of the Watercolor Society of America.

Younger, emerging painters also receive attention. William McNamara's watercolors have recently won acclaim. while the paintings of Benham Dangers are included in several notable collections. Stoneware and cloth sculpture of American Indians by Carol Whitney, and works by Jean Richardson and Dan Rippe are also featured.

LITTLE ROCK

Arkansas Arts Center Box 2137 Little Rock, AR
46 72203 (501) 372-4000; Mon-Sat: 10-5, Sun: 12-5 dir: Townsend D. Wolfe III

Concerned with changing exhibitions of works from the Renaissance to the present, the gallery mounts museum quality exhibitions highlighting mostly works on paper of major artists as diverse as Rembrandt and Richard Diebenkorn. Not all pieces are for sale, excepting those borrowed from commercial sales galleries. Such works include those of Al Allen, a photorealist who uses patterns and space in his work. Realist Robert Andrew Parker also shows his works, often in conjunction with workshops he conducts at the center. Figurative expressionist works of Mimi Hyatt may also be found. The center's rental gallery features works of many local artists.

VAN BUREN

Art Gallery and Studio 423 N. 12th St., Van Buren,
47 AR 72956 (501) 474-7767; Mon-Fri: 9:30-5:30 Sat: 9:30-1:30; dir: Carolyn Holmes

The Art Gallery and Studio is a nonprofit organization promoting local and regional artists, both professional and amateur. One-person shows open the first Sunday of every month at two o'clock.

Artists whose work has been exhibited include Tim Andrews, Ethel Ashley, Bradly Ball, Josh Bear, Sylvia Bell, Alice Boatright, Jan Bruce, Betty Campbell, Ann Carrico, J.R. Denton, Lola Doom, Doris Echols, Rod Fleming, Lenice Gordon, Helen Hallum, Tonia Holleman, Judy Howard, Alice Hyman, Arba Landers, Bonnie Marrs, Val McKinney, Bell Cain Morrow, Kay Moss, Georgia O'Kelley, Patsy O'Kelley, Rema Pence and Joy Poole.

CALIFORNIA

BERKELEY

Ames Gallery 2661 Cedar St., Berkeley, CA 94708
48 (415) 845-4949; Wed-Sat: 2-6 and by appt; owner/dir: Bonnie Grossman

Comfortably located in the home of its director in the hills north of the Berkeley Campus, the gallery has specialized in the work of contemporary Bay Area artists. It has become known for periodic presentation of theme shows (e.g. "Eat Your Art Out", edible art and food images; three "pig shows"; "Inside Out", self-portraits by Bay Area artists), educational exhibits (e.g. "Plate, Board and Stone: the Image and the Source", a print show where the usually unseen printing elements were shown with the finished works), and introductions of new artists (Stan Washburn, Elin Elisofson, Alex Maldonado). American folk art and contemporary naives are a specialty of the Ames Gallery.

The main gallery has a six week rotation of shows. There is a continuous exhibit in its second room by each of the artists the gallery represents.

BEVERLY HILLS

Harry A. Franklin Gallery 9601 Wilshire Blvd., Bev-
49 erly Hills, CA 90210 (213) 271-9171; Tue-Fri: by appt; owner/dir: Valerie B. Franklin

The gallery's specialty is traditional tribal sculptures. The focus is on sub-Saharan black Africa. Nonacculturated Oceanic art made for native use also is found here, as well as antiquities and pre-Columbian artifacts.

The gallery is now in its second-generation ownership under the direction of Valerie B. Franklin. A former professor and writer in the area of primitive art, Ms. Franklin offers appraisal services. She also can guide individuals, corporations, and institutions in forming collections of primitive art.

B. Lewin Galleries 266 N. Beverly Dr., Beverly Hills,
50 CA 90210 (213) 550-1852; Tue-Fri: 10-5 Jul 8-31: closed; owner/dir: Bernard Lewin

One of the most noted galleries in the world in its area of interest, the B. Lewin Gallery presents 20th century Mexican masters.

The gallery's collection embraces practically all the principal figures of modern Mexican art. The great muralist Diego Rivera, mainspring of the "Mexican Renais-sance," and fellow muralist David A. Siqueiros, teacher of Jackson Pollock, are both represented, as is Rufino Tamayo, a pioneer colorist in abstract figurative forms whose style presents an alternative to muralism,

while drawing on the same folk and Pre-Columbian sources. The gallery also features pioneer abstractionist Carlos Merida, a Mayan Indian from Guatemala who worked with Modigliani; Rafael Coronel, Mexico's leading figurative artist, whose precise vision recalls the Spanish masters; and Jose Luis Cuevas, Mexico's noted draftsman and printmaker. Sculptor Felipe Castaneda's classical figures recall Maillol in their repose and rounded volume, while Francisco Zuniga's figures enclose tensions in their asymmetrical poise and the abstract line of their gestures.

Other Mexican masters include Gustavo Montoya, Jose Clemente Orozco (Rivera's great rival), lyrical abstractionist Leonardo Nierman, Raul Anguiano and others.

Louis Newman Galleries 322 North Beverly Dr., Beverly Hills, CA 90210 (213) 278-6311; Mon: 10-6:30 Tue-Sat: 10-9:30 Sun: 1-9:30; owner Louis Newman dir: Gregg Davis
51

The gallery specializes in contemporary paintings, sculpture, ceramics and prints by important local, national and international artists.

Artists include David Aronson, a leading West Coast artist known for his bronze sculpture and pastels; Martin Green, known for his monotypes and cliches-verre; and Doug Hyde, a sculptor in stone who portrays stories and legends of the American Indians. Matsumi Kanemitsu, an Abstract Expressionist who was part of the New York School in the 1950s, is at home in sumi, watercolor, lithography and painting. The gallery features prominent watercolorists Gerald Brommer, Katherine Liu and Lee Weiss; printmakers Peter Milton and Tom Fricano; realist figurative painter Wade Reynolds, and ceramic sculptors Harrison MacIntosh, Otto Natzler, Paul Soldner and Kris Cox. Soldner has been particularly influential in this country by introducing and expanding the Japanese technique of *raku*, a very rapid, wood firing which typically results in porous, unpredictably crackled ware.

Peterson Galleries 332 N. Rodeo Dr., Beverly Hills, CA 90210 (213) 274-6705; Tue-Fri: 10-6 Sat: 11-5 & by appt; dir: Mr. Jean Stern
52

The main areas of concentration of the gallery are American Impressionism (1880-1930), California Impressionists (1900-1930), and Western masters (prior to 1930).

Artists whose work is displayed include Frederic Remington, Charles M. Russell, Thomas Moran, Childe Hassam, E.W. Redfield, Edgar A. Payne, William Wendt, Franz A. Bischoff, Alson S. Clark and others. The gallery also features the work of American primitive artist Jane Wooster Scott. The gallery has published monographs on important California Impressionists.

CARMEL

The Friends of Photography Sunset Center, San Carlos at 9th St., P.O. Box 500, Carmel, CA 93921 (408) 624-6330; daily: 1-5; dir: James Alinder
53

The Friends of Photography is a nonprofit gallery committed to excellence in creative photography. Its programs provide support for the photographic community and further the understanding of photography for the general public. Gallery presentations reflect the diversity of contemporary photography. Work by important historical figures is also exhibited. Recent exhibitions have presented works by Max Yavno, Beaumont Newhall, Nicholas Nixon, Dave Reed, Mary Ellen Mark, Kenneth Josephson, Ansel Adams and Marion Post Walcott.

Pasquale Iannetti Art Gallery P.O. Box S-3131, Carmel, CA 92921 (408) 625-2923; Mon-Sat: 10-6; owner: P. Iannetti dir: Carrie Curtis
54

See listing for San Francisco, CA.

Gallery New World P.O. Box 5732, Lincoln Ave., Carmel CA 93921 (408) 624-3307; daily: 11-5; owner: Chin-Teh Woo dir: Sue Rankin The Gallery New World features fine art of the East and West. The main focus is on abstract paintings, by Chinese artists and by the 20th century School of Paris. The gallery also exhibits traditional Chinese art.
55

The most noted Chinese artists exhibited, Fon Chung-Roy and Liu Kuo-Sung, are both members of the Fifth Moon Group. The traditional School of Chinese art is represented by Chang Dai-Chen.

Young emerging artists include Leonard, whose chief mastery is the monotype, using a brilliant palette in small landscapes; and Gene Holtan, who works in oil pastel to produce prima vista landscapes of the West Coast.

The Weston Gallery, Inc. P.O. Box 655 6th Ave., Carmel, CA 93921 (408) 624-4453; Tue-Sun: 1-5; owner: Maggi Weston dir: Russ Anderson
56

The gallery specializes in fine 19th and 20th century photographs, photographic portfolios and books, with emphasis on works by masters of the photographic medium.

The 19th century collection includes works by Talbot, Hill & Adamson, Cameron, Fenton, LeGray, Bisson, Emerson, Watkins and Muybridge. The 20th century is represented by Stieglitz, Strand, Weston, Adams, Man Ray, Steichen, Brandt and Frank.

Contemporary artists shown include Olivia Parker, Paul Caponigro, Harry Callahan, Jerry Uelsmann and others. The gallery also exhibits 20th century sculpture, with works by contemporary painter and sculptor Nicki Marx.

LAGUNA BEACH

Haggenmaker Galleries 372 North Coast Hwy., Laguna Beach, CA 92651 (714) 494-2675; daily: 10-5; owner: H-G Fine Arts dir: G. Haggenmaker
57

The gallery specializes in traditional realism as interpreted by nationally and internationally known Southern California artists working in oil, acrylics, etching and lithography, bronze and ceramics.

Artists include Liliana Frasca, who achieves a delicate facture with built-up palette knife work; and Raymond Page, who employs the Old Master technique of glazing in his genre paintings. Raymond Sipos paints landscapes dominated by a sense of design. Belgian artists Lisette DeWinne works in abstraction and portraiture. Other artists include Sue Krause, handcolored embossed etchings; DANI, bronzes, mostly nudes; Alan Murray, pastel portraits; William Powell, Old World landscapes; Russell Moreton,

impressionistic landscapes; Ann Davis, realist painting with impressionistic elements; Marty Bell, plein air English scenery; and Jim Hosmer, marine paintings of old sailing ships.

LA JOLLA

Gallery Eight 7464 Girard Ave., La Jolla, CA 92037
58 (619) 454-9781; Mon-Sat: 10-5; dir: Ruth Newmark

The gallery specializes in fine contemporary crafts in all media, as well as traditional and ethnic crafts.

The gallery has exhibited works by such artists as ceramists Laura Andreson, Curtis and Susan Benzle and Harrison McIntosh; glass designers Dale Chihuly, Ann Warff and Italo Scanga; jewelry makers Kim Bass, Edward DeLarge and Lorelei Hamm; master wood artisans David Ellsworth and Robert Stocksdale; basket weavers Ferne Jacobs, John Garrett and Jane Sauer; and papier mache sculptor Pedro Linares.

The gallery always features work of young, emerging craftspeople. Recently displayed work includes baskets by Priscilla Henderson, anodized aluminum jewelry by David Tisdale, ceramic chairs by Lana Wilson, porcelain bowls by Joann Spamer, and wood objects by Dennis Stewart.

The Jones Gallery 1264 Prospect St., La Jolla, CA
59 92037 (619) 459-1370; Mon-Sat: 10-5 & by appt; owner/dir: Doug Jones

Since 1965, the Jones Gallery has featured some of the best American realist painters. The gallery also features a broad selection of sculpture, especially bronze and wood. Works of 19th and early 20th century realists also are available, with emphasis on the California school.

The gallery's exhibitions include oil paintings of the human figure by Tom Darro; figures and landscapes by Chet Engle, William George, Howard Rogers, James Verdugo and Eileen Monaghan; landscapes by Walter Gonske, and Thomas Kinkade; seascapes by Doris Hilbert and Robert Wee; and still lifes by Claire Ruby and Anton Van Dalen. Watercolors of landscapes by June Maxion, Jason Williamson and Craig Smith also are shown.

Sculpture is represented with the bronzes of Stanely Bleifeld, Kent Ullberg, Betty Davenport Ford, Laura Craig, Robert Krantz and Fritz White. The gallery also shows wood carvings by J. Chester Armstrong and Fletcher Carr, and metal sculpture by Anthony Melendy.

The gallery also exhibits etchings by Luigi Kasimir and Sandy Scott.

Knowles Gallery 7420 Girard Ave., La Jolla, CA
60 92037 (619) 454-0106; Mon-Sat: 10-5 Sun: 1-5; owner/dir: Mary Knowles

The emphasis of this long-established gallery is on presenting the works of some of San Diego's most gifted artists. A large selection of regional art can be found in diverse styles and media.

Artists presented include Frederick O'Hara, Western lithographs and woodcuts; B.J. Franklin, impressionist watercolors of the Pacific Coast; and Malcolm Jones, illusionary acrylic sculpture. Among the many watercolors featured are the understated realism of Nancy Wostrel;

vibrant scenes from around the world by Georgeanna Lipe; bright, spontaneous florals by Joan McKasson; and surrealist gouaches by Chatelain.

The gallery also presents three bold Color Field painters: Vera Felts, Don de Llamas and Beth King. Other painters include Tania, who paints hard-edged geometrics; Ruth Gewalt, Mavis Parker and Francis Crowell, who present rich abstractions in collage-paintings; and Jim Saw, who creates subtle airbrush impressions of light.

Kay Whitcomb is considered a pioneer in enameling, and Lilli Hill's cloisonne jewelry delights in fine detail. The sculptors presented include Barry Bunker, polished wood abstractions; and Theresa Cherny, Peter Hord and Shirley Lightman, who all interpret the human figure in bronze and stone.

The Photography Gallery 7468 Girard Ave., La Jolla,
61 CA 92037 (619) 459-1800; Mon-Sat: 11-6; dir: Holly Howell

Established in 1979, the Photography Gallery specializes in rare, vintage, and contemporary fine art photography.

The gallery's inventory features over 40 major photographers, including works by Ansel Adams, Paul Caponigro, Irving Penn, Henri Cartier-Bresson and Josef Koudelka. Select images by Richard Avedon, Edouard Boubat, William Clift, Bruce Davidson, Robert Doisneau, Yousuf Karsh, Brett Weston and Olivia Parker are also included in the inventory. The gallery features work by new contemporary artists as well, including Sandra Haber, Ernesto Bazan, Alice Steinhardt and Robert Glenn Ketchum.

The Photography Gallery has a fine selection of posters. It has published five posters which are distributed nationally, and recently published a retrospective catalogue entitled *Paul Caponigro—Photography: 25 Years*. The gallery often makes it possible for the public to meet masters of photography by sponsoring lectures and workshops in conjunction with its exhibitions.

Tasende Gallery 820 Prospect, La Jolla, CA 92037
62 (619) 454-3691 Tue-Sat: 10-6; owner/dir: Jose Tasende

Tasende Gallery opened in La Jolla in 1979. The gallery building was designed by La Jolla architect Robert Mosher, with assistance from gallery director Jose Tasende.

The ample exhibition space, part of which is in the open air, is particularly apt for the exhibitions of sculpture by international artists that the gallery has been presenting. These have included an exhibition of sculpture and drawings by British sculptor Henry Moore, with monumental pieces installed in various locations in La Jolla.

Among the other sculptors featured are Lynn Chadwick, a younger contemporary of Moore whose work, though abstract, carries strong figurative suggestions; Basque artist Eduardo Chillida, whose abstract work in forged iron, wood and stone expresses the raw mass and strength of his materials and the historic vision of his heritage; and Italian artists Marino Marini and Giacomo Manzu. Both are recognized masters of the human figure, which in Manzu's work is charged with classical poise, and in Marini's work reveals the primitive forces that mold human gestures.

Paintings and drawings by Chilean Surrealist

Ansel Adams, *Aspens, Northern New Mexico,* photograph, Weston Gallery (Carmel, CA).

Peter Milton, *The First Gate,* 20 x 30, etching, Louis Newman Galleries (Beverly Hills, CA).

Roberto Matta and Mexican artist Jose Luis Cuevas have been presented as well.

LARKSPUR

R.E. Lewis, Inc. 60 E. Sir Francis Drake Blvd., Larkspur, CA 94939 (415) 461-4161; Mon-Fri: 10-5 by appt only, mailing address: P.O. Box 1108 San Rafael, CA 94915
63

R.E. Lewis began business in 1952 in San Francisco, dealing in original prints and drawings, and now operates as a "print shop" by appointment in offices at Wood Island near the Larkspur ferry terminal. The stock includes Old Master prints, American printmakers, Japanese woodblock prints, and 19th and 20th century prints.

Clients sit at a table and look through solander boxes containing prints dating roughly from Schongauer to Picasso. At a given time one may find works by Durer, Rembrandt, the Tiepolos, Italian cinquecento engravings, Goya, Delacroix, Millet, Corot, Renoir, etc., and a range of European and American 20th century artists.

Japanese stocks include the great (and less great) artists from Moronobu to Yoshitoshi, usually a large selection of Osaka actor prints, and occasionally Hanga prints. The Oriental miniatures emphasize the Indian schools, and range from masterpieces to less important but highly decorative prints and drawings.

The gallery issues about four catalogs a year, usually at least one on Japanese prints and the others on special topics, eras, artists, techniques, etc. R.E. Lewis is internationally acknowledged as a print expert, and provides a wide range of services.

LOS ANGELES

Ankrum Gallery 657 La Cienaga Blvd., Los Angeles, CA 90069 (213) 657-1549; Tue-Sat: 10-5:30; dir: Joan Ankrum
64

Established in 1960, the gallery exhibits the work of contemporary artists.

The following artists work in two-dimensional media such as painting, prints and photography: Warren Anderson, Irving Blick, Morris Broderson, Naomi Caryl, Bernie Casey, Mariana Cook, Keith Crown, Luis Gabotto, Jill Gibson, Shirl Goedike, Gus Heinze, Susan Hertel, Jessie Homer, Suzanne Jackson, Bob Kane, David Kreitzer, Leza Ledow, Harry Lieberman, Marilyn Lowe, Phyllis Manley, Joe Price, David Remfry, Jean Rose, Jan Sawka, Jean Swiggett and Duane Wakeham. Artists working in sculpture and constructions are: Richard Bauer, Ken Goldman, Eli Karpel, Gene Logan, Andy Nelson, Melvin Schuler, Robert Seyle, Emily Steele, Terry Stringer and Ronald D. Young.

ARCO Center for Visual Art 505 S. Flower St., Los Angeles, CA 90071 (213) 488-0038; owner: Atlantic Richfield Co. dir: Fritz A. Frauchiger
65

A nonprofit public exhibition space, the center concentrates on West Coast contemporary art, with occasional historic or craft exhibitions.

Among the artists who have exhibited at the center are Herbert Bayer, an original Bauhaus instructor; James Turrell, a California light/space artist; Larry Bell, a well-known artist working in coated glass; David Gilhooly, a Northern California ceramist making frogs, hippos, bug-eyed monsters, etc. in the Funk genre; the late Stanton MacDonald-Wright; Ed Ruscha, who has gone from painting lonely vistas of gas stations to painting lettered "messages"; Joe Goode, Peter Alexander, and Montana-based sculptor Deborah Butterfield.

A specialty of the center has been large installations. some of the artists who have made major installation works are: James Turrell, Michael Hayden, Tom Eatherton, Carl Cheng and Larry Bell.

Asher/Faure 612 N. Altmont Dr., Los Angeles, CA 90069 (213) 271-3665; Tue-Sat: 11-5; dir: Betty Asher, Patricia Faure
66

In addition to showing the work of young artists the gallery has held exhibitions of painting and sculpture by celebrated contemporary American artists such as early abstract painter Arthur Dove, Abstract Expressionists Franz Kline and Philip Guston, and Morris Louis, a pioneer in the movement beyond Abstract Expressionism. Louis poured thinned-out acrylic across his canvases, definitively eliminating the *gesture* and making way for Color Field and other kinds of process painting. Other exhibitions have included Sam Francis paintings of the 50s, drawing and sculpture by Joel Shapiro, and sculpture and painting by Richard Artschwager.

Among the young Southern California artists presented are Elaine Carhartt, Bruce Cohen, Paul Dillon, Kathryn Halbower, Michael C. McMillen, Gwynn Murrill and Margaret Nielson. Also featured are painter John Buck, and sculptor Deborah Butterfield, who makes images of horses from different materials, including sticks and mud. Others are Ronald Davis, Robert Graham, Craig Kauffman, John Okulick and Robert Wilhite. From New York, the gallery has had installations of the work of Nicholas Africano, Alex Katz and Robert Zakanitch.

Molly Barnes Gallery 750 N. La Cienaga Blvd., Los Angeles, CA 90069 (213) 854-1966; Tue-Sat: 11-5; owner: Molly Barnes
67

Molly Barnes specializes in contemporary painting and sculpture from the Southern California area with particular emphasis on young Californians working downtown: Jack Reilly, Dan Cytron, Bruce Houston, Ed Gilliam, Robert Neuwirth, Mo McDermott, Lisa Lombardi and Hannah Stills.

In addition to mounting shows the gallery makes an effort to inform its clients about the work of Southern California artists through trips to artist's studios and frequent exposure to their painting and sculpture. In this way artists such as DeWain Valentine, Laddie John Dill, Guy Dill, Vasa, Ed Moses, Roland Reese, Billy Al Bengston and Sam Francis have become part of growing local collections.

Several humorists are also shown in the gallery, including Martin Mull, Steve Martin and Lyn Foulkes.

Jan Baum Gallery 170 S. La Brea Ave., Los Angeles, CA 90036 (213) 932-0170; Tue-Sat; 11-5 and by appt; owner: Jan Baum dir: Jan Baum, Diane Cornwall
68

Paul Soldner, *Pedestal Vessel (4-24)*, 13 high, ceramic, Louis
Newman Galleries (Beverly Hills, CA).

Morris Broderson, *The Stolen Painting*, 30 x 40, watercolor,
Ankrum Gallery (Los Angeles, CA).

The gallery exhibits both contemporary and primitive art. Emerging California artists are a strong interest. Exhibitions of primitive and contemporary art are concurrent.

Betty Gold, who works in Cor-ten steel and bronze, has installed monumental works at six major U.S. museums. Abstract painting, both gestural and geometric, is represented by Claude Kent, Guy Williams and Trevor Norris. The constructivist ethic is still alive in the architectural paintings of Steve Heino. The Romantic vision of women is expressed in Milano Kazanjias's painting, primitive power in young artist Alison Saar's *Icons of the City*.

Although solo shows are the usual format, provocative group shows have recently been featured: Theatrical Imagery, Theatrical Abstraction, and Figure Fascination.

Roy Boyd Gallery 170 S. La Brea Ave., Los Angeles,
69 CA 90036 (213) 938-2328; Tue-Sat: 11-5:30; owner: Roy Boyd dir: Mary Venner Shee

The Roy Boyd Gallery exhibits contemporary art from Chicago and Los Angeles. Local artists featured in the Los Angeles gallery include Michael Davis, Roy Dowell, Ned Evans, Joe Fay, Ernie Silva and Jay Phillips.

See Chicago, IL, listing.

Cirrus Gallery 542 S. Alameda St., Los Angeles, CA
70 90013 (213) 680-3473; Tue-Sat: 11-5; owner/dir: Jean R. Millant

The unusual combination of an art gallery, a print workshop and a publisher of fine graphics makes Cirrus stand out. Since 1970 Cirrus has shown and published the work of leading contemporary California artists.

Presently featured are painters Damian Andrus, Richard Baker, Charles Hill, William Hemmerdinger, Ted Kerzie, Jay McCafferty and Gillian Theobald; and sculptors Michael Farber, Jim Lawrence, Jay Willis and Judith Vogt.

Cirrus is a major publisher of print editions. Jean Millant, Tamarind Master Printer, is known for producing fine quality limited editions with special sensitivity to the artist's work. Ed Ruscha's lithographs and food prints, the silk tissue lithography of Ed Moses, and the torn and sewn prints of Joe Goode and Charles C. Hill are examples. In Cirrus's extensive inventory one will also find works by Peter Alexander, John Baldessari, Vija Celmins, Ron Cooper, Tony Delap, Craig Kauffman, Jay McCafferty, Bruce Nauman, Kenneth Price and William Wiley.

James Corcoran Gallery 8223 Sta. Monica Blvd.,
71 Los Angeles, CA 90046 (213) 656-0662; Tue-Sat: 11-5; owner: J. Corcoran

The gallery offers an eclectic inventory of styles selected from established and less well-known contemporary American artists.

Works by well-known artists such as Ellsworth Kelly, Richard Diebenkorn, James Rosenquist, Andy Warhol, Cy Twombly, Jasper Johns, Sam Francis, Willem de Kooning and Joseph Cornell are shown regularly; but individual shows feature artists of great variety and versatility.

Some recent examples are: H.C. Westerman, a "humorous" artist who works in a variety of media; Laddie John Dill, fractured landscapes

with cement, glass and polymer on plywood; Charles Moore, architect; Charles Arnoldi, known for his large twig pieces and sculptures created from tree branches; Ken Price, ceramist; Paul Wonner, painter; and Tom Holland, creator of fiberglass wallpieces and "standup" paintings of aluminum with epoxy. One could round out the list with designs for dream houses by inter-nationally recognized architects such as Emilio Ambasz, Cesar Pelli, Arata Isozaki and Charles Moore.

William & Victoria Dailey 8216 Melrose Ave., Los
72 Angeles, CA 90046 (213) 658-8515; Tue-Fri: 10-6 Sat: 11-5; owner/dir: William & Victoria Dailey

This combination gallery/rare bookshop offers a fine selection of graphics as well as art and rare books of all periods. In the field of graphics, 19th century French artists are a specialty, with works by Manet, Delacroix, Gericault, Tissot, Lepere, Meryon, Daumier and Daubigny among those offered. English and American artists are also available, including works by Whistler, Haden, Turner, Hassam, Bellows and Sloan.

To complement the graphic offerings, catalogues raisonnes and monographs are available, as well as books on the history of printmaking. Apart from the art-book section, there are rare books in science, literature, printing history, decoration and bibliography.

Kirk Degooyer Gallery 1308 Factory Place, Los An-
73 geles, CA 90013 (213) 623-8333; owner/dir: Kirk de Gooyer

The emphasis at Kirk Degooyer's gallery is on large-scale contemporary artwork, mostly paintings, but including some sculpture.

The artists whose work is exhibited at the gallery are usually from California. Artists exhibited include Robert Walker, Jacqueline Dreager, Jack Scott, Tom Bianchi, Kharlene Boxenbaum, Donald Karwelis and Gordon Thorpe.

De Ville Galleries 8751 Melrose Ave., Los Angeles,
74 CA 90069 (213) 652-0525; Mon-Fri: 9-5; owner: Christian Title dir: Ted Nittler

De Ville Galleries carries 19th and 20th century American Impressionist paintings.

American master paintings are available by Philip Leslie Hale, William Merritt Chase, Robert Reid, Jane Peterson, Louis Ritman. The Gallery also handles work from the estates of Bernhard Gutmann, A.C. Goodwin and J. Barry Greene. A section of the gallery is devoted to 19th century French paintings by Edmond Petitjean, Dagnan-Bouvert, and Lebasque. Contemporary impressionists include John Powell and Henri Plisson.

DeVorzon Art Gallery 8687 Melrose Ave., Los An-
75 geles, CA 90069 (213) 659-0555; Mon-Fri: 10-5:30; owner: Barbara DeVorzon dir: Meri Ellens

The gallery features contemporary American artists, mostly from Southern California, in painting, drawing, graphic and sculptural media.

Among the artists presented are Nancy Louise Jones, Cory Quilan, John Harris, Richard Casey, Vasa, Ray Bingham and Karen Davidson. The

gallery also carries a selection of 20th century master prints.

Dubins Gallery 11948 San Vicente Blvd., Los Angeles, CA 90049 (213) 820-1409; Tue-Sat: 10-5; owner/dir: Lisa Dubins
76

In 1977 the Dubins Gallery opened in Brentwood with the initial purpose of serving corporate collections, architects and designers. With an emphasis mostly on larger works on canvas and original works on paper, the gallery now attracts business from private clients, too.

The gallery presently shows well-known painters and sculptors from the U.S., whose styles range from Lyrical Abstraction through Abstract Expressionism, Minimalism and Photorealism. With its exhibition space expanded in the last four years, the gallery now displays younger artists in a rotating show, in addition to continuing monthly previews of the work of artists it represents.

Factory Place Gallery 1308 Factory Place, Los Angeles, CA 90013 (213) 627-5043; Tue-Sat: 11-5; owner: Milou de Reiset, Don Bowman, Karen Murphy dir: M. de Reiset
77

The Factory Place Gallery handles work in all media, with concentration on 20th century Latin American artists.

Among the artists featured, Richard Carbajal captures surreal images of space and time on small canvases. Roberto Humphrey's watercolors also reveal the profound effects the Surrealist Movement had on Latin American art. The Neo-Expressionist paintings of John Howard, an artist from the U.S., are also shown.

In additon, the gallery shows works by contemporary artists Pedro Friedeberg, Carmen Parra, Juan Jose Gurrola, Manuel Villazon, Diego Matthai and many others.

Feingarten Galleries 8380 Melrose Ave, Los Angeles, CA 90069 (213) 655-4840; Tue-Fri: 11-6 Sat: 12-5; owner/dir: Gail Feingarten
78

In business for over thirty-five years, Feingarten is dedicated primarily to exhibiting fine sculpture by 20th century masters, as well as works by regional artists.

Bronzes and marbles are available by such seminal figures as Auguste Rodin, Henry Moore, Alexander Archipenko, and Jean Arp, and by other distinguished artists, including Barbara Hepworth, Auguste Renoir, Emile-Antoine Bourdelle, Joseph Csaky and Chana Orloff.

Tengenenge stone sculpture from Zimbabwe has become an innovative addition to an already illustrious collection. Although paintings are not the central interest of the gallery, Feingarten does show master drawings and watercolors, the work of Csaky's Art Deco period, as well as the work of gallery artists Charley Brown, Howard Newman, Sandra Sloane and Louis Pearson.

Flow Ace Gallery 8373 Melrose Ave., Los Angeles, CA 90069 (213) 658-6980; Tue-Sat: 10-6; dir: Douglas Chrismas
79

Flow Ace Gallery was created in 1961 (Ace Gallery, with locations in Venice and Los Angeles) to showcase major contemporary artists.

Artists associated with the Minimalist aesthetic are well represented in the gallery. Among

these are sculptor Carl Andre, whose floor pieces of nearly identical elements also were also an early manifestation of site-specific works; luminic sculptor Dan Flavin, whose installations of fluorescent lights create an atmosphere seemingly corporealized by light; sculptor Donald Judd, whose work has taken the form of precisely engineered "primary structures"; and painter Robert Mangold.

There are works by influential British sculptor Anthony Caro, known for his welded metal sculpture made of prefabricated elements; and by American sculptor Mark di Suvero, whose early found-object pieces were the three-dimensional equivalent of Abstract Expressionist painting. This latter movement is represented at the gallery by works of Sam Francis and Helen Frankenthaler. One may also see works by California artist Bruce Nauman, associated with the Conceptual and Body Art movements, as well as Ellsworth Kelly, Jasper Johns, Roy Lichtenstein, sculptor Jene Highstein and photographer Robert Mapplethorpe.

Other artists shown are: Guy Dill, Dennis Oppenheim, Larry Poons, Robert Rauschenberg, Roland Reiss, James Rosenquist, Edward Ruscha, Richard Serra, Frank Stella, Jim Turrell, Robert Therrien, Mario Merz, Claude Viallat, Cy Twombly and Andy Warhol.

Gemini G.E.L. 8365 Melrose Ave., Los Angeles, CA 90069 (213) 651-0513; Mon-Fri: 9-5:30; dir: Sid Felsen
80

Gemini G.E.L. (Graphic Editions Limited) is an internationally known print publisher. Housed in a building designed by famed Los Angeles architect Frank Gehry, the gallery shows graphics by some of the most acclaimed American artists, all of which are produced in Gemini's workshop. The work is created and closely supervised by the artists, who are present in the workshop itself during the entire proofing session.

Most of the exhibits center around lithography and etchings by major artists, including Ronald Davis, Sam Francis, David Hockney, Michael Heizer, Jasper Johns and Robert Rauschenberg. Woodcuts and some silkscreen prints are also shown.

The gallery also shows limited edition sculpture by Isamu Noguchi, Mark di Suvero, Ellsworth Kelly, Claes Oldenburg, Richard Serra, and Edward and Nancy Reddin Kienholz, among others.

Susan Gersh Gallery 8426 Melrose Ave., Los Angeles, CA 90069 (213) 653-4181; by appt; owner/dir: Susan Gersh
81

The gallery deals in 20th century paintings, drawings and sculpture from the modern through the contemporary period.

Although the inventory is not large, the gallery handles work of excellent quality. Among the artists featured are Surrealist painter, poet and sculptor Jean Arp; Abstract Expressionist Sam Francis; Frank Stella, whose recent brightly painted and freely assembled constructions contrast with his early monochrome geometric abstraction; David Hockney; and Pablo Picasso.

Goldfield Galleries 8400 Melrose Ave., Los Angeles, CA 90069 (213) 651-1122; Mon-Fri: 11-4; owner/dir: Alan Goldfield
82

Goldfield Galleries specializes in Western artists, American Impressionists, and other important American artists of the 19th and 20th century.

The gallery features American Impressionists Frank W. Benson, Joseph R. DeCamp, Thomas W. Dewing, F. Childe Hassam, Willard L. Metcalf, Robert L. Reid, Edward E. Simmons, Edmund C. Tarbell, John H. Twachtman, J. Alden Weir, William Merritt Chase, Frederick Frieseke, and others. The Ashcan School of Social Realists is represented by Robert Henri, William Glackens, George Luks, John Sloan, and Everett Shinn. Artists associated with the Ashcan School in exhibitions of the period include romantic Arthur B. Davies, Neo-Impressionist Maurice Prendergast, Jerome Myers, Ernest Lawson and Robert Spencer. The Western scene is depicted by Frederic Remington, Charles M. Russell, William R. Leigh, William Glooings, E.I. Couse, J.H. Sharp, E. Martin Hennings, O.E. Berninghaus and Victor Higgins.

Other artists include Albert Bierstadt, 19th century landscape painter; Thomas Hart Benton, American regionalist famous for Midwestern farm scenes; Stanton MacDonald-Wright and Morgan Russell, two of the first abstract painters; Edgar Payne; Guy Pene DuBois, an artist and critic who provided social commentary of the 20s; Charles Hawthorne; and Reginald Marsh, a New York Social Realist.

G. Ray Hawkins Gallery 7224 Melrose Ave., Los
83 Angeles, CA 90046 (213) 550-1504; Tue: 12-9 Wed-Sat: 12-5; dir: David Fahey

The G. Ray Hawkins Gallery is Los Angeles' oldest gallery devoted exclusively to photography. The gallery opened a new space in 1980 with Murals and Polaroids by Ansel Adams. Since opening the new space, exhibitions have included the work of Robert Frank, Walker Evans, George Hurrell, Max Yavno, Garry Winogrand, Arthur Tress, Helmut Newton, Henri Cartier-Bresson, Robert Doisneau and Andre Kertesz. Representing approximately 100 vintage, modern and contemporary masters, the gallery has produced portfolios by Max Yavno, Umbo, Alice Steinhardt and Helmut Newton. The gallery also sponsors public information programs, symposiums and workshops.

Heritage Gallery 718 La Cienaga Blvd., Los Angeles,
84 CA 90069 (213) 652-7738; Tue-Sat: 11-5; dir: Benjamin Horowitz

The gallery stresses figurative painting as well as rare prints by international artists.

Social Realists Raphael Soyer and William Gropper are among the artists whose work is shown. Soyer's style is looser and more impressionistic than that of Gropper, who works in a linear, satirical manner akin to the caricatures of 19th century painter Honore Daumier. Other artists exhibited include Charles White, Robert Russin, Milton Hebald, and Sherman.

The gallery also carries prints by Picasso, Miro, 19th century French genre painter James Tissot, Ashcan School painter John Sloan, and many others.

Bernard Jacobson Ltd. 8364 Melrose Ave., Los An-
85 geles, CA 90069 (213) 655-5719; Tue-Sat: 10-5; dir: Kimberly Davis

See listing for New York City, NY.

Janus Gallery 8000 Melrose Ave., Los Angeles, CA
86 90046 (213) 658-6084; Tue-Sat; 10:30-5:30; owner: Jan Turner dir: Deborah McLeod dir, furniture display: Carolyn Watson

The gallery handles painting, sculpture and ceramics by contemporary artists. Many of the artists are from California. Though most work in non-representational modes, some are representational artists—for example, Carlos Almaraz and David Bungay.

Paintings and works on paper are available by the following artists: Lita Albuquerque, Carlos Almaraz, Laurie Browm, David Bungay, Sigrid Burton, Tony DeLap, Laurence Dreiband, Denise Gale, Vivian Kerstein, Michael Mazur, Ed Moses and Margit Omar. Works by sculptors Lita Albuquerque, Tony DeLap and John Frame are also available. Ceramics shown are by Juan Hamilton, Mineo Mizuma and Elsa Rady. Many other artist are exhibited as well.

Finely crafted furniture by Memphis Furniture, Milano, and by Peter Shire is on permanent display.

Gallery K 8406 Melrose Ave., Los Angeles, CA
87 90069 (213) 651-5282; Wed-Sat: 12-5; owner: Barry Kitnick dir: Rene Sweig

The gallery specializes in African and primitive art. Authentic sculpture is on display from Africa, Indonesia, the Pacific region and the Philippines. Antique pieces are available from the 17th to early 20th century.

Koplin Gallery 8225 1/2 Sta. Monica Blvd., Los An-
88 geles, CA 90046 (213) 656-3378; Tue-Sat: 11-5; owner/dir: Marti Koplin

The gallery features a wide selection of contemporary art with emphasis on works by California artists. Painting and sculpture are shown, with some photography and prints.

Painters include realists Joan Brown, Connie Jenkins, David Ligare, John Nava, and James Doolin, who paints desert landscape. Muralists shown are John Wehrle and Terry Schoonhoven, who is currently working on a mural for the Los Angeles Olympics. Roger Boyce paints colorful shaped canvases, while Frank Liegel works in mixed media, and Victoria Nodiff works in acrylic. Sculptors are Michael Cochran, bronzes; John Mottishaw, wood sculpture; Rick Ripley, wall constructions; and Eugene Sturman, metal sculpture, wall constructions and metal drawings.

Photographs by German-born artist Gisele Freund include portraits of famous personages such as Virginia Woolf, Henry Miller, Marcel Duchamp, James Joyce, Evita Peron and Jean Cocteau.

The gallery also shows New York artists such as Minimalist painter Robert Yasuda, Ida Applebroog and Elyn Zimmerman. Some prints by Robert Rauschenberg, Jasper Johns, and Max Ernst are also available.

Richard Kuhlenschmidt Gallery 4121 Wilshire
89 Blvd., Los Angeles CA 90010 (213) 385-8649; Sat: 12-5 and by appt; owner/dir: Richard Kuhlenschmidt

Established in 1980 as a forum for New York and Los Angeles artists, the gallery is committed to showing progressive work that gets little expo-

Laurie Pincus, *Palm Springs Weekend* (1984), 13 x 24 x 10, acrylic on wood, Jan Baum Gallery (Los Angeles, CA).

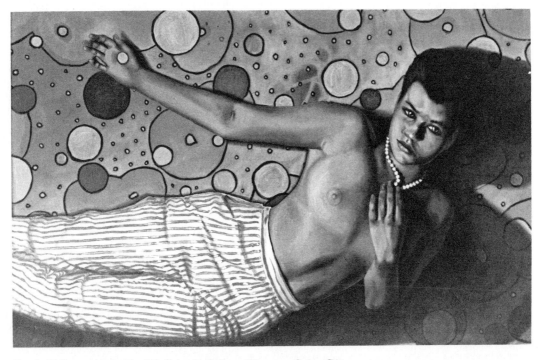

Cynda Valle, untitled, 36 x 66, Orlando Gallery (Sherman Oaks, CA).

sure in commercial galleries. The exhibitions take many forms ranging from conceptual works through "new figurative" painting, installations and photography.

The gallery has shown Sherrie Levine's appropiated imagery, Richard Prince's media-related photography, figurative painting by Robin Winters and paintings by writer/critic Thomas Lawson.

Also shown are William Leavitt's tableau drawings, the furniture of Jim Isermann, Kim Hubbard's neo-pop paintings, Mitchell Syrop's advertising photocollages, and work by Raul Guerrero, Jim Morris and Ali Acerol.

Kurland/Summers Gallery 8742 A Melrose Ave.,
90 Los Angeles, CA 90069 (213) 659-7098; Tue-Sat: 11-6; owner/dir: Ruth T. Summers

Contemporary sculptural glass is the specialty of this gallery, which shows three-dimensional glass works made with many different techniques: blown glass, slumped glass, fused glass, flat glass, and plate glass sculpture.

The artists exhibited at the gallery who work in this versatile medium come from the U.S., Canada and Europe. A partial list of the artists would include: Rick Bernstein, Dan Dailey, Dale Chihuly, William Dexter, Flora Mace and Joey Kirpatrick, Christopher Lee, John Luebtow, Colin Reid, Ann Warff, David Huchthausen, Giani Toso, and Bertil Vallien.

L.A. Artcore 652 Mateo St., Los Angeles, CA 90021
91 (213) 617-3274 Tue-Sun: 11-4; owner: Corporation dir: Lydia Takeshita

L.A Artcore shows contemporary art by emerging artists and some established artists in Southern California, in addition to hanging international exchange shows with the Dongsanbang Gallery of Sedul, Korea, and Gallery Q and News of Tokyo, Japan.

Artists shown include Shigeo Miura and Satoru Shoji of Japan, and Myeung Ro Youn and Chung Chang Sop of Korea, and Iraqi artist Talibal Allaq. Among the more well-known Los Angeles artists are Craig Antrim, Helen Pabhgian, Lynn Bassler, Jean Edelstein, Bruce Edeletein and Julia Chu.

Younger, emerging artists from the area are: Robert Aisawa, Rita Barnes, Julie Belnick, Paul Carmichael, Roy Herwick, Bettina Brendel, Tom Canny, Hyun Sook Cho, Madelin Coit, Cheri Pann, Robin Ghelerter, Eugene Greenland, Bonita Helmer, Tai-Hsing Hsiao, Seta Injeyan, Beanie Kaman, Chitrakar Kottler, Hoon Kwak, Mitsuko Namiki, Harold Nathan, Mye Sook Park, Carolee Parker, Yando Rios, Caryn Roseman, Jane Ulman, William Wiley, Jin Sook You, and Yda Ziment.

LACE 240 S. Broadway, 3rd fl., Los Angeles, CA
92 90012 (213) 620-0104; Wed-Sat: 11-5; dir: Joy Silverman

LACE (Los Angeles Exhibitions, Inc.) is a non-profit art center which serves as a community forum for artists. LACE programs direct themselves to serious new art that has received little or no exposure in commercial galleries.

The main exhibition space, the Front Gallery, primarily presents group shows tha cover the spectrum of contemporary issues. Typical of the

exhibitions here are "El Salvador", an environment by Doug Humble; the "Fix-It-Up Show", where Jeffrey Vallance and Michael Uhlencott altered works by other artists; and many theme and annual shows. Solo shows are sometimes featured: Louie Lunetta, installation; Jeffrey O'Connell, paintings; Mike Roddy, drawings; and David Schirm, paintings.

The Middle Gallery is devoted to emerging Los Angeles artists. Some of the artists are: Joe Grant, Stephen Grossman, Gary Lang, Constance Mallinson, Lee Moser, Lari Pittman, Doni Silver and Andrew Wilf.

LACE schedules performance, video, film, dance and multi-media events on a monthly basis. Over 150 artists have participated in "time arts" experimentation, including Eric Bagosian, Glenn Branca, Chris Burden, Carole Caroompas, Fernando Doty, Kim Jones, Mike Kelly, Jill Kroesen, Gary LLoyd, Tony Ourster, Patti Podesta, Alexis Smith, Barbara Smith, Min Tanaka and John White.

Martin Lawrence Gallery 313 N. Robertson Blvd.,
93 Los Angeles, CA 90049 (213) 272-1251; Mon-Fri: 10-8 Sat-Sun: 11-5; dir: Dennis Weiss

See listing for Sherman Oaks, CA.

Margo Leavin Gallery 812 N. Robertson Blvd., Los
94 Angeles, CA 90069 (213) 273-0603; Tue-Sat: 11-5; owner/dir: Margo Leavin

Since opening in 1971, Margo Leavin Gallery has mounted exhibitions of American contemporary paintings, drawings, sculpture, and graphics. The gallery's offerings include prints and drawings by Jasper Johns, Jennifer Bartlett, Lynda Benglis, Jim Dine, Charles Gaines, Jud Fine, Agnes Martin, Louise Nevelson, Robert Moscowitz, Claes Oldenburg, Lucas Samaras, Hap Tivey, Bryan Hunt, and Tom Wudl. There also are paintings by David Hockney, Robert Motherwell, Ellsworth Kelly, Andy Warhol, Roy Lichtenstein, Ed Ruscha, George Segal, and Robert Rauschenberg, and others.

In July 1984 the gallery opened an additional space at 817 N. Hilldale, one block east of the original gallery. The inaugural show presented American sculpture. The hours at the new space are Tuesday-Saturday, 12-5.

Los Angeles Municipal Art Gallery 4804 Hollywood
95 Blvd., Los Angeles, CA 90027 (213) 485-4581; Tue-Sun: 12:30-5; owner: City of L.A. dir: Josine Ianco-Starrels

The Municipal Gallery of the city of Los Angeles provides exhibition space for emerging and established artists from the West Coast. All media are represented in the exhibitions, including drawings, paintings, collage, installations, graphics, ceramics, sculpture and photography.

Among the many artists who have exhibited in this space are Max Yavno, Marvin Hardin, Laddie John Dill, Arnold Mesches, Carlos Almaraz, Masami Teraoka, Charles Arnoldi, John Buck, Jay Phillips, Tom Holland and Peter Alexander. Raymond Saunders has shown his abstract paintings, which use collage elements such as photographs, words and diagrams to create meanings beyond the merely visual or aesthetic. Betye Saar, who has worked in printmaking and found-object assemblage, and Paul Wonner, a realist who

paints still lifes inspired in the Dutch tradition, have also shown their work. The gallery has exhibited paintings by Lee Mullican, an established abstract painter whose recent paintings combine natural and geometric design, and by Helen Lundeberg, a realist whose later paintings reveal the power of light and shadow to create abstract pattern in landscape and architecture.

Mekler Gallery, Inc. 651 N. La Cienaga Blvd., Los
96 Angeles, CA 90069 (213) 659-0583; Tue-Sat: 11-5 & by appt; owner/dir: Adam Mekler

The Mekler Gallery specializes in 20th century and contemporary sculpture, painting, collage and graphics.

Rotating exhibitions feature contemporary sculpture by George Baker, Robert Cremean, Sorel Etrog, Dimitri Hadzi, Minoru Niizuma, Jack Zajac, Paul Suttman, Hardy Hanson, and Karen Nelson; painting and graphics by Ynez Johnston, John Paul Jones, Bon Gordon, Susana Lago, Ulfert Wilke and Corda Eby; and collage by William Dole. The gallery shows work from the estate of Rico Lebrun, an American Expressionist, designer of stained glass and muralist who portrayed the human figure in a semi-abstract style.

Special exhibitions have featured works on paper by Alberto Giacometti, Pablo Picasso and Henri Matisse. Other exhibitions have shown the work of Joan Miro, Antoni Tapies, Paul Wonner, Robert Natkin, and Max Ernst.

Tobey C. Moss Gallery 7321 Beverly Blvd., Los
97 Angeles, CA 90036 Tue-Sat: 11-4; owner/dir: Tobey C. Moss

The gallery offers four centuries of prints and drawings, with focus on 20th century American works in all media from the Ashcan School, through California Modernist and landscape painting of the 20s and 30s; Regionalist, Post-Surrealist and Social Realist art of the 30s and 40s; to California Hard Edge of the 40s and 50s.

The gallery features the work of Helen Lundeberg and Lorser Feitelson, who worked in a Post-Surrealist style in the 30s, and went on to become leaders of California Hard Edge painting in the 50s, along with John McLaughlin, Frederick Hammersley and Karl Benjamin, whose works are also offered.

Other artists include Werner Drewes, a Bauhaus-trained artist who became a founding member of the American Abstract Artists Group in New York in 1936. This organization grew out of the contacts of artists in the WPA and in the American Artists Congress, and sought to give abstract art a firm theoretical basis. The gallery has also shown June Wayne, painter and printmaker, founder of the Tamarind Lithography Workshop; Oskar Fischinger, pioneer in the 20s and 30s of abstract imagery on film; Palmer Schoppe, a regionalist who captured the rhythm and music of Harlem, New Orleans and Los Angeles; Jay Rivkin, who draws geometrical constructions and still lifes in pencil; and Thomas Pomatti, whose watercolors depict abstract natural forms.

Newspace Gallery 5241 Melrose Ave., Los Angeles,
98 CA 90038 (213) 469-9353; Tue-Sat: 11-4 Aug: closed; owner/director: Joni Gordon

Newspace concentrates on contemporary Southern California painting, sculpture, and drawings. Owner/director Joni Gordon and her assistant Mo Shannon exhibit 18 artists in depth each year.

Works by the gallery's stable of artists include paintings and drawings by Martha Alf, constructive wall paintings by Tom Holste, mixed media paintings by Paul Knotter, monumental columns by Christopher Georgesco, installations by Patricia Patterson, bronze sculptures by Wade Saunders, landscape paintings by Astrid Preston, biomorphic sculpture by Eileen Senner, paintings by Frederick White, photography by Judy Fiskin, and collages by Anne Marie Karlsen.

The gallery also specializes in American modernist painting and sculpture, with an emphasis on the period 1919-59. Newspace presents master works by European painters and sculptors such as Henry Moore, Claude Monet, and Fernand Leger.

Neil G. Ovsey Gallery 705 E. Third St., Los Angeles,
99 CA 90013 (213) 617 1351; Tue-Sat: 11-5 and by appt; owner/dir: Alice and Neil Ovsey

This gallery specializes in contemporary American painting, drawing, sculpture and installations by both West and East Coast artists whose careers are in varying stages of development, from new talent to mid-career and established artists.

Throughout the year Ovsey Gallery focuses on one-person exhibitions of the artists they represent: Ron Cooper, Susan Hall, Mary Jones, Ron Linden, Donal Lumbert, Constance Mallinson, Stephan McKeown, Eric Orr, Bobby Ross, Ron Rizk, Judith Simonian and Leonard Skuro.

By merging historical with current trends, Alice and Neil Ovsey hope to present multi-faceted views through their exhibition choices.

Paideia Gallery 765 N. La Cienaga Blvd., Los An-
100 geles, CA 90069 (213) 652-8224; Tue-Sat: 11-4:30; dir: Stevan Kissel

The Paideia Gallery has a varied inventory which includes 17th to early 20th century works, Renaissance drawings, Russian and European bronzes, and European and American paintings by noted artists.

Paideia is especially interested in American artists of the 19th and early 20th centuries. Among the oil paintings at the gallery are works by Bruce Crane, Maurice Braun, Albert Bierstadt, Maynard Dixon, Edgar Payne, Robert Philipp, Granville Redmond, Guy Rose, and others working usually in an impressionistic idiom.

Marilyn Pink/Master Prints and Drawings 608 N.
101 Westmont, Los Angeles, CA 90069 (213) 657-5810; Mon-Fri: 12-5 and by appt; owner/dir: Marilyn Pink

A small white house set in a garden away from busy La Cienaga Blvd. encloses an extraordinary collection of art on paper, drawings and prints from the 15th through the mid-20th century. Major artists and schools of Europe and America are represented.

One is likely to find first edition Audubon prints, Currier and Ives popular lithography, as well as work by well-known American artists of the 19th and 20th century: American Impression-

ists Julian Alden Weir, William Merritt Chase, Mary Cassatt and James Abbott MacNeill Whistler; Regionalists Thomas Hart Benton and John Steuart Curry; John Sloan, Paul Landacre, and Rockwell Kent. Here also you may find American Modernists such as Arthur Dove, Louis Lozowick, Louis Schanker, Marsden Hartley and Max Weber, for this is a specialty of the gallery.

The gallery is noted for drawings of the Old Masters and contemporary European masters. Drawings by the French Intimists Pierre Bonnard and Edouard Vuillard are a mainstay of the gallery, as are watercolors and drawings by Impressionists, Post-Impressionists and other 19th and early 20th century French artists. The Russians are represented with works by avant-garde artists Mikhail Larionov and Nathalie Gontcharova, drawings of the dance by Leon Bakst, who collaborated with Diaghilev and Fokine, and works by other costume and stage designers.

German artists presented are: social realist Kathe Kollwitz; Expressionists Max Pechstein, Erik Heckel, Franz Marc and Viennese artist Oscar Kokoschka; and German Impressionists such as Lovis Corinth and Max Liebermann.

Contemporary artists include Ynez Johnston, who works in a semi-abstract style; Ralph Gilbert, a new figurative artist working in large color monotypes; abstract artist Paul Kelpe; and photographer Erven Jourdan.

M.M. Shinno Gallery 5820 Wilshire Blvd., Los An-
102 geles, CA 90036 (213) 935-1010; Tue-Sat: 11-5; owner/dir: Marjorie Shinno

Work by contemporary Asian artists, both from abroad and from the local community, is the specialty of the gallery.

The gallery devotes space to special solo and group shows. Exhibits have featured stone sculpture from Korea by Tai Sung Kang, ceramic lighting sculptures from Japan by Enryu Kanno, festival scenes by Tokyo silksceen artist Masaaki Tanaka, Japanese calligraphy by Hoko Horie of Tokyo. Kuo Sung Liu, a leading painter from Hong Kong, has had a recent show, as has Chung Ray Fong, another outstanding painter originally from Taipeh.

Other exhibits have shown the wall hangings of Tomiko Pattison, who makes her own natural dyes and processes the cotton fabrics herself, and the color etchings of Kunito Nagaoka. Works by Thai, Phillipine and Indian artists have also been displayed at the gallery.

Along with prints from Japan, the continous display of local ceramic pieces is of special interest.

Southern California Contemporary Art Gallery 825
103 La Cienaga Blvd., Los Angeles, CA 90069 (213) 652-8272; Tue-Fri: 12-5 Sat: 12-4 Sun: 2-4; dir: Helen Wurdemann

The Southern California Contemporary Art Gallery is the exhibition arm of the Los Angeles Art Association, a nonprofit California Corporation organized in 1925 which exhibits works of professional Southern California artists from San Diego to Santa Barbara. Many gifted young artists first introduced by the gallery have gone on to receive wide recognition. One-person shows have been organized for older artists as well, such as Anders Aldrin, Stanton MacDonald

Wright, Lorser Feitelson, Nick Brigante, Ron Blumberg and Mabel Alvarez.

In its 55 years of history, the gallery has been instrumental in giving artists a place to show their work, and in bringing European art to Southern California, too. The gallery carries on monthly exhibits in a wide variety of media and styles. Exhibiting members must be accepted by the Art Committee.

Space Los Angeles 6015 Sta. Monica Blvd., CA
104 90038 (213) 461-8166; Tue-Sat: 11-5 and by appt mid-Aug-Labor Day: closed dir: E.D. Lau

Since 1975 Space Los Angeles has presented local contemporary artists as well as ones from Japan, Sweden, Hawaii, and many states on the mainland U.S. Besides artists with established reputations, such as sculptor Seiji Kunishima, who works in metals and granite; Masami Teraoka, watercolor and prints; sculptor Mac Whitney; and Norman Lundin, pastels, the gallery works with many emerging artists. Its schedule includes performances, concerts, special group shows—such as the 1979 Thanatopsis Exhibit—and occasional panel discussions.

In addition to the artists mentioned, Space shows the following: assemblages and ballpoint drawings by Robert D. Anderson; acrylic paintings by Bob Alderette; Phyllis Davidson's oils on canvas; ceramic sculpture by Carlos Padilla; Kazuo Kadonga's wood and paper sculptures; mixed- media paper constructions by Ann Page; Karl Petrunak's oil and wax on canvas; mixed-media works on paper by Tom Stanton; Richard Thompson's oils on canvas; and Boyd Wright's wood and mixed-media sculptures.

Space also publishes graphics by Masami Teraoka.

Stella Polaris Gallery 301 Boyd St., Los Angeles, CA
105 90013 (213) 617-2846; Tue-Sat: 11-5; owner/dir: Peter Nelson

The gallery emphasizes contemporary West Coast American painting and sculpture by established artists and by promising younger artists. The common element is sensibility rather than style. Though most of the work is abstract, the gallery increasingly shows representational work as well.

Jerome Kirk is a masterful builder of kinetic sculpture for outdoor and indoor installation. Andy Warhol's silkscreen portraits are represented with his recent series "Three Portraits of Ingrid Bergman". Craig Antrim's oil-pastel drawings and paintings of wax-like surface provide richly layered textures. Carl Cheng's conceptual and sculptural artworks include luminous, computerized water installations. Mixed-media paintings by Sheila Elias, layered shaped canvases by Jack Reilly and routed-wood paintings by Michael Peter Cain strongly emphasize a third spatial dimension.

Julia Nee Chu's paintings combine traditional Chinese methods with Western abstraction. Sue Dirksen's abstract paintings reveal open California sensibility with a disciplined Japanese sumi influence. Ford Crull paints intricately gestural Color Field works. Representational painters include Nick Boskovich, oil still lifes and portraits on wood; Carolyn Cardenas, egg tempera on wood; and Randye Sandel, interiors and gardens.

Daniel Weinberg Gallery 619 North Almont Dr., Los
106 Angeles, CA 90069 (213) 271-1701; Tue-Sat:
11-5; owner/dir: Daniel Weinberg

Contemporary American painters and sculptors
are represented, with an emphasis on artists that
Weinberg considers current and provocative.

Mostly New York artists are shown, including
painters Julian Schnabel, Robert Ryman, Robert
Mangold, Terry Winters, and Sol LeWitt, and
Richard Artschwager. Among the gallery's sculp-
tors are Richard Tuttle, Scott Burton, Bruce Nau-
man, and Judy Pfaff. The also shows works by
two California artists, painter and sculptor Robert
Irwin and painter John McLaughlin.

The gallery exhibits younger artists as well.
Recent shows have featured painters Carroll
Dunham and Harriet Korman and sculptors John
Newman and Lizbeth Marano.

Gallery West 107 S. Robertson Blvd., Los Angeles,
107 CA 90048 (213) 271-1145; Tue-Sat: 10:30-5;
owner/dir: Roberta Feuerstein

The gallery carries contemporary paintings,
drawings, sculpture and graphics of both the East
and West Coasts, by both established and emerg-
ing artists.

Abstract painters featured by the gallery are
Charles Villiers, Roger Weik, Stuart Williams,
Helen Bershad, and Jimmy Leuders. Realist
painters include Paul Kane, Alberto Magnani,
and Lawrence Taugher. Of the sculptors at the
gallery, Vasa works in laminated acrylic; Eugene
Hardin creates fantasies in fiberglass and resin;
Dorothy Gillespie makes painted metal sculpture;
and Franco Assetto uses Surrealist/Pop imagery
in his sculpture and painting. The gallery also
features the transformable metal sculpture of
Yaacov Agam.

One may also see the sculptural constructions
of Andre Miripolsky, and the constructions and
handmade paperworks of Kamol Tassananchalee.

Zeitlin & ver Brugge Gallery 815 N. La Cienaga
108 Blvd., Los Angeles, CA 90069 (213) 655-7581;
by appt: Mon-Fri: 9-5 Sat: 10-2; owner: Jack
Zeitlin dir: Susan Patterson

The big red barn which houses Zeitlin and ver
Brugge Book-sellers is charmingly conspicuous
amid the concrete and glass modernity of the La
Cienaga area. The side door opens on a wealth
of old and unusual books, particularly rare books
concerned with medicine and science. There is a
large, well-stocked section of art reference
books, both new and out-of-print.

The art gallery is located in the upstairs loft
area. Zeitlin presents a wide range of fine art
from Old Masters to works by 19th and 20th
century European and American artists, as well
as maps and Natural History plates. A special
interest is California art and ephemera.

NEWPORT BEACH

Martin Lawrence Gallery 3429 Via Oporto, Newport
109 Beach, CA 92663 (714) 673-0171; Mon-Fri:
10-10 Sat: 11-11 Sun: 11-6; dir: Dennis Weiss

See listing for Sherman Oaks, CA.

Susan Spiritus Gallery 522 Old Newport Blvd., New-
110 port Beach, CA 92663 (714) 631-6405; Tue-Sat:
10-5 or by appt; dir: Susan Spiritus

As one of Southern California's galleries de-
voted exclusively to contemporary photography,
the Susan Spiritus Gallery shows the work of
many well-known photographers, such as Ansel
Adams, Jerry Uelsmann, Emmet Gowin, Eikoh
Hosoe, George Tice and Marsha Burns, as well
as many emerging photographers across the
country, and in Europe and Japan.

The gallery has published two portfolios to
date: "1979 WESTCOASTNOW," a portfolio
of 12 contemporary photographers' works, and
in 1981 the "CIRCUS" portfolio by Jacqueline
Thurston, gelatin silver prints from the Barnum
and Bailey Circus.

Among the artists that the gallery shows on a
regular basis are: Joan Myers, Patrick Nagatani,
John Divola, Marsha Burns, Brian Taylor, Neil
Chapman, Henry Gilpin, John Sexton, George
Tice, Herb Quick, Jon Gordon, Andre Kertesz
and Eikoh Hosoe, among others. Other photog-
raphers who show at the gallery include Gregory
Spaid, Jeanne O'Connor, Naomi Weissman,
Dick Arentz, Victor Landweber, David Plow-
den, and many others.

The gallery also has a wide selection of fine
art photography books and fine art posters.

OAKLAND

Crown Point Press Gallery 1555 San Pablo Ave.,
111 Oakland, CA 94612 (415) 835-5121; Tue-Fri:
10-4 Sat: by appt; dir: Kathan Brown

Founded in 1962 by Kathan Brown, Crown Point
Press has become internationally recognized as
one of the best workshops specializing in the
printing and publishing of artists' etchings.
Crown Point maintains an imaginative approach
to the 500-year-old techniques of etching, and
encourages artists to experiment in its workshop.

In 1977 the press embarked upon a full-time
publishing program. Etchings by Richard Die-
benkorn and Wayne Thiebaud, two California
artists who worked with the press in the early
60s, and by California artists Tom Marioni and
Robert Bechtle are now included with those by
Vito Acconci, Robert Barry, Iain Baxter, Chris
Burden, Daniel Buren, John Cage, Francesco
Clemente, Joel Fisher, Dan Flavin, Terry Fox,
Hamish Fulton, Hans Haacke, Joan Jonas, Jannis
Kounellis, Joyce Kozloff, Robert Kushner, Sol
LeWitt, Steve Reich, Pat Steir and William T.
Wiley.

In addition to the published prints by the
artists mentioned above, Crown Point offers a
small inventory of proofs by others who have
worked there over the years, including Claes
Oldenburg, Robert Ryman, Chuck Close, Robert
Mangold, Brice Marden and Bryan Hunt.

Victor Fischer Galleries 1333 Broadway, Oakland,
112 CA 94612 (415) 444-2424; Wed-Sat: 11-6;
owner/dir: V. Fischer

The gallery focuses on contemporary California
sculptors doing large scale outdoor and public
work, and exhibits contemporary figurative and
non-objective paintings.

Featured artists include Jacques Schnier, an
innovator in cast and carved acrylic resin; Terry
St. John, a noted Bay Area plein air painter;
Jerome Kirk, kinetic sculpture; and Roger Barr,
stainless steel and metal works.

Emerging artists include figurative painter Lisa Baack and abstract landscape painter Glenn Watson. Sculptor Gerald Walburg is known for large Corten steel pieces. Roslyn Mazzilli is gaining recognition for her aluminum and painted sculptures

Other artists are sculptors Roger Bolomey, J. B. Blunk, Kati Casida, Aristides Demetrios, Andrew Harader, Bruce Johnson, Richard Mayer, Jack Nielsen, Richard O'Hanlon, Arthur Silverman, Joseph Slusky, Gale Wagner and William Wareham; and painters Margaret Apgar, Michael Beck, Jack Galliano, Robert Hartman, Leta Ramos, Vicki Scuri, Elizabeth Voelker, Ricki Kimball and Helen Licht.

The gallery's location in Orinda, "Brook House," is open for viewing outdoor sculpture by appointment.

PALM SPRINGS

Adagio Galleries 193 S. Palm Canyon Dr., Palm
113 Springs, CA 92262 (619) 320-2230; Wed-Mon: 10-5 Aug: closed

Adagio Galleries concentrates on art of the Southwest, and has one of the most extensive collections of Southwestern art on the West Coast. Among the artists featured are R.C. Gorman, Amado Pena, John Nieto, Dolona Roberts, Carlo Wahlbeck, Bert Seabourn, Katalina Ehling, Robert Ortlieb, Jacqueline Rochester, Bob Garcia and Ted Creepingbear.

R.C. Gorman is a Navajo artist who paints with classic grace, and his works are internationally known. Amado Pena, one of the foremost painters of the Southwest, combines Spanish and Indian cultures in his art. Dolona Roberts works in pastels, and is a fine colorist. She is known for her rendition of Indian blankets, with which she adorns her subjects.

Other Indian artists presented are Carlo Wahlbeck, who creates cast-paper sculptures depicting the American Indian; Bob Garcia, an Apache, who sculpts his Indian subjects in alabaster; and John Nieto, whose bold images of Indian figures dance across his large canvases.

B. Lewin Galleries 210 S. Palm Canyon, Palm
114 Springs, CA 92262 (619) 325-7611; daily: 10-5 Jul-Aug: closed; owner/dir: Bernard Lewin

See listing for Beverly Hills, CA.

PALO ALTO

Smith Andersen Gallery 200 Homer Ave., Palo Alto,
115 CA 94201 (415) 327-7762; Tue-Sat: 10:30-4:30; owner: Paula Kirkeby dir: Dede Evans

Concentration of the gallery is on 20th century artists, primarily works on paper, with emphasis on monotypes.

Monotypes are unique works executed with printing media; a simple technique (used extensively by Edgar Degas) consists of painting directly on lithographic stone or metal plate and printing the image there created by laying paper directly on the inked surface. Susceptible to infinite variations, monotypes have recently become an important medium for many contemporary artists.

Artists whose work is shown at the gallery include Sam Francis, Tom Holland, Ed Moses, Claire Falkenstein, Bruce Conner, Matt Phillips, Steve Sorman and others.

RIVERSIDE

Robertson Gallery 3643 Main St., Riverside, CA
116 92501 (714) 684-6450; Mon-Sat: 10-5:30 Sun: by appt; owner: Pat Capsavage dir: Perri Guthrie

Concentration is on contemporary American painting, sculpture and original graphic works.

Artists include Arthur Secunda, internationally known for his torn paper collages and original prints; R.C. Gorman, well-known for his Images of American Indians; and Martin Green, who is recognized for his work with monotypes and cliche verre. Robertson Gallery also presents an important American sculptor, Harry Jackson, along with Missouri sculptor Larry Young, and Jacqueline Spellens, who works in terra cotta, alabaster and bronze.

SAN DIEGO

A.R.T./Beasley Gallery 2802 Juan St., San Diego,
117 Ca 92110 (619) 295-0075; Mon-Fri: 10-5:30 Sat: 11-5:30 Sun: by appt; owner/dir: Dorothy Beasley

A.R.T./Beasley Gallery presents artists of regional, national and international importance working in all media.

On view one may find raku vessels by Michael Gustafson, paper constructions by Marshall Taylor, and stainless steel sculpture and drawings by Jose Bermudez. Drawings, paintings and monotypes by Masoud Yasami and oil paintings by Chris Ranes are also shown. Avery Faulkner's drawings, David Herschler's polished stainless steel sculptures, Gary Hawthorne's paintings and Claude Conover's stoneware are further examples of the variety offered. The gallery also shows work by Norma Andraud, Lau Chun, David Herschler, Sandee Kinee, Gita Landwehr, Hiroshi Miyazaki, Diane O'Leary, Sheri Schrut, Ann Taylor, Thep Thavonsuk and Cathy Woo.

Other artists featured include Charles Bracken, oil paintings; Katherine Hagstrum, monotypes; Chick Hayashi, watercolors; James Lovera, ceramics; Joan McKasson, watercolors; Gary Fey, deyed and painted silk; Carl Provders, collage and paint; and Karen Rhiner, fiber wall sculpture. Fritzi Morrison, Mary Patlinian, Carolyn Prince Batchelor and J.R Reed work in paper and handmade paper.

Orr's Gallery 2222 4th Ave, San Diego, CA 92101
118 (619) 234-4765; Mon-Sat: 10-5; owner/dir: Dan Jacobs

Concentration is on important 19th and 20th century works, including oil paintings, watercolors, drawings, original prints and sculpture.

Works are available by California Impressionists circa 1890-1950, including Alfred A. Mitchell, Maurice Braun, J. Christopher Smith, Charles Reiffel, and many others. The gallery collection features a large selection of late 19th to early 20th century English watercolors by such noted artists as Sir William Russell Flint, as

Dan Namingha, *Chanter* (1983), 72 x 54, acrylic on canvas, The Gallery Wall (Scottsdale, AZ).

Bob Parks, *In Hot Pursuit,* 19 x 17, bronze, Bob Parks Gallery (Scottsdale, AZ).

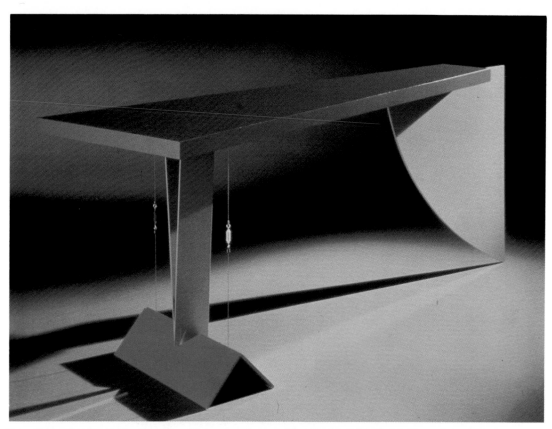

Peter Shire, *Brazilia Table,* 36 x 94 x 20, lacquered wood, The Hand and The Spirit (Scottsdale, AZ).

Olivia Parker, *Pomegranates* (1979), 8 x 10, dye transfer print, Weston Gallery (Carmel, CA).

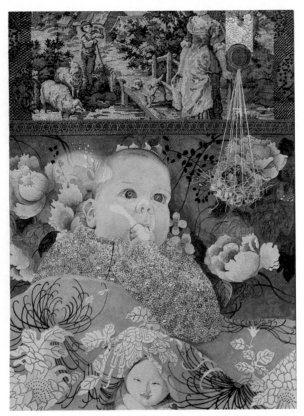

Morris Broderson, *Challee,* 29 x 22, watercolor, Ankrum
Gallery (Los Angeles, CA).

Will Caldwell, *Baringo Sunrise,* 18 x 24, pastel, Bishop
Gallery (Scottsdale, AZ).

Martin Green, *Moon Garden* (1984) 22 x 41, monotype, Louis Newman Galleries (Beverly Hills, CA).

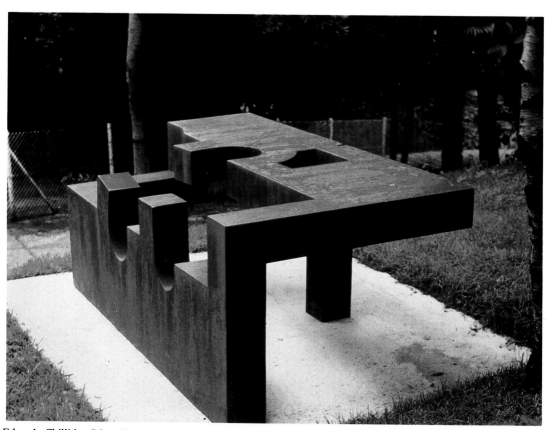

Eduardo Chillida, *Silent Music II* (1983), 31 x 75 x 41, steel, Tasende Gallery (La Jolla, CA).

Leza Lidow, *Memories* (1983), 72 x 96, oil, Ankrum Gallery (Los Angeles, CA).

Susan Clover, *Fossil Beach—Lake Lopez,* 48 x 60, oil on linen, Orlando Gallery (Sherman Oaks, CA).

Henry Moore, *Reclining Woman* (1981), 87 long, bronze, Tasende Gallery (La Jolla, CA).

Michael Ansell, *The Diner*, 17 x 23, prisma ink and pencil, Walton-Gilbert Gallery (San Francisco, CA).

Robert S. Duncanson, *Italian Landscape,* 26 x 36 oil, Atelier Dore (San Francisco, CA).

Carl Hoeckner, *The Yes Machine,* 30 x 40, oil, Atelier Dore (San Francisco, CA).

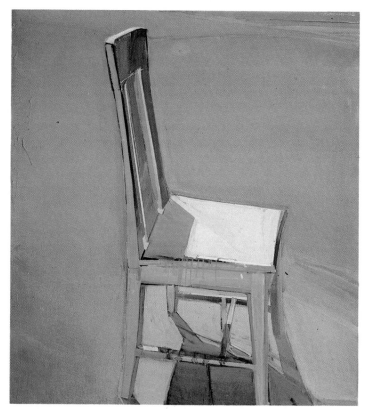

Raimonds Staprans, *Chair in Sunlight,* 40 x 44, oil on canvas, Maxwell
Galleries (San Francisco, CA).

Pierre-Auguste Renoir, *Enfants Jouant a la Balle* (c. 1900), 24 x 20
lithograph, Harcourts Gallery (San Francisco, CA).

Nicoli Fechin, *Sheila*, 20 x 16, oil on canvas, Hunter
Gallery (San Francisco, CA).

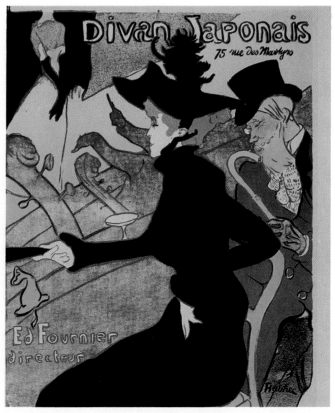

Toulouse-Lautrec, *Le Divan Japonais* (1892), 31 x 23, color
lithograph, Pasquale Iannetti Art Gallery (San Francisco, CA).

Matsumi Kanemitsu, *Pacific Series #5 Silent Wave,* 55 x 40, acrylic on canvas (1983), Louis Newman Galleries (Beverly Hills, CA).

Robert Natkin, *Bern Series* (1983), 41 x 31, acrylic on paper, Ivory/Kimpton (San Francisco, CA).

Yasuhiro Esaki, *Blue Sheet #15,* 14 x 9, pencil on
acrylic, Graystone Gallery (San Francisco, CA).

Robert Motherwell, *Bastos* (1974), 62 x 40, lithograph, Harcourts Contemporary (San Francisco, CA).

DeLoss McGraw, *W. D. Escapes* (1984), 60 x 120, watercolor/pastel triptych, Harcourts Contemporary Gallery (San Francisco, CA).

Hoon Kwak, untitled (From the Chi Series), 54 x 27, mixed media on rice paper, Harcourts Contemporary Gallery (San Francisco, CA).

Willard Dixon, *Springfield with Cows,* 48 x 72, oil on canvas, William Sawyer Gallery (San Francisco, CA).

Marc Chagall, *Maternite et Cheval Jaune* (1962), 12 x 9,
monotype, Harcourts Gallery (San Francisco, CA).

Richard Earl Thompson, *Ti's Spring,* 30 x 40, oil on canvas, Richard Thompson Gallery (San Francisco, CA).

Kirk Pederson, watercolor, Hoover Gallery (San Francisco, CA).

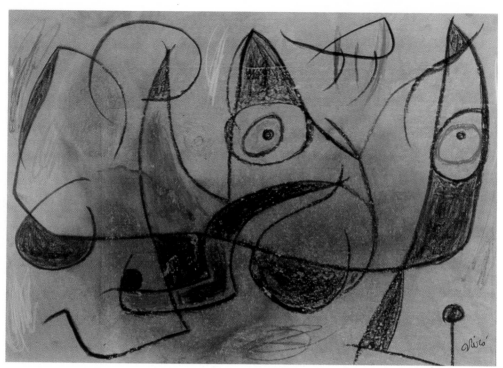

Joan Miro, *Personnage et Oiseau* (1975), 19 x 27, oil/pastel on paper, Harcourts Gallery (San Francisco, CA).

Kruesmann Van Elten, *Hudson River Scene—Winockie River*, 48 x 68, oil on canvas, Hunter Gallery (San Francisco, CA).

Wayne Thiebaud, *Four Cakes,* 16 x 24, drypoint and aquatint, Graystone Gallery (San Francisco, CA).

Herman Maril, *Cat in Studio,* Franz Bader Gallery (Washington, DC).

well as etchings by Augustus John, James McBey, Sir Frank Short and others. Contemporary works include paintings, prints and sculpture by Fritz Scholder, and a collection of contemporary American crafts.

Quint Gallery 664 9th Ave., San Diego, CA 92101
119 (619) 239-8592; Wed-Sat: 10-4 Aug: closed; owner/dir: Mark Quint

The Quint Gallery handles contemporary art by beginning and mid-career artists working in painting, sculpture and, to a lesser extent, graphics. Most artists are from the West Coast. Recent exhibitions have included works by Manny Farber, Ernest Silva, Gary Lang, Raul Guerrero, Richard Allen Morris and Frank Dixon. The gallery has also dealt in works by artists of an earlier generation, including Milton Avery, Charles Burchfield and Max Weber.

Riggs Galleries 2550 Fifth Ave., Suite 167, San Diego, CA 92103 (619) 235-9065; Mon-Sat: 9-5;
120 owner/dir: Mary Riggs

Since 1980, the gallery has shown an international selection of paintings and graphics, from turn-of-the-century works from Europe and America to contemporary works. Photography and small-scale sculpture also are featured.

Among the two-dimensional works are the nudes of Jan De Ruth, the impressionistic paintings of Nancy Bowen, and the representational oil paintings of Melinda Miles, whose style recalls Edward Hopper.

A unique facet of the gallery is a selection of painted fabrics. Notable among these are the works of French painter Francoise Gilot, now a California resident, who presents large-scale works with strong imagery. Another highlight is Marie Illie's painted silks.

The gallery's graphics and sculpture are diverse in style and media. There are the monotypes and prints of Martin Green, symbolic landscape artist Arthur Secunda, non-representational Thai artist Wattana Wattanapun, and Marta Chaffee; the etchings of Jules Madioff; and the sculptures of Ernestine Voss, David Aronson, Robert Holmes and German artist Cornellia Megenhausen.

Wenger Gallery 4683 Cass St., San Diego, CA 92103
121 (619) 454-4414; Mon-Sat: 9-5 & by appt; owner/dir: Muriel Wenger

Wenger Gallery was established in the San Diego Area in 1963 by Muriel and Sigmund Wenger, who previously had been active in the art world in Mexico City. The gallery shows contemporary paintings, drawings and sculpture, and also features limited edition prints and tapestries.

Artists regularly shown include Op Art painter Richard Anuskiewicz, Nixson Borah, Guy John Cavalli, Hugo Duchateau, Judith Foosaner, Helen and Newton Harrison, Pol Mara, Eduardo Nery, David Provan, George Rickey, Elizabeth Sher, Vasa, Jan Van Riet and Kay Walking Stick.

The gallery also shows work by Francisco Farreras, Alfred Jensen, Antonio Rodriguez Luna, Joan Miro, Joan Moment, Marta Pan, Panamarenko, Picasso, Robert Rauschenberg, Dan Snyder and Mark Tobey.

SAN FRANCISCO

Allport Associates Gallery 126 Post St., San Francisco, CA 94108 (415) 398-2787; Tue-Sat:
122 10:30-5:30; owner/dir: Ardys Allport

Concentration is on contemporary American artists whose works have received university or museum recognition. Emphasis is on figurative works and mixed media pieces.

Norman Lundin portrays interiors, usually inhabited only by light, which assumes the role of a demiurge in his pastels, creating form out of the void by its mysterious presence. Other artists shown are Alan Magee, acrylics, drawings and watercolors; David Lund, oils and pastels; DeWitt Hardy, watercolors; Shelia Elias, mixed media; and Don Williams, pastels. Emerging artists shown by the gallery include Deborah Garber, pastel landscapes; Yasmin Bar-Dor, mixed media; Patrick Maloney, oil paintings of landscapes and interiors; Robin Eschner Camp, watercolors; and Susan Van Campen, watercolors.

The Allrich Gallery 251 Post St., San Francisco, CA
123 94108 (415) 398-8896; Tue-Sat: 11-5; dir: Louise Allrich

The gallery shows abstract painting and sculpture from California artists, as well as tapestry and fiber art by leading Japanese and American artists.

Painters Jerry Concha, Robert Gonzales, Stephanie Weber and Geoffrey Williams, and sculptors Dan Snyder and Roger Bolomey are among the California artists exhibited. New York abstract painter Adja Yunkers is also featured. Nance O'Banion's work in handmade paper, Kris Dey's painted fabric constructions and Masakazu Kobayashi's suspended fabric sculpture reflect the diversity of fiber art at the gallery, which also shows Lia Cook's optical tapestries, Neda Al Hilali's paper constructions, paper works by Glenn Brill and Angelita Surmon, and painted rayon works by Thomasin Grim.

The Allrich Gallery is known for its commissions of large-scale tapestry and sculpture by well-known artists.

Gallery Paule Anglim 14 Geary St., San Francisco, CA
124 94108 (415) 433-2710; Tue-Fri: 11-5:30 Sat: 11-5; owner: Paule Anglim dir: Jane Trotter Oleson

Gallery Paule Anglim presents Bay Area and West Coast artists, in addition to arranging exhibitions of work by New York artists.

Exhibitions in collaboration with New York galleries include one-person shows of work by Milton Avery, Jess, Leon Golub, William King and Leon Polk Smith. The gallery shows historical exhibitions such as "Sight/Vision/The Urban Milieu", a group show with work by California artists Bruce Conner, Jay DeFeo, Wally Hedrick and George Herms. Plays, concerts and poetry readings add to the activities of the gallery.

Among the painters featured are Hassel Smith, Judith Linhares, Jay DeFeo, Wally Hedrick, Tom Marioni, and Christopher Brown, and sculptors David Bottini, Michael Todd, Jim Huntington and Victor Royer. Paintings by Drew Beattie and Scott Bell, and sculptures on wood by naive artist John Abduljaami are among the works by emerging artists presented by the gallery.

Atelier Dore 771 Bush St., San Francisco, CA 94108
125 (415) 391-2423; owner/dir: John & Chester Helms

Founded with the proceeds from the sale of two huge canvases by French wood engraver Gustave Dore, the gallery specializes in American paintings of the late 19th and early 20th century, and also houses an eclectic collection of European painting of the same period.

The gallery carries paintings by artists of the Hudson River School, Academic Realism, American Impressionism, and various schools of the American Scene painting, such as Social Realism, Regionalism, Precisionism, and artists of the WPA and various Federal Arts Projects. Included are works by J. Carroll Beckwith, George Winter, Will Sparks, Joseph Henry Sharp, Ernest Lawson, Thomas Hill, Robert S. Duncanson, Joshua Johnston, Julian Rix, Jules Tavernier, Mauritz de Haas, Grant Wood, Thomas Hart Benton, Carl Hoeckner and Doris Lee. Historical paintings of the American frontier, including those of California, Taos and Santa Fe, and the pioneer movement are also featured.

Hank Baum Gallery & Graphics Gallery 2140 Bush
126 St., San Francisco, CA 94115 (415) 921-7677; Mon-Fri: 11-5:30, Sat: by appt; owner: Hank Baum dir: Joan Joy

The gallery specializes in work by contemporary California artists. In addition to paintings and sculpture, there are many original works on paper.

Some of the artists shown are James Bolton, Martin Camarata, Lew Carson, Guy Diehl, Georg Heimdal, Dick Kakuda, David King, Robert McGill, John Ploeger, Mel Ramos, Richard Wilson, Emerson Woelffer, Karl Benjamin, Kathleen Marshall, Rolando Castellon and Bruce Kortebein.

The owner Hank Baum was formerly associate director of the Tamarind Lithography Workshop in Los Angeles, executive director of the Atelier Mourlot (N.Y.) and Collectors' Press in San Francisco.

The Graphics Gallery maintains an extensive collection of works on paper in all media. Works are available by the following well-known artists: Ay-O, Richard Anuskiewicz, Jose Luis Cuevas, Allan D'Arcangelo, Joseph Albers, Richard Diebenkorn, Robert Indiana, Masuo Ikeda, Nicholas Krushenick, Roy Lichtenstein, Mel Ramos, Arnaldo Pomodoro, Philip Pearlstein, Frank Stella, Claes Oldenburg and Emerson Woelffer. Other artists include: William Anderson, James Bolton, Eleanor Coppola, Guy Diehl, Ke Francis, Harold Gregor, Georg Heimdal, John Hunter, John P. Jones, Akira Kurosaki, Laureen Landau, Robert McGill, Joel Oas, John Ploeger, Steve Poleskie, Barbara Romney, Seymour Rosofsky, Anne Rothman, Sherry Schrut, David Simpson, Richard Wilson, Don Woodford, Susan Wooten, Sheila Benow, Ynez Johnston, Maurice Lapp, Mimi LaPlant, Nancy Macko, Edward Mackenzie, Cynthia Stan and Frances Valesco.

George Belcher Gallery 500 Sutter St., San Francisco,
127 CA 94102 (415) 981-3178; Tue-Sat: 12-5; owner/dir: George Belcher

George Belcher specializes in Mexican and Latin American paintings. The gallery buys and sells work by 19th and 20th century Mexican and Latin American painters, including Dr. Atl, Fernando Botero, Jean Charlot, Gunther Gerzso, Frida Kahlo, Wifredo Lam, Ricardo Martinez, Carlos Merida, Jose Clemente Orozco, Emilio Pettoruti, Diego Rivera, David Alfaro Siqueiros, Rufino Tamayo, Francisco Toledo and Jose Maria Velasco.

The gallery also includes in its inventory works by Mexican sculptor Francisco Zuniga.

John Berggruen Gallery 228 Grant Ave., San Fran-
128 cisco, CA 94108 (415) 781-4629; Mon-Fri: 9:30-5:15 Sat: 10:30-5; owner/dir: John Berggruen

The John Berggruen Gallery Specializes in 20th century paintings, drawings, sculpture and prints.

Exhibitions of historical interest have included works by Pablo Picasso, Henri Matisse, Georgia O'Keeffe, Marsden Hartley and Arthur Dove. The gallery's range of exhibitions also encompasses important sculpture by Henry Moore, Alexander Calder, George Rickey, H.C. Westermann, Mark di Suvero and Beverly Pepper.

Works are available by major New York artists, including Robert Motherwell, Helen Frankenthaler, Frank Stella, Robert Rauschenberg, Hans Hofmann, Jasper Johns, Ellsworth Kelly, Friedel Dzubas, Roy Lichtenstein and Franz Kline.

West Coast artists Wayne Thiebaud, Richard Diebenkorn, Ron Davis, Joseph Raffael, Fletcher Benton, Nathan Oliveira, Tom Holland, Sam Francis, Manuel Neri, Paul Wonner, Elmer Bischoff and Mark Adams are also featured.

Bluxome Gallery 173 Bluxome St., San Francisco,
129 CA 94107 (415) 546-0449; Tue-Fri: 10-5 Sat: 11-4; owner: M.S. Clark, Marilyn Mindel, Fred Karren dir: Morley Clark

The gallery is devoted to contemporary paintings, sculpture, graphics and drawing.

The artists featured are: Ian Banks, Roger Berry, Barbara Brenner, Jim Growden, Marcia Hafif, Robert Hartman, Andrew Hoyem, Joseph Hughes, Larry Hurst, Leigh Hyams, David Kelso, Gordon Kluge, Patsy Krebs, David MacKenzie, Ann Nadel, Richard Putz, Bruce Richards, James Rosen, Kent Rush, Phil Sims, Jean St. Pierre, Larry Thomas and Mia Westerlund Roosen.

Braunstein Gallery 254 Sutter St., San Francisco, CA
130 94108 (415) 392-5532; Tue-Sat: 11-6 Aug 23-30: closed; owner/dir: Ruth Braunstein

This adventuresome gallery has moved several times since first opening in Tiburon in 1961. Known for its willingness to take risks on behalf of unknown artists, the gallery shows contemporary art by new and established artists from the Bay Area and from around the world.

John Altoon, Jeremy Anderson, Tony Costanzo, Nell Sinton, Mary Snowden, ceramist and sculptor Peter Voulkos and assemblage artist Richard Shaw are among the established artists who have been with the gallery for over 15 years. New to the group are sculptors David Anderson, Robert Brady, Karen Breschi, Ben

Kaiser, and glass artist Dale Chihuly, as well as painters Paul Pratchenko, Franklin Williams, and Julia Huette.

Charles Campbell Gallery 647 Chestnut St., San
131 Francisco, CA 94133 (415) 441-8680; Tue-Fri: 11-5:30 Sat: 12-4; owner/dir: Mrs. Charles Campbell

The gallery mostly displays work by San Francisco Bay Area painters, with emphasis on figurative and representational paintings and drawings.

Among the artists featured are Morris Graves, known for his highly personal images of birds and small animals, as well as Mirian Ahn, Michael Barnes, Harry Bowden, Kristina Branch, Gordon Cook, Charles Eckart, Charles Griffin Farr, Keith Jacobshagen, James Johnson, Walter Kuhlman, Bruce McGaw, Ann Morency, Geer Morton, Hank Pitcher, Giovanni Ragusa, Fred Reichman, Mary Robertson, Stephanie Sanchez, Wayne Thiebaud, Stan Washburn, James Weeks and Donald Weygandt.

Joseph Chowning Gallery 1717 17th St., San Fran-
132 cisco, CA 94122 (415) 626-7496; Tue-Fri: 11-6 Sat: 12-4; owner/dir: Joseph Chowning

Over the years Joseph Chowning has exhibited a diverse group of local artists, painters and sculptors.

Several of the artists exhibited are working in realist styles. Bill Martin has become well-known for his visionary landscapes, often in tondo form, executed with extreme clarity. Diane Sloan, Eduardo Carrillo, William Snyder and Ken Waterstreet are figurative painters, while John Battenberg casts life-size bronze nudes. Joe Draegert paints landscapes and still lifes, often of brilliantly colored flowers with intricate reflections in vases. Howard Hack shows his silverpoint drawings and paintings. Redd Ekks incorporates ceramic into his acrylic paintings. Sculptor Clayton Bailey makes robots. Other sculpture includes Richard Berger's work in wire, Michael Bishop's assemblage bronze sculpture, Bill Geis's abstractions, and Laura Myers's painted wood abstractions.

The gallery also shows works by Stanton Macdonald-Wright and Morgan Russell, co-founders of Synchromism, a theory of color which developed from Neo-Impressionism. Using color much the way a composer uses musical sound, they painted some of the first abstractions.

Ernest F. de Soto Workshop 319 11th St., San Fran-
133 cisco, CA 94103 (415) 863-3232; Mon-Fri: 9-5:30 Sat: 9-12; owner/dir: Ernest F. de Soto

Ernest F. de Soto are publishers of graphic works by contemporary Latin American and North American artists.

Editions have been published by Mexican artists Jose Luis Cuevas and Rufino Tamayo, by New York abstract painter Adja Yunkers, by California artists Richard Shaw and Roy DeForest, and by many others, including young Mexican artists Alejandro Colunga, Edmundo Aquino, Maximino Javier, and Arevalo.

Eaton/Shoen Gallery 315 Sutter St., San Francisco,
134 CA 94108 (415) 788-3476; Tue-Sat: 10-6 Mon: by appt; owner/dir: Timothy A. Eaton & Mary Anna Shoen

The Eaton/Shoen Gallery is newly located in the heart of San Francisco's gallery district. The gallery shows contemporary painting, sculpture, photography and prints by international artists.

The gallery exhibits work by emerging and established artists from this country and abroad, including Edouard Boubat, John Baldessari, Jonathan Borofsky, Rosemarie Castoro, Francesco Clemente, Susan Dannenfelser, Kate Delos, Martin Disler, Robert Doisneau, Timothy Ely, Eric Fischl, Roger Herman, William Klein, Bernard Plossu, Nassos Daphnis, Philippe Salaun and others.

The gallery has also included in its numerous group shows a display of artists' books.

Editions Limited West One Market Plaza, San Fran-
135 cisco, CA 94105 (415) 777-5711; Mon-Fri: 10-5:30; owner: Marc Chappell dir: Joanne Chappell

Editions Limited west are publishers of fine art posters and limited edition graphics. Working as corporate art consultants, the gallery handles contemporary artists and handles paintings, photography, tapestries, graphics, handmade paper pieces and ceramics.

Many young artists who are establishing strong reputations are featured, including Peter Kitchell, Deborah DeWitt, Bruce Weinberg and Stephen McMillan. The gallery also handles and publishes the work of Jurgen Peters and Joe Price and includes works by Gabor Peterdi, Harold Altman, Peter Milton and Joseph Raffael in its collection.

Fraenkel Gallery 55 Grant Ave., San Francisco, CA
136 94108 (415) 981-2661; Tue-Sat: 10:30-5:30; owner/dir: Jeffrey Fraenkel

The gallery deals exclusively in photography. Notable shows of the past have included an exhibition of the Carleton E. Watkins album, "Photographs of the Pacific Coast", a group of rare mammoth-plate photographs from 1872. The gallery was the first to exhibit work from the four major periods of Timothy O'Sullivan's distinguished photographic career. Other important exhibitions have included vintage, unpublished photographs by Diane Arbus and the first West Coast retrospectives of work by Garry Winogrand and Lee Friedlander.

The Fraenkel Gallery handles the photographs of John Gutmann, Lew Thomas, Henry Wessel, Jr., and Bill Dane, four contemporary Bay Area artists who have achieved national renown.

Gregory Ghent Gallery 420 Sutter St., San Francisco,
137 CA 94108 (415) 956-0626; Tue-Sat: 11-5:30; owner/dir: G. Ghent

Changing monthly exhibits of Bay Area painting and sculpture may be seen at the gallery, as well as an occasional show of a 20th century American or European master. Always on display are artworks from Africa, Oceania, and Pre-Columbian cultures of Mexico and South America, which range from small carvings to large architectural pieces.

Established Bay Area artists include sculptors Richard Bauer, Al Farrow, Rand Schlitz, Louis Quaintance and Michelle Greene; and painter and etcher Roberta Loach. Richard Bauer uses

body-casting to make plaster casts which he then cracks, polishes, weathers and paints. Al Farrow creates series of small bronzes, often figures based on the dance. Rand Schlitz makes miniature, detailed bronzes using animal images and bizarre architectural structures to create surrealist narratives. Emerging artist Pam Dixon uses found materials in her assemblage and collage.

Fuller Goldeen Gallery 228 Grant Ave., San Francisco, CA 94108 (415) 982-6177; Mon-Fri: 10:30-5:30 Sat: 10:30-5; owner/dir: Diana Fuller & Dorothy Goldeen
138

The gallery deals in contemporary American art, and presents a strong group of innovative artists from the San Francisco Bay Area and the rest of the United States.

The ceramic sculptor Robert Arneson is among the artists featured; his humorous work has recently given way to a series of sculptures on the effects of nuclear war. Marilyn Levine uses clay to create photorealist sculpture. Other sculptors include Lynda Benglis, known for her fiberglass wall pieces; James Surls, who works in laminated wood; and Robert Hudson, who has made painted geometric sculpture in metal. Painters include William Wiley, Roy DeForest and Jay DeFeo. The work of Charles Ginnever is also featured, as well as work by many younger artists such as painters Laddie John Dill, John Buck, Charles Arnoldi and sculptor Deborah Butterfield.

Grapestake Gallery, Inc. 2443 Fillmore St., San Francisco, CA 94115 (415) 931-0779; by appt; owner/dir: Tom Meyer, Ursula Gropper
139

Showing large-scale paintings and sculpture, and photographs, the gallery presents 20th century painting and photography side by side.

Most of the painters and sculptors reside on the West Coast; many are concerned with experimental use of painting process and media. Among the artists are Rick Grafton, William Wareham, Steve Heino, Gregg Renfrow, Jay McCafferty, Bob Nugent and Takako Yamaguchi.

The photography program is balanced between traditional and experimental modes. In the collection of 20th century masters one may find work by Ansel Adams, Berenice Abbott, Imogen Cunningham, Harry Callahan, Robert Frank, Andre Kertesz and Minor White. Younger exponents of the medium such as Joel Meyerowitz, Ralph Gleason, Lewis Baltz, Richard Misrach, Arthur Ollman, Jerry Uelsmann and Judy Dater are among the many photographers featured.

Graystone Gallery 527 Sutter St., San Francisco, CA 94102 (415) 956-7666; Mon-Sat: 10-6; owner: Edmund Russell, Edie Caldwell
140

Formerly Rabak & Russell, the Graystone specializes in contemporary prints, works on paper and sculpture by established and emerging American and European artists.

The gallery handles graphics by such established artists as Wayne Thiebaud, first associated with Pop Art for his thickly painted studies of food (cream pies, etc.), and now known also for his landscapes and city scenes. The gallery also carries work by Superrealists Richard Estes and Robert Bechtle, as well as etchings by Peter Milton.

Emerging artists featured include Yasuhiro Esaki, Yuji Morita, and Anne Dykmans. Morita and Dykmans specialize in virtuoso mezzotints. Esaki has become known for his beautifully rendered drawings and prints.

Gump's 250 Post St., San Francisco, CA 94108 (415) 982-1616; Mon-Sat: 9:30-5:30; dir: Helen F. Heninger
141

The gallery presents 20th century American painting, prints, ceramics and glass. American artists such as Robert Motherwell, Jasper Johns, adn artists from California, New Mexico and the Northwest are the mainstays of the gallery.

Harcourts Gallery 535 Powell St., San Francisco, CA 94108 (415) 421-3428; Mon-Sat: 9-6; owner: Fred Banks dir: James P. Healey
142

Harcourts Gallery carries rare and historic works by 19th and 20th century European, American and Latin American painters, sculptors and printmakers.

The inventory of the gallery contains works by French Impressionist Pierre-Auguste Renoir; Post-Impressionist Georges Rouault; 20th century European masters Joan Miro, Pablo Picasso, Marc Chagall, Georges Braque and Henri Matisse; 20th century sculptors Alexander Calder and Henry Moore; and German painter and graphic artist Friedensreich Hundertwasser. Latin American artists include Mexican muralist David Alfaro Siqueiros, painter Rufino Tamayo, painter and draftsman Jose Luis Cuevas, sculptor Francisco Zuniga, painters Francisco Toledo and Carlos Merida.

The gallery also presents the classical Mediterranean sculpture of Antoniucci Volti, and the painting of Austrian Fantastic Realist Erich Brauer.

Harcourts Contemporary 550 Powell St., San Francisco, CA 94108 (415) 421-5590; Mon-Sat: 9-6; owner: Fred Banks dir: Robert H. Ballard
143

Harcourts Contemporary handles 20th century American and European works of art, including paintings, graphics, sculpture and works on paper.

Contemporary American masters include California gestural realist Richard Diebenkorn, Abstract Expressionists Sam Francis, Paul Jenkins and Robert Motherwell; Robert Rauschenberg and Jasper Johns, whose work represents a break with Abstract Expresionism while maintaining a painterly style; Pop artist Roy Lichtenstein and David Hockney, a painterly realist and excellent draftsman associated with Pop Art in some respects.

The gallery also shows R. Lee White's Brule Sioux picto-graphs, "found object" collage by Gladis Goldstein, naive watercolors by DeLoss McGraw, French artist Jeanick Bouy's color fields, English realist Michael Potter's watercolors, the abstract collage of Murray Jones, James Groff's abstracts, Adrienne Anderson's mixed media assemblage, David Maes Gallagos's realist landscapes, Yuji Morita's detailed etchings reminiscent of Escher, and works by Hoon Kwak.

Holos Gallery 1792 Haight St., San Francisco, CA 94117 (415) 668-4656; Tue-Sun: 12-6; pres: Gary Zellerbach
144

Joseph Henry Sharp, *Hunting Song,* 20 x 24, oil on canvas, Atelier Dore (San Francisco, CA).

Thomas Hart Benton, *The Woodcutters,* 8 x 11, oil on board, Atelier Dore (San Francisco, CA).

Holos Gallery offers rotating exhibitions of holograms by America's top artists in the field.

The three-dimensional virtual images created by the holographic process actually appear to come through the film and out into the room with the viewer. In a recent show John Kaufman displayed reflection holograms of moss-lined branches, rocks and other objects from around his Point Reyes home. A more recent exhibition called "Light-scapes: Photography and the Laser" featured fifteen Bay Area kinetic artists. Their specially created works combined 20th century media, including lasers, holography and dichroic glass, with classical landscape.

As well as showing work that blends art and technology, Holos deals in custom and commercial holographic products, wholesale and mail-order distribution, and educational and instructional services.

Hoover Gallery 1681 Folsom St., San Francisco, CA
145 94103 (415) 558-8944; Mon-Fri: 10-5 Sat: by appt; owner: F. Herbert Hoover dir: Allan Carr

Founded in 1969, the gallery relocated at its present address in 1983, in what was formerly an old ceramic shop built in 1928. Completely transformed by the owner, it is now a streamlined contemporary gallery.

Featuring the work of Harold Christopher Davies, who lived and worked in East Hampton and latterly in Inverness, Scotland, and notable young artists such as Kirk Pedersen, the gallery also holds occasional group shows. These shows are quite varied in scope and include works by 19th century European masters, 20th century American sculptors, and the exotic and bizarre art of the Cuzco painters.

Francis Herbert Hoover serves as a consultant to many corporations. He also undertakes many research projects for schools and historical societies, and has published numerous articles. Director Allan Carr was formerly of the staff of Edinburgh College of Art and the Department of Art History at the University of Edinburgh.

Hunter Gallery 278 Post St., #23 Mezzanine, San
146 Francisco, CA 94108 (415) 392-3182; Mon-Fri: 10-5; owner/dir: Mary Hunter

Hunter Gallery handles 19th century paintings, specializing in American Impressionism, the Hudson River School, Early California and Western paintings.

The gallery's inventory includes works by American Impressionist Childe Hassam, who interpreted the landscape of his native New England and the Northeast, and landscapes by Albert Bierstadt, founder of the so-called Rocky Mountain School, which enlarged the scope of the Hudson River painters to embrace whole mountain ranges. Other artists are Abbott Graves, William Keith, Thomas Hill, Frank Benson, Charles Curran, Bruce Crane, J.H. Sharp, O.E. Berninghaus, Nicolai Fechin, Donald Teague, Percy Gray and William Coulter.

The gallery also features the bronzes of contemporary Western sculptor Harry Jackson.

Pasquale Iannetti, Inc. 575 Sutter St., San Francisco,
147 CA 94102 (415) 433-2771; Mon-Sat: 10-6

Pasquale Iannetti, Inc., deals in original prints and drawings as well as painting and sculpture.

The gallery features works from the 16th through the 20th century and offers a full range of professional services.

Included in the gallery's collection are old masters such as Durer and Rembrandt, master etcher Jacques Callot, and English satirical etcher and painter William Hogarth. Late 19th century French artists are well represented with works by Honore Daumier, Fantin-Latour, Toulouse-Lautrec, Edouard Manet, Auguste Renoir, Camille Pissarro, Paul Gauguin, Paul Signac, and Odilon Redon. The gallery has work by *art nouveau* designers and graphic artists such as Alphonse Mucha. The 20th century is represented by such artists as Fernand Leger, Georges Rouault, Emil Nolde, Wassily Kandinsky, Lionel Feininger, Paul Klee, Georges Braque, Kathe Kollwitz, Joan Miro, Pablo Picasso, Salvador Dali and Marc Chagall. Contemporary artists include German printmaker Johnny Friedlander, French painter Pierre Alechinsky, Swiss graphic artist Jean-Michel Folon, and Mexican sculptor Francisco Zuniga.

Images of the North 1782 Union St., San Francisco,
148 CA 94123 (415) 673-1273; Daily: 11-5:30; dir: Helen F. Sobol

As San Francisco's only gallery specializing in Native North American art, Images of the North has gained a reputation for the scope and quality of its collections.

The comprehensive selection of Eskimo art from Alaska and Canada includes sculpture by today's leading Eskimo artists such as Pauta, Etungat, Arluk and Lukta. Recent exhibitions have included one-person shows of works by George Arluk and Marie Kuunnuaq, both of Baker Lake, as well shows featuring "The Eskimo Miniature", "Mothers and Children", "Wildlife of the North", and sculpture from Baffin Island and Arctic Quebec.

The gallery features yearly Eskimo print collections, including Cape Dorset stonecuts, which have become known for their striking, colorful and imaginative images.

A collection of Indian pottery and jewelry from the Southwest and masks from the Northwest Coast are also on display in this distinctive gallery.

Ivory Kimpton Gallery 55 Grant Ave., San Fran-
149 cisco, CA 94108 (415) 956-6661; Tue-Fri: 10:30-5:30 Sat: 12-5:30; owner/dir: Jane Ivory, Kay Kimpton

Opened in 1980, the gallery specializes in paintings on paper and canvas; however, handmade paper, sculpture and various types of prints are shown as well.

Most of the gallery's artists are based in San Francisco or Los Angeles and therefore would be considered of the California school. Martin Facey, Cheryl Bowers and Barbara Weldon would be good examples. Artists from other areas are featured, though, including a number from New York—Robert Natkin, Stanley Boxer, Dan Christensen, Harriet Shorr and Sigrid Burton, to name a few.

Stylistically , lyrical abstraction or formalism is the rule. Robert Natkin's and Richard Phipp's paintings share this aesthetic along with Stanley Boxer's canvases, Nancy Genn's handmade

Toulouse-Lautrec, *Nicolle . . .* (1893), 14 x 10, lithograph, Harcourts Gallery (San Francisco, CA).

Harry Jackson, *John Wayne* (1981), 37 high, painted bronze, Hunter Gallery (San Francisco, CA).

Peter Milton, *Daylilies,* 20 x 32, etching/engraving, Graystone Gallery (San Francisco, CA).

paper pieces and Mim Spertus's collages. There are inspired exceptions: a range of work encompassing Susan Crile's and Jerry Byrd's constructivist painting, the tough, visceral paintings of Martin Facey or Cheryl Bowers, William Gatewood's architecturally scaled screens and kites, and the marble wall sculpture of Sal Pecoraro. Within the framework of abstraction one finds a kind of realism, as in Linda K. Smith's, Marcea Rundquist's, Jeff Long's or Harriet Shorr's paintings, that focuses more on composition than on achieving a likeness. What each of the artists has in common is an emphasis on surface and texture rather than on subject matter.

La Mamelle, Inc. 70 12th St., San Francisco, CA
150 94103 (415) 431-7524; mailing address: P.O. Box 3123, San Francisco, CA 94119; Tue-Fri: 12-5; dir: Carl E. Loeffler

Established in 1975, La Mamelle, Inc., is an experimental art gallery for video, performance, and idea-oriented situations. The gallery is the publisher of *Art Com* magazine, *Videozine, Audiozine, Imagizine,* and the book series *Contemporary Documents. Performance Anthology: Source Book for a Decade of California Performance Art* was published in 1980. *Correspondence Art: Source Book for the Network of International Postal Art Activity,* published in 1984, covers works realized worldwide through the mail, for some artists a crucial means of communication.
 La Mamelle is also a producer of Art Video. Some recent videotapes were used in a series entitled "Made for Television"—live performance works shown on PBS and European television, featuring Chris Burden, Lynn Hershman, Chip Lord (formerly of Ant Farm), and Barbara Smith.
 In addition to housing extensive archives of Art Video, correspondence art, artists' publications and marginal works, La Mamelle records on microfiche contemporary art from a number of current magazines.

Lawson Galleries 56 Kissling St., San Francisco, CA
151 94103 (415) 626-1159; Tuesday-Saturday: 11-5; owner: Don Lawson dir: Peggy Gotthold

Concentration is on Bay Area art; sculpture, painting, prints, photography, and site-specific installations.
 Among the artists exhibited are painters Roger Boyce, Ralph Du Casse and Mary Pacios Humphrey, and sculptors Michael Carey, Bob Laney, Gerald Sisco, Andrew Steinhauer and Sherry Stuart. Gerald Sisco works in both media. William DeKoornbolt makes illusionistic collages.
 Other artists include painters Margeaux Klein, Ellen Cubit, Al Payne, Jan Siegel and Tom Thompson; sculptors Nelda Barchers, Joshua Greenberg, Vickie Jo Sowell and Andrew Steinhauer; and photographers Greg Reeder and Jane Terry. Rudy Lemcke, Bernard Lubell and Judy Moran make site-specific installations. Christine Creazzi Bastell works in mixed-media.

Maxwell Galleries 551 Sutter St., San Francisco, CA
152 94102 (415) 421-5193; owner: Mark Hoffman dir: Penny Perlmutter

Maxwell Galleries specializes in late 19th century and early 20th century American and European painting and sculpture. The gallery maintains an extensive collection of California art.
 Included in the gallery's collection are paintings by Edward Potthast, Frederick Frieseke, Robert Reid and other important American Impressionists. Paintings by artists of the Hudson River School such as A.T. Bricher, Alexander Wyant and Martin Johnson Heade are part of the collection as well. The California collection features painter and sculptor Raimonds Staprans, Armin Hansen, Marion Wachtel, Joseph Raffael, Edgar Payne, Maurice Braun and Maynard Dixon. Maxwell Galleries also shows works from the estate of gestural realist David Park.

Miller/Brown Gallery 355 Hayes St., San Francisco,
153 CA 94102 (415) 861-2028; Tue-Sat: 11-5; owner/dir: Edward Brown & Michael Miller

In 1984 Michael Miller joined Edward Brown, who had already devoted several years to running a wide-ranging gallery, as codirector of this new, expanded skylight space near the Louise M. Davies Symphony Hall.
 The gallery is focused on the textile arts, both contemporary and ethnographic, but also exhibits paintings, prints and sculpture. Recent shows have included works by well-known textile artists Gerhardt Knodel, Anne Wilson, Cynthia Schira and Sherri Smith; painter Dennis Martin and printmaker Rebecca Salter. Exhibitions change monthly.

Modernism 236 8th St., San Francisco, CA 94103
154 (415) 552-2286 Tue-Sat: 11-6; dir: Martin Miller

Modernism is a contemporary gallery of international scope. Primarily a painting gallery, Modernism also exhibits photography, sculpture, and, less often, architecture, video and performance. Abstract and realist painting are equally emphasized, by both emerging and established American artists, mostly from California and New York.
 American and European masters are the focus of the historical program, including pioneers of abstract art, early modern photography, international Constructivism, German Expressionism, American Pop art, and especially Russian Avant-Garde.
 Individual artists featured by the gallery include: Max Almy, John Baeder, Robert Cottingham, Robert Crumb, Charles Fuhrman, Max Gimblett, Peter Gutkin, Woody Gwyn, Richard Haas, D.J. Hall, Duncan Hannah, James Hayward, Charles Hess, Ralph Humphrey, Glen Jampol, Donald Lipski, Cork Marcheschi, Martin Myers, Hans Namuth, John Nava, Mel Ramos, John Register, Erik Saxon, David Simpson, Robert Slutzky, Leo Valledor, Alan Wayne.

Moss Gallery 310 Sutter St., San Francisco, CA 94108
155 (415) 433-7224; Tue-Sat: 10-6; dir: Marvin Moss

Moss Gallery mostly deals in modern Latin American and Mexican paintings; however, they have begun to show other work from all points of the compass. The gallery is also interested in French Impressionist paintings by the major painters of the movement, such as Edgar Degas, Auguste Renoir and Henri Fantin-Latour.
 Among the Latin American artists featured is

Pablo Picasso, *Minotaure* . . . (1943), 9 x 13, aquatint, Harcourts Gallery (San Francisco, CA).

Jeanick Bouys, untitled (1983), 52 x 42 oil on canvas,
Harcourts Contemporary (San Francisco, CA).

Colombian Constructivist painter Omar Rayo. Other artists include Julio Larraz, Francisco Rocca, Bernard Dreyfus, Antonio Segui, Andres Monreal, and Felix Angel.

The most well-known of the Mexican artists shown are Rufino Tamayo and Jose Luis Cuevas. Tamayo, long a resident of New York, works in a vibrant surrealist style, often culling images from the traditions and folklore of his native land. A notable draftsman, Cuevas molds and deforms the human figure in his socially critical drawings and paintings. Sculptor Francisco Zuniga, Guatemalan-born painter Carlos Merida, Armando Morales and Maximino Javier are some of the other artists exhibited.

Museum of Modern Art Rental Gallery Building A, *156* Fort Mason, San Francisco, CA 94123 (415) 441-4777; Tue-Sat: 11:30-5:30; dir: Sally Lillienthal & Marian Parmenter

Located in Fort Mason overlooking historic Gashouse Cove, the Rental Gallery provides art by unknown, emerging and established artists for rent and for sale. The gallery is especially interested in giving support to artists whose work is not well-known. Eleven shows are mounted each year. Some are group shows, but most are two- and three-person shows that permit an in-depth glimpse of an artist's work. Most of the work is by Northern California artists. Rental fees help support the San Francisco Museum of Modern Art. A discount is offered to members.

North Point Gallery 872 North Point St., San Francisco, CA 94109 (415) 771-3548; Tue-Sat: 1-5; *157* owner/dir: J. A. Baird, Jr.

The North Point Gallery was established in 1972 by Joseph A. Baird, Jr. Dr Baird's scholarly background and interest in a wide variety of artistic areas has given the gallery a particular diversity and flavor which underlie its general emphasis on art in the United States.

California art from 1850 to 1940 is only one focus of the gallery's program. From the beginning, there have been exhibitions of period and modern work. The gallery has mounted several "rediscovery" retrospectives of figures of the recent past such as Martin Baer, Franz Bischoff, Ray Boynton and Selden Connor Gile. Works by contemporary painters such as Bruce Conner, Helen Lundberg and Robert Schwartz have also been exhibited.

In photography and the graphic arts the 19th century has been emphasized. Future exhibitions of old master drawings, paintings and period graphic arts are planned. Dr Baird is always available for special appointments to discuss the needs of collectors and corporations.

The John Pence Gallery 750 Post St., San Francisco, *158* CA 94109 (415) 441-1138; Mon-Sat: 10-5; owner/dir: John Pence

The John Pence Gallery occupies an opulent old garage space hand-crafted by local artisans and gallery artists. Emphasis is on living American realists, but leading Western abstractionists and constructionists are also featured. The gallery devotes two shows each year to newly discovered and emerging talent.

Artists regularly shown include: Michael Bergt, evocative egg tempera paintings; Donald

Jurney, oil landscapes of New England; Robert Maione, old-master style landscapes fron around the world; Frank Mason, still lifes, interiors and portraits; Will Wilson, white-lead media; John Franklin Koenig, abstract works in various media; Douglas Fenn Wilson, impressionistic work in watercolor and pastel; and Robert Wingate, miniature oil paintings. Sculptors Donald Davis, Robert Gove and Kirk St. Maur carve marble and cast bronze.

John Pence stages an annual competition for new artists, and presents artists selected in two yearly group shows. The gallery sponsors at least one yearly travelling exhibition as well, generally of older American works.

Postcard Palace 756 Columbus Ave., San Francisco, *159* CA 94133 (212) 781-8250; Mon-Sat: 11-7 Sun: 12-6; dir: Barbara Wyeth

Postcard Palace offers gallery space to local Bay Area artists as an alternative to high-priced, conservative galleries in San Francisco.

Postcard Palace has shown the work of several artists working in color-copier and electrostatic processes. Among them are Robert Rockola Carioca, Tom Patrick, Buster Cleveland, Richard Stein and Nouriman. The Palace has also featured the work of photographers Debby Weiss, Garrett Williams, Barbara Wyeth, f-stop Fitzgerald, Rudy VanDerlans, Beate Priola and Michael Shemchuk. Other artists shown, representing a variety of media, include Michael May, Jack Frost, Passarelli, Rex Ray, Colleen Christie-Putnam, Gail Wiese, Kim Rubens, Martha Paulos, Stan Peskett, Diane Best and Gavin Flint.

Elaine Potter Gallery 336 Hayes St., San Francisco, *160* CA 94102 (415) 431-8511; Tue-Sat: 10-5; owner/dir: Elaine Potter

The gallery focuses on art from the craft media: clay, glass, fiber, wood, metal (including jewelry), by artists and craftsmen from the U.S., with select shows of Japanese and European artists.

American artists working in glass include Dan Dailey, Linda MacNeil, Mark Peiser and Stephen Dee Edwards. Clay artists are Michael Gustavson, James Irwin and Thomas Hoadley. Bob Stocksdale works in wood.

Exhibitions change monthly.

Quay Gallery 154 Sutter St., San Francisco, CA *161* 94108 (415) 982-3292; Tue-Sat: 11-6; dir: Rena Bransten

The Quay Gallery began as an outgrowth of the Braunstein / Quay Gallery. The demand for representation of California ceramics persuaded Ruth Braunstein and Rena Bransten to open a gallery, which was later taken over by Rena Bransten.

While ceramic sculpture is still a primary interest, other media such as painting, drawing and photography are featured. Among the artists exhibited are sculptors Ron Nagle, Viola Frey, Dennis Gallagher, and John Mason; painter Oliver Jackson, and photographer Bruce Handelsman.

The Braunstein and Quay Galleries share the same second floor location in a building on Sutter Street.

Dana Reich Gallery 278 Post St., San Francisco, CA *162* 94108 (415) 433-2525; Tue-Sat: 10-5; owner/dir: Dana Reich

Henri Matisse, *La Grande Liseuse* (1923), 21 x 16, lithograph, Harcourts Gallery (San Francisco, CA).

Harry Jackson, *Ropin' a Star,* 28 high, painted bronze, Hunter Gallery (San Francisco, CA).

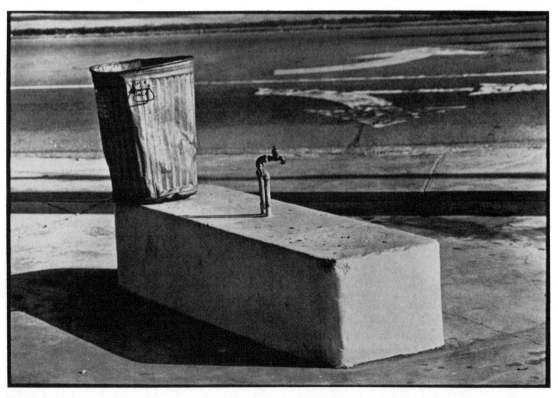

Robert Rauschenberg, from ''American Mix'' (1983), 20 x 26, photographure, Harcourts Contemporary (San Francisco, CA).

The gallery shows young California artists, both emerging and established, who work in a wide range of styles.

The artists include painters Michael Mastrogiacomo, Richard Camire, Margaret Rinkovsky, Daniel Phill, June Felter and Michael Gregory, ceramic sculptor Mark McCloud, and James Elaine, whose acrylics have sculptural elements.

There is also an extensive collection of contemporary graphics by such artists as California painter Richard Diebenkorn, associated both with the New York School of Abstract Expressionism and with West Coast gestural realism and figuration, Sam Francis, Helen Frankenthaler, David Hockney, Jasper Johns, Ellsworth Kelly, Roy Lichtenstein, Robert Motherwell, Claes Oldenburg, Robert Rauschenberg, Frank Stella and Wayne Thiebaud.

Rorick Gallery 637 Mason St., San Francisco, CA
163 94108 (415) 885-1182; Tue-Sat: 10-5 mid-Dec to mid-Jan: closed; owner/dir: Rick Prudden

Concentration is on contemporary paintings and works on paper—realism and representational imagery as well as colorful, lyrical abstraction are emphasized. About half the artists shown are Californian.

The artists shown include established figures and emerging artists: Roland Petersen, Karl Kasten, Bruce Lauritzen, Rosali Lang, Robert Dash, David Shapiro, Christian Heckscher, Thomas Brooks, Elizabeth Ennis, Theodora Varnay Jones, Marcus Uzilevski, Ching Ho Cheng, Richard Cramer, Larry Rivers, Alex Katz and Marisol Escobar.

William Sawyer Gallery 3045 Clay St., San Fran-
164 cisco, CA 94115 (415) 921-1600; Tue-Sat: 11-6; owner/dir: William Sawyer

One of the oldest and most respected galleries in San Francisco, the William Sawyer Gallery, located in Pacific Heights, features contemporary paintings by local, national and internationally known artists. The gallery exhibits both realistic and abstract art, and has changing one-person shows every month. The Sawyer Gallery is noted for its program of introducing young emerging artists.

Over 30 artists are regularly shown by the gallery. Abstract painter David Izu is known for his organic, lyrical paintings; his recent work has veered towards a tough Minimalism. Ida Kohlmeyer's paintings are internationally known for their playful abstract symbols and bright colors. Willard Dixon paints traditional landscapes which capture the drama and breadth of Western landforms. Guy John Cavalli explores the elemental relations of geometry in his paintings. Barbara Spring makes wood sculptures that often express witty satirical views of people and animals.

Soker-Kaseman Gallery 1457 Grant Ave. & 50A
165 Bannam Place, San Francisco, CA 94133 (415) 989-6452; Tue-Sat: 12-6; owner/dir: Don Soker, Carol Kaseman

This gallery was opened in 1972 to present new graphic works by contemporary international artists, with an emphasis on contemporary Japanese artists.

Kunito Nagaoka, a resident of Berlin for fifteen years, shows a concern for textural contrast in his watercolors and etchings. While his surreal landscapes appear Germanic in their attention to detail, his line and color are very Japanese. Michi Itami of Berkeley and Shoichi Ida of Kyoto both use traditional imagery of Japan. Calligraphic lines and kimono patterns appear in the etchings and paintings of Itami, while Ida uses images of stones or empty white space. Both employ photographic processes in their work.

The gallery space at 50A Bannam Place is used for large-scale work and performance. Takesada Matsutani recently exhibited a 75 foot pencil drawing in this area.

Recent exhibitions have featured the color woodblock prints of Akira Kurosaki, new prints from New Zealand, the "Diary" series of Tetsuya Noda, drawings and etchings by Jory Schmeisser, etchings of bicycles and umbrellas by Shigeki Kuroda, lithographs by Colorado artist Minna Resnick and Texas artist Peter Nickel, and the large vinyl sculptures and drawings of Takesada Matsutani. The gallery also features work by Bay Area artists Shane Weare, Ricki Kimball, Kenji Nanao, Kaoru Ogora and Erin Goodwin.

Soma Fine Art 78 First St., San Francisco, CA 94105
166 (415) 495-7997; daily: 10-6; owner/dir: Sarah Henderson

Concentration is on the publishing of collaborative limited edition serigraphs and unique works by national and international contemporary artists.

Artists who have collaborated with Soma Press include Tetsumi Minoh, Japan; Andreas Nottebohm, Germany; Marco Sassone, Italy; Kenneth Price, Karl Benjamin and Robert Moon, U.S.A. Editions have also been printed for Yaacov Agam, Leo Valedor and John Vissor.

The serigraphs, monoprints and unique works of master printer Gary Lichtenstein are also featured. His luminescent images evoke the sensations of blended colors in skies and landscapes. Soma has recently published *The Plain of Smokes* in conjunction with Arabesque Books, with serigraphs by Ken Price and text by poet Harvy Mudd.

Stewart American Art 500 Sutter St., Suite 204, San
167 Francisco CA 94102 (415) 433-1576; Tue-Sat: 12-5 & by appt holidays: closed; owner/dir: Jeffrey Stewart

The main interest of the gallery is in American paintings, watercolors, drawings, pastels and sculpture done between about 1850 and 1930. Emphasis is on works of that period from around San Francisco. Stylistically, works range from the sort done in the Hudson River and Rocky Mountain Schools of landscape, forward through Barbizon-influenced landscape to the American versions of Impressionism.

The 19th century is represented by such painters as William Keith, Thomas Hill, F. Richardt, R.D. Yelland, W. Marple, J.W. Rix, J. Tavernier, E. Deakin, S.M. Brookes, Emil Carlsen and G. Cadenasso. 20th century artists include Arthur Mathews, G. Redmond, F.J. McComas, R.A. Graham, J. Raphael, T. Welch,

R. Lee White, *Off His Horse* (1983), 30 x 40, mixed media on board, Harcourts Contemporary (San Francisco, CA).

Dan Christensen, untitled (1981), 38 x 50, acrylic on paper, Ivory/Kimpton (San Francisco, CA)

P. Dougherty, C.H. Davis, C. Rockwell and P. Gray.

The work of Frederik Ebbesen Grue and other selected contemporary artists is also exhibited. Grue's work ranges from finely detailed studies of Oriental objects, flowers and fruit to atmospheric landscape.

Jeremy Stone Gallery 126 Post St., San Francisco, *168* CA 94108 (415) 398-6525; Tue-Fri: 10:30-5:30; Sat: 12-6; dir: J. Stone

Jeremy Stone Gallery exhibits 20th century American drawing and painting, with an emphasis on New York School abstract painters Willem de Kooning, Franz Kline, and their contemporaries Arshile Gorky and John Graham. The gallery also exhibits the work of contemporary artists from the Bay Area as well as other parts of the United States. Emerging artists are regularly exhibited in group exhibits showcasing new talent.

Contemporary artists featured include Carlos Almaraz, Robert Baribeau, Judith Foosaner, James Grashow, Susan Hauptman, Alan Hunter, Suzanne Klotz-Reilly, Sylvia Lark, Joanne Leonard, Mary Lovelace O'Neal, Rooney O'Neil, Richard Sheehan, Edvins Strautmanis and James Watkinson.

Thackrey & Robinson 2266 Union St., San Francisco, *169* CA 94123 (415) 567-4842; Tue-Sat: 11-6; owner/dir: Sean Thackrey, Sally Robinson

The gallery deals in 19th and early 20th century works on paper, and maintains a magnificent collection of early photography. The collection includes photographs by William Henry Fox Talbot, David Octavius Hill, Robert Adamson, Peter Emerson and Roger Fenton.

The gallery's diverse holdings range from prints by 19th century Scots etcher D.Y. Cameron and English etcher and poet William Blake, prints by American painter J.A.M. Whistler, who lived most of his life in London, to old, rare original posters. Blake etched illustrated editions of the Book of Job and of his own hermetic poetry. Whistler, an innovative artist influenced by Japanese prints, scandalized the critics but earned the friendship and admiration of the French Impressionists.

While not active in contemporary art, the gallery shows work by graphic artist David Goines and English artist Hamish Fulton.

Richard Thompson Gallery 80 Maiden Lane, San *170* Francisco, CA 94108 (415) 956-2114; Mon-Sat: 10:30-5; owner/dir: Richard Thompson

Specialization of the gallery is in contemporary American Impressionists. The gallery exclusively represents Richard Earl Thompson, Sr., an artist whose fame dates back to the 1930s. Thompson's study of color is most noted in the luminous atmosphere of his landscapes of his native Wisconsin. He has also worked extensively as a portraitist, and has paintings in major museum collections throughout the U.S.

The gallery represents other contemporary Impressionists, including Claire Ruby, Hollis Alling and Henry Casselli. In addition, the gallery publishes and distributes limited edition prints by Richard Earl Thompson and Claire Ruby.

Triangle Gallery 95 Minna at 2nd St., San Francisco, *171* CA 94105 (415) 777-2710; dir: Jack Van Hiele

The gallery was established in 1961, but has occupied this naturally lit, loftlike space since 1980. It shows painting and sculpture by West Coast artists, as well as work by many Japanese painters.

Among the painters at the gallery are Louis Siegriest, abstract desert landscapes; Carl Morris, abstract paintings which sometimes recall Northwest Coast landscape; Joel Barletta, geometric abstractions; Nancy Steele, landscape derived abstractions; and Michael Kennedy, abstracts. Ronald Chase exhibits his collages. Sculptors are Steven Gillman, stone sculpture; Kek Tee Lim, bronzes; and Joseph Romano, paper sculpture.

Over the years the gallery has shown many Japanese painters: Soichiro Tomioka, Snow Country series; Tatsuo Kondo, geometric abstractions; Kaoru Eda, Fresh Egg and Spoon series. Ceramics by Mei Yen-lan and Ban Kajitani are also available.

Bruce Velick Gallery 55 Grant Ave., San Francisco, *172* CA 94108 (415) 398-3345; Tue-Sat: 10-5:30; owner/dir: Bruce Velick

Emphasizing diversity rather than a specific style or medium, the gallery exhibits contemporary artists, mostly from the Bay Area and California.

Jo Whaley shows her painted photographs and assemblages of contemporary shrines. Tom Foolery creates collages in the surrealist spirit. Stan Fullerton paints witty allegories in unabashed color. Shari Laminet draws large psychological landscapes. Sculptors Bill Albright and Michael Riegel create in ceramic abstract figures and forged steel structures evoking primitive totems, respectively. Paul Beattie's gestural abstract paintings reflect his interests in astronomy; Donald Fritz's paintings reflect back on symbols of his childhood. Tom Stanton uses painting, drawing and performance to explore different planes of reality.

Other work that may be seen at the gallery includes Richard Turner's political installations, Mineko Grimmer's sound sculpture using bamboo, melting ice and pebbles, David Perry's radical furniture, James Albertson's allegorical painting, Nancy Burson's computer-manipulated photographs, and Michael Naimark's film installations.

Vision Gallery 1151 Mission St., San Francisco, CA *173* 94103 (415) 621-2107; Mon-Sat: 10-6

Formerly The Douglas Elliot Gallery at the same address, Vision exhibits photographic work by world renowned figures as well as emerging artists working in black and white, color and alternative processes.

Works are shown by Vilem Kriz, Neil Folberg, Jack Welpott, Robert Ketchum, Karin Rosenthal, Hans Hammarskiold, Eikoh Hosoe, Francis Sakamoto, Edmund Teske, Wynn and Edna Bullock, Benno Friedmann, Allen Dutton, David Holland, Chris Bastien, Collette Bravo and Brett Weston.

Other gallery artists are Manuel Bravo, Henry Gilpin, Ansel Adams, Steve Collins, Edward Curtis, Don Worth, Don Ross, William Garnett,

Linda K. Smith, *First Day* (1982), 38 x 54, pastel & paint on paper, Ivory/Kimpton (San Francisco, CA).

Thomas Hill, *View of Yosemite,* 35 x 53, oil on canvas, Maxwell Galleries (San Francisco, CA).

Rembrandt, *Self Portrait* (1639), 8 x 6, etching, Pasquale Iannetti Gallery (San Francisco, CA).

WeeGee, Peter Stackpole, Barbara Morgan, Dick Arentz, Johnny Alterman and Cravo Neto.

The gallery presents major shows at six-week intervals. There is also an interesting selection of posters, postcards, magazines and books.

Vorpal Gallery 393 Grove St., San Francisco, CA
174 94102 (415) 397-9200; owner/dir: Muldoon Elder

Specialization is in contemporary art—paintings, prints and sculpture. Along with major gallery artists, each gallery (Soho, San Francisco, Laguna Beach) handles local artists. Artists exhibited include M.C. Escher, Yozo Hamaguchi, Ivan Kustura, Jesse Allen, Gary Smith, Jack Hooper, Robert Holmes, Wally Peets, Carson Gladson, Katherine Hagstrom, Piet Bekaert, David Blackburn and Andy Wing.

See also New York, New York listing.

Walton-Gilbert Galleries 420 Sutter St., San Fran-
175 cisco, CA 94108 (415) 391-8185; Mon-Fri: 10-6 Sat: 10-5; owner: Harris J. Stewart dir: Bonnie Hayes

The gallery specializes in established and emerging contemporary painters and sculptors. It maintains an extensive collection of master graphics of the 19th and 20th centuries. In addition, it handles both figurative and non-representational works on canvas, paper and experimental media by leading California Illusionist, Expressionist and Photorealist painters.

Works are available by David Hockney, Jim Dine, Roy Carruthers, George Tooker, Wayne Thiebaud and Fritz Scholder. The graphics collection includes American Regionalists such as Thomas Hart Benton and Grant Wood, 19th century masters such as Toulouse-Lautrec and Auguste Renoir, and 20th century masters Joan Miro, Georges Braque, Pablo Picasso and Marc Chagall.

Artists featured by the gallery include contemporary satirist Michael Ansell, Photorealist Gustav Alsina, photo assemblage artist Helena Kolda, abstract illusionist Mark Erickson, multimedia and neon sculptor Janet Fryer and experimental painters Nazim Ozel and Kathleen Laskey. The graphic and sculptural work of Erwin Binder and R.C. Gorman is on continuing exhibition.

Dorothy Weiss Gallery 256 Sutter St., San Francisco,
176 CA 94108 (415) 397-3611; Tue-Sat: 11-5; owner/dir: Dorothy Weiss

The gallery's specialization is American contemporary ceramics and glass sculpture, created both by established and up-and-coming artists.

Among the nationally known glass artists featured at the gallery are Richard Marquis, Michael Cohn, Jay Musler, Hank Murta Adams, and Ann Warff. Clay objects demonstrating the California clay tradition include works by ceramics artists Philip Cornelius, Juta Savage, Scott Chamberlain, and Stan Welsh.

Recent shows at the gallery featured ceramics sculpture by Yoshio Taylor, porcelain vessels by Philip Cornelius, and ceramic work and an installation by Jamie Walker.

James Willis Gallery 109 Geary St., San Francisco,
177 CA 94108 (415) 989-4485; Mon-Sat: 12-6; owner: James Willis dir: Jean Willis

The James Willis Gallery exhibits major pieces of African, Oceanic and Indonesian art. James Willis has been a specialist in this area for over fifteen years.

The gallery has been an influential force in the promotion of Indonesian art in particular, offering both textiles and sculpture. The gallery presented the first exhibition of Batak sculpture in the United States.

Other important exhibitions in the field of African art include Art of the Ibo, Tribal Furniture and Household Objects, Art of the Dogon, Art of Gabon, Art of the Yoruba and Djenne Terracottas, and Prehistoric Sculpture of Mali.

Stephen Wirtz Gallery 345 Sutter St., San Francisco,
178 CA 94108 (415) 433-6879; Tue-Sat: 10:30-5:30; owner/dir: S. Wirtz

The Stephen Wirtz Gallery provides an expansive multi-leveled environment for 20th century and contemporary art. Interspersed with historical works of artists rarely seen on the West Coast, such as Man Ray or Antoni Tapies, are works by contemporary European and American sculptors, painters and photographers.

The artists shown work in a variety of media and styles. Arnaldo Pomodoro, Jack Zajac and Alan Shepp use traditional materials such as bronze and stone. Complimenting these artists in their vigorous use of different media are young sculptors Sandra Shannonhouse, Daniel Weiner and Rick Soss.

The painters shown in the gallery also bespeak the gallery's support of emerging talent. Raymond Saunders, Emili Tadini, George Miyasaki, Theodore Waddell, Harold Paris, Pat Klein amd Marc Katano reflect an international sensibility in their art.

The Wirtz Gallery has also helped introduce photography as a fine art on the West Coast, rediscovering such seminal photographers as Ralph Steiner, Willard Van Dyke and Gyorgy Kepes, and maintaining a program that includes Richard Avedon, Michael Kenna and Ira Nowinski. In collaboration with other galleries, Wirtz has brought the work of such artists as Gregory Amenoff, Gianfranco Pardi and Jedd Garet to the Bay Area.

Wylie Wong Asian Art and Antiquities 144 Wetmore
179 Place, San Francisco, CA 94108 (415) 433-7389; by appt; owner/dir: Wylie Wong

Located on San Francisco's Nob Hill, the gallery specializes in Asian scrolls, fans, album leaves, painting and calligraphy from the 17th to the 20th century.

Subject matter from the extensive inventory includes calligraphy, landscape, bird and flower painting, portraits, figures and other subjects. There are woodblock prints of the Ch'ing dynasty and the late Meiji period of Japan. Major artists featured in the collection include: Chang Ta-Chien (1899-1983), Chi Pai-Hsih (1863-1957), Chien Tu (1783-1844), Fu Pao-shih (1904-1965), Huang I (1744-1802), Jen Po-nien (1840-1896), Yoshitoshi Tsukioka (1839-1892), and C.C. Wang (1907-).

Artworks are exhibited in changing monthly exhibitions, in austere chambers reminiscent of traditional Chinese scholars' studies. Visitors in-

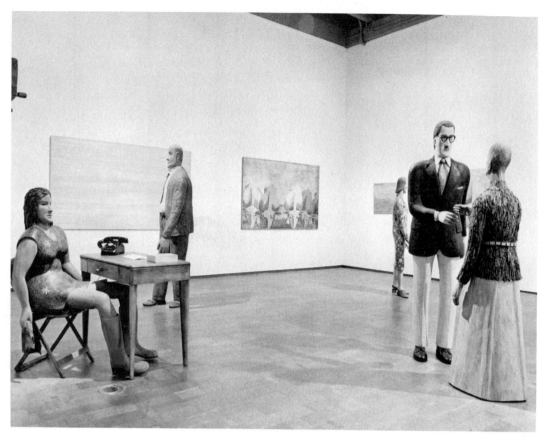

Barbara Spring, installation, life size, wood, William Sawyer Gallery (San Francisco, CA).

Claire Ruby, *Petunias*, Thompson Gallery (San Francisco, CA).

terested in specific artists or works are encouraged to request a private showing.

SANTA BARBARA

Santa Barbara Contemporary Arts Forum 7 W. De
180 La Guerra, Santa Barbara, CA 93101 (805)
966-5373; Wed-Sun: 12-5; dir: Betty Klausner

A nonprofit organization, SBCAF presents a wide variety of contemporary art, including exhibitions of painting, drawing, photography, sculpture, installations, as well as video, performances, new music, and art in public places. SBCAF exhibits work by internationally respected as well as emerging artists. The gallery has supported work by California and New York artists, and is firmly committed to presenting work by artists who live in Santa Barbara.

Some of the artists whom SBCAF has exhibited are William Wiley, Peter Shelton, Wayne Thiebaud, Susan Vogel, Elena Siff, Sam Erenberg, Dan Rice, Diamanda Galas, Rachel Rosenthal, Joseph Clower, Kim Adams, Chris Enos, Rosamund Purcell, R.H. Ross, David Trowbridge, Michael McMillen, Roland Reiss, Margaret Nielson, Carl Cheng, Nancy Graves, Jim Risser and John Okulick.

SAN JOSE

Young Gallery 140 W. San Carlos St., San Jose, CA
181 95113 (408) 295-2800; Tue-Fri: 10-5 and by
appt

The Young Gallery is located in an attractive building in downtown San Jose, near the convention center. Gallery space features local and nationally known artists. Sculpture is shown in an enclosed garden behind the gallery.

Both realistic and abstract works are carried, and the quality is consistently high. The gallery features four to six shows each year, mostly one-person exhibitions. Recent exhibitions have included intaglio prints, raku ceramic pottery, paintings, collage, and sculpture.

SANTA MONICA

Bolen Gallery, Inc. 2904 Main St., Santa Monica, CA
182 90405 (213) 399-9128; Wed-Thu: 10-6 Fri-Sat:
12-11 Sun: 12-5 and by appt; owner/dir: John &
Lynne Bolen

Concentration is on 19th century and 20th century to contemporary American paintings, drawings, sculpture and prints, with attention to the American Regionalists.

American masters in the gallery inventory include members of the American Regionalist School, which arose in the 1930s in reply to the European influenced art sparked by the Armory Show of 1913. The gallery has work by Thomas Hart Benton, John Steuart Curry, Grant Wood and John Stockton deMartelly. The most influential member of the Regionalist School, Benton was its leader in many respects. Like Wood and Curry, he saw the true expression of American art in the simple life, close to the earth, of the Midwestern farmer, and worked in a plain, stylized realism. Grant Wood's realism, on the other hand, has ironic overtones where Benton reaches for heroic imagery.

Karl Bornstein Gallery 1662 12th St., Santa Monica,
183 CA 90404 (213) 450-1129; Tue-Sat: 11-5;
owner: K. Bornstein dir: Meta Fleisher

Emphasis of the gallery is on West Coast artists who are expressing contemporary moods and themes.

Kim Abeles makes constructions based on kimono and altar forms. Bruce Dean works in large paper collages. Walter Gabrielson's paintings depict interacting people. The paintings of William Gatewood combine Oriental and American elements in richly ornamented surfaces. Candice Gawne's richly impastoed surfaces depict scenes of contemporary life. George Geyer makes glass, wood and metal sculpture based on tension and equilibrium. Larry Gray paints scenes far removed from city life, while Tom Jenkins portrays life in the cities with such urban media as enamel on aluminum. Leonard Kosciasnki uses animals as a metaphor in his episodic paintings. Barbara Kasten photographically explores two- and three-dimensional perceptions. Arnold Mesches paints a humanistic world in expressionistic terms. With expressionist intensity, Janet McCloud weaves motifs from Mexican folk imagery. Coleen Sterrit's sculpture derives its forms from mythology.

Other artists exhibited are Laurel Huggins, Jeffrey Bishop, Joan Ross Bloedel, Stephen Danko, Michael Levine and Jack Lillis.

Pink's/Fine Arts 250 26th St., Santa Monica, CA
184 90402 (213) 393-0531; Mon-Fri: 12-5 Sat: 11-5;
owner/dir: Marilyn Pink

A new gallery of contemporary art, Pink's/Fine Art is associated with Marilyn Pink/Master Prints and Drawings in Los Angeles. Separate from the long-established gallery in La Cienaga Boulevard, the new gallery will showcase emerging as well as established artists.

The first exhibition, *A Contemporary Overview, Prints and Monotypes* featured works by Richard Lindner, Werner Pfeiffer, Jacob Kainen, Ralph Gilbert, Joe Tilson, R.B. Kitaj and John McCracken.

Tortue Gallery 2917 Santa Monica Blvd., Santa Monica, CA 90404 (213) 828-8878; Tue-Sat: 11-
185 5:30; dir: Mallory Freeman

Tortue Gallery, established in 1969, was the first gallery on the far west side of greater Los Angeles. It has established a reputation for featuring varied works ranging from international figures to young, emerging Southern California artists. In addition, the gallery exhibits 20th century master graphics and drawings.

Included in the gallery's list of exhibiting artists are realists Daniel Douke, D.J. Hall, Richard Pettibone, Shirley Pettibone and Joyce Treiman. Sculptors shown at the gallery are Claire Falkenstein, Stephen DeStaebler and Michael Todd. Abstract painters include Martin Facey, Allen Harrison, Patrick Hogan, Patsy Krebs, Robert Natkin, Jim Morphesis and David Schirm. Photography by Robbert Flick, Larry Clark and John Pfahl is featured. The gallery also represents the estate of vanguard California artist John Altoon.

Yuji Morita, *Paper Aeroplane 1,* 12 x 18, etching and mezzotint, Graystone Gallery, (San Francisco, CA)

Philip Orlando, untitled, 14 x 11, mixed media, Orlando Gallery (Sherman Oaks, CA).

George Tooker, *Voice,* 21 x 18, lithograph, Walton Gilbert (San Francisco, CA).

SHERMAN OAKS

Martin Lawrence Gallery 15301 Venture Blvd., Sherman Oaks, CA 91403 (818) 783-2410; Mon-Fri: 10-9 Sat: 10-6 Sun: 12-5; dir: Dennis Weiss

186

Martin Lawrence Gallery presents a broad spectrum of limited edition graphics as well as many one-of-a-kind originals in different media by such contemporary international artists as Yaacov Agam, Marc Chagall, Yankel Ginzburg, Joan Miro, Aldo Luongo, Max Papart and Hiro Yamagata. The gallery also presents the work of new artists such as Susan Rios, Frank Liscko, S. Takara and Guy Buffet.

Orlando Gallery 14553 Ventura Blvd., Sherman Oaks, CA 91413 (213) 789-6012; Tue-Sat: 10-4; owner/dir: Philip Orlando, Robert Gino

187

Since opening in 1958, the Orlando Gallery has encouraged experimentation in the arts. The gallery has shown such new forms as mail art, sound art, xerography, video, microfiche, performance art and process art. Though the emphasis is on contemporary art, the gallery has held exhibitions of pre-Columbian art, folk art, art deco, African and New Guinean arts.

Notable exhibitions have been a show of paintings and drawings by Mexican muralist Jose Clemente Orozco, who with Diego Rivera and David Alfaro Siqueiros was a primary force in Mexican mural art; and a show of the last work of American graphic artist and painter Ben Shahn, a social realist perhaps most famed for his series of gouaches on the trial of Sacco and Vanzetti.

Artists presently exhibiting at Orlando include: Don Lagerberg, California bikini girls, water scenes and portraits; Susan Clover, figurative pastels and oil pastels; Walt Impert and David Whalen, realistic interiors; Bob Partin, field paintings; Richard Atkins, Hollywood imagery; Manlyn Groch, domestic still lifes; and Kyoko Asano, realist oils of "Moon Beach Series". Artists working in a surrealist style are Ernest Velardi, Pam Mower-Connor, Laura Lasworth and Cynda Valle. Artists working in mixed-media process of paint, collage and construction are Lynne Westmore, Steve Kingman and Philip Orlando. Artists working in various media include Jerome Sander, Lucy Anderson, Terrence Osmond, Valeria Patton, Ruth Bavetta, John Millei, Susan Santiago, Joyce Wisdom, Bob Haas, Michael Lloyd and Jack Selleck.

STINSON BEACH

Anna Gardner Gallery 3445 Shoreline Hwy., Stinson Beach, CA 94970 (415) 868-0414 (415) 868-0761; by appt; owner/dir: Anna Gardner

188

Established in July 1977, the gallery is located in Marin County, 45 minutes north of San Francisco. The gallery specializes in showing young contemporary Bay Area artists. As one of the few galleries in Marin County doing this, and as one of the few contemporary arts galleries in the Marin County area, it has become a home for young artists from Berkeley, Oakland, San Francisco, and nearby art schools and universities.

The gallery usually shows two or three artists at each exhibition, with a strong emphasis on ceramics. The shows change every four to five weeks.

VENICE

Flow Ace Galleries 185 Windward Ave., Venice, CA 90291 (213) 658-6980; by appt only; dir: Douglas Chrismas

189

See listing for Los Angeles, California.

L.A. Louver Gallery 55 N. Venice Blvd. & 77 Market St., Venice, CA 90291 (213) 822-4955; Tue-Sat: 11-5; owner/dir: Peter Goulds

190

L.A. Louver, Market St., presents large scale exhibitions of painting and sculpture by leading American and European contemporary artists as well as by newly emerging talents. The Venice Blvd. location augments the exhibition program with more space, private viewing and office facilities.

The gallery features works by California assemblage artists Tony Berlant, George Herms, Edward and Nancy Reddin Kienholz, and works from the estate of seminal assemblage artist and poet Wallace Berman. Other California artists include romantic surrealist William Brice, abstractionists Ed Moses and Tom Wudl, expressionist Charles Garabedian, and William Wiley. The gallery also exhibits British New Realist David Hockney, German Neo-Expressionist K.H. Hodicke, Leon Kossoff, Loren Madsen, Sandra Mendelsohn Rubin, Richard Shaffer, Max Cole, Peter Shelton, Rick Stich and Don Suggs.

Works are also available by the following artists: Abstract Expressionists Richard Diebenkorn, Robert Motherwell, Michael Goldberg and John Chamberlain; German Neo-Expressionists Georg Baselitz, Markus Lupertz, Salome, Bernd Koberling and Rainer Fetting; Italian New Image painter Francesco Clemente; American Postpainterly Abstractionists Jasper Johns, Frank Stella and Cy Twombly, and painterly Pop Artist Jim Dine; British New Realists Lucian Freud and R.B. Kitaj; as well as Frank Auerbach, John Cage, Jene Highstein, Robert Janz, James Surls, John Walker and expressionistic realist James Weeks.

COLORADO

ALLENSPARK

Bishop Gallery Hwy 7, Allenspark, CO 80510 (303) 747-2419; daily: 10-5; dir: W.P. Bishop

191

See listing for Scottsdale, AZ.

BRECKENRIDGE

Breckenridge Galleries, Inc. 124 S. Main St., Box 650, Breckenridge, CO 80424 (303) 453-2592; daily: 10-5; owner: Gary Freese dir: Nancy McCurdy

192

The Breckenridge Galleries handles contemporary works of art with emphasis on Southwestern imagery.

Paintings and prints by vibrant colorist Veloy Vigil, subtle yet emotionally expressive landscapes by John Axton, skillful realist painting by Frank Howell and batiks by Katalin Ehling are available, along with Southwest impressionism by Dane Clark, and Westerns and landscapes by Richard D. Thomas.

DENVER

Art Resources: Levin/Youngquist 1825 Blake St.,
193 Denver, CO 80202 (303) 297-0424; Mon-Fri:
9-5; owner/dir: Carol Levin & Lori Youngquist

Directors Levin and Youngquist feature works by
contemporary regional and national artists work-
ing in all media, including painting, fiber, sculp-
ture, photography and limited edition graphics.

The gallery displays manipulated paper works
by Beth Ames Swartz, contemporary canyon
landscape by Merrill Mahaffey, and abstract can-
vases by Herb Jackson combining color and ges-
ture into complex textures. David Kessler's air-
brush photorealism on canvas interprets a world
of personal subject matter. Masoud Yasami
creates *trompe-l'oeil* canvases and pastels juxta-
posing geometric forms against soft landscape
elements.

Ed Mell's straight edge landscape shapes em-
phasize design, form and color. Symbols of Na-
tive American culture counterpoint abstract com-
positions in Jaune Quick-To-See Smith's pastels
and lithographs. Sculptor Jeff Low makes
bronzes, monotypes and prints based on abstract
natural forms. Florence Putterman's monotypes
and prints employ abstract landscape forms.
Gary Slater's corten steel and stainless copper
sculpture ranges from small to monumental.
John Doyle's lithographic suites "The Great Hu-
man Race" depict an interpretation of the vari-
ous races of mankind, his history, medicine,
architecture and laws.

The gallery also provides opportunities for
emerging abstract artists to exhibit, and main-
tains a large inventory of graphics, including
works by New York School artists such as Rob-
ert Rauschenberg, Jack Youngerman, and Claes
Oldenburg, and many Southwestern printmakers.

The Camera Obscura Gallery 1309 Bannock St.,
194 Denver, CO 80204 (303) 623-4059; Mon-Sat:
10-6 Wed: 10-8 Sun: 1-5; owner/dir: Hal Gould

The Camera Obscura Gallery specializes in vint-
age and contemporary photographic work and
contemporary sculpture.

The gallery carries images by many 19th cen-
tury Western photographers, including William
H. Jackson, D.H. Barry, Frank Fiske, Edward
Curtis and others. Original prints are available
by such American masters as Edward Weston,
Ansel Adams, Berenice Abbott, Ernest Knee,
Laura Gilpin, Todd Webb, Beaumont Hall, Wil-
lard Van Dyke, Eva Rubinstein and Judy Dater.

Contemporary artists featured by the gallery
are Howard Bond, Lucien Clergue, Dick Arentz,
Anthony Beckesh, Marilyn Littman, Otis Sprow,
Michael Rubin and Olaf Nielsen.

Inkfish Gallery 1810 Market St., Denver, CO 80202
195 (303) 297-0122; Mon-Sat: 11-5 & by appt Jul-
Aug: closed Mon; owner/dir: Paul & Nancy
Hughes

Inkfish Gallery exhibits contemporary abstract
art, featuring Colorado artists. Many of the
works exhibited depart from two-dimensional
formats.

Colorado artists include Dave Yust, paint-
ings, serigraphs and lithographs; Susan West,
clay paintings; Charles Parson, sculptures and
wall constructions; Lee Simpson, paintings and

serigraphs; Vance Kirkland, paintings and draw-
ings; Sandra Kaplan, paintings, serigraphs and
monotypes; James Day, sculptures; Susan
Cooper, oil pastels; and Don Coen, paintings and
lithographs.

The gallery also displays works by nationally
known artists such as sculptors Harry Bertoia
and George Rickey, and Op art painter Richard
Anuskiewicz.

C.G.Rein Galleries 2827 E. 3rd St., Denver, CO
196 80306 (303) 399-1942; Mon-Sat: 10-5:30;
owner: C.G.Rein dir: Sandra Mitchell

See listing for Scottsdale, AZ.

Robischon Gallery 1122 E. 17th Ave., Denver, CO
197 80218 (303) 832-8899; Tue-Fri: 11-6 Sat: 11-4;
owner: James Robischon dir: Sandra Martinez

Concentration is on contemporary art in all me-
dia, with a focus on living artists working in the
region which includes Texas, Colorado and New
Mexico. The stylistic range is broad, from con-
temporary realism to abstraction.

Artists featured by the gallery include Garo Z.
Antreasian, abstract formalist printmaker and
painter, and John Fincher, well-known for his
highly charged and sophisticated paintings deal-
ing with the mythology of the American West.
Jesus Bautista Moroles, a young sculptor from
Corpus Christi, Texas, combines chiseled, rough-
hewn and polished cuts to form medium to large
scale sculpture. Peter Rogers, an English born
and trained artist, paints mystical landscapes in a
naive style.

Among the other artists shown at the gallery
are Georgia Sartoris, a ceramic sculptor inter-
ested in symmetry, repetition and pattern; and
Russell Hamilton, who paints expressionistic
Southwestern landscape, with controlled gesture
and vivid color. Also featured are Betsy Margo-
lius, lyrical abstract painter and printmaker, and
Kevin Oehler, whose drawings and painted
wood sculpture are psychologically intense and
evocative.

Rosenstock Arts 1228 E. Colfax Ave., Denver, CO
198 80218 (303) 832-7190; Mon-Fri: 10-5 Sat: 10-3;
owner: Fred Rosenstock dir: Linda Lebsack

The gallery specializes in older paintings of the
American West and late 19th to early 20th cen-
tury representational art, and carries books about
American art and artists.

Works are available by the Taos Society of
Artists, including O.E. Berninghaus, E.L. Blu-
menschein, E.I. Couse, W.H. Dunton, E.M.
Hennings, Victor Higgins, Bert Phillips, Joseph
Sharp and Walter Ufer. Works by Western artist
Charles Russell and Frederic Remington are also
on view, as well as landscapes by Henry Farny,
Thomas Moran, Albert Bierstadt, Maynard
Dixon and others.

GEORGETOWN

Saxon Mountain Gallery 406 6th St., Box 112, George-
199 town, CO 80444; daily: 10-6; owner: Bill Alex-
ander dir: Wolfgang Lehnhardt

Watercolor is the medium most abundantly
shown, but the gallery also carries a wide range
of other media, including bronze sculpture, pot-
tery, and applique.

An exclusive feature of the gallery are the ski watercolors of Bill Alexander. Also shown are appliques by Arlette Gosieski, serigraphs by Ron Hoeksema, egg tempera by Lev Lominago, watercolors by Patrick Howe, Ed Jagman, Sharon Hults, Linda Roberts, Rob O'Dell, Walter Parke and Stan Dudek. Bronze sculptors are Chester Comstock, Jim Mcnealy, Joe Campbell and Gary Ginther.

GRAND JUNCTION

Frame Works and Gallery 309 Main St., Grand Junction, CO 81501 (303) 243-7074; Mon-Fri: 9:30-5:30 Sat: 10-4:30; owner/dir: Michael Gibbs

200

The gallery carries contemporary Southwestern art by local and national artists, including lithographs, serigraphs, paintings and sculpture.

American artists such as Paul Pletka, Merrill Mahaffey, Charles Hardy, Jerry Schurr, Michael Gibbs, David Kessler and Jac Kephart are just a few of those whose work is regularly exhibited at the gallery. Paul Pletka's lithographs portraying American Indian culture, Charles Hardy's mythological characters, and Merril Mahaffey's landscapes of Southwestern canyonlands have long been appreciated by patrons of the gallery. Works are also available by Volker Kuhn and Joseph Raffael.

MOUNT CRESTED BUTTE

The Marks Gallery 611 Gothic Rd., P.O. Box 5253, Mt., Crested Butte, CO 81225 (303) 349-2121; Mon-Sat: 10-5 Apr-May & Oct-Nov: closed; owner/dir: Jim Marks

201

The Marks Gallery specializes in both American historical art and contemporary American realism.

Several members of The Society of American Historical Artists are shown at the gallery, including Tom Beecham, John Duillo, J.N. Muir, David Powell, Jim Triggs, Don Troiani, Ron Tunison, Ed Vebell, Joe Velazquez, Charlie Waterhouse and Chris Blossom. The gallery also exhibits work by New York illustrators Mark English, John Collier, Charlie Gehm, Robert Heindel, Milt Kobayashi, Skip Liebke and Walter Spitzmiller, and the romantic realism of young artist Geoffrey Geary.

Contemporary artists include Mike Curtis, realistic wildlife bronzes, especially eagles; Norma Andraud, lithographs of Native American culture; Greg Beecham, wildlife paintings; and Norman Boyles, bronzes. Roger Davis's humorous pottery, Betsy Lewin's floral watercolors, and Harrison Rucker's impressionistic portraits are further offerings of the gallery. Tom Dickerson, a potter and historian, specializes in recreating Indian pottery styles. Mary and Lee Sievers are well-known for their one-of-a-kind paper mache sculptures. Other artists featured are Kyoko Jimbo Hunt, Simonne Hulett, Tom Talbot and Leonard Wren.

TELLURIDE

Gallery of the 21st Century 210 W. Colorado Ave., Telluride, CO 81435 (303) 728-3414; daily: 10-8; owner: Steven Fox dir: Susan Griggs & Abby Zurier

202

See listing for Santa Fe, NM. Local artists exhibited include Pam Zoline, Melanie Brittain and Elaine Cantor.

VAIL

Driscol Gallery 100 E. Meadow Dr., Vail, CO 81657 (303) 476-4171; daily: 10-9 May: closed; owner: Deane Knox dir: Chuck Whitehouse

203

Representing artists of the West, Driscol Gallery exhibits original unique works in oil, egg tempera, acrylic and watercolor, as well as sculpture in bronze and stone. Paintings tend to landscape or figurative works, in a wide range of styles. Sculptures are usually wildlife or figurative pieces.

M. Charles Reinhart's "Romantic Landscapes" and "Consciousness" paintings are featured along with the colorist abstractions of Veloy Vigil, who often explores the theme of horse and rider. S. Mark Thompson's exacting egg tempera paintings and Sandy Scott's wildlife etchings are exhibited. Figures sculpted in bronze by George Lundeen, Glenna Goodacre and Dennis Smith provide a thematic balance to the wildlife sculpture of Chester Comstock, Thomas H. Dickson and Gerald Balciar.

Driscol's reputation derives in good measure from its group of sculptors, who keep the gallery supplied with an large selection of outdoor sculpture. Driscol Gallery scored a diplomatic first when it sent an exhibit of Western art to China in 1981. The gallery hosts a number of workshops, and holds special exhibitions and receptions for groups visiting Colorado.

CONNECTICUT

AVON

Farmington Valley Arts Center 25 Bunker Lane, Avon Park North, Avon, CT 06001 (203) 678-1867; Tue-Sat: 11-4 Sun: 1-4; dir: Betty Friedman

204

The Fisher Gallery at the Farmington Valley Art Center shows American contemporary craft and fine arts. The usual format of exhibitions is one- and two-person shows. Most of the artists are working in the Connecticut region.

A visit to the gallery should include a visit to the studios at the Arts Center where 40 artists work and sell their art. Best day to visit is Saturday from 11 to 4.

BRIDGEPORT

Renaissance Art Foundry and Gallery 250 Smith St., Bridgeport, CT 06607 (203) 384-6363; Mon-Fri: 9-5 Sat: 9-3; owner/dir: Ronald J. Cavalier

205

The gallery is dedicated exclusively to bronze sculpture, and features work in this medium by 20th century artists who sculpt in both representational and abstract modes.

American masters whose work is displayed include Solon H. Borglum, Mount Rushmore sculptor Gutzon Borglum, Doris Caesar, Western artist Frederick Remington, famed for his dynamic bronzes as much as for the nostalgic impressions of the West in his paintings, and Reubin Nakian.

The gallery also exhibits the work of many emerging young artists who work in figurative

and abstract styles. Presently on display are over seventy-five bronzes ranging from small to life size.

DANBURY

The Print Cabinet Spruce Mtn. Trail, Danbury, CT
206 06810 (203) 797-0814; by appt; owner/dir: Pat Wilson

The Print Cabinet is a gallery of original works of art, specializing in fine prints by master printmakers from the 16th to the 20th century.

The gallery also handles the Paul Cadmus Collection of photographs, as well as vintage photographs by George Platt Lynes, Cecil Beaton, Pajama, and others.

FARMINGTON

Tribeca Gallery 768 Farmington Ave., Farmington,
207 CT 06034 (203) 674-8225; Tue, Thu, Sat: 12-4:30; owner/dir: W. Rappaport

Concentration is on contemporary painting, graphics, sculpture and glass. A separate area of the gallery features pottery and art posters. Both representational and abstract styles are carried.

The gallery features up and coming contemporary artists such as Thomas McKnight, J.B. Thompson and Ted Jeremenko. In addition to young emerging artists from across the United States, the gallery shows work by local artists. Many of the posters are by historic masters; however, the gallery focuses on current art. A spacious garden and outdoor greenhouse permit the display of large sculpture.

GUILFORD

Greene Art Gallery 29 Whitfield St., Guilford, CT
208 06437 (203) 453-5995; Mon-Fri: 11-4 Sat: 11-5 Sun: 1-5; owner/dir: Richard Greene

The Greene Gallery presents paintings, sculpture, graphics and works on paper by over 100 contemporary artists from New England, the United States, France, Italy, England and Scotland. A recent expansion has endowed the gallery with a sculpture garden where many well-known sculptors will be exhibiting their work.

Artists whose work is featured include Pamela Holeman, acrylic paintings; John Neff, A.W.S., watercolors; James Grabowski, acrylic paintings; Peyton Higgison, serigraphs; Alfred Hammer, mixed media; David Burt, sculpture; Walter Du Bois Richards, lithographs; Hermann Wiemann, stainless steel sculpture; and Deborah Frizell, marble sculpture.

HARTFORD

The Galleries BKM 222 Pitkin St., Hartford, CT
209 06108 (203) 773-0801; Wed-Sat: 12-5 Aug: closed; owner/dir: Paul Alpert

See listing for Gallery 1, New Haven, CT.

NEW HAVEN

Munson Gallery 33 Whitney Ave., New Haven, CT
210 06511 (203) 865-2121; Mon-Sat: 10-5:30 Aug: closed Sat; owner: R.M. Pelton dir: Judy Birke

The Munson Gallery handles contemporary art in all media, with works by both regional and inter-national artists. The gallery provides many services, including corporate consultation, framing, appraisals and restoration.

Contemporary American artists exhibiting at the gallery include Lester Johnson, Richard Lytle, Howard Fussiner, S. Adam, George Chaplin and Anna Held Audette.

Gallery 1 1 Whitney Ave., New Haven, CT 06108
211 (203) 773-0801 Wed-Sat: 12-5 Aug: closed; owner/dir: Paul Alpert

Gallery 1 shows works by contemporary New England artists, most of whom are working in representational modes, including impressionist styles, but some of whom work in abstract expressionist styles.

Artists featured by the gallery include maritime historian John Noble, black and white hand-pulled lithographs; John Faleto, watercolor photorealism; and Nick Scalise, fractional watercolor realism using minimal color; David Hayes, environmental outdoor sculpture. John Neff and Paul Marra both paint watercolors of New England land and seascapes, while Cynthia Eckstrom paints watercolors of still lifes and New England landscape. Sculptor and Pop artist Leo Jensen exhibits work in the National Gallery of Sport as well as in Gallery 1.

Detailed pen and ink drawings by Dalia Ramanauskas are also exhibited, as well as photorealist seascapes in acrylics by Ian MacLanoy, and impressionistic batik on rice paper works by Helene Glass.

RIDGEFIELD

Branchville Soho Gallery W. Branchville Rd., Ridge-
212 field, CT 06877 (203) 544-8636; Wed-Fri: 1-5 Sat: 12-5 & by appt Jul-Aug: by appt only; owner/dir: Paula Reens

A "New York" gallery in Connecticut, the Branchville Soho Gallery shows work by contemporary artists, all of whom have had exposure in New York, Paris or London exhibitions. Museum trustee and art critic Paula Reens emphasizes emerging, conceptual and unique talents in order to stock affordable art. A tax deductible leasing service is available to low budget corporations.

The gallery features works from the estates of Ben Benn (1884-1983), an early American expressionist lauded by critic Hilton Kramer; Solon Borglum (1868-1922), whose bronzes brought him acclaim in Paris as "le sculpteur de la prairie"; and James Daugherty, a member of the Stieglitz group. Reuben Nakian, Lester Johnson, Alexander Calder, and other established artists are also shown.

The gallery represents about fifty contemporary conceptual artists, whose work ranges from abstract to surreal. Among these are impressionist Alberta Cifolelli, realist Marvin Hayes, surrealist Lynn Sweat, narrationist Karen Butler, lyrical abstractionist Belle Manes, classicalist Don Purdy and high-tech sculptor Constance Livingston, to mention only a few.

STAMFORD

Smith-Girard One Strawberry Hill Rd., Stamford, CT
213 06902 (203) 325-2979; by appt Dec: closed; owner/dir: Jerry Jackson

Smith-Girard exhibits works by 20th century American artists. Among those currently carried by the gallery are Theresa Bernstein, noted etcher William Meyerowitz, and Fred Terna. Bernstein's and Meyerowitz's paintings and prints were the subject of an exhibition, "New York Themes," at the New York Historical Society from October 1983 to April 1984.

WESTPORT

Connecticut Fine Arts 2 Gorham Ave., Westport, CT
214 06880 (203) 227-8016; by appt; owner/dir: Burt Chernow

Connecticut Fine Arts handles post-World War II modern art in all media. In addition to important American and European modern and contemporary drawings, paintings and graphics, the gallery carries Japanese prints, Indian stone carvings and African art.

The gallery displays works by Milton Avery, Alexander Calder, Christo, Lester Johnson, Reuben Nakian and printmaker Gabor Peterdi, as well as hanging changing selections of works by other major 20th century American artists. There are also representative works by European masters such as Pablo Picasso, Joan Miro, Marc Chagall, Jean Dubuffet and Henri Matisse.

The gallery always carries a selection of graphics by Pop artist Richard Lindner, Gabor Peterdi and others, and publishes and distributes the graphic work of Ann Chernow, with its imagery derived from films, particularly images of women in films.

DELAWARE

GREENVILLE

Gallery at Greenville Greenville Center, Suite E-129,
215 Greenville, DE 19807 (302) 652-0271; Mon-Sat: 10-5; owner/dir: Vicki Manning

The Gallery at Greenville specializes in 20th century American painting; however, it also handles some sculpture and contemporary American crafts, as well as 19th century European and American poster art.

The gallery has a large selection of Brandywine School original paintings, notably by Peter Sculthorpe, Jamie Wyeth, Philip Jamison, Ann Wyeth McCoy, Andrew Wyeth and others, as well as works by Philadelphia realist painters Mark Bryce and David Coolidge. Paintings, prints and drawings by the important American abstractionist Deborah Remington are also available.

Contemporary artist Bernard Langlais sculpts large animals in wood. The gallery's collection of contemporary American crafts includes porcelain by Thomas Hoadley, glass by John Kuhn, handcrafted jewelry by Krupp and Bryan, Donald Pywell and others. Bob Chadwick makes intricate fossilized bone boxes inlaid with wood and metal.

The gallery features work by several emerging artists, including Jeff Moulton, oil paintings on canvas; Rob Evans, mixed media; and Ed Rafferty, watercolors. Other artists shown are Jenny Schurr, original serigraphs; and P. Buckley Moss, well-known primitive painter from Virginia.

WILMINGTON

Carspecken-Scott Gallery 1707 N. Lincoln St., Wil-
216 mington, DE 19806 (302) 655-7173; Mon-Fri: 9-5 Sat: 10-3; owner/dir: F.J. Carspecken

Carspecken-Scott primarily represents contemporary painters who live in the Mid-Atlantic region. Stylistically these artists range from very realistic, traditional watercolors and oil painting to very modern, non-objective paintings and collages. The gallery also sells contemporary graphics: lithographs, serigraphs, etchings, etc., as well as prints and posters.

Among the many artists whose work a casual visitor may find on display are Mary Page Evans, Carolyn Anderson, and Scott Woolever. Evans uses bold painterly techniques in her colorful Abstract Expressionist acrylics. Anderson and Woolever are realist watercolor painters. While Anderson specializes in American landscape, seascape and still life, Woolever paints extremely realistic American wildlife subjects, especially birds of prey.

Delaware Art Museum's Downtown Gallery 13th &
217 Market St., Wilmington, DE 19801 (302) 571-9594; Mon-Fri: 9-5; dir: Lial A. Jones

An outreach exhibition space of the Delaware Art Museum, the Downtown Gallery shows mostly contemporary American art in one-person and thematic group shows.

Artists who have had one-person shows include Joe Nicastri, Nicholas Africano, Bernis von zur Muehlen, Matt Phillips, Joseph Raffael, Bernard Chaet, Roger Laux Nelson, Ben Schonzeit, Dorothy Gillespie and others.

Mail should be addressed to: Lial A. Jones, Delaware Art Museum, 2301 Kentmere Parkway, Wilmington, DE 19806.

DISTRICT OF COLUMBIA

WASHINGTON

Adams Davidson Galleries 3233 P St. NW, Washing-
218 ton, DC 20007 (202) 965-3800; Tue-Fri: 10-5 Sat: 12-6; owner/dir: Ted Cooper

Since 1965, Adams Davidson has consistently represented the 19th and early 20th centuries in American art, from the Hudson River School through American Impressionism. The gallery mounts four group exhibitions each year, featuring paintings, watercolors, and drawings by noted American artists. Past shows have included Rembrandt Peale, Thomas Cole, Frederic Church, Thomas Eakins, Winslow Homer, Childe Hassam, Robert Henri, and Maurice Prendergast. American landscape painters are also represented, including Jasper Cropsey, Albert Bierstadt, John Henry Hill, and Fitz Hugh Lane.

The gallery has recently begun concentrating in 19th century American sculpture. A show in Fall 1984, "Marble and Bronze," exhibited works by American sculptors spanning the period 1840-1940. The sculptors shown included Hiram Powers, Thomas Ball, Frederick MacMomies, and Daniel Chester French.

David Adamson Gallery 406 7th St. NW, Washing-
219 ton, DC 20004 (202) 628-0257; owner: David Adamson dir: Laurie Hughs

David Adamson Gallery/Editions exhibits contemporary prints as well as work in other media. Recent shows have included Pop artists Jim Dine, Claes Oldenburg and James Rosenquist, Washington color painter Gene Davis, and contemporary realists Philip Pearlstein and David Hockney. The gallery also exhibits work by emerging artists from the Washington area, among them Kevin MacDonald, Michael Clark, Virginia Daley, Janis Goodman and James Sundquist.

David Adamson is also a master printer who prints for and publishes artists in his lithographic atelier. Among those published are Gene Davis, Kevin MacDonald and Virginia Daley.

The Art Barn Association 2401 Tilden St. NW, Rock
220 Creek Park, Washington, DC 20008 (202) 426-6719; Wed-Sun: 10-5; dir: Mrs. Karen Montgomery

A nonprofit, community-oriented gallery, the Art Barn is devoted to showing work by groups of area artists. Recent examples include shows by Ann Zahn's print workshop and exhibits curated by Franz Bader and Leon Berkowitz. Located in a rustic old mill in the middle of Rock Creek Park, the Art Barn exhibits artwork in a unique setting. Exhibits change monthly, and works are for sale. The sylvan setting makes a visit worthwhile, and there are free art demonstrations that take place on the weekends.

The Atlantic Gallery Ltd. 1055 Thomas Jefferson St.,
221 Washington DC 20007 (202) 337-2299; Mon-Sat: 10-6 Sun: 1-5; dir: Malcolm Henderson, Virginia Smith

Located in the foundry building on the historic C and O Canal, the Atlantic Gallery is in its ninth year of offering 19th and 20th century British and American art, especially marine and sporting genre.

The gallery features the limited edition prints of John Stobart, depicting the port cities of America as they were in the 19th century. It also presents the original works of British marine artist Robert Back, whose romantic ship portraits it publishes in limited editions.In addition it offers a fine selection of watercolors by 19th and 20th century artists, including Chris Watkiss, Dominic Serres, Spurling, W.E. Norton and W.L. Wylie.

The gallery has a broad range of prints including 19th century etching by John Taylor Arms, Whistler, and Hayden; antique prints by David Roberts, R.A., Redoute and others; and contemporary graphics and limited editions.

Franz Bader Gallery & Bookstore 2001 I St. NW,
222 Washington, DC 20006 (202) 337-5440; Tue-Sat: 10-6; dir: Franz Bader

Since 1939, when he left his Vienna bookshop just ahead of the Nazis, Franz Bader has become a legendary figure in Washington as proprietor of the city's longest-running commercial gallery.

Bader began his career with big-name Europeans, but soon was championing a growing band of artists working in Washington after World War II, who had practically no place to exhibit. Among those who joined him were Sarah Baker, Ben Summerford, Herman Maril and Leonard Maurer of American University,

and Pietro Lazzari, Mitchell Jamieson, color painter Alma Thomas, and many others. Watercolorist Lee Weiss and famed printmaker Peter Milton had their first shows with Bader and continue to show there. Anita Bucherer from Germany and Dutch painters Henri Plaat, Pim Leefsma and Franz Boon are also gallery regulars. Recently Helmtrud Nystrom from Sweden and Austrian Gottfried Salzman have joined the gallery.

Each fall the Bader Gallery holds a major exhibition of stone sculpture and prints by Canadian Eskimo artists. The gallery also presents a large selection of work by ceramic artists Gertrud and Otto Natzler.

Other gallery artists include Herman Maril, Alfred McAdams, Arthur Hall Smith, Robert Marx, and whimsical sculptors Berthold and Slaithong Schmutzart. Among the many distinguished printmakers who also show with Bader are David Freed, David Becker, Prentiss Taylor, Carole Sue Lebbin, Naul Ojeda and Evan Summer.

Baumgartner Galleries, Inc. 2016 R St., Washington,
223 DC 20009 (202) 232-6320; Tue-Sat: 11-6; dir: Manfred Baumgartner

After a decade in the area as a private agent for the eccentric Austrian artist Friedensreich Hundertwasser, Manfred Baumgartner, also Austrian-born, has now opened a gallery in a townhouse just a few blocks from the Phillips Collection. Hundertwasser's paintings and graphics are highly patterned and colored, with Persian, Arabic or African feelings for design and ornament. In this respect they ressemble the paintings of 19th century Viennese artist Gustav Klimt, but with qualities of children's art and naive art. Hundertwasser continues to be the gallery's star, along with a group of Viennese artists. These include Attersee, fantastic realist Erich Brauer, and Arnulf Rainer, an early proponent of Tachism, the European parallel to Abstract Expressionism, whose recent work uses the human image, frequently in photographic form, as a support and subject for painting.

Since the gallery opened it has promoted a new group of artists both here and abroad, including realists Sherry Zvares Kasten and Humberto Calzado, and abstract expressionists Mindy Weissel and Shahla Arbabi.

During the gallery's monthly changing shows other international artists not previously seen here have been introduced, among them "Dado", a Yugoslavian surrealist living in Paris, and Patricia Nix, who makes painted assemblages and box constructions.

Robert Brown Contemporary Art 1005 New Hamp-
224 shire Ave. NW, DC 20037 (202) 822-8737; Wed-Sat: 12-5 or by appt July-Aug: by appt; owner/dir: Robert Brown

In Washington since 1981, when it moved here from New York City, Robert Brown Contemporary Art specializes in contemporary European painting, prints and sculpture, and also handles work by some local artists. Both abstract and representational styles are presented.

The gallery exhibits the drypoint etchings, both two- and three-dimensional, monoprints with drypoint, watercolors, gouaches and chalk

drawings of Oleg Kudryashov, a Russian-born artist who works in London. His work is in many museum collections, including that of the National Gallery in Washington. Argentinian artist Oliveira Cezar, who works in New York and Paris, shows his realistic studies of light and space, executed in acrylic on canvas. Swiss artist Fifo Stricker's surrealist drawings and etchings are also exhibited, as well as the work of U.S.-based Uruguayan sculptor Alfredo Halegua, who makes large outdoor pieces. American photorealist Richard Niewerth's current work depicts light reflections on automobiles.

Local artists include Kit Kan, who has adapted classical Oriental styles in his contemporary landscape drawings; Jay Dunitz, abstract color photography; and Rakuko Naito, flower paintings.

Capitol East Graphics 600 E St. SE, Washington, DC
225 20003 (202) 547-8246; Thu-Sun: 2-6 or by appt; dir: H. Elaine Jackson

Capitol East Graphics provides art accessorizing services for corporate and residential interiors. Services include help in the selection, placement and presentation of two- and three-dimensional work. The gallery offers a wide selection of fine art originals and posters.

The gallery portfolio includes selections by European and American printmakers with a focus on the works of contemporary Afro-American printmakers.

Among those included in the portfolio are: Earl Miller of Seattle; Vincent Smith, New York City; Herbert Gentry, New York City-Paris; Norma Morgan, Woodstock; Michael Ellison, Atlanta; and Donald Locke, Tempe, Az.

The gallery also features work by contemporary craft artisans, fiber artists and sculptors.

Kathleen Ewing Gallery 1609 Connecticut Ave. NW,
226 Suite 200, Washington, DC 20009 (202) 328-0955; Wed-Sat: 12-6 Aug: by appt; owner/dir: Kathleen Ewing

The gallery specializes in contemporary photography, both from the Washington area and across the United States and Europe. An inventory of 19th and early 20th century photography is available. Washington artists working in lithography and silkscreen are also featured.

Not all the photographers displayed follow tradition. Allen Appel adds collage and paint to his images; Claudia Smigrod surrounds hers with trimmings that repeat the patterns and subject matter of the photograph. Both photographers have appeared at the Corcoran Gallery, as have most of the other DC photographers: Steven Szabo, Allan Janus, Mark Power, David Allison, Frank DiPerna, and Richard Rodriguez. Other photographers with national reputations are Denny Moers, Bruce Barnbaum, Judy Dater and O. Winston Link. The gallery also offers works from the estate of Baltimore photographer A. Aubrey Bodine.

The gallery's most successful exhibit to date was during the spring of 1984 with the photographs of O. Winston Link, entitled "Ghost Trains, Railroad Photographs of the 1950s". Other important exhibitions have been Allen Appel's series "Nature Morte" and Stephen Szabo's series "On the Road to Skye"

Fendrick Gallery 3059 M St. NW, Washington, DC
227 20007 (202) 338-4544; Mon-Sat: 9:30-5:30; owner: Barbara Fendrick dir: Julia C. Fendrick

Concentration is on contemporary American masters in all media. Exhibitions have ranged from paintings, prints, and drawings to architectural ironwork, books as art, ceramic sculpture, and other new or revived media. The gallery solicits commissions for gallery artists in architectural ornamentation, paintings and sculpture.

Starting in the 60s, the gallery began to show works by Abstract Expressionists and the then emerging Pop artists. It continues to show work by Helen Frankenthaler, whose stained, unprimed canvases presented a lyrical approach to gesture painting; Robert Rauschenberg, whose assemblages known as "combines" extended ideas rooted in gestural painting to found urban objects and materials; and Jim Dine, a gestural and lyrically ironic Pop artist. Works are also available by Robert Arneson, William Bailey, Robert Cottingham, and Joseph Raffael.

Important craft artists presented by the gallery include metalsmith Albert Paley, woodcarver and furniture maker Wendell Castle, and glass artists Dale Chihuly and Thomas Patti. The gallery also handles work by leading Washington artists such as Sam Gilliam, watercolorist Patricia Tobacco Forrester, A. Brockie Stevenson and Roger Essley.

Fondo del Sol Visual Art & Media Center 2112 R St.
228 NW, Washington, DC 20001 (202) 483-2777; Wed-Sat: 12:30-6:30

This nonprofit gallery and community arts center is part of a growing national network of alternative spaces devoted to projecting the new energies Hispanic artists, Afro-American and Native American artists, and artists representative of other minority groups are channeling into American art. This three-story house near the Phillips Collection houses not only exhibition spaces but also workshops for video. It is one of the few places in Washington were new video can always be viewed.

The Center opened in 1977 with grants from the Cafritz Foundation, and continues to receive support from the National Endowment for the Art and the D.C. Commission on Arts and Humanities.

Exhibitions, usually group shows, change monthly; some have toured. The inaugural "Roots & Visions", organized with the help of the National Collection of Fine Arts, was the first traveling show of work by contemporary Hispanic-American artists from all over the country, and toured 20 museums. Luis Jimenez, Rafael Ferrer, Rafael Ortiz, Dino Aranda and Larry Fuente are but a few of the 48 artists included in that revealing survey. Subsequent shows have featured work by Chilean exile artists now scattered all over the world, including Roberto Matta. There have been retrospectives of performance artist Jonas dos Santos and video artist Juan Downey.

Video art plays a major role at Fondo del Sol. Through Osiris Productions, the Center produces and exhibits films and videotapes dealing with the diverse cultural and artistic heritage of the Americas. Video programs are offered every Saturday afternoon.

Guarisco Gallery, Ltd. 2828 Pennsylvania Ave. NW,
229 Washington, DC 20007 (202) 333-8533; Mon-Fri: 10-5:30 Sat: 12-5; dir: Jane Studabaker, Laura Guarisco, Elizabeth Guarisco

The gallery presents 19th century European, British and American paintings, concentrating on genre, landscape, British marine and sporting paintings.

British, American and European masters exhibited include Monamy, Serres, Gilpin, Alken, Watts, Richards, De Blaas, Verboeckhoven, and Sonntag. Peter Monamy and Dominic Serres were early English marine painters (18th century) whose work follows the Dutch tradition of Willem Van de Velde in portraying shipping, marine views and sea fights. 19th century English painter John Alken was known for his portraits of horses, in the tradition of the distinguished artist George Stubbs. The Picturesque style that prepared the ground for English Romantic painting was ably developed by William Gilpin. Reacting to Romantic excesses George Frederick Watts sought an ideal of beauty in alle-gorical paintings in a Neo-classical mold.

''300 Years of British Marine Paintings'' was recently shown, and continues to grow as a collection with additional acquisitions. Sailmaker, Monamy, Serres, Luny, Cooke, Buttersworth, Carmichael and Cleveley are among those included in the collection.

Jane Haslem Gallery 406 7th St. NW, Washington,
230 DC 20004 (202) 638-6162; Tue-Fri: 11:30-3:30 Sat: 12-5; dir: Jane Haslem

The Jane Haslem Gallery specializes in American art from 1900 to the present. A major feature of the gallery inventory is the collection of American prints, especially prints made by the artists themselves. The scope of the collection makes it of interest to scholars, who may become familiar with the entire oeuvre of some of America's major print innovators, as well as the works of the generations of artists that followed them.

Among the artists whose work has been exhibited at Haslem are Mauricio Lasansky, Gabor Peterdi, Antonio Frasconi, Leonard Baskin, Misch Kohn, Michael Ponce de Leon and Rudy Pozzatti. The gallery has also shown works by Will Barnett and Mark Tobey. Contemporary printmakers include Barbara Kerne, William Livesay, Wanda Matthews, Michale Mazur, Bruce McCombs, Michael Nushawg, Elizabeth Peak, Clare Romano and Richard Ziemann.

The gallery has also handled original political cartoons and comic strips by Pat Oliphant, Gary Trudeau, Tony Auth and Jules Feiffer, to mention only a few.

Henri Gallery 1500 21st St. NW, Washington, DC
231 20016 (202) 659-9313; Tue-Sat: 11-6 Sun: 2-6; owner/dir: Henrietta Ehrsam

The longest-running gallery on the P St. strip is operated by Henrietta Ehrsam, who moved to Washington from Alexandria in 1967, after successfully running an avant-garde gallery there for a decade.

The gallery has always been inclined to non-traditional art, which a decade ago in Washington included showing Washington Color Painters Gene Davis and Tom Downing, and sculptor Ed McGowin. The Color Painters, who also counted Kenneth Noland in their number, structured pure color into contrasting areas with clear shapes. In Gene Davis's case, the paintings consisted of vertical stripes, whose apparent accessibility eventually brought them a considerable public appreciation, including a quarter mile-long installation of stripes painted on a street.

Some of the best and most unusual art in the gallery is by sculptors Robert Stackhouse, John Van Alstine, Czech sculptor Stanislav Kolibal, Bob Jensen (who makes huge objects, including surfboards), Michael Bigger, Peter Charles, Lester Van Winkle (who makes improbable furniture), Skip Van Houten, Gary Kulak and jjon Glidden.

The gallery also shows paintings, all abstract, by Frank Herrmann, Leya Evelyn, Clemon Smith, Wilhelm Bronner, Traute Ishida, Tom Nakashima, Jim Sullivan and Leslie Exton. Dye transfer photographer Graeme Outerbridge from Bermuda has also shown here.

Hom Gallery 2103 O St. NW, Washington, DC 20037
232 (202) 466-4076 Tue-Sat: 11-5; owner/dir: Jem Hom

This distinguished print gallery specializes in late 19th and early 20th century European masters such as Matisse, Gauguin, Cezanne, Toulouse-Lautrec, Picasso, Degas, Klee and Munch, as well as early 20th century American masters such as John Sloan, Reginald Marsh, Martin Lewis, Max Weber, Maurice Prendergast, James McNeill Whistler, Childe Hassam and Edward Hopper.

An Old Master department has recently been added. Its fulltime curator, Carolyn Bullard, is an authority on prints by masters such as Rembrandt, Durer, Piranesi, Callot and Goya.

In the field of contemporary art, the gallery features Washington wood and marble sculptor Leonard Cave and printmaker Mark Leithauser.

Hom regularly publishes catalogs of his inventory, and is always interested in acquiring fine works of art, either singly or in collections, by purchase or trade.

Hull Gallery 3301 New Mexico Ave. NW, Washing-
233 ton, DC 20016 (202) 362-0507; Mon-Sat: 9:30-5; owner/dir: Anne D. Hull

Located in Foxhall Square, an indoor office and shopping complex, this pleasant two-room gallery has managed to mix good exhibitions of American 19th and early 20th century works with shows by American contemporary artists, most of whom paint or draw or print in a lyrical, traditional or semi-abstract style.

The contemporary artists include Alexis de Boeck, a Bel-gian artist residing in Washington who paints abstracted interiors and exteriors with strong architectural elements; Rosaline Moore, who paints impressionist interiors and landscapes; as well as Bernice Duvall, Mary Page Evans, Jae Roosevelt, Carrita Smith and others.

The 19th and early 20th century American artists, whose oil paintings, watercolors, drawings and prints are part of the gallery's collection are George Bellows, Thomas Hart Benton, Oscar Bluemner, Charles Demuth, Sanford R. Gifford, Reginald Marsh, William T. Richards, John Sloan and others.

In its changing monthly shows the gallery most often features contemporary artists, though the earlier works are always available for viewing.

Gallery K 2032 P St. NW, Washington, DC 20036
234 (202) 223-6955; Tue-Sat: 11-6; owner: Komei Wachi & H. Marc Moyens dir: Komei Wachi

Established in 1976 by Washington collector and dealer Marc Moyens and Komei Wachi, this gallery offers a broad spectrum of styles ranging from minimalism to realism. The gallery features both U.S. and foreign artists.

Among the Washington artists shown at the galleries are Ed Ahkstrom, Lisa Brotman, Susan Firestone, Fred Folsom, Steve Kruvant, Jody Mussoff, Wayne Paige, Lolo Sarnoff, Eve Watts and Alan Weatherley.

Other U.S. and Canadian artists include James Bumgardner, Durwood Dommisse, Ian Baxter, Roy DeForest, Robert Knipschild, Bernard Martin, Maureen McCabe, Seymour Remenick, Ken Saville, Julius Schmidt, George Sawchuck, William Sullivan and Franklin Williams.

Finally, the gallery has always made a point of showing well-known foreign artists, such as Olivier Debre, Jacques Poli and Christian Gardair (France), Bert-Johnny Nilsson (Sweden), Carsten Svensson (Denmark), Harry Kivijarvi (Finland), Yoshi Taniguchi (Japan), and many others.

The gallery has private and corporate clients, and acts as a consultant on large projects. Its collection includes over 4,000 works by well-known artists such as Richard Lindner, Robert Motherwell, Roberto Matta, Jackson Pollock, Andy Warhol, Wayne Thiebaud, Ben Nicholson, and more. These works may be seen by appointment only.

B.R. Kornblatt Gallery 406 7th St. NW, Washington,
235 DC 20004 (202) 638-7657; Tue-Sat: 10:30-5; owner: B.R. Kornblatt

The B.R. Kornblatt handles contemporary American painting, sculpture and works on paper.

Artists whose works are in the gallery include Kenneth Noland, Carolyn Brady, Michael Todd, Eric Fischl, Robert Longo, Louise Nevelson, Alex Katz, Larry Rivers, Ronnie Landfield, Roger Laux Nelson, Robert Motherwell, Helen Frankenthaler, Wayne Thiebaud and others.

Recent exhibitions have featured new paintings by Sally Kearsley, a Neo-Expressionist from Baltimore; paper constructions by Katherine Allen, which incorporate silhouettes of Japanese robes and capes; and contemporary screens by New York artist Jim Jacobs, who uses traditional Oriental lacquering techniques, but constructs his free-standing screens with asymmetrically-angled panels.

Mickelson Gallery 707 G St. NW, Washington, DC
236 20001 (202) 628-1734; Mon-Fri: 9:30-5 Sat: 9:30-4; owner/dir: Sidney and Maurice Mickelson

Since the sixty year old Mickelson frame shop added a gallery in 1962, its owners have hung an impressive array of works by master printmakers. They were the first dealers in America to display the works of M.C. Escher, creator of dazzling visual paradoxes and tranformations that combine realistic imagery and mathematical concepts. Mickelson also boasts a large collection of prints by Ashcan School painter George Bellows and Fairfield Porter, a realist contemporary of the Abstract Expressionists. The whimsical landscapes of English contemporary etcher Anthony Gross and aquatints by Norman Ackroyd are also featured. On the contemporary American scene one can find prints by David Bumbeck, Florence Putterman, Kaiko Moti, Philip Pearlstein, Marianne Hornbuckle and Luigi Lucioni.

The Mickelson gallery painters generally reflect the feeling of realism in painting. From contemporary Impressionism to American Primitives, with a multitude of different styles in between, one can find local, Southern, and Western painters such as Gary Shankman, Anne Shreve, William Preston, John Loeper, W.T. Kinkade, Katharine Renninger and Joseph Reboli.

Middendorf Gallery 2009 Columbia Rd., Washing-
237 ton, DC 20009 (202) 462-2009; Tue-Fri: 11-6 Sat: 11-5; dir: Christopher Middendorf

One of Washington's handsomest art spaces, Middendorf Gallery's two-story converted residence houses one of the city's leading galleries for 20th century American art in all media.

Among the contemporary Americans are abstract painter Sam Gilliam, whose work retains a gestural attack and all-over texture while exploring such non-gestural ideas as geometric form and spatial illusions; and sculptor Manuel Neri, a California artist who paints his plaster and marble figures in addition to using textural markings on them; as well as painter Nicholas Africano, and interna-tionally recognized photographers William Christenberry and William Eggleston.

Well-known Washington artists include color painter Leon Berkowitz, minimalist Robin Rose, realists Joe White and Betsy Falk, along with Tom Dineen, Stephen Ludlum, and sculptors Christopher Gardner and Joe Ferrugia.

Old Print Gallery 1220 31st St. NW, Washington, DC
238 20007 (202) 965-1818; Mon-Sat: 10-6; owner/dir: James Blakely, Judy Blakely, James von Ruster

Specializing in original 18th and 19th century American prints and maps, this thirteen-year-old Georgetown establishment is located just a few blocks from M Street. It has a very large stock which includes wood engravings by Winslow Homer and Thomas Nast, taken from old *Harper's Weekly* magazines, and prints from other publications such as *Judge* and *Puck,* which published political cartoons.

Of major interest are prints from George Catlin's 1841 ''North American Indian Portfolio'' and Carl Bodmer's aquatints made to accompany Prince Maximilian's journal, *Travels in the Interior of North America,* published in 1832-34. Catlin's lifework was the recording of the life of the American Indian, a task he undertook with an anthropologically accurate eye and a profound respect for his chosen subject.

Views of cities and landscapes taken from old books and newspapers from all over the world are numerous, as are historical prints and maps.

Natural history prints—flowers by Redoute from France and Thornton from England, along

Otto Natzler, untitled (1978), ceramic, 10 high, Franz Bader (Washington, DC)./

William Christenberry, *Rebel Gas* (1984), 17 x 24 x 43, mixed media, Middendorf Gallery (Washington, DC).

Lee Weiss, untitled, oil, Franz Bader Gallery (Washington, DC).

with birds by America's Audubon—are also available.

Osuna Gallery 406 7th St. NW, Washington, DC
239 20004 (202) 296-1963; Tue-Sat: 11-6; pres: Ramon Osuna dir: Josephine G. Greco

Osuna Gallery is located in a renovated building downtown which it shares with several other leading dealers. The basic intersets of the gallery lie in paintings, drawings and sculpture by a mix of contemporary Latin American and American artists, including Surrealists Roberto Matta of Chile and Cuban Wifredo Lam. The gallery has special expertise in Pre-Columbian, Colonial and contemporary Latin American art.

The majority of Osuna's changing monthly shows feature contemporary American painters and sculptors of various persuasions. These include Tom Downing, minimal painting, and Ann Pruitt, sculpture—both of the Washington Color School. Others are realist painters Rebecca Davenport, Manon Cleary, Stanley Sporny and Margarida Kendall; John Van Alstine, steel and stone sculpture; Reuben Nakian, clay sculpture; and abstract painters Philip Wofford, Ann Purcell and Natalie Alper. Other noted artists featured by Osuna are Peter Dean, Albert Stadler, Frank Anthony Smith, Robert Warrens, Ken Nevadomi and Paul Davis.

Pensler Galleries 1656 33rd St. NW, Washington, DC
240 20007, (202) 333-3565; by appt only; owner/dir: Alan Pensler

This tiny gallery, just off Wisconsin Ave. at the top of 1 Georgetown, is for the collector interested in hunting down 19th century American, and occasionally European, paintings, drawings, and watercolors. The stock is small, but those who know the field will probably find something of interest.

Although the inventory changes, of course, one visit might reveal a late painting by Washington Allston, exhibited at the Boston Museum of Fine Arts in 1881; a luminist landscape by painter John F. Kensett, deaccessioned by the Metropolitan Museum in the late 1960s; drawings by American Impressionists Abbott Thayer and Maurice Prendergast; and a French genre scene of resting soldiers, painted by Etienne Berne-Bellecour in 1877.

There are always portraits, still life and landscape paintings by lesser-known painters, American, English, Italian and French.

Paul Rosen Graphics, Ltd. 3417 M St. NW, Washington, DC 20007 (202) 333-6782; Tue-Sat: 10-6
241 Thu: until 9; owner/dir: Paul Rosen

This friendly gallery located across from Key Bridge in Georgetown features contemporary art in a variety of media, with concentration in graphics by leading contemporary European and American artists. Featured artists include R.C. Gorman, Marcel, Patierno, Zweig, Snyder, Uffelman, Vo-Dinh, Oku, Davila, Lorand and others. Individualized service for the first-time purchaser as well as the seasoned collector is provided. Museum-quality custom framing of works on paper is a specialty.

Shogun Gallery 1083 Wisconsin Ave. NW, Washington, DC 20007 (202) 965-5454; Wed-Sun: 11-6;
242 ton, DC 20007 (202) 965-5454; Wed-Sun: 11-6; owner: Toni Liberthson mgr: Gary Gestson

One flight up over the busy intersection of Wisconsin Ave. and M St. in Georgetown is the Shogun Gallery, specializing in Japanese woodblock prints from the 18th century to the present day. Emphasis, however, is upon 19th century ukiyo-e prints and the so-called transitional period from 1912-50, when woodblock prints were still very traditional in style, but had begun to incorporate Western perspective and modeling.

The *ukiyo-e* style arose before 1750, at the time of the flowering of the popular *kabuki* theater. *Ukiyo-e* means literally "pictures of the floating (i.e. transient) world", and prints generally depicted scenes of everyday life, actors and actresses, landscape, legends, animals, etc. The woodblocks were inked with a brush, a technique that permitted many gradations of color and tone.

Among the better-known artists of this style represented in the gallery are 18th century master Kitagawa Utamaro, and 19th century masters Katsushika Hokusai, Utagawa Hiroshige, and Yoshitoshi. Two of the finest landscape artists from the transitional period are Hiroshi Yoshida and Kawase Hasui. Among the leading contemporary woodblock artists are Yoshitosha Mori, Jun'Ichiro Sekino, Saito, Tajima, and many more.

The gallery has a selection of books on Japanese prints, as well as many posters.

Spectrum Gallery, Inc. 1134 29th St. NW, George-
243 town, Washington DC 20007 (202) 333-0954; Tue-Sat: 10-5 Fri: 7-11 Sun: 2-5; cooperative dir: Millie Shott

Spectrum, one of Washington's oldest and most respected artist-run galleries, presents a large and varied selection of works. Featured are abstract and representational paintings, prints, sculpture and pottery by 27 outstanding area artists.

One-person shows by members take place on a three-week rotating basis, with work by other members always on view.

Tolley Galleries 821 15th St. NW, Washington, DC
244 20005 (202) 347-0003; Mon-Fri: 10:30-5:30; owner/dir: Eleanor and William Tolley

Opened in 1976, this is a small gallery specializing in traditional, realistic paintings and sculpture, including select 19th century paintings, together with paintings and sculpture by a small group of contemporary artists. One of its most recent specialties is portrait painting.

Touchstone Gallery 2130 P St. NW, Washington, DC
245 20037 (202) 223-6683; Tue-Sat: 11-5 Sun: 12-5; dir: Luba Dreyer

Work by the 31 artist members of this cooperative gallery covers a wide range of media, from painting, sculpture, prints and ceramics to photography.

Works displayed include intriguing sculptures made from molded tapa-bark by Morella Belshe, "portrait benches" of molded fiberglass by Altina, and paintings by Brenda Belfield, who was commissioned to design 44 stained glass windows for the Washington Cathedral. Painter Anne Marchand makes free-standing paintings enhanced by geometric motifs on the legs that merge into the painting above, and jewel-like, glowing paintings that float on top of larger velvety black rectangles.

Several painters cover the gamut from realism to abstraction, among them Maria Tourau, Kit-Keung Kan, Judith Turim, Ellen Liftin, Jo Harrop and Harriet Rosenbaum. Zinnia and Frank Van Riper are the only photographers. Gretchen Friend-Jones and Mansoora Hassan combine graphics techniques with monoprinting. Potter Rima Schulkind produces both unique and production pieces in stoneware and porcelain.

Touchstone features two member-artists at a time in shows that change every three weeks, with work by all members always on view in the rear of the gallery.

Venable-Neslage Galleries 1742 Connecticut Ave.
246 NW, Washington, DC 20009 (202) 462-1800;
Mon-Sat: 10-6

In operation since 1892, this gallery associated with a framing business shows work in various media by contemporary European and American artists, representational and abstract. American Impressionist painter Frederick McDuff from Washington is a featured painter, along with French artist Marcelle Stoianovich and Italian printmaker Mario Micossi. American painters include Margaret Cornelius, William Aiken and Tseng-Ying Pang. Local artists Yury Kokoyanin, Lillian August and Joseph Hurwitz also exhibit their work here.

In addition, the gallery handles contemporary original prints by American, European and Japanese printmakers.

Via Gambaro Gallery 416 11th St. SE, Washington,
247 DC 20003 (202) 547-8426; Thu-Sat: 10-5 Sun:
1-5 and by appt; owner/dir: Retha Walden Gambaro & Stephen Gambaro

Specializing in American Indian art, this gallery was established in 1976 in a charming old carriage house on Capitol Hill. Visitors enter through a small enclosed garden which also houses the studio of sculptor and gallery founder Retha Walden Gambaro.

The gallery space features work that is sometimes traditional, sometimes highly advanced. Painting, prints, sculpture and some extraordinary ceramics—some of them trompe-l'oeil—are included in the gallery's busy schedule. Group shows such as "The National American Indian Women's Art Show", held in the summer of 1980, reveal important facets of Native American art.

Among the gallery regulars are Kevin Red Star, a well-known Crow Indian artist from Montana, who confronts the viewer with agressively drawn, ironic images; Johnny Tiger, Jr., a Creek-Seminole; King Kuka, of the Blackfeet tribe; Kevin Brown and Bert Seabourn.

Volta Place Gallery Volta Place & 33rd St. NW,
248 Georgetown, Washington, DC 20007 (202)
342-2003; Tue-Sat: 12-6; owner/dir: Mona and James Gavigan

Volta Place Gallery was established in 1979. It is the only gallery in metropolitan Washington specializing in authentic, traditional African art. Ritual, utilitarian and decorative works are featured.

Exhibitions are frequently thematic, focusing on objects from specific regions of Africa or selected artforms, for example, masks, ancestor statues, etc. Occasionally, the gallery carries works by recognized, contemporary artists influenced by the traditions of cultures other than our own.

The gallery is well-known among collectors and museums, and internationally recognized in the field of African arts. Consultations and appraisals are offered.

Washington Project for the Arts 400 7th St. NW,
249 Washington, DC 20004 (202) 347-4813; Tue-Sat: 11-5 Aug: closed; dir: Jock Reynolds

The W.P.A. is a nonprofit visual and performing arts organization devoted to showcasing local, national and international artists. Since its inception in 1975, WPA has served as a vital forum for the newest developments in contemporary art and has received national recognition for its interdisciplinary programs.

Facilities include over 7000 square feet of exhibition and performance space and a bookstore featuring unique, handmade and limited edition artists' books, art magazines, and new music recordings. WPA has used two outdoor sites, a vacant lot and a vest-pocket park, to commission site-sculpture by artists from all over the country. WPA also has an active experimental dance, theater and video program where interdisciplinary work is encouraged.

Washington Women's Arts Center 420 7th St. NW,
250 Washington, DC 20004 (202) 393-0197; Tue-Fri: 11-5 Sat: 11-5; dir: Taina Litwak

In 1983 the Center moved to its present location, the Lundberg Cultural Center, a former department store now renovated to house arts organizations, performance groups, and shops. This nonprofit alternative space holds monthly juried shows, curated by museum curators, artists, and critics. Hundreds of women artists (and a few men as well) have been showcased at the Center during its eight-year history. Painters, sculptors, graphic artists, photographers, and mixed-media artists are featured, some for the first time, and others as part of growing careers.

Recent shows included "Artist in the Art," an examination of the relation between the artist as a person and the work she creates, juried by Carol Ravenal, professor of studio art at American University; a printmakers exhibit at the U.S. Geological Survey in Reston, VA, juried by Carol Pulin, curator of fine prints for the Library of Congress; and an annual Halloween Art Show, curated by Mary Swift.

Zenith Gallery 1441 Rhode Island Ave. NW (rear),
251 (202) 667-3483 Mon-Sat: 11-6; dir: Margery Goldberg

Located in a remodeled carriage house in an area with a multitude of artists' and craftsmen's studios, Zenith Gallery specializes in contemporary crafts, sculpture and painting, as well as providing craft services.

As a gallery attentive to the community, Zenith often shows work by Zenith Square Artists, but not exclusively. Resident artists are gallery founder Margery Goldberg, wood sculpture and sculptured furniture; Laima Simanavichus, enamel on acrylic painting; Chas Colburn and Beatriz Blanco, steel sculpture; and Byron Peck and Ellen Sinel, paintings. Other national

artists include Guenther Riess, who does three-dimensional constructions of cities; James Carter and Andreas Nottebaum, who work in airbrush painting; and Boston artist Robert Freedman. Locally the gallery shows neon artist Ted Bonar, paper mache artist Ann Hanson, and craft artists working in various media, such as wearable art designers Sue Klebanoff, known for her tapestries, and Kathe Koumoutseas, who makes clothing and wearable art.

Gallery services are available in custom wood working, metalsmithing, stained glass, interior design, custom fountains, video and neon.

FLORIDA

BAY HARBOR ISLANDS

Gloria Luria Gallery 1033 Kane Concourse, Bay Harbor Islands, FL 33154 (305) 865-3060; Tue-Sat: 10-5; owner/dir: G. Luria
252

The Gloria Luria Gallery exhibits contemporary painting, sculpture and graphics by internationally and nationally known American artists, as well as featuring works by artists living and working in Florida.

Much of the work displayed is abstract in style. A few established artists such as Robert Rauschenberg, Larry Rivers and Robert Goodnough are exhibited. Among the many well-known mid-career artists whose work is available through the gallery are Conceptualist painter Shusaku Arakawa, New Image painter Jennifer Bartlett, contemporary abstractionists Robert Natkin, Nancy Graves, Ida Kohlmeyer and De-Wain Valentine, as well as Dan Christensen, Joel Perlman, Ray Parker and Joan Thorne.

Florida artists featured at the gallery are Debbie Schneider, Lynne Golob Gelfman, Carol Kapelow Brown, Lisa Parker Hyatt, Mindy Shrago, Claire Satin, Margaret Murphy-Reed, Katherine McCauley, Enrique Castro-Cid, Philip Brooker, Dan Stack and Barbara Neijna.

Habatat Gallery 1090 Kane Concourse, Bay Harbor Islands, FL 33154 (305) 865-5050; Tue-Sat: 10-5; owner: T. Boone, F. Hampson dir: Linda & Thomas Boone
253

See listing for Lathrup Village, MI.

Hokin Gallery Inc. 1086 Kane Concourse, Bay Harbor Islands (305) 861-5700; Tue-Sat: 10-5 Summer:closed Sat; owner: Grace E. Hokin dir: Dorothy Blau
254

See listing for Palm Beach, FL.

Ana Sklar Gallery 1019 Kane Concourse, Bay Harbor Islands, FL 33154 (305) 868-2008; Mon-Sat: 10-5; owner/dir: Ana Sklar
255

The gallery concentrates on contemporary, American, European, and Latin American art, and also serves as art consultants.

Contemporary artists whose work is available include the noted Mexican artist Jose Luis Cuevas, and Catalonian painter and graphic artist Antoni Tapies, a forceful abstractionist whose work emphasizes materials, gesture and texture, at times incorporating elemental images or actual objects. Other artists exhibited are Victor Gomez,

Enrique Grau, Nenad Jakesevic, Hal Kaye, Sonja Lamut, Rolando Lopez-Dirube, Jerry Lubensky, Christopher Mangiaracina, Antonio Maro, Julio Matilla, Jan Sawka, Dee Shapiro and Juan Ramon Velasquez.

BOCA RATON

Galleria Berenson, Inc. Suite 105C 470 NW 20th St., Boca Raton, FL 33431 (305) 395-0333; by appt Aug-Sep: closed; owner/dir: Felice Berenson
256

Concentration of the gallery is on contemporary Italian masters. Most of the artists represented are working in representational styles, although Italian constructionists are also exhibited. The gallery also represents the estate of Manfred Schwartz, and provides consultation and acquisition services for corporate collections.

An artist active in the WPA, whose work now is in many noted museum collections, Manfred Schwartz experimented in color field painting. The gallery is presently negotiating exhibitions of his work.

The contemporary Italian artists whose work is displayed at the Galleria Berenson are representative of both the distinguished tradition of Italian figure painting, and the more recent, yet still uniquely Italian vanguard tendencies in painting, sculpture and design. Angelo Vadala is well-known for his post-modern realism in oil painting and sculpture. Sculptor Sergio Benvenuri quotes Renaissance styles in his polyester resin bas reliefs and freestanding pieces. Painter Ricardo Benvenuri is concerned with contemporary symbols of woman in his romantic realist canvases. Sculptor Franco Scuderi creates abstract wall constructions and freestanding pieces in wood and metal.

The gallery also will find and place important works, such as Fernand Leger paintings, Henry Moore sculpture and graphics, or Old Master works.

Patricia Judith Art Gallery Ltd. 720 E. Palmetto Park Pd., Boca Raton, FL 33432 (305) 368-3316; Mon-Sat: 10-6; owner: Patricia & Arnaldo Cohn dir: Patricia Cohn
257

In an ample Mediterranean style building, the Patricia Judith Gallery shows work by living contemporary international artists. With the extensive space available, the gallery shows art on a continuous basis.

The paintings of Max Papart, a French artist working in a Cubist style, are among the works available. One may also encounter works by Theo Tobiasse, a French modernist painter whose figurative style reveals the influence of his studies with Marc Chagall. There are also works by Al Hollingsworth, one of America's leading Black artists.

The gallery exhibits a wide range of work by other artists. The paintings of Spanish born artist Felix Mas portray romantic, delicately rendered female figures. Colombian born artist Orlando Agudelo Botero's work reflects his admiration for the performance arts. American sculptor Willi Tobias makes her Southwestern style works in stone. American painter David Roth—formerly director of public television's "Sesame Street"—works in an abstract style.

COCONUT GROVE

Greene Gallery 3300 Rice St., Suite 4, Coconut
258 Grove, FL 33133 (305) 448-9229; Tue-Sat: 11-5
Aug: by appt; owner/dir: Barbara Greene

The Greene Gallery exhibits contemporary paintings, sculpture, works on paper and graphics by regional artists as well as by those nationally and internationally known.

Works are available by John Chamberlain, Grover Cole, Mel Bochner, Robert Peterson, David Smith, Roy Lichtenstein, Robert Rauschenberg and Andy Warhol.

The gallery also carries works by Chris Kirk, Pablo Cano, Fernando Garcia, Carol Levy, Robert Moorhouse, Bill Humphreys, Thomas Minor, Marcia Athens, and Arlene Florence. The stylistic approach of these artists ranges from abstract to expressionistic.

CORAL GABLES

ArtSpace/Virginia Miller Galleries 169 Madeira
259 Ave., Coral Gables, FL 33134 (305) 444-4493;
Mon-Sat: 10-6; owner/dir: Virginia Miller

Concentration of the gallery is on contemporary American and Latin American painting and sculpture. In recent years 19th and 20th century photography has become an increasingly important part of the gallery's offerings.

Several artists of international and national prominence are featured by the gallery. Master colorist Trevor Bell, Argentine born painter Perez Celis and Minnesota born abstract painter Richard Pousette-Dart stand out among this group of painters. Young American artist John Raimondi, Cuban born Roberto Estopinan and C. Andres Davidt top the list of sculptors. Photographs by Jerry Uelsmann, known for his mysterious superposed images, and by Tony Mendoza are displayed along with works by master photographers of the past 130 years.

Richard Carter's acrylic paintings, Claudia DeMonte's papier mache figures, Frank Fleming's unglazed porcelain and Maria Raventos's textural weaving are only are few examples of the variety of works presented by the gallery. Painters Gina Pellon from France, David McCullough and abstract illusionist Jack Reilly, as well as master lithographer Tadeusz Lapinski are exhibiting work during the 1984-85 season.

Rudolph Galleries Inc. 338 Sevilla Ave., Coral
260 Gables, FL 33134 (305) 443-6005; daily: 10-4
May-Nov: closed; owner/dir: Lilian Frederick-Fiolic

With locations in Woodstock, NY, as well as in Coral Gables, the Rudolph Galleries handle works by contemporary artists, including 20th century masters.

Works are available by such distinguished artists as Milton Avery, whose drawings, paintings, watercolors and monotypes are exhibited by the gallery; as well as Wolf Kahn, Sidney Laufman, early American abstractionist Ilya Bolotowsky, Abstract Expressionist Philip Guston, Beryl Goss, Surrealist Max Ernst, and calligraphic abstractionist Mark Tobey.

FORT LAUDERDALE

Carone Gallery SE 2nd Court, Fort Lauderdale, FL
261 33301 (305) 463-8833; Mon-Sat: 10-5; owner/
dir: Jodie & Matthew Carone

The Carone Gallery specializes in 20th century and contemporary art, including both figurative and non-objective paintings and sculpture.

Noted artists featured by the gallery include Carol Anthony, Karel Appel, Martin Bradley, Nicolas Carone, James Brooks, Wolf Kahn, Paul Jenkins, Roberto Matta, Jacques Soisson, and Syd Solomon.

An important role is accorded to contemporary sculpture. The gallery displays the work of Glyn Jones, whose style may be described as lyrical fantasy; as well as the abstract sculptures in wood, lacquered wood, marble and bronze of Henry Moretti; and the figurative bronzes of Norma Penchansky. Sculptor Helen Finch works in polyester resin and Marlite, creating hands and faces which she paints with acrylic. Sal Zagami, working in polyester resin and metal, creates figurative and surreal forms.

MIAMI

Marvin Ross Friedman & Co. 15451 SW 67th Ct.,
262 Miami, FL 33157 (305) 233-4281; by appt;
owner/dir: Marvin Ross Friedman

Marvin Ross Friedman and Company handle Major modern and contemporary works of art, including drawings, sculptures and paintings.

Important European modern masters and major contemporary artists whose work is available include Abstract Expressionists, lyrical abstractionists, Pop, Minimal, Conceptual and Neo-Expressionist artists. Among the many artists featured are Josef Albers, Shusaku Arakawa, Alexander Calder, Christo, Joseph Cornell, Willem de Kooning, David Hockney, Jasper Johns, Ellsworth Kelly, Fernand Leger, Sol LeWitt, Roy Lichtenstein, Morris Louis, Henri Matisse, Henry Moore, Claes Oldenburg, Picasso, Jackson Pollock, Robert Rauschenberg, James Rosenquist, Cy Twombly, and Andy Warhol.

Barbara Gillman Gallery 270 NE 39th St. & 3886
263 Biscayne, Miami, FL 33137 (305) 573-4898;
Mon-Fri: 10-6 Sat: 11-4; owner/dir: Barbara Gillman

The Barbara Gillman Gallery specializes in the work of young, emerging Florida artists. One may judge the variety and energy of these artists by the scale and diversity of the gallery, which exhibits paintings, drawings, prints, constructions, mixed media works, tapestries and sculpture in its 3000 square feet of space. Most of the work exhibited is abstract, but high quality representational works are also shown.

The gallery also shows work by nationally and internationally recognized artists. The recent prints of Andy Warhol from the portfolios "Myths" and "Ten Jews of the Twentieth Century," and the photographs of Linda McCartney are among the works available. There are also prints by Israeli artist Yaacov Agam, and prints by James Rosenquist from his portfolios "High Technology and Mysticism" and "A Meeting Point." Among the other offerings of the gallery are recent works by Miriam Shapiro, prints and

recent works by Joyce Kozloff, and mixed media works and painted vessels by Roberta Marks.

Lanvin Gallery 50 NE 40th St., Miami, FL 33137
264 (305) 576-0108 Mon-Fri: 10:30-5; owner/dir: Robin Lanvin

The Lanvin Gallery exhibits contemporary art by South Florida artists working in all media, including painting, sculpture, fiber, ceramics, glass, photography, wearable art and furniture.

Artists include award-winning photographer Bill Frakes, whose photographs may be seen in such publications as "Newsweek" and "The National Geographic'; award-winning fiber artist Eunice Hall Grobb; award-winning sculptor Marc Berlet, whose wood and metal sculpture is in international collections, including the Museum of Modern Art; and award-winning jewelry maker Terry Kaplan, who creates ceramic jewelry.

Conceptual artist Fernando Garcia's recent show of erotic art received favorable national attention. The huge, colorful abstracts of Ward Shelley have proved very popular, too. Artist-made furniture, including tables and chairs, by artists Ray Pirello and David Shankman has been featured in national publications.

NAPLES

Naples Art Gallery 275 Broad Ave. So., Naples, FL
265 33940 (813) 262-4551; Mon-Sat: 9:30-5; owner: S. Nelson, C. Nelson, William B. Spink

The emphasis of the Naples Art Gallery is on contemporary American artists—realists, impressionists, and abstractionists. Some European artists are also exhibited, along with upcoming young talent.

Visitors to the gallery may encounter the landscapes of Gisson, which employ a French Impressionist style; the fantasy paintings of Winifred Godfrey, filled with large flowers; Albert Scroder's painted record of American architectural history; or Mon-Sien Tseng's colorful portrayal of Mongolian history in acrylic and gold leaf. John Soulliere uses as many as twenty-five colors in his batiks. Gold and silver leaf, sand and marble chips, and calligraphic brushstrokes distinguish the abstract of Romanos Rizk. Sculptor Michael Barkins carves his works in onyx and marble.

Contemporary Italian impressionist Nicola Simbari is widely known for his hot Mediterranean colors. James Van Darzen's colorful glass forms impart a sense of humorous animation to his sculpture. Al Buell, an American illustrator, paints the figure against a background of sand and surf.

Valand Art Gallery 363 12th Ave. So., Naples, FL
266 33940 (813) 263-1010; Mon-Fri: 10-6 Sat: 10-5 Aug: closed; owner: Peggy V. Lustig dir: John B. Lustig

The Valand Art Gallery presents works by contemporary artists, both American and European. Styles range from representational to abstract in painting, graphic and sculptural media.

Artists featured by the gallery include Romero, Azoulay, Alvar, Hansen, Vasarely, Hazen, Chagall, Spears, Simbari, Kravjanski, Uzilevski and Agam.

NORTH MIAMI

Oscar Dior Art Gallery 581 NE 125th St., North
267 Miami, FL 33161 (305) 893-8722; Mon-Sat: 11-5; owner/dir: Dr. Edward Pezzi

The Oscar Dior Gallery features work by contemporary artists, notably paintings by Oscar Dior.

Other artists featured include Alex Penalver, Ruby Pacheco, Edward Pezzi and Carlos Pezzi.

PALM BEACH

Gallery Gemini 245 Worth Ave., Palm Beach, FL
268 33480 (305) 655-5924; Mon-Sat: 10-5; owner/dir: Albert Goldman

Gallery Gemini carries works by modern master painters as well as by Florida artists.

Artists whose work is available include American painters Milton Avery and Raphael Soyer, Abstract Expressionist James Brooks, early American abstractionist Ilya Bolotowsky, British sculptors Henry Moore and Anthony Caro, American figurative painter Robert Natkin, as well as Miro, Picasso, Stern, Martinus and many others.

Helander/Rubinstein 125 Worth Ave., Palm Beach,
269 FL 33480 (305) 659-1711; Mon-Sat: 10-6 Aug-Sep: closed; dir: Bruce Helander

The Helander/Rubinstein Gallery features contemporary American painters, sculptors and photographers. Many internationally recognized mature and mid-career artists are presented, as well as emerging artists.

Artists with major reputations include Roy Carruthers, Robert Rauschenberg, Andy Warhol, William Nichols, Paul Sarkisian, Italo Scanga, Robert Zakanitch, Dale Chihuly, Janet Fish, Robert Beauchamp, Aaron Siskind, Robert Helsmoortel, Robert Natkin and Roger Brown.

Emerging artists who have had one-person shows or are represented by the gallery include Philip Michaelson, Franc Palaia, Bill Drew, Walter Ferris, Todd Moore, Tim Fortune, Harry Anderson, Chris Van Allsburg, Jason Hunsinger, Alfred DeCredico and Gary Komarin.

Hokin Gallery Inc. 245 Worth Ave., Palm Beach,
270 FL 33480 (305) 655-5177; Mon-Sat: 10-5 Aug: closed; owner: Grace E. Hokin dir: Wayne Rodberg

Concentrating on recognized contemporary American and European artists, Hokin Gallery maintains locations in Palm Beach and Bay Harbor Islands. Most of the work exhibited tends to nonobjective modes of expression in drawing, painting and sculpture.

Artists featured by the gallery in its 1983-84 season included sculptors Henry Moore, Louise Nevelson and Niki de Saint Phalle, known for her brightly colored, whimsical "nana" figures. Painters exhibited included abstract illusionists James Havard and George Green, as well as Colombian artist Fernando Botero, Jim Dine, Stephen Edlich, Herbert Ferber and Conrad Marca-Relli.

Other artists whose work is available are abstract illusionist painters Jack Lembeck and Michael Gallagher; painters Robert Motherwell, Sam Francis, Friedel Dzubas, Stanley Boxer,

Larry Poons and Jean Dubuffet; and sculptors Ernest Trova, Kieff, and the early 20th century French sculptor of Mediterranean female nudes, Aristide Maillol. Drawings by Mexican sculptor Francisco Zuniga are also available in the gallery.

Holsten Galleries 206 Worth Ave., Palm Beach, FL
271 33480 (305) 833-3403; Mon-Sat: 10-6 Jun-Sep: closed; owner/dir: Chandra & Kenn Holsten

See listing for Stockbridge, MA.

Irving Galleries Fine Arts 332 Worth Ave., Palm
272 Beach, FL 33480 (305) 659-6221; Mon-Sat: 10-5 Aug: closed; owner: Irving Luntz dir: Holden Luntz

Concentration of the gallery is on post-World War II American and European painters and sculptors.

American masters whose work is exhibited in the gallery include Abstract Expressionist Robert Motherwell, gestural realist Larry Rivers, and second generation Abstract Expressionist Helen Frankenthaler, all of whose work is strongly representative of the New York School. Also available are works by Pop Artist Jim Dine, whose work shows the traces of his admiration for the Abstract Expressionists; as well as Washington color painter Kenneth Noland and New York painter Charles Hinman, whose work reveals an affinity with Minimal Art. Noland's recent work in particular has taken on lyrical qualities of color and brushwork, in contrast to his former flat surfaces.

Also featured are works by French master Jean Dubuffet, by Italian sculptor Arnaldo Pomodoro, by Edward Giobbi and Cleve Gray.

SARASOTA

Adley Gallery 1620 Main St., Sarasota, FL 33577
273 (815) 366-4059 by appt; owner: Harry & Joan Adley dir: J. Adley

The Adley Gallery specializes in organization of off-site exhibitions, working with both corporate and private collectors interested in acquiring or divesting fine art works. Most of the work handled is of museum- or auction-quality, largely works from the 20th century, including painting, sculptures, prints and drawings. The gallery often acts as a "broker" for important works from private collectors in the area.

Works are available through the gallery by major artists now living in Florida, such as American sculptor John Chamberlain, whose sculpture made from junked automobile parts has been likened to Action Painting; and American painter Conrad Marca-Relli. The gallery handles work from the estate of Jimmy Ernst, and works by Syd Solomon.

Foster Harmon Galleries of American Art 1415
274 Main St., Sarasota, FL 33577 (813) 955-1002; Mon-Sat: 10-5 Sep-early Oct: closed; owner/dir: Foster Harmon

The Foster Harmon Galleries exhibit the works of major 20th century American artists, including regional artists who are featured in annual group and juried shows.

Artists include Darrel Austin, Milton Avery, Will Barnet, Isabel Bishop, Byron Browne,

Charles Burchfield, Paul Cadmus, Alexander Calder, Balcomb Greene, Milton Hebald, Ernest Lawson, Stanton MacDonald-Wright, Loren McIver, Conrad Marca-Relli, Raphael Soyer, Max Weber, Andrew Wyeth and Karl Zerbe.

Other artists whose work is featured include Jane Armstrong, Raymond Barger, Leonard Baskin, Allen Blagden, Clarence Carter, Ruth Cobb, Harrison Covington, James Dean, Adolph Dehn, Lamar Dodd, Burhan Dogancay, F. Browne Eden, Douglas Gorsline, Robert Alan Gough, Gunther Gumpert, Ralph Hurst, Ben Johnson, Frank Kleinholz, Sidney Laufman, Jack Levine, Walter Meigs, Hans Moeller, LeRoy Nieman, Lowell Nesbitt, Eliot O'Hara, William Pachner, John Rood, William S. Schwartz, Hiram Williams, Jamie Wyeth and Larry Zox.

Joan Hodgell Gallery 46 S. Palm Ave., Sarasota, FL
275 33577 (813) 366-1146; Mon-Fri: 10-5; Sat: 11-4 summer: Mon-Fri: 10-4; owner/dir: Joan Hodgell

The Joan Hodgell Gallery exhibits contemporary art from all around the U.S., with emphasis on established and emerging artists from the Southeast region. The gallery represents close to 40 artists. Paintings, works on paper, sculpture and craft objects are available.

The gallery carries an inventory of contemporary prints which includes works by leading American artists such as Joseph Raffael, Philip Pearlstein, James Rosenquist, Lowell Nesbitt and many others.

Image of Sarasota, Inc. 1323 Main St., Sarasota, FL
276 33577 (813) 366-5097; Mon-Sat: 10-5 Jun-Oct: closed; owner/dir: Ruth Katzman

Fine American crafts are available at Image of Sarasota, including works in fiber, metal, wood, clay, glass, and leather. A particularly wide selection of handwrought jewelry is on display.

Jewelers whose work is presented at the gallery include Jane Campbell, Jaclyn Davidson and Ruth O. Frank. Ceramists include James Kraft, Maishe Dickman and Barbara Joiner. Craft artists working in glass are Bill Slade, Richard Jolley and Henry Summa. Mark Lindquist and Michael Elran work in wood, while Lee Wilson Tiffany works in wood and mixed media sculpture.

Galleries of Frank J. Oehlschlager 28 S. Blvd. Presi-
277 dents, Sarasota, FL 33577 (813) 388-3312; Mon-Sat: 10-5; owner/dir: Frank J. Oehlschlager

Located in Sarasota since 1962, the Oehlschlager Galleries handle contemporary works of art by American and European artists, most of whom work in non-abstract styles. Not a gallery to be swayed by fashion or the latest wrinkle of the market, Oehlschlager presents works which the gallery considers enjoyable and worthwhile.

The gallery carries works by figurative painter Jon Corbino, by Richard Florsheim, known for his views of Manhattan, and by Midwest painter Aaron Bohrod, as well as the tropical surrealist paintings of Julio de Diego, and paintings by Eugene Berman, Al Buell, Edna Hibel, Jerry Farnsworth, Adam Grant, Raphael Soyer, Helen Sawyer, Oreta Williams, Fletcher Martin, Eliot O'Hara and Louis Bosa. Younger painters whose work is available in-

clude Fiore Custode, Sydney Hauser, Harry McVay and Valfred Thelin.

European artists featured by the gallery include Lilian Latal, a Viennese primitive artist; Spanish painter Fausto de Lima; French artists impressionist Diez Edzard, Suzanne Eisendieck and Pierre Lavarenne; German artist Kurt Polter; and Denes Holesch of Hungary and Paris.

Sculptors exhibited by the gallery include well-known Southeastern artists Saul Ades, Philip Blake, Hushi Garfield, Muriel Kelsey, and the late Henry Borchardt.

SOUTH MIAMI

Netsky Gallery 5759 Sunset Dr., South Miami, FL
278 33143 (305) 662-2453; Mon-Sat: 10-5; owner/ dir: Harriet Netsky

The Netsky Gallery specializes in contemporary crafts, with works in clay, fiber, glass, wood, metal and leather.

Artists working in clay include Susana Espinosa, Neil Tetkowski and Elizabeth MacDonald. Fiber artists are Lissa Hunter, John Garrett, Bob Nugent, Suzanne Kores and Michele Tuegel. Ed Nesteruk, Janet Kelman, Rick Bernstein and Ira Sapir work in glass. Philip Moulthrop, Michael Elkan and Steven Paulsen work in wood. David Bacharach, Gene Massin and Carolyn Morris Bach work in metal, while John Fleming and Sid Garrison are leatherworkers.

SURFSIDE

Medici-Berenson Collection Box 54-6784; Surfside,
279 FL 33154 (305) 864-5355; by appt; owner: Margo Finn dir: Lois Cutler

The Medici-Berenson Collection includes contemporary paintings, sculpture and graphics, with emphasis on American artists.

Artists featured by the gallery include Dorothy Gillespie, Helen Bershad, Tom Graboski, Richard Saba, Charles Hinman, Alberto Magnani, Peter Reginato and Stephanie Peckins.

GEORGIA

ATLANTA

Artists Associates, Inc. 3261 Roswell Rd. NE, At-
280 lanta, GA 30305 (404) 261-4960; Tue-Sat: 10-5; dir: Chris Riley

Artists Associates was formed by a group of 20 artists in April 1961 with the purpose of cooperatively exhibiting and showing their work. All were from Atlanta to begin with, but over the years others from the Southeast have become members. The group now consists of 30 painters, potters, sculptors and printmakers. The painters, sculptors and printmakers work in contemporary styles, from representational to abstract.

Jane Beckerton Fine Art 1440 High Point Place, At-
281 lanta, GA 30306 (404) 874-4750; by appt; owner: Jane Beckerton

The Jane Beckerton Gallery specializes in original American and European limited edition prints.

Exhibits have included work by David Hockney, Howard Hodgkin, Francesco Clemente,

Enzo Cucchi, Sandro Chia, Pat Steir, Joan Jonas, Hans Haacke, Robert Kushner, Richard Diebenkorn, Richard Smith, Georg Baselitz, A.R. Penck, Martin Disler, John Baldessari and Jonathan Borofsky.

Shirley Fox Galleries 1590 Piedmont Ave NE, At-
282 lanta, GA 30324 (404) 874-7294; Mon-Sat: 10-6 Thu: 10-9; owner/ dir: Shirley Fox

The gallery offers a diverse selection which includes contemporary graphics, contemporary European and American art, works by local and regional artists, and art posters.

The graphics shown at the gallery include works by Alvar Sunol, Salvador Dali, Victor Vasarely, Leroy Nieman, Mari, Ed Sokol, and Wayland Moore. Original works are also available by these artists.

Regional artists featured at the gallery include Hugh Wallace, Mary Cooper Smith, Wayland Moore, Steffen Thomas, Mari, and William Wolk, among others. The 1984 season included one-person shows by New York artist Ed Sokol, international artist from Jerusalem Sevy Raphaely, and by Atlanta artists Mari and Wayland Moore.

Gillette-Frutchey Gallery, Ltd. 1925 & 1931 Peach-
283 tree Rd. NE, Atlanta, GA 30309 (404) 351-3179 or 351-8210; Tue-Sat: 10-5; dir: Dean Gillette, Jere Frutchey

The Gillette-Frutchey Gallery is a product of the recent merger of Image South and Great American Galleries under a new name. The direction of the gallery represents contemporary American artists who are doing abstract, non-objective work in painting, sculpture, photography, prints, clay, glass, wood, fiber, paper, metal, etc.

Artists working in clay are Paul Soldner, Don Reitz, Robert Sperry, Wally Mason, Donna Poseno, Neil Tetkowski, and Sally Bowen Prange. Artists working in glass are Peter Aldridge, Joe Philip Myers, Hank Murta Adams, Ira Sapir, Jon Kuhn, Kreg Kallenberger, Brent Young, William Dexter, and Tom Philabaum.

Artists working in paper are Gisella Moyer, Marith Berens, Raymond Tomasso, Tom Grade, and Ed Lewis; in wood, David Ellsworth, Hap Sakwa, Grant Miller, Gilbert Goff, Roy Superior, and John Whithead; in metal, June Schwarcz, Earl Pardon, William Harper, and Gregory Piro.

Fiber artists include Jan Myers and Pam Studstill. Painters include Anne Vaccaro, James Stevens, Richard Carter, Adrienne Sherman, James Byrd and Roger Dorset. Photographers are Robert Brewer, Gary Faye, Robert Eginton, and Tom Bladgen, Jr.

The gallery also features clay prints by Mitch Lyons, alabaster sculpture by Bob Lockhart, metal sculpture by William Morningstar, glass sculpture by Gene Koss, and clay sculpture by Robert Dixon and Indira Johnson.

Fay Gold Gallery 3221 Cains Hill Place, Atlanta, GA
284 30305 (404) 233-3843; Tue-Sat: 10-5:30 Mon: by appt; owner/dir: Fay Gold

The Fay Gold Gallery exhibits contemporary art by internationally recognized masters and mid-career artists, and 20th century photography.

Contemporary artists whose work is exhibited

include historical figures such as Jacques Lipchitz, Milton Avery, and Jean Dubuffet, whose recent work includes monumental public sculptures; established artists of the New York School such as Robert Motherwell, Robert Rauschenberg, Louise Nevelson, Frank Stella, Louisa Chase, and figurative painters Philip Pearlstein and Robert Jessup; artists currently active in forging new styles such as Susan Rothenberg, Lois Lane, Keith Haring, Judy Rifka, Jean Michel Basquiat, Richard Bosman; folk artist Howard Finster; and European artists associated with Neo-Expressionism such as A.R. Penck, Georg Baselitz, Jorg Immen-dorf, Markus Lupertz, Per Kirkeby and Theo Lambertin.

The photographers shown are an equally noteworthy group, including pioneer Eugene Atget, whose thousands of photographs of Paris in the early 20th century are a unique document; as well as Henri Cartier-Bresson, Jacques Henri Lartigue, Edouard Boubat, Brassai, Robert Doisneau, Larry Clark, Robert Mapplethorpe, Willy Ronis, Harry Callahan, Aaron Siskind and Annie Leibovitz.

Greggie Fine Art 32 Forrest, Atlanta, GA 30328 (404)
285 256-9417 Mon-Fri: 9-5 Aug: closed; owner: Pegg & Ellen Gregory

With locations at 6075 Roswell Rd., Suite 314, and 404 The Arts, as well as at 32 Forrest in Atlanta, Greggie offers a wide range of artworks. Specialization is in the area of 19th and 20th century graphics, including important works by modern masters. Printed works of the 17th and 18th century are also offered on a specialized basis. Modern original oils are featured in the gallery, as are over 10,000 decorative pieces.

The most distinguished works in the gallery inventory are by European masters such as Auguste Renoir, Picasso, Claude Monet, Henri Toulouse-Lautrec and Salvador Dali. Old Master prints by artists such as Rembrandt and Durer are also available, as well as works by many other well-known masters. Contemporary artists such as Alexander Calder, Rufino Tamayo, and Joan Miro are also featured.

The gallery offers the works of Thomas McKnight, as well as the work of Danish artist Benny Dore, whose blending color strokes typify his paintings and murals.

Ann Jacob Gallery Phipps Plaza, 3500 Peachtree Rd.
286 NE, Atlanta, GA 30326 (404) 262-3399; Tue-Sat: 10-6 Thu: 10-9; owner/dir: Ann M. Jacob

Concentration of the Ann Jacob Gallery is on contemporary sculpture, painting and graphics.

Internationally recognized artists whose work is exhibited include Italian sculptor Arnaldo Pomodoro, known for his expressive abstract bronzes and organic machine imagery; Gio Pomodoro, brother of Arnaldo, who has worked extensively in cast bronze and porcelain reliefs; Italian sculptor Pietro Consagra, known for his *ferri transparenti* of shaped and overlapped metal sheets; French *art nouveau* designer Erte; Per Arnoldi; and American sculptor Frank Gallo, whose figures in cast resin have gained wide recognition. The gallery also handles work from the estate of Ferdinand Warren, whose work follows the Ashcan School.

The gallery also features the unique paper

sculpture of Ed Pieters, contemporary sculpture of Ted Chatham, and the paintings of Sallie Whistler Marcucci, Carlo Marcucci, Greta Schelke, Peter Polites, Lucinda Carlstrom and Eva Macie. As an affiliate of Circle Fine Arts (see listing for Chicago) the gallery carries the graphics of some 250 contemporary artists handled by Circle.

Kraskin/Mitchell Gallery 618 A⅛9Ct. NW, Atlanta,
287 GA 30327 (404) 256-0879; by appt; owner/dir: Carol Mitchell

The main area of interest of the Kraskin/Mitchell Gallery is contemporary art, generally of internationally known artists. The gallery specializes in the work of sculptor Henry Moore, with particular attention to his graphic work. Some sculpture by the British master is available as well. Apart from works by Moore, the gallery includes works of young sculptors Anne Harris of Toronto, Canada, and Naima Penchansky of Michigan. The gallery also maintains a continuing interest in printmakers.

Lagerquist Galley, Inc. 3235 Paces Ferry Place NW,
288 Atlanta, GA 30305 (404) 261-8273; Tue-Sat: 10:30-5; owner/dir: Evelyn Lagerquist

The Lagerquist Gallery handles paintings, watercolors, works on paper and sculpture by regional and national artists. Works in both abstract and traditional realist modes are available.

Artists include Roman and Constatine Chatov, Dale Rayburn, Carole Connely, M. L. Carpenter, Linda Fouts, Larry Anderson, Sidney Butches and Jean Sauls. Shows by nationally recognized upcoming artists and gallery artists are featured throughout the year.

McIntosh Gallery 1122 Peachtree St. NE, Atlanta,
289 GA 30309 (404) 892-4023; owner: Louisa McIntosh mgr: Allison Sauls

Concentration of the gallery is on 20th century painting, sculpture and works on paper by international and American artists. The gallery exhibits a broad cross-section of artistic styles and concerns.

Artists exhibited include Romare Bearden, an American master working in assemblage and collage with polymer paint, taking his subject matter from Black American life and music in New Orleans and Harlem; and Hans Erni, National Artist Laureate of Switzerland, a distinguished draftsman and painter known for the classically tempered line in his figures, who exhibited with leading artists in Paris in the heady 1930s.

Contemporary artists include Kenneth Shaw, a prize-winning new figure artist, and Philip Link, known for his North Carolina landscapes. Recently McIntosh Gallery has featured rising young sculptors such as Doug Dougan, who works with colored marble, and William Maze, who creates shadow-box type constructions. 1984 season shows included works by David Sampson, Robert Gibson, and the dyed fabric tapestries of Sylvia Grogan.

Nexus Contemporary Art Center 608 Ralph McGill
290 Blvd., Atlanta, GA 30312 (404) 688-1970; Mon-Fri: 11-6 Thu: 11-9 Sat: 1-6 Jul 15-Sep 7: closed; dir: Louise Shaw

Nexus Contemporary Art Center specializes in non-commercial, "avant-garde", or community-oriented work, including installations, off-the-wall pieces, etc.—many by young artists. The Center also shows traditional media, and has a standing commitment to photography. Above all, however, Nexus favors experimental work.

Several young Atlanta artists work in installation. These include Mary Jane Hasek, Dave Sinrich, Chris Lewis, Laurie Wilson, Tony DeLeo, Elizabeth Lide, Scott Gilliam and D'Angelo Dixon. Other artists include photographers Barbara Crane, John McWilliams, Lawrence McFarland, and others; sculptors are Curtis Patterson and Maria Artemis; painters Roger Brown, Tom Ferguson, and many others.

Portfolio Gallery 277 E. Paces Ferry Rd., Atlanta, GA
291 30305 (404) 233-3661; Tue-Sat: 11-6

The Portfolio Gallery handles painting, ceramics, fiber and jewelry by local and regional contemporary artists.

The gallery specializes in emerging artists. Among the artists who have exhibited their works are Texas painter Gary Komarin, Keith Rasmussen of Georgia, Margaret Tolbert of Florida, and Betty Robinson of Tennessee.

James S. Ramus, Ltd. 273 East Paces Road, Atlanta,
292 GA 30305 (404) 266-0044; Mon-Fri: 10-5 Sat: 12-4; owner: David S. Ramus dir: Charlene James

Concentration of the gallery is on 19th and early 20th century American and European paintings and works of art.

The gallery collection includes works by French Post-Impressionists Raoul Dufy and Henri Martin; by American naturalist, painter and printmaker John James Audubon; by American Impressionists Mary Cassatt and John Twachtman, by Marc Catesby, and by Ashcan School painters George Luks, Everett Shinn and William Glackens.

Gallery Two Nine One 1 Rhodes Center North, At-
293 lanta, GA 30309 (404) 874-9718; Tue-Sat: 10-6; owner/dir: Kevin Brown

Gallery Two Nine One represents contemporary American artists working in painting, sculpture and photography. Both nationally recognized and regional artists are featured. Eight individual and thematic shows are mounted each season. The gallery provides consultation and acquisition programs for corporate and private clients.

Some of the artists featured are Benny Andrews, Robert Courtwright, Arata Isozaki, Michael Flick and Christine Federighi. Photographers presented by the gallery include Marcus Leatherdale, Kim Steele and Norman McGrath.

Gallery Two Nine One is well known for exhibitions of sculpture in large format, including the work of Susan Gall, Ric Snead and Greely Myatt. The gallery actively solicits commissioned work for its corporate clients.

MARIETTA

Knoke Galleries 93 Church St., Marietta, GA 30060
294 (404) 428-1797; Tue-Sat: 11-5 & by appt; owner/dir: Dave Knoke

Knoke Galleries specializes in 19th and early 20th century American oil paintings, including important paintings of the South and by Southern artists.

The inventory usually includes both traditional landscapes and impressionist works by such artists as Theodore Earl Butler, Guy Wiggins, Marguriete Pearson, William J. Kaula, Ernest Lawson, Anthony Thieme, Henry Ward Ranger, William Anderson Coffin, Robert C. Minor, Robert Loftin Newman and Joseph R. Meeker.

Knoke Galleries handles works from the estate of Eugene H. Thomason, "The Ashcan Artist of Appalachia." Thomason painted and taught with George Luks in New York, then settled in his home in North Carolina, where he continued to create masterful paintings with the hill people as his inspiration.

HAWAII

HILO

Wailoa Center P.O. Box 936, Hilo, Hawaii, HI 96721
295 (808) 961-7360; Mon-Sat: 8:30-4; dir: Mabel Meyer

Owned and operated by the State Parks of Hawaii, the Wailoa Center specializes in ethnic and cultural exhibits that represent the diversity of cultures in Hawaii, while offering local contemporary artists in various media and styles the opportunity to exhibit their work.

HOLUALOA

Hale O Kula, Goldsmith Gallery P.O. Box 416,
296 Holualoa, Hawaii, HI 96725 (808) 324-1688; Tue-Sat: 10-4 & by appt; owner/dir: Sam Rosen

Specializing in gold jewelry and *objets d'art* wrought by goldsmith Sam B. Rosen, the gallery also shows selected works by recognized Big Island artists working in painting, drawing, woodwork and ceramics.

Studio 7 Gallery P.O. Box 416, Holualoa, Hawaii, HI
297 96725 (808) 234-1688; Tue-Sat: 10-4; owner: Hiroki Morinoue dir: Robbin Rosen

Dedicated exclusively to work by Big Island artists, the Studio 7 Gallery exhibits work in all media, including painting, sculpture, prints, woodwork and pottery.

The gallery concentrates on works by owner Hiroki Morinoue, an artist well-known in Hawaii, who is becoming recognized in Japan. His preferred medium is watercolor, but he also works in oil, acrylic and sculpture.

HONOLULU

International Connoisseurs P.O. Box 10301, Honolu-
298 lu, HI 96816 & 47-421 Mahakea Rd., Kaneohe, HI 96744 (808) 235-5775; Mon-Fri: 10-4 by appt; owner/dir: Larry V. LeDoux

Concentration of the gallery is on contemporary American painting in representational and presentational modes.

The gallery carries works by classical realist and portrait painter Americo Makk, and modern impressionists Eva and A.B. Makk, as well as paintings by primitive expressionist Luigi Fuma-

galli, surrealist Andrea Smith, realistic wildlife artist Robert Nelson and whimsical painter Guy Buffet. Hiroshi Tagami paints in a style combining elements of impressionism and expressionism. Martin Charlot paints in realistic and surrealistic modes, while Deborah Scales specializes in illustration.

Queen Emma Gallery 1301 Punchbowl St., Honolulu,
299 HI 96813 & P.O. Box 861, Honolulu, HI 96808 (808) 547-4397; daily: 9-4; dir: Masa Morioka Taira

Queen Emma Gallery is an alternative space located in Honolulu's largest health system, Queen's Medical Center, and is sponsored by its Auxiliary. It concentrates on small and medium scale works by young emerging artists in photography, painting, printmaking and sculpture.

The gallery has exhibited well-known established artists from the U. of Hawaii faculty, including Murray Turnbull, acrylic paintings, and Ron Kowalke. Kowalke's recent work has consisted of 14 low relief panels in gesso and polyurethane foam. Honolulu Academy of the Arts curator Joseph Fehler has shown mixed media works and wash drawings. The gallery hangs numerous theme shows, such as "Human Form: from Egypt to the Renaissance," and sponsors lectures and theatrical performances as well.

KAILUA-KONA

Kona-Mini Gallery P.O. Box 1134, Kailua-Kona, HI
300 96740 (808) 329-3757; Mon-Sat: 9-6 Sun: 9-3; owner: A.W. & Gayle Anderson dir: Gayle Anderson

The gallery specializes in contemporary watercolors, photography, prints, handmade paper and posters. Most works are small scale. The gallery also carries handmade jewelry with a volcanic look.

The gallery exhibits local artists and such well-known regional artist as Herb Kane, Pegge Hopper and Otsuka. Regularly on view are impressions of Hawaiian landscape and flowers by Gayle Anderson, Lenny Katz, Mae Johnson and Vicki Serva; tropical fish by Penelope Culbertson; and watercolors of Hawaiian birds by Marian Berger. Marilyn Wold works in traditional Japanese papermaking, using natural fibers of Hawaii. Claudia Suen prints her own etchings, block prints and collographs, and makes cast paper Hawaiian dancers. Dale Addlesburger prints his landscapes by handrubbing. The gallery also shows landscapes by S.E. Coleman, ceramic beads by Ginger Otis, drawings and paintings of Hawaiian women by Kitty Hoven, and photographs by Scott Berry.

The rare and precious *koa* wood is material for sculptures by Ed Medieros. The gallery exhibits wearable art by Carolyn Ainsworth, Jane Watkins Gay and Kimberly Culbertson, paintings of bamboo on handmade paper by Jennifer Carlstrom, ceramic masks by Ira Ono, and leis made of thousands of shells from Niihau by Ron DePontes.

The Showcase Gallery P.O. Box 4895, Kailua-Kona,
301 HI 96745 (808) 329-3090; daily: 9-9; owner/dir: Jean Josepho-Hamilton

The gallery specializes in work by regional art-

ists, ranging from paintings to handblown glass and featherwork.

Artists shown include John Thomas, watercolors, acrylics and serigraphs; Edwin Kayton, oil painting, drawings and reproductions; Wilfred Yamazawa, handblown glass; Mike Bryant, acrylic painting; Paul Ygartua, oil paintings; and Phan Barker, batik on silk.

KAPALUA

Kapalua Gallery 123 Bay Dr., Kapalua, Mauai, HI
302 96761 (808) 669-5047; daily: 9-9; owner: J. Killett dir: Gary Smith

Established in 1976, the Kapalua Gallery exhibits original works by artists of international stature living or working in Hawaii.

In addition to a continuous exhibit, which includes works by Robert Wood, George Inness and Norman Rockwell, the gallery hangs several solo exhibitions each year by established artists such as Andrea Smith, Robert Lyn Nelson, Guy Buffet, Americo Makk, Eva Makk, A.B. Makk and Bruce Turnbull.

The gallery covers an eclectic range of media and styles from the watercolors of Smith to the exotic wood sculpture of Turnbull.

Recent exhibitions have included the photosensitive marine paintings of Robert Lyn Nelson, the mystical mindscapes of Andrea Smith, the whimsical paintings of colorist Guy Buffet, and the traditional realism and impressionism of the Makk family.

LAHAINA

Casay Galleries 658 Front St., Lahaina, HI 96761
303 (808) 661-0839; owner: Jim & Nancy Killett dir: Michael Azevedo

Casay Galleries exhibits work by contemporary American artists. The gallery offers original seascapes and prints by Anthony Casay; limited edition serigraphs of Hawaiian ladies by Pegge Hopper; classical Japanese subjects by Otsuka; and colotypes and originals by Andrea Smith.

Lahaina Gallery 117 Lahaina Luna Rd., Lahaina, HI
304 96761 (808) 367-2926; daily: 9-9; owner: J. Killett dir: M. Azevedo

The gallery specializes in early and late 20th century American painting, including works by the principal artists of the state of Hawaii.

The gallery collection includes oil paintings by Robert Wood, George Inness, Norman Rockwell and Americo Makk, author of the official presidential portrait of Ronald Reagan. Works are also available by impressionist and cathedral mural artist Eva Makk, primitive Guy Buffet, marine painter Robert Lyn Nelson—particularly known for his paintings of whales, geometric abstractionist Art Long, and classical Chinese painter David Lee.

In addition, there are works by environmental impressionist George Sumner; Japanese artist Otsuka, who paints on kimono silk; Captain Bill Christian, scrimshaw artist on slate; A.B. Makk, neo-classical painting; Bruce Turnbull, wood sculpture; and Cody Houston, bronze.

Village Galleries 1287 Front St. & 120 Dickenson St.,
305 Lahaina, HI 96761 (808) 661-4402; daily: 10-6; owner/dir: Lynn Shue

Guy Buffet, *Ladies of Diamond Head,* 22 x 28, watercolor, Kapalua Gallery (Kapalua, HI).

Robert Lyn Nelson, *Window on the Sea,* 22 x 28, acrylic, Kapalua Gallery (Kapalua, HI).

Original artwork by the artists of Hawaii is shown at the Village Galleries. Emphasis is on paintings and prints. While many of the artists concentrate on the landscape, seascape and people of Hawaii, some prefer to work in abstract styles investigating color and form.

Oil painters include George Allan, Joyce Clark, Lau Chun, Betty Hay Freeland, Lowell Mapes and Macario Pascual. Watercolorists are Peter Hacka, Frederick Ken Knight, Pamela Hayes and Curtis Wilson Cost. Printmakers include Shirley Hasenyager, Evan Robinson, David Warren and Jay Wilson. A few West Coast artists such as Keith Lindberg, Dan McMichael and Michele Taylor are also shown.

LIHUE

Stones Gallery 2042 Kukui Grove Center, Lihue,
306 Kauai, HI 96766 (808) 245-6653; Mon-Sat: 9:30-6 Fri: 9:30-9 Sun: 10-4; owner: Carol Adams dir: Julie Halpern

Stones Gallery concentrates on contemporary artists and craftspeople living in Hawaii, including representational and impressionistic painting, ceramics and glassware, wood bowls, sculpture and handcrafted furniture. The gallery also carries photography, fiber works and antique Oceanic and South Pacific crafts.

Artists dealing with traditional Hawaiian subjects include Boone Morrison, photographs of hula dancers; Pegge Hopper, drawings and serigraphs of Hawaiian women; James Hoyle, impressionistic oils and pastels of the island of Kauai; and Dan de Luz and Jack Stracka, *koa* wood bowls.

James Kay paints realistic "local" street scenes and buildings; Carol Bennett's realistic pastels portray swimmers underwater. Mark Daniell's acrylics and watercolors depict local plant and marine life. Porcelain by White-Smith is utilitarian yet evokes images of mountains and ocean. Wilfred Yamazawa's glass represents volcanic eruptions and starry skies at sea. Wayne Jacinto makes beautiful wood cabinets and sea chests.

IDAHO

BOISE

Ochi Gallery 459 Main St., Boise, ID 83702 (208)
307 342-1314; owner/dir: Denis Ochi

The Ochi Gallery carries works by contemporary American artists, including painting, drawing, prints and sculpture by artists from New York and the West Coast, as well as by regional artists.

The gallery exhibits works by Robert Rauschenberg, James Castle, Laddie John Dill, Star Moxley, Jack Roth, Geoffrey Williams and Julian Schnabel.

SUN VALLEY

Sun Valley Center Gallery Box 656, Sun Valley, ID
308 83353 (208) 726-9491; daily: 9-5 May-Nov: closed; dir: Kristin Poole

A not-for-profit gallery of the Sun Valley Center for the Arts and Humanities, the gallery specializes in contemporary American arts and crafts.

All media are represented, including video and performance. Sales of work support educational programs.

Contemporary artists of established reputations include Christo, William T. Wiley, William Wegman, Terry Allen, James Henkel, Peter deLory, James Romberg, Richard Shaw, D.W. Wharton, Linda Connor, John Pfahl, Michael Bravo, Jun Kaneko, Mary Lucier, Betty Woodman, David Shaner, James Butler, Philip Cornelius, and others.

The gallery also shows work by emerging artists from the Western region in periodic thematic exhibitions. Many of the artists represented are visiting artists at the Sun Valley Center for the Arts and Humanities. The gallery also sponsors lecture series, films, video, and an array of other activities.

ILLINOIS

CHICAGO

Aiko's 714 N. Wabash Ave., Chicago, IL 60610 (312)
309 943-0745 Tue-Sat: 10-5; owner/dir: Aiko Nakane

Existing in Chicago for over 25 years, Aiko Nakane's small gallery-store is one of the few in Chicago specializing in contemporary Japanese prints, authenticated reproductions of old Japanese prints, and Japanese folk pottery. Some of the Japanese artists represented here include woodcut printers Kiyoshi Saito, Junichiro Sekino, Ansei Uchima, Yasushi Ohmoto and Umetaro Azechi. The Japanese silk screens of Masaaki Tanakaare also featured, along with the stencil dyeing of Yoshitoshi Mori and Sadao Watanabe.

What is unique about this Chicago establishment is that it maintains an Oriental supply and paper store. Materials available include handmade paper and Japanese art supplies such as sumi brushes, inks in different forms, and fabric dyes from Japan, as well as decorated papers from Japan, Italy, Sweden, France, Korea and China. One corner of the store is devoted to bookbinding supplies. There is also a book section with books on Oriental art and handmade artists' paper.

American West 2110 N. Halsted St., Chicago, IL
310 60614 (312) 871-0400; Tue-Sat: 1-6 Thu: 1-8 Sun: 1-5 mid-Aug-Labor Day: closed; owner/dir: Alan & Yoshi Edison

The gallery shows a broad selection of contemporary art coming out of the American Southwest. The works tend to be primarily paintings and graphics based on Indian and cowboy themes, and Southwestern landscape.

Major artists include Len Agrella, R.C. Gorman, Fritz Scholder, Harry Fonseca, and T.C. Cannon, whose woodcuts and graphics are strongly influenced by his one-time teacher, Scholder. The art shown includes the embossed etchings of Norma Andraud, and the graphics of Imagist Amado Pena, Jr.

Recently the gallery has added three-dimensional works to its display. Metal and wood sculpture, wood carvings and painted sheet metal works are available by Max Alvarez and Mark Kluck, among others.

The gallery maintains a large collection of Native American artifacts which includes historic Southwestern pottery, Plains beadwork, baskets and Navajo textiles, and Northwest Coast basketry, staffs and woven hats. The artifacts shown date from 1800 to 1900.

ARC Gallery 6 W. Hubbard St., Chicago, IL 60610
311 (312) 266-7607 Tue-Sat: 11-5 Sun: 12-4 August: closed; dir: Mary Min

ARC (Artists, Residents of Chicago) was established in 1973 as an artist-run alternative space for women desiring exhibition opportunities, and as an environment where women could share ideas and critique each other's work.

Today the gallery has expanded, and although the goals are similar, additional programs embrace more of the community at large. The ARC Educational Foundation provides a forum for lectures and discussions of problems and issues confronting artists. ARC has also begun programs in Performance Art and New Music.

Along with monthly shows by members on the main floor, the new "Raw Space" is a basement gallery designed for experimental and "temporary site-specific installations." Works are made for the Raw Space and remain on site for a month, after which—they disappear. Non-gallery artists are encouraged to exhibit in the Raw Space, and artists are chosen by a jury that meets once a year.

Most of the artists work in non-traditional modes, but some do operate within a more conventional framework. Current members are Carol Austin, Mary Bourke-Burns, Jan Calek, Constance Cavan, Catherine Doll, Laurel Fredrickson, Anne Farley Gaines, Sue Gertz, Margot Gottfried, Thelma Heagstedt, Ursula Kavanagh, Joan Lyon, Susan Mart, Barbara Sliwa-McGuffin, Mary Min, Katherine Parks, Cyrilla Power, Fern Samuels, Charlotte Segal, Gail Andrea Simpson, Cynthia Staples and Jane Stevens.

ARC is funded through the Illinois Arts Council and the National Endowment for the Arts.

Artemisia Gallery 341 W. Superior, Chicago, IL
312 60610 (312) 751-2016; Tue-Sat: 11-5 Aug: closed; dir: Fern Shaffer

Artemisia is a woman's cooperative gallery and an educational organization. Its principal ambition is to promote public awareness of women artists. Aside from regularly showing work by its 18 artist members, Artemisia mounts special theme, group and invitational shows funded by grants, and makes a special point of providing low cost space for emerging artists. Three to four emerging artists selected by a review committee are shown monthly.

Work by the members is extremely diverse. Iris Adler creates kinetic electronic works on Biblical themes. The fascination of moving machinery is suggested by Liz Atlas's well-crafted, formal yet humorous wall objects. Still life, often transmuted by decay, is the theme of Jane Calvin's small format color photographs. Nicole Ferentz has used texts as subject matter in stand-up paintings on wood and papier mache. Judy H. Finer's paintings investigate texture and color in geometric designs. The paintings of Olivia Petrides portray ele-

mental forces. Other artist members are Barbara Ciurej, Anita David, Michelle Fire, Margaret Lanterman, Nancy Plotkin, Alice Shaddle, Fern Shaffer, Maureen Warren, Toby Zallman, Lyndsay Lochman, Christine O'Connor and Susan Kuliak. Their work ranges from painting to performance, sculpture, and multi-media installation.

Jacques Baruch Gallery 40 E. Delaware Pl.—Pent-
313 house, Chicago, IL 60611 (312) 944-3377; Tue-Sat: 10-5:30; owner/dir: Jacques & Anne Baruch

Located in a penthouse near Michigan Avenue, the Baruch Gallery has established a reputation for over 17 years as the place to see exceptional art from Eastern Europe. Jacques and Anne Baruch have introduced artists from Poland, Czechoslovakia, Hungary and Yugoslavia to Chicago. Styles and expressions in prints, drawings, tapestries, photographs, paintings and sculpture vary greatly in each country, but the quality, strength and technical perfection have brought these artists international recognition. Since 1972 the gallery is also known for its outstanding fiber art exhibitions featuring renowned artists from the United States and Europe.

Among the notable artists presented are painters and graphic artists Jiri Anderle, Jiri Balcar, Albin Brunovsky, Jan Krejci, Alena Kucerova, Oldrich Kulhanek and Adriena Simotova; master photographers Jan Saudek and Josef Sudek; and fiber artists Magdalena Abakanowicz, Zofia Butrymowicz, Francoise Grossen, Jolanta Owidzka, Sherri Smith and Han-Lien Wu.

Loan exhibitions to museums, universities and institutions are circulated throughout the U.S. and abroad. The Jacques Baruch offers visitors an enriching experience.

Mary Bell Galleries 361 W. Superior St., Chicago, IL
314 60610 (312) 642-0202; Mon-Fri: 9-5; Sat: 1-5; owner/dir: Mary Bell

Mary Bell Galleries handles paintings, sculpture, wall hangings, prints and unique paper works by established and upcoming contemporary artists. The gallery specializes in working with corporate clients, as well as with private collectors, and works displayed generally appeal to corporate environments.

Among the artists featured, Tom Gathman and Edward Evans paint illusionist canvases, and Lee Goldstrom paints works that employ a vocabulary of textures. Many artists work primarily on paper: Alice Welton uses handmade paper as the principal expressive element in her work, while Esther Brenner makes monoprints which are folded to give the paper support of the image an active role in molding space. Mark Dickson works in pastels, Audrey Leaman in watercolor, and Leine Sebastian in various drawing media. Sculptors Jim Knowles and Yvonne Tofthagen both work in bronze.

The gallery also handles master graphics, including works by Joan Miro, Yaacov Agam, Karel Appel, Folon, Marc Chagall, and others.

Benjamin-Beattie Ltd. 1000 N. Lake Shore Dr., Chi-
315 cago, IL 60611 (312) 337-1343; Tue-Sat: 11-5; dir: Orville C. Beattie

Located in a condominium building on Chi-

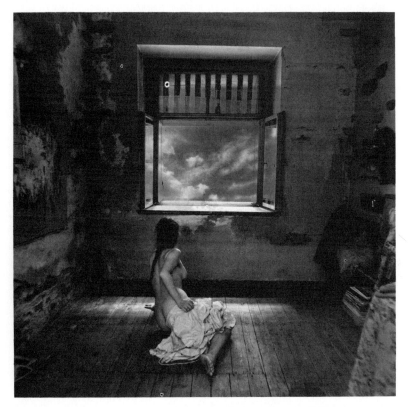

Jan Saudek, *Image 132*, 9 x 12, photograph, Jacques Baruch Gallery (Chicago, IL).

Theodore Halkin, *Trumpet Vine*, 52 x 60, oil on canvas, Jan Cicero (Chicago, IL).

cago's "Gold Coast," the gallery offers medium- to small-size sculpture and graphics by well-known American artists.

The graphics collection includes lithographs, etchings and screen prints by recognized artists such as Will Barnet, Alexander Calder, Richard Florsheim, Sam Francis, Adolph Gottlieb, Robert Motherwell, Robert Rauschenberg and Carol Summers.

In addition to contemporary graphics, Benjamin-Beattie offers perhaps the largest selection of "American Scene" prints in the city of Chicago. Regionalists Thomas Hart Benton, John Steuart Curry and Grant Wood are represented in the collection, along with Ashcan School painters George Bellows and John Sloan, as well as Childe Hassam, Adolf Dehn, Reginald Marsh, Wengenroth, Lewis and Landeck. There are also works by Winslow Homer and Chicago hyperrealist Ivan Albright.

The sculpture offered is varied, but mainly abstract and created for conventional tastes. Although many of the sculptors are well known, they do not have the wide reputation of the graphic masters featured by the gallery. Sculptors Maryon Kantaroff, Jim Myford, Minna Reich, Clement Renzi and Vasa offer examples of great interest.

The gallery also displays photo-etchings and works on handmade paper by Lu Dickens, Nancy Thayer and Giedre Zumbakis. Shows change monthly, with formal gallery openings four times a year.

Roy Boyd Gallery 215 W. Superior St., Chicago, IL
316 60610 (213) 642-1606; Tue-Sat: 10-5:30 Mon: by appt; dir: Roy & Ann Boyd

In October of 1981 Roy Boyd opened an additional gallery in Los Angeles. He represents artists from the Chicago and New York areas as well as from New York in both galleries.

The Chicago gallery is strongly represented by Chicago abstract painters William Conger, John Dilg, Vera Klement, Sarah Krepp, Richard Living, Dan Ramirez and Susan Sensemann. Sculptors featured by Boyd cover the entire United States: David Bottini, David Bower, Jeff Colby, Gary Cudworth, Michael Davis, Herbert Ferber, Robert McCauley, Dan Nardi, Joel Perlman, Jay Phillips, Gordon Powell, Barry Tinsley and Bruce White.

New York painters include Jay Phillips, Tom Levine, Mark Williams and Frank Faulkner. West Coast artists are Ernest Silva, Richard Overstreet, Joe Fay, Steve Heino and Bob Nugent.

The gallery offers well-executed work with the primary emphasis being abstract, contemporary paintings and sculpture. Changing monthly exhibitions often include two-person shows in the two separate gallery spaces.

Campanile Galleries Inc. 200 S. Michigan Ave., Chi-
317 cago, IL 60604 (312) 663-3885; Mon-Fri: 9-5:30 Sat: 9:30-4; owner: Mrs. G.L. Campanile dir: Howard B. Capponi

Located across the street from the Art Institute, the gallery offers American paintings from the late 18th to the 20th century, French Impressionist paintings, and one contemporary show a year. The gallery also handles drawings and some small sculpture.

The gallery hangs an annual show of American Impressionists, which is their major show. Included are works by members of "The Ten", a group of painters, mostly Easterners, who studied in France and brought the *plein air* style back to this country; and of "The Eight", or Ashcan School, who employed Impressionist technique in the service of social realism. Works are available by Robert Henri, George Luks and Everett Shinn of the Ashcan School. There are also works from the estate of James P. Butler, grandson of Claude Monet.

The one contemporary artist handled by the gallery is marine painter Charles Vickrey. Vickrey specializes in historic naval and merchant ships. Named official marine painter of 1982 by the U.S. Navy, he has been commissioned to record leading battleships and aircraft carriers for the American Maritime Museum and other naval institutions.

Merrill Chase Galleries 835 N. Michigan Ave., Chi-
318 cago, IL 60611 (312) 337-6600; Tue, Wed, Fri: 10-6 Mon, Thu: 10-7 Sun: 12-5

Located in downtown Chicago's Water Tower Place, as well as in suburban locations at the Woodfield Mall, Schaumberg and Oak Brook Center, Oak Brook, Merrill Chase Galleries handles a wide variety of fine prints and *objets d'art*.

The extensive collection of fine prints boasts examples by old masters such as Rembrandt, Durer and Goya. Works by Picasso, Miro, Chagall and Dali are among the highlights of the 20th century collection. Examples from Picasso's acclaimed *Suite Vollard* and Dali's *Les Chants de Maldoror* are available. Merrill Chase Galleries offers the work of contemporary artists such as Nierman, Kipniss, McCormick, Locker, Altman, Likan, and Erte. The galleries also carry the work of Robert Addison and sculptor Frederick Hart.

A recent addition to the galleries is the "AR-Tique," a specialty department at all locations offering a glittering array of art-inspired items and fanciful bibelots, as well as books, notecards and posters.

Jan Cicero 221 W. Erie St., Chicago, IL 60610 (312)
319 644-5374 Tue-Sat: 11:30-5 Aug 15-31: closed; owner/dir: Jan Cicero

Jan Cicero became an art dealer by selling works from her home. Beginning with just five abstract artists, the gallery today represents about thirty painters, sculptors and printmakers whose styles are mostly abstract, but cover an ample range from minimal to expressionistic.

The works exhibited include the bright, patterned canvases of Susan Michod, the realistic paintings of St. Louis artist Bill Kohn, landscape paintings by School of the Art Institute instructor Theodore Halkin; and works by painter/critic Peter Plagens. Other artists are Corey Postiglione; Chicago realist painter Arthur Lerner; Peggy Schaps, whose paper installations on walls are derived from primitive sources; printmaker and painter Julie Richmond; abstract painter David McCullough of Dallas; Barbara Blades and Bonnie Hartenstein of Chicago; and Frances Barth, Budd Hopkins and James Merrell of New York. James Juszczyk adds his color

constructivist paintings to the interesting network of art displayed in the gallery.

Cicero offers a fine variety of works, with the emphasis on "good painting" and skillful facture.

Circle Gallery 540 N. Michigan Ave., Chicago, IL
320 60611 (312) 670-4304; Mon-Fri: 9:30-6 Thu: 9:30-8 Sun: 12-5; owner: Circle Fine Art Corporation

If one is looking for good, affordable art, then this gallery is well worth a visit. Circle publishes limited edition prints in its own ateliers. Although most of the works shown are prints, occasionally paintings and sculpture occupy the gallery.

Circle Fine Art Corporation has galleries in almost every major city in the U.S.; consequently the artists shown are from all parts of the country and from all over the world. Works exhibited in Circle's many galleries include lithographs and serigraphs of fashionable women by French *art nouveau* designer Erte. Circle has also published two portfolios in collaboration with the Metropolitan Opera Association of New York, in 1978 and 1984. The artists selected operatic subjects from the Associations repertory. The 1978 mixed media edition included works by Antonio Clave, Leonor Fini, Richard Lindner, Marino Marini, Andre Masson, Larry Rivers, Paul Wunderlich and Jamie Wyeth. The 1984 portfolio includes lithographs by Will Barnet, Karel Appel, George Tooker, Tom Wesselman, Sandro Chia and Rufino Tamayo.

Contemporary Art Workshop 542 W. Grant Place,
321 Chicago, IL 60614 (312) 525-9624; Mon-Fri: 9:30-5:30 Sat: 12-5; nonprofit dir: Lynn Kearney

Contemporary Art Workshop was the first artist-created, artist-run alternative gallery in the country. Founded in 1950 by artists John Kearney, Leon Golub, Cosmo Campoli, Ray Fink and Al Kwitz, the Workshop has hosted shows of such Chicago artists as June Leaf, Leon Golub, Seymour Rosofsky, Emerson Woelffer and Robert MacCauley.

The spacious remodeled dairy where the Contemporary Art Workshop has been housed since 1960 offers studio, class and gallery space on three floors. The Workshop is committed to actively seeking out the best of young Chicago and Midwestern artists to give them a forum for expressing new visual concepts, while providing the art-conscious public the opportunity to experience fresh and exciting new work. The Workshop also serves to bridge the gap between art school and the world of the professional artist by offering advice and guidance in the practical aspects of a professional art career.

Artists who have recently exhibited at the Workshop include John Kearney, Alex Nelson, Joe Houston, Laurie Auth, Didier Nolet, Ellen Nadeau, Paula Pia Martinez, Michele Hemsoth, Cherri Ritttenhouse, Christine O'Connor and Gonzalo Jesse Sadia, to name just a few of the hundreds of emerging artists who have exhibited here.

Marianne Deson Gallery 340 W. Huron, Chicago, IL
322 60610 (312) 787-0005; Tue-Fri: 10-5:30 Sat: 11-5; dir: Marianne Deson Herstein

In a newly renovated and expanded space in a Louis Sullivan building, Marianne Deson's gallery continues to offer Chicagoans art that is often innovative, experimental and important. Although she represents artists from all over the country, Deson's main stable includes many Midwestern and Chicago-based artists.

Some of these are Kenneth Shorr, a provocative painter-photographer; Michiko Itatani, a painter whose finite work becomes installation art; Mary Ahrendt, a painter-photographer who deals with the concept of self-image; Dennis Kowalski, a sculptor who employs multi-faceted metaphor; Gary Justis, a kinetic sculptor who uses light and motion as a vehicle for myth; and Edith Altman, a conceptual artist working with the categories of time and space.

Some artists like Jackie Ferrara and Nancy Davidson live in New York and are included in shows periodically. New York graffiti artists, including Keith Haring and Kenny Scharf, are scheduled to be shown in 1984; there will also be two shows of European artists.

With a large roster, Deson also carries work by internationally known artists like Jake Berthot, Bruce Nauman, John Baldessari, Ernesto Tatafiori and Gerhard Richter. Non-traditional artists such as Conceptualist Dennis Oppenheim are also featured.

Two one-person shows usually run consecutively in separate spaces in the large, attractive gallery.

Exhibit A 361 W. Superior St., Chicago, IL 60610
323 (312) 944-1748 Tue-Sat: 10:30-5 & by appt; owner/dir: Alice Westphal

The place is devoted to contemporary art, but only art made out of clay, with the exception of work by two painters. Ethereal beauty of form marks some pieces, while others reveal the raw earthiness clay suggests. Most works are nonrepresentational sculpture, wall pieces or pottery forms whose function is a secondary matter, but some functional wares are shown.

The contemporary tableware of Jim Makins is functional in form, but spiritually close to to nonfunctional sculpture. The pieces are a personal visual statement, as well as objects for the consumption of food.

Sculpture in ceramic idioms by accomplished artists such as Peter Voulkos, Thom Bohnert, Dennis Mitchell, George Timock and Rudy Autio is always available. Works by other noted ceramists such as Ruth Duckworth and Richard DeVore are regularly shown as well. Bronzes and prints by Peter Voulkos, abstract oils by Jan Hall and abstract drawings and paintings by Daniel Brush provide the walls of the gallery with a visual counterpoint to the ceramic art displayed throughout the gallery space. The variety of works and the subtleties of personal style of the artists make the gallery a unique place to visit.

Fairweather Hardin 101 E. Ontario, Chicago, IL
324 60611 (312) 642-0007; Tue-Sat: 10-5:30 Aug: closed; owner/dir: Shirley Hardin, Sally Fairweather

Established in 1947, the gallery has developed a reputation for exhibiting the work of major artists. Not limited in scope to an exact style or time period, the gallery tends to show contemporary American art from Chicago and the Mid-

west, and from throughout the U.S., by both established and relatively unknown artists.

The work of sculptor Harry Bertoia is prominently displayed in the gallery. Bertoia's work ranges from large architectural works to smaller pieces based on organic forms, particularly flowers, plants and seeds handled with a virtuoso's sensitivity to materials. The artist is known for his sound sculptures of flexible metal rods that produce non-repetitive chiming.

The gallery has also exhibited works by Mark Tobey, Morris Graves, Ulfert Wilke and Martyl in a recent exhibi-tion on the Eastern influence in Western art. Other artists exhibited include Robert Courtright, Joyce Treiman and Max Kahn, contemporary painters whose work contains figurative elements, and non-figurative painters Lillian Florsheim and Cleve Gray.

Wally Findlay Galleries 814 N. Michigan Ave., Chi-
325 cago, IL 60611 (312) 649-1500; Mon-Fri: 9:30-5:30 Sat: 9:30-5; pres: Walstein Findlay dir: Helen Findlay

Having recently celebrated their 114th year, this is Chicago's oldest commercial gallery and the third oldest in the entire United States. In 1870 William Wadsworth Findlay established the original gallery, and the enterprise has never stopped growing. Today there are four more galleries in Paris, New York, Palm Beach and Beverly Hills. The Chicago gallery is still the business base.

The thrust of the collection is contemporary European Impressionists and Post-Impressionists, with an emphasis on French painters. Some impressive original paintings by 19th and 20th century artists like Claude Monet, Auguste Renoir, Georges Braque, Henri Matisse and Jean Dufy give added character to the gallery. Other artists whose works are much more abundant include Bernard Ganter and Andrew Hambourg, French Impressionist artists; Constantin Kluge, Ardissone, Nessi, Andre Vignoles, and Fabien. Although styles differ, the essential statement emanates from an impressionist attitude.

Allan Frumkin Gallery 1306 W. Byron, Chicago, IL
326 60613 (312) 883-0888; by appt; dir: Carol Ehlers

Vintage photographs from the 1920s and 1930s may be viewed at the Allan Frumkin Gallery. Artists included in the gallery inventory are Eugene Atget, the prodigious photographer of the streets of Paris; Laszlo Moholy-Nagy, Hungarian sculptor and painter associated with the Bauhaus and the Chicago Institute of Design who experimented with photomontage and photography; Man Ray, an American Surrealist in Paris, famed as a fashion photographer as well as an innovator of new photographic techniques; Edward Weston, the American master photographer; and Joseph Sudek, among others.

Frumkin & Struve Gallery 309 W. Superior St.,
327 Chicago, IL 60610 (312) 787-0563; Mon-Fri: 10-5:30 Sat: 10-5; dir: William Struve

Recently moved to a larger space in Chicago's River North area, the Frumkin & Struve Gallery has greatly expanded its exhibition capabilities. However, the primary focus, contemporary American art, has not changed. The gallery's

commitment to showing major artists has brought to Chicago some of the best work from all over the U.S.A., and helped to discover and promote many younger, less established artists as well. An ambitious schedule and two public galleries ensure ample exposure for artists and a wide variety for the public.

Gallery artists include Jack Beal, Philip Pearlstein, Peter Dean, Rafael Ferrer and James Valerio from the East Coast; Robert Arneson, Joan Brown, Roy DeForest, Robert Hudson and William T. Wiley from California; painter and printmaker James Butler, Robert Barnes, Susanne Slavick, Ellen Lanyon and James Winn from the Midwest, as well as many others.

In addition to the above activities, the Frumkin & Struve Gallery is one of the few in the country to have a special department devoted to architecture. Concentrating primarily on 20th century Chicago architecture, the gallery has exhibited contemporary and historical drawings, photographs by the Chicago firm Hedrich-Blessing, and Frank Lloyd Wright windows and furniture.

Galeries d'Art International 720 S. Dearborn, Chi-
328 cago, IL 60605 (312) 427-1666; Tue-Sat: 10-6; dir: Ante Glibota

Galeries d'Art International is a 7,000 square foot gallery located in Chicago's historic Printer's Row with branches in Paris and Milan. The gallery specializes in contemporary European and American masters as well as emerging artists. The gallery's collection ranges from small prints to large outdoor commissions. Posters and catalogs complement the abstract and representational paintings, sculptures and fabric works.

Artists featured by the gallery include Claude Bellegarde, Rafael Canogar, Alberto Cavalieri, Elizabeth Franzheim, Leon Gischia, Sheila Hicks, Robert Malaval, Jean Messagier, Edo Murtic, Achille Perilli, Armando Pizzinato, Charles Pollock, Frederick Wight, Ferdinand Kulmer, Augusto Barros, John F. Koening, Tomislav Nikolic, Gualtiero Mocenni, Adevor, Karel Appel, Bony, Max Ernst, Chiara Fiorini, and Lindstrom.

Gilman Galleries 277 E. Ontario St., Chicago, IL
329 60610 (312) 337-6262; Tue-Sat: 10-5:30; owner/dir: Mack Gilman

Gilman is a veteran of 25 years as an art dealer who represents contemporary Midwestern artists. The works cover a variety of media, styles and ideas, sometimes humorous, sometimes realistic, contemplative or clever.

The large gallery lends itself to the many sculptures that Gilman shows. The epoxy-resin sculptures of Frank Gallo, Emily Kaufman, and Angela Lane; the granite and marble sculptures and sculpted fountains of Charles Herndon; and the papier mache works of Stephen Hansen have an important place in the gallery. Other sculptors are Dennis Jones, who works in stainless steel; and Herbert House, who creates figurative sculpture using bumper steel.

Gilman also shows the paintings of Chicago blues musician Bob Novak. Gilman has pioneered in the creation of videotapes about his artists. The videotape on Bob Novak is currently being aired on P.B.S. stations nationwide. Other videotapes on Boris Anisfield, Bernard Beck,

Stephen Hansen and Rudolf Weisenborn are available for viewing in the gallery.

Although sculpture is strongly emphasized, painting is also important. Chicago and area painters include: Morris Barazani, Walter Fydryck, Craig Anderson, Mimi Dolnick, Ghita Hardimon, David Bushman, Bruce Thorn, Gloria Schabb, Audrey Ushenko, and Roland Poska. Other painters are Tom Balbo, Leslis Poole, Tom Parish, Alba Corrado, Howard Storm, Ante Sardelic, Anton Cetin and Geoffrey Lardiere.

Goldman-Kraft Gallery, Ltd. 233 E. Ontario St.,
330 Chicago, IL 60611 (312) 943-9088; Mon: by appt Tue-Fri: 10-5:30 Sat: 11-5; owner: Goldman/Kraft dir: Jeffrey Kraft

Concentration of the gallery is on 20th century contemporary paintings, graphics and sculpture. The gallery collection includes important international and Israeli artists.

Internationally acclaimed artists include Italian painter Valerio Adami, famous for his ironic treatment of historic and philosophic subjects; Belgian painter Pierre Alechinsky, a founder of the COBRA group, which had affinities with American gesture painting; and French-American sculptor Arman, who makes works by assembling accumulations of ready made objects; as well as Viennese Fantastic Realist Arik Brauer, Marc Chagall, Joan Miro, and Henry Moore. American painter Mark Tobey's work may also be viewed; a recent survey exhibition revealed the figurative as well as the calligraphic roots of his style. Another highly influential American painter handled by the gallery is Frank Stella, whose earliest work categorically rejected the tenets of Abstract Expressionism in favor of a Minimalist style, but whose recent works combine geometric construction with gesture painting. The gallery also exhibits graphics and paintings by Giancarlo Impiglia, who works in an Art Deco figurative style with interlocking geometric shapes of flat color.

Israeli artists featured by the gallery include sculptor Aharon Bezalel, who makes interchangeable sculpture in wood and bronze, as well as Michael Eisemann, Manashe Kadishman, Reuven Rubin, Heinz Seelig, Yevgeni Abeshaus and Moshe Castel. Editions of graphic works are also available through the gallery.

Richard Gray Gallery 620 N. Michigan Ave., Chi-
331 cago, IL 60611 (312) 642-8877; Mon-Sat: 10-5:30; owner/dir: Richard Gray

Like most galleries, Richard Gray operates as both private dealer and open gallery. Unlike almost any other gallery in Chicago, Richard Gray will have major canvases by Willem de Kooning on display and major canvases by Edgar Degas sitting in private rooms awaiting buyers.

Gray's emphasis is on the most important of the modern masters, from Impressionists to Cubists to Abstract Expressionists—Degas, Cezanne, Picasso, Braque, Matisse, Leger, Arp, de Kooning, Rothko. Much of this work is not displayed in the gallery's many exhibition rooms.

Instead, the exhibition rooms feature more contemporary works by artists such as Robert Rauschenberg, Jasper Johns, Roy Lichtenstein, Jim Dine, David Hockney, Claes Oldenburg, Al Held, Saul Steinberg, Lucas Samaras, and Milton Avery. One may also find Louise Nevelson constructions, Anthony Caro sculptures, canvases by Hans Hofmann and Willem de Kooning, or works by Jean Dubuffet. One small gallery room is devoted to ancient and primitive works, ranging from Roman statuary to a Mayan bowl to Bakongo nail fetish.

The gallery has long been involved with Chicago artists, and from time to time will have a major show featuring accomplished local figures. One might single out the found paper collages of the late Robert Nickle, who peers out from his photo set in a "porthole" in the back of his handmade frames; the magical realism of Ellen Lanyon, with its interpenetration of the man-made and the natural world; or the airbrush paintings of Frank Piatek, where opalescent, cylindrical forms intertwine; or works by Seymour Rosofsky, Jerry Peart, Tony Gilberto, Ben Benson and Sondra Jorgensen.

Carl Hammer Gallery 620 N. Michigan Ave., Chi-
332 cago, IL 60611 (312) 266-8512; Tue-Sat: 10-5:30; owner: Carl Hammer dir: Ken Hodorowsky

The pieces shown at the Carl Hammer Gallery are bound to look familiar—they are the stuff of the American experience, made by naive or untrained artists.

Carl Hammer specializes in American folk art of the 18th, 19th and 20th centuries. Most of the pieces shown here are sculptural and three-dimensional—quilts, carvings in stone or wood, weathervanes, or decoys.

About three-fourths of the work is anonymous, the identity of the artist is not considered important. The work of Edgar Tolson, however, is an exception. The figures done by this contemporary Kentucky artist are shown in many important collections, including the Whitney and the Smithsonian. His biblical scenes are reminiscent of Easter Island figures.

Other artists include Bill Taylor, Joseph Yoakum, Simon Sparrow, Inez Nathaniel-Walker and Mr. Imagination. The gallery occasionally mounts theme shows which place folk art in a contemporary or historical context. Recent overviews included: "Joseph Yoakum: His Influence on Contemporary Art and Artists" and "Amish Quilts."

Rhona Hoffman Gallery 215 W. Superior St., Chi-
333 cago, IL 60610 (312) 951-8828; Mon: by appt Tue-Fri: 10:30-5:30 Sat: 11-5:30 Jul-Aug: closed Sat; owner/dir: Rhona Hoffman

Showing emerging and established American and European artists, the Rhona Hoffman Gallery rewards the visitor with a glimpse at some of the most provocative art being made today. The painting, drawings and sculpture exhibited cover a wide range of styles, and confront both aesthetic and social problems with integrity. The gallery also handles outdoor sculpture commissions.

Works in realist styles include the paintings of Leon Golub, drawings by trompe-l'oeil muralist Richard Haas, sculptor John Ahearn's moving portraits of people from the South Bronx, and Sylvia Plimack Mangold's illusionistic inquiries into the nature of the painting process. Artists associated with Minimalism include painters Robert Mangold and Robert Ryman, and sculptors Sol LeWitt, Donald Judd,

and Richard Artschwager. In contrast with the purely abstract forms of these other artists, Artschwager's. sculpture refers to furniture as a formal object. Jenny Holzer, Barbara Kruger and Nancy Spero all use texts in various ways. Holzer's texts are put on industrially produced signs and installed in contexts that create an ironic tension about their meaning. Kruger couples texts with found images to reveal the hidden workings of contemporary social iconography. Spero's paintings and drawings of female figures and anthropomorphic monsters question the part sex roles play in social history, particularly their bearing on war and peace. Other artists exhibited include performance artist and sculptor Vito Acconci, painter Mike Glier, sculptors Jene Highstein and Italo Scanga, fiber artist Claire Zeisler, sculptor John Obuck, known for his wall reliefs, and Tom Otterness.

The gallery also shows paintings and drawings by German Neo-Expressionists Georg Baselitz, Jorg Immendorf, Walter Dahn, Georg Jiri Dokoupil, and A.R. Penck.

Hokin/Kaufman 210 W. Superior St., Chicago, IL
334 60610 (312) 266-1211; Tue-Fri: 10-5 Sat: 11-4; owner: Laurie Kaufman dir: Karen Indek

Specializing in contemporary paintings, drawings, sculpture and graphics, the Hokin/Kaufman Gallery also handles an extensive selection of art furniture.

The contemporary artists shown include several who have achieved a notable influence in the stylistic idioms of the last twenty years. Red Grooms, active in the 50s as an instigator of "happenings," currently builds large-scale constructed and painted cityscapes with an air of theatrical assemblage. James Havard and George Green paint in an abstract illusionist style, while Stanley Boxer paints textural color-field canvases.

Chicago artists include realist painter and printmaker Claire Prussian, Frank Morreale, Fred Brown and Burton Eisenstein. Chicago sculptor Lynn Hall creates "soft" sculptures in organic shapes and materials, some of which verge on non-functional furniture.

The furniture collection, however, is functional but handmade and sculptural. Works available include furniture sculpture by Peter Shire, who works in aluminum tubing, fiber, and other materials; and tables, chairs, coffee tables, etc., by Chicago craft artists Judy Lichtenstein and David Robbins, Andy Pawlin, John Cockrell, George Pempeck, and Richard Robb, and New Yorkers Bob Trotman, Forest Myers, Chris Sproat, and Carmen Spiera.

B.C. Holland 222 West Superior St., Chicago, IL
335 60610 (312) 664-5000; by appt; owner/dir: B.C. Holland

B.C. Holland essentially works as a private art dealer. The gallery offers visitors the opportunity to view important 20th century works in comfortable settings set up for private showings and consultations. Antiquities and exotic art objects from a panoply of cultures complement the contemporary masterpieces for which the gallery is famed.

The inventory revolves around European art before the 1930s and American art before the 1960s, with excellent representation of New York School paintings. Holland deals in such internationally renowned artists as Picasso, Balthus, Rothko, Kline, de Kooning, Rivers and Johns. As a general rule, Holland emphasizes individual works rather than the oeuvre of a particular artist.

The ethnographic and archaic art collection affords the visitor a wealth of possibilities, from African and Indonesian, as well as Pre-Columbian textiles, to Egyptian, Greek and Roman artifacts. A specialty of the gallery is a collection of classical modern furniture.

Billy Hork Galleries 109 E. Oak St., Chicago, IL
336 60611 (312) 337-1199; 1621 Chicago Ave., Evanston, IL 60201 (312) 492 1600; 3015 N. Broadway, Chicago, IL 60657 (312) 528-7800; 3033 N. Clark St., Chicago, IL 60657 (312) 528-9090; Mon-Sat: 11-7 Sun: 12-6; owner/dir: Billy Hork

Dealing essentially in framed and unframed graphics, the Billy Hork Galleries does a volume business. In a new space in its North Clark Street "Factory" the gallery will be showing unique works and paintings as well.

The kind and caliber of this art vary considerably. A large part of Hork's inventory consists of easily identifiable, popular graphics. There is a large selection of commercial lithographs by stellar names—Picasso, Chagall, Miro, Calder and Vasarely. There is also a wide variety of colorful, contemporary poster art, featuring such highly salable names as Folon, Brian Davis, and Harvey Edwards. For this type of work prices can go as low as $7.

Then, too, prices can go as high as $10,000. Hanging next to a couple of humble etchings is Miro's marvelously rendered aquatint *La Calebasse*. Other works of fine quality are hung throughout the galleries. Carcan etchings, serigraphs by Marcus Uzilevski, graphics by Seattle artist M. Hayslette, and graphics by Kozo are shown prominently, as are the witty, well-crafted drypoints of Charles Bragg, and the lithe, elegant sculptures of Bruno Bruni.

The recently opened exhibition gallery on North Clark Street was inaugurated with the paintings of Daniel Lencioni. Director Hork looks forward to displaying a wide variety of works, including paintings and multiples of Paul Maxwell, and unique works by many other artists.

Joy Horwich Gallery 226 E. Ontario St., Chicago, IL
337 60611 (312) 787-7486; Tue-Sat: 11-5; owner/dir: Joy Horwich

Opened in 1974, the Joy Horwich Gallery represents a considerable experience working in art in Chicago. All of the art is contemporary, but a wide variety of media and styles are used by the emerging and mid-career artists shown at the gallery. Director Horwich's intent is to display work she likes, whether the artist is well-established or not. Paintings, sculptures and fiber pieces by abstract, realist and folk artists are all part of the gallery's offerings, which have long included quilts, ceramics and hand-painted silk hangings as art forms.

Artists featured include Charles Wickler, William Wolter, Pamela Redick, Dennis Bayuzick, Eric Appel, Darryl Halbrasks, Rhonda Root,

James Butler, *An Evening View From Ray-Mar* (1984), 36 x 48, pastel on paper, Frumkin & Struve Gallery (Chicago, IL).

Jean Dufy, *Vue de Paris,* 14 x 18, oil, Wally Findlay Galleries (Chicago, IL).

Bob Novak, *They know each other since before they were born*, 42
x 56, acrylic on canvas, Gilman Gallery (Chicago, IL).

Susan Michod, *Tempest Sunset,* 90 x 48 x 12, acrylic on
canvas/wood, Jan Cicero Gallery (Chicago, IL).

William Conger, *Militant State,* 54 x 60, oil on canvas, Roy Boyd Gallery (Chicago, IL).

Zofia Butrymowicz, *Flame* (1979), 67 x 83, linen, Jacques Baruch Gallery (Chicago, IL).

James Michael Smith, *Trevy Bon,* 46 x 72, acrylic on wood, Joy Horwich Gallery (Chicago, IL).

Andrea Smith, *Flowering Energy,* 30 x 22, watercolor, Kapalua Gallery (Kapalua, HA).

Raymond Olivero, Joseph Rozman, Gretchen Sigmund, James Michael Smith, Gary Komarin, Nancy Kittredge, Alfred Maurice, Barbara Frets, Frank Gunter, Robert Appel, Robert Amft and Jan Miller. The gallery exhibits picture quilts by Steve Stratakos, hand-painted silk wall-hangings by Marie Laure Ilie, and sculpture by Gensburg/Eichengreen.

Edwynn Houk Gallery 233 E. Ontario Ave., Chicago,
338 IL 60611 (312) 943-0698; Tue-Sat: 10-5:30; dir: Edwynn Houk

The gallery shows vintage photographs of the 20th century by American and European masters, with an emphasis on photography of the 20s and 30s.

One may see works by distinguished American photographer Alfred Stieglitz, who was instrumental in freeing photography from being an imitation of painting. Stieglitz is also remembered as the director of the "Photo-Secession Gallery" at 291 Fifth Avenue in New York, where he introduced the best work of the European avant-garde to this country, while encouraging the American avant-garde. Photographs by Precisionist painter Charles Sheeler are also available, and works by Man Ray, an influential American photographer active in the Parisian avant-garde in the 30s. Man Ray contributed solarization to the technical processes of photography, and experimented with the use of objects placed directly on photographic paper to make images in his "Rayograms." There are also photographs by Andre Kertesz, a European photographer who has long lived in New York City.

Illinois Arts Council 111 N. Wabash, Chicago, IL
339 60602 (312) 793-6750; Mon-Fri: 8:30-5:00; dir: Adrienne Hirsch

The IAC Gallery is but one aspect of the work of the Illinois Arts Council, nonprofit state agency. The gallery housed here shows work by individual Illinois artists every month. Slide portfolios submitted by artists are reviewed twice a year for possible one-person shows in the gallery. Work must be consistent and usually must be limited to work in one medium. The shows are of high quality and vary in style from the minimal and abstract to the most realistic imagery. Generally, the IAC Gallery is a good place to see the work of serious, upcoming Illinois artists.

Further information on the resources of the IAC, which include grants, programs and services, are available by writing or calling the agency.

R.S. Johnson International 645 N. Michigan, Chi-
340 cago, IL 60611 (312) 943-1661; Mon-Sat: 9-5:30; dir: R. Stanley Johnson

A spacious place accessible through the Erie Street entrance of the modern Blair Building, this second-floor gallery offers the opportunity to see works of notable quality from historical and contemporary periods. Director R. Stanley Johnson is one of the world's major dealers in Old Master prints, and a tireless researcher for his carefully written exhibition catalogs.

Important exhibitions have included 70 lithographs by Toulouse-Lautrec, 110 etchings by Piranesi, and 60 etchings by Goya. The gallery has acquired works by French Impressionists and

Expressionists, including Honore Daumier, Maurice Vlaminck, Jacques Villon, Georges Rouault, Odilon Redon, and Felix Vallotton. The German Expressionists breathed new life into printmaking, particularly woodcuts, and there are distinguished works by Emil Nolde, Ernst Kirchner, Max Beckmann and others.

Although master graphics are clearly the emphasis of the gallery, Johnson also carries paintings and drawings. Gallery exhibitions have included paintings and drawings by Leger, works from Giorgio de Chirico's realist period, four Picasso shows, as well as the charming works of American Impressionist Mary Cassatt.

Between the four main exhibitions per year, the gallery shows work from its inventory of approximately 500 pieces. The 3,000 square foot gallery lends itself to shows which approach a small exhibit in a museum.

Kamp Galleries, Inc. 1441 N. State Pkwy., Chicago,
341 IL 60610 (312) 787-1153; by appt only; owner: Nicholas Vahlkamp

Kamp Gallery is designed to facilitate acquisition of rare and unique works of art for collectors. The principal field of expertise is late 19th to early 20th century American painters, expatriate American painters, European painters of the Munich, Berlin and Vienna Secession and their graphic art. The gallery also is interested in Symbolist painters of France and Belgium, as well as French, German and Italian Post-Impressionists. The 20th century collection concentrates on "New Realism" in Germany and Russia, and early American and European art photography of the Secession.

Douglas Kenyon Gallery 155 E. Ohio, Chicago, IL
342 60611 (312) 642-5300; Tue-Sat: 9:30-5; owner/dir: Douglas Kenyon

The Douglas Kenyon Gallery carries the Midwest's largest selection of works by John J. Audubon, as well as works by 19th century naturalists Gould, Catesby and others. Photographs of well-known 19th and 20th century artists are available.

Douglas Kenyon also specializes in the restoration of works of art on paper of all kinds, except photographs. The gallery has its own laboratory on the premises. Kenyon, a former conservator at the Art Institute of Chicago, publishes an informative booklet "Framing and Conservation of Works of Art on Paper," which is available without charge.

Phyllis Kind Gallery 313 W. Superior, Chicago, IL
343 60610 (312) 642-6302; Tue-Sat: 10-6 June-Aug: Tue-Fri: 10-6; owner: Phyllis Kind dir: William H. Bengstonson

Having gained a controversial reputation by exhibiting unusual art, the gallery is interested in showing untraditional works that center around American artists, many of whom are Chicago and New York painters. The gallery also emphasizes contemporary naive artists.

After establishing a gallery in Chicago, the owner expanded and opened a branch in New York, to which she brought a selected group of young Chicago artists, many of whom later came to be known as the Chicago Imagists. Roger Brown's mysterious curtained skies hang over stylized scenes with a humorous or political in-

tent. Gladys Nilsson's organic figures are sensitively painted, usually in watercolor. Ed Paschke's drawings and paintings, which lately are modeled after video imagery, reflect the anxiety of the computer age. Jim Nutt paints scenes that have an air of surreal burlesque. Painter Karl Wirsum, who uses the figure structurally, is also included among the Chicago Imagists.

Other prominent gallery artists are William Copley, Russ Warren, Cham Hendon, and Spanish figurative artist Zush. Artists working in three dimensions include Tom Nussbaum, Luis Jimenez, and Martin Johnson. Sculptor Margaret Wharton uses chairs as a source of structural elements and associated meanings. The gallery also carries works from the estate of Dennis Smith.

Naive works by gallery artists include Howard Finster's intricate narratives, carvings by Elijah Pierce, fantastic geographical landscapes by Joseph Yoakum, and obsessive linear drawings by Martin Ramirez. The gallery also shows the works of Robert Gordy, a figurative painter from New Orleans, and Irene Kubota, who also works in figurative modes. Earl Staley, Diane Simpson, Mary Stoppert, and Myoko Ito are also shown.

Klein Gallery 356 W. Huron St., Chicago, IL 60610
344 (312) 787-0400 Tue-Sat: 11-5:30; dir: Paul Klein, Gwenda Klein

The Klein Gallery carries paintings, sculpture, drawings and graphics focusing on the relationships between two and three dimensions in painting and sculpture. The artists handled are young or mid-career contemporary artists, many of whom have been making major contributions to the international art world.

Among the most well-known artists shown at the gallery are Alice Aycock, whose sculptures and environments are based on architectural elements or, more recently, on kinetic and machine imagery; California artist Charles Arnoldi, who employs painted sticks assembled on his canvases as a counterpoint to painted lines; and California artist Michael Todd, a sculptor in welded steel and iron whose recent series of works "Daimaru" ('circle" in Japanese) explores the spatial elaboration of a circular form. Other leading artists are Tony Hepburn, Harmony Hammond, Jun Kaneko, Sam Richardson and David Middlebrook.

Younger, emerging artists exploring new territory in contemporary art include Christine Bourdette, Edward Flood, Glenn Jampol, Brian Longe and Salvatore Pecoraro.

Landfall Press Inc. 5863 N. Kenmore, Chicago, IL
345 60659 (312) 787-6836; Mon-Fri: 9-5 Sat: 12-4 Aug: closed; dir: Jack and Ethel Lemon

Publishers of hand-pulled lithographs, etchings and woodcuts, Jack and Ethel Lemon have been in Chicago since 1970. The internationally recognized artists that are published include Vito Acconci, William Allan, Terry Allen, Robert Arneson, Chuck Arnoldi, Roger Brown, Lynda Benglis, Phyllis Bramson, John Buck, Dan Christensen, Christo, Robert Cottingham, Peter Dean, Laddie John Dill, Martha Erlebacher, Vernon Fisher, Ron Gorchov, Charles Gaines, Denise Green, Richard Haas, Luis Jimenez,

Peter Julian, James Juszczyk, Ellen Lanyon, Ed Larson, Alfred Leslie, June Leaf, Sol LeWitt, David Ligare, Tony Naponic, Don Nice, Claes Oldenburg, Ed Paschke, Philip Pearlstein, Joseph Picillo, Martin Puryear, Pat Steir, Jack Tworkov, Bernar Venet, and William T. Wiley.

Landfall has also opened a showroom in New York City (see listing for Downtown N.Y.C.).

In addition, Landfall records on Fate Records the work of piano-player/songwriter Terry Allen, who also does drawings, collages and prints; and on EJ Records the blues by Mike Henderson, who also does paintings and watercolors; as well as the Sundowners Country and Western music, and the Hellbillys rock-a-billy.

R.H. Love Galleries 100 E. Ohio St., Chicago, IL
346 60611 (312) 664-9620; Mon-Sat: 9-5:30 Fri: 9-8; owner/dir: Richard Love

Consisting of three galleries under one roof, the R.H. Love Galleries specializes in 18th and 19th century American masters, from pre-Revolutionary War days to the American Impressionists. This large collection occupies the main gallery. Another gallery is devoted to American folk art, while the most recent addition is a space for showing 20th century art. The gallery also shows some European artists, as well as young contemporary artists from the U.S.

Although the gallery has handled over 2,000 artists, the primary collections feature those most well-known and recognized. Works by Benjamin West, the first American painter to achieve an international reputation, and Gilbert Stuart, the famous American portrait painter, are part of the gallery's collections. Equally impressive are paintings from the Hudson River School, including works by its founder Thomas Cole, works by genre painters, and works by American Impressionists Theodore Robinson, Childe Hassam and John Twachtman.

The 20th century collection ranges from works of the Ashcan School to contemporary art, including works by Dutch artist Karel Appel, German-American artist Hans Hoffman, and American artist Paul Jenkins.

The folk art collection features quilts, samplers, and paintings. One may even find an antique carousel horse. While most of the artists are unknown, the paintings include works by Joseph Badger and an unidentified artist known as the Frost-Pepperell Limner, both 18th century American artists.

Michael's Edition Inc. 505 N. Lake Shore Dr., Chicago, IL 60611 (312) 661-1660; by appt only;
347 dir: Solomon Fima

Michael's Edition is a major distributor of contemporary original graphics, specializing in rare inventories. All pieces carried by the gallery are signed and numbered, with accompanying documentation.

The concentration is on European masters such as Chagall, Miro and Picasso. There is also work by Salvador Dali, Alexander Calder, Victor Vasarely, Leonor Fini, Tobiasse and Boulager, among many others.

Peter Miller Gallery 1961 N. Halsted St., Chicago, IL
348 60614 (312) 951-0252; Tue-Sat: 11-5 Sun: 1-5; owner/dir: Peter Miller

Robert McCauley,*Inheritors,* 96 x 60, copper, lead, wood, Roy Boyd Gallery (Chicago, IL).

Emily Kaufman, *The Rose,* life size, epoxy resin, Gilman Gallery (Chicago, IL).

Jean-Pierre Capron,*A travers les arbres,* 23 x 28, oil on canvas Wally Findlay Galleries (Chicago, IL).

This gallery concentrates on showing emerging American Expressionists. Most artists are in their mid-thirties and have had varying degrees of museum exposure.

Perhaps the best-known of the artists exhibiting is Lance Kiland, whose wax and oil figurative paintings were exhibited in the 1983 Whitney Biennial. Also on view are Sharon Burns's small colorful stream-of-consciousness paintings; Wesley Kimler's large scale gestural paintings of endangered species; Linda King's mid-size pieces depicting haunting faces of women; Raylin Johnson Ross's mysterious landscapes; Mark Schwartz's impastoed, humorously crazed figures; Rock Harlow's large-scale floral jungle paintings; Matt Stabb's graffiti-style spray paintings of urban life; Susan Choyses-Whitie's gestural, dreamlike figures and objects in motion; and Judy Simonian's landscapes involving waterfalls and realistic incorporation of ceramic tile on the pieces.

Works by other painters and sculptors are regularly included in group shows.

The Mindscape Collection 300 W. Superior St., Chicago, IL 60610 (312) 664-2660; Tue-Sat: 11-4:30 & by appt; owner/dir: Ron Isaacson, Deborah Farber
349

Opened in late 1983 in the heart of Chicago's River North gallery district, The Mindscape Collection specializes in contemporary American sculpture. Browsers and serious collectors alike can view non-traditional works by some of the nation's leading designers in metal, fiber, glass, wood and clay. Artforms range from intimate glass sculpture to monumental steel constructions, and from primitive raku vessels to modular wallhangings of hand-painted silk.

Artists Jan Myers, Barbara Smith, Ted Gall, Joseph Burlini, Paul Seide, Richard Marquis and Michael Glancy are just a few of the talents represented. There are eight to ten shows per year, which change every month or six weeks. Recent exhibits have included Mindscape's well-established national glass invitational, sculptural raku ceramics, figurative sculpture and large-scale experimental fiber art.

As an additional service, The Mindscape Collection offers an extensive slide registry, which features work in various media by more than 500 artists nationwide. A knowledgeable staff is on hand to assist private collectors, corporate curators and designers. Slide presentations are arranged by appointment.

See also Evanston, Illinois, listing.

Mongerson Gallery 620 N. Michigan Ave., Chicago, IL 60611 (312) 943-2354; Tue-Sat: 11-5; owner/dir: Mel & Susan Mongerson
350

Mongerson Gallery has recently expanded to include another gallery on the same floor, enabling the gallery to hang two shows at once. The gallery specializes in 19th and 20th century American art, including paintings and sculpture of the American West, American Impressionist paintings, American folk art, American Indian pottery, Native American painting and sculpture, and a few contemporary realist paintings.

Unlike many galleries, there no changing monthly exhibitions. When the Mongersons collect enough of a particular artist's work, they hold an exhibition. Artists whose work has been displayed in the gallery are N.C. and Andrew

Wyeth, Frank C. McCarthy, and more recently Richard Haley Lever. There are also fine paintings by American Impressionist, Western artist Frederic Remington.

Important works by contemporary Western artists include pieces by Grant Speed, Joe Beeler, Richard Greeves and Kenneth Bunn. The sculptures are mostly of Indians and Wild West figures. Other Western artists featured are Leon Gaspard, Tom Lovell, Charles Russell, and members of the "Taos Society." Several 19th century painters are shown, including E. Irving Couse, Victor Higgins, Ernest Blumenschein and Bert Phillips.

The gallery also has 19th and 20th century Marine paintings, and 19th century prints and posters.

N.A.M.E. Gallery 9 W. Hubbard, Chicago, IL 60610 (312) 467-6550 Tue-Sat: 11-5; dir: Kyle Gann
351

Having the distinction of being one of Chicago's first artist-run alternative spaces, this is a non-profit enterprise, managed cooperatively by men and women artists who want to further the exhibition and realization of art that is innovative and current. The large renovated store front gallery is not fancy, but is well-equipped to show paintings and sculpture to best advantage.

In 1973 eight artists ventured into the organization which has continued to change and develop both in concept and direction. Their goal was to provide a place for art and artists to interact. While none of the original artists is now a member, the gallery's thriving program testifies to the clarity of their vision.

Monthly exhibitions include works by emerging artists, many of whom have gone on to establish solid reputations nationally and internationally. Music, performance, video, dance, panel discussions, slide shows and guest speakers are an integral part of the gallery's schedule. Recent exhibitions have included a "Mid-Career Review" of painter Ray Yoshida's work; an exhibition of kinetic sculpture, "The Desiring Machines"; and a group exhibition of current realism. Director Kyle Gann, a composer, plans to continue and increase the programming of musical events at the gallery, which has become a center for experimental jazz, new music, and performance art in Chicago.

O'Grady Galleries Inc. 333 N. Michigan Ave., Chicago, IL 60601 (312) 726-9833; Mon-Fri: 9:30-4:30; owner: Jack O'Grady dir: Carol O'Grady
352

The O'Grady Galleries shows contemporary American painters and sculptors.

Among the artists whose work is displayed are Paul Dyck, Mark English, Martha Slaymaker, Jo Sickert, Bernie Fuchs, Lu Bellamak, Bart Forbes, Jamie Young, Pegge Hopper, Bill Papas, Ala Masijczuk (batiks), Robert Peak, and George Carlson (bronzes).

Pallas Photo Gallery 315 W. Erie St., Chicago, IL 60610 (312) 664-1257; Mon-Fri: 9-6 Sat: 9-12; owner: Mickey Pallas curator: Robert Lightfoot
353

Showing both commercial and fine photography of high quality, this gallery is primarily interested in Chicago photographers, with the exception of two or three special shows each year.

James Valerio, *Study for Night Fires* (1984), 29 x 41, pencil on paper, Frumkin & Struve Gallery (Chicago, IL).

Frank Gunter, *Summer House—Wisconsin,* 22 x 30, acrylic on canvas, Joy Horwich (Chicago, IL).

Such shows have included Jean Bresson, Victor Skrebneski, Bruce Davidson, Jacques Lartigue, Ernst Haas, Hiroshi Hamaya, Don McCulin, Gordon Parks, Marc Ribuoud, Roman Vishniac, Cornell Capa and W. Eugene Smith.

Mickey Pallas, founder of the gallery, started showing photography in 1973 at his Center for the Photographic Arts, where he exposed well-known international photographers to the Chicago public. At that time the gallery was the largest of its kind in Chicago. After closing for a while, the gallery reopened in 1978 as Pallas Photo Gallery.

The gallery at first functioned as a photography art gallery and did not sell work commercially, but now has a curator, Robert Lightfoot, and does sell exhibited work. Shows usually run for five weeks, and are booked six months to a year in advance.

Perimeter Gallery 356 W. Huron St., Chicago, IL
354 60610 (312) 266-9473; Tue-Sat: 11-5:30; owner: Karen Johnson Boyd dir: Frank Paluch

The Perimeter Gallery carries work by established and emerging contemporary artists, including painting, drawing, prints and sculpture in both abstract and representational modes.

The work presented by the gallery is truly eclectic in scope, and ranges from figurative drawing and painting by Paul Caster to artist's furniture by Dick Wickman. John Colt paints abstract works in acrylic washes. Warrington Colescott is a printmaker whose main concern is etching. Printmaker Ralston Crawford is also featured by the gallery. Other artists include Paul Wong, handmade paper sculpture and wall reliefs; Keiko Hara, abstract painting and works on paper; Ken Loeber, metalsmithing; Jack Earl, figurative works in clay; Natasha Nicholson, small sculptural environments; Mary Walker, large sculpture in such diverse materials as paper and brass; Eleanor Moty, metalsmithing; Walter Hamady, collage/assemblage; and John Wilde, representational and surreal images.

Randolph Street Gallery 756 N. Milwaukee Ave,
355 Chicago, IL 60622 (312) 666-7737; Tue-Sat: 11-5; dir: Nancy Forest Brown

A cooperative gallery with a very open and flexible exhibition policy, the Randolph Street Gallery provides emerging Chicago artists with an ample space and open forum for their ideas. The gallery has no artist members; it is open to all artists. Exhibitors are chosen by a committee which usually reviews slides. Some exhibitions are open to all who wish to participate, such as the annual Outdoor Installation Show, which occupies six city blocks around the gallery during the month of July.

Aside from its large group shows, the gallery presents one-person and smaller group shows. The 1983-84 season included noted Chicago painter Gladys Nilsson, whose work reveals a colorful world of biomorphic personnages charged with ironic humor; photographer Larry Clark, who exhibited two suites, "Teenage Lust" and "Tulsa'; ceramics by the Whitehead Studio; and an exhibition of works by the Chicago Mural Artists, a group which has been active throughout the city.

Performance art is an integral and lively part of the Randolph Street Gallery, which reflects the importance of performance in current Chicago art. There is a space reserved for performance in addition to the two spaces dedicated to painting and sculpture. The gallery employs a performance director, Randolph Alexander, to manage the year-long performance series, which includes as many as eighty performances and installations.

Rizzoli Gallery Water Tower Place, 835 N. Michigan
356 Ave., Chicago IL 60611 (312) 642-3500; Mon-Sat: 10-10 Sun: 11:30-5:30; mgr: Steven Schulze

Located in back of and upstairs from an elegant bookstore, the gallery is a simple, very low-ceilinged exhibition room. Almost always the art shown in the gallery is either tied into the bookstore through a book promotion or is seen as having a cultural tie-in to Chicago. However, there are no set rules for the gallery.

The gallery shows many photographers, ranging from internationally known masters to local talent. Often the photographers are featured while one of their books, perhaps published by Rizzoli, is being promoted in the bookstore below. The photographic works of Ruth Orkin, O.E. Goldbeck, Monte Nagler, Jaye King and Emily Grimes have recently been shown in the gallery. After several successful shows, Nancy Swan Drew continues to be a major gallery artist.

The gallery also has shown work by Chicago designers and graphic artists. The most recent exhibition in this line has been a "Made in Chicago" collection of phantasmagorial lamps, furniture, paintings, etc. by Corky Neuhaus and Paul Punke, featuring trompe-l'oeil style painting and unique designs.

Betsy Rosenfield Gallery 212 W. Superior St., Chi-
357 cago, IL 60610 (312) 787-8020; Tue-Fri: 10-5:30 Sat: 11-4:30; owner/dir: Betsy Rosenfield

Founded in 1980, this energetic gallery handles contemporary painting and sculpture. A collection of pieces by contemporary American artists working in glass is a particularly felicitous aspect of the gallery.

Betsy Rosenfield exhibits a strong group of Chicago artists. Don Baum uses the form of a house constructed with found materials in three dimensions to evoke complex associations of city life, memory and social relations. Mark Jackson's realistically painted human figures appear in interior, psychological situations. Noraldo de la Paz creates brightly colored figurative painting, in addition to his figurative sculpture. Joseph Hilton's paintings explore mythological themes.

Glass artists shown at the gallery are Dale Chihuly, Joel Philip Myers, Dan Daily, William Morris and William Carlson, as well as Harvey Littleton, considered the founder of the modern art glass sculpture. Works range from small pieces to extensive sets and very large non-functional vessels. The gallery also shows ceramic artists Rod Nagle and Tom Rippon, and furniture maker Alan Siegel.

In collaboration with the Robert Miller Gallery in New York, Betsy Rosenfield Gallery shows the work of Louisa Chase, Roberto Juarez, and Jedd Garet, who work in current idioms associated with the "new figuration." California

artists Susan Adan and Michael Stevens are also featured.

J. Rosenthal Fine Arts, Ltd. 212 W. Superior St.,
358 Chicago, IL 60610 (312) 642-2966; Tue-Fri: 11-5:30 Sat: 12-5; owner: Dennis Rosenthal dir: B. Flynn

The gallery features contemporary art by celebrated masters as well as prominent new and local artists.

Among the artists contemporary art by celebrated masters as well as prominent new and local artists.

Among the artists whose work is exhibited are contemporary realists Manon Cleary, Audrey Frank, John Deom, Harold Sudman and Dennis Wojtkiewicz; figurative expressionists Dan Gustin, Roy Kinzer and Judith Roth; abstract figurist Thomas Hilty; and color field artists Richard Cramer and Elaine Kurtz. Sculptors at the gallery include Robert Winslow, who works in stone, and Rosalind Shaffer, who works in wood.

The School of the Art Institute of Chicago Gallery
359 Columbus Dr. at Jackson Blvd., Chicago, IL 60603 (312) 443-3703; Mon-Sat: 10:30-4:15 Thu: 10:30-7:30 Sun: 12-4:15; owner: SAIC dir: Joyce Fernandes

The SAIC Gallery presents works by students and faculty of this distinguished art school, as well as special exhibitions. There is a continuous stream of imaginative and experimental works through the light, airy space attached to the Art Institute. Entrance is easiest through the Columbus Drive East Wing, where after passing the Louis Sullivan Trading Room the visitor arrives at the gallery. Established in 1976 as the permanent exhibition space for the school, the gallery was completed through the Centennial Fund Project which made the new building possible.

As director of the gallery Joyce Fernandes curates the exhibitions jointly with the faculty Committee on Exhibitions and Events. Although many exhibitions draw on the talent that abounds in the school's studios, some bring in work from the outside. A recent exhibition , *The Greater Troubles of the Human Race,* displayed prints, drawings, masks and giant puppets by the internationally known Bread and Puppet Theater, in conjunction with performances at Chicago's Goodman Theater.

SAIC Superior St. Gallery 341 W. Superior St., Chi-
360 cago, IL 60610 (312) 443-3886; Tue-Sat: 10-5 Aug: closed; dir: Joyce Fernandes

Located in the midst of Chicago's burgeoning gallery enclave, the SAIC Superior Street Gallery focuses on the work of M.F.A. candidates at the School of the Art Institute of Chicago. Small group shows are selected by a faculty Exhibitions and Events Committee and invited Chicago art professionals (curators, dealers or critics).

The school's excellent M.F.A. program is highlighted at the Superior Street Gallery. While traditional media may be used, this is clearly a place where new idioms are being forged and honed by public exposure. Performance events not infrequently spill out into the street.

The gallery is staffed by graduate students

under the direction of Joyce Fernandes, Director of Exhibitions.

Samuel Stein Fine Arts 620 N. Michigan Ave., Chi-
361 cago, IL 60611 (312) 337-1782; Mon-Fri: 10-5:30 Sat: 10:30-5; owner/dir: Samuel Stein

With a commitment to aquatints, etchings, lithographs and serigraphs, the gallery offers a strong selection of works by 20th century masters. Works found in the gallery, which has relatively few of the pieces actually on view, are made by Marino Marini, Miro, Calder, Toulouse-Lautrec, Robert Motherwell, Carol Summers, and other artists of comparable reputation and quality. Stein also shows works by lesser-known artists, and upcoming local talent.

Recent exhibitions—there are about four a year—have included works by Robert Natkin, Marc Chagall, Joan Miro and Paul Jenkins, an American abstract artist who creates vivid abstractions suggestive both of chance and control, using veils of overlapping color.

The place is uncluttered and has an inviting atmosphere. Browsers are welcome, although since most works are not on display one has to ask to see specific works.

Galleries Maurice Sternberg 612 Michigan Ave.,
362 Chicago, IL 60611 The Drake Hotel Arcade, N. Michigan Ave. at Walton St. Chicago, IL 60611 (312) 642-1700 (both locations) owner: M. Sternberg dir: J. Sternberg

Specialists in American and European painters of the 19th and 20th century, Galleries Maurice Sternberg has been called a "mini-museum" for the quality and diversity of its collections. Genre and Impressionist schools from both Europe and America are particularly well represented.

The gallery carries French paintings by Eugene Galien Laloue, Georges Stein and Victor Gilbert. The gallery is premiere source for French Impressionist Henri Le Sidaner. Other important French paintings are available by Henri Martin, Firmin-Girard, Lhermitte, Ziem and Edouard Cortes.

In the American collection, works are available by John George Brown, Reginald Marsh, Edward Redfield, Gardner Symons and Harry Roseland. There are also Western paintings by Oscar Berninghaus, E. Irving Couse and Frank Tenney Johnson, as well as works by William McGregor Paxton, Gilbert Gaul and Paul Jenkins.

Van Straaten Gallery 361 W. Superior, Chicago, IL
363 60610 (312) 642-2900; Mon-Sat: 10-5; owner/dir: William van Straaten

This award-winning, cheerful place offers an enormous selection of original prints and works on paper, as well as contemporary paintings. Works by nearly 500 artists fill the inventory, and styles and statements vary signif-icantly. The gallery emphasizes work by artists who are recognized nationally and internationally, although some new and relatively unknown artists are also exhibited.

The most complete source for original prints and drawings in Chicago, van Straaten carries works by David Hockney, Jasper Johns, Helen Frankenthaler, Jim Dine, Robert Motherwell, Claes Oldenburg, Robert Rauschenberg, James Rosenquist, Pat Steir, Jan Hashey and T.L. Solien.

Recent shows have included Pat Steir, new paintings; James Rosenquist, paintings and prints; and Robert Rauschenberg, paintings and works on paper.

Worthington Gallery 233 E. Ontario, Chicago, IL
364 60614 (312) 266-2424; Tue-Sat: 10-5:30; owner/dir: Eva-Maria Worthington

Showing international artists exclusively, the gallery shows a variety of 20th century styles in a wide range of media, mostly paintings, drawings and prints.

German Expressionism is a strong area of interest at the gallery, particularly works by artists associated with the *Blaue Reiter* group. Founded by Wassily Kandinsky, Franz Marc, Gabriele Munter, August Macke and Alfred Kubin, this group showed works by many European artists in its exhibitions, including French colorist Robert Delaunay, before disbanding during the First World War, following the deaths of Marc and Macke.

The gallery also carries sculpture by the Expressionists, and by American artist Gaston Lachaise. Contemporary artists shown include German artist Horst Janssen, whose books, drawings, graphics and posters are in a New Expressionist style; Ynez Johnston, sculpture, paintings and graphics; Jane Egan, box assemblages; and Hildegard Auer, oil paintings.

WPA 2013 W. North Ave., Chicago, IL 60647 (312)
365 278-9724; Thu: 1-8, Fri-Sat: 1-5 Aug-Sep: closed; dir: Chuck Eaton

Named in honor of the Works Progress Administration and with humorous reference to a guiding motto of the gallery, "we put up anything," WPA is an experiment whose history of success takes the peculiar path of changing it from a privately owned gallery into a cooperative. Soon-to-be-ex-owner Chuck Eaton explains that the gallery is based on the idea that artists can decide best what art should be exhibited, and in doing so they can communicate more directly with the art-conscious public.

WPA shows include open exhibitions, where all works brought to the gallery are hung (as long as there's room), survey shows of three artists each, and three one-person shows annually. Artists active in the gallery decide among themselves who is to be featured in survey and one-person shows. The gallery has also been active in the neighborhood, which includes many artists' studios, with its "Wicker Park Design Competition" and "Neighborhood Show."

The nine artists who have so far been chosen for one-person shows are evenly divided between men and women, include two photographers, and produce work that tends to express both social and aesthetic concerns, often employing the human figure, but with an abstract awareness of form and materials. The artists are Monika Bruder, Henry Davilas, Linda Ansay, Chris Million (1951-1982), Deborah Bright, Ray Bemis, Don Clanton, John Schacht and Henry Friedman.

Walton Street Gallery 58 E. Walton St., Chicago, IL
366 60611 (312) 943-1793; Mon-Fri: 9:30-6 Thu: 9:30-8 Sun: 12-5; owner: Circle Fine Art Corporation

See listing for Circle Gallery, Chicago, IL.

Michael Wyman Gallery 300 W. Superior, Chicago,
367 IL 60610 (312) 787-3961; Mon-Sat: 12-5:30

Unique among Chicago galleries in its area of specialization, the gallery deals exclusively in Primitive and Ancient art: the traditional arts of tribal Africa and Oceania, and the archaic arts of the Mediterranean basin and the Near East. Exhibitions range from ancestral fetishes from the old Belgian Congo, to Indonesian magic divination wands, to marble and terra cotta sculpture from Hellenistic Greece.

A visit to this modern second-floor gallery presents a strong argument toward redefining one's sense of artistic sophistication. Arrayed against severe white walls, isolated on pedestals, each piece of sculpture creates its own space, an aura of the world of which it was once an integral part. Mute testimony of other ways of seeing and understanding the world, these objects reveal an art of ceremonial purity energized by myth and ritual.

A reference library aids in research, documentation and informal discussion with clients. The gallery provides appraisal, authentication and consultant services.

Yolanda Fine Arts 300 W. Superior St., Chicago, IL
368 60610 (312) 664-3436; Tue-Sat: 10-5; owner/dir: Yolanda Saul

With locations in Chicago and Winnetka, Illinois, Yolanda Fine Arts specializes in 20th century naive and folk painters—untrained and unschooled—from America, Europe and Asia.

The featured artists work in fabric, carved wood, oil on canvas, watercolor, acrylic on canvas and board, and mixed media collage and assemblage. The collection includes decorative and "outsider" pieces depicting such subjects as work and leisure on farms, in small towns and villages, and in cities around the turn of the century; animal imagery; Biblical, mythological, legendary and personal allegories, fantasies and memories. Artists include Andre Duranton, Josephus Farmer, Cilly Gascard, Sister Gertrude Morgan, Marcia Muth, Mattie Lou O'Kelly, Linda Ominsky, Julian Parada and others. A catalog with resumes of the artists is available from the gallery.

Also featured are the Jinshan Peasant Painters of the People's Republic of China, whose colorful paintings portray modern rural life in China. Yolanda Fine Arts also handles ceramics by Picasso, an artist powerfully influenced by primitive and folk art.

Donald Young Gallery 212 W. Superior St., Chicago,
369 IL 60610 (312) 664-2151; Tue-Fri: 10-5:30 Sat: 11-5:30; dir: Donald Young

The Donald Young Gallery features contemporary American painting and sculpture by Bruce Nauman, Martin Puryear, Sol LeWitt, Robert Ryman, Robert Mangold and Sylvia Plimack Mangold. Bruce Nauman and Martin Puryear recently completed outdoor sculpture projects at Governors State University in Illinois. In addition to his well-known Minimalist dissections of the cube, Sol LeWitt has created a series of participatory wall drawings executed by people other than the artist. A 97 by 72 foot outdoor wall sculpture by LeWitt will be installed in Chicago's Loop beginning in 1984.

Other major artists whose development stems from the 50s and 60s are also shown. For example, an exhibition of Jim Dine's paintings and drawings from the 1960s included important examples of the artist's early work anticipating many current developments in art.

The gallery has also exhibited works by European 20th century masters, confirming its commitment to presenting a diversity of work of rigorous aesthetic quality and significance in its influence on art today.

The Zaks Gallery 620 N. Michigan Ave., Chicago, IL
370 60611 (312) 943-8440; Tue-Fri: 11-5:30 Sat: 12-5 July: closed Sat Aug: closed; dir: Sonia Zaks

A relatively small but active gallery founded in 1977, the Zaks Gallery exhibits work by contemporary American painters and sculptors. Most of the artists featured are from Chicago and vicinity. The work is highly professional and in some cases has been identified with the city itself stylistically, as Chicago Imagists and New Expressionists have gained national prominence.

Painter Paul LaMantia's strongly colored, distorted and fragmentary figures recall images dredged up from the subconscious. David Sharpe, another artist identified with the city, also paints the human figure, but with distortions and textures that recall Cubist analysis rather than psychoanalysis. Other accomplished painters shown in the gallery are Ben Mahmoud and Richard Wetzel.

Provocative environments by George Klauba and limestone sculpture by William Willers can also be viewed in the Zaks Gallery.

Zolla/Lieberman Gallery 356 W. Huron St., Chi-
371 cago, IL 60610 (312) 944-1990; Tue-Sat: 11-5:30; owner/dir: Robert Zolla, Roberta Lieberman

Located in an ample converted factory space, the gallery shows all forms of contemporary art.

The gallery represents a host of young, increasingly well-known artists, work in a wide variety of styles, materials and techniques. Edgar Buonagurio uses heavily layered paints which he grinds down to give a stained glass effect. Arie Galles creates color-calibrated aluminum-tube wall sculptures. Susan Doremus paints large decorative art canvases, similar in spirit to Dennis Neckvatal's highly patterned paintings and Jim Perry's polystyrene wall sculptures. Laddie John Dill has several glass, marble and plaster constructions at the gallery. Internationally known sculptor Loren Madsen works with timber and cables in creating large pieces that paradoxically defy and define space. Horses of sticks, mud, plaster, papier-mache and other materials, by Deborah Butterfield, stand out prominently in the gallery.

The gallery also features John Buck, paintings on wood; Clinton Hill, fiberglass-over-canvas pieces and works on paper; Dean Snyder, eccentric wood geometric pieces; and Terence Karpowicz, beautifully crafted maquettes for sculpture. New additions to the gallery include Terence La Noue, a master of painted tapestries; Chema Cobo, a leading Spanish New Figurative painter; and Edward Larsen, a politically ori-

ented artist working in marble sculpture and quilt-tapestries.

EVANSTON

Billy Hork Galleries 1621 Chicago Ave., Evanston,
372 IL 60201 (312) 492 1600; Mon-Sat: 11-7 Sun: 12-6; dir: Billy Hork

See listing for Chicago, IL.

Mindscape Gallery 1521 Sherman Ave., Evanston, IL
373 60201 (312) 864-2660; Tue-Sat: 10-6 Thu: 10-9 Spring/Summer: Sun: 1-5; owner/dir: Ron Isaacson, Deborah Farber

Mindscape abounds with beautiful contemporary American crafts by approximately 350 artists from 45 states. Browsing is encouraged, and there is an enormous selection of objects which are mostly non-traditional and range from small functional items such as goblets and perfume bottles to avant-garde neon sculpture and large-scale tapestry.

Founded in 1974 to display innovative crafts, the gallery opened a second location, The Mindscape Collection (see Chicago listing), in downtown Chicago in 1983. Sculpture, blown and fabricated glass, handmade ceramics, jewelry, woodwares, fibers and wallhangings fill the large, dramatically displayed showroom.

All artists displayed must pass a five-person selecting jury. Exhibitors include both newcomers and nationally recognized talents, offering the public one of the largest and most varied selections of contemporary crafts in the United States today.

Neville-Sargent Gallery 509-511 Main St., Evanston,
374 IL 60202 (312) 328-9395; Mon-Fri: 10-6 Thu: 10-8 Sat: 10-5; owner/dir: Don & June Sargent

Opened in 1974, the gallery sells paintings, sculpture, graphics and leather wall hangings from South Africa, with a major interest in developing corporate art collections.

Neville-Sargent publishes posters and prints. Artists represented are from France, South America and Spain, as well as from the Chicago and the Midwest.

One of the featured artists at the gallery is David Faber, a printmaker whose work often contrasts strong graphics with mixed media. Faber does lithographs, etchings, and monotypes (one-of-a-kind prints). Neville-Sargent Gallery and the Atelier Ymagos of Sao Paulo, Brazil, sent Faber to South America. Ten lithograph editions, as well as posters, were the result of this collaboration.

Other gallery artists include Lu Dickens, handmade paper; Beatrice Bosch, of South Africa, leather tapestries; Glenn Bradshaw, casein and watercolor on rice paper paintings; as well as Chicago-area artists and teachers Harry Breen and Edward Betts; Graham Clarke of England; Paco Sanchez of Sevilla, Spain; and Eduardo Iglesias of Sao Paulo, Brazil. The gallery also shows work by Michigan sculptor Derek Wernher; Chicagoans Jackie Sullivan, Kathleen Eaton, Melinda Stickney-Gibson, Richard Borso, Marge Allegretti and Bruce Campbell; and California artists Don Irwin and Daniel Joshua Goldstein.

HIGHLAND PARK

Eva Cohon Gallery 2057 Greenbay Rd., Highland
375 Park, IL 60035 (312) 432-7310; Mon-Sat: 10-4;
owner/dir: Eva Cohon

This spacious suburban gallery offers a broad
range of international contemporary art. Both
world-famous and lesser-known artists are shown
by director Cohon, who travels throughout the
world in search of good art. All media are repre-
sented at the gallery, with an emphasis on paint-
ings and works on paper.

The gallery had the first American showing
of the Spanish artist Gardy-Artigas. A student
and collaborator with Miro on his ceramics, Arti-
gas works his sculpture in metals and ceramics
and does drawings in mixed media. Cohon ar-
ranged for the first one-person showing of Aus-
trian artist Gottfried Mairwoeger, a recent win-
ner of the prestigious Otto Mauer award.

The gallery carries a fine collection of origi-
nal prints. Cohon's Miro aquatints are outstand-
ing and extensive. The print collection includes
Alexander Calder, Sam Francis, Robert Natkin,
Italian Pop artist Valerio Adami, and Spanish
Informalist Antoni Tapies.

The gallery also displays many original sculp-
tures, including the works of British artist Lynn
Chadwick, Sorel Etrog and Kieff. Of particular
interest are the acrylic plastic works of Vasa.

There are a number of other notable works in
the gallery, including wrapped drawings by
Christo; oils by Clarence Measelle; paintings by
Alice Baber, George Snyder and James Yun
Yohe; ceramic wall reliefs and works on hand-
made paper by Margie Hughto; and tapestries by
Spanish artist Josep Royo, to note just a few.

NORTHBROOK

Circle Gallery-North 1070 Northbrook Court, North-
376 brook, IL 60062 (312) 564-5860; Mon-Fri:
9:30-6 Thu: 9:30-8 Sun: 12-5; owner: Circle Fine
Art Corporation

See listing for Circle Gallery, Chicago, IL.

PEORIA HEIGHTS

Tower Park Gallery 4709 N. Prospect Rd., Peoria
377 Heights, IL 61614 (309) 682-8932; Mon-Fri:
10-8 Sat: 10-5 Sun: 1-5; owner/dir: Jacqueline
Buster

20th century painting and graphics, primarily in
representational modes, are exhibited by the
gallery.

Artists whose work is exhibited include
American realists Robert Kipniss, Harold Alt-
man, Philip Pearlstein and Randall Higdon. Kip-
niss is known for his landscapes. In his small
format, impressionistic etchings of figures in ur-
ban park settings Altman demonstrates a precise
and luminous modeling of volume with hatched
lines and aquatint. His color lithographs, notably
of market scenes, continue his preoccupation
with light. Chicago artist Susan Hunt-Wulkowicz
works in graphic media, creating imaginary land-
scapes and interiors in a realist style. The expres-
sionistic works of Thom Kapheim, whose pastel
drawings portray figures and animals in the same
settings, and the abstractions of Glenn Bradshaw
are also shown.

SKOKIE

Prestige Galleries 3909 W. Howard St., Skokie, IL
378 60076 (312) 679-2555; Mon-Wed: 10-9 Sat-Sun:
11-5 Thu-Fri: by appt; owner/dir: Bernard &
Betty Schutz, Louis Schutz

Unpresumptuously located in a plain section of
Skokie, this family-run gallery offers three floors
of paintings, prints, sculptures and assorted ob-
jets d'art.

When it first opened over 25 years ago, the
gallery dealt exclusively in 18th and 19th century
art. Today the lower level "museum" carries an
extensive collection of antique paintings. The
mostly romantic, narrative canvases are painted
by such artists as Harry Campotosts, Arthur Tre-
vor Haddon, James Thom, G. Sheridan, C.
Payen, Luigi Zuccoli, P. Fligny, and well as
several Dutch masters. The gallery also features
a host of bronzes and other objects.

The first-floor gallery features contemporary
work, particularly original graphics and paint-
ing. The graphics collection, directed by Louis
Schutz, includes works by such artists as Vic-
tor Vasarely, Norman Rockwell, Salvador Dali,
Marc Chagall, Leroy Nieman, Will Barnet and
Yamagata. Most of the paintings are decor-
ative. Richard Zolan, Androgert, Proferio
Grossi, Jacques LaLande and Karen Schaefer
are a few of the better-known names in this
collection. The soft, impressionistic works of
Edna Hibel are given a special space in the
gallery.

Prestige is the exclusive world agent for
"The Surrealistic World of Tito Salomoni," pre-
senting his internationally known paintings,
prints and bronzes. The gallery also handles Erte
bronzes, as well as graphics, posters and jewelry
by the French *art nouveau* designer.

A private gallery on the upper floor displays
the family collection which ranges from restored
Tiffany lamps to still lifes by Henk Bos, and an
alabaster statuary group of the family by Sandra
Sloane.

WINNETKA

Yolanda Fine Arts 542 Lincoln Ave., Winnetka, IL
379 60093 (312) 664-3436; Tue-Sat: 10-5; owner/
dir: Yolanda Saul

See listing for Chicago, Illinois.

INDIANA

FORT WAYNE

Artlink Contemporary Artspace 1126 Broadway,
380 Fort Wayne, IN 46802 (219) 424-7195; Tue-Fri:
12-5 Sat: 10-4; dir: Lee Bailey

Artlink is a nonprofit organization incorporated
in 1978 and dedicated to showing the works of
contemporary local, regional and national artists.

Artists who have been featured at Artlink
include George McCullough, a contemporary
impressionist; Marti Svoboda, an artist from La-
fayette, Indiana, well-known for her ceramic
art; Linda Summers, an internationally known
weaving artist from Aspen, Colorado; and Lois
Main Templeton, an internationally known ab-
stract painter from Indianapolis, Indiana.

Recent group shows have highlighted works from painters Russell Oettel, Bob Milligan, Marilyn Bock-Tobotski, Carl Miller and H.A. Biggs, ceramist James Feninger, and printmaker Howard Hitzemann.

Thomas Smith Fine Art 6521 Monarch Dr., Fort
381 Wayne, IN 46815 (219) 493-3009; Mon-Sun: 10-5 by appt; owner/dir: T. Smith

Emphasis of the gallery is on prints, Multiples, and works on paper by major contemporary and emerging American artists working in all modes of imagery.

Artists featured by the gallery include Ed Baynard, Stanley Boxer, Ronald Davis, Richard Diebenkorn, Jim Dine, Willem de Kooning, Mark di Suvero, Helen Frankenthaler, Nancy Graves, Michael Heizer, David Hockney, Donald Judd, Roy Lichtenstein, Joan Mitchell, Malcolm Morley, Robert Motherwell, Kenneth Noland, Alan Shields, Richard Smith, Carol Summers and others.

One may also encounter works by Steven Sorman, known for his ingenious and elegant prints, drawings and paintings, as well as by David Shapiro, whose contrasted images of random and ordered markings induce a contemplative frame of mind. In the last several years the gallery has shown prints by such important new artists as Louisa Chase, Valerie Jaudon, Robert Longo and Susan Rothenberg.

INDIANAPOLIS

Editions Limited Gallery, Inc. 8702 Keystone Cross-
382 ing, Indianapolis, IN 46240 (317) 848-7878; Mon-Sat: 10-6 Thu: 10-8:30 Sun: 1-5; president/dir: Eva Bogar

The concentration of the gallery is on contemporary regional artists working in a variety of media, including painting, sculpture, drawings, ceramics and fiber works. Works by nationally and internationally known printmakers are always available as well.

Regional artists exhibited regularly in the gallery include painters Amanda Block, Nanci Blair Closson, William DeHoff, Phyllis Fannin, James Faust, Peter Kitchell, Walter Knabe, John Kortlander, Margie Marx, Rob O'Dell, Dennis Puhalla, Harriet Shorr and Robert Williams.

Featured ceramists include Julia Blackburn, Jeffrey Chapp, Leanne Ellis, Marjorie Levy and Marti Svoboda. Works by fiber artists Pamela Becker, Laura Militzer Bryant and Sherri Smith are also exhibited.

The gallery exhibits original prints by Harold Altman, Alvar, Will Barnet, Robert Kipniss, Steven McMillan, David Mayer, Jurgen Peters, Joe Price, Nicola Simbari, Carol Summers, Bruce Weinberg and Charles Wolters. Most of these artists work in representational styles.

IOWA

DES MOINES

Percival Galleries, Inc. 210 Shops Building, Des
383 Moines, IA 50309 (515) 243-4893; Mon-Fri: 10-5 Sat: 11-4; owner/dir: Bonnie Percival

Concentration is on contemporary American and European prints, watercolors, oils, sculptures and tapestries.

Original prints are available by Robert Rauschenberg, David Hockney, Sol LeWitt, Helen Frankenthaler, Geer Van Elk, Richard Lindner, Arakawa, Christo, Claes Oldenburg, Martin Disler, Tom Wesselman and A.R. Penck.

Iowa artists featured at the gallery include Karen Strohbeen and Bill Luchsinger, prints and sculptures; Frank Miller, Wendell Mohr, Richard Leet, Jo Myers and Elizabeth Miller, watercolors; Elizabeth Miller, Judith Whipple and Gene Hamilton, acrylics. Gene Hamilton and Carrie Hamilton produce original prints, while Jean Graham makes clay vessels.

Nationally known artists whose work is displayed include Ulfert Wilke, David Coolidge, Larry Stark, Lloyd Menard and Bruce Stillman.

MARSHALLTOWN

Fernette's Gallery of Art Hwy. 30 West, Marshall-
384 town, IA 50158 (515) 753-7322; Mon-Fri: 10-5 Sat: 10-4; owner/dir: Fernette Smith

The gallery specializes in contemporary graphics (1960 to the present) by well-known artists. Unique works, including oils, watercolors, drawings and sculpture make up a smaller part of the gallery's collection.

American contemporary artists featured in the graphics collection include Roy Lichtenstein, Paul Jenkins, Carol Summers, Joseph Raffael, Frank Gallo and Robert Kipniss. Representative works by such internationally famous artists as Joan Miro, Rufino Tamayo, Victor Vasarely, Bruno Bruni, Alvar Sunol, Salvador Dali and Paul Fairley are also present in the collection.

The gallery features works by Barbara Vaske, a sculptor who works in life-size aluminum mesh sculpture and focuses on the modern ''costumes'' we clothe ourselves in. the gallery has a collection of varied graphics and unique works by the Japanese artist Shigeki Kuroda, known for his images of bicycles and umbrellas.

WEST DES MOINES

Olson/Larsen Galleries 203 MQ9, West Des Moines,
385 IA 50265 (515) 277-6734; Tue-Fri: 11-5 Sat: 11-4; owner/dir: Marlene Olson

The Olson/Larsen Galleries shows contemporary works of art in all media, offering a broad range of exhibitions to meet the needs of an area with few dealers or galleries.

Well-known regional artists are prominently featured in the gallery, as well as emerging artists from Iowa and other parts of the country. Among the works shown are paintings by Robert Bauer, engravings and other graphics by Amy Worthen, and paintings by Florence Kawa.

KANSAS

KANSAS CITY

Douglas Drake Gallery 4500 State Line, Kansas City,
386 KS 66103 (913) 831-3880; Sat: 11-5 & by appt; owner: Douglas Drake dir: Elisabeth Kirsch

The Douglas Drake Gallery focuses on contemporary American art, including conceptual, figurative, and abstract painting and sculpture, as

well as photography and ceramics. Major contemporary artists and well-known regional artists are featured.

Works are available by many important abstract painters, notably Robert Motherwell, Kenneth Noland, Robert Natkin, and Dan Christensen. Conceptual artists such as John Baldessari, Allan McCollum and Cindy Sherman—known for her disturbing series of self-portrait personae—are also shown. The gallery also exhibits works by well-known ceramic artists such as William Daley, Elsa Rady and Betty Woodman. Group shows have included work by outstanding East and West Coast artists such as Richard Diebenkorn, Helen Frankenthaler and Robert Longo.

The gallery exhibits work by the best-known regional painters: landscapes by Barbara Frets, abstract paintings by Kansas City Art Institute faculty members Warren Rosser and Ron Slowinski, sculpture by University of Missouri professor Louis Cicotello, conceptual painting by Shea Gordon, abstract photography by John Gutowski, and expressionist figurative works by Tony Naponic.

In The Spirit Gallery 1911A W. 45th St., Kansas
387 City, KS 66103 (913) 262-3377; Tue-Sat: 10:30-5; owner/dir: Tippy Fuchs

Concentration is on art of the American Southwest and Midwest, including Indian and Western subjects and landscape.

Several noted Southwest artists are featured by the gallery. Santa Fe artist Dolona Roberts has gained renown for semi-abstract oil paintings, serigraphs and monotypes on themes from Native American culture. One may also encounter oil landscapes by Tom DeDecker, acrylics, serigraphs and painting on fabric by Jacqueline Rochester, bronzes by Jack Woods, oil painting by Dan Bodelson, and lithographs by Frank Howell, as well as watercolors and acrylics by Donal Jolley and watercolors and oil paintings by Marjorie Rodgers.

In addition the gallery shows watercolors and etchings by Linda Okatch Brown, bronzes by Becky Clark, and oil paintings by Hal Holoun.

MANHATTAN

Strecker Gallery 332 Poyntz, Manhattan, KS 66502
388 (913) 539-2139 Mon-Sat: 10-5; owner: Julie Strecker dir: Kate Cashman

Specializing in contemporary regional artists, the gallery also handles internationally known printmakers.

Regional artists include Margo Kren, Philip Hershberger, Diane Lawrence, Mary Palffy, Yoshiro Ikeda, Mike Henry, Judi Kellas and Edward Pennebaker. The gallery also shows many artists who are not well-known, but who have achieved noteworthy skill and power of expression.

TOPEKA

Jan Weiner Gallery 3014 Eveningside, Topeka, KS
389 66614 (913) 272-5535; by appt; owner/dir: Jan Weiner

At the Jan Weiner Gallery the accent is on contemporary abstract artworks—large canvases, paper works, mixed media, and monotypes.

Most of the artists shown are from the Kansas-Missouri region, but the gallery also features non-objective artists from Texas, New Mexico and other regions. The gallery is attentive to the needs of emerging artists, and tries to actively promote new works. With many of its clients in the corporate as well as the private sector, the gallery specializes in art placement with an emphasis on environmental installation.

Among the artists featured is Michael Stowe, whose muted canvases, assembled in assymetrical geometric shapes, consist of parallel horizontal bands of brush strokes which recall stratus clouds or prairie grasses. Other artists presented by the gallery include Colette Bangert, Shellie Bender, Philomene Bennett, Aggie Beynon, Barbara Frets, James Groff, Philip Hershberger, Zanne Hochberg, Dalton Howard, Jim Hunt, David Jansheski, Sandy Kinnee, Margo Kren, Jerry Lubensky, Jim Malone, Lou Marak, David McCullough, Philip Mullen, Edward Navone, Don Perry, Barbara Reser, Warren Rosser, Yvonne Rosser, Roger Routson, Robert Russell, Jayne Schell, Carlos Setien, Roger Shimomura, Richard Slimon, Ron Slowinski, Michael Smirl, George Thompson and Michael Tichansky.

WICHITA

The Wichita Gallery of Fine Art 100 N. Broadway,
390 Wichita, KS 67202 (316) 267-0243; Mon-Sat: 10-5; owner/dir: Robert Riegle

Featuring nationally recognized artists in all media, the Wichita Gallery of Fine Art presents original works of contemporary realism.

Leading contemporary impressionists shown include members of the National Academy of Western Art Walt Gonske, Rod Goebel, John Free, William F. Reese, as well as Robert Daughters, Ray Vinella, Ron Barsano, Julian Robles, Caroline Norton, James Pilatos and Bill Harrison.

Watercolorists shown include Doran Barham, Frederic James, Cal Dunn, Jayne Kiskadden, Paula Plott and Jack O'Hara. Buffalo Kaplinski and Douglas Atwill are known for their strong work in acrylics. Dan Rippe and Leonard Wren are versatile painters exploring a range of themes and interpretations.

KENTUCKY

FRANKFORT

Capital Gallery of Contemporary Art 314 Lewis
391 St., Frankfort, KY 40601 (502) 223-2649; Tue-Sat: 10-5; owner/dir: Cecelia Hromyak & Ellen Glasgow

Capital Gallery strives for a regional flavor or viewpoint while reflecting national currents of American art. Both non-representational and traditional realist painters and printmakers are featured. The gallery also occasionally exhibits pottery.

Prints are available by Robert Kipniss, Richard Zieman and Gordon Mortensen, who are known for their landscapes.

Of the other artists shown, Diane Tesler works in realist oils and pastels. Kathleen Middleton pulls small editions of luminous aquatint

etchings which reflect the American landscape. Ellen Glasgow's impressions of landscape in large scale oil paintings strive to reflect the meeting of land, sky and sea. David Hare's patterned watercolors of landscape and still life are handled in broad swatches of color. The gallery also features intaglio prints by Meredith Dean, naive oil paintings by Lynne Loshbaugh, and woodcuts by Phyllis Cohen.

LEXINGTON

Cross Gate Gallery 219 E. High St., Lexington, KY
392 40507 (606) 233-3856; Mon-Fri: 10-6 Sat: 10:30-4; owner/dir: Greg Ladd

The gallery specializes in 19th and 20th century sporting art with emphasis on European equine art.

British artists featured include Michael Lyne, Lionel Edwards, Peter Curling, Peter Biegel, John Skeaping and Sir Alfred Munnings. Contemporary American artists are George Claxton and Katie Sutphin, among others.

Skydome Gallery 251 W. 2nd St., Lexington, KY
393 40507 (606) 252-8871; Mon-Thu: 9-9 Fri-Sat: 9-5 Sun: 1-5; dir: Marcia Freyman

Concentration of the gallery is on area and regional artists working in a variety of media and styles. The Skydome Gallery specializes in showing emerging , but as yet unknown regional artists.

LOUISVILLE

Byck Gallery 606 W. Main St., Louisville, KY 40202
394 (502) 587-1646; Mon-Fri: 10-4 Sat: 11-3; owner/dir: Marilyn Byck Grissom

Concentration is on 20th century artists in painting, sculpture and graphics. Most of the artists shown work in non-representational styles, though some work in contemporary realist styles.

Mary Ann Currier's oil paintings and pastels include realistic still lifes whose frontal composition recalls the school of Spanish master Zurbaran. Alan Kluckow's meticulous realism reaches for the limits of exact vision. Sally Michel Avery paints in the luminous style of Milton Avery, striving for formal simplicity. Peter Rockwell casts impressionistic bronzes and carves abstract pieces in stone. Clifford Ross paints in both abstract and representational modes, and makes lifesize female figures in lead, bronze and gold leaf. Sculptor Paul Fields carves abstract pieces in wood and marble. English painter John McLean creates lyrical abstractions on canvas and paper.

The gallery also shows fine prints by such major artists as Ernest Trova, Pablo Picasso, Jim Dine, David Hockney, Richard Diebenkorn, Jasper Johns, Josef Albers, Milton Avery, Robert Motherwell, Helen Frankenthaler, Joan Miro, Jean Dubuffet, Henri Matisse and others.

Contemporary Crafts Gallery ArtsSpace, 2003 Frank-
395 fort Ave., Louisville, KY 40206 (502) 896-1911; owner: Frederick A. Merida & Charles L. Weisberg dir: Christina A. Coke

The gallery promotes, exhibits and sells fine crafts in clay, fiber, glass, metal, wood and mixed media by professional craft artists, both regional and national.

Changing exhibitions have featured works by gallery artists: Curtis and Suzan Benzle, Lin Fife, Walter Hyleck, Tim Mather, John McNaughton, Michael Nourot, Don Pilcher, Fred Shepard, Steve Smyers and Budd Stalnaker.

Recent group invitationals include a national "teapot" exhibition, and a "National Endowment for the Arts Craft Fellows Exhibition" with fine work in all craft media by twenty-four grant recipients of the 1983 award period.

Matchmaker Gallery ArtsSpace, 2007 Frankfort
396 Ave., Louisville, KY 40206 (502) 896-2331; Mon-Sat: 10-5; owner/dir: Yvonne Rapp

A gallery dedicated to diversity of style among contemporary artists, the Matchmaker Gallery exhibits paintings, drawings and small sculpture. The gallery's unusual space-sharing arrangement with the Merida Gallery is an example of conviviality with few parallels in the competitive world of galleries.

Artists whose work may be seen on a continuing basis are Sylvia J. Berger, Stephanie Baldyga-Stagg, Nancy Fletcher Cassell, Ron O. Decker, Rachel Harper, Etta Jansen, Michael Kirk, Catherine Orrok, Elizabeth Ellen Smith, Catherine S. Tuggle and Fran Watson. All these artists work in painting and drawing media. Sculptors shown at the gallery are Beverly Willett Goldstein and Albert Nelson.

The gallery actively presents promising new artists, in whom it seeks quality and diversity—and a willingness to take imaginative risks. Group shows of new talent allow the gallery to "push the edge" on what is comfortable for most viewers, while presenting innovative artists to sophisticated collectors.

Merida Galleries ArtsSpace, 2007 Frankfort Ave.,
397 Louisville, KY 40206 (502) 896-2331; Mon-Sat: 10-5; owner/dir: Frederick A. Merida

Concentration of the gallery is on regional artists, who are shown in one-person exhibitions. Nationally known artists are also represented and exhibited. In addition, the gallery has a selection of 19th century European and American paintings.

Merida shares six rooms with Matchmaker Gallery. The two galleries also share each other's time, experience, and gallery duties. The space is divided according to the needs of the moment, with each gallery maintaining its collections and list of artists represented separate.

Regional artists featured by Merida include Robert Jones Foose, John Michael Carter, Robert Lockhart and Tom Butsch. The gallery has mounted exhibitions of New York artists such as painter George Deem, who inserts quotations from art of the past in his work; black artist Benny Andrews, whose paintings and collages express the political struggle of the black people and the horrors of war; and Marjorie Freund.

The 19th century collection includes works by William Troost Richards, Carl Brenner, and Harvey Joiner.

Park Gallery 3932 Chenoweth Square, Louisville, KY
398 40207 (502) 896-4029; Mon-Sat: 10-5; owner/dir: Lucy Marret & Ellen Guthrie

Park Gallery specializes in unique and unusual

ceramics, glass, fabric, weaving and sculpture as well as a wide variety of two-dimensional art from the United States and some foreign countries. Styles range from primitive to contemporary.

Artists include Margery Parker of Hilton Head, South Carolina, who paints large impressionistic oils, and Guillaume Azoulay, currently living in California, whose etchings are in many museum collections.

The gallery presents many other artists from around the country, including painter Suzanne Stupka, and ceramists Sue and Russell Bolt. Watercolors by nationally recognized artist Keith Spears, and contemporary oils by emerging artists Pamela Pfister and Michael Culver are available.

Swearingen Gallery 4806 Brownsboro Center, Louis-
399 ville, KY 40207 (502) 893-5209; Mon-Sat: 10-5; owner/dir: Carol Swearingen

The gallery handles prints by 20th century American artists, and paintings and sculptures by regional artists.

The print collection features works by Will Barnet and other printmakers. There are figurative plywood constructions by Ron Isaacs, paintings by William Woodward, equestrian paintings by Henry Koehler, and ceramics by Wayne Bates.

Regional artists presenting their work in the gallery are Steve Cull, primitive painting with contemporary influences; Anne Lindstrom, ceramic columnar sculpture; Harlan Hubbard, impressionistic landscape painting, Judy Wells, abstract painting, among others.

Martha White Gallery 330 W. Main St., Louisville,
400 KY 40202 (502) 589-3347; Mon-Fri: 10-5 Sat: by appt; owner/dir: Martha White

The Martha White Gallery exhibits contemporary American paintings and sculpture, and fine prints. Many New York artists are represented in the gallery's inventory and exhibitions. Most of the works handled are abstract; some are representational.

Artists whose work may be viewed include Abstract Expressionists Friedel Dzubas, Helen Frankenthaler, Hans Hoffman and Theodore Stamos; painter and printmaker Jacob Kainen; color field painter Jules Olitski; sculptors Henry Moore, Alexander Archipenko, and Herbert Ferber; abstract illusionist James Havard; and painter Milton Avery.

Younger, emerging contemporary artists, predominantly abstract colorists, are also featured at the gallery. Some of these are Darryl Hughto, Dan Christensen, Sigrid Burton, Michael Steiner, Bayat Keerl, Kikuo Saito, Tom Goldenberg and Ronnie Landfield.

LOUISIANA

NEW ORLEANS

Monte Beall Fine Arts 5229 Camp St., New Orleans,
401 LA 70115 (504) 895-4660; by appt; owner/dir: Ms. Monte E. Beall

Monte Beall Fine Arts focuses on original contemporary art by regional and national artists, concentrating on prints, paintings and sculpture.

Casell Galleries 633 Royal St., New Orleans, LA
402 70116 (504) 522-8307; 818 Royal St., New Orleans, LA 70116 (504) 524-0671; daily: 10-7; owner/dir: Joaquin Casellas

Concentration is on etchings and silkscreen limited edition prints by local artists. A special area of the gallery is dedicated to the many festival posters printed in the New Orleans area for Mardi Gras, etc.

The gallery also carries prints by such international artists as Salvador Dali, Joan Miro, Norman Rockwell, Peter Max and Leroy Nieman.

Galleria 539 539 Bienville St., New Orleans, LA
403 70130 (504) 522-0695; Tue-Sat: 12-5 summer: closed; owner: James R. Lamantia dir: William Drummer

Galleria 539 specializes in fine architectural prints and books, including an extensive collection of works by the great 18th century Italian etcher G.B. Piranesi, whose carceri were considered a historical source of their ideas by the Surrealists. The gallery also carries 19th century Japanese woodblock prints.

Besides the *carceri*, an imaginary series of prison torture chambers, there are other works by Piranesi, including views of Rome and architectural studies.

Japanese 19th century artists such as Hiroshige, Eisen and Kunisada were famous in their own time for their landscapes, popular vignettes, studies of animals, domestic scenes and actors. Works by these masters and others in the woodblock tradition are available.

A Gallery for Fine Photography 5423 Magazine St.,
404 New Orleans, LA 70115 (504) 891-1002; Tue-Sat: 11-6; owner: Joshua Mann Pailet

A Gallery for Fine Photography specializes in 19th and 20th century photography, as well carrying a selection of posters and books. The photographs available include works by many notable American masters.

Ansel Adams's classic landscapes, perhaps the most widely known images of North American scenery, and the brilliant innovative images of Photo-Secessionists Alfred Stieglitz and Edward Steichen are displayed, along with works by American Surrealist Clarence John Laughlin, portraits by Canadian Yousuf Karsh, and works by E.O. Goldbeck. In addition, there are color landscapes by Eliot Porter, and works by such distinguished 20th century and contemporary photographers as Henri Cartier-Bresson, whose notion of the "critical moment" (probably acquired from his contact with Andre Kertesz) has become a keystone of modern photography; Berenice Abbott, famed for her documentation of New York City streets and storefronts; Hungarian born master photographer Andre Kertesz; W. Eugene Smith and Diane Arbus.

Hanson Galleries 229 Royal St., New Orleans, LA
405 70130 (504) 566-0816; Mon-Thu: 10-7 Fri-Sat: 10-11 Sun: 11-5; owner: Scott Hansen dir: Stephanie Baus

The Hanson Galleries specializes in contemporary, investment-quality graphics, sculpture and

unique works by internationally and nationally recognized artists from several countries.

The gallery's collection includes works by modern masters such as Joan Miro, Salvador Dali, Rufino Tamayo, Alexander Calder and Pablo Picasso. Also featured are works by famous sports artist Leroy Nieman; G.H. Rothe, known for figures of dancers executed in a virtuoso mezzotint technique; French-Moroccan artist Guillaume Azoulay, internationally known for his sensitive etchings of horses and figures; and naive-style painter Thomas McKnight, as well as many others.

Also available are watercolors, oils, and graphic works by Joanna Zjawinska. Past one-person exhibits have included works by Leroy Nieman, satirist Charles Bragg, and turn-of-the-century posters by French designer and illustrator Jules Cheret.

Live Oak Gallery 102 Amaryllis Dr., Lafayette, LA
406 70503 (318) 233-3477; owner/dir: Bob Crutchfield

The Live Oak Gallery shows artists of the New Orleans area, although over half the gallery artists are from out of state. Styles range from abstract to photo-realist, with everything in between.

Some of the artists featured are Steve Watson, who paints photographically precise scenes of swamps, Cajun houses and landscapes; William Tolliver, who paints some of the same subjects in an impressionist style; and Jean Angelle and Clementine Hunter, who paint in colorful primitive styles. Larry Russell and Robert Ziegler paint abstractions. Bryant-Geer, Maxine Krielow, Marta Fielding, Raul Gutierrez and Jim Hill use watercolor as their preferred medium. Painters working in oil media are Eva Makk, Americo Makk, A.B. Makk, Joann Quillman, Mary Kennedy, Kirby Rogers, Evelyn Clouatre, and impressionist Paul Burkle.

Arthur Roger Gallery 3005 Magazine St., New Orle-
407 ans, LA 70115 (504) 895-5287; Mon-Sat: 10-5; owner: Arthur Roger

The Arthur Roger Gallery carries contemporary fine art, with works by regional and New York artists, including paintings, sculpture, photography and graphics.

Among the artists whose work is featured are Ida Kohlmeyer, whose paintings are populated by graphic signs fused with color into a subjective lexicon; painter Robert Gordy, a symbolic realist whose figuration is marked by geometric design; and Harry Soviak, whose high-keyed paintings based on iconic images such as vases are simultaneously abstract and representational; as well as Jim Richard, Gene Koss and Ed Whiteman.

Other contemporary artists include Barry Bailey, Dub Brock, Gerald Cannon, Debbie Fleming Caffery, Adrian Deckbar, Randy Ernst, Doyle Gertjejansen, Carol Stoops Hurst, John Lawrence, Michael Ledet, Elemore Morgan, Well-ington Reiter, W. Steve Rucker and Allison Stewart.

Tahir Gallery Inc. 823 Chartres St., New Orleans, LA
408 70116 (504) 525-3095; Tue-Sat: 10-5; owner/dir: Abe M. Tahir

Visitors to the Tahir Gallery will find a large selection of original prints by major American artists from the 19th century to the present. The gallery's inventory includes works by Regionalists, American Impressionists and members of the Ashcan School, as well as more recent works.

American Regionalists Thomas Hart Benton and Grant Wood were notably active in the lithographic medium, which with the advent of Currier & Ives prints had established itself as a source of popular imagery. Martin Lewis is also remembered for his portrayal of the American scene. Ash Can School painters John Sloan and George Bellows were prolific printmakers, whose skills had been honed by their work as newspaper illustrators. In her color etchings, Impressionist Mary Cassatt portrayed domestic scenes in the style of Japanese woodblock prints. Jack Levine employs biting satire, and Ben Shahn, understated pathos to express social concerns in their graphic works and paintings. The gallery also carries works by Jacques Hnizdovsky, widely known for his forceful yet delicate landscapes, by Pop artist Red Grooms, and by many others.

Mario Villa Gallery 3908 Magazine St., New Orleans,
409 LA 70115 (504) 895-8731; daily: 10-6; owner/dir: Mario Villa

The Mario Villa Gallery specializes in Post-Modern art. The scope of the works presented embraces sculpture, painting, photography and some graphics. The gallery mostly represents Louisiana artists, as well as some New York and international artists. Emphasis of the gallery is on contemporary sculpture.

Major artists featured in gallery exhibitions include Arthur Kern, a sculptor whose mastery of the human form is paralleled by his skill in handling resin media. His images draw on classical sources, yet are infused with an air of mystery and the bizarre. Also exhibited are works by Gyuri Hollosy, Sidney Garrett, Norman Therrien, Patty Whitty Johnson, Carol Leake, Bill Wiman, Ann Harding, Pam Kelly Sills, Tom Young and Joe Bova.

One may also see the works of Daniel Piersol, a representational painter who employs brilliant color; the works on paper of Nancy Pruett, dominated by a strong sense of design and color; and Rosalie Ramm's elegant designs in rich, subdued color. Other noteworthy artists include Karen Blockman, Steve Boutte, Chris Guarisco, Josephine Sacabo, Greely Wyatt, Sandra Blair, D. Nuego, Jesselyn Zurik, Brenda Katz, Michael Daugherty, Brian Borrello, Ed Barbier, Lynn Green, John Malveto and Ron Dale.

MAINE

OGUNQUIT

PS Galleries Hoyt's Lane, Ogunquit, ME 03907 (207)
410 646-3254; Mon-Sat: 10-5 Sun: 1-6; dir: Michael Palmer & Peter Spear

See listing for Dallas, TX.

PORTLAND

Hobe Sound Galleries North One Milk St., Portland,
411 ME 04101 (207) 773-2755; Tue-Sat: 10:30-5;
owner: John W. Payson dir: Peter A. Bullock

Hobe Sound Gallery North features paintings,
original prints and sculpture by contemporary
artists living and working in Maine.

Among the artists whose work is exhibited
are John Muench, Cabot Lyford, Beverly Hal-
lam, John Swan, Barbara J. Sussman, Gary
Buch and Celeste Roberge.

ROCKPORT

Maine Photographic Gallery 2 Central St., Rockport,
412 ME 04856 (207) 236-8581; May-Oct: daily: 9-5;
owner: David H. Lyman dir: Kate Carter

The gallery specializes in black and white pho-
tography with an emphasis on contemporary
photographers, although some vintage prints are
also handled. Large format platinum or palla-
dium prints are an area of special interest. The
gallery also promotes educational programs.

American masters include contemporary black
and white artists such as Paul Caponigro, Arnold
Newman, George Tice, Olivia Parker, Marsha
Burns, Craig Stevens, Kate Carter and Lilo Ray-
mond, as well as color photographers Eliot Porter
and Ernst Haas.

The gallery also handles the photographic
work of the young members of its staff, includ-
ing Steve Bliss, Ann Kuntz and George Relney.

MARYLAND

BALTIMORE

G.H. Dalsheimer Gallery 519 Charles St., Baltimore,
413 MD 21201 (301) 727-0866; Tue-Sat: 10-5 Aug:
closed; owner/dir: George Dalsheimer managing
dir: Michele Moure Elliott

The focus of the gallery is contemporary photog-
raphy and works on paper. The photography in-
cludes, in addition to the contemporary images,
a fine selection of 19th and 20th century vintage
work. The works on paper include watercolors,
drawings, handmade paper and monoprints.

Some of the American master photographers
featured are Harry Callahan, Aaron Siskind,
Frederick Sommer, William Garnett, Eliot Por-
ter, Ansel Adams, Arnold Newman, and noted
contemporary photographers Jerry Uelsmann,
Olivia Parker and Ray Metzker. Works on paper
by Herman Maril are also included in the
gallery's collection.

The gallery presents a selection of talented
emerging photographers and "paper" artists, in-
cluding Michel Krzyzanowski, Daniel Ranalli,
Stephen Phillips, Denny Moers, Christopher
James, Marsha Burns, Joel Peter Witkin, Helen
Frederick and Sirpa Yarmolinsky.

C. Grimaldis Gallery 928 N. Charles St., Baltimore,
414 MD 21201 (301) 539-1080; Tue-Sat: 10-5 Aug:
closed; owner/dir: Constantine Grimaldis

The gallery specializes in 20th century American
art with an emphasis on Abstract Expressionism
and the New York School. Regional artists also
are actively presented.

The New York School collection includes
works by gestural realists Elaine de Kooning and
Grace Hartigan, as well as by Aristodemos Kal-
dis. Works by New York realist Alice Neel are
available, as well as landscape paintings by Rob-
ert Dash, Eugene Leake and Raoul Middleman.

Other artists shown include Keith Martin,
collages; Scott Kesler, paintings and monoprints
dealing with social change and alienation; Chris-
tine Neill, watercolors of abstract natural im-
agery; and Nan Montgomery, architectural ab-
stractions, images of a silent world suspended in
time. Sculptor John van Alsiten works in granite
and steel, and fellow sculptors John Mcarthy and
Wade Saunders work in welded steel and painted
bronze, respectively.

Meredith Contemporary Art Gallery 805 N. Charles
415 St., Baltimore MD 21201 (301) 837-3575; Tue-
Fri: 10-5 Sat: 11-5 summer: closed Sat; owner/
dir: Judith Lippmann & Mandy Lippmann

Featuring local, regional and nationally promi-
nent artists, the gallery presents contemporary
American art in a variety of media: painting,
works on paper, ceramics, fiber and sculpture.

Among the established artists shown are Paul
Jenkins, Margie Hughto, Ed Baynard, Katte
Brittin Shaw, Jamie Davis, Arlene Slavin, Eliza-
beth Osborne, Robert Milnes, Alex Katz and
Robert Motherwell.

Other artists shown include Brian Kava-
naugh, Rebecca Kamen, Michael Clark, Kevin
MacDonald, Niles Lewandowski, James Ander-
son, Diana Sutten and Harry Evans.

BETHESDA

Bethesda Art Gallery 7950 Norfolk Ave., Bethesda,
416 MD 20814 (301) 656-6665; Wed-Sat: 11-5 Aug:
closed; owner/dir: Betty Minor Duffy

This tiny but highly-respected gallery exhibits
and deals exclusively in early 20th century
American prints.

Welcoming expert and novice alike, the
gallery stocks etchings and lithographs by such
great American printmakers as George Bellows,
John Sloan, Thomas Hart Benton, Raphael
Soyer, John Steuart Curry, Walt Kuhn, Louis
Lozowick, Martin Louis and Howard Cook, as
well as wood engravings by Rockwell Kent,
along with many works by less well-known art-
ists of the period.

Monthly shows are instructive, and often in-
troduce little known aspects of the period, such
as "Prints from the World's Fair of 1939,"
"Early American Silkscreens from the WPA"
(where the first American fine art silkscreens
were made), and "Women Printmakers from the
20s, 30s and 40s," featuring Isabel Bishop, the
late Washington caricaturist Aline Fruhauf,
Peggy Bacon, and Marguerite Kumm, who still
makes delightful miniatures on the artist's life in
Washington.

The Glass Gallery 4931 Elm St., Bethesda, MD
417 20814 (301) 657-3478; Tue-Sat: 11-5; owner/
dir: Sarah Eveleth Hansen & Anne Smith
O'Brien

A full range of studio glass is presented in this gallery space, which was designed for glass display by museum specialist George Sexton. The focus is on non-functional container forms, sculpture and commissioned pieces.

Monthly shows of significant work supplement the ongoing presentation of work by established artists and craftsmen, including Robert Coleman, Audrey Handler, W. Stephen Hodder, Ben Kaiser, Kreg Kallenberger, Tom Mc-Glauchlin, Marvin Lipofsky, Karel Mikolas, Edward Nesteruk and David Schwarz. The gallery also shows up-and-coming young talents like Hank Adams, Dorothy Bauer, Melodie Beylik, Jose Chardiet, Karen Flynn-Miller, Bernard D'Onofrio, David Leppla, Kurt Swanson and Patrick Wadley.

KENSINGTON

Plum Gallery 3762 Howard Ave., Kensington, MD
418 20795 (301) 933-0222; Tue-Sat: 11-4 Aug: closed

Located in what has become the "antiques row" of suburban Kensington, Plum Gallery handles a broad selection of high-quality, upbeat art in all media and varied styles.

Works range from the handmade paperworks of Helen Frederick, Margery Freeman Appelbaum, Liz Kregloe and Janet Wheeler to the fantasy landscapes and seascapes of Boston artist Walter Crump. Among the other artists featured are sculptor William Calfee, fiber and paper artists Sirpa Yarmolinsky, and painters Patricia Friend, Helen Corning, Darlein Stein and Val Lewton. Printmakers are Shlomith Haber-Schaim, Susan Rogers, Minna Resnick, Lenore Fried, Eleanor Rubin and Aline Feldman. Two unusual artists who work in constructions are Roderick Slater from Maine and Jody Kline from Massachusetts.

A special jewelry gallery has recently been added featuring some of the outstanding jewelry artists of the United States, including Mary Lee Hu, Arline Fisch, Eleanor Moty, Belle and Roger Kuhn, Laura Popenoe, Jamie Bennett, Gretchen Raber, Komelia Okim and many others.

MASSACHUSETTS

BOSTON

Alianza 140 Newbury St., Boston, MA 02116 (617)
419 262-2385; Mon-Sat: 10-6 Wed: 10-8; dir: Karen Rotenberg

Alianza carries contemporary crafts by over 100 American artists working in glass, sculptural and functional ceramics, quilts, boxes in rare woods and handwrought jewelry. A few of the artists featured by the gallery are Ed Risak, who makes *raku* pottery; furniture maker Steve Hynson; Judith Larzclere, a quiltmaker; and Ilene Richard, who fashions jewelry.

Alpha Gallery 121 Newbury St., Boston, MA 02116
420 (617) 536-4465 Tue-Sat: 10-5:30; owner/dir: Alan Fink

Alpha Gallery exhibits contemporary art in all media, both figurative and abstract, as well as late 19th and 20th century American and European master graphics.

Contemporary artists featured by the gallery include Lester Johnson, a gestural figurative painter whose work first emerged in the 50s in the New York School; Harold Tovish , a highly regarded figurative sculptor whose best known works are of bronze portrait heads emerging from an abstract matrix; Gyorgy Kepes, an abstract painter whose work as a teacher has been influential in the field of visual design; Katherine Porter, an abstractionist; and Aaron Fink, a realist who paints monumental, isolated images. Works are available from the estate of Milton Avery, a painterly realist of great formal simplicity and restrained but scintillating color.

Master graphics available include works by Toulouse-Lautrec, Max Beckmann, Picasso, Emil Nolde, and others.

Other artists whose work is exhibited are Ralph Coburn, Bernard Chaet, Dimitri Hadzi, Nancy Hagin, Susan Heideman, Peter Milton, Peter Plamondon, Barnet Rubenstein, Richard Sheehan, Barbara Swan and Richard Ziemann.

The David Bernstein Gallery 36 Newbury St., Bos-
421 ton, MA 02116 (617) 267-3779; Tue-Sat: 10-5:30 Aug: closed; owner/dir: David Bernstein

The David Bernstein Gallery specializes in contemporary art glass.

Of the numerous artists exhibited by the gallery, some of the most acclaimed are Herb Babcock, Rick Bernstein, William Bernstein, Dan Daily, Stephen Dee Edwards, Michael Glancy, Alan Klein, Robert Levin, Harvey Littleton, Flora Mace and Joey Kirkpatrick, Andrew Magdanz and Susan Shapiro, Richard Marquis, Linda MacNeil, Jack Wax, Jan Williams and Brent Young.

Other artists exhibited include Hank Murta Adams, Mary Angus, Robert Bartlett, Gary Beecham, Donald Carlson, James Carpenter, Michael Cohn, Bernie D'Onofrio, Robert Dane, Leonard Di Nardo, Fritz Dreisbach, William Dexter, Stephen Edwards, Dudley Gibberson, William Glasner, James Harmon, Tom and Pia Hart, Page Hazelgrove, Eric Hopkins, Sidney Hutter, Joseph Kivlin, William Lequeir, John Lewis, Walter Lieberman, J. Littleton and K. Vogel, Klaus Moje, Joan Pagalies, Elizabeth Pannell, Tom Patti, Mark Peiser, Florence Perkins, Art Reed, Peet Robison, Amy Roberts, Louis Sclafani, Josh Simpson, Bill Slade, Dennis Elliot Smith, Molly Stone, Doug Sweet, George Thiewes, Steve Tobin, Vitrix, Meredith Wenzel, David Willard, Bill and Sally Worcester, and Maryanne Toots Zynski.

Childs Gallery 169 Newbury St., Boston, MA 02116
422 (617) 266-1108 Tue-Fri: 9-6 Sat: 10-5; owner/dir: D. Roger Howlett

The Childs Gallery specializes in 18th, 19th and early 20th century American and European paintings, prints, and drawings. In addition to a collection of paintings by American master painters, the gallery has an extensive inventory of prints, including works by Old Masters.

Works are available by American masters Impressionist Edmund Tarbell, still life painter Martin Johnson Heade, famous American Ro-

mantic Washington Allston, A.T. Bricher, Severin Roesen, Silva, Ross Turner, William T. Richards, Michele Felice Corne, Jos. Decker, and many others.

Master printmakers include Rembrandt, James McNeil Whistler, Albrecht Durer, and Piranesi. American printmaker Martin Lewis is known for his vignettes of American life in the 20s and 30s. Works by American Impressionist Frank Benson, a member of "The Ten" associated with Childe Hassam, and regionalists Thomas Hart Benton and Grant Wood, and many others are included in the collection, which contains between 12,000 and 15,000 prints.

Graphics I & Graphics II 168 Newbury St., Boston, *423* MA 02116 (617) 266-2475; Mon-Sat: 9:30-5:30; owner: L. Feinberg, B. Beck dir: L. Feinberg

Graphics I and Graphics II, as the name implies, carry original prints. Concentration is on contemporary works by American and European masters. Both abstract and representational works are available.

The gallery's collection includes works by artists such as Joan Miro, a forceful innovator in graphic media as well as in painting; Abstract Expressionist Robert Motherwell; sculptor Alexander Calder, in whose joyful graphics spirals, stars and geometric shapes float across the significant void of the paper; designer and fiber artist Sonia Delaunay; and American painter Carol Summers, as well as other American and European printmaking masters.

The gallery is also actively promoting young local talent, especially artists who work in unique paper media such as monotype and collage. Recent shows have included work by Scott Sandell, Diana Gonzalez Gandolfi, and Woody Jackson.

The Harcus Gallery 7 Newbury St., Boston, MA *424* 02116 (617) 262-4445; Tue-Sat: 10-5:30; owner/ dir: Portia Harcus The Harcus Gallery specializes in post-World War II paintings, sculpture, prints and photographs. Tendencies represented in the collections and exhibitions of the gallery range from Abstract Expressionism, post-painterly abstractionism and Pop Art to recent figurative painting.

Works are available by British sculptor Anthony Caro, by Louisa Chase, and by Abstract Expressionists Robert Motherwell, Willem de Kooning, Adolph Gottlieb, Hans Hofmann, Helen Frankenthaler, Richard Diebenkorn, and Friedel Dzubas, as well as by Robert Rauschenberg, Jasper Johns, Ellsworth Kelly, Philip Pearlstein, Alex Katz, Jules Olitski, Frank Stella, Wayne Thiebaud, Andy Warhol and David Hockney. New Figurative painters David Salle and Julian Schnabel are also featured by the gallery, as well as painterly realist Neil Welliver, and other artists such as Susan Shatter, Sandi Slone, Michael Steiner, Pat Steir and Robert Zakanitch.

One may also see the paintings of Robert Goodnough, which have evolved from his earlier Abstract Expressionist style to carefully structured aleatoric constellations of geometric shapes, and the whimsical ceramic sculpture of David Gilhooly, as well as works by Joel Beck,

Fletcher Benton, Dan Christensen, Linda Etcoff, Chuck Holtzman, Marcia Lloyd, George Nick, Carl Palazzolo, John Stephan, Andrew Tavarelli and Valta Us.

Kingston Gallery 129 Kingston St., Boston, MA *425* 02111 (617) 423-4113; Tue-Sat: 12-6 Aug: closed: owner/dir: Joanne Jolly

Concentration of the gallery is on New England contemporary artists. Works exhibited include installations, sculpture, painting, drawing, handmade paper, photography and wood construction. The gallery is a membership gallery, run much like a cooperative. All of the artists are new or emerging local people.

Therese Bisceglia makes handmade paper which she employs in her collages. Steven Blendowski works in painting and collage, as does Jan Filios. Paintings and drawings are available by Jeff Melzack, Brenda Pinardi, Richard Moody and Gerald Schertzer. Other painters include Tim Hawksworth, oils, Barbara Holian, painting and oil pastel, Beth Catherwood, Paul Laffoley, Fran Watson and Walter Worden. Beth Galston, Jeff Moy and Joanne Jolly all work in sculptural installation, while Dan Doe and Joan Winkler make constructions. Photographers at the gallery are David Kay and Donna Ferreia.

Robert Klein Gallery 216 Newbury St., Boston, MA *426* 02116 (617) 262-2278; Tue-Sat: 11-5:30 Aug: by appt; owner/dir Robert Klein

Robert Klein Gallery exhibits 19th and 20th century fine photographs for corporate and individual collections.

Major photographers whose work is included in the collection of the gallery are Bill Brandt, Eugene Atget, Brassai, Giacomelli, Cartier-Bresson, Carleton Watkins, Diane Arbus, Bernice Abbott, E.S. Curtis, and others.

Exhibitions promote works by new and emerging talent, including Rosamand Purcell, Arno Minkkinen and Marilyn Bridges.

Barbara Krakow Gallery 10 Newbury St., Boston, *427* MA 02116 (617) 262-4490; Tue-Sat: 10-5:30; owner/dir: Barbara Krakow

The Barbara Krakow Gallery specializes in post-World War II painting, drawing, prints and sculpture.

Among the artists featured by the gallery, Jim Dine has been associated with Pop Art, though his concern with formal problems and generous, painterly technique reveal his sympathies with Abstract Expressionism. Louise Nevelson's wall-like sculptures of found objects and large-scale steel sculptures represent a distinguished achievement in American art. Chuck Close has progressed from large-scale photorealist portraits to portraits built with a grid of dots or squares, like pointillism passed through a computer, and often executed in media that present tactile as well as visual readings. Lucas Samaras presents a considerable variety in his work, from Neo-Dada collections of objects, to sculpture, manipulated Polaroid photographs and works in fiber.

Other artists featured by the gallery include painter Michael Mazur, whose large-scale monotypes are included in many museum exhibitions, as well as emerging artists Joel Janowitz, water-

colorist Todd McKie, watercolorist and sculptor Catherine Bertulli, Victoria Faust, Flora Natapoff and Scott Hadfield.

Lopoukhine Gallery 10 Newbury St., Boston, MA
428 02116 (617) 262-4211; Tue-Sat: 10-5:30; owner/dir: Andre Lopoukhine

Contemporary painting and sculpture is featured at the gallery, with an emphasis on innovative work by up-and-coming as well as established artists. There also is a unique selection of antique and primitive textiles from Africa, China, Japan, Peru, and Indonesia.

Works by gallery artists include collages and constructions by Alfred De Credico, restated scores of music by Ellen Banks, mixed media on paper by Nan Freeman, bronze sculpture by Max Harries, laquered screens by Jim Jacobs, stainless steel and painted sculptures by Obie Simonis, mixed media on paper and canvas by Al Souza, wood figures by Joseph Wheelwright, paintings and neon installations by Czech artist Miroslav Antic, painted wood constructions by Fritz Buchner, forged steel structures by George Greenamyer, and dried pigment on paper and canvas by Irene Valencias.

Nielsen Gallery 179 Newbury St., Boston, MA 02116
429 (617) 266-4835 Tue-Sat: 10-5:30; owner/dir: Nina I.M. Nielsen

The gallery handles late 19th century and early 20th century master prints and drawings, as well as contemporary abstract painting and sculpture.

The inventory of the gallery includes works by Jake Berthot, and many other artists, such as Gregory Amenoff, Anne-Marie Cuchiara, Porfirio DiDonna, Elizabeth Dworkin, Neill Fearnley, Jon Imber, Dexter Lazenby, Sam Messer, Lee Newton, Fernando Ramos Prida, Harvey Quaytman, Paul Rotterdam, Lee Sherry, Joan Snyder, Christopher Wilmarth, and Adja Junkers.

Rolly-Michaux 290 Dartmouth St., Boston, MA 02116
430 (617) 536-9898 Tue-Sat: 10:30-5:30; owner/dir: Ronald Rolly, Ronald Michaux

See listing for New York City.

Thomas Segal Gallery 73 Newbury St., Boston, MA
431 02116 (617) 266-3500; Tue-Sat: 10-5:30 or by appt; Aug 15-31: closed; owner/dir: Thomas Segal

Thomas Segal Gallery exhibits contemporary American painting, sculpture and works on paper.

A number of artists of signal importance in the post-World War II period are included in the exhibitions of the gallery. The work of Jasper Johns provided a new departure in the doldrums of Abstract Expressionism, with its conceptual intricacy and careful facture of painterly gestures. George Rickey pioneered kinetic sculpture, while pioneer Abstract Expressionist Helen Frankenthaler has developed a highly personal vein of lyrical abstraction. Italian sculptor Arnaldo Pomodoro, photographer Harry Callahan, Miriam Shapiro and photographer Chris Enos, who is best known for her close-ups of dying flowers and plants, are also featured.

Emerging artists shown at Segal include painters Cliffton Peacock, Ralph Hamilton and Liz Rosenblum; sculptors Michelle Samour and Bruce Monteith; and photographers Denny Moers and Lorie Novak.

Helen Shlien Gallery 14 Newbury St., Boston, MA
432 12116 (617) 267-9418; Tue-Sat: 11-5; owner/dir: Helen Shlien

Helen Shlien specializes in contemporary painting and sculpture, with an emphasis on New England artists.

The gallery's painters include Natalie Alper and James Hendricks, abstract painters; Harry Bartnick, a realist; watercolorist Marci Gintis; and Jim Ann Howard, Carolyn May, and Elizabeth Ohbert. Sculptors Nancy Selvage and Michael Timpson primarily do installations. Other sculptors who regularly show at the gallery are Mark Cooper, who works in cement and clay; Daniel Devine, who works in mixed media; Penelope Jencks, who works in clay and bronze; and Jessica Straus and Marty Holmer, who work in wood.

Signature Fine Art & American Crafts Dock Square,
433 North St., Boston, MA 02109 (617) 227-4885; Mon-Wed: 11-8 Thu-Sat: 11-9 Sun: 12-6; owner/dir: Arthur T. Grohe

The Signature Gallery exhibits fine art and contemporary crafts, with special emphasis on blown and flat glass, clay, metals, fiber and fine jewelry.

American craft artists include David Bacharach, who works in metals. John Kuhn, Rick Bernstein, Ira Sapir and Thomas Buechner all work in blown glass. Thomas Hoadley, Karl Borgeson, and Laney Oxman create their art in clay, while Hap Sakwa works in wood. Jewelry makers at the gallery are John Heller and Ronald Pearson.

Signature Gallery has a second location in Hyannis (see listing for Hyannis, Mass.), and recently constructed a second gallery adjoining their Boston location. On a rotating basis, both gallery locations are spotlighting leading contemporary American craft artists.

Stavaridis Gallery 73 Newbury St., Boston, MA
434 02116 (617) 353-1681; Tue-Sat: 10-5:30 Summer: closed Sat; owner/dir: Pat Stavaridis

The gallery promotes emerging and up-and-coming artists, with a focus on Boston and New York talent. About 90 percent of the artists shown are young Boston artists, mostly painters.

Works by gallery artists include abstract expressionist paintings by John McNamara, wooden constructions by Alvin Winant, urbanscapes by Adam Cvijanovic, imaginal landscapes by Bob Ferrandini, figurative paintings by Al Rizzi, abstract metal constructions by Jack Klift, color field paintings by Marjorie Menkin, paintings employing primitive iconography by Alfonose Borysewicz, and mythological landscapes by Gabrielle Barzaghi.

Stux Gallery 36 Newbury St., Boston, MA 02116
435 (617) 267-7300 Tue-Sat: 10-5:30 Aug: closed; owner/dir: Linda & Stefan Stux

One of Newbury Street's most energetic galleries, Stux encourages a strong regional identity among its artists, while promoting them nationally and internationally. The work of the Boston and New England artists featured at the gallery reflect the vital concerns of the present moment and a vigorous approach to materials. Exhibi-

tions include painting, sculpture, works on paper and performance.

Sculptor Jod Lourie creates lifesize human figures in environments such as a swimming pool or a women's locker room, as well as smaller fragments. In her technique of body-casting she uses an innovative material, a synthesis of porcelain and nylon. Alex Grey's performances often involve a psychological confrontation with the fact of death and destruction; his recent paintings reveal the interior anatomy of the human figure and its psychic energy systems. Sculptor Ralph Helmick composes wooden busts and hands of horizontal layers of laminated masonite and wood. Painter Gerry Bergstein creates complex and contradictory frames of reference, both spatial and stylistic. Painter Doug Anderson uses a harsher palette and flat colors in his expressionistic canvases. Both use their art to confront the real and potential horrors of post-industrial civilization. Artist Paul Oberst has worked in stage design as well as in painting.

Vose Galleries 238 Newbury St., Boston, MA 02116
436 (617) 536-6176; Mon-Fri: 8-5:30 Sat: 9-4; dir: Abbot W. Vose

Vose Galleries, Inc., deals in 18th, 19th and 20th century American and European paintings. Works by American masters are well represented in the Gallery's collection. The gallery has been run by the Vose family for five generations, and is currently operated by twin brothers Abbot W. Vose and Robert C. Vose.

Works by 18th century painters such as John Smibert, Joseph Badger and John Singleton Copley may be viewed at the gallery. The Hudson River School painters, the Luminists, such as Sanford Gifford, Fitz Hugh Lane and Martin Johnson Heade are also represented. The latter half of the 19th century is represented by American Impressionists John Twachtman, Childe Hassam and Willard Metcalf, and realists Winslow Homer, Thomas Eakins and Eastman Johnson.

When available, the gallery stocks Western art by Frederic Remington, C.M. Russell, Henry Farny, William Ranney and the Santa Fe and Taos Schools.

Wenniger Graphics, Inc. 174 Newbury St., Boston,
437 MA 02116 (617) 536-4688; Mon-Sat: 10-5:30; pres: Mary Ann Wenniger treas: Mace Wenniger

With locations in Boston and Rockport, Massachusetts, the Wenniger Gallery carries an international collection of original graphics which embraces Japanese, French, English and American 19th and 20th century works. Wood engravings and lithographs of the 1930s from England and the United States are represented in depth. Mezzotints are also a specialty, with works by Japanese, English and American printmakers. Handmade paper works are available as well.

The gallery offers watercolor monotypes by Mace Wenniger, collagraphs and large handmade paper images by Mary Ann Wenniger. The gallery collection of over 300 printmakers includes works by Barnet, Eichenberg, Milton, Abeles, Noda, Kozo, Fairclough, Greenwood, Honda, Hamaguchi, Nason, Dorny and Louttie.

Westminster Gallery 132A Newbury St., Boston, MA
438 02116 (617) 536-2581; Mon-Sat: 11-6; owner: Kenneth Bridgewater dir: Susan Pomerleau

Concentration of the gallery is on glass, porcelain, jewelry, ceramics and other fine collectibles by British craftsmen.

British ceramists whose work is exhibited by the gallery include Mick Casson, Lucie Rie, David Leach, Colin Pearson, Alison Britton, Jacqui Poncelet, Mary Rogers, Geoffrey Swindell, Ursula Morley-Price, Nick Homoky and Eileen Nibet. The gallery carries jewelry designed and made by Wendy Ramshaw and by David Watkins. Glass is available by Sam Herman, by Steven Newell, by Anthony Stern, and from the craft artists of The London Glasshouse and The London Glassblowing Studio. The fiber art and textiles of Kaffe Fasset, Polly Bins and Sue Lawty are also displayed at the gallery.

Recent exhibitions include Anthony Stern, glass; an exhibition curated by Mick Casson with works by Sheila Casson, Walter Keeler, Madoline Keeler, Andrew McGarva, Colin Pearson, David Leach, Peter Starkey and Janice Tchalenko; Polly Bins, textile art; and Alison Britton and Jacqui Poncelet, ceramics.

CAMBRIDGE

Mobilia 348 Huron Ave., Cambridge, MA 03238
439 (617) 876-2109; Mon-Sat: 11-6 Jul-Aug: closed Sat-Mon; dir: Libby Cooper

Mobilia shows contemporary American sculpture, ceramics, paintings, furniture, tapestries and wearables by established and emerging artists.

Artists exhibited by the gallery include Adria Arch, Thea Cadabra, Gregory Curci, Tina Depuy, Arthur Ganson, Gina Halpern, Tempe Biddle Hill, Joe Lytle, Thomas Mann, Marian McNair, Liza Jane Norman, Larry Page, Jane Rake, James Rooke and Jean Williams-Cacicedo.

Seventeen Wendell Street Gallery 17 Wendell St.,
440 Cambridge, MA 02138 (617) 864-9294; call for hours; owner/dir: Constance Brown, Jane Shapiro

The Seventeen Wendell Street Gallery shows the work of distinguished Black artists based in New York, California and Boston, most of whom are representational artists.

Artists whose work is featured include New York artists Benny Andrews, known for his paintings on Black liberation and the horrors of war suffered by children; Romare Bearden, whose unique style of collage and polymer paint depicts in vibrant tones the life of Black people in the cities; Boston artist Robert Freeman; Massachusetts artist Richard Yarde; and California artist Varnette Honeywood. The gallery also shows work from the estate of Alma Thomas, late of Washington. D.C.

Ten Arrow 10 Arrow St., Cambridge, MA 02138
441 (617) 876-1117; Mon-Sat: 10-6 Thu: 6-9 Sun: 1-5; prop/dir: Elizabeth Tinlot

The gallery carries a broad range of fine American crafts, including ceramics, blown glass, metal work, jewelry, wood carving and furniture.

Distinguished furniture maker Wendell Castle is among the artists featured. Other artists exhibiting their work include ceramicists Nancee Meeker, Jenny Lind and Mona Brooks; glass

artists Josh Simpson and Henry Summa; wood workers Al Stirt and Stephen Paulsen; and jewelry maker Glenda Arentzen.

CHESTNUT HILL

Quadrum Gallery The Mall at Chestnut Hill, Chestnut
442 Hill, MA 02167 (617) 965-5555; Mon-Fri: 10-9:30 Sat: 10-6 Sun: 12-5; owner: Cynthia del Piano dir: Jan Ehrenworth

The Quadrum Gallery has been showing contemporary paintings, drawings, prints and sculpture for the past ten years. Much of the work exhibited is representational, although abstract painting and prints are included in the inventory with an eye to maintaining a selection that will appeal to a broad range of collectors.

Contemporary painters whose works have been acquired by museum collections include watercolors by Philip Michelson and Mike Burns (A.W.S.). The work of William Dunlap, who has been with the gallery since its inaugural year, has recently been acquired by the Corcoran Gallery in Washington, D.C. Quadrum also maintains a commitment to leading younger painters and printmakers.

In the past three years, Quadrum has established a firm commitment to representing and selling fine art jewelry by outstanding graduates of the most reputable metals departments across the U.S. Artists in the collection include Bob Ebendorf, Ivy Ross, Larry Seegers, Enid Kaplan, Rafael Sanchez and Patricia Von Musilin.

HYANNIS

Signature Fine Art & American Crafts The Village
443 Market Place, Stevens St., Hyannis, MA 02601 (617) 771-4499; Mon-Wed: 11-8 Thu-Sat: 11-9 Sun: 12-6; owner/dir: Arthur T. Grohe

(See Boston, MA, listing)

LINCOLN

Clark Gallery Box 339, Lincoln Station, Lincoln. MA
444 01773 (617) 259-8303; Tue-Sat: 10-5 Aug 15-Labor Day: closed; owner/dir: Meredyth Hyatt Moses

A congenial gallery on the outskirts of Boston, Clark features paintings, drawings, sculpture, prints and jewelry by emerging and established Boston area artists.

The works exhibited include large-scale abstract works by Frank Campion, Rick Harlow and Robert Kelly; contemporary realism by Maxine Yalovitz-Blankenship, Carole Bolsey, Robert Freeman and Phillip Gabrielli; large-scale drawings by Donald Shambroom; and constructed sculpture by Robert Cronin, Joyce McDaniel and Howard Ben Tre.

Judith Berman draws views of underwater life in pastels. Jennifer Berringer creates large-scale unique prints. Sculptors David Phillips and Carlos Dorrien explore the sensuous qualities of met-.al and stone, while Sandra Stone makes painted reliefs.

LEXINGTON

Gallery on the Green 1837 Massachusetts Ave., Lex-
445 ington, MA 02137 (617) 861-6044; Tue-Sat: 10-5; prop/dir: Molly Nye

Gallery on the Green shows 19th century and early 20th century American art as well as having changing shows of contemporary artists.

Contemporary artists exhibiting their work at the gallery include the highly regarded artist and teacher Maud Morgan, paintings and collages; Anthony Howe, large scale watercolors of New Hampshire landscapes; Henry Drexler, oils and acrylics of New York State landscapes; and Alexander Pertzoff, watercolor and egg tempera landscapes. Lissa Hunter exhibits collages of leather, handmade paper and cloth, as well as handmade baskets ornamented with feathers, shells and found objects. The gallery also presents the work of English artist Verina Warren, who paints and embroiders on silk.

PROVINCETOWN

Long Point Gallery/An Artists' Place 492 Commer-
446 cial St., Provincetown, MA 02657 (617) 487-1795; Tue-Sat: 11-2 & 6-9 Oct-May: closed; dir: Elizabeth O'Donnell

Open rainy afternoons, this cooperative gallery caters to Provincetown's summer population, which annually crowds the tip of Cape Cod with 50,000 bodies. Ever since Hans Hofmann founded a summer workshop here in the 50s, the town has been a center for contemporary art. Many of the American painters exhibiting at the gallery are summer residents on the Cape. Those willing to brave the crowds will be rewarded by the excellent work displayed in this small but lively gallery.

Exhibitions include both abstract and representational works. The casual visitor may find recent work by Robert Motherwell, abstract paintings and collages by Leo Manso, (founder of the Provincetown Workshop, which continues the tradition of Hofmann's teaching), enigmatic wood and bronze constructions and drawings by Varujan Boghosian, or landscapes by Paul Resika. The gallery also shows works by Fritz Bultman, who works in collage, sculpture and painting; Carmen Cicero, a jazz musician who does small collages and large paintings; Sideo Fromboluti, landscape and figure painting; Ed Giobbi, drawings and large paintings; Budd Hopkins, collages and complex ensembles of painted shaped panels; Judith Rothschild, a student of printmaker Stanley Hayter and Hans Hofmann; Sidney Simon, sculpture; Nora Speyer, figure and landscape painting on canvas; and Tony Vevers, sand and found objects on canvas and collages.

ROCKPORT

Wenniger Graphics, Inc. 19 Mt. Pleasant St., Rock-
447 port, MA (617) 546-7822; Mon-Sat: 10-5:30 Nov-May: closed; pres: Mary Ann Wenniger treas: Mace Wenniger

See listing for Boston, MA.

STOCKBRIDGE

Holsten Galleries Elm St., Stockbridge, MA 01262
448 (413) 298-3044 Mon-Sat: 10-6 Sep-May: closed; owner/dir: Chandra & Kenn Holsten

Holsten Galleries specializes in contemporary

American art glass and ceramics. The gallery also handles painting, prints, paper works and handmade jewelry.

Artists working in glass include studio glass pioneer Harvey Littleton and Dale Chihuly, whose recent works are evocations of the vivid colors and forms of sea animals and plants found in tidal pools, as well as Tom Patti, Mark Peiser and Joel Philip Myers. The ceramics collection includes works by Don Reitz, Paul Soldner, Paula Rice, Bennett Bean, Harvey Sadow and Frank Fleming.

MICHIGAN

ANN ARBOR

Clare Spitler Works of Art 2007 Pauline Court, Ann
449 Arbor, MI 48103 (313) 662-8914; Tue: 2-6 & by appt; owner/dir: Clare Spitler

The visitor to Clare Spitler may see works by contemporary American artists, with emphasis on those working in mid-America, as well as a few European artists' work, mostly original prints. Media handled include painting, sculpture, graphics and crafts.

Artists with established reputations include Jean-Ives Bourgain, French painter and printmaker; American artists Fritz Dreisbach, master in glass; and David F. Driesbach, internationally known printmaker.

The main thrust of CSWA is to promote the best talent emerging from mid-America. The list of artists shown includes painters on paper, canvas and board A.J. Barrish, Jeanne H. Butler, Judy Jashinsky, Cheryl Roark and Bruce Thayer; painters on silk Marie-Laure Ilie and Pat Whyte-Lehman; printmakers or artists in handmade paper Jo Ann Alber, Brigitte Kranich (Germany), Dorothy Linden and Barbara Young; sculptors in clay, metal or paper George Cismoski, Jer Patryjak and Floy Shaffer.

Alice Simsar Gallery 301 N. Main St., Ann Arbor,
450 MI 48104 (313) 665-4883; Tue-Sat: 10-5 Aug 15-31: closed; owner/dir Alice Simsar

Concentration of the gallery is on American and English printmakers, painters and sculptors. The gallery places particular emphasis on handmade paper works.

Gallery artists include Adja Yunkers, John W. Mills, John Brunsdon, William Weege, Joseph Zirker, Vasa and Julian Stanczak.

BIRMINGHAM

Cantor/Lemberg Gallery 538 N. Woodward Ave.,
451 Birmingham, MI 48011 (313) 642-6623; Tue-Sat: 11-5:30; owner: Claire J. Cantor, Corrine Lemberg dir: Robert L. May

The Cantor/Lemberg Gallery shows contemporary American art, including painting, drawings, sculpture and prints.

Artists featured by the gallery include West Coast abstractionist Sam Francis, Aris Koutroulis, Mel Rosas, innovative printmaker and painter Steven Sorman, and painter Walasse Ting. Other artists include Jim Dine, Louise Nevelson, Minimalist painter Al Held, and California painters William T. Wiley and Wayne Thiebaud.

GMB Gallery, Inc. 344 Hamilton Row, Birming-
452 ham, MI 48011 (313) 642-6647; Tue-Sat: 10:30-5; owner: Michael Zennedjian dir: Robert Zennedjian

The GMB Gallery specializes in contemporary American artists working in painting, sculpture, ceramics and graphics, with an emphasis on abstract colorism.

Among the many artists whose work is displayed in the gallery are Robert Natkin, known for his abstract works of painterly textures and subtly vibrant color; Los Angeles abstract illusionist Jack Reilly; Michael Dillon; and Russel Klix. The gallery handles work by many other artists locally and nationally.

The Halsted Gallery 560 N. Woodward Ave., Bir-
453 mingham, MI 48011 (313) 644-8284; Tue-Sat: 10-5:30; owner: Thomas Halsted dir: T. Halsted & Melanie S. Johnson

Specialty of The Halsted Gallery is 19th and 20th century fine art photography and rare photography books.

The gallery carries photographic prints by such contemporary master photographers as Ansel Adams, Brett Weston, Cole Weston, John Ward, Lilo Raymond, Edward S. Curtis, Joel Meyerowitz, Walker Evans, William Mortensen, Olivia Parker, Henri Cartier-Bresson and Max Yavno. In addition, the gallery acts as agent for Douglas Frank, Marsha Burns, Christopher James, August Sander and Michael Burns.

The Halsted Gallery also handles monotypes by a California artist, Mireille Morency-Lay, paintings on canvas and paper by Theodore Waddell, and a collection of Native American Indian baskets.

Susanne Hilberry Gallery 555 S. Woodward Ave.,
454 Birmingham, MI 48011 (313) 642-8250; Tue-Sat: 11-6; owner/dir: Susanne Hilberry

Concentration of the gallery is on contemporary and modern American and European painting, sculpture and drawing, with an emphasis on contemporary American painting, sculpture and drawing.

The gallery exhibits important works by Richard Artschwager, Lynda Benglis, Alexander Calder, John Egner, Ron Gorchov, Alex Katz, Nancy Mitchnick, Malcolm Morley, Elizabeth Murray, Alice Neel, Judy Pfaff, Ellen Phelan, Italo Scanga, Joel Shapiro, Tony Smith, John Torreano, Frank Stella and Joe Zucker.

A wide range of stylistic categories is represented, the focus being on the evolution of an entire body of work. A modern approach is represented by Alex Katz's simplified and nostalgic paintings and cutouts, and again by Nancy Mitchnick's sensuous, expressionistic representations. In a more narrative vein, the work of Italo Scanga associates the modern and the mythological. The constructions of Frank Stella, sculpture of Lynda Benglis, and paintings of Ron Gorchov deal with pictorial and sculptural concerns of space, shape, light and color.

Carol Hooberman Gallery 155 S. Bates, Birming-
455 ham, MI 48011 (313) 647-3666; Tue-Sat: 10:30-5; owner/dir: Carol Hooberman

The Carol Hooberman gallery deals in fine contemporary American crafts for the collector.

Works are available in the media of blown glass, textiles, ceramics, wood, and handcrafted jewelry.

Donna Jacobs Gallery Ltd. 574 N. Woodward Ave.,
456 Birmingham, MI 48011 (313) 540-1600; Tue-Sat: 11-5:30; owner/dir: Donna Jacobs

Specializing in ancient art, the Donna Jacobs Gallery displays work from diverse cultures of antiquity in permanent and changing exhibitions. Artifacts of glass, bronze, terra cotta, marble and stone, as well as jewelry and fine archaeological textiles are available from ancient Egyptian, Greek, Roman, Near Eastern and Pre-Columbian American cultures.

The gallery also displays some contemporary work reminiscent of ancient objects. Neo-Classical goldsmith Claire Bersani employs time-hallowed techniques such as granulation, believed to have originated in Asia Minor in the Second Millenium B.C., to fashion jewelry. Earl Krentzin, a silver sculptor represented in many international collections, works in gold, silver and semi-precious stones, representing imaginary animals and humans in a style which shows respect for ancient and folk traditions.

Donald Morris Gallery, Inc. 105 Townsend St., Bir-
457 mingham, MI 48011 (313) 642-8812; Tue-Sat: 10:30-5:30; dir: Donald Morris, Florence Morris, Mark Morris, Steven Morris

The gallery devotes its space to exhibiting 20th century American and European paintings, drawings and sculpture.

The gallery carries works by such distinguished European masters as Pablo Picasso, Henri Matisse, Joan Miro, Fernand Leger, Jean Dubuffet, and Aristide Maillol.

American art includes works by artists associated with the Stieglitz group in particular, as well as other post-war American masters. There are works by Joseph Stella and Arthur Dove, who developed highly individual styles, at times abstract or near-abstract, from their personal interpretations of European styles of their epoch. Dove reveals qualities of Fauvism, or the abstract art of Kandinsky, where Stella tended more to Expressionist and Futurist influences. Arshile Gorky's biomorphic abstractions represent a similar virtuoso act of synthesis, evident in his early works in imitation of Cezanne, Picasso and Miro. One may also find later work of representational colorist Milton Avery and sculptor Alexander Calder. In addition to works by these artists, who exerted a powerful influence on contemporary American art emerging in the 50s, the gallery carries works by Joseph Cornell, Hans Hofmann, Clement Meadmore, Al Held, Christo, Lester Johnson and Philip Pearlstein.

Pierce Street Gallery 217 Pierce St., Birmingham, MI
458 48011 (313) 646-6950; Wed-Sat: 11-5 Aug: closed; owner: M. Boxman, N. Karnick & E. Yorker

20th century photography is the main interest of the Pierce Street Gallery. Most of the photographic prints displayed are black and white, though a few are in color—especially hand-tinted color.

The gallery carries work by a number of photographers, including O. Winston Link, whose 1950s "Ghost Train" series is available. Denny Moers is represented by hand-fixed photographs of architectural and textured spaces. His technique results in an exquisite palette on originally black and white images. Jane Luckerman, head of Harvard's Photography Department, contributes black and white infrared imagery to the gallery inventory. There are small panoramic views, delicate in their imagery and tonality, by Allan Janus. Howard Brand creates classic landscapes in the tradition of Ansel Adams.

Sheldon Ross Gallery 250 Martin St., Birmingham,
459 MI 48011 (313) 642-7694; Tue-Sat: 11-5 Aug 15-31: closed; owner/dir: Sheldon Ross

Sheldon Ross Gallery handles early 20th century American paintings, drawings and prints, and German Expressionist drawings and prints.

The major part of the gallery's stock is in American realists. The gallery carries works by Oscar Bluemner, a member of Stieglitz's circle who helped introduce progressive European tendencies to American art; by romantic painter Louis Eilshemius; by Edward Hopper, who portrayed American cities and scenery with powerful effects of light that transform the commonplace; by watercolorist Charles Burchfield, whose painting seeks to reveal the abstract organic patterns at work in nature; and by social realist Reginald Marsh. The gallery also features collages and watercolors by Romare Bearden.

German Expressionist prints are available by sculptor Ernst Barlach, Max Beckmann, American expatriate Lionel Feininger, Georg Grosz and Kathe Kollwitz.

The gallery has on hand John Sloan etchings, prints by the great Belgian painter, forerunner of the Expressionists and Surrealists James Ensor (many from the estate of Augusta Boogaerts, Ensor's lifelong companion), and Alexander Calder gouaches. There are also sculptures from Oceania and Africa. The gallery rounds out its inventory with works by Michigan artists, including Leo Mardirosian, Richard Jerzy and Sue Linburg.

Schweyer-Galdo Galleries 330 Hamilton Row, Bir-
460 mingham, MI 48011 (313) 647-0390; Tue-Sat: 11-5:30; owner: Olga Chao dir: Cathy Ferguson

This is a contemporary art gallery that shows original works, both representational and abstract, by internationally recognized masters from the U.S., Europe and Latin America. The gallery also represents a select group of regional and local artists.

Artists shown include Richard Pousette-Dart, a first generation Abstract Expressionist known for his lyrical style and coruscating textures, and American sculptor Roberto Estopinan; as well as Alexander Calder, Antoni Tapies and Joan Miro. A number of Latin American artists are featured, including Mexico's great draftsman Jose Luis Cuevas, abstract colorist Bencomo, Perez-Celis, Wifredo Lam and Rufino Tamayo. The gallery carries work by Post-Modernist painter Osvaldo Bomberg, who represented Israel in the 1984 Venice Biennial. Local sculptor Jay Lefkowitz works in marble and steel. Ramon Carulla creates figure paintings and collage in a figurative style.

Xochipilli 568 N. Woodward Ave., Birmingham, MI
461 48011 (313) 645-1905; Tue-Sat: 11-5 Aug 23-31: closed; owner/dir: Mary Wright

The gallery concentrates on works by emerging American artists. Among those featured are: John Aaron, Dewey Blocksma, Lowell Boileau, Maggie Citrin, Claudia DeMonte, Rita Dibert, Stephen Goodfellow, Misha Gordin, Stephen Hansen, Daniel Morper, Bruce Scharfenberg and Douglas Warner.

DETROIT

London Arts Gallery 321 Fisher Bldg., Detroit, MI
462 48202 (313) 871-2411; Mon-Fri: 10-6; owner: Eugene Schuster dir: David Zelmon

London Arts Gallery publishes contemporary American and European graphics. The gallery carries a large selection of prints by the COBRA Group, as well as new graphics by Photorealist artists. Late 19th and early 20th century graphics, and prints by American Regionalist artists of the 20s and 30s are also available.

COBRA (for Copenhagen, Brussels, Amsterdam, cities of origin of the artists) artists include Karel Appel, Alechinsky and Corneille. Photorealist works are on hand by John Baeder, Fran Bull, Tom Blackwell, Arne Besser and C.J. Yao.

The gallery has mounted shows of works by Yaacov Agam, Romare Bearden, Gene Davis, Lester Johnson, Peter Max, Richard McLean, Lowell Nesbitt, Raphael Soyer, Julian Stanczak, Walasse Ting and Larry Zox.

C.A.DE. Gallery (Contemporary Arts Detroit) 8015
463 Agnes St., Detroit, MI 48214 (313) 331-1758; Tue-Sat: 12-7 Aug 15-Sep 15: closed; owner/dir: Joe Fugate

C.A.DE. Gallery specializes in local contemporary art but is not limited to local artists, having shown works by artists from outside the Michigan area. The gallery displays a wide variety of fine art and craft media.

That the "total work of art" is the artform most typical of our era, is born out by the contemporary artists exhibiting at C.A.DE. Many are multi-media artists or use multi-media techniques to amplify their chosen medium.

Painters include Russell Keeter, Erica Chappuis, abstract illusionist Mark Solsburg, Neo-Expressionist Kristin Hermanson, and multi-media painter Susan Raisig. Young Black painter Donna Bruton paints in a folk art primitive style, while Ken Giles works in a textural style influenced by Near Eastern architectural motifs.

Sculptors include Hugh Timlin, bronze and stone; Ted Hadfield, multi-media; Robert Bielat; and Ronald A. Leax, installations. Ann Maria D'Anna creates multi-media installations, and Peggy Midener, mythical fantasy boxes.

Printmakers include Joe Poole and Susan Goethal Campbell, who works in multi-media graphics. Joe Fugate, who founded the gallery in 1977, works in multi-media art. John Gerard works in paper and fiber, while Gretchyn Steele works in fiber and textile. John Ganis, a photographer, rounds out this diverse and active group.

The Detroit Artists Market 1452 Randolph St., Detroit, MI 48226 (313) 962-0337; Tue-Sat: 10-5
464 Aug: closed; dir: Mary Denison

The Detroit Artists Market is a nonprofit art gallery which exhibits the work of artists in southeastern Michigan. Artists submit work monthly to changing professional jurors for exhibition in the upper gallery. The first floor gallery shows thematic invitational exhibits. Emerging artists are shown, as well as mature artists without gallery representation.

The gallery shows work in all media, including clay by Elizabeth Lurie; glass by Herb Babcock, Janet Kelman and Albert Young; works on paper by Mary Aro, Lynn Auadenka and Julie Russell; realist painting by Michael Jackson, and abstract painting by Julie Rettke.

LAKESIDE

Lakeside Studio 15263 Lakeshore Rd., Lakeside, MI
465 49116 (616) 469-1377; Mon-Fri: 9-5 Sat-Sun: 10-4 Oct-May: closed; owner/dir: John D. Wilson

The Lakeside Studio specializes in Early and Modern Master prints. A new specialization includes an emphasis on ceramics produced in the Artist-in-Residence program for ceramists started in 1981. The Lakeside Studio also publishes contemporary prints by such artists as Richard Black, Adrian Van Suchtelen and Richard Hunt.

LATHRUP VILLAGE

Habatat Galleries 28235 Southfield Rd., Lathrup
466 Village, MI 48076 (313) 552-0515; Tue-Sat: 10-6 Fri: 10-9; owner: Ferdinand Hampson & Thomas J. Boone dir: F. Hampson

Habatat Galleries exhibits artists who work in glass as their primary material. The gallery concentrates on experimental statements and sculptural forms. Artists exhibited come from all over the world.

Habatat Galleries features some of the most noted artists using glass, including artists who have been associated with the Rhode Island School of Design, such as Dale Chihuly, Michael Glancy and Stephen Weinberg. The gallery also carries works by important Czechoslovakian artists working in glass.

OKEMOS

Bel Esprit Fine Arts 4516 Oakwood Dr., Okemos, MI
467 48864 (313) 349-2074; by appt; owner/dir: Bonnie Stebbins

Bel Esprit Fine Arts specializes in high-quality original prints by national and international artists from the 17th century to the present. A cross-section of printmaking media and style over a wide price range is available.

Important printmakers include members of the COBRA group Karel Appel, Pierre Alechinsky and Corneille. Original prints by Victor Vasarely are available, as well as works by Joan Miro, Pablo Picasso, Henry Moore, Mark Tobey, Honore Daumier, David Hockney, Marc Chagall and many others.

The gallery carries an extensive selection of contemporary artists, which includes James Coignard, carborundum etchings; G.H. Rothe, mezzotints; silkscreens by Peter Max, Arthur Secunda, Bob Sanders, Robert Indiana, Jack Youngerman,

Corita, Eyvind Earle, Max Sabin and Clement Wescoupe; lithographs by Graciela Rodo Boulanger, Graham Sutherland, Michel Delacroix, Fanch, Paul Wunderlich and Garo Antreasian; and etchings by Paula Crane, Johnny Friedlander and Adrian Van Suchtelen, among others. There are also handmade paper works by Van Suchtelen, William Weege and Doug Warner.

ROYAL OAK

Arnold Klein Gallery 4520 N. Woodward Ave.,
468 Royal Oak, MI 48072 (313) 647-7709; Tue-Sat: 11-5:30; owner/dir: Arnold Klein

The Arnold Klein gallery specializes in 19th and 20th century original prints, West European and American. The gallery also handles pastels, watercolors and drawings.

Of particular interest are etchings by James Whistler and his circle, particularly Alphonse Legros and Seymour Haden. Born in France, Legros was instrumental in reviving popular interest in the print in England, where he worked and taught. Haden came to art comparatively late, after a successful career as a doctor, yet he is accounted one of England's finest printmakers of the epoch. The gallery also handles woodcuts and etchings by Auguste Lepere, as well as 1950s lithographs by Jean Dubuffet. Significant illustrated books—*livres d'artiste*—are on hand also.

Contemporary artists whose work is shown include English printmaker Norman Ackroyd, aquatints; and American artists Karen Klein, color pencil; Donna Rae Hirt, watercolor and pencil; A.G. Smith, pencil; Mary Harney, pencil; and Larry Blovits, pastel. The gallery carries an exceptional collection of mezzotints as well.

SOUTHFIELD

Park West Galleries 29469 Northwestern Hwy.,
469 Southfield, MI 48034 (313) 354-2343; Mon-Wed: 10-6 Thu-Fri: 10-9 Sat: 10-5 Sun: 12-5; owner: Albert Scaglione dir: Morry Shapiro

An expansive, diverse and high quality collection occupies Park West Galleries' extensive facilities. The gallery specializes in contemporary painting, sculpture and fine prints by American and European masters. Also features are major emerging artists, select 19th century Belle Epoque works, and a small selection of Old Masters.

Paintings and prints are available by Yaacov Agam, Harold Altman, Alvar, Marc Chagall, Erte, Dus, Robert Kipniss, Toulouse-Lautrec, Leonardo Nierman, Auguste Renoir, Pablo Picasso, Joan Miro, Victor Vasarely and numerous others. The gallery also offers publications by Agam, Vasarely, Dus and Alaniz. Major shows in 1984 include Agam, Miro and Dus.

TROY

Troy Art Gallery 755 W. Big Beaver, Suite 131,
470 Troy, MI 48084 (313) 362-0112; Tue-Sat: 11-5:30 Aug: closed Sat; owner/dir: Miriam Feldman

The Troy Gallery specializes in Japanese woodblock prints of the *ukiyo-e* period (18th and 19th

century) and 20th century Japanese prints. The gallery also handles works by American and European printmakers, as well as paintings by local Michigan artists.

Masters of the immensely popular *ukiyo-e* style include 19th century landscape artist Ando Hiroshige; Utagawa Kuniyoshi, known for his many warrior and actor prints; Yoshitoshi and Utagawa Kunisada, known for images of beautiful courtesans; Toyokuni III, and many others. Among the 20th century artists are Kawase Hasui (1883-1957), declared a National Treasure of Japan, Hiroshi Yoshida, a classical landscape artist; Kiyoshi Saito, a popular modern artist; Naoka Matsubara; Jan Sekino; Kazuhisha Honda, mezzotints; Haku Maki, cement woodblocks; and Shigeki Kuroda, bicycles and umbrellas.

The gallery also features lithographs of congressmen and attorneys by social realist William Gropper; prints of women, cats and birds rendered in broad planes of color by Will Barnet; prints by Dutch artist Karel Appel; geometric serigraphs by Jurgen Peters; serigraphs of American landscapes in fragmented and layered colors by Jerome Schurr. Works by Michigan artists include mixed media painting of surrealistic figures by Evelyn Rast, and German Expressionist oils and watercolors by Johanna Haas.

MINNESOTA

MINNEAPOLIS

Avanyu Gallery Butler Sq., Suite 218, 100 N. 6th St.,
471 Minneapolis, MN 55403 (612) 333-5246; Mon-Thu: 11-6 Fri-Sat: 11-10 Sun: 12-5; owner/dir: John M. Boler

On view in the Avanyu Gallery are continuous and special showings of Native American and Southwest art, featuring a large selection of Navajo weaving and Pueblo Indian pottery. Also featured are contemporary paintings, original graphics, sculpture, drawings, ceramics and posters by over thirty national and local artists.

Contemporary Southwest artists include Norma Andraud, John Axton, Clifford Beck, Louis de Mayo, Katalin Ehling, Frank Howell, Jon Lightfoot, Ed Mell, John Nieto, Amado M. Pena, Jr., Dolona Roberts, Ed Singer, Shirley Thomson Smith, Veloy Vigil, Beatien Yazz and Nancy Young—each of whom uniquely and reverently portrays the people, land and culture of the Southwest.

The gallery has also introduced many emerging artists whose work is based on the Indian heritage of Minnesota: Robert Desjarlait, Slats Fairbanks, Cris Fulton, Kevin Johnson, David Kline and Sanyan Tawa Wicasta. Transplanted Southwesterners Richard Sternberg and Jack Stephens recreate their memories of the Southwest, though they live now in Minnesota. Traditional art by Oklahoma Indians William Rabbit, Robert Redbird and Donald Vann is also featured by the gallery.

Peter M. David Gallery, Inc. 430 Oak Grove St., Suite
472 101, Minneapolis, MN 55403 (612) 870-7344; Mon-Fri: 12-4 and by appt Aug: closed; owner/dir: Bonnie Sussman

The Peter M. David Gallery specializes in contemporary works on paper by American artists, including original prints, drawings, photographs, as well as works using paper as their principal medium, such as artists' books and handmade paper works.

Artists whose work has achieved considerable renown in Minnesota, as well as nationally, include Cynthia Starkweather-Nelson, Lee Bjorkland, Terry Streich, Mark Rediske, Bonnie Cutts and Dyan McClimon. The gallery also shows works by international artists such as Robert Motherwell, David Hockney, William Weege, Caroline Greenwald and others who make prints. Among the other artists exhibited, one could mention Sandy Kinnee, who had his first commercial exhibition here and went on to become known nationally.

Dolly Fiterman Gallery Suite 238, Plymouth Bldg.,
473 Minneapolis, MN 55402 (612) 370-8722; Mon-Fri: 10-5; owner/dir: Dolly Fiterman

The Dolly Fiterman Gallery specializes in contemporary American, European, local and regional art, encompassing a broad range of contemporary styles in both representational and abstract modes. The gallery handles a comprehensive selection of works in all major disciplines: painting, drawing, sculpture and fine prints.

Many artists of national and international stature are featured by the gallery, including Allan D'Arcangelo, Jim Dine, Sam Francis, Dorothy Gillespie, Grace Hartigan, Jasper Johns, Mary Francis Judge, Luciano Lattanzi, David McCullough, Henry Moore, Robert Motherwell, Matt Phillips, John Raimondi, Robert Rauschenberg, James Rosenquist, Richard Smith, Joe Tilson, Andy Warhol and Adja Yunkers.

Local and regional artists featured by the gallery are Mary Ingebrand, Raymond Jacobson, Aribert Munzner, Malcolm Myers, David Rich, John Rooney, Gayle Cole and Thomas Wolfe, among others.

C.G. Rein Galleries 3646 W. 70th St., Minneapolis,
474 MN 55435 (612) 927-4331; Mon-Fri: 10-9 Sat: 10-6 Sun: 12-6; owner: C.G. Rein dir: Judy Cavanaugh

See listing for Scottsdale, AZ.

John C. Stoller & Co. 400 Marquette Ave., Minne-
475 apolis, MN 55401 (612) 339-7060; Mon-Fri: 10-5:30 Sat: by appt; owner/dir: John Stoller

Concentration is on post-World War II American paintings, drawings, sculpture and prints. The gallery tends to show major figures of the Abstract Expressionist School, as well as many present day masters.

Some of the artists whose work is featured are: Josef Albers, Arakawa, William Bailey, Jennifer Bartlett, Alexander Calder, Joseph Cornell, Richard Diebenkorn, Jim Dine, Helen Frankenthaler, Robert Graham, Hans Hofmann, David Hockney, Jasper Johns, Ellsworth Kelly, Roy Lichtenstein, Michael Mazur, Robert Motherwell, Louise Nevelson, Claes Oldenburg, Robert Rauschenberg, Frank Stella, Bradley Walker Tomlin and Terry Winters.

MISSISSIPPI

JACKSON

Bryant Galleries Box 4651 Highland Village, Jackson,
476 MS 39216 (601) 362-2717; Mon-Sat: 10-6; owner/dir: Bryant Allen

The Bryant Gallery exhibits contemporary American art. The gallery also maintains an extensive collection of third generation Haitian art.

Artists whose work is exhibited at the gallery include Noel Rockmore, Donny Finley, Rex Robinson, George Thurmond and Alan Flattman.

Jackson Arts Alliance/Creative Exchange Gallery
477 175 E. Capitol St. Jackson, MS 39201 (601) 960-1557; Mon-Fri: 9-5; dir: Connie Beardsley

Managed by the city arts council, the gallery mounts exhibitions concerned with contemporary art. Recent one-person exhibitions have included works of Blanche Batson, Lynn Green, Ron Lindsey, Loy Moncrief, Frank Neal, Karen Papania, Yvette Sturgis. Other artists represented are Nanette Beaumont, Carol Cox, Fletcher Cox, Carolyn Olsen, Bill Rusk, Ramona Ward.

Whittington Gallery 176 Highland Village Jackson,
478 MS 39211 (601) 362-6656 Mon-Sat: 10-6 dir: Beecy Whittington

Contemporary art in all media is shown, however the primary emphasis is prints and photographs. Recent one person exhibitions have included works of Barbara Cerniglia, Mitch Crimm, Stephen Kilpatrick, Michael Schreck. Other artists represented are Marion Brown, Gretchen Haien, Jim Hardin, Michelle Devereaux Hardy, Birney Imes III, Jay Koelzer, Gary Richardson, Phillip Sage and Jon Whittington.

MISSOURI

KANSAS CITY

Art Research Center 922 E. 48th St., Kansas City,
479 MO 64110 (816) 931-2541; Sun: 2-6 & daily by appt; coordinator: T.M. Stephens

Founded in 1966, the Art Research Center is devoted to presenting new and experimental art to the public, while advancing research in the constructive arts. A.R.C. is one of the oldest alternative spaces in the United States.

In 1983 A.R.C. presented various exhibitions, including visual poetry and constructivist fictions by Richard Kostelanetz; 12 years of projects and proposals for constructions by Carlos Setien; and kinetic and luminic constructions and computerized prints by Thomas Michael Stephens. The gallery also presented an exhibition of computer prints based on the hypercube (a four dimensional version of the cube) by Manfred Mohr, an internationally known artist based in Berlin and Paris. Will Nettleship exhibited a series of sculptures and projects for public sculptural fountains. Tim Forcade's work included sonic realizations, photographic works and synthesizer-generated music and cathode-ray images.

1984 has included alpha structure drawings and new music by Michael Winkler, a composer from Philadelphia. Notable exhibitions since the founding of A.R.C. include a retrospective of

the work of architect Stanley Tigerman, a major show of kinetic and luminic works by Zbigniew Blazeje, and the first American shows of Op Art pioneer Francois Morellet and Max Mahlmann and Gudrun Piper, from Hamburg. A.R.C. presents many traveling group shows, symposia, and international surveys.

Batz/Lawrence Gallery 4116 Pennsylvania, Kansas
480 City, MO 64111 (816) 531-4438; Mon-Sat: 11-5; owner/dir: Susan Lawrence & Sally Batz

The Batz/Lawrence Gallery presents American and European paintings, drawings, original prints and sculpture of the 20th century. The directors center their collection on works that reflect traditional artistic and humanistic values, as in American Social Realism, the historical avant-garde of Europe or the New York School. The gallery also provides a space for regional artists to exhibit.

The extensive graphics collection includes a large selection of works by Joan Miro, as well as prints by Alexander Calder, Paul Wunderlich, Karel Appel, Rene Magritte, George Segal, Bruno Bruni, Roberto Matta, Peter Paul, David Itchkawich, American realist Harold Altman and Canadian printmaker Bonnie Baxter. Part of the gallery is devoted to American Social Realists such as William Gropper, Phillip Evergood, Raphael Soyer, Moses Soyer, Ernest and Alicia Fiene, Chaim Gross and Ben Zion.

Works by contemporary regional artists include computer art by Colette and Charles Bangert; drawings by Colette Bangert; handmade paper by Jean Van Harlingen and Lloyd Menard; sculpture by David Vertacnik, Jim Bass and Joanne Nuss; and paintings by Mike Stack, Douglas Freed, Jerry Lubinsky, Philomene Bennett and Joan Froth.

New Structures 820 E. 48th St., Kansas City, MO
481 64110 (816) 333-0260 & 931-2541; by appt; owner: Thomas Michael Stephens dir: Sue Scott

New Structures is devoted to systematic and abstract art with a unique specialty, "Apparative Art": computer-generated works, experimental photography, film, video and other machine-produced or apparatus-assisted work. The gallery handles work by 50 international, national and local artists.

Artists involved in computer art include Manfred Mohr, Herbert W. Franke, new music composer Herbert Brun, and T.M. Stephens, who produces spatial paintings, experimental photography and computer-driven kinetic work. Other experimental photographers are Tim Forcade, who also works in film and video, Gloria DeFilips, John Baird and Michael Zagalik. Toronto artist Zbigniew Blazeje and Italian Alberto Biasi both make kinetic and luminic art.

Elizabeth Willmott of Toronto, Jaya James Kern, and Horst Linn and Hartmut Bohm of the "Gruppe fur Gestaltung," Lunen, Germany, all work in structural reliefs. Willmott also does photography, while the two Germans are printmakers. Clark Richert of Boulder, Colorado, is a painter and theoretician in the *Crisscross Group*. Others whose work is featured in the gallery include Romanian architect, designer and Constructivist Virgil Salvanu, composer and draftsman Michael Winkler, former Bauhaus student An-

dreas Weininger, and leading German systematic artists Max Mehlmann and Gudrun Piper.

SAINT LOUIS

Timothy Burns Gallery 393 Euclid Ave., St. Louis,
482 MO 63108 (314) 361-7466; Tue-Sun: 12-5 Wed, Fri: 12-9; owner/dir: Timothy Burns

The Timothy Burns Gallery opened in October 1979, continuing the tradition of the Terry Moore Gallery as a contemporary exhibition space devoted to the promotion of prominent and promising artists from the Saint Louis area. In order to establish an active dialogue with other American art centers, the Timothy Burns Gallery also represents significant contemporary artists from Chicago, Minneapolis, Kansas City and other midwestern cities, as well as New York and San Francisco.

Major midwestern contemporary painters shown at the gallery include Keith Achepol, William Kohn, Susan Moore and Arthur Osver, who work in oil and watercolor; Steve Sorman, working in prints and mixed media on paper; and Kim Strommen, who works in acrylic on canvas and steel sculpture. Gary Passanise paints with oil on canvas and wood and makes steel, glass and marble sculpture.

Among the other artists shown are Ken Brown, a Neo-Expressionist figurative painter; Michael Eastman, a photographer who emphasizes architectural imagery; Von Eisenhardt, who works in oil, encaustic and acrylic on canvas; and photorealist painter Robert Forbes. Greg Gomez works in cast paper, collographs, chine colle; Jennifer Harroun, mixed media collage; Art Kleinman, oil and encaustic on wood and canvas; Hylarie McMahon, paint on sewn fabric constructions. Also on view are Genell Miller's large scale non-representational paintings, Mickey Sellard's drawings documenting travels, habitats and whimsical imagery, and Jerry Wilkerson's silkscreen prints and acrylic on canvas paintings.

Gallery of the Masters 453 N. Lindbergh, St. Louis,
483 MO 63141 (314) 993-4477; Mon-Fri: 8:30-4:30; dir: Martin Kodner

American Impressionism of the 19th century takes up the largest part of the exhibition space. Some works by American and European masters may also be found juxtaposed with contemporaries. Many important works by artists of the Taos school are collected, most noticeably those of Oscar E. Berninghaus and Joseph Sharp. Works of many artists of the Old West often include those of Frederic Remington and C.M. Russell. Other pieces often found among the collections include those by Lionel Feininger, F.C. Frieseke, Childe Hassam, Franz Kline, Walt Kuhn, Ernest Lawson, Alfred Jacob Miller, Thomas Moran, Jay Alden Weir, Andrew Wyeth and Thomas Hart Benton

Greenberg Gallery 44 Maryland Plaza, St. Louis, MO
484 63108 (314) 361-7600; Mon-Sat: 10-5; dir: Ronald K. Greenberg

Contemporary American art in all media are the subjects of the many one person exhibitions. Works are mainly culled from both coasts including many prominent Californians such as

Tom Holland and Peter Voulkos. Recent works are often available by New York painters including Ellsworth Kelly, Roy Lichtenstein, Robert Motherwell, Frank Stella and British-born David Hockney.

Many pieces by main protagonists of abstraction are found including works by Louise Nevelson, Josef Albers, Robert Motherwell and Alexander Calder. Other artists include Chuck Close, Ken Ferguson, Viola Frey, Sandy Skoglund, Rudy Autio, and Betty Woodman.

Carol Shapiro Gallery 329 N. Euclid Ave., St. Louis, *485* MO 63108 (314) 361-3655; Wed-Sat: 1-5; owner/dir: Carol Shapiro

Emphasizing the work of emerging young artists with regional or national reputations, the Carol Shapiro Gallery shows work in all media, including graphics, drawings, constructions, ceramics and sculpture.

Artists whose work is featured include painter and printmaker Robert Gordy, who recently had a 20 year retrospective at the New Orleans Museum of Art; painter Jerry Wilkerson, represented in the collection of the St. Louis Art Museum and the Kansas City Art Museum; sculptor and painter Gary Passanise, represented in the collection of the St. Louis Art Museum; and Tony Gilberto, whose work is in the permanent collection of the Museum of Contemporary Art in Chicago.

In addition to works by these artists, one may view canvas constructions and works in cast paper by Judith Weltman, who reveals the influence of Louise Nevelson; cast paper reliefs by Stan Helfrich; translucent porcelain pieces by Curtis and Suzan Benzle; *raku* and earthenware ceramics by Bob Smith; photorealist painting by Barbara Frets, and the work of Charles Clough, a young "new image" painter, co-founder of the Hallwalls alternative space in Buffalo, New York.

Nancy Singer Gallery 31 Crestwood Dr., St. Louis, *486* MO 63105 (314) 727-1830; by appt only; owner/dir: Nancy Singer

The Nancy Singer Gallery specializes in prints by contemporary masters, most of them American, as well as small sculpture and handmade paper art.

Among the artists represented in the graphics collection of the gallery are Jasper Johns, Robert Rauschenberg, Roy Lichtenstein, Claes Oldenburg, Ellsworth Kelly, Sam Francis, Kenneth Noland, Philip Pearlstein, Alex Katz, David Hockney, Richard Diebenkorn, Jim Dine, Helen Frankenthaler and Robert Motherwell. The gallery also carries graphics by many emerging or mid-career artists. There are the multicolor woodblock prints of sculptor and printmaker Daniel Goldstein, prints by sculptor Dewain Valentine, by "Pattern and Decoration" painter Robert Kushner, and by Jennifer Bartlett, who is best known for her modular baked enamel on steel pieces. Also available are works by West Coast painters Tom Holland, Charles Arnoldi and abstract illusionist Ron Davis, as well as by Carolyn Brady, Beth Van Hoesen and Ed Baynard.

B.Z. Wagman Gallery 34 N. Brentwood, St. Louis, *487* MO 63105 (314) 721-0250; Wed-Sat: 11-4 Aug 15-Sep 1: closed; owner/dir: Barbara Z. Wagman

The gallery features outstanding national and local artists who work in glass, ceramics, paper and fiber, metal, and painting.

Masters of contemporary glass include: Harvey Littleton, Dale Chihuly, Joel Philip Myers, William Carlson, Tom McGlauchlin, David Huchthausen, Tom Patti, Dan Dailey, Steven Weinberg, Ann Warff, Richard Ritter, Herb Babcock, Mark Peiser, Paul Seide, Sonja Blomdahl, Margie Jervis & Susie Krasnican, Stephen Dee Edwards, Harry Umen, and Klaus Moje & Kyohei Fujita.

Paper/fiber artists include Neda Al Hilali, Glenn Brill, Pat Campbell, Lia Cook, Joan Hall, Beverly Moor, Kenneth Noland, Nance O'Banion, Jane Sauer and Angelita Stover.

Ceramic artists include John Donoghue, Margie Hughto, Elsa Rady and Peter Shire. Painters include Leon Anderson, Jerry Concha, Sarah Krepp, Peter Marcus, Jay Phillips, Phyllis Plattner and Dan Ziembo.

MONTANA

BILLINGS

Art in the Atrium 401 N. Broadway, Billings, MT *488* 59101 (406) 657-1353; Mon-Fri: 8-5; owner: Billings Gazette dir: Bernadine Fox

Living contemporary artists from the Montana and Western region are shown at Art in the Atrium. The gallery exhibits a full scope of regional art from non-representational painting and sculpture to Native American folk art and miniatures.

Contemporary Atrium exhibitors include James Haughey, AWS, a well-known Montana landscape watercolorist, Donna Loos, an abstract modernist working in oil and acrylic, and Bob DeWeese, an innovator of Western imagery.

Castle Gallery/Second Story 622 North 29th St., *489* Billings, MT 59107 (406) 259-6458; Tue-Fri: 10-5 Sat: 10-3; owner/dir: Tom Nelson & Jane Deschner

Castle Gallery specializes in contemporary art and fine crafts. The Second Story is an exhibition space for monthly exhibitions featuring from one to five artists. The first floor of the building features regional artists work in a continuing show.

The gallery hosts an international miniature show and a national juried (color show) each year.

Gallery '85 Emerald Dr., Billings, MT 59105 (406) *490* 259-6969; Mon-Sat: 10-5 Jan-Feb: closed; owner: Karolyn Gainan dir: Maribeth Dietrich

The gallery handles contemporary work by nationally recognized Western and wildlife artists.

Work shown includes Western landscapes by Clyde Aspevig; watercolors of songbirds by Patti Canaris; wildlife paintings by James Killen; Western landscape watercolors by Jean Halveson; contemporary landscape by Robert Blair; and hand-colored etchings of wildlife by Sandy Scott. The gallery also exhibits portrayals of Western life by Anthony Sinclair; bronze wildlife sculpture by Clark Bronson; and bronze sculpture of Western life from the estate of E.E. Heikka.

BOZEMAN

Artifacts Gallery 308 E. Main St., Bozeman, MT
491 59715 (406) 586-3755; Mon-Sat: 10-5; owner/
dir: Patricia Blume

The gallery is committed to exhibiting contemporary art as well as fine craft. It emphasizes regional artists while occasionally showing well-known artists from other regions. Monthly one and two-person shows are complemented by a permanent sales gallery. Work is exhibited in two and three-dimensional media.

Among the contemporary Montana artists shown in 1984 are Rudy Autio, Dennis Voss, Patrick Zentz, Rudy Svehla and David Shaner. Upcoming exhibitions include work by John Buck and Ted Waddell.

GREAT FALLS

Gallery 16 319 Central Ave, Great Falls, MT 59404
492 (406) 761-4659; Mon-Sat: 10:30-4; dir: Judy
Ericksen

A cooperative gallery of women artists, Gallery 16 is operated by twelve artist members. Over 100 contemporary artists and craftspeople are represented, the majority of whom are from Montana. The gallery features work in fiber, clay, painting, intaglio graphics, jewelry, glass, baskets and mixed media.

Among the artists who have recently exhibited are Sandi Antonich, Marcia Ballowe, Mercedes Brown, Judy Crowder, Theresa Gong, Todd Hileman, Sandy Hogevar, Mike Hollern, Mike Jensen, Martha Mans, Nancy Meldahl, Jim Morrison, Seth Paulson, Kathy Shiroki, John Swanberg, Joyce Thomas, Matt West and Joyce Wilson.

KALISPELL

Cottonwood Gallery & Print Co. 3195 Hwy. 93 N.,
493 Kalispell, MT 59901 (406) 752-2933; owner:
Ken LeDuc dir: Dick Wyman

The gallery carries works by contemporary and deceased artists, offering a complete line of prints as well as bronzes, pottery and woodcarvings.

Some of the artists featured are Tom Sander, Fred Fellows, Bud Helbig, Larry Janoff, Gloria West, Dave Malloney, Gary Schildt, Dave Manuel, Dick Wyman, Sheryl Bodily and Mark Ogle.

Glacier Gallery 1498 Scenic Old Hwy. 21 E., Kalis-
494 pell, MT 59901 (406) 752-4742; Mon-Sat: 9-5
Owner: Van Kirke Nelson dir: Thelma Powell

Glacier Gallery handles paintings and bronzes by contemporary Western artists, as well as works by such major historic Western artists as C.M. Russell, Olaf Seltzer, Edgar Paxson, J.H. Sharp and others.

NEBRASKA

LINCOLN

Haymarket Art Gallery 119 S. 9th St., Lincoln, NE
495 68508 (402) 472-1061; Tue-Sat: 10:30-4:30 Sun:
1-4; nonprofit dir: Judith Wilson

Devoted to the development of regional artists working in all media, the Haymarket Gallery answers their needs very directly by providing space for monthly exhibits and display and consignment sales. In addition the gallery is associated with a program which includes art education, and provides studio space.

While none of the artists represented have achieved stellar fame, a few, like Reinhold Marxhausen, are beginning to achieve national recognition. Over 100 regional artists regularly consign work to the gallery. Among them are printmaker and painter Tom Bartek, sculptor Les Bruning, painter Hal Holoun and painter Susan Puelz.

OMAHA

Gallery 72 2709 Leavenworth, Omaha, NE 68105
496 (402) 345-3347; Wed-Mon: 10-5; owner/dir:
Robert D. Rogers

Gallery 72 carries contemporary American art in a wide range of styles. The gallery provides corporate consulting and framing services as well.

The artists shown include both regionally and nationally known figures. Photographer Tom Butler, assistant director of the Sioux City Art Center, is well-known throughout the Midwest. Painters shown in the gallery include abstractionists James Eisentrager, New Yorker Douglas Martin, Edward Evans, who works in airbrush, and Warren Rosser, recently moved to Kansas City from Wales. Dan Howard paints both figurative and abstract canvases. Painted and sewn abstracts by Yvonne Rosser evoke landscape. Realists include Fred Faudie, Robert Miller, David Sullivan, and Missouri landscapist Gary Bowling. Two of the gallery's realist painters, Joseph Raffael and Sarah Supplee have achieved a considerable national reputation. Supplee's work, in contrast to the coloristic, sometimes nearly abstract images of Raffael, is of a meticulous realism that takes months to achieve in a single painting. German writer Gunter Grass, a visual artist before his literary success, produces realist drawings and etchings. Also involved in printmaking are Michael Nushawg, as well as Sarah Supplee and Fred Faudie. Sculptors at the gallery include Jake Grossberg, whose abstract forms evolve from landscape forms and textures; and George Neubert, director of the Sheldon Memorial Art Gallery in Lincoln, Nebraska.

NEVADA

BOULDER CITY

The Burk Gallery 400 Nevada Hwy., Box 246,
497 Boulder City, NV 89005 (702) 293-3958; Mon-
Sat: 10-5 & by appt; owner/dir: Darlene Burk

The gallery specializes in Western landscapes and nostalgic portrayal of activities and figures of the Old West, with works in oil, watercolor, mixed media, bronze and wood. There is also a selection of impressionist painting.

Contemporary artists include Joni Falk,

known for her miniature still life images of Indian pottery and Indian scenes; Carol Harding, pastel, oil and pencil drawings of Western life; and Spike Ress, Southwestern watercolor landscapes. Other artists shown include Mike Miller, Lynne Thomas, Biette Fell, Barbara Jean Sullivan, Don Miles, B. Di'Anne, Jeff Craven, Bernard Vetter and Don Ely.

INCLINE VILLAGE

Lake Gallery Box 7470, 930 Tahoe Blvd., Incline
498 Village, NV 89450 (702) 831-4544; Mon-Sat: 11-6 Sun: 12-5; owner: M. Marshman & S. Useem dir: M. Marshman

Concentration of the gallery is on contemporary painters, sculptors, printmakers and photographers, with emphasis on regional works from Great Basin artists, as well as California impressionists and Bay Area artists.

Artists exhibited include Chris Ranes, a New York School artist with roots in pre-World War II Europe. Works are also exhibited by Jeff Nicholson, a traditional painter from the Great Basin, Bill Yahnke, a California impressionist, and Ramon Munoz, an abstract painter from the emerging Los Angeles School.

The gallery also shows contemporary graphics by such noted artists as Amado Pena, Rufino Tamayo, R.C. Gorman, Azoulay and Giusti.

LAS VEGAS

Minotaur Fine Arts 3200 Las Vegas Blvd. N, Las
499 Vegas, NV 89109 (702) 737-1400; Mon-Wed: 9:30-6 Thu, Fri: 9:30-9 Sat: 9:30-6 Sun: 12-5; dir: Richard C. Perry

The gallery exhibits 18th and 19th century American and European paintings, and also handles contemporary painting, sculpture and prints.

Among the contemporary artists featured are realists Leroy Nieman, known for his brilliantly colored sports scenes, and Robert Kipniss, who is best known for his landscapes. Native American artist Carlos Wahlbeck has become known for his cast paper reliefs. Other artists are Robert Addison, Phyllis Cubb, T. and C. Rowland, Victor Salmones and Avie Thaw.

RENO

Artist Co-op Gallery 627 Mill St., Reno, NV 89502
500 (702) 322-8896; Tue-Sat: 10-5 Sun: 1-4:30

This artist-run gallery features 20 artists from Reno, exhibiting painting and sculpture on contemporary and Western themes, as well as pottery.

Stremmel Galleries, Ltd. 1400 S. Virginia St., Reno,
501 NV 89502 (702) 786-0558; owner: Peter Stremmel curator: Joseph Craven

Concentration is on contemporary American art, including a broad representation of styles in oil and watercolor.

Artists exhibited include Chen Chi, Wolf Kahn, Leonard Chmiel, George Carlson, Theodore Waddell, Joe Baker, Mark Daily, Thomas Aquinas Daly, Jaune Quick-To-See Smith, Kitty Wallis and Bruce Kurland.

Stremmel Galleries offers a department of restoration and conservation in addition to consulting services.

NEW HAMPSHIRE

ASHLAND

Artist Express Depot 38 Depot St., Ashland, NH
502 03217 (603) 968-3163; Sat-Sun: 12-6; Mon-Fri: by appt; owner/dir: Bill Bernsen

Artist Express Depot handles 19th and 20th century American and contemporary New Hampshire painting and sculpture.

The contemporary works shown present various aspects of advanced 20th century art. Director Bill Bernsen works in assemblage and welded sculpture. James Fortune uses pigmented paper pulp to create works where color and material are inseparable. Jeanne Vigen works in cloisonne enamel, giving contemporary vigor to an ancient medium. Also on view are Christopher Kressy's large abstract paintings, Annette Mitchell's abstract drawings and paintings, and David Bradstreet Wiggins's collage and painting works.

The 19th and 20th century collection varies according to availability of works, but generally features works by New England artists. New Hampshire has provided abundant welcome to artists in the past—the Isles of Shoals once supported a famous artists' colony—and works by early folk painters, limners, noted artists such as Milton Avery, and even early abstract artists may be found.

MANCHESTER

Currier Gallery of Art 192 Orange St., Manchester,
503 NH 03104 (603) 669-6144; Tue-Sat: 10-4 Thu: 10-10 Sun: 2-5; dir: Robert M. Doty

The Currier Gallery of Art is a museum facility with an active community program that includes travelling exhibitions, film and concert series, and a children's art center located across the street from the museum.

The museum collection includes 13th through 20th century European and American paintings, sculpture and decorative arts. The museum also shows and sells work by contemporary American artists. Recent exhibitions have included works by Edward Koren, Frank French, Rollie McKenna, Randy Miller, Nora Unwin and Herber O. Waters.

The Manchester Institute of Arts and Sciences 148
504 Concord St., Manchester, NH 03104 (603) 623-0313; Mon-Sat: 10-5

The Manchester Institute of Arts and Sciences provides educational programs in the arts to the Manchester and southern New Hampshire community. In addition to offering courses in the arts, including a two-year certificate program in photography, the Institute operates an exhibition gallery and an art and craft shop.

Exhibitions in the gallery are scheduled throughout the year and feature works by New England artists and craftspeople as well as students and faculty of the Institute. The shop carries works by professional artists and craftspeople from throughout the Northeast. On hand are

jewelry, stoneware and porcelain, blown and stained glass, weavings and prints.

Unique in New Hampshire are the Institute-sponsored Arts and Crafts Biennials, the only regularly scheduled juried exhibitions which are open to all professional resident artists and craftspeople in New Hampshire.

NEW JERSEY

BARNEGAT LIGHT

Sidney Rothman/The Gallery 21st St. on Central
505 Ave., Barnegat Light, NJ 08006 (609) 494-2070; Jun-Sep: daily: 1-5; owner/dir: S. Rothman

Located in a summer resort, The Gallery specializes in work by living American artists, with the exception of those it has represented in the past. The Gallery presents all styles and media.

The gallery shows work from the estates of painterly realist Abraham Rattner, figurative realist Joseph Hirsch, and Leon Kelly, a painter of the human form who eventually adopted a abstract style. Living artists shown by the gallery include John Gable, a realist painter of Maine scenes; Phillip Pearlstein, whose prints of the human figure are shown; Shoz Nagano, a Japanese-American who works in geometric constructions, and Marge Chavoosian, a watercolorist of architectural forms.

Other artists include Richard Jeffries, wood sculpture of totem-like figures; Paul Pollaro, acrylic paintings in monotone values; Sevilla Diehl, acrylic on rice paper paintings of birch trees and florals; Jo Gregory, seascapes in triptych format; Kyokuho Okada, colorist sunsets and sunrises; Harry Buckley, small scale landscapes and seascapes; Arthur Glickman, bonded bronze female sculpture; and John B. Lear, Jr., human form in surrealistic patterns.

BASKING RIDGE

Whistler's Daughter Gallery , Inc. 88 S. Finley
506 Ave., Basking Ridge, NJ 07920 (201) 766-6222; Tue-Sat: 10-5 Sun: 12-4 & by appt; owner/dir: Douglas & Kendra Krienke

Concentration is on 19th and 20th century paintings, including work by contemporary artists.

Emphasis is on 19th century American Hudson River School masters (Durand, Kensett, Smillie and others), Tonalists (Inness, Wyant, Murphy, etc.), and American Impressionists (William Merritt Chase, Childe Hassam, Crane, etc.).

Contemporary artists featured include Andrew Wyeth, Ken Davies, Robert Vickrey, Dan Campbell, Pauline Campbell, Gary Erbe, Philip Jamison, Ray Ellis, Bill Morgan, etc.

CHATHAM

Gallery 9 9 N. Passaic Ave., Chatham, NJ 07928
507 (201) 635-6505; Mon-Sat: 9-5; owner/dir: George M. Dembo

Gallery 9 exhibits oil paintings, watercolors and prints by New Jersey artists, as well as an extensive collection of vintage and contemporary posters.

Some of the artists shown are George Bjorkland, Helen Frank, Dorothy abelson, Pat San Soucie, Nicholas Reale and Pat Denman. Works by major poster artists such as James Montgomery Flagg, Howard Chandler Christy, Jessie Wilcox Smith and Ludwig Hohlwein are available.

EAST HANOVER

John Bradley's Gallery 631 Ridgedale Ave. East Han-
508 over, NJ 07936 (201) 887-0149; Tue-Sat: 10-5; owner/dir: J. Bradley

The gallery specializes in 19th and 20th century Japanese Woodblock prints and early 20th century paintings, mostly by local artists. The gallery also offers a sculpture restoration service.

Prints include works by the most noted and popular artists of the *ukiyo-e* period, among them Hokusai, Hiroshige, Kunisada, Toyokuni III, Yoshitoshi and many others. The gallery also carries many paintings by lesser known painters of the early 20th century.

FAIR LAWN

Kornbluth Gallery 7-21 Fair Lawn Ave., Fair Lawn,
509 NJ 07410 (201) 791-3374; Tue-Sat: 10-5:30 Thu: 10-9 Sun: 1-5 Aug: closed; owner/dir: Lillian Kornbluth

The gallery handles contemporary American paintings, drawings, prints, sculpture and museum-quality crafts. Both abstract and representational mode are featured.

American artists include Milton Avery, printmaker Will Barnet, Wolf Kahn, Emily Mason, painterly realist Byron Browne, Paul Resika, Richard Segalman, Anne Silber, Al Wilson, Hans Van de Bovenkamp, Paul Zimmerman and others.

FREEHOLD

Jentra Fine Art Gallery Rte. 33 & Millhurst Rd.,
510 P.O. Box 727, Freehold, NJ 07728 (201) 431-0838; Tue-Sat: 10-4:30 Thu: 10-8; owner/dir: Judy Borell

An eclectic gallery offering works to satisfy a wide range of interest from contemporary to traditional American art, with particular emphasis on Southwestern art, Jentra carries paintings, watercolors, serigraphs, lithographs and woodcuts, plus a selection of hand-crafted ceramics, studio glass and jewelry by American craftspeople.

Artists featured include Amado Pena, Jacob Landau, Diana Kung, James Llewelyn, Kathy Cantin, Thomas McKnight, Yokoi, Azoulay and Maxwell.

MONTCLAIR

Double Tree 76 Church St., Montclair, NJ 07006
511 (201) 783-5022; Wed-Sun: 11-5 Jul-Aug: closed; pres: Robert W. Worth

Doubletree is a cooperative gallery. Its members work in contemporary modes of art and crafts.

Artist members of the gallery are: Gusta Abels, painting; Michele Chandless, macrame; Selma Eron painting; Harold Friedlander, sculpture; Nancy Friedlander, painting; Jean Kawrecki, sculpture; Nancy Kraemer, fiber; Martin

Litchman, jewelry; Johanna Marcus, jewelry; Peg Miller, enamels; Morton Panish, photography; Bettie Weiss, painting; Gail Willard, painting; and Robert Worth, photography.

The Simon Gallery 31 The Crescent, Montclair, NJ
512 07042 (201) 783-5480; by appt; owner/dir: Harold Simon

The Simon Gallery presents 19th and 20th century photography, specializing in contemporary photographers producing platinum prints.

The gallery features works by distinguished historian and photographer Allan K. Ludwig. Also featured are Wendy Holmes, Sandy Noyes, Tom Shillea and John Hafey, all of whom have made important contributions to platinum process photography. Geanna Merola exhibits her expressionistic hand-colored photographs.

The gallery has also shown works by George Tice, Patricia Vullo, Vincent DiGerlando, Gladys Tietz, Michael Rosen and Gwen Akin.

NEWARK

City Without Walls Gallery 140 Haley St., Newark,
513 NJ 07102 (201) 622-1188; Tue-Fri: 11-6 Sat: 12-4 Aug: closed; dir: Colleen Thornton

C.W.W. is a nonprofit artists collective, founded in 1975 to stimulate and reflect contemporary visual art in the metro-Newark area. Educational programs are open to the public. The gallery provides many support services to artists, and maintains an artists' gift shop open to the public and members.

Artists who have been selected to exhibit in the recent past include Michael Bactalos, Brian Buzak, Robert Colescott, Tim Daly, Sandra DeSando, Jean Foos, Steve Gianakos, Henry Khudyakov, Komar and Melamid, Geanna Merola, Roland Mochary, Franc Palaia, Malcolm Ryder, Lucas Samaras, Sandy Skoglund, Ted Vitoria and Marcia Zerman.

The gallery has over 200 member artists. The variety of styles and sensibilities reflect the diversity of contemporary American culture. Exhibits are group shows based on relevant themes.

NEW BRUNSWICK

Dumont-Landis Fine Art 1050 George St. 1-M, New
514 Brunswick, NJ 08901 (201) 249-7776; Mon-Fri: 9-5; owner/dir: James O. Dumont & Raye Landis

In addition to showing both emerging and established contemporary artists, the gallery concentrates on post World War II American art, and American art in general. From time to time 20th century European works are available.

Contemporary masters that have been purchased through the gallery in the 1983-84 season include Robert Rauschenberg, Frank Stella, Richard Estes, George Segal, Christo, Andy Warhol, Robert Mangold, Wayne Thiebaud, Richard Pousette-Dart, Tom Wesselman and others.

The gallery considers very highly a number of other artists, such as Walter Darby Bannard, Katherine Porter, Pat Steir, Natvar Bhavsar, A.R. Penck, Aaron Fink and others, whose work it frequently handles.

Contemporary works in clay are available by

Toshiko Takaezu, Philip and Marilyn Garnick, and Barbara Schaff, to mention only a few.

Old Queens Gallery Monument Square, New Bruns-
515 wick, NJ 08901 (201) 846-1347; Tue-Fri: 10-5 Sat: 10-3; dir: Meyer Frischli & Sally Frischli

Contemporary American art, Canadian Eskimo stone carvings, and a number of 19th century American paintings are the main points of interest in this gallery.

Of particular note are graphic works by Ben Shahn and Jacob Landau, artists who have expressed human and social concern with a profound artistic awareness. Watercolors by Margery Soroko, wall hangings by Josee Lippens, and paintings and graphics by Ben Joseph are also featured.

One may also encounter watercolors by B.J. Anderson, and ravelled and folded canvas pieces by Whitney B. Hansen. Graphic works shown include etchings by Helen Frank, wood engravings by Stefan Martin, and woodcuts and etchings by Pearce Bates and Ellen Nathan Singer.

PLAINFIELD

Tweed Gallery 112 E. Front St., Plainfield, NJ 07060
516 & P.O. Box 2957, Plainfield, NJ 07062 (201) 754-9350; Wed-Sat: 12-5; dir: A.K. Blackburn

Tweed Gallery is operated by Tweed Arts Group, a nonprofit membership group open to all. The display format is of group theme shows and group shows selected by guest curators. Recent curators have included noted realist, painter and draftsman Paul Cadmus, muralist Richard Haas, and Sam Cady.

PRINCETON

Princeton Gallery of Fine Art 8 Chambers St.,
517 Princeton, NJ 08540 (609) 921-8123; Tue-Fri: 10-5 Sat: 11-5; owner/dir: Arline Snyder

Concentration is on 20th century American art, particularly contemporary painters. Prominent New Jersey artists are also featured, along with a diverse selection of graphic work.

Early 20th century American painters in the gallery include painter and printmaker Werner Drewes, Clarence Carter, B.J.O. Nordfeldt, Milton Avery and Raymond Johnson. The gallery also carries recent works by Carter and Drewes, as well contemporary works by Thomas George, Ralph Rosenborg, Herb Jackson, Donald Localio and others.

SHORT HILLS

Petan Art Gallery 545 Millburn Ave., Short Hills, NJ
518 07078 (201) 379-5577; Mon-Sat: 10-6 Thu: 10-9; owner/dir: Steven R. Lucas

The gallery specializes in 20th century paintings, graphics and sculpture with emphasis on works by gallery artists.

Works are available by Yaacov Agam, Alexander Calder, Anna Continos, Salvador Dali, Amram Ebgi, Leonor Fini, Thomas McKnight, Tjelda Michas, Joan Miro, Leroy Nieman, Pablo Picasso, Victor Vasarely and Friedensreich Hundertwasser. The gallery has a very large selection of Leroy Nieman serigraphs.

SPARTA

Sparta Gallery 14 Winona Pkwy., Sparta, NJ 07871
519 (201) 729-8075; Mon-Fri: 9:30-5:30 Sat: 10-5;
owner/dir: Mary Lewis

Sparta Gallery features contemporary American art, with emphasis on regional artists.

Abstract painters Ray Lewis, Patricia Gray Redline and experimental printmaker Ruth Bilane are among the artists shown. Regional representational artists include Al Bross, P. David Ganek, Carol Kraemer, Charles Dougherty and Irma Cerese. Ray Lewis current work is large format, involving pastel line in open space. Ruth Bilane works with texture and multiple printing processes.

TENAFLY

America House Gallery 24 Washington Ave., Tenafly, NJ 07670 (201) 569-2526; Mon-Sat: 10-
520 5:30; owner/dir: Betty Turino

The gallery specializes in contemporary American craft artists working in clay, metal, fiber and glass.

Ceramicists working with wood firings include Maishe Dickman, Rosemary Aiello, Mary Roehm, Mark Lang, and Hiroshi and Judy Nakayama. In a more painterly vein are ceramicists Laura Wilensky, Pat Fahie, Christine Zimmerman and Barbara Strassman. A spectrum of possibilities in art glass is revealed in the work of George Thiewes, Steven Correia, Steven Maslach and Janet Kelman. Glenda Arentzen, Judy Curlett, Paul Movelli and Pat Flynn work in gold, silver and beads to create award-winning jewelry.

In addition to a continuing show of gallery artists, seven yearly group shows feature wearable art, furniture, sculptural glass and other media.

WATCHUNG

Only Originals 757 Somerset St., Watchung, NJ
521 07060 (201) 756-7475; Mon-Sat: 9-5; owner/dir: Dorothy H. Kenney

Concentration of the gallery is on 20th century paintings in oil, watercolor, mixed media, and handmade paper creations. The gallery also deals in signed limited edition prints.

WYCKOFF

Wyckoff Gallery 210 Everett Ave., Wyckoff, NJ
522 07481 (201) 891-7436; Mon-Sat: 10-6; owner/dir: Jock MacRae

The Wyckoff Gallery specializes in contemporary American art, mostly in a painterly figurative mode. However, the gallery also carries abstract painting and sculpture by contemporary American artists.

The gallery exhibits figurative paintings in oil and watercolor and drawings by Nell Blaine and Charles Reid, as well as abstract expressionist acrylics and watercolors by Jack Roth and abstract paintings by Kay Walking Stick.

In addition, the gallery shows emerging artists, including Kiyoko Sakai, Carolyn Harris, John Schlereth and Susie Baudoin Suarez.

NEW MEXICO

ALBUQUERQUE

Adobe Gallery 413 Romero NW, Albuquerque, NM
523 87104 (505) 243-8485; Mon-Sat: 10-6 Sun: 1-4;
dir: Alexander E. Anthony, Jr. asst dir: J. Brent Ricks

Adobe Gallery specializes in authentic Southwestern Indian art, including pottery, blankets, kachinas, watercolors, pastels, lithographs and serigraphs.

Pottery is the highlight of the gallery with high quality pieces created by all the pottery-making tribes represented. Contemporary pottery obtained from the artists as well outstanding examples of older, historic pottery are beautifully displayed in a 103-year-old adobe structure. Kachina dolls carved by skilled Hopi carvers are prominently displayed. Contemporary and historic handwoven Navajo rugs and blankets are available.

Adobe Gallery has gained renown for its specialization in Pueblo Indian figurine pottery. Storyteller figurines and other human and animal forms appear throughout the gallery's six rooms.

Prints, watercolor and pastel originals, and oil paintings by many Southwest Indian artists line the thick adobe walls. Works by Tommy Edward Montoya, a Tewa Indian from the San Juan Pueblo, Navajo artist R.C. Gorman, Choctaw artist Dyanne Strongbow, Jim Fred and many others are on continuous display. The gallery also carries graphics by Mexican sculptor Francisco Zuniga.

The gallery's exhibits are complemented by a wide selection of books, magazines and pamphlets of interest to collectors. Exhibition catalogs are also available.

Galeria Del Sol 206 San Felipe NW, Albuquerque,
524 NM 87104 (505) 243-7104; Mon-Sat: 10-5 Sun: 1-5; owner: W.R. Smith, Jr.

Galeria Del Sol specializes in Southwestern art, mostly by New Mexico artists working in oils, watercolors, pastels, as well as stone and bronze sculpture.

Realism predominates in the work shown. Among the artists featured are Betty Sabo, oil painting; Jane Mabry, oils and pastels; and Carol McIlroy, traditional impressions of New Mexico in oils. Santa Fe area watercolorist Alan Polt paints Southwest landscapes and portraits. Realist Irene Ricker works in egg tempera. Other well-known Southwest artists exhibited at the gallery include Filomena Martinez, Robert Conine, Charles Moyers, George Marks, Julian Robles, Esta Bain and Jim Watson.

Two sculptors are among the artists exhibited. William Moyers, president of the Cowboy Artists of America, shows bronze and stone sculpture of scenes of Western life. Sculptor Cliff Fragua of the Jemez Pueblo carves his works in stone.

Hoshour Gallery 417 Second SW, Albuquerque, NM
525 87102 (505) 842-5332; Tue-Sat: 11-5; owner/dir: Lise Hoshour

Opened in 1977, the gallery specializes in contemporary art. Exhibitions are held throughout the year, primarily one-person shows.

Among the artists featured is sculptor William King, who has been associated with Pop Art. His groups and assemblages of figures frequently have a humorous intent, underlined by the use of caricature and "modern" materials such as vinyl. Unadorned and precise, Clement Meadmore's sculpture typically investigates twisted volumes in Corten steel and other media. Other artists include Barton Lidice Benes, Daniel Buren, Judith Dolnick, Maria Gooding, Frederick Hammersley, William Masterson, Richard Nonas, and Robert Yasuda. Works by Robert Therrien and Michael Asher, who were featured in the "In Context" show at the Los Angeles Museum of Contemporary Art, are also exhibited at the gallery.

Mariposa Gallery, Inc. 113 Romero St. NW, Albuquerque, NM 87104 (505) 842-9097; Mon-Sat: 10-5 Sun: 12-5; owner/dir: Peg Cronin, Fay Abrams

526

Mariposa presents new and unusual directions in contemporary crafts. Since 1974 the gallery has maintained an extensive collection of contemporary jewelry, ceramics, fiber, glass, and wearable art.

The craft items in the gallery's collection represent the work of outstanding New Mexico craft artisans, such as Jennifer Lind, who is an accomplished glaze painter and production potter. Known for her porcelain sketches, Lind considers function as important as form and drawing. The tapestries of Janusz and Nancy Kozikowski are based on Pueblo, Navajo and Spanish traditions, and are influenced by the New Mexico landscape and mystique. Liz Anderson hand-builds pieces from slabs of clay, and fires them using the *raku* method. The subtle textures and tones of gray, peach and sand of her "platters" and vessels reveal a quiet beauty. Jewelry in cloisonne by Karen Arch and Gail Rapoport may be seen, as well as the inlay work of Luis Mojica.

Glass and wood are prominently displayed. GloryHole Glassworks, owned and operated by Peter Vanderlaan and Mary Beth Bliss, is represented by glass designs that employ symmetrical forms, silken matte surfaces, bright colors and organic imagery. It is conservative work, but contemporary in feeling. The gallery's include Steve Madsen and Peter Bilan.

The gallery holds monthly in-depth exhibitions of work by two or three gallery artists, and a yearly invitational theme show, where artists are encouraged to experiment in other media besides the one they have mastered.

Tamarind Institute 108 Cornell Ave. SE, Albuquerque, NM 87106 (505) 256-9646; Mon-Fri: 8-12 & 1-5 by appt; nonprofit dir: Clinton Adams

527

Institute began in 1960 as a "rescue operation"—the art of the lithograph was in decline in the United States, and Tamarind's goal was to create conditions for a rebirth of the medium. The Tamarind Lithography Workshop was located in Los Angeles from 1960 to 1970, where it printed over 2,900 lithographs by distinguished artists. Since then the Institute has moved to Albuquerque, where it is a division of the University of New Mexico.

Artists work at Tamarind in collaboration with professional artisan printers. All lithographs are printed by hand, from stones or metal plates, and all editions are limited and fully documented.

Among the well-known artists who have worked at Tamarind is Fritz Scholder, who has produced 150 lithographs at the Institute since 1970. Other artists who have worked at Tamarind include Billy Al Bengston, whose witty, lively and colorful images are cut and collaged; Janet Fish, a painterly realist known for her still lifes of glass objects; Craig Kauffman, a Los Angeles artist who incorporates images of chairs in his work; Judy Rifka, who combines abstract and figurative elements in her cut and collaged works, which sometimes become three-dimensional; and Jaune-Quick-To-See Smith, a Native American artist whose contemporary images reflect on her Indian heritage. Steve Sorman, Roy DeForest, Andrew Dasburg, and Jack Tworkov have also worked at Tamarind.

Tamarind offers a unique professional printer training program, which after the first year allows students to collaborate with professional artists in the Tamarind workshop, as well as a one-year curatorial program.

Impressions of original lithographs printed at Tamarind are often available for purchase. The Institute welcomes inquiries from dealers and collectors.

Weems Gallery 2801 M Eubank N.E., Albuquerque, NM 87112 (505) 293-6133; Mon-Sat: 10-6; owner: Mary Ann Weems, Suzanne Prinz, Jone Chappell dir: M.A. Weems

528

The gallery carries traditional and contemporary art and crafts in all media, by over a hundred artists.

Artists exhibited include members of the Maroger School in America Siegfried Hahn, Howard Wexler and Joan Cochrane. Realists Hubert Wackermann and Jean Martin are represented with both oils and watercolors, while realist Patricia Rose works in acrylics. The fine batiks with Southwestern themes by Alice Valdez and Marilyn Gruntmeir are featured, as are the Indian themes of Jacque Evans, who works in pencil, oil and acrylics.

There are also scratchboards by well-known artist Charles Ewing, delicate Oriental brush painting florals by Edith Clow, and award-winning serigraphs by Gwen Entz Peterson. Established artists Marie Fuertsch and C.J. Buckner share the spotlight with young artists such as Ralph Roybal and his Indian bronzes, Robert Sterba's lacquered bowls, and alabaster sculptors Jay Tsoodle, Joseph Chavez and Chris Quintana. The paper relief sculpture of Sonny Rivera is also featured.

SANTA FE

Contemporary Craftsman Gallery 100 W. San Francisco St., Santa Fe, NM 87501 (505) 988-1001; Mon-Sat: 10-5:30; owner/dir: Jane Kent Gann

529

Contemporary Craftsman Gallery offers handmade crafts including carved and turned wood, ceramics, glass, fiber, paper and jewelry. The artists shown are mostly from New Mexico, but

Cochiti Pueblo potters, figurines, ceramic, Adobe Gallery (Albuquerque, NM).

R. C. Gorman, *Lady Chatterly,* 36 x 60, oil/pastel, Gallery of the 21st Century (Santa Fe, NM).

the remainder are from all parts of the country. All are dedicated to their work, and frequently engaged either in recuperating forgotten techniques or experimenting with new ones.

Work is available by the following artists: Rabbit Art Works, ceramics; Sally Bachman, tapestry; Larry & Nancy Buechley, furniture; John Sherrif, furniture; Lori Gottlieb, porcelain; Kit Carson, jewelry; Ann Rodgers, glass; Bill Hedden, wood; Mary Sue Walsh, pastel; Coleen Barry-Wilson, paper; Steven & Ann Kilborn, ceramics; Todd Hoyer, wood; Terry Bumpass, ceramics; Vaughn Burlingham, wood; George Zarolinski, ceramics; Eileen Clark, weaving; Lou & Christine Columbarini, ceramics; Michael Nourot, glass; John Dyas, ceramics; Deirdre Engstrom, basketry; Michael Elkan, wood; and Greg Frye-Weaver, wood.

Shows featuring selected gallery artists are scheduled in July, August and October of each year.

Cristof's 106 W. San Francisco St., Santa Fe, NM
530 87501 (505) 988-9881; Summer: Mon-Sat: 9-5:30 Winter: 9:30-5; dir: Bill Cristof, Bob Cristof

Cristof's is committed to the exceptional weaving artistry of Navajo women. All the weavings tend to be of museum quality. Other works by Native American and Southwestern artists are on display.

Sculpture includes unique welded metal pieces by John Praden, as well as wood and stone sculpture by Sioux artist Earl Eder, and hand-carved Hopi kachina dolls.

The gallery exhibits the creations of David "Chethlahe" Paladin. Fine traditional Navajo sandpaintings are also exhibited, as well as a selection of contemporary designs by Navajo artist Eugene "Baatsolslanii" Joe.

Cristof's offers a variety of special exhibits throughout the year, including weaving demonstrations, selections of Native American art, and educational lectures.

Enthios Gallery 1111 Paseo de Peralta, Santa Fe, NM
531 87501 (505) 988-1505; daily: 9:30-5:30 winter: closed Tue; owner/dir: Marian Frank

Enthios Gallery is housed in a charming adobe building. The gallery shows the paintings and graphics of Southwestern artists. R.C. Gorman, a Navajo artist of international standing, is the mainstay of the gallery, which also features the works of John Axton, John Nieto, Jean Richardson and the tapestry weavings of Janusz and Nancy Kozikowski.

John Nieto is a Mescalero Apache and Makes his home in Santa Fe. He uses bold color and style in depicting his native heritage on canvas. John Axton is a contemporary painter who treats the Southwest landscape in a serene yet haunting manner. Janusz and Nancy Kozikowski are both painters who now weave. They have a unique style that incorporates many shades of wool, which they hand-dye themselves. Their recurring image is of brilliant sunrises and sunsets against the mountains of the Southwest.

Fenn Galleries Ltd. 1075 Paseo de Peralta, Santa Fe,
532 NM 87501 (505) 982-4631; Mon-Sat: 8:30-5:15; pres: Forrest Fenn dir: Harry McKee

The Fenn Gallery exhibits American art from the 19th century to the present, including painting and sculpture, as well as work by Native Americans.

Works are available by Thomas Moran, by noted cowboy artist C.M. Russell, and by Henry Farny. The gallery specializes in work by members of the Taos Society of Artists, including J.H. Sharp, Herbert Dunton, Bert Phillips and E.I. Couse. A fine collection of Nicolai Fechin and Leon Gaspard may be seen, as well as sculptures by Doug Hyde, Veryl Goodnight, Glenna Goodacre and Ken Bunn. Also featured are Native American artifacts, old pottery, baskets, beadwork and jewelry.

Gallery of the 21st Century 102 E. Water, El Centro
533 Mall & 201 Galisteo, Santa Fe, NM 87501 (505) 983-2002; daily: 10-6; owner/dir: Stephen Fox

Featuring an eclectic mix of international and Southwestern contemporary art, the gallery shows works by highly acclaimed Native American artists. Extensive exhibitions have been organized through the gallery, and have traveled to museums and universities including the Museum of the American Indian, Stanford University, Vassar College, and Lincoln Center for the Performing Arts.

Works by Darren Vigil, a young Jicarilla Apache painter and musician, are one of the most gratifying experiences the gallery offers. His large acrylic portrait canvases recall the work of the late T.C. Cannon, whose work director Fox holds as a touchstone for the gallery. Vigil is a master serigrapher, and works extensively in acrylic on paper. Other Native American artists include Ishii Sakahaftewa (Hopi) and Bruce King (Oneida). One may also find lithographs by R.C. Gorman, woodblock prints by T.C. Cannon, and paintings by Choctaw artist Maurice Burns, as well as works by Jaime Chase.

The gallery maintains an extensive collection of graphics, including rare Georgia O'Keeffe lithographs, to serve both interior designers and collectors.

Gondeck Gallery/Publisher 211 Old Santa Fe Trail,
534 Santa Fe, NM 87501 (505) 988-3580, Mon-Sat: 10-5, owner/dir: Gondeck

Opened in 1981, the gallery and publishing company features original graphics and sculpture made of bronze, steel, and cast paper.

The gallery's original graphics are by contemporary Indian artists. Kevin Red Star, a Crow Indian from Lodge Grass, MT, is represented in lithographs, etchings, wood engravings, serigraphs, and monotypes. Graphics by Benjamin Harjo Jr. and Jean Bales are also published by Gondeck.

Bill Prokopiof, of Juneau, AK, creates bronze, welded steel, and cast paper sculptures for both indoor and outdoor presentation.

Graphics House 702 Canyon Rd., Santa Fe, NM
535 87501 (505) 983-2654; hours by coincidence and appointment; owner/dir: Anne Sawyer

The oldest original print gallery in Santa Fe maintains an open studio in the Canyon Road tradition. The gallery shows work by several

Harold Joe Waldrum, *Dos Cruces,* 63 x 63, acrylic on linen, Gerald Peters Gallery (Santa Fe, NM).

Frederic Remington, *Supper in the Corral,* 21 x 21, pen & ink wash, Gerald Peters Gallery (Santa Fe, NM).

artists whose work inclines to be realist and representational.

Silkscreen prints by the late Louie Ewing are available, mostly of local landscapes. John Hogan works in all print media—lithography, etching, collagraphy and silkscreen. His work is representational and usually depicts landscapes. Other gallery artists include Carol Mothner, a painter who also does etchings, small watercolors and oils on paper, and Stephan McMillan, who works in aquatint. The floral collage and miniature landscape etchings of Anne Sawyer, and the landscape etchings of Jerry R. West are also shown.

Hand Graphics, Ltd. 418 Montezuma Ave., Santa Fe,
536 NM 87501 (505) 988-1241; Tue-Sat: 10-6 Xmas to New Year: by appt; owner: Ron Adams dir: Lynn Macri

The gallery displays original lithographs, etchings, and monotypes which have been printed by master printers Ron Adams and Ron Goad in the Hand Graphics workshop by artists from all around the country.

Graphics by over 40 artists are represented in widely varied styles. One may see Native American imagery by R.C. Gorman, Earl Bliss and John Nieto; surrealist works by emerging artists Mark Spencer and Mary Sundstrom; and abstract prints by Doris Cross, Alonzo Davis and Sergio Moyano, as well as Southwestern imagery by Jack Boynton, Noble Richardson and Ron Robles.

Other artists who have work published at Hand Graphics include Luis Jimenez, known for his lusty depictions of Mexican-American culture; Woody Gwyn, whose realistic Southwestern landscapes are recognized across the country; Judy Chicago, nationally known feminist artist; and Charles White and John Biggers, two of the country's most well-known Black American artists.

Elaine Horwitch Galleries 129 W. Palace Ave., Santa
537 Fe, NM 87501 (505) 988-8997; Mon-Sat: 9:30-5:30; owner: Elaine Horwitch dir: Julie Sasse

See listing for Scottsdale, Arizona.

The Jamison Galleries 111 E. San Francisco St.,
538 Santa Fe, NM 87501 (505) 982-3666; Summer: Mon-Sat: 10-5:30 Winter: Tue-Sat: 10-5; dir: Zeb Conley, Jr.

Jamison specializes in traditional Southwestern realism, in both painting and sculpture. The works offered are by important early artists of Taos and Santa Fe, as well as by contemporary artists living in the Southwest.

Among the Taos Founders exhibited at the gallery are Sharp, Blumenschein, Berninghaus, Couse and Leon Gaspard. Early Santa Fe painters shown include Fremont Ellis, Jozef Bakas and Henry Balink. A large collection of works by Alfred Morang is featured, both his impressionistic and more abstract oils and watercolors.

Some contemporary artists are also shown, including William Lumpkins and Foster Hyatt, watercolorists from Santa Fe; P.A. Nesbit, who very realistically interprets the Southwestern

landscape; Gloria Roybal, whose expressionistic oils and acrylics reflect her New Mexico background; and John Wilkinson, who paints large oils and watercolors of Southwestern and Southern landscape. New to the gallery are Monika Steinhoff and Frank LaLumia, whose works include local subjects.

Western art is represented by the stone carvings of Victor Vigil and the Western bronzes of Jack Riley, George Walbye and Duke Sundt.

Janus Gallery 110 Galisteo, Santa Fe, NM 87501
539 (505) 983-1590 Mon-Sat: 10-5 Summer: closed Mon; dir: Victoria L. Andrews

Janus is one of Santa Fe's oldest contemporary art galleries. The gallery features paintings, sculpture, prints, and works on paper. Artists represented are mostly from the Southwest and include some of New Mexico's leading artists. The gallery's two-level space offers a large, expansive room for one- and two-person shows and a downstairs space devoted to the stable of gallery artists.

Dolona Roberts, a native Santa Fean, works with Indian subject matter in pastel, oil, silkscreen, and monotypes. Ken Saville, also from New Mexico, uses elements of Hispanic folk art. Reg Loving's graphic paintings depict nontraditional aspects of the Southwest. Works on paper include watercolors by Pat Wolf, Jean Morgan George, and Marianne Hornbuckle; mixed media on handmade and rice paper by David Jansheski; and vibrant pastels by Howard Post. The gallery also shows prints and sculpture by Texas artists Jesus Bautista Moroles and John Hogan.

Keats Gallery 644 Canyon Rd., Santa Fe, NM 87501
540 (505) 982-6686; Jun-Jan: daily: 10-5 Feb-May: Tue-Sat: 11-5; owner/dir: Martha Keats

Most of the artists whose work is exhibited at the Keats Gallery live and work in New Mexico. Their styles range from abstract expressionism to mixed media assemblage and process art. There is a strong emphasis on all other media in which each artist works in addition to painting and sculpture. These media include lithography, etching, monotypes, woodcuts, watercolor, pastel, collage and mixed media assemblage.

John Connell utilizes painting, sculpture and lithography with a highly energetic concern for process. Well known as a concrete visual poet, Doris Cross works in various art and technological media. Dana Newmann's collages reveal formal possibilities in the association of everyday objects. Eugene Newmann is an oil painter whose work ranges from figurative to abstract, and includes pastels, monotypes, lithographs, drawings and watercolors. Iren Schio's imaginative universe is realized in painting, assemblage, mixed media and monotype. Well known painter Sam Scott explores watercolor, color etching, monotype, lithography and woodcut media.

Little Plaza Gallery 125 E. Palace, Sena Plaza, Santa
541 Fe, NM 87501 (505) 982-8181; Mon-Sat: 10-5 Winter; closed Mon; owner: Kathleen Peters dir: Minna Golinko

The Little Plaza Gallery carries a collection of Native American weavings, as well as graphics by some leading figures in 20th century American and Mexican art.

Cyrus Dallin, *Pretty Eagle,* 29 high, bronze, Gerald
Peters Gallery (Santa Fe, NM).

Doug Dawson, *The White Collar,* 24 x 18, pastel,
Gallery of the Southwest (Taos, NM).

Jose de Creeft, *Ecomiones* (1940), 6 x 12, tempera on paper, Santa Fe East (Santa Fe, NM).

Jack Silverman offers from his own collection of Native American weavings chief blankets, child blankets and *mantas*. All weavings date from the second half of the 19th century. Silverman also offers his own silkscreen prints.

The gallery handles prints as well, specializing in mixographs by Mexican painter Rufino Tamayo and lithographs by Mexican sculptor Francisco Zuniga, as well as carrying lithographs by Mexican artist Jose Luis Cuevas. There are etchings by Ashcan School painter John Sloan, who visited this region and produced many Southwest landscapes to complement his images of life in the big city; aquatints and etchings by California painter Richard Diebenkorn, who associated with the Abstract Expressionists in the 50s, working in abstract and gestural realist styles; and etchings by Conrad Marca-Relli, an Abstract Expressionist who developed a technique of collage painting. Also on hand are collages by James Coignard and lithographs by Argentine surrealist Leonor Fini.

The Marcus Gallery 207 W. San Francisco St., NM
542 87501 (505) 982-9363; Mon-Sat: 10-5 Sun: 12-5; owner: A. Marcus Perkins dir: Nancy Perkins

The gallery features contemporary Southwest art, with works ranging from impressionistic to realistic.

Continually on display are the batiks of Katalin Ehling portraying the serene everyday life of the Navajo and Hopi in her brilliant colors. Oils by Richard D. Thomas depict the life of today's cowboy and the subtly changing Southwest landscape. Ron Hoeksema's serigraphs capture the dawn and dusk light of the Southwest landscape.

Contemporary work includes watercolor landscapes by Mary Hoeksema; flowing pastel portraits of Native Americans by Karen Damyanovich; heavily textured oils by Mick Shimonek; and soft, natural watercolors by Art Usner. Sculpture includes the ceramic Indian images of Mark Snowdon, bold bronzes of James Roybal, and detailed stone mountain men of Bob Thornley.

Ernesto Mayans Gallery 601 Canyon Rd., Santa Fe,
543 NM 87501 (505) 983-8068; July-Oct: daily: 10-5 Nov-May: Tue-Sat: 10-5; owner: Ernesto Mayans dir: Maria Martinez

Established by Ernesto Mayans in 1977, the gallery exhibits work by artists from Santa Fe, New York, Boston and California. Northern New Mexico *santos* and Native American pottery are permanently on display. The gallery exhibits a wide variety of subjects and styles.

Eli Levin, a New York artist who came to prominence with a series of bar paintings, is represented with still lifes, interiors, and nudes. Robert Cenedella paints realist works of social concern. Whitman Johnson is a straightforward modern painter of plein-air landscapes and sumptuous still lifes. Arthur Haddock (1895-1980) is represented through an inventory of 50 years of landscapes in watercolors and oils. Ralph Leon shows cityscapes with somber overtones. David Barbero's landscapes meld a Fauvistic use of color with a Cubist division of space. Cathy Folk-Williams exhibits lyrical, detailed still lifes.

The gallery maintains a collection of Indian pottery, centered around vases from the Acoma

Pueblo and nativity scenes from the Cochiti Pueblo.

Linda McAdoo Galleries 503 Canyon Rd., Santa Fe,
544 NM 88220 (505) 983-7182; Mon-Sat: 9:30-5; owner/dir: Linda McAdoo Linda McAdoo Galleries carries work by Southwestern artists who paint and sculpt in representational modes, including early Santa Fe and Taos artists, such as members of the Taos Society of Ten. The gallery presents work from the estates of Odon Hullenkremer and Willard Nash.

Artists featured include A.D. Greer, traditional oil paintings of Western landscapes; Jim Asher, watercolors of Mexico and New Mexico; Robert Daughters, oils of Northern New Mexico; Sandy Scott, etchings and bronzes; Bill Harrison, oils, pastels and watercolors; Richard Maitland, oils in surreal and romantic realist style; Mike Norvel, impressionistic pastels; Hollis Wolliford and Dora Perry, bronzes; Gordon Van Wert, bronzes and stone sculpture; Douglas and Don Ricks, Western landscapes; Cliff Sanderson, impressionistic oils; Tim Jones, oils; and Richard Bibby, watercolors.

Mudd Carr Gallery 339 E de Vargas, Santa Fe, NM
545 87501 (505) 982-8206; Mon-Sat: 10-5 and by appt

Housed in an old territorial landmark building, the Mudd Carr Gallery emphasizes the arts of the Southwest: pre-1900 Navajo weaving, Spanish and Mexican textiles, prehistoric and contemporary Pueblo ceramics, and Spanish and Mexican colonial painting.

Due to the fact that almost all the art represents "finds", it is difficult to know what to expect from the exhibitions. The one common denominator is that the exhibits are invariably well-researched and attractively displayed. One month may spotlight Southwestern basketry, another may feature rare Acoma or Zia artifacts.

Located just below the foot of Canyon Road, the gallery is worth a visit even for those interested in contemporary art. The rich heritage of the Southwest seen in the exhibits provides an excellent historical perspective on today's Southwestern art.

Munson Gallery 653 Canyon Rd., Santa Fe, NM
546 87501 (505) 983-1657 Summer: Mon-Sat: 10-5 Sun: 11-4 Winter: Tue-Sat: 10-5 owner/dir: Larom Munson

The Munson Gallery was founded in 1860 in New Haven, CT, and opened its Santa Fe gallery in 1979. Though traces of its New England heritage remain, the gallery presents a wide range of contemporary artists of the Southwest. The gallery's emphasis is on landscape. Besides oil and acrylic paintings, the gallery shows watercolors, pastels and prints. An outdoor sculpture garden provides a handsome setting for the work of regional artists.

Among the gallery's regular artists is painter James Harrill, who paints the sun-drenched adobe architecture of Northern New Mexico. Woody Gwyn's highway paintings capture the vast sweep of New Mexico landscape. Dennis Culver's bold paintings reveal a fascination with cloud formations.

Other gallery artists include Maggie Much-

Emil Bisttram, *Bridge to Infinity,* 36 x 27, oil on board, Gallery West (Taos, NM).

Allan Houser, *Gossip,* 28 high, bronze, The Gallery Wall (Santa Fe, NM).

John Wilkison, *Passages,* 48 x 96, oil, Jamison Gallery (Santa Fe, NM).

more, whose delicate pastels explore arroyos and forest paths in different seasons and times of day. Agnes Sims, a long-time Santa Fe artist, is known for her bear fetish figures and kachinas in terra cotta. The bronze animal sculptures of Una Hanbury are displayed in the garden and the gallery.

New Trends Gallery, Inc. 228 Old Santa Fe Trail,
547 Santa Fe, NM 87501 (505) 988-1199; Mon-Sat: 9:30-5; owner/dir: Tana Y. Kennedy

The gallery specializes in works by contemporary artists, most of whom work in the Southwest or California. The gallery handles all media, including painting, sculpture and fiber works.

Artists shown include Jacqueline Rochester, Bert Seabourn, Connie Seabourn-Ragan, Rose Mary Stearns, Daniel Van Fleet, Wylene Vinall, Byron Gardner, Bill Dodgen, Kim Arnoh, Margaret LeFranc, Dennis Downey, Laura Ronstadt, Julia Penney and Dora Kaminsky Gaspard.

The Gerald Peters Gallery Box 2524, 439 Camino del
548 Monte Sol, Santa Fe, NM 87504-2524 (505) 988-8961; Mon-Fri: 9-5 Sat: 10-3; dir: Gayle Maxon

The gallery's main thrust is toward works by the classic American Western artists such as Alfred Jacob Miller, Thomas Moran, Frederic Remington, Charles Schreyvogel, Frank T. Johnson, William R. Leigh, Olaf Seltzer, Charles M. Russell and Henry Blumenschein, Oscar Berninghaus, E. Irving Couse, Victor Higgins, and Walter Ufer.

One may also find works by Milton Avery, Andrew Dasburg, Ernest Lawson, Charles Demuth, John Marin, Georgia O'Keeffe, Pablo Picasso and Edgar Degas. Contemporary and American Impressionist works are available by such artists as George Carlson, Rod Goebel, Ramon Kelley, Harold Joe Waldrum and Gary Niblett, as well as by James Kramer, Robert Loughheed, Clark Hulings, and Morris Rippel.

The gallery presents works from the estates of several artists, including Emil Bisttram, Nicolai Fechin, Hilaire Hiler, and John Ward Lockwood. The gallery acts as agent for Henriette Wyeth, Peter Hurd, and Michael Hurd.

Prescott Gallery 110 E. Palace St., Santa Fe, NM
549 87501 (505) 892-9407; daily: 10-5 Summer: 10-9; owner/dir: Frederick Prescott

This large new gallery with attached studio space specializes in contemporary abstract painting, graphics and sculpture. Some figurative and representational works are shown as well. The gallery executes corporate commissions in addition to presenting art for the general public. Much of the work is large scale.

Frederick Prescott works in a variety of media, including acrylic and torn canvas collage on canvas, bronze and steel standing sculpture, and high-polish body casts. His recently opened studio in Dallas serves as headquarters for architectural commissions. Of the other artists featured, New York resident Patrick Stone creates large abstract stone sculptures in travertine, marble and serpentine. Well-known painter Lindy Lyman is included in many museum collections. Monotypes by Christina Hall and highly abstract

acrylic and oil paintings by Darrel Dunlap are also available.

Visitors are welcome to visit the studio and observe the works in progress.

C.G. Rein Galleries 122 W. San Francisco St., Santa
550 Fe, NM 87501 (505) 982-6226; Mon-Sat: 10-5:30; owner: C.G. Rein dir: Mary Pat Day

See listing for Scottsdale, Arizona.

Running Ridge Gallery 640 Canyon Rd., Santa Fe,
551 NM 87501 (505) 988-2515; Mon-Sat: 10-5 Sun: 12-5; owner: Grabowski/Farnham dir: Nina De Large

Running Ridge is a contemporary crafts gallery specializing in non-functional ceramics, handblown glass, jewelry, paintings and sculpture. A nationwide selection of artists is represented.

In the group of ceramists are such nationally known artists as Beatrice Wood, Laura Andreson and James Lovera. The contemporary crafts range from the large *raku* vessels of Michael Gustafson to the richly colored handblown glass of William Morris and the fine weavings of Mary Balzer Buskirk. The painters featured, including Donald Louthian and Betsy Margolius, produce work in non-representational styles. Lois Dvorak creates highly intricate handmade paper works. The jewelry shown emphasizes innovative design in contemporary fashion.

Santa Fe Center for Photography 104 W. San Francisco St., Santa Fe, NM 87501 (505) 983-8236;
552 Tue-Sat: 12-4; dir: Cissie Ludlow

The Santa Fe Center for Photography is a nonprofit organization specializing in changing exhibitions originated by the Center, which also supports other projects related to photography, such as workshops, lectures, and the publishing of portfolios and books (including a directory of New Mexico photographers).

Exhibitions have included work by Eliot Porter, Manuel Alvarez Bravo, August Sander, Doris Ulman, Beaumont Newhall, Cynthia Gano Lewis, Francis Frith, Bernard Plossu, Martin Chambi and Edward Curtis. Senior photographers who have worked in the Santa Fe area include Ansel Adams, Paul Caponigro, Laura Gilpin and Paul Strand. Today, the Santa Fe community is home to Paul Caponigro, Beaumont Newhall, Eliot Porter and over a hundred other creative photographers.

Santa Fe East 200 Old Santa Fe Trail, Santa Fe, NM
553 87501 (505) 988-3103; Mon-Sat: 9:30-5; dir: Alma S. King

Santa Fe East Gallery features two large exhibition spaces for American art. Works from 1880 to the present, painting, sculpture, designer jewelry and Native American crafts are harmoniously displayed.

The South Wing is devoted to fine works of art dating from 1880 to 1950. Recent exhibitions include modernist masters Arthur Dove and John Marin, noted sculptor and teacher Jose de Creeft, painter and socially concerned graphic artist Ben Shahn, Carroll Tyson, Lilla Cabot Perry, Leon Gaspard and Jane Peterson, as well as a comprehensive 19th century still life exhibition.

Contemporary paintings by Sheila Lichaz, Bernique Longley, Millard Sheets, R.B. Sprague

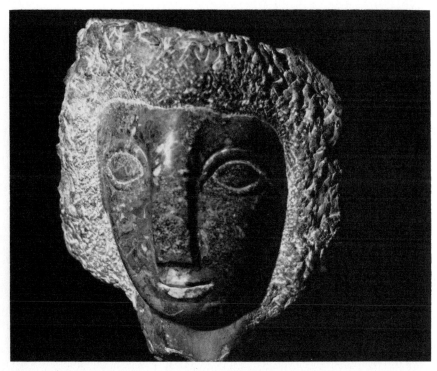

Jose de Creeft, *Cyprus,* 8 high, marble, Santa Fe East (Santa Fe, NM).

Ray Vinella, *Open Shade,* 12 x 16, oil, Taos Art Gallery (Taos, NM).

and Fremont Ellis are featured in the North Wing, along with Southwestern jewelry by such skilled artists as Charles Loloma, Luis Mojica, Charles Lovato and Vasquez. Pottery by Native American artists using ancient techniques is also shown, including the work of Al Qoyawayma and Grace Medicine Flower. Guest jewelers include Byzantium and Collaboration.

Scheinbaum & Russek 615 Don Felix, Santa Fe, NM
554 87501 (505) 988-5116; Summer: Tue-Fri: 10-12, 1-4 Sat: 10-2 Winter and Fall: call for hours; owner/dir: J. Russek & R. Scheinbaum

The gallery has been open to the public since 1980, though it has been operating privately for a longer time. Contemporary photography is exhibited, with a wide range of vintage work by some of the leading contemporary photographers, including Beaumont Newhall, Willard Van Dyke, Walter Chappell, and Eliot Porter.

No one type of work is represented, but the gallery carries a wide selection, both silver and non-silver. Limited edition portfolios are also available. In addition to the aforementioned the gallery shows works by Paul Caponigro, Ike Fordyce, Walter Nelson, Eric Renner, Sam Samore, Jean Dieuzaide, Nathaniel Lieberman, Manuel Carrillo, Laura Gilpin, Frank Hunter, John Lampkin, Lynn Lown, David Lubbers, Cissie Ludlow, Pier Mahaim, Duane Monczewski, David Noble, Janet Russek, David Scheinbaum, and Richard Wickstrom.

The gallery provides community educational and individual consulting services regarding contemporary photography and collecting. Currently the gallery is involved in travelling the works of Willard Van Dyke and Beaumont Newhall. The black-and-white photographs of Eliot Porter are also being made available to the public.

Taylor's Gallery 113 E. San Francisco St., Santa Fe,
555 NM 87501 (505) 982-4562; Summer: Mon-Sat: 9-6 Sun: 10-5 Winter: daily: 9:30-4:30

The gallery exhibits nationally known contemporary Western and Indian artists

Among the featured artists is Alfredo Rodriguez, who is known for his realistic Southwestern portraits. James Ralph Johnson is an authority on historical cavalry paintings, and Jodie Boren paints Western watercolors and oils. The gallery also features several pieces of work by deceased Cowboy Artists of America.

Bronze sculptures by Western and Indian artists are shown. The gallery also carries Indian woven rugs, pottery and jewelry. An extensive selection of limited edition prints by nationally known artists is available as well.

Altogether the gallery features some 50 artists. A sample list might include: John Cox, Gerald Farm, Dan Deuter, Cat Deuter, Dorris Harrison, Howard Bobbs, John Jellico, Lynette Watkins, Charlie Eubank, Frances O'Farrell, Paul Abram, Jr., Ross Stefan, Nate Owens, Esther Marie Versch, Terie Knapp and J.D. Challenger.

Wadle Galleries Ltd. 128 W. Palace Ave., Santa Fe,
556 NM 87501 (505) 983-9219; Mon-Sat: 9:30-5; owner: Albert Wadle dir: Cecile Moochnek

Wadle Galleries offers works by 19th and early 20th century realists, as well as contemporary

painters, sculptors and Native American artisans. The work show is representational, and frequently Western in theme.

Painters whose work is shown at the gallery include Paul A. Strisik, a distinguished landscape painter; Earl Carpenter, noted for his many paintings of the Grand Canyon; Southwestern landscape painters Laurence Sisson and Irby Brown; Western artists Harvey Johnson, Harry J. Schaare, Nicholas Firefires, Gary C. Niblett and Roy Grinell; and Mike Larsen, who paints studies of Plains Indian life. Other painters are Marilyn Bendell, figures and portraits; Caroline Norton, still lifes and figures; John Asaro, impressionist paintings; and Don Seegmiller, figures. The gallery also displays the work of noted watercolor artist James Kramer, pastels by author Albert Handell, and pencil drawings by Robert "Shoofly" Shufelt.

Sculptors include Christie Keith, Dave McGary and Fritz White, who cast Western bronzes. Also working in bronze are John Hampton, Pat Niblack and Clyde Morgan. Jemez sculptor Cliff Fragua sculpts in stone. Carol Whitney is known for her stoneware sculpture. Joyce Sisneros Gallegos makes miniature clay sculptures of pueblo life; Cherokee sculptor Bill Glass also works in clay. Storyteller Alma Concha Loretto shows her nativity scenes.

Webb Gallery 114 Old Santa Fe Trail, Santa Fe, NM
557 87501 (505) 983-7852; Winter: Mon-Sat: 9:30-5 Summer: Mon-Sat: 9:30-5:30

Webb Gallery emphasizes contemporary Western art and also shows works by early American masters. There is a sister Webb gallery in Amarillo, TX.

Among contemporary artists, the gallery features Arizona landscapist Fred Lucas, artist-historian David Powell, and impressionist Jack Sorenson. Other contemporary works include sculpture by John Free Ca and Jack Bryant, and painting by James Butler, Jorge Tarallo, Al Radomski, and Shef Chankaya.

Alfred Jacob Miller, Albert Bierstadt, Thomas Moran, Frederick Remington, and Charles M. Russell are some of the early American masters shown at the gallery. Historically significant works by American illustrators also are on display.

The gallery offers a selection of Indian pottery, kachina dolls, and weaving.

Woodrow Wilson Fine Arts, Inc. 319 Read St., Santa
558 Fe, NM 87501 (505) 983-2444; Mon-Sat: 10-5

Woodrow Wilson Fine Arts has been in Santa Fe since 1971. The gallery handles 19th and 20th century art, and specializes in work by early Santa Fe and Taos artists.

The Taos Society painters are well represented; oils by Berninghaus, Blumenschein, Couse, Hennings, Adams, and Ufer can be found, along with some watercolors and prints by these artists. The gallery also shows work from the estate of Taos artist John Young-Hunter.

The gallery carries works by early Santa Fe artists Sheldon Parsons, Gerald Cassidy, Gustave Baumann, Randall Davey, Warren Rollins, Julius Rolshoven, and others. Most of these artists worked in a representational style and

Gary Niblett, *Rabbit Stew,* 32 x 44, oil on canvas, Gerald Peters Gallery (Santa Fe, NM).

Ron Barsano, *Tangerine,* 14 x 20, oil, Taos Art Gallery (Taos, NM).

Jim Fred, *Crow Mother Kachina Doll*, 10 feet high, mixed media, Adobe Gallery (Albuquerque, NM).

Dennis Jeffy, *Crystal Energy,* 60 x 50, oil on canvas, Fennel Art Gallery (Taos, NM).

James Pilatos, *The First Snow,* 20 x 24, oil, Gallery of the Southwest (Taos, NM).

Thomas Moran, *Yellowstone Lake*, 9 x 18, watercolor, Gerald Peters Gallery (Sante Fe, NM).

Jaime Chase, *Pedernal in Summer*, 30 x 48, acrylic, Gallery of the 21st Century (Santa Fe, NM).

Jackson Hensley, *Running Free*, 36 x 52, oil, Gallery of the Southwest (Taos, NM).

Tom Macaione, *Sunflower*, 48 x 36, oil on board,
Gallery West (Taos, NM).

Alfred Morang, *Country Road,* 15 x 20, oil, The Jamison Galleries (Santa Fe, NM).

Tom Nicholas, *New England Hillside,* 30 x 30, oil, Gallery of the Southwest
(Taos, NM).

Ramon Kelley, *The Little Dancer,* 14 x 10, pastel, Gerald Peters Gallery (Santa Fe, NM).

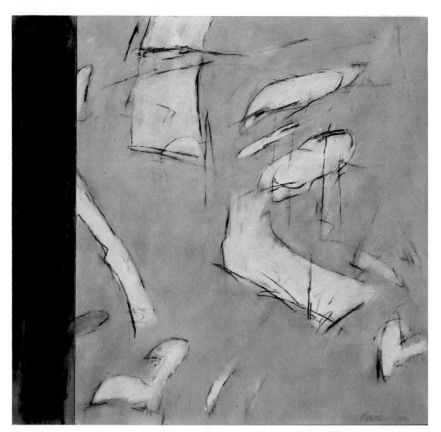

Tony Magar, untitled, 54 x 54, oil on canvas, New Gallery (Taos, NM).

Linda Tasch, *Sky Song* (1984), 42 x 48, acrylic, New Gallery (Taos, NM).

concentrated on Southwest subject matter—Indians, New Mexico architecture, scenery and mountains.

Work by other well-known Southwest artists is available, including New Mexico scenes in egg tempera and watercolor by Peter Hurd; impressionist oils by Fremont Ellis; and regional contemporaries Paul B. Wilson, Jean Parrish, Sallie Ritter and Ron McDowell.

TAOS

Gallery A Box 1221, Taos, NM 87571 (505)
559 758-2343; Summer: daily: 10-5 Winter: daily: 9:30-4:30; dir: Mary Lowe Sanchez

Gallery A features work by sculptors, painters and printmakers, both traditional and contemporary. Most of the artists' subjects are rooted in the Southwest.

In two-dimensional works, the emphasis is on landscapes. The oil paintings of Pamela Mason, John Duncan, Mick Shimonek and Will-Amelia Sterns are among those shown. Tom Talbot interprets landscape and figures in an impressionistic manner, often evolving his images from abstract color patterns. Gene Kloss's copperplate etchings depict the American Indians of the Northern New Mexico pueblos and landscapes of the Southwest.

The gallery also displays batiks by Philomena Clark, who portrays Indian cultures, the beauty of the land, and the poignant loneliness of the nomadic life.

Clay & Fiber Box 439, Taos, NM 87571 (505)
560 758-8093; Mon-Sat: 10-5; dir: Art Adair & Mark Adair

Clay & Fiber is a contemporary craft gallery representing craft artists in the Southwest who work in ceramics, fiber, blown glass, turned wood and furniture, artwear, jewelry, and baskets. Monthly two-person exhibits of nationally known artisans are held May through December. January through April the gallery exhibits ethnic textiles and artifacts.

Ceramists Robert Piepenburg, Frank Boyden, Jim Romberg, Mary Witkop, Jenny Lind and Ginger Mongiello show work at the gallery, as do tapestry artists Sally Bachman, Jack Roush, and Claribel MacDaniel. Jonathan Krout creates hand-woven baskets cured in pinion pitch and beeswax. The gallery shows the pine-needle baskets of Fran and Neil Prince, and coiled baskets covered with handmade paper and decorated with leather, made by Lissa Hunter. A new room displays hand-painted furniture by Taos artist Jim Wagner, and willow furniture by Roger and Jan Badash.

The gallery displays one-of-a-kind clothing made by many different artists with various materials and techniques. Handpainted silks and woven garments are featured, along with intricately pieced "artwear" fashioned by Joann Lopez and Michael Meyer.

El Taller Taos Box 1347, Kit Carson Rd., Taos, NM
561 87571 (505) 758-4887; daily: 10-5 winter: Sun: closed; owner: Pena & Merritt dir: M.A. Merritt

The gallery exhibits contemporary Southwestern artwork by a wide variety of artists.

Works exhibited include the figurative paintings, graphics and posters of Amado M. Pena, the batiks of Katalin Ehling, and the bronze and pressed clay sculpture of Oklahoma City sculptor Shirley Thomson Smith. Patrick Coffaro's vivid Southwestern canvases and chine colle works are on display, as well as Liese Jean Scott's drawings and original graphics of women and kachinas.

The gallery also shows jewelry by Santa Fe craftsman Ross Lewallen, Mexican Zapotec weavings and Quezada family pottery in the Casas Grandes tradition.

Fennell Art Gallery Box 1723, 118 B Kit Carson
562 Rd., Taos, NM 87571 (505) 758-0749; daily: 9-6; owner/dir: Jeannie Fennell

The gallery specializes in contemporary Southwestern art, by Indian and non-Indian artists. Paintings, sculpture, pottery, weaving and photography are shown.

Dennis Jeffy is a Navajo painter working in oils, acrylics and mixed-media. Zuni Indian sculptor Faye Quandelacy works in stone. Tse'Pe, a potter from the San Idelfonso Pueblo, works in traditional clay, sometimes using turquoise and silver. Manuelita Lorato of the Santo Domingo Pueblo makes ceramic sculpture relating the legends of her people.

Other artists presented are Rollie Grandbois and Bruce La Fountain, both of Chippewa, Cree, and French descent, who carve stone sculpture; and Native American artists Rhett Lynch, who weaves natural dyed fibers, and Mark Ortiz, who paints geometric designs in acrylic. The work of George Albracht, Western photographer, and ceramist Mark Snowdon are also shown.

Gallery G #1 Bent St., Taos, NM 87571 (505)
563 758-0454, 776-2211 Mon-Sat: 10-5; owner/dir: Annette Grubiss

This is a small gallery featuring watercolors, South-western photographs, and Spanish Colonial handmade furniture, "santos" and crosses.

Jonathan Scott's watercolors portray the variable moods of the Southwest landscape. Jonathan Waugh's hand-crafted furniture made from original designs with a Spanish Colonial influence is constructed without screws or nails of carefully selected Ponderosa pine. Dick Spa's photographs of the Southwest countryside present images concerned with the dynamics of contrast in organic design. "Santos", images of saints, sculpted in Rio Grande cedar by Michael Salazar, and Spanish Colonial crosses by Josie Ward Cox are also available.

Gallery of the Southwest Box 1442, Taos, NM 87571
564 (505) 758-8088; Summer: daily: 9-5 Winter: daily: 10-5; co-owner/dir: Jackson Hensley

The gallery specializes in high quality contemporary paintings and sculpture. Many artists are represented, and all gallery artists are shown regularly.

Work displayed includes the drawings of John Groth, New Mexico Landscapes by Jackson Hensley, landscapes by Paul Strisik, expressionist works by Gustav Rehberger, still lifes by Rudy Colao, realist landscapes by Tom Nicholas, and impressionist works by James Pilatos, Robert Maionne, and Peter Layne. Also handled by the gallery are oil landscapes by Herbert Abrams, pastels by Doug Dawson, paintings by

Albert Handell, and the art of Rosie Alford, who works in all media.

Several Taos artists are exhibited by the gallery. These include John Koenig, who paints portraits of Native Americans, and Charles Berninghaus, who creates Taos landscapes. The works of co-owner and director Jackson Hensley also are on view.

Grycner Gallery Box 2107, Taos, NM 87571 (505)
565 776-2421; daily: 9-6; dir: Greg Grycner

Grycner Gallery combines studio and gallery facilities to show handcast paper and ceramics in the process of being made by the artist. The work displayed ranges from traditional to contemporary.

Among the artists at the gallery , the best-known is R.C. Gorman, an extremely versatile artist in various media, who can be seen here working in ceramics and handcast paper. Doug Coffin and Kent Jones also work in cast paper. Native artist Miguel Martinez works in oil pastels. Other artists include Ray Tomasso, Ellie Hamilton, Gary Mauro and Ken Black.

The Ledoux Gallery One Ledoux St., Taos, NM
566 87571 (505) 758-9101 daily: 9:30-5

Founded in 1976, the gallery features Southwest contemporary and traditional artists who have been in the region for at least two years.

Abstract Expressionist Hyde Solomon, who was active in the second generation of the New York School in the 50s, painted in Taos from 1972 to 1981. Lee Simpson, who has spent 10 years in Taos, paints elegantly executed abstractions. Tom Noble, a Taos native, works mainly in watercolors. In Taos since 1974, Susan Keelbocki works in oils on canvas and on paper.

Other Taos artists include Ann Crombie, who has been painting abstracts in oil since 1973. The gallery handles the ceramics of Sister Mary Levey, especially noted for her raku, and the works of Charles H. Jeffres, who expresses Southwestern themes in prints, serigraphs and silver collages. Also featured are Chris Hotvedt's woodblock prints of Indian and Spanish ceremonies.

Magic Mountain Gallery Box 1267, 202 N. Plaza
567 Rd., Taos, NM 87571 (505) 758-9604; Mon-Sat: 10-5:30 Sun 11-5; owner/dir: Kathleen M. Decker

Magic Mountain Gallery exhibits contemporary Southwestern painting, sculpture and graphics, as well as traditional Pueblo pottery.

One may see impressionistic oil painting by Doug Higgins, figurative watercolors by D. Pendleton Bennion, abstract mixed media oil pastels by Mark Dickson, and watercolors by King Kuka and Jason Williamson. Printmakers Nancy Young and James Eder depict the Southwestern landscape. James Roybal casts traditional Western figures in bronze. Painter Rita Sutcliff bases her imagery on ancient desert pictographs of the Anasazi and prehistoric hunters. Robert Garcia carves stone sculpture of traditional Indian themes.

The gallery shows bronze pots by Clarke Jensen, large coiled earthenware pots by Ilena Grayson, and contemporary ceramics by Jacquie Stevens. Traditional Pueblo pottery is also available by Joseph Lonewolf, Blue Corn, Roy Ta-

foya, Geri Naranjo, Dolores Curron, Goldenrod, Effie Garcia, Belen Tapia, Anita Suazu and Dora Tse Pe.

Merrill's Gallery Box 886, Taos, NM 87571 (505)
568 758-4565, 758-9223; Mon-Sat: 9-5; owner/dir: Otis & Dixie Floyd

Started in the 1940s by artist Art Merrill, this is one of the oldest galleries in Taos. Works shown at the gallery are by artists from all parts of the United States.

Realistic scenes and landscapes predominate, and are well represented in the Southwestern paintings of Lee K. Parkinson, James Ralph Johnson and Bill Barber. Roy Kerswill paints the mountain men of the 1800s, and Lloyd Thorsten paints landscapes with aspens. Bill Maratta is a sculptor from Oklahoma who works in bronze. The gallery also shows the miniature paintings of Doug Miley.

The New Gallery 802 Ranchitos Rd., Taos, NM
569 87571 (505) 758-0100 daily: 11-4:30; dir: Thom Andriola

The gallery features several internationally renowned contemporary painters who now maintain residence studios in Taos, Among them are artists Lawrence Calcagno of the second generation of New York Abstract Expressionists of the 50s; Lee Mullican, one of the founders of the Dynaton group of the late 40s; 80-year-old Japanese born Michio Takayama, whose work is in the lyrical abstraction style of the 40s and 50s; and Bea Mandelman, one of the first non-objective painters in the Southwest.

The gallery also features work by action-field painters in the Southwest. These young artists are working in a lyrical gestural style that is rooted in the universal art tradition yet reflective of the unique environment of Taos. This group includes Tony Magar, Linda Tasch, Ginger Mongiello, Lilly Finachel and Sam Scott.

In 1984 the gallery opened a Houston branch.

Return Box 53, Taos, NM 87571 (505) 758-3993;
570 Thu-Tue: 11-6 Feb: closed; dir: Board of artists

Return was established in 1976 to provide a creative environment for the emerging tradition of the Southwest. The focus of the general inventory has been on contemporary works in traditional media, with concentration on the works of Northern New Mexico. Over a dozen of the participating artists helped in the construction of the gallery, to make the display of their work blend with the environment.

Media represented include painting, wood and stone sculpture, ceramics, jeweled sculpture and jewelry. Watercolorist Douglas Johnson is a mystical realist. His miniature works in casein are exacting glimpses of traditional and ceremonial life of North and South American Indian and Hispanic cultures. The gallery also displays a selection of jeweled sculpture fashioned in silver, gold, copper or brass with inlaid semi-precious stones. Artists in this medium include John Hernandez, Larry Herrera, Edward Merrifield, Sam Quintana and Jennifer Sihvonen.

Larry DeWitt makes miniature to life-size terra cotta sculpture of Native Americans. Unusual, fine concho belts are made by Pepe Rochon.

Michael Hensley, *Elevation of the Cross,* 14 x 18, oil, Gallery of the Southwest (Taos, NM).

Vladimir Bachinsky, *Mirage,* 16 x 20, oil, Gallery of the Southwest (Taos, NM).

Tally Richards Gallery 2 Ledoux, Taos, NM 87571
571 (505) 758-2731 72-205 Painters Path, Palm Desert, CA 92260 (619) 346-8117 owner/dir: Tally Richards

Housed in a 200-year-old adobe building, the gallery specializes in paintings, sculpture and graphics by internationally known artists working in the Southwest.

One of the most innovative artists exhibited is Larry Bell, whose boxes of iridescent glass are seen in many museum collections. The boxes are made by a technique of coating glass with vaporized metal filaments in a 6-ton vacuum chamber. Painters Fritz Scholder and Earl Linderman, both dynamic colorists, combine Expressionism with other elements of contemporary style. Jerome Kirk's kinetic sculptures are aluminum circles or ellipses that swing like pendulums, sustained by gravity.

Harold Joe Waldrum has gained international recognition for his magnificent collection of approximately 7,000 Polaroids of New Mexico churches, many on the verge of disappearing. The photographs have served as a source of visually transformed images for his paintings.

Shriver Gallery Box 1237, 400 N. Pueblo Rd., Taos,
572 NM 87571 (505) 758-4994; dir: Marge Harrison & Bill Harrison

The Shriver shows work by artists working in pastel, watercolor, oil, charcoal drawing, and bronze sculpture. Most work in realist styles, creating landscapes, Western and historic painting.

The subject matter of Dan McCaw's impressionistic paintings includes landscapes, scenes of the American West and romantic nostalgia. Lowell E. Smith's frequent trips to the Southwest are reflected in his watercolors. Don Stone and Gerald Fritzler are other watercolorists exhibited in the gallery. Mike Desatnick's oils depict New Mexico Indian festivals and ceremonials, while Douglas Ricks portrays life among the 19th Indians in the Northwest. Jim Rey paints the life of the contemporary cowboy and the mountain men of the Old West.

The gallery features the bronze sculpture of Joe Beeler, Star Liana York, and Dee Toscano. Paintings by William F. Reese, Donald ''Putt'' Putman, Gerald Farm and Michael Stack are also exhibited.

Rounding out the gallery's stable of artists are Harley Brown, Jimmy Dyer, Jerry Venditti, William Shriver, and George Fischer, among others. The gallery recently introduced the work of impressionistic painters Francis Donald, John Galvan, and John Encinias.

Galeria Sigala Box 3195, Cabot Plaza Mall, Taos,
573 NM 87571 (505) 758-9844; Summer: daily: 10-5:30 Winter: Mon-Sat: 10-5

Established in June of 1980, Galeria Sigala's five rooms of architectural beauty house works of forty artists of both international and regional fame, representing contemporary and traditional Southwestern painting, sculpture and graphics.

Among the artists exhibited are Zoltan Szabo, Louis De Mayo, George Pate, Pat Smoot, Jinni Thomas, Sandra Humphries, Ron Arena, Irmgarda Hoban and Jim Wagner. Sculptors include

Ted Egri, Marc Davis, Eduardo Rael and Theodore Shillock.

Southwestern Arts Box 1408, Taos, NM 87571,
574 (505) 758-8418 Mon-Sat: 10-5

Southwestern Arts opened in 1978 and is devoted to the display, promotion, and sales of Navajo weavings dating from the mid-1800s to the present. In addition the gallery shows antique and contemporary Pueblo pottery and Plains Indian beadwork.

The gallery obtains antique Navajo weavings from various collections all over the world. Contemporary weavings are purchased directly from the weavers on the Navajo reservation. Southwestern Arts shows a representative cross-section of the different styles of Navajo weaving that are being done today.

The selection of contemporary weaving includes work by Alice Roy from Teec Nos Pos, Betty Lee from Two Grey Hills, Bessie George from Wide Ruins, Nita Begay from Crystal, and Mabel Burnside Meyers from Pine Springs.

Historic and contemporary Pueblo pottery is shown. Contemporary work is available by potters Stella Shutiva from Acoma, Pauline Martinez and Doug Vigil from San Idelfonso, and Mary E. Toya from Jemez.

Taos Art Gallery Box 1007, Taos, NM 87571 (505)
575 758-2475; Mon-Sat: 9-5

Established in 1950, the Taos Art Gallery specializes in traditional Western art. The gallery features oils. watercolors, and bronze sculpture portraying Western subjects, and also has a fine selection of American Impressionism.

Two Cowboy Artists of America, William Moyers and George Marks, are well represented. Both artists are painters and sculptors. The gallery also features realist landscapes by Curt Walters, who frequently depicts the Grand Canyon. Still life painting inspired in the Dutch tradition is shown by Paul DiBert, and the gallery shows a large selection of American Impressionist work by Rod Goebel, Robert Daughters, Ray Vinella and Ron Barsano.

Don Enright specializes in watercolors of wildlife. Oil portraits of Taos Indians, nude figure studies by Chet Engle, and painting by John Moyers and Terri Kelly Moyers are also found in the gallery.

Over a hundred pieces of bronze sculpture are on display. Cowboy themes are well represented in the work of Moyers and Marks. The gallery's third major sculptor is Jasper D'Ambrosi, who works in both Western and classical bronzes, of miniature to monumental size.

Total Arts Gallery Box 1744, Taos, NM 87571 (505)
576 758-4667 Summer: daily: 10-5:30 Sep-May: daily: 11-5; owner/dir: Harold Geller

The name of the gallery is descriptive of its purpose: to show fine works of art in all media and techniques, from the traditional to the modern.

A number of prominent contemporary artists are represented: Walt Gonske, a member of the NAWA (National Association of Western Artists) and the National Cowboy Hall of Fame, does watercolor and oil impressions of the

Southwest. Barbara Harmon shows her fantasy paintings and lithographs; painter Cliff Harmon explores the subtle gradations of color of the New Mexico landscape. Bill Harrison paints landscapes of the middle United States and the Southwest.

In addition, the gallery shows works by Michio Takayama, a distinguished Taos abstractionist; by Marsha Howe, who does etchings; and by Walt Kuhlman, Richard Lange, Joan Potter, Dan Rippe, Sonny Apinchapong, Alice D. Webb, John T. Axton, Jonathan Scott and Barbara Thayer.

The Variant Gallery 230 Don Fernando, Taos, NM
577 87571 (505) 758-4949; Summer: daily: 10-5 Winter: Thu-Mon: 10-5; owner: Bob & Marnie Johnson dir: Roy Johnson

Located in the main shopping center of Taos, the gallery exhibits contemporary as well as traditional art.

Impressionist John Asparo shows his painting here, and is noted for his light. Also shown are works by Rulon Hacking, one of the few landscape artists who works from imagination, and by Sergei Bongart, who depicts landscapes and lush, lilac still lifes. Marnie Johnson's interiors are marked by a strong sense of composition and an abstract handling of form.

Bob Johnson's Westerns reflect his own past, as well as his sensitivity to the tools of yesteryear. Rick Loewenkamp's fantasy Indians are drawn on clear air-brushed landscapes. Jane Ellen Burke's work leads the viewer to an encounter with form as an object of contemplation in a pure design. Ben Konis's bright colors fill his paintings of Taos landscapes and Indian portraits with a fiery gleam.

Gallery West Box 1589, Taos, NM 87571 (505)
578 758-9637; June-Oct: daily: 10-5 Winter: Thu-Sun: 10-5; owner: James Parsons dir: Jane Hamilton

The gallery was established in 1964 in Denver and opened in Taos in 1978. American Indian paintings and sculpture by regional artists are featured, with occasional works by early Taos artists. Works from the estates of Arthur Haddock, Dorothy Brett and Eric Gibberd are presented.

Leading contemporary artists are shown, including Randy Lee White, a Sioux painter who uses pictographic images; P.G. Jensen; Tom Macaione, Amy Adshead; Rebbecca Riley; Buck McCain; John Suazo, a Taos Pueblo sculptor; and Clifford Brycelea, a Navajo painter of mystical imagery. Works by contemporary folk artists Virginia Stroud, Marilyn Massey and Nina are also exhibited. The gallery always maintains a selection of works by early Taos artists, especially Arthur Haddock, Alfred Morang, Dorothy Brett and E.I. Couse. A large selection of Western prints is available as well.

NEW YORK

BRIDGEHAMPTON

Elaine Benson Gallery Montauk Hwy., Bridgehamp-
579 ton, Long Island, NY 11932 (516) 537-3233;

daily: 12-6 Wed: closed May 15-Sep 15: closed; owner/dir: Elaine Benson

Founded in 1964, this large gallery concentrates on works by artists and craft artists, preferably with a relationship to the Hamptons. Occasionally Pre-Columbian, Thai or Rajasthani works are shown.

Artists whose work is displayed include Willem de Kooning, prime mover of Abstract Expressionism; Elaine de Kooning, whose work retains representational subject matter with the gestural attack of Abstract Expressionism; gestural realist Larry Rivers; contemporaries of Willem de Kooning James Brooks and Esteban Vicente, whose gestural abstraction tends to a cool lyricism; as well as many other artists. Works by early abstractionist Jimmy Ernst are available, and there are also paintings of Long Island landscape by such distinguished realists as Fairfield Porter, Jane Freilicher, Robert Dash and others.

Craft artists shown by the gallery include Toshiko Takaezu, Lenore Tawney, and Dale Chihuly. Many young artists have made their debut here. The seven galleries and two sculpture areas permit exhibition of as many as twenty-five artists in one of the frequent theme shows.

BUFFALO

CEPA Gallery 700 Main St., 4th floor, Buffalo, NY
580 14202 (716) 856-2717; Tue-Fri: 11-5 Jul-Sep 14: closed; dir: Gary Nickard

CEPA is a nonprofit, artist-run space dedicated to the advancement of photographic related art, primarily serving emergent professional artists. Programs include exhibitions, a guest lecture series, an artist project series that publishes artist's books, a video-art program, and a public art program that includes installations in public transit facilities and on billboards. CEPA provides a place for non-market-oriented innovative work that engages current art issues.

Many well-known and emergent artists have exhibited at CEPA—one might mention John Baldessari, James Casabere, Sandy Skoglund and Hollis Frampton, among many others in recent years. In the 1983-84 season the following exhibited at CEPA: Mary Ahrendt, Joel-Peter Witkin, Brian Weil, Patt Blue, Patty Wallace, Jim Pomeroy, Dianne Blell, Eldon Garnet, Don Rodan, Paul Szp, Reed Estabrook, Leandro Katz, Tony Conrad, Tseng Kwong Chi, James Welling, Vikky Alexander, Anita David, Kathry High, William Wegman, George Legrady and Joyan Saunders.

Nina Freudenheim Gallery 560 Franklin St., Buf-
581 falo, NY 14202 (716) 881-1555; Tue-Sat: 10-5 Mon: by appt Aug: closed; owner: Nina Freudenheim dir: Ann Duffy

The Nina Freudenheim Gallery exhibits contemporary American and European paintings, sculpture, drawings, prints, photographs, ceramics and baskets.

Paintings and works on paper are available by Edward Avedisian, Charles Clough, Susan Crile, Piero Dorazio, Sharon Gold, Robert Goodnough, Robert Janz, George Segal, Pat Steir, Robert Swain, Joan Thorne and Thornton Willis. There

are handmade paper works by Nancy Genn, Sam Gilliam, Czashka Ross and Ellen Steinfeld, and ceramics by Rick Dillingham, David Gilhooly, Margie Hughto and Neil Tetkowski, among others. Photographs are available by Russell Drisch, Les Krims, Andrew Moore, John Pfahl and Brian Wood.

Other artists featured include Elaine Lustig Cohen, Joseph Di Giorgio, Richard Gubernick, Shirley Kassman, Lyman Kipp, Georges Noel, Rina Peleg, Paul Sharits, Barbara Siegel, Andrew Topolski, Catherine Warren, William Weege, Don Wynn and Joe Zucker.

CEDARHURST

Loring Gallery 661 Central Ave., Cedarhurst, NY
582 11516 (516) 295-1919; daily: 10:30-5:30 Tue & Sun: closed; owner/dir: Rosemary Uffhen

American artists of the recent period of the 20th century are the focus of the Loring Gallery. Original works, graphics and sculpture are exhibited.

Artists whose work the visitor to this gallery may encounter include Harry McCormick, Charles Apt, Daniel Greene, Vincent Longianno, Alex Katz, Fletcher Martin, Laura Shechter, Karen Winslow, John Winslow, Philip Pearlstein and Robert Rauschenberg, as well as Nettie Simon, James Morlock, Paul Goldberg, Byron Browne, Robin Morris and Will Barnet.

ENDICOTT

Spectrum 15 Art Gallery 124 Washington Ave., En-
583 dicott, NY 13760 (607) 785-7415; Tue-Fri: 11-4 Sat-Sun: 12-5 & by appt; cooperative dir: Harold Westgate

Spectrum 15 was the first cooperative gallery to open in the area, in 1975. Membership is limited to fifteen. The variety of work displayed includes oils, acrylics, egg tempera, photographs, prints, stoneware, portraits, wood carvings, stained glass, hand-painted porcelain, and batiks, as well as gift items such as mirrors, porcelain dolls, and greeting cards.

Services provided by the gallery include a decorating service for offices and homes, with direct consultation with the artist selected; and rental and approval services for paintings. The gallery features five completely new exhibitions each year.

EAST HAMPTON

Gallery East 257 Pantigo Rd., East Hampton, NY
584 11937 (516) 324-9343; daily: 12-6 Wed: closed Jan-Apr: closed; owner/dir: Rose Millevolte

Concentration of the gallery is on living artists of the region painting in a representational mode. Group and three person shows are hung for two or three weeks in the downstairs gallery, while an upstairs gallery is reserved for prints.

Four of the artists shown have achieved a strong regional reputation. James del Grosso emulates the old masters in his paintings. Richard Karwoski paints brilliant large fruit and floral watercolors. Jane Ritchie is a realist working in the understated school of Fairfield Porter. Susan Tessem combines hard edge borders with diffused landscapes. All four artists are young, and promise many years of continuing growth.

Other artists shown in the 1984 season include Steve Klein, Jacqueline Penney, Mary E. Whelan, Jo Gregory, Janet Jennings, Catherine Kelsey, Donna Levinstone, Leo Revi, James Seeman, Lauren Jarrett, Dick Shanley, Kenneth Bainton, Ann Stanwell, Ted Jeremenko, Bill Zingaro, Miriam Dougents and Rose Millevolte.

Vered Gallery 68 Park Place, East Hampton, NY 11937 (516) 324-3303; Thu-Mon: 12-6; owner: Ruth Vered dir: Dyan Gray

The Vered Gallery shows painting and sculpture by contemporary American artists.

One may see the paintings of Chuck Close, who began his career with very large scale photorealist portraits. Portrait heads still dominate his work, but they have become the ground for an extensive repertory of unadorned marks beneath which they momentarily vanish, only to reappear floating above the surface as the composite image produced by the marks. There are also the gestural, representational paintings of Elaine de Kooning, as well as paintings by Jack Goldstein and Francoise Gilot. The paintings of Balcomb Greene, a founding member of American Abstract Artists, range from his early geometrical abstractions to a "metaphysical Humanism" combining figurative and abstract elements. The gallery also shows sculpture by William King and by William Tarr.

EAST MEADOW

Now & Then Gallery 797 Merrick Ave., East Mea-
586 dow, NY 11554 (516) 481-1447 & (212) 895-1145; Mon-Sat: 9-5:30 Sun: 1-5; owner: Jack Bjurland dir: Aphrodite Zuks

Concentration of the Now and Then Gallery is on contemporary American Southwestern graphics.

Works are available by well-known artists living and working in the Southwest, such as R.C. Gorman, Amado Pena. and John Axton, who are particularly noted for their innovative lithographic techniques. Most works exhibited depict Southwestern landscapes. Other artists whose work is available include Jerry Schurr, Mexican sculptor Francisco Zuniga, Boulanger, Lowell Nesbit, Arthur Secunda, Leroy Nieman and Bruno Bruni.

GREAT NECK

V & R Fine Arts 169 Middle Neck Rd., Great Neck,
587 NY 11021 (516) 466-4899; Tue-Sat: 10-5:30; owner/dir: Vincent Sorrentino

The gallery exhibits contemporary art in all media, including paintings, graphics and multiples, by both established and emerging artists.

Works by contemporary American and European artists include the photorealist paintings of Richard Estes, one of the first to work in this style, whose paintings depict the complex reflections and raw colors of the urban milieu of New York City. Philip Pearlstein's figure paintings are the result of a tour de force of observation, bypassing academic canons. His recent color etchings and paintings achieve an almost baroque richness of detail and texture. Michelangelo Pistoletto, who also contributed to the Italian *arte povera* movement, is best known for his startling

trompe-l'oeil figures on mirror-polished steel. In addition to work by these artists, one may see photographs by Berenice Abbott, whose images of 1930s city life have earned a distinguished place in American art.

Other contemporary American artists featured are Carole Jeane Feuerman, Elwood Howell, Andrew Teabo, Al Alexander, Richard Milani and Michael Tetherow, whose distinctive styles range from Photorealism to Expressionism.

HARTSDALE

Alan Brown Gallery 210 E. Hartsdale Ave., Hartsdale, NY 10530 (914) 723-0040; Tue-Sat: 10:30-5:30 & by appt; owner/dir Alan Brown
588

The Alan Brown Gallery exhibits graphics, paintings and sculpture by contemporary American artists.

Specialty of the gallery is Andy Warhol silkscreens, including the suites "Myths" and "Endangered Species." Photographs by Edward Steichen are available individually or in portfolio. Large format cast paper and composition wall reliefs by Helene Trosky are available for corporate display. There are also paintings and ink drawings by Franz Kline, and monoprints by Sam Francis.

Other works featured include paintings and sculpture by Tommy Simpson, boxes and collages by Roy Simmons, Jim Ridlon and Leo Kaplan, as well as Frederic Remington bronzes, hyperrealist paintings by James Fender, and Haitian primitive paintings.

ITHACA

The Upstairs Gallery 215 N. Cayuga St., Ithaca, NY 14850 (607) 272-8614; Tue-Fri: 11-3 Sat: 11-1 Summer: closed; dir: Johnnie Parrish
589

A nonprofit gallery devoted to showcasing professional artists in the Ithaca area, as well as other American artists, The Upstairs Gallery shows contemporary paintings, graphics, sculpture and photography.

Artists exhibited vary from year to year. For the 1984-85 season the gallery will feature works by John Hartell, N. Peter Kahn, Eliot Porter, and Stephen Porter.

JERICHO

Gillary Gallery 62 Maiden Lane, Jericho, NY 11753 (516) 681-2015; daily by appt; owner/dir: Sylvia V. Gillary
590

Both American and European contemporary art is exhibited at the Gillary Gallery, including paintings, lithographs and sculpture.

Artists featured at the gallery include Graciela Rodo Boulanger, Michael Delacroix, Jack Levine, Kaiko Moti, Beatrice Brook Ross, Miriam Axelrod, Bronka Stern, Alexander Ross and Leo Gillary.

LOCUST VALLEY

Country Art Gallery 198 Birch Hill Rd., Locust Valley, NY 11560 (516) 676-6886; Tue-Sat: 10-5 Jul-Aug: closed; dir: Clarissa Watson
591

Concentration of the gallery is on American and European contemporary art, with accent on realism and naive art.

Artists featured are American sporting painter Joseph W. Golinkin; English sporting painter Raoul Millais; American realists Wayne Davis, Reynolds Thomas and A.N. Wyeth. Among the naifs whose works are exhibited are French primitive Beatrice Jouty, Steven Klein, Elsie Heindl and Luis Idigoras. Other French and American artists featured are Trafford Klots, Francoise Gilot, Ernest Chiriacta, Jean Hugo, Marie Stobbe and Gabriel Spaf.

Four strongly emerging artists featured at the gallery are Wendy Chazin, Gaudin, Jurg Mikiver, and Dinah Maxwell Smith.

NEW YORK CITY

ACA Galleries 21 E. 67th St., New York, NY 10021 (212) 628-2440 Tue-Sat: 10-5:30 July-Aug: 10-5; dir: Sidney L. Bergen
592

The gallery concentrates on late 19th and early 20th century American painting, including work by contemporary artists. American masters include members of the Ashcan School of realist painters, notably Robert Henri, George Luks, Everett Shinn and William Glackens. Other American masters belong to the Stieglitz group, namely Georgia O'Keeffe, Charles Demuth and Marsden Hartley. American Impressionists Childe Hassam and Ernest Lawson are also featured. The gallery represents the estates of early abstractionist Gertrude Greene, figure painter Leon Kroll, Moses Soyer, the family of Joseph Cornell, precisionist Francis Criss, social realist William Gropper, and realists C.K. Chatterton and Ernest Fiene. ACA's exhibition of 20th century art also includes works by Reginald Marsh, Milton Avery and Thomas Hart Benton.

The gallery features mainly representational contemporary artists whose work spans the past fifty years and exhibits new trends in paintings. They include Joseph Solman, Balcomb Greene, Margit Beck, Anthony Toney, Robert Vickrey, Emilio Sanchez, John Dobbs, Barkley Hendricks, Roy Carruthers, Fritz Scholder, Paul Pletka, Judy Chicago, Jeffrey Kronsnoble, Lionel Kalish, Linda Chapman and John Bayalis, Jr.

Acquavella Galleries 18 E. 79th St., New York, NY 10021 (212) 734-6300 Mon-Sat: 10-5; dir: William R. Acquavella
593

Established over fifty years ago, the gallery features works by 19th and 20th century master painters and sculptors, including Pierre Bonnard, Eugene Boudin, Georges Braque, Mary Cassatt, Paul Cezanne, Marc Chagall, Edgar Degas, Jean Dubuffet, Max Ernst, Henri Fantin-Latour, Juan Gris, Paul Klee, Fernand Leger, Claude Monet, Pablo Picasso, Camille Pissarro, Odilon Redon, Pierre-Auguste Renoir, and Alfred Sisley.

Acquavella Contemporary Art, a subsidiary gallery in the same building, is open Tuesday-Saturday, 10-5, and on Mondays by appointment. There are works by such major artists as Anthony Caro, Christo, Willem de Kooning, Sam Francis, Helen Frankenthaler, Philip Guston, Franz Kline, Roy Lichtenstein, Morris Louis, Jackson Pollock, Robert Rauschenberg, Marc Rothko, Frank Stella, and Cy Twombly.

Gallery artists are Billy Al Bengston, Willard Boepple, Maureen Connor, Rachel Epstein,

Todd McKie, Peter Robbie, Mark Schlesinger, Sandi Slone, Catharine Warren, and Edward Youkilis.

Pam Adler Gallery 37 W. 57th St., New York, NY
594 10019 (212) 980-9696 Tue-Sat: 10-5:30 & by appt; owner/dir: Pam Adler

The primary purpose of the gallery is to work individually with twelve artists, all of whom are emerging figures in American art. Their experimental styles give the gallery a fresh and unpredictable image.

Sarah Canright, Marina Cappelletto, Jack Chevalier, Don Dudley, Ira Joel Haber, Jonathan Santlofer, Jack D. Solomon and Jeff Way frequently deal with artforms midway between painting and sculpture. Works by Ed Baynard, Charles Clough, Barbara Zucker and Harry Soviak are exemplary of the range of highly individual imagery shown at the gallery.

Rachel Adler Gallery 58 E. 79th St., New York, NY
595 10021 (212) 831-3824; Tue-Sat: 10-5 Aug: closed; owner/dir: Rachel Adler

The gallery specializes in early 20th century art, sculpture and Latin American art, with particular attention to the Russian Avant-Garde and Italian Futurism.

Among the Russian artists active immediately after the revolution is Kasimir Malevitch, founder of a radically abstract art which he called Suprematism, and whose influence may be seen in today's Minimalism. Others of that epoch are Constructivists El Lissitzky, Alexander Rodchenko and Lyubov Popova. The Italian Futurists sought to embody the world of the machine, of speed and motion in their painting and sculpture. Among those shown at the gallery are Umberto Boccioni—author of the first Futurist manifesto, Giacomo Balla and Carlo Carra.

Latin American artists include Fernando Botero, Rufino Tamayo and Mexican muralist Diego Rivera. In sculpture, the gallery's most notable works are by French sculptors Auguste Rodin and Aristide Maillol.

A.I.R. Gallery, Inc. 63 Crosby St., New York, NY
596 10012 (212) 966-0799 Tue-Sat: 11-6 Jul & Aug: closed; dir: Berenice Reynaud

A.I.R. Gallery is a cooperative gallery of women artists founded in Soho in 1972 as an organization designed to change ideas and attitudes about art by women. There are 20 members in New York City who have solo exhibitions on a biennial rotating basis, and 10 affiliate members across the U.S.A. and in Canada, who have annual group shows. The gallery also organizes group shows on a special theme.

Current members include painters Daria Dorosh, Loretta Dunkelmann, Lenore Goldberg, Mary Grigoriadis, Nancy Spero and Clover Vail; sculptors Donna Byars, Louise Kramer and Patsy Norvell; and Mary Beth Edelson and Harmony Hammond, who work in both media. Dotty Attie makes prints and drawings; Sari Dienes, collages; Sarah Draney, reliefs; Elaine Reichek, installations. Sculptors Sandra Eisenstein and Anne Healy, film-maker and photographer Kazuko, and performance artist Ann Wilson also do installations.

Affiliate members in the 1982-83 group show were Ursula Kavanagh, Lorraine Archacki, Salli Lovelarkin, Rebecca Seeman and Barbara Garber; and in the 1983-84 show, Gerda Meyer Bernstein, Nicole Jolicoeur, Diane Samuels, Nancy Storrow and Faith Wilding.

Jeffrey Alan Gallery 1568 Second Ave., New York,
597 NY 10028 (212) 744-4070; by appt; owner/dir: J. Marqusee

The gallery deals exclusively in 19th and early 20th century American paintings, works on paper and small sculptures. Included in its collection are landscapes, still lifes, portraits, genre and marine painting.

The gallery owns and acquires paintings by Frank Duveneck, Walter Launt Palmer, Alexander Wyant, Thomas Anshutz, Richard LaBarre Goodwin, Bruce Crane, Albert Bierstadt, Milne Ramsey, Gilbert Gaul, Edward Potthast, John F. Francis, George Fuller and others. In addition to work by artists of the Hudson River School, Impressionists, Tonalists and Realists, the gallery appreciates work of the 20s and 30s.

Brooke Alexander, Inc. 20 W. 57th St., New York,
598 NY 10019 (212) 757-3721; Tue-Sat: 10-6 Jul-Aug: Mon-Fri: 10-5; owner: Brooke & Carolyn Alexander dir: B. Alexander

The focus of the gallery is painting and sculpture by con temporary artists. Contemporary prints are also important.

The artists who exhibit at the gallery can roughly be divided into three groups. The first of these groups would be younger artists who are primarily concerned with an exploration of figurative images, such as John Ahearn, Richard Bosman, Ken Goodman, Martha Diamond, Richard Mock, Tom Otterness and Judy Rifka. The second group consists of artists who have been exhibiting for a number of years, and they are primarily concerned with landscape imagery: Richard Haas, Yvonne Jacquette, Sylvia Plimack Mangold and Ann McCoy. The third group are painters who deal with elements of abstraction: Stephen Buckley, George Negroponte and Troels Worsel.

Prints published by Brooke Alexander, Inc., during the past year are by Richard Bosman, Elizabeth Murray, Neil Welliver, Yvonne Jacquette, Robert Longo and Joel Shapiro. In addition, graphic works by Sam Francis, Jim Dine, David Hockney, Jasper Johns, Sol Lewitt, Robert Motherwell and Robert Rauschenberg are included in the inventory.

American State of the Arts Gallery Exchange 162
599 W. 4th St., New York, NY 10014 (212) 242-6234; Tue-Sun: 12-12; owner: Nona Gianlorenzi, Gene Waering dir: N. Gianlorenzi

Concentration of the gallery is on contemporary art, mostly paintings by young emerging artists. The gallery also exhbits prints by contemporary masters. The work exhibited is generally American and has been executed in the last 20 years, although preference is given to work executed in the last one to five years.

The collection of master prints has included works by Andy Warhol, Frank Stella, Roy Lichtenstein, Ralph Goings, Robert Rauschenberg, Claes Oldenburg, Nicholas Krushenick, George Segal, David Hockney, Helen Frankenthaler,

Richard Anuszkiewicz, Alan Shields and Larry Zox.

The framed movement paintings of D.R. Jacobson have been called kinetic wall paintings and are a hallmark of the gallery. Other young artists exhibited at the gallery include Claire Moore, Yudel Kyler, Chris Chambers, Martha Bloom, Elizabeth Kudar, James Goodwill, Jack Curtis, Nona Gianlorenzi, Tony Yates, Janet Richmond, Chet Michael Baker, Fernando Garcia and Alan Guttman.

David Anderson Gallery, Inc. 521 W. 57th St., New
600 York, NY 10019 (212) 586-4200; by appt; owner: David Anderson dir: Christopher C. Colt

The gallery was formerly the Martha Jackson Gallery, first opened in 1954. In less than fifteen years Martha Jackson became a legend as one of the first New York art dealers to exhibit artists such as vanguard Abstract Expressionists Willem de Kooning and Jackson Pollock, and sculptor David Smith, an innovator in abstract sculpture who used industrial materials in a lithe, muscular style. Pop artists Jim Dine, Jasper Johns and Claes Oldenburg also surged into public light in her gallery, as well as many artists of international acclaim such as Antoni Tapies, Karel Appel and William Scott.

Since Martha Jackson's death in 1969, her son David Anderson has carried on the gallery's tradition of excellence in abstract art.

Although the gallery no longer represents artists on an exclusive basis, due to a unique buying policy, its inventory contains outstandingly broad selections of works in all media by many of the artists exhibited. They include Louise Nevelson, Karel Appel, Antoni Tapies, Lester Johnson, Julian Stanczak, William Scott, Joan Mitchell, John Hultberg, Norman Bluhm, Michael Goldberg, Sam Francis, Paul Jenkins, James Brooks and others.

Parallel to the collection are the gallery documentarchives, which provide extensive sources of information on the history of art in the third quarter of this century. The gallery keeps records of all works it has exhibited or sold. Under most circumstances, the gallery is willing to loan works to qualified institutions for public exhibitions.

W. Graham Arader III 23 E. 74th St., New York,
601 NY 10021 (212) 628-3668; owner: W. Graham Arader dir: Sharon McIntosh

See listing for King of Prussia, Pennsylvania.

Artists Space 105 Hudson St., New York, NY 10013
602 (212) 226 3970 Tue-Sat 11-6 Aug: closed; dir: Linda Shearer

The gallery, which presents new works by unaffiliated artists, is dedicated to committed, innovative art. Group and individual exhibitions of painting, sculpture, mixed media, drawing, performance, film and video are organized by the gallery staff, guest curators and artists.

The gallery provides a number of services to artists. The Unaffiliated Artists Slide File documents the work of over 1,800 New York State artists who are not represented by commercial galleries. The Emergency Materials Fund and the Independent Exhibitions Program provide grants to help artists pay exhibition-related costs in alternative or non-profit spaces in New York State.

Art Spectrum 305 E. 63rd St., New York, NY 10021
603 (212) 593-1812 Mon-Fri: 9:30-5:30; owner: Mitch Morse Gallery, Inc. dir: Mitch Morse

The gallery deals in contemporary American art, and publishes and distributes limited edition prints—etchings, lithographs, serigraphs and monoprints. Though it handles painting and sculpture, works on paper are its specialty.

Among the artists featured at the gallery, South American Rimer Cardillo is a printmaker who combines etching, aquatint and engraving to create an illusionistic realism. North American Maury Colow's massive metal sculpture is a blend of primitive and modern.

Other artists are Linda Lobel, who makes kinetic constructions; Dan Gabriel, who paints flowing abstraction in oil on paper; and Mary Hoffman, and watercolorist who paints American landscape in an impressionistic style. Jack Sher's paintings on canvas and paper are heavily textured works in epoxy and acrylic. Marg Edholm's deep relief intaglio plates are printed white on white.

Art Students League of New York 215 W. 57th St.,
604 New York, NY 10019 (212) 247-4510; Mon-Fri: 9-4:30 Sat: 9:30-9 Summer: closed; dir: R. A. Florio

The Gallery of the Art Students League of New York exhibits work in all styles by League instructors, students and members. Winners of the Edward MacDowell Scholarships are exhibited, and each class at the League exhibits its work for the period of one week during the first half of the year, January through May.

There are occasional theme shows, such as an exhibition of work by students of the Eight (Ashcan School), or of works by members of the Society of Independent Artists. Exhibitions of League artists include works by Allan Tucker, Robert Phillip, Julian Levi, and many others.

The League takes no commission for sale of work from its gallery. Historical theme exhibitions are advertised and reviewed in various important newspapers and periodicals involved in the arts.

Associated American Artists 20 W. 57th St., New
605 York, NY 10019 (212) 399-5510; Tue-Sat: 10-6 Summer: Mon-Fri: 10-6; dir: Estelle Yanco

Founded in 1934, the gallery deals exclusively in original prints by both old masters and contemporary artists. The gallery moved in 1983 to a striking new space with an expanded exhibition area.

There is a heavy emphasis on 20th century American prints, including works by Thomas Hart Benton, John Steuart Curry, Grant Wood, and George Bellows. A large number of old master prints are available, including works by Rembrandt, Albrecht Durer, and Callot. European master prints include works by Picasso, Chagall, Pierre Bonnard, Felix Valloton, and Jacques Villon. Among the contemporary printmakers shown are Will Barnet, Isabel Bishop, and Raphael Soyer, all featured in one-person exhibitions at the gallery.

Recent shows have highlighted James Ensor; British masters William Blake, Frederic Griggs, and Samuel Palmer; and Lyonel Feininger,

whose estate is represented by the gallery. Younger contemporary printmakers are occasionally shown in gallery exhibits of new talent.

Atlantic Gallery 458 W. Broadway, New York, NY
606 10012 (212) 228-0944; Tue-Sun: 12-6 Aug: closed; dir: Kate Rabinowitz

Atlantic is artist-run, showing work in all styles and media. One-person shows change every three weeks, and there is a group invitational show at least once a year.

Gallery artists and their work for 1984-85 include Sally Brody, high color still lifes; Ruth Gray, paintings and photographs; Paul DiLella, figurative sculpture in unconventional materials; Michael Hayes, paintings and collages; Phyllis Janto, wood sculpture; Carol Hamann, watercolors and drawings of New York; Stephanie Lebowitz, weaving and fiber; Roger Mignon, socially concerned realism; Naomi Plotkin, graphics and paintings; Kate Rabinowitz, figurative paintings and drawings in a cloisonne style; Rich Samuelson, encaustic; Fabio Salvatori, abstract Symbolist painting; Barbara Spiller, drawings and paintings from photographs; Patricia Stegman, landscape and figure painting; John Stone, abstract painting; Rebecca Weisberg, Abstract Expressionist painting; and Laura Young, combined collage and painting.

Babcock Galleries 20 E. 67th St., New York, NY
607 10021 (212) 535-9399; by appt; dir: Michael St. Clair

Established in 1852, the gallery is one of the oldest in New York and is devoted exclusively to American art.

The collection of 19th and 20th century art includes landscapes, still lifes, figurative and abstract works. Paintings, drawings and sculptures of many different schools are represented. Artists include Ashcan School painter William Glackens, whose impressionistic style recalls Renoir; Impressionist Childe Hassam; Marsden Hartley and Alfred Maurer, of the Stieglitz group; and E. Ambrose Webster.

Contemporary painters shown include Byron Burford and Werner Groshans. There are also works from the estate of Sol Wilson.

Baskerville ⅛ Watson 24 W. 57th St., New York, NY
608 10019 (212) 582-0058; Tue-Sat: 10-5:30 Aug: closed; owner: Lewis Baskerville, Simon Watson dir: Carole Ann Klonarides

The gallery exhibits emerging contemporary artists of all media. The emphasis is on abstract or conceptual work.

Artists exhibited include R.M. Fischer, who fashions lamp/sculptures from industrial objects, depicting themes of futuristic nostalgia. Richard Prince uses photographs of images that have been re-photographed, edited and altered from magazine and newspaper advertisements. Sherrie Levine is a conceptual artist widely recognized for her art historical appropriations taken from book reproductions. Deborah Kass brings a new way of seeing to American landscape painting. Steve Wood sculpts abstract forms with anthropomorphic or primitive allusions.

Also shown are Gary Lang, a California painter who paints fragmentary media images from cultural magazines; brilliant color painters

Ti Shan Hsu, Carroll Dunham, John Torreano and Nicholas Krushenick; and photographers Nangoldin, Frank Majore and Starr Ockenga. The gallery also features the work of abstract painter Louise Fishman.

Jayne H. Baum Gallery 12 W. 37th St., New York,
609 NY 10018 (212) 695-7200; Mon-Fri: 9-6; owner/ dir: Jayne H. Baum

The gallery focuses on contemporary works in fiber, paper, ceramics, limited edition prints, sculpture, painting and photography, mostly by emerging artists.

Artists Sean McLaughlin, Gerald Siciliano, Schlomo Cassos and Robert Schmid produce paintings, drawings and limited edition prints. Stephen Sholinsky, Masaaki Noda and Bruce Bleach are printmakers. David McCullough works in painting, drawing, wall reliefs and sculpture. Ceramicists include Raymond Elouza, Bruce Lenore, Barbara Takiguchi and British artist Kate Wickham. Pamela Becker works in fiber; Martin Schreiber, photography; Joan Melnick, Astrid Fitzgerald and Barbara Thomas, paintings and drawings; Marith Berens, paper; Arnold Iger, assemblages; Marie Lyman, kesa; and Deborah Chase works in fabricated metal sculpture.

Other artists include Arlene Holmes, Debrah Pearson, Harriet Stanton, Zelda Tanenbaum, Pamela Holland Schmitt, Louise Sloane, Pamela Becker and Diane Burchard.

William Beadleston, Inc. 60 E. 91st St., New York,
610 NY 10128 (212) 348-7234; Mon-Fri: 9:30-5:30; owner/dir: William L. Beadleston

The work exhibited ranges from American and European Impressionist masters, Post-Impressionists and early 20th century masters to contemporary painting and sculpture.

One may find works by Pierre Auguste Renoir, Claude Monet, Edouard Manet, Alfred Sisley, Edgar Degas—the primary figures of French Impressionism—as well as by Post-Impressionists Paul Gauguin and Vincent Van Gogh. Works by seminal sculptor Auguste Rodin, and by modern masters Pablo Picasso, Henri Matisse, Fernand Leger and Henry Moore are also available. The gallery also exhibits works by American watercolorist and painter Winslow Homer, American Impressionists Childe Hassam and Maurice Prendergast, contemporary painter David Hockney, and many others.

Galleri Bellman 41E. 57th St., New York, NY 10022
611 (212) 486-7944 dir: Roland Augustine

19th and 20th century European and American graphics and paintings, and contemporary European and American painting and sculpture are this gallery's areas of concentration.

One may see work by Edvard Munch, Norwegian bohemian who came in contact with the Symbolist poets in *fin-de-siecle* Paris. Munch was a powerful influence on the German Expressionists, whose work may also be viewed. The work of Chaim Soutine, though influenced by the Fauves and the Expressionists in its use of color and direct, violent yet sensual handling of paint, remains deeply individual. The gallery also carries works by French Impressionists.

Judy Rifka, *Beach III* (1984), 74 x 109, oil on linen & wood, Brooke
Alexander (New York, NY).

Kurt Schwitters, *Merz 275* (1921), 7 x 5, collage, La
Boetie (New York, NY).

Contemporary artists featured by the gallery include Peter Dean, sculptor Jon Kessler, and painters Catherine Lee and Peter Chevalier.

Aaron Berman Gallery 50 W. 57th St., New York,
612 NY 10019 (212) 757-7630; 660 E. 19th St., Bklyn., NY 11230 (212) 434-9308 Mon-Fri: 11-5

Concentration is in American art of the Ashcan School and the Stieglitz Group (Robert Henri, Ernest Lawson, Max Weber, John Marin, Oscar Bluemner and others), American realists from the 10s to the 50s (E. Speicher, B. Benn, R. Soyer, L. Kroll, A. Dobkin and others), and contemporary Israeli art (J. Zaritsky, A. Arikha, L. Nikel, I. Tumarkin, S. Bok and others).

In addition to oils and drawings by Robert Henri, watercolors by John Marin, and oils by Raphael Soyer, the gallery carries work by modern masters such as mixed media works on paper by Willem de Kooning, and lithos and sculpture by Jean Dubuffet. Work by Jules Pascin, Nicolas de Stael, Gabriel Muenter, Max Ernst, Salvador Dali, D. Aronson, C. Bombois and others is also available.

Among the contemporary artists shown are George McNeil, Janet Fish, S. Lipton, Joseph Hirsch, Roberto Matta, J. Hultberg and others. Works by contemporary artists include acrylics by Karl Hageforn, works on canvas and paper by Mariam Miller and Herb Aach, works in all media by Jay Milder, collages and drawings by Richard Miller, collages by Iris el Ayoubi, photographs by Robin Landa and acrylics and drawings by S. Boardman.

David Bernstein Fine Art 12 E. 86th St., New York,
613 NY 10028 (212) 794-0389; by appt Aug: closed; owner/dir D. Bernstein

David Bernstein specializes in ancient arts of the Americas, including the Caribbean, Mexico, Guatemala, Colombia, Ecuador, Peru, Chile, Bolivia and Argentina. Concentration is on antique weavings and gold work. The weavings have been sold to various corporate collections and museums in the U.S. and in Europe.

Ancient gold from Colombia and Peru is certified authentic by an expert in the particular of its provenance. The Pre-Columbian weavings date back to 500 B.C. from the Chavin culture of Peru through to Post-Conquest Inca textiles. Other important textile traditions include Saltillo *serapes* from Mexico, dating from the 1840s, and Araucanian *ikat* wool ponchos from Chile.

Blue Mountain Gallery 121 Wooster St., New York,
614 NY 10012 (212) 226-9402 Tue-Sat: 12-6, Jul-Aug: closed; dir: Joe Giordano

This is an artist-run space showing contemporary artists in revolving one-person exhibitions. Most works shown are representational. Arthur Cohen, Michael Chelminski, Meg Leveson, Robert Godfrey, and Rosemary Naegele paint landscapes and cityscapes. Charles Kaiman paints realist still lifes. Jacqueline Lima paints whole environments on spherical surfaces; similarly, Lucien Day paints watercolor cityscapes on curved surfaces. Janet Sawyer's paintings express the anxiety of big city life. Linda Peer sculpts clay figures, painted plaster animals in aggressive poses and mechanical environments. Joe Gior-

dano paints large still life compositions, while Judith Evans paints still lifes with mirrors.

Other members include Nancy Gelman, Judith Evans, Helene Manzo, Teri Bartol, Dick Dougherty, Rudy Burckhardt, Ken Ecker, Dave Orban, Matthew Feinman, Joe Giordano, Louise Hamlin, Richard Rappaport and Greg Wulf.

Blum Helman Gallery 20 W. 57th St., New York,
615 NY 10019 (212) 245-2888; Tue-Sat: 10-6 Aug: by appt; owner: Joseph Helman dir: Peter Freeman

Concentration of the gallery is on post-World War II American art. Much of the work shown is by artists of the New York School, including works from the 50s and 60s up to the present.

Of the artists regularly featured, two of the most well-known are Richard Serra and Ellsworth Kelly. In his sculpture, Serra has employed unconventional materials in an attempt to convey the literal sense of sculpture as an object where, as in Frank Stella's early paintings, "what you see is what you get." Ellsworth Kelly's Hard Edge style balances the implied expansion of plastic form beyond the picture plane, a characteristic of Abstract Expressionism, against a classical demand for clarity and simplicity.

Other artists exhibited include Ron Davis, Jan Groover, Bryan Hunt, Craig Kauffman, Steve Keister, Andrew Lord, Robert Moskowitz, Edda Renouf, Bruce Robbins, Donald Sultan, Hap Tivey, Richard Tuttle and John Tweddle. The gallery also handles work from the estate of William Baziotes.

Mary Boone 417 W. Broadway, New York, NY
616 10012 (212)431-1818 Tue-Sat: 10-6; owner/dir: Mary Boone

An early outpost of the current artistic movement which has loosely been termed "new figuration" or "Neo-Expressionism," this gallery is open to many tendencies. Boone has assembled a group of pioneer artists in this evolving movement from both sides of the Atlantic.

Often working in diptychs and triptychs, David Salle uses strong figures in an ordered yet subtly colored compositional space. Eric Fischl's suburban genre pictures reveal hidden conjunctions of power, sexuality, and repression in which both artist and viewer are implicated as witnesses reconstructing an event. Street artist Jean Michel Basquiat is known for his graffiti-like imagery in acrylic and oil stick on masonite or canvas.

Of the German Neo-Expressionists shown by Boone, Georg Baselitz works in an aggressive painterly style, often painting his images upside-down to free them from the traditional associations of his figurative subject matter. Markus Lupertz restlessly shifts styles from figurative to abstract in a deliberate, mad "dithyramb" of images. Jorg Immendorf's allegorical paintings confront questions of German cultural and political identity. A.R. Penck uses pictographic figures to "get behind" cultural presuppositions and reach primitive psychic areas. Danish artist Per Kirkeby shares some of Penck's concerns with "prehistoric" figuration.

The gallery also features two of the principal Italian "trans-avantgarde" painters, Francesco

Jean Michel Basquiat, *Grazing/Soup to Nuts—MGM 1930* (1980), 66 x 120, acrylic & oil on canvas, Mary Boone (New York, NY).

Carl Andre, *Camemorial to After Ages* (1983), 18 x 180 x 360, quincy granite, Paula Cooper (New York, NY).

Clemente and Enzo Cucchi. Clemente, who has recently revived the fresco, presents figures and objects associated by a complex web of world cultural references, visual rhymes and metaphors. Cucchi uses a grand scale and heavy impasto in his turbulent landscapes, figures, and symbolic images.

Troy Brauntuch's figuration makes subtle use of photographic images. Matt Mullican works in a simpler, graphic figuration on narrative panels. Abstract painter Gary Stephan uses thickly painted, solid bars to evoke a cathedral-like space. Ross Bleckner paints tactile black and white abstractions.

Bonnier Gallery 420 W. Broadway, New York, NY
617 10012 (212) 334-8414; Tue-Sat: 10-6; dir: Helen Horwitz

The focus is on contemporary paintings and sculpture. Among the artists represented are Jack Barth, Sandro Chia, Lee Jaffe, Donald Judd, Alain Kirili, Roy Lichtenstein, Malcolm Morley, Robert Ryman, Italo Scanga, Tony Scherman, Joel Shapiro, Martin Silverman, Frank Stella, and Cy Twombly.

A recent group show spanning three decades of art, from 1960 to the present, featured works by Macyn Bolt, Roger Brown, Christo, Enzo Cucchi, Jim Dine, Ron Gorchov, Jaffe, Judd, Lichtenstein, James Rosenquist, Julian Schnabel, and Peter Schuyff.

Grace Borgenicht Gallery, Inc. 724 Fifth Ave., New
618 York, NY 10019 (212) 247-2111; Tue-Fri: 10-5:30 Sat: 11-5:30 Summer: Tue-Fri: 11-5; Owner/dir: Grace Borgenicht Brandt

In 1951, painter Grace Borgenicht Brandt founded the gallery as a showcase for her artist friends. Today the gallery regularly exhibits the work of established contemporary artists whose media and materials are as diverse as their styles.

Recent shows by gallery artists included painted aluminum and painted wood works by Charles Biederman; late works by action painter Paul Burlin; still lifes by Stuart Davis; forged iron sculpture by Martin Chirino; stainless steel works by Roy Gussow; the "rabid dog" works of Elbert Weinberg; paintings and pastels by Wolf Kahn; the mature paintings of John Opper; and metal constructions by Jose de Rivera.

Milton Avery, Max Beckmann, David Lee Brown, Edward Corbett, Hans Hokanson, Angelo Ippolito, Reuben Kadish, David Lund, Gabor Peterdi, and Mark Tansey are also among the gallery's stable of artists.

An annual invitational exhibition features works by younger artists. Among the works seen in a recent show were wooden sculptures by John Monte, landscape drawings and paintings by Michael Zwack, and small-scale, mysterious paintings by Mark Innerst. The gallery also holds a show of German expressionist artists each year.

Harm Bouckaert 100 Hudson, New York, NY 10013
619 (212) 925-6239 Tue-Sat: 11-6, Aug: by appt; owner/dir: Harm Bouckaert

One of TriBeCa's newest and most modern exhibiting facilities, the gallery shows an array of contemporary painting and sculpture, with a recent emphasis on figurative work in a synthetic style.

Among the painters of the gallery, Max Coyer incorporates figurative references into painterly colorist canvases; George Deem interprets the old masters with skill and humor; Voy Fangor, a former Op artist, dwells on mass media images; Philip Tsiaras refers to primitive images of other cultures; while Edgar Franceschi melds painting and sculpture with references to music, poetry and art history. Sculptor Alex McFarlane cuts architectural fantasies in solid graphite, incorporating metals and cast bronze. Gilles Jean Giuntini and Peter Brown both work in wood: the former focuses on the objects of daily life, while the latter uses human, landscape and architectural forms in a primitive style.

Damon Brandt Gallery 45 Bond St., New York, NY
620 10012 (212) 475-2224; Tue-Sat: 11-6 Aug: closed; owner/dir: Damon Brandt

Concentration of the gallery is on contemporary drawings by emerging artists. Its specialization is indicative of an important trend in 20th century art. With a panoply of techniques and materials which embraces prehistoric pictograms and modern precision drafting, drawings are no longer regarded as mere preparatory works, but as a medium of intrinsic interest.

Drawings are regularly exhibited by the following artists: Joel Fisher, Stephen Hale, Caspar Henselmann, Richard Milani, Ed Rainey, Alan Saret, Juliao Sarmento, Serge Spitzer, Carol Steen, Francesc Torres, Ernst Trawoger, William Tucker and Vladimir Zakraewsky.

Brewster Gallery 41 W. 57th St., New York, NY
621 10019 (212) 980-1975; Tue-Sat: 10:30-5:30 Summer: closed Sat; Owner/dir: Jerry Brewster

The gallery's selection consists of international 20th century paintings, drawings, and graphics, with a strong concentration in Latin American art.

Mexican sculptor Francisco Zuniga is well represented. The gallery publishes his lithographs in addition to exhibiting his drawings and bronze sculptures. Zuniga is known for his expressive portrayal of Mexican Indian women. Works by Mexican masters Diego Rivera, Francisco Toledo, and Rufino Tamayo are also exhibited, as are several South American artists. The gallery exclusively represents English-born Surrealist painter Leonora Carrington, who has a long association with Mexico.

The gallery shows the colorful and imaginative works of the Yugoslavian naive painters, among them Branko Bahunek, Ivan Generalic, and Ivan Rabuzin.

A large selection of Miro aquatints is found at the gallery. Other modern masters, such as Chagall, Alexander Calder, Picasso, and Marino Marini, are well represented in both unique and multiple works.

Hal Bromm Gallery 90 W. Broadway, New York,
622 NY 10007 (212) 732-6196, Tue-Sat: 11-6, August: closed; owner: Hal Bromm dir: R. Barnett

A vanguard gallery for new art, this was the first commercial gallery to open in the now chic TriBeCa area of Manhattan. The gallery exhibits painting, sculpture, photography and drawing by American and European artists, with attention focused on emerging young talent.

Exhibitions have included "Climbing: The East Village", the first major group exhibition dealing exclusively with East Village artists; "A Matter of Choice: Selections by Critics, Artists and Collectors", the first in a series of guest-curated exhibitions; and "Agitated Figures: The New Emotionalism", which was curated by Hal Bromm for Hallwalls in Buffalo, New York.

Gallery artists include the internationally famous sculptors Rosemarie Castoro and Jody Pinto. Also exhibited is the work of Polish sculptor Krzysztof Wodiczko, who will do a series of Public Projections in New York, and that of Roger Cutforth, who is known for color landscape photographs of the American Southwest.

New discoveries include David Wojnarowicz, who was recently acquired by the Museum of Modern Art in New York, as well as Luis Frangella, Russell Sharon, and Rick Prol.

Diane Brown Gallery 100 Greene St., New York, NY
623 10012 (212) 219 1060 Tue-Sat: 10-6 Aug: closed; owner/dir: Diane Brown

The gallery concentrates on contemporary art with a strong emphasis on sculpture.

Wade Saunders makes small scale painted, cast bronze sculpture which has a narrative quality. James Casabere photographs his matboard and plaster constructions. David Hatchett's sculpture is composed of industrial materials. Rockne Krebs has done major sculpture commissions nationwide using laser, neon, prisms and natural light. John Van Alstine makes large and small scale sculpture in granite and steel. Joel Fisher makes abstract sculpture. His current work is in bronze. Jim Sanborn works primarily in sandstone. His concerns are with geology and anthropology. Brower Hatcher makes large and small scale sculpture in aluminum and steel, into which he incorporates narrative elements in bronze.

Aldis Browne Fine Arts, Ltd. 16 E. 78th St., New
624 York, NY 10021 (212) 772-6222; Tue-Fri: 10-5:30 Aug: closed; owner: Aldis Browne dir: Saralinda Bernstein

The gallery specializes in fine original prints of the 19th and early 20th century, and related unique works on paper, as well as oil painting of the period.

Artists from Goya to early Picasso, Miro and Chagall fall within the scope of the gallery. Works by Goya, Gericault, Delacroix, Daumier and Ingres may be viewed at the gallery. The largest selection of material comes from the Impressionist, Post-Impressionist, Nabis and Cubist schools—from the hand of Toulouse-Lautrec, Manet, Degas, Cezanne, Pissarro, Cassatt, Whistler, Munch, Redon, Bonnard, Vuillard, Marcoussis, Villon, Braque, Picasso, Miro, Chagall, etc. The gallery also carries the fascinating graphics of M.C. Escher.

Exhibitions are usually organized thematically and include works by many artists; however, recent one-person shows have been "Edward Munch: Paradox of Woman", and "Edgar Chahine: Images of Venice and Belle Epoque".

Frank Caro 41 E. 57th St., New York, NY 10022
625 (212) 753-2166 TueSat: 9-4:30 Summer: Tue-Fri: 9-4:30 Aug: closed; owner/dir: Francis J. Caro

The concentration of the gallery is primarily in art from China, but art from India and Southeast Asia is also available. Most of the works handled are antiquities, but some contemporary Chinese painters' work is displayed.

The range of Chinese antiquities is extensive, including items from Neolithic China, through the Bronze Age, the Han, T'ang, Sung, Ming and Ch'ing dynasties. The inventory contains pottery, porcelain, paintings, furniture and lacquerware, all antique.

Work from India is mostly sculpture.

Modern Chinese painters who have been exhibited in one-person shows are: Shi Pai Shih; Chang Dai-Chien, and Wang Fong-Yu.

Castelli Feigen Corcoran 113 E. 79th St., New York,
626 NY 10021 (212) 628-0700; Mon-Fri: 9-6 Sat: 10-6 Aug: closed; owner: Richard L. Feigen & Co. dir: Frances F. L. Beatty

Located in the townhouse office buiding of Richard L. Feigen & Company, the gallery specializes in 19th and 20th century masters, including impressionist, postimpressionist, and early 20th century master painters. The gallery also handles a variety of works that span the 14th through the 20th centuries.

Among the artists the gallery focuses on are James Rosenquist, Jasper Johns, Joseph Cornell, Ed Ruscha, and Charles Simonds. Approximately two large exhibitions are held each year. Recent shows included a major Cornell exhibition and a Roman landscape painting show. Castelli Feigen Corcoran usually produces catalogues to accompany the shows.

Leo Castelli 420 West Broadway & 142 Green St.,
627 New York, NY 10012 (212) 431-5160; Tue-Sat: 10-6; Owner/dir: Leo Castelli

The gallery premiered in 1957 with an exhibition of well-known European and American painters that included de Kooning, Delaunay, Leger, and Pollock. Over the years Castelli has maintained a reputation for introducing ground-breaking art with early exhibits of such artists as Jasper Johns, Robert Rauschenberg, Cy Twombly, and Frank Stella. Roy Lichtenstein, Andy Warhol, James Rosenquist, Richard Artschwager, Donald Judd, and Robert Morris had their first shows at the gallery in the 1960s. Bruce Nauman, Richard Serra, Keith Sonnier, and Dan Flavin joined the gallery during the early 1970s.

At present, the Castelli Gallery represents 34 artists. In addition to the abovementioned artists, the group includes David Salle, Claes Oldenburg, Ellsworth Kelly, Ed Ruscha, Ken Price, and Sandro Chia.

The Greene Street location accommodates extremely large paintings and sculpture by gallery artists. A third gallery, Castelli Graphics, shows prints and graphics by gallery artists and other printmakers and photographers.

Castelli-Sonnabend Tapes and Films was created to provide video art and artist's films for viewing, rental, or sale. The gallery also maintains an extensive archive department that has slides, photographs, transparencies, and biographical information on gallery artists.

Cayman Gallery 381 W. Broadway, New York, NY
628 10012 (212) 966 6699 Tue-Sat: 11-6 Aug: closed; owner/dir: Nilda Peraza

Cayman Gallery features contemporary artists of Latin American lineage in the U.S. working in painting, sculpture, photography and environmental installation. The gallery has frequent group and individual exhibitions in its main space, as well as individual exhibitions in an additional small gallery.

Group exhibitions scheduled for 1984-1985 include Contemporary Art Works by Mexican Women Artists; works by eight Latin American artists from Washington, D.C.; East to West Coast, a traveling exhibition; and TRENDS #8, an annual exhibition for emerging artists. The gallery will also hang a retrospective of work by Uruguayan painter Julio Alpuy, and one-person shows including a mixed-media installation by Ricardo Viera, an installation/performance of metal sculpture and Caribbean rhythmic symbolism by Jorge Luis Rodriguez; kinetic sculpture by Antonio Perez Melero, a participatory installation by Ismael Frigerios and Alfredo Jaar, constructions by Marta Perez, and machine imagery by Joseph Ramos.

Contemporary master printmakers shown include Omar Rayo, Sergio Gonzalez Tornero, Victor Mira, Hugo Consuegra, Rodolfo Abularach, Myrna Baez and Isabel Vazquez. Other artists include Laura Marquez, Juan Bujan, Luis Stand, Ramon Carulla, Judite Dos Santos, Rafael Colon Morales, Marcos Irizarry and Judithe Hernandez.

C D S Gallery 13 E. 75th St., New York, NY 10021
629 (212) 772-9555 Mon-Sat: 10-6; dir: Clara D. Sujo

C D S Gallery is dedicated to contemporary art of Europe and the Americas.

Paintings by the great Cuban Surrealist Wifredo Lam vibrate in tropical colors rhythmically counterpointed by incisive lines that resolve into tropical birds, beasts and plants. Work by Chilean Surrealist Roberto Matta, and by influential Uruguayan Constructivist Joaquin Torres-Garcia is also available, as well as work by Fernando Botero, Jacobo Borges, Bravo, Figari, Toledo and others.

North American artists include Hedda Sterne, Adja Junkers, Chicago Expressionist Vera Klement and Color Field painter Warren Rohrer. Roxi Marsen, Michael Young and Jane Swavely are young artists who were selected by more established artists as part of a recent series, "Artists Choose Artists"

John Christian Gallery 90 Prince St., New York, NY
630 10012 (212) 431-8601; Tue-Sat: 12-6 Aug: by appt; owner/dir: John Christian

The John Christian Gallery concentrates on works by emerging and mid-career American artists. Works exhibited are in both abstract and representational styles in various media on canvas or paper.

Artists whose work may be viewed include Petey Brown, a figurative painter known for his beach scenes; Freddie Fong, an illusionistic painter in a trompe-l'oeil style; Michael Joyce, a surrealist; Peter Kitchell, who paints abstract landscapes in watercolor; and Donald Wass, who also paints abstract landscapes. Betty Tompkins paints animals in a realist style. Susan Weil's landscapes and figures use color and line in an expressionistic manner. Kathy Gura's collage paintings, James Byrd's color field abstract paintings, Adrianne Wortzel's architectural landscapes and Paul Garland's abstract watercolors are also shown at the gallery.

Christie's Contemporary Art 799 Madison Ave.,
631 New York, NY 10021 (212) 535-4422; Mon-Sat: 10-6; dir: Myles Cooke

Established in 1981 to meet an expanding American print market, Christie's now has more than 25,000 active members who purchase prints from its collection. Each year approximately 160 new editions are published, in eight separate launchings. All editions are accompanied by a certificate of authenticity and a biography of the artist.

Christie's also deals in works by Henry Moore, Miro, David Hockney, Chagall, Graham Sutherland, and other internationally known artists. The gallery features a large collection of Moore graphics and bronzes. Christie's occasionally schedules one-person shows of artists such as Hockney and Moore.

City Gallery Columbus Circle, New York, NY 10019
632 (212) 974-1150; Mon-Fri: 10-5:30; dir: Elyse Reissman

City Gallery opened to the public in 1980. Sponsored and funded by the New York City Department of Cultural Affairs, it is dedicated to art which expresses New York City's variety and vitality, its cultural mix, and the personality which the city's neighborhoods add to the wider community.

Recent exhibitions have included works by emerging young artists, contemporary photographers, sixteen printmakers from the Printmaking Workshop, and a retrospective exhibition of James Van Der Zee's photography.

Civilian Warfare 526 E. 11th St., New York, NY
633 10009 (212) 475-7498; owner/dir: Allan Barrows, Dean Savard

One of several new galleries in the East Village, Civilian Warfare exhibits contemporary painting and sculpture. Works by many of the artists can be found in the surrounding streets on city walls. The artists regularly shown are Jane Bauman, Bronson Eden, John Fekner, Luis Frangella, Judy Glantzman, Greer Lankton, Michael Sypulski, David Wojnarowicz and Steve Doughton.

The Clock Tower 108 Leonard St., New York, NY
634 10012 (212) 233-1096; Thu-Sun: 12-6 Jul-Sep: closed; Admission: by donation; dir: Alana Heiss

The Clock Tower is one of two permanent exhibition and work spaces of the Institute for Art and Urban Resources. The building, which is owned by the City of New York, is used for court rooms and municipal offices on its first twelve floors. On the thirteenth and top floor is one of New York's most unique art spaces. There is a magnificent view, complete with a balcony that affords a 360-degree panorama of the city.

The Clock Tower's exhibitions change about

once a month. Special emphasis is given to emerging artists. Many artists first attracted public attention with shows at the gallery, including Denise Green, Deborah Turbeville, Doug Sanderson, and Win Knowlton. Recent exhibits featured drawings by Michael Hurson and altered photographs by Sarah Charlesworth. A group show in Fall 1984 showed San Francisco artists in a "San Francisco Science Fiction" show.

A poetry and new music series on Thursday evenings has been very well received, and has featured performers such as poet John Ashbery and musician/composer David Behrman.

Concord Gallery 451 Broome St., New York, NY
635 10013 (212) 925 2994 Tue-Sat: 10-6 August: closed; dir: Ragland Watkins

Concord Gallery specializes in paintings and drawings by emerging New York City artists.

The gallery has recently presented abstract paintings and charcoal drawings by David Storey, paintings of archetypal images by John Mendelsohn, and gouaches on paper and paintings of personal allegorical images by Judith Linhares. John Mendelsohn and Judith Linhares are both included in the 1984 Venice Biennial. Nancy Chun, Gary Hall, Gordon Voisey and Al Calderaro are other New York artists that have exhibited their work.

Convergence 484 Broome Street, New York, NY
636 10013 (212) 226 0028 Tue-Sat: 12-6; dir: Dan Thomas & Jorge Cao

A showcase for emerging talent, Convergence presents work in craft media: clay, wood, glass and metal. Emphasis is on young artists who are merging craft and fine art traditions.

Artists presented by the gallery include Joseph Kivlin and Robert Dane, in glass; Wally Mason, Susanne Stephenson and Marvin Bjurlin, in clay; Wendy Maruyama and Bob Trotman, in wood; and Rachelle Thienes and David Tisdale, in metal.

The importance of design as a leading force in contemporary art is evident not only in the work displayed, but also in its presentation in the gallery space.

Paula Cooper Gallery 155 W. Wooster St., New
637 York, NY 10012 (212) 674-0766 Tue-Sat: 10-6 June-July Mon-Fri: 10-6; owner/dir: Paula Cooper

One of the first galleries in Soho, Paula Cooper Gallery has continuously focused on new developments in contemporary art in a broad range of styles and media.

Minimalist Carl Andre makes flat floor pieces, usually of uniform units in a grid. Sculptor Robert Grosvenor works in grand scale, in contrast to Joel Shapiro's small evocations of space, and dynamic figures constructed of rectangular prisms of metal or wood. Lynda Benglis makes airy fiberglass wallpieces. Painter Alan Shields uses grid imagery in his unstretched canvases. Jonathan Borofsky sketches his dreams, now numbered in the millions, and creates large scale installations. Painter Jennifer Bartlett orchestrates monumental systems symbolizing the universe and the process of painting; typically, she works with enamel on steel modules. Elizabeth Murray's paintings use "classical" abstract

elements of line, form and color in biomorphically shaped formats. Michael Hurson's zany paintings and drawings reveal a puppetmaker's eye for people and places.

Cordier & Ekstrom 417 E. 75th St., New York, NY
638 10021 (212) 988-8857 Tue-Sat: 10-5:30 June-Aug: closed Sat; dir: Arne H. Ekstrom

Noted for its provocative theme shows, the gallery handles a number of unconventional artists. Gallery artists are on permanent display in an upper floor, while monthly one-person shows are held downstairs.

Among the artists presented are Romare Bearden, Varujan Boghosian, Margaret Israel and Howard Newman, independent and innovative spirits. Romare Bearden's earthy imagery in his collages and Varujan Boghosian's lyrical constructions of wood and bronze reveal two mature styles. Margaret Israel works in mixed-media combines. Howard Newman sculpts in bronze and shows numerous drawings.

Painter Michael Flanagan shows his finely detailed narrative studies. Herk van Tongeren shows paintings and constructions, loosely after the style of de Chirico. Constructions by Alan Siegel and currency collages by Sandra McIntosh also form part of the gallery's offerings.

Charles Cowles Gallery, Inc. 420 W. Broadway,
639 New York, NY 10012 (212) 925 3500 Tue-Sat: 10-6; owner/dir: Charles Cowles

The gallery shows contemporary art in diverse media, mostly abstract, often interdisciplinary, with some figurative work.

Tom Holland constructs bright, geometric paintings and sculpture. Gerald Incandela's photographs are collages of negatives developed in a painterly style. Sculptors in bronze Manuel Neri and Michael Todd work in a figurative and an abstract, lyrical style, respectively. Michael Lucero creates expressionistic figures in porcelain and Ron Nagle makes trim, abstract forms. Other sculptors include Dale Chihuly in glass, ceramicist Peter Voulkos, and Italo Scanga. Abstract painters are Dennis Ashbaugh, Ronnie Landfield and Laddie John Dill. Peter Alexander shows his underwater fantasies. David Bates paints large scale figures inspired by naive art. Patrick Ireland and Alan Saret have designed installations for the gallery.

Works by major contemporary painters such as Nathan Oliveira, Gene Davis and others are shown, as well as paintings by Italian New Image artist Gino Longobardi.

Andrew Crispo Gallery 41 E. 57th St., New York,
640 NY 10022 (212) 758-9190; Mon: by appt Tues-Fri: 11:30-4:30 Sat: 10:30-5:30; owner/dir: Andrew Crispo

The gallery is located on the second and third floors of the Fuller Building, an outstanding Art Deco building completed in 1929.

In 1973 when the gallery opened, an auspicious thematic exhibition, "Pioneers of American Abstraction", featured works by Oscar Bluemner, Stuart Davis, Charles Demuth, Arthur Dove, John Marin, Georgia O'Keeffe, Charles Sheeler, Joseph Stella and Max Weber. The following year the gallery organized another thematic exhibition, "Ten Americans—Masters of

Watercolor'' with works by Charles Demuth, Arthur Dove, John Marin, Milton Avery, Charles Burchfield, Winslow Homer, Edward Hopper, Maurice Prendergast, John Singer Sargent, and Andrew Wyeth. Another thematic exhibition, ''Twelve Americans, Masters of Collage'', included works by Arthur Dove, Frank Stella, Romare Bearden, Joseph Cornell, Robert Courtright, William Dole, Lee Krasner, Robert Motherwell, Robert Rauschenberg, Ad Reinhardt, Anne Ryan and Tom Wesselman.

The gallery basically deals in 19th and 20th century American art, with special emphasis on members of the Alfred Stieglitz group. Works by distinguished European artists are also featured.

One-person exhibitions are often held by regular gallery artists. Bronzes by Douglas Abdell, collages by Robert Courtright, illusionistic images by Ellery Kurtz, and works by visionary realist Lowell Nesbitt are shown, as well as works by Frank Keller, Hubert Long, Cynthia Polsky and Elizabeth Thompson, and other well-known artists.

Andrew Crispo Graphics Ltd. 41 E. 57th St., New
641 York, NY 10022 (212) 758-9190; Tue-Sat: 10:30-4:30; owner/dir: Andrew Crispo

The graphics department of the Andrew Crispo Gallery carries work by gallery artists in a separate location at the same address. artists featured are Lowell Nesbitt, Robert Courtright and Jon Carsman.

Crown Point Press 545 Broadway, New York, NY
642 10012 (212) 226-5476; Tue-Fri: 10-4 Sat: by appt; dir: Karen McCready

See listing for Oakland, California.

Maxwell Davidson 43 E. 78th St., New York, NY
643 10021 (212) 734-6702; Tue-Sat: 10-6 Aug: closed; owner/dir: Maxwell Davidson III

The gallery specializes in master works of the 19th and 20th centuries, with emphasis on American and French art. Only paintings, drawings and sculpture are shown. In addition to master works, the gallery is committed to exhibiting works by young painters of exceptional promise with little or no gallery experience.

The concentration is on 20th century American masters such as Sam Francis and George Rickey, who have had one-person shows. Works by such acclaimed artists as William Baziotes, Louise Nevelson, Alfred Jensen and Alexander Calder are also available.

The gallery has a particular interest in drawings and watercolors by the French Impressionists and other 19th century masters. Included in the current holdings are works by Fernand Leger, Edouard Vuillard, Pissarro and Degas.

Exhibiting contemporary artists are diverse in style. The gallery features the landscapes and still lifes of Carol Anthony, realist works by Scott Prior and Deborah Deichler, and the gestural abstractions of Gary Komarin.

Davis & Langdale Company, Inc. 746 Madison
644 Ave., New York, NY 10021 (212) 861-2811; Oct-May: Tue-Sat: 10-5 Jun-Sep: Mon-Fri: 10-5; dir: Leroy Davis

Formerly Davis & Long, the gallery exhibits a large collection of British and American oil paintings, watercolors, drawings, and pastels spanning three centuries.

Specializing in British art of the 19th and 20th centuries, the gallery has works by such renowned painters as Thomas Gainsborough, John Martin, Edward Lear, and Gwen John. The gallery also features works by American painters Maurice Prendergast, James MacNeil Whistler, and Albert Bierstadt.

A growing stable of contemporary American artists is regularly exhibited at the gallery. Gallery artists Lennart Anderson and Aaron Shikler are primarily realists, with Shikler specializing in portraits; Robert Kulicke is a jewelry maker and painter; Addie Herder creates collage constructions; and Albert York paints landscape paintings and still lifes. Conceptual artist Michael Langenstein works in three dimensions, and recently displayed his ''Proposals'' at the gallery. The first American exhibit of works by figurative English artist Lucian Freud was held at the gallery.

Tibor de Nagy Gallery 29 W. 57th St., New York,
645 NY 10019 (212) 421-3780 Tue-Sat: 10-5:30; dir: John Post Lee

After starting a marionette company, the owner was encouraged by some first generation Abstract Expressionists, like Jackson Pollock and Bill de Kooning, to open a gallery. In 1950 he opened the Tibor de Nagy Gallery with John Bernard Myers, a grand enthusiast of the avantgarde. Grace Hartigan, Helen Frankenthaler, Larry Rivers, Fairfield Porter, Al Leslie and Robert Goodnough were then given one-person shows at the gallery.

The gallery currently features Frank Bowling, Ken Bowman, Rosemarie Castoro, Richard Chiriani, Garth Evans, Ray Ciarrochi, Chuck Forsman, Maurice Golubov, Harold Gregor, Andrew Hudson, Richards Jarden, Richard Kalina, Stephanie Kirschen-Cole, Jonathan Lasker, Ida Lorentzen, Chuck Magistro, Rafael Mahdavi, Forrest Moses, Yvonne Muller, George Nick, Patricia Patterson, Archie Rand, Tony Robbin, Leatrice Rose, Joe Shannon, Nancy Wisseman-Widrig and works from the estates of William Schwedler and Horatio Torres. The gallery also carries works by Walter Darby Bannard, Stanley Boxer, David Budd, Thom Cooney-Crawford, Robert Goodnough, Tom Holland, Darryl Hughto, Stephen Mueller, Kenneth Noland, Fairfield Porter, Larry Rivers and Sam Scott.

Sid Deutsch Gallery 20 W. 57th St., New York, NY
646 10019 (212) 765-4722 Tue-Sat: 10-5:30 Jul-Aug: Tue-Fri: 1-5; dir: Robert Randlett

The gallery regularly exhibits paintings and drawings by artists of the Eight, the Stieglitz Group, the Precisionists, the American Abstract Artists, and WPA artists.

Exhibitions of contemporary painting and sculpture for the 1984 season included: collage paintings by Benny Andrews, box constructions by Abe Ajay, paintings by Ken Aptekar and Stephen Schultz, a three gallery exhibition of paintings, prints and constructions by Jan Sawka, and a two person exhibition with painter Stanley Lewis and sculptor Tim Kelly.

The gallery also exhibits selections from its extensive collection of Southwest Indian pottery.

David Hockney, *Terrace—Pool & Living Room* (1984), 36 x 60, oil on canvas, Andre Emmerich (New York, NY).

Troy Brauntuch, untitled (1984), 96 x 108, charcoal/cotton, Mary Boone (New York, NY).

Martin Diamond Fine Arts 1014 Madison Ave.,
647 New York, NY 10021 (212) 988-3600; Tue-Sat: 11-5 June 15-Sept 15: closed owner/dir: Martin Diamond

The gallery specializes in American modernists of the abstract movement, 1910-1950.

Among the artists whose work is available are Emil Bisttram, Arthur N. Christie, Eleanor De Laittre, Werner Drewes, Elsie Driggs, Herzl Emanuel, Ed Garman, James Guy, Hananiah Harari, Blanche Lazzell, William Lumpkins, Louis Schanker, John Sennhauser, John Von Wicht, Vaclav Vytlacil, Fred J. Whiteman, Beatrice Wood and Janet Young.

One-person shows in 1983 included works by Byron Browne, James Guy and Lawren Harris.

Jim Diaz Gallery 242 W. 16th St., New York, NY
648 10011 (212) 620-9093; Tue-Fri: 5-10 Sat-Sun: 3-10; owner/dir: Jim Diaz

The Jim Diaz Gallery is dedicated to the concept that the diverse arts are one: that theater, dance, music and painting may be unified in their essential purpose and structure though their apparent forms differ greatly.

The artists at the gallery are all involved with performance art in one way or another. The general format of presentation is determined in collaboration with the gallery director, and consists in creating a unique and total environment for their art. The reason behind the installations and performances is important; it can provide a sense of atmosphere linking all aspects of a work.

Some of the young artists performing are Pepie Krakower, a surrealist painter; Jack Carter, a constructionist; Charles Stuart; and Gayle Tufts, a performance artist. The gallery has shown the work of "Avant", a New York group, in a black light performance, as well as a collection of vases by J. Kathleen White. It has also mounted several plays, including "Frankenstein, the Broadway Version."

Terry Dintenfass Gallery 50 W. 57th St., New York,
649 NY 10019 (212) 581-2268 Tue-Sat: 10-5:30 Jun-Jul: Mon-Fri: 10-5:30; dir: Bobbie Goldberg

Exhibiting both established and emerging artists, the gallery emphasizes contemporary American art with a concentration in figurative works.

The estates of Arthur Dove and Samuel Adler are handled. Paintings by Jacob Lawrence, sepia chalk drawings by Herbert Katzman, and satirical pen and ink drawings by Edward Koren can also be seen. Sidney Goodman's paintings show figures against a surrealistic landscape. Robert Gwathmey's paintings usually depict Southern scenes involving social commentary. Donald Sandstrum makes aluminum abstractions of rural American towns.

The gallery also features Peter Blume, Tony Dove, Antonio Frasconi, Elias Friedensohn, Suzi Gablik, John Himmelfarb, Frances Hynes and William King. Other artists shown are Ronald Markham, Richard Merkin, Robert Andrew Parker, Paul Suttman, Carl Nicholas Titolo, Harold Tovish and Nancy Grossman.

Dorsky Galleries 58 W. 57th St., New York, NY
650 10019 (212) 838-3423; Mon-Sat: 10-5; owner/dir: Samuel Dorsky

Specialization is in 20th century contemporary works both by recognized masters and by emerging artists.

The gallery has available works by distinguished artists such as: Henry Moore, sculpture, lithographs and drawings; Pablo Picasso, ceramics; Marc Chagall, lithographs and etchings; Joan Miro, lithographs; Fernand Leger, sculpture and lithographs; David Smith, sculpture; and Rufino Tamayo, paintings and lithographs.

Works by younger artists include paintings and drawings by Gerald Scheck; drawings by Hank Virgonia; paintings by Chaim Tabak; sculpture, drawings and lithographs by Richard Hunt; egg tempera paintings by Riko Mikeska and sculpture by Dorothy Dehner.

Germans Van Eck Gallery 420 W. Broadway, New
651 York, NY 10012 (212) 219 0717 Tue-Sat: 10-6 Jul and Aug: closed; owner/dir: Wouter F. Germans Van Eck

The gallery mostly shows emerging young artists who work in a variety of media ranging from assemblage to painting on canvas.

Among the contemporary American artists presented are Agnes Denes, David Stoltz and Donald Lipski. The gallery also handles selected works by such recognized masters as box builder Joseph Cornell, pop artists Roy Lichtenstein and James Rosenquist, abstractionist Cy Twombly, figurative painter Jorge Salazar, German Neo-Expressionist A. R. Penck, and new figurative painters Robert Longo and Julian Schnabel.

Other contemporary artists include Mark Demuro and -RAYBERRY (C), who work in mixed media and on canvas, painter Paula Collery, Carl Affarian, Nina Yankowitz, Michele Oka Doner, and Nigel Van Wieck, all young and primarily American artists.

Gallery 84 30 W. 57th St., New York, NY 10019
652 (212) 581-6000 Tue-Sat: 11-5 Jul-Aug: closed; dir: Harriet Hirshfield

The second oldest cooperative in New York, Gallery 84 was founded in 1962. Artists members of Gallery 84 are veterans of private galleries and juried shows. The gallery exhibits contemporary oil painting and watercolor (both abstract and representational), stone, metal and bronze sculpture, and color and black and white photography.

G.W. Einstein Co., Inc. 243 E. 82nd St., New York,
653 NY 10028 (212) 628-8782; Tue-Sat: 10-5:30 mid-Aug-Sept: closed; owner: Gilbert W. Einstein dir: R. Blumanfield

The gallery features work by contemporary American artists and also deals in 19th and 20th century American masters and vintage photographs.

The artists shown include Thomas Cornell, Lawrence Fadan, Daniel Morper, Mel Pekarsky, Linda Plotkin, Lucy Sallick, Sylvia Sleigh, Jeanette Pasin Sloan, Mary Joan Waid and Melanie Wygonik. Their work is in various media, such as oil, pastel, pencil, hand-sewn books and collage.

Works by the following well-known contemporary artists are available: Jasper Johns, Roy

Elga Heinzen, *U.S.A. No. II* (1983), 90 x 28, acrylic on canvas, Kornblee (New York, NY)

Edward C. Leavitt, *Chinese Plums,* 38 x 11, oil on canvas, David Findlay Jr. Fine Art (New York, NY).

Lichtenstein, Robert Rauschenberg, Richard Diebenkorn, Frank Stella and Philip Pearlstein. Vintage photographs by Eugene Atget, Bernice Abbott, Laszlo Moholy-Nagy, Man Ray and Carleton Watkins are also available.

Robert Elkon Gallery 1063 Madison Ave., New
654 York, NY 10021 (212) 535-3940; Tue-Sat: 10-5:45 mid-July-Aug: closed; owner: Dorothea Elkon dir: Alfred Richter

The gallery specializes in works by modern masters and contemporary artists. It exhibits paintings, sculptures and works on paper by a wide range of American and European artists.

Major 20th century artists exhibited include such masters as Jean Dubuffet, Matisse, Alberto Giacometti, Wassily Kandinsky, Rene Magritte, and Yves Tanguy. Artists of the New York School such as Jackson Pollock, Robert Motherwell, Mark Rothko and Clyfford Still are also featured, along with color field painters Morris Louis, Friedel Dzubas and Jack Bush. Other eminent artists include Sam Francis, Agnes Martin, and Roberto Matta.

Works by contemporary artists seen at the gallery include paintings by Jean-Pierre Pericaud, David Roth and John Wesley; drawings by Koenigstein; and sculptures and two-dimensional works by Charles Arnoldi, Tony Delap, Nigel Hall and William Tucker.

Most of the work carried is abstract, although the gallery does not adhere to any particular style.

Andre Emmerich Gallery Inc. 41 E. 57th St., New
655 York, NY 10022 (212) 752-0124; Tue-Sat: 10-5:30 Summer: Mon-Fri: 10-5 dir: Nathan Kolodner

The Andre Emmerich Gallery was founded in 1954 and specializes in two fields: modern and contemporary painting and sculpture, and Classical antiquities and Pre-Columbian art. Authoritative books on Pre-Columbian art written by Andre Emmerich have become part of the scholarly literature in this field.

A leading gallery in post-World War II Abstract Expressionism and American Color Field painting, the firm handles internationally renowned painters including Helen Frankenthaler, Kenneth Noland, Jules Olitski, Lawrence Poons, Sam Francis, David Hockney, Al Held and the estates of Morris Louis, Hans Hofmann, Jack Bush, Burgoyne Diller, John Graham, John McLaughlin and Ben Nicholson. The gallery emphasizes abstract sculpture, and exhibits works by noted sculptors such as Anthony Caro, Alexander Liberman, Beverly Pepper and Michael Steiner.

Also featured are important abstract painters Stanley Boxer, William Conlon and Robert Goodnough, as well as contemporary abstract sculptors Arthur Gibbons, Joel Perlman and Anne Truitt. The gallery also carries the work of Piero Dorazio, a leading Italian color abstractionist, and of Ernesto Tatafiore, an Italian Neo-Realist painter.

In 1973 the gallery opened a branch in Zurich, Switzerland. It continues to espouse a mutually enriching juxtaposition of early art of the past with the best art of our time.

Amos Eno Gallery 164 Mercer St., New York, NY
656 10012 (212) 226-5342 Tue-Sat: 12-6 Sun: call for hours Aug: closed; dir: Virginia Maksymowicz

Amos Eno is an artist-run, cooperative gallery, which consequently exhibits contemporary art. The work ranges from conceptual art to figurative painting and sculpture, and includes non-objective painting and sculpture, photographic and performance art.

Artists currently exhibiting in the cooperative include Joanne Segal Brandford, Miriam Brofsky, Connie Dodge, Phyllis Dukes, Michael David Eastman, Diane Fitzgerald, Suellen Glashausser, James Green, Emily Hixon, Madeleine Kaufmann, Lori Lawrence, Peter Leyh, Jane McClintock, Molly Moskowitz, Jose Presman, Gary Rauchbach, Joyce Sills and Walter Swales.

Ericson Gallery 23 E. 74th St., New York, NY
657 10021 (212) 737-6155; Tue-Sat: 11-6; dir: Takis Efstathiou

The gallery exhibits works by young, emerging New York artists and well-established artists. Works shown are contemporary, non-objective paintings, collages, constructions, and sculpture in various media.

One-person shows change once a month, and occasionally there is a group show of gallery artists.

Edith Newhall is a new artist, whose simple abstract forms refer to landscape. Abstract Expressionist Theodoros Stamos paints floating colors, so that his work has an ethereal feeling similar to stain paintings. Robert Quijada makes architectonic constructions of canvas, wood, string and acrylics that deal with color. Abstracted masks by Clayton Mitropoulos interpret personality in a constructivist style. Hans Hinreiter, of the Swiss Concrete Art movement, works in color theory and design. Other artists whose work is exhibited are Christopher White, Stan Gregory and Nanette Carter.

Rosa Esman Gallery 121 Spring St., New York, NY
658 10012 (212) 219-3044; Tue-Sat: 10-6 Aug: closed; owner/dir: Rosa Esman

The Rosa Esman Gallery mostly exhibits contemporary art. Among the artists exhibited are Scottish figurative expressionist John Bellany, who currently is living in London; Patricia Johnson, a sculptor who makes large-scale landscape pieces; contemporary American abstract painter Tom Nozkowski; and Dan Hazlitt, who exhibits his paintings and constructions. The gallery also represents the estate of Jan Mueller, a figurative expressionist associated with the second generation of Abstract Expressionists, whose gestural figures and landscapes depict a complex personal mythology born of social concern.

Young, emerging artists exhibited include Abraham David Christian, Jean Feinberg, Ed Kerns, Lizbeth Mitty and Joan Witek.

Eleanor Ettinger, Inc. 155 Avenue of the Americas,
659 New York, NY 10013 (212) 807-7607; Mon-Fri: 9-5:30 Aug: closed; owner/dir: Eleanor Ettinger

Eleanor Ettinger, Inc., are publishers of limited edition lithographs with a concentration on representational and realist imagery. Facilities include

a sales and marketing division, a complete lithography studio, and a gallery.

Artists published include Norman Rockwell, Alice Neel, Adolf Sehring, Bruce Bomberger, Gerrit Greve and many others. The most recent publications have been three images by Italian Neo-Classicist Angelo Vadala, and works by Gail Bruce, Terri Priest and Audean Johnson, all of whom are making their debut in hand-drawn lithography.

Ronald Feldman Fine Arts Inc. 31 Mercer St., New
660 York, NY 10013 (212) 226-3232; Tue-Sat: 10-6 Jul: Tue-Fri: 10-5:30 Aug: by appt; owner/dir: Frayda Feldman, Ronald Feldman

Much of the work at the gallery is experimental and represents a broad range of media. It is not unusual to find performances as well as video pieces or films, in addition to works in traditional media such as paintings, drawings, graphics, sculpture and photography.

Several of the artists have helped shape current ideas about art. Considered a leader of the Arte Povera movement and an originator of performance art, German artist Joseph Beuys has made sculptures of refuse and discarded materials. Inventor Buckminster Fuller's mosaic style of relating humanistic ideas to engineering and scientific concepts has been a powerful stimulus for artists. Japanese conceptualist Arakawa uses texts, silhouettes of objects and geometric concepts to create open canvases where the viewer assumes an active, detective-like role. Pop artist Les Levine was one of the first artists to use video in sculptural installations.

Other contemporary artists featured include Vincenzo Agnetti, Eleanor Antin, Ida Applebroog, Conrad Atkinson, Chris Burden, Douglas Davis, Jud Fine, Terry Fox, Helen Mayer Harrison and Newton Harrison, Margaret Harrison, Komar and Melamid, Piotr Kowalski, Edwin Schlossberg, Todd Siler, SITE, and Hannah Wilke.

The gallery publishes and distributes prints and videotapes. Print editions by Andy Warhol published by the gallery include "Ten Portraits of Jews of the Twentieth Century", "Myths" and "Endangered Species." The gallery has recently collaborated with WilliWear Productions in a collection of artist's T-shirts.

David Findlay, Jr., Fine Art 41 E. 57th St., New
661 York, NY 10022 (212) 486-7660; Mon-Sat: 10-5 Aug: closed; owner: David Findlay, Jr. dir: Penny Schmidt

Concentration of the gallery is on 19th and 20th century American art, including contemporary realism.

Artists of the 19th and early 20th century whose work is available include members of the Hudson River, Luminist, Ashcan, and other related schools, such as A.T. Bricher, Jasper Cropsey, Childe Hassam, Franks Benson, Henry Farny, George Inness, C.M. Russell, Edward Redfield, Severin Roesen, Edward Rook, Olaf Seltzer and Thomas Moran.

Among the contemporary artists working in realist styles are Brooks Anderson, Emily Brown, Adele Alsop, John Meyer, Katherine Doyle, John Chumley, Michael Filmus, Charles

Moser, Richard Pitts, Philip Mullen, Marguerite Walsh, John Wilde and Robert Rasely.

Peter Findlay Gallery 1001 Madison Ave., New
662 York, NY 10021 (212) 772-8660; Mon-Sat: 10-5; owner/dir: Peter Findlay

The gallery specializes in European, mostly French, paintings, drawings and sculpture from the Impressionists to the early 20th century.

Among the artists whose work is shown is 19th century French landscape painter Eugene Boudin, whose studies of skies were greatly praised by his notable contemporary, poet and critic Charles Baudelaire. Impressionists in the gallery include Claude Monet, Camille Pissarro and Alfred Sisley, who are linked by a similar freedom in their loosely flowing brushwork and concentration on landscape. Also available are paintings by Maurice Utrillo, famed for his views of Paris, and by Maurice de Vlaminck, a Fauve who maintained an Expressionist style in his later landscapes and still lifes. Works by the great French painter Georges Rouault may also be seen.

There are also works by French Cubists, including painter Albert Gleizes and sculptor Henri Laurens, whose polychrome constructions marked a significant step in the dissolving of the stylistic barriers separating two- and three-dimensional art. One may also view works by Picasso and by Ferdinand Leger, the first artist to make the relation of man and machine the subject of his art, and by Jean Dubuffet, who has emphasized the value of naive and outsider art as a source of new vision.

Wally Findlay Galleries 17 E. 57th St., New York,
663 NY 10022 (212) 421-5390; Mon-Sat: 10-6; dir: James R. Borynack

Though the gallery still bears the name of its founder, it is now separate from the Findlay chain. The gallery continues to show work by contemporary American and European artists and works by French Impressionists and Post-Impressionists.

The most notable paintings shown are rare Impressionist works by Claude Monet, Auguste Renoir, Maurice de Vlaminck and Maurice Utrillo, among others. Many second generation Impressionists are featured, such as Lebourg, Valtat, Manguin, Maufra, Montezin, Loiseau, etc. Contemporary European artists include Francois d'Izarny, Ferrer Guasch, and Martin Bessega.

Recently the gallery has been developing a collection of paintings by living American artists, such as portraitist Zita Davisson, Loren Dunlap, impressionist Sam Barber, Jack Nagler, Steve Fredericks, realist Clede Enders, naive Alice Geddes-Woodward, Mimi Rockefeller, and realist Brad Shoemaker. Also shown are works by George Elmer Browne, an impressionist who painted during the early 20th century.

'International" exhibitions have included works by two notable artists of the P.R. of China, Chen Dan Qing and Yuan Yun Sheng, and naive works by Jinshan commune artists. Tapestries by Senegalese artists and British primitives have also been featured.

First Street Gallery 386 W. Broadway, New York,
664 NY 10012 (212) 226-9011 Tue-Sat: 12-6 Aug: closed; dir: Camille Eskell

This is a cooperative gallery showing only contemporary artists working in representational styles in all media.

Among the artists exhibiting are cityscape painter Marcia Clark, painter and printmaker Deborah Clearman, pastel artist Bill Creevy, large scale figure painter Domenic Cretara, still life and portrait painter Mary Napolitano, painter and printmaker Marianne Perry, still life and landscape painter Ellen Piccolo, landscape painter Henry Raleigh, pastel still life artist Jane Schoenfeld, watercolor landscape artist Marge Traverman, and sculptor Gilbert Kevlin, who makes small figures. Anna Goth Werner paints interiors in oil and tempera. Camille Eskell, Penny Kronengold and Lisa Zwerling use dream and psychological imagery. Printmaker Alan Petrulis creates Symbolist landscapes. Other artists include Fred Badala-menti, Salley Benton, Peter Carella, Ronnie Carson, Peter Charlap, Wendy Gittler, Gary Godbee, Rallou Malliarkis, Leonard Petrillo, Edward Pramuk, Pearl Rosen, Eric Sparre, Margot Rubin and David Smith.

Fischbach Gallery 24 W. 57th St., New York, NY
665 10019 (212) 759-2345; Tue-Sat: 10-5:30; dir: A. Aladar Marberger

The gallery concentrates on paintings, mostly by contemporary American painterly realists working in landscape and still life.

Jane Freilicher and Nell Blaine are perhaps the best known artists shown by the gallery. Freilicher's style is loosely realistic, while Blaine is even more impressionistic. Both paint landscape, with occasional forays into still life. Maurice Grosser paints subdued impressionistic landscapes and classical still lifes. Jane Wilson paints still lifes, as does Leigh Behnke, who also paints architectural works. Susan Shatter's landscapes have recently been shown at the gallery. Anne Arnold makes sculptural animals from canvas stretched over wood armatures. Realist works by Elizabeth Osborne, cityscapes by John Button, acrylics by Ian Hornak, and egg tempera paintings by Philip Tarlow are also featured by the gallery. Other artists shown include Herman Rose, Willard Dixon, Nancy Magin, Lois Dodd and John Gundelfinger.

Forty-Ninth Parallel 420 W. Broadway, New York,
666 NY 10012 (212) 925-8349; Tue-Sat: 10-6 Aug: closed; dir: France Morin

49th Parallel is a project of the Bureau of International Cultural Relations of the Department of External Affairs of Canada, and is operated as an extension of the Canadian Consulate General in New York.

The 49th Parallel specializes in works by Canadian contemporary artists.

Forum Gallery 1018 Madison Ave., New York, NY
667 10021 (212) 772-7666 Tue-Sat: 10-5:30; dir: Bella Fishko

Specializing in American art with an emphasis on figurative works of the late 19th and 20th centuries, the gallery carries an extensive inventory of works by prominent artists and sculptors.

Artists shown include sculptors Chaim Gross and Bruno Lucchesi, and landscape painter Herman Maril. David Levine is noted for exquisite watercolors and whimsical facial studies. Paintings by realists Edward Hopper and Raphael Soyer are exhibited. Works from the estates of Max Weber and Hugo Robus are also available, as well as works by George Bellows, Arthur B. Davies, Stuart Davis, Philip Evergood, George Grosz, Charles Hawthorne, John Marin, Reginald Marsh, Elie Nadelman, Jules Pascin, Ben Shahn and James Abbott McNeil Whistler.

Laura Ziegler shows her portraits in terra cotta. Other artists include Carroll Cloar, Alan Feltus, Jules Kirschenbaum, William McElcheran, Elliot Offner, Carole Robb, Cornelis Ruhtenberg, Honore Sharrer, Marina Stern and Jack Zajac.

Xavier Fourcade, Inc. 36 E. 75th St., New York, NY
668 10021 (212) 535-3980; Mon: by appt Tue-Sat: 10-5 Jul-Aug: closed: Sat; owner/dir: Xavier Fourcade

The gallery deals mainly in painting, sculpture, drawings and prints by American and European contemporary artists, but also handles major old masters and 19th and 20th century masters.

Living artists featured by the gallery include Tony Berlant, John Chamberlain, William Crozier, Willem de Kooning, Raoul Hague, Michael Heizer, Joan Mitchell, Malcolm Morley, Catherine Murphy and Dorothea Rockburne. The gallery also shows work from the estates of Arshile Gorky, whose surreal abstract painting was a powerful influence on the Abstract Expressionists; Barnett Newman, whose paintings, pared down to basics of line, form and color, laid the groundwork for Post-painterly Abstraction and Minimalism in the generation following the Abstract Expressionists; and H.C. Westermann, former circus acrobat, master carpenter and champion of Dada in the Post-Modern era.

Also available are works by Georg Baselitz, Jan Henle, Marcel Duchamp, Raymond Duchamp-Villon, Henry Moore, Tony Smith and Bram van Velde.

14 Sculptors Gallery 164 Mercer St., New York, NY
669 10012 (212) 966-5790, Tue-Sun: 11-6; dir: Harold Olejarz

Now in its tenth year, 14 Sculptors is one of the few cooperative galleries in the world dedicated exclusively to sculpture. The co-ops' members are scattered throughout greater New York City and neighboring states, and exhibit widely across the United States.

A healthy diversity of techniques and materials is present in members' work, from multi-media assemblage, painted wood, industrial materials such as steel and cement, to traditional "noble" materials such as marble or carved wood. While most members work in abstract styles, with a certain predominance of assemblage and structural styles over formal, "carved" sculpture, a few are concerned with the human figure.

Current members include James Angelus, David J. Brooks, Allan Cyprys, Joan Fine, Joyce Goldstein, Elise Gray, Esther A. Grillo, Caroline Hallas, Diane Kaiser, Akiko Mashima, James A. Mills, Harold Olejarz, Tim Pollock, Siena Porta, Susan Reinhart, Lila Ryan, Shaw Stuart, Jill Viney and Walter Weissman.

Reeve Schley, *Palais Bourbon* (1983), 18 x 24, watercolor, Graham Modern (New York, NY).

Michele Oka Doner, *Mutation* (1980), 24 length, bronze, Germans Van Eck Gallery (New York, NY).

Seymour Fogel, *War Machine* (1979), 37 x 42, wood construction, Graham Modern (New York, NY).

Franklin Furnace Archive, Inc. 112 Franklin St.,
670 New York, NY 10013 (212) 925-4671, Tue-Sat:
12-6; dir. Martha Wilson

The gallery was founded as an alternative space
specializing in artists' books and publishing. A
permanent collection of 10,000 titles includes
historical and contemporary examples of artists'
use of the printed page. None of the books are
for sale; they are available for perusal by ap-
pointment only.

Principally an archive, this loft space also
contains offices, a gallery and a stage. There is a
high level of activity, with performances at least
twice a week and frequent shows by emerging
artists. Performances and installations have in-
cluded works by Belgian artist Guillaume Bijl,
Cuban artist Ana Mendiata, and by P. D. Bur-
well, a London percussionist. Exhibitions have
featured books of the Russian avant-garde from
1910 to 1930, contemporary artists' books from
the Eastern-bloc countries, Cubist illustrated
books, and an ongoing collaboration among mi-
nority artists, ''Carnival Nocturne', which in-
volves work in photography, performance and
music. A show of Japanese artists' books is
planned.

Sherry French Gallery 41 W. 57th St., New York,
671 NY 10019 (212) 308-6440; Mon-Sat: 10-6;
owner: Sherry French dir: Donna Tennant

The main interest of the gallery is in representa-
tional painting of poetic intent. The gallery also
deals in abstract sculpture by several young art-
ists.

Robert Birmelin's cityscapes of New York
are already well known. Peter Poskas is known
for his rural Connecticut landscapes. Robert Jor-
dan, also a landscape painter, lives in St. Louis.
Daniel Lang paints both still life and interiors in
Europe and the U.S. William L. Haney paints
various aspects of contemporary culture. The
gallery also shows abstract prints and works on
paper by Ida Kohlmeyer, Philip Mullen and
Alice Phillips.

Other contemporary artists include watercolo-
rists Matthew Daub and Jerald Silva; painters
Dean Hartung, Ronni Bogaev, Les Reker and
Fran Beallor; sculptors Jim Martin, Nancy
Arlen, F.L. Schroder, Clayton Mitropoulos and
Kathleen Armstrong.

Barry Friedman, Ltd. 26 E. 82nd St., New York, NY
672 10028 (212) 794-8950; Tue-Sat: 10-6 Summer:
closed Sat; owner/dir: Barry Friedman

The gallery carries 19th century European Sym-
bolist painting and 20th century European Real-
ism, as well as furniture and objects by 20th
century designers.

Symbolists include French painter Gustave
Moreau, teacher of Henri Matisse, Odilon Re-
don, Georges Rouault and Albert Marquet; Bel-
gian Fernand Khnopff; and English Pre-Raphae-
lites Dante Gabriel Rossetti and David Burne-
Jones. 20th century artists include Tamara de
Lempicka, German realist Christian Schad and
New Objectivity social critic, painter Otto Dix.

Some of the designers whose work is handled
by the gallery include Marcel Breuer, Hoffmann,
Moser, Frank Lloyd Wright and Charles Eames.
Recent exhibitions organized by the gallery in-
cluded ''Tamara de Lempicka: Male Portraits of

the 1920s'' and ''Fernand Khnopff and the Bel-
gian Avant-Garde''.

Allan Frumkin Gallery 50 W. 57th St., New York,
673 NY 10019 (212) 757-6655; Tue-Fri: 10-6 Sat:
12-5:30 mid-Aug-Sep: closed; owner/dir: Allan
Frumkin

The gallery shows a varied group of contempo-
rary American artists ranging from the very real-
istic to the wildly imaginative. Realists include
Philip Pearlstein, whose compositions with nude
figures have forged a new image in a classical
discipline, and Jack Beal, whose paintings tend
to vivid colors and baroque composition. Wil-
liam Beckman is known for his closely scrutin-
ized figure paintings and his broad, sweeping
landscapes in pastels. James Valerio paints large-
scale figurative and still life subjects.

The gallery also presents a strong group of
West Coast artists whose work tends toward the
imaginative. Robert Arneson's ceramic sculp-
tures and William Wiley's recent polychrome
steel sculpture will tour museums in the next two
years. Also well-known are San Francisco Bay
area artists Joan Brown, Roy De Forest and Ro-
bert Hudson.

The gallery hangs about ten shows a year,
including thematic exhibitions of gallery and
guest artists.

Fun Gallery 254 E. 10th St., New York, NY 10009
674 (212) 473-4606 Tue-Sun: 12-6; owner/dir: Patti
Astor, Bill Stelling

'Ultra-Contemporary'' urban art, post-nuclear
painting and sculpture, is featured at Fun
Gallery, which along with several other New
York galleries has brought new legitimacy to that
most ancient form of street art, *graffiti*. After
years of legendary exploits, which saw their
handiwork blossom like some mysterious fungal
invasion over the hide of subway cars and up
inaccessible walls, many graffiti artists have re-
tired to the comparative safety of studios to paint
on canvas, most often with their tried and trusty
medium, spray paint.

Futura, called the ''Kandinsky of spray
paint'', Zephyr, Eno, Dondi White and Fred
Brathwaite are some of the artists whose work
has come in from the streets to grace galleries
and salons. Other artists who exhibit at the
gallery include Kiely Jenkins, a Neo-Pop sculp-
tor; Kenny Scharf, from whose painterly can-
vases emerge nuclear cartoon images; and Arch
Connelly and Dan Friedman, sculptors whose
environmental installations blur the distinction
between ''good'' and ''bad'' taste.

Hilde Gerst Gallery 685 Madison Ave., New York,
675 NY 10021 (212) 751-5655 Mon-Sat: 11-5;
owner/dir: Hilde W. Gerst

The gallery has specialized in paintings by
French Impressionists and Post-Impressionists.
Works by Maurice Utrillo, Raoul Dufy, Marie
Laurencin, Henri Manguin and others are dis-
played along with paintings by Marc Chagall and
younger masters such as Roberto Matta, Andre
Lanskoy and Serge Poliakoff. Numerous emerg-
ing French and Spanish artists have been pre-
sented in the gallery.

A large space in the gallery has been devoted

Rayberry, *Life's American Popgun* (1984), 10 x 14, mixed media, Germans Van Eck Gallery (New York, NY).

John Raimondi, *Lupus* (1984), 22 feet high, steel, Graham Modern (New York, NY).

Robert DeNiro, *Moroccan Woman* (1983), 70 x 60, oil on canvas, Graham Modern (New York, NY).

to graphics by the world's leading artists: Chagall, Picasso, Braque, Miro and others. Modern sculpture, tapestries, and antique Oriental paintings and weaving complement the painting displayed in the gallery.

Getler/Pall/Saper 50 W. 57th St., New York, NY
676 10019 (212) 581-2724; Tue-Sat: 10-5:30 July-Aug: closed Sat; dir: Carol Saper, Helen Getler

The gallery carries both major contemporary artists and young, emerging artists.

Works by the latter are both figurative and abstract. Charlotte Brown uses a 3M color computer printer to transfer images to various materials. Richard Carboni works in acrylic and mixed media on wood, canvas and paper. David Shapiro and Steven Sorman, and figurative artists T.L. Solien , Lance Kiland, Stephanie Rose and Squeak Carnwath work on canvas and paper.

Prints are exhibited by Jim Dine, David Hockney, Jasper Johns, Roy Lichtenstein, Robert Rauschenberg, Frank Stella and others. Prints by many of the younger, emerging artists are also exhibited.

Gimpel & Weitzenhoffer 1040 Madison Ave., New
677 York, NY 10021 (212) 628-1897 Tue-Sat: 10-6 Sat: 10-5:30; dir: Joseph Rickards

The gallery specializes in contemporary abstract painting and sculpture. Both European and American artists are represented. There is also a small graphics department. The gallery is associated with Gimpel Fils in London and with Gimpel-Hanover in Zurich.

Among the artists shown are Paul Jenkins, Alan Davie, Robert Natkin and Pierre Soulages, who have developed distinguished non-objective styles. Works of figurative artists such as William Scott, Clarence Carter and Joachim Berthold are also exhibited. Niki de St. Phalle's frolicsome polyester figures may also be seen.

Sculpture exhibited at the gallery is diverse. The geometrical cast bronzes of English sculptor Robert Adams contrast with the small, light tinplate pieces by Robert Cronin. Minoru Niizuma is the only sculptor shown who uses marble in his work.

Barbara Gladstone Gallery 152 Wooster St., New
678 York, NY 10012 (212) 505-8690; Tue-Sat: 10-6; dir: Richard Flood

The Barbara Gladstone Gallery exhibits contemporary works in all media, and also publishes limited print editions. Most of the artists featured are young or mid-career, and work in a range of styles from Conceptual to Modern Graffiti, Pattern and New Figuration.

Perhaps the most established of the artists shown is sculptor Paul Thek, whose horrorific constructions of machined glass and metal enclosing realistic wax models of bloody meat present an oblique form of social comment. Conceptualist Jenny Holzer's bronze plaques with found texts, often installed and documented in unlikely sites, and Chicago expressionist Hollis Sigler's interiorized landscapes of cultural debris similarly question accrued social values. Miriam Shapiro's Pattern and Decoration paintings and drawings, apart from their intrinsic beauty, represent the validation of materials and designs through the recovery of women's history.

Other artists exhibited include graffiti artist Lee Quinones, sculptor Anish Kapoor—known for his soft sculptures of fruit, seed and plant forms, Terry Allen, Kathleen Thomas, Bill Woodrow, Daisy Youngblood, Lothar Baumgarten, Ellen Brooks, Vernon Fisher, Bill Komoski, Joyce Kozloff, Gerry Morehead, John Obuck, Alan Vega and Robert Youngblood.

Glass Gallery 315 Central Park West, New York, NY
679 10025; Wed-Sat: 1-6 July-Aug: by appt; Prop/dir: Wendy D. Glass

20th century works on paper and graphics in the representational mode are offered by this gallery, which carries a collection of Japanese Ukiyo-e prints as well as American and European graphics.

Among the American artists shown are Max Weber, a contemporary of John Marin and Charles Sheeler and a close friend of Parisian naive painter Henri Rousseau; as well as Benny Andrews, Edward Hopper, Louise A. Freedman and Ann Freilich. Restrikes of graphics by Renoir, Degas and Manet are also available. Among the Japanese woodblock prints are works of the Edo period (1603-1868) by masters Kunisada, Toyokuni and Eisen; and of the following Meiji period by masters Kunichika, Toshikoba and Yoshitoshi.

Contemporary artists working in figurative styles include Suzanne Kneger, Maran Gerrice Cohen, Edna Buff, Fran Foy, Claude Marks, Helen Burr and Alexander Clubar.

Goffman Fine Art 18 E. 77th St., New York, NY
680 10021 (212) 744- 5190; by appt; owner/dir: Judy & Alan Goffman

The gallery carries late 19th and 20th century American paintings, especially works by important illustrators.

Artists featured by the gallery include N.C. Wyeth, father of Andrew Wyeth; Howard Pyle, whose histories of pirates were illustrated in a lively realist style; and Maxfield Parrish, whose commercial illustrations and murals have been considered the height of *kitsch*, but whose ingenious use of photographic images curiously foreshadows contemporary Super-Realism. Other illustrators are Norman Rockwell and J.C. Leyendecker.

The gallery also shows 20th century American Moderns, particularly those associated with the Pennsylvania Academy of the Fine Arts, such as Arthur B. Carles, Hugh Breckenridge, Henry McCarter, Carl Newman and others.

Judith Goldberg Gallery 1045 Madison Ave., New
681 York, NY 10021 (212) 288-1276; Tue-Sat: 11-6; owner/dir: Judith Goldberg

The gallery mostly exhibits 20th century American and European prints, with emphasis on American prints from the 60s and 70s.

European artists exhibited include Picasso and Miro, both of whom were master etchers whose painting styles were notably adaptable to graphic art; Marcel Duchamp; and Henri Matisse, whose use of flat expanses of color in his painting had particularly felicitous results when translated into the serigraphic medium. American artists include Pop artist Roy Lichtenstein, whose use of halftone dots is the most noticeable

aspect of his classically composed prints and paintings; Abstract Expressionist Helen Frankenthaler, whose stained canvases have been delicately echoed in her aquatint etchings; Jasper Johns, who has made extensive experiments in lithography; and Hard Edge painter Ellsworth Kelly.

Lucien Goldschmidt Inc. 1117 Madison Ave., New
682 York, NY 10028 (212) 879-0070; Mon-Fri: 10-6 Sat: 10-5; dir: Lucien C. Goldschmidt

The gallery presents graphic art from Albrecht Durer to Picasso, Henri Matisse and Jacques Villon. It emphasizes not only famous artists such as Rembrandt, Goya or Henri Toulouse-Lautrec, but also many printmakers of French, German and Dutch schools. Illustrated catalogs are issued at regular intervals.

Exhibitions of both drawings and prints are held. Recently on view were designs by the Navone brothers executed for a Roman theater in 1791, and *Pasiphae,* ninety linoleum cuts by Matisse, which were not printed until 1981 and were first displayed at the gallery.

The owner has a special interest in prints by Piranesi, French and Italian Mannerists, and Jacques Villon, as well as in ornament prints and architectural drawings. Piranesi's brooding etchings of prisons were hailed by the Surrealists. The work of Villon also employs architectural spaces, but in the spirit of Cezanne and the Cubists. The gallery also specializes in modern illustrated books.

James Goodman Gallery, Inc. 1020 Madison Ave.,
683 New York, NY 10021 (212) 772-2288 Mon-Sat: 10-5 Summer: closed Sat; dir: James Neil Goodman

The gallery handles painting, sculpture, watercolor and drawings by 20th century masters and contemporary artists.

The collection of works on paper is of special interest. This includes small works by Roy Lichtenstein and original drawings by Saul Steinberg. Pencil drawings by Amadeo Modigliani and gouaches by Alexander Calder are exhibited, in addition to works by Adolph Gottlieb, Sam Francis, Pablo Picasso, Hans Hofmann, Jean Dubuffet, Matisse, Henry Moore, and Fernando Botero.

Paintings are available by Roy Lichtenstein, Mark Rothko, Matisse, Willem de Kooning, Fernand Leger, Andy Warhol, Tom Wesselmann, Jim Dine and Claes Oldenburg. The gallery also shows watercolors and washes by Miro.

The collection of sculpture includes small object pieces by Joseph Cornell, bronzes by Albert Giacometti and mobiles by Alexander Calder, as well as pieces by Barbara Hepworth, Marino Marini and Auguste Rodin.

Gracie Mansion 167 Avenue A, New York, NY
684 10009 (212) 477-7331; Wed-Sun: 1-6; owner/ dir: Gracie Mansion

The gallery is in its third year at a new location, a much bigger storefront that allows more exhibition space. The gallery terms its specialization "Post-Contemporary." There is one show a month, with an annual fall group show of gallery artists.

Stephen Lack's canvases use sensational newspaper articles and were presented in a show called "The Crime of Your Life." Marilyn Minter and Christof Kohlhofer paint canvases together, with Minter painting the background and Kohlhofer painting over it. Ronda Zwillinger's "objects of desire" are furniture pieces and kitschy American subjects that use sequins, broken glass, and mixed media.

Other works by gallery artists include surreal metal sculpture by Jonathan Ellis, decorative painting on furniture by Rodney Greenblat, neo-primitive painting by Gay Augeri, brightly colored sculpture installations by Ted Rosenthal, totem-like sculptures by Craig Coleman, collages by Buster Cleveland, and portraits by E. F. Higgins.

Graham Gallery 1014 Madison Ave., New York, NY
685 10021 (212) 535-5767; Oct-May: Tue-Sat: 10-5 Jun-Sep: Mon-Fri: 10-5; owner/dir: Robert Graham

One of New York's oldest galleries, the Graham Gallery exhibits American art from the 19th century to the present. The 1983-84 season included a retrospective of works by Guy Pene du Bois, a distinguished painter and acute satirist most active in the 1930s. Where many social realists of his epoch tended to adopt Impressionist or Regionalist styles, Pene du Bois maintained a crisp realism, classically simple yet wryly observant of detail.

Other artists exhibited by the gallery include John White Alexander, Thomas Anshutz, Henry Glintenkamp, John R. Grabach, John Held, Hermann Dudley Murphy and Helen Torr.

Graham Modern Gallery 1014 Madison Ave., New
686 York, NY 10021 (212) 535-5767; Tue-Sat: 10-5 Summer: Mon-Fri: 10-5; dir: Berta Walker

Graham Gallery, founded in 1857, recently opened a new department, Graham Modern, to concentrate on contemporary American artists.

The gallery specializes in painters Seymour Fogel, Richard Anuzkiewicz, Susan Crile, and Irving Kriesberg, and sculptor John Raimondi, among others. Recent major one-person exhibitions included shows of New York figurative expressionists Carmen Cicero and Robert De-Niro, abstract painters Richard Anuszkiewicz and Susan Crile, and realist painters Paul Resika and Reeve Schley.

Grand Central Art Galleries 24 W. 57th St., New
687 York, NY 10019 (212) 867-3344 Mon-Fri: 10-6; dir: James Cox

Founded in 1922 by John Singer Sargent and Edmund Greacen, the gallery shows paintings and sculpture that range from turn-of-the-century works to the contemporary.

Most of the two-dimensional works tend to be representational in the traditional modes of landscape, figure and still life. Among the contemporary artists displayed are Priscilla Roberts, Charles Pfahl, Thomas A. Daly, David A. Leffel, Milt Kobayashi and Bruce North.

Another facet of the gallery is the display of works by American masters, including Impressionists Edmund Greacen and John Singer Sargent, and their contemporaries. The gallery also features sculpture by American artists working in a realist style, and some Western art.

Greene Space 105 Greene St., New York, NY 10012
688 (212) 925 3775 Wed-Sun: 12-6; dir: Tony Goldman

This multi-media gallery and performance space features local Soho artists who work in painting, sculpture, dye transfer and photography.

One-person shows have included suspended bluestone sculpture by Pamela McCormick and standing sculpture by Daniel Johnson in a memorial to Ralph Bunch, as well as dye transfers of the sculpture. Also exhibited were abstract representations of the merging of painting and architecture by painter and architect Francoise Schein, paintings and posters by Clayton Cambell, and photographic explorations of water surfaces by Adger Cowan.

Several times a year there are thematic exhibits. A show of contemporary Latin American artists coincided with the Soho Latin American cultural festival. The space, which is a community gathering place, is used by several Soho organizations for meetings and events.

Performance artists Eiko and Koma Dancers, Eric Bojasion and Arlene Schloss have been featured. There is also an avant-garde concert series for which musicians such as jazz masters Henry Threadgill, Charles Hayden and Don Cherry have played.

Daniel B. Grossman, Inc. 1100 Madison Ave., New
689 York, NY 10028 (212) 861-9285; Mon-Sat: 10-6; owner/dir: Daniel B. Grossman

The exhibition rooms of the gallery usually display paintings that fall into its two primary areas of specialization, which are 19th century European and American academic paintings, and European and American Impressionism and Post-Impressionism.

The gallery's academic offerings typically include museum-quality paintings by the French Barbizon artists Charles Francois Daubigny, Jean-Baptiste-Camille Corot, and Paul Desire Trouillebert; the Orientalist artists who painted Arabian subjects, such as Adolf Schreyer and Theodore Frere; and the American still life masters Severin Roesen and William Michael Harnett, among others.

Impressionist and Post-Impressionist paintings of a light palette and loose, painterly brushstroke are displayed together in the rear of the exhibition room. The gallery's inventory includes fine works by French Impressionists Camille Pissarro and Gustave Caillebotte; German Impressionist Max Liebermannn; American Impressionists Mary Cassatt, Childe Hassam and Frederick Carl Frieseke; and French Post-Impressionists Henri Lebasque, Maximilien Luce, Armand Guillaumin and Henri Martin.

As well as featuring fine paintings of the 19th and early 20th centuries, Daniel B. Grossman actively seeks and purchases these works from private collections around the world.

Nohra Haime Gallery 1000 Madison Ave., New
690 York, NY 10021 (212) 772-7760; Tue-Fri: 10-6 Sat: 11-6; owner/dir: Nohra Haime

The gallery features contemporary North American, European and South American artists.

Among the artists shown is Alexander Archipenko, a Russian-born sculptor who joined the Cubist movement in Paris, where he applied their collage techniques to mixed-media sculptural constructions. Painters Julio Larraz, Paton Miller and Gary Haven-Smith are also shown.

Experimental artists from Europe and Latin America include Pierre Dunoyer, Ramiro Llona, Jorge Tacla and Volker Seding. The gallery also shows works by Fernando Botero, Claudio Bravo, Guccione, Rufino Tamayo and Matta.

Hammer Galleries 33W. 57th St., New York, NY
691 10019 (212) 644-4400 Mon-Fri: 9:30-5:30 Sat: 10-5 Jun-Aug: closed Sat; dir: Richard Lynch

Established in 1928, the gallery specializes in 19th and 20th century European and American paintings and graphics. There is an extensive Impressionist and Post-Impressionist collection, and a selection of art of the American West.

The French collection contains works by Auguste Renoir, Eugene Boudin, Berthe Morisot, Henri Fantin-Latour, Maurice de Vlaminck and Maurice Utrillo. The American collection features the works of Eastman Johnson, Jasper Cropsey, John Singer Sargent, Martin Johnson Heade, Maurice Prendergast, William Glackens and William Horton. As well as showing works from the estate of Grandma Moses, the gallery presents contemporary American artists Eric Sloane, Leroy Nieman, Bob Timberlake, Peter Ellenshaw and David Armstrong. The graphics department includes works by Leroy Nieman, Andrew Wyeth, Miro, Chagall and Picasso. The Hammer Publishing Company associated with the gallery publishes limited edition graphics, including works of Eyvind Earle and G.H. Rothe.

Susan Harder Gallery 37 W. 57th St., New York,
692 NY 10019 (212) 308-0043; Tue-Sat: 11-6 Jul and Aug: closed; owner/dir: Susan Harder

The gallery offers a broad range of material by fine image makers working with light sensitive surfaces: traditional silver gelatin photographs, color and Cibachrome prints, platinum/palladium prints, collage, and hand-colored photographic work. Artists shown at the gallery are actively committed to the photographic medium. All prints are processed to archival standards and bear the signature of the artist. Most of the prints are made in limited editions or are unique.

The imagery by the artists handled by the gallery is diverse. It ranges from Andre Kertesz's very early naive pictures of Pre-World War I European family life, to Sylvia Plachy's spontaneous photographs made ''on assignment'' for the *Village Voice,* Robert Mahon's calculated collages of small prints, Jo Alison Feiler's painfully intimate studies of human emotions, and Grace Knowlton's sophisticated platinum and palladium prints of architectural interior details. It includes William Clift's classic and monumental landscapes and new work in portrait and still life, Mikael Levin's delicate landscapes in Europe, Arthur Tress's classic work in surrealistic situations and new divergent work in abstract geometric models, and rounds out its sweep of styles and epochs with Kertesz's new color pictures of Paris 1984.

The gallery provides extensive services for museums and collectors, backed by Susan Harder's long experience in curating photo-

Howard Buchwald, *Zone,* 23 diameter, oil on linen, Nancy Hoffman Gallery (New York, NY).

Isaac Witkin, *Firebird* (1983), 55 high, bronze, Hirschl & Adler Modern (New York, NY).

graphic work. Since 1978 she has specialized in the work of the artists she has chosen to represent, most notably Mr. Kertesz, whose work she "curates" for exhibitions and portfolios.

O. K. Harris Works of Art 383 W. Broadway, New York, NY 10012 (212) 431 3600 Tue-Sat: 10-6 Aug: closed; owner: Ivan Karp dir: Carlo Lamagna
693

An eclectic, spacious gallery, O. K. Harris exhibits painting, sculpture, conceptual work and photography. At one time identified with precise realist styles, the gallery still exhibits scenes by Californian Robert Bechtle, still lifes by Ralph Goings, and the disturbingly real sculpted nude figures of John DeAndrea and middle-American people of Duane Hanson. However, these styles represent only part of the gallery's regular artists.

The size of the gallery makes room for large-scale art, such as a concrete structure studded with home appliances by Nancy Rubins or a wall relief by Sharon Quasius. Deborah Butterfield's horses, often executed *in situ* with available materials, are more modest in scale, yet can fill the gallery with an arresting presence. Peter Saari's plaster on canvas reliefs recall fragments of ancient wall paintings. The gallery also exhibits small scale works, such as the hyperrealist miniatures of Daniel Chard. A wide range of styles may be seen in paintings by Davis Cone, John Baeder, John Kacere, Ian Hsia and Keung Szeto.

Photography on view includes Eric Staller's multiple exposure images of light, Denny Moers's black and white photographs manipulated during development to produce pastel colors, and Al Souza's boxes combining collage and photography. Other photographers on view are Joel Levinson and Doug Coder. Conceptual artist Don Celender annually displays his surveys and correspondence.

Jane Hartsook Gallery/Greenwich House Pottery 16 Jones St., New York, NY 10014 (212) 242-4106; Tue-Sat: 1-5; owner: Greenwich House dir: Susan B. Wood
694

This gallery offers exhibits of ceramic work, both sculptural and functional, by recognized and emerging ceramic artists. Occasionally the gallery sponsors exhibitions of historical interest in the field of ceramics.

Greenwich House Pottery has offered its exhibition space to such ceramic artists as Rudi Autio, Warren Mackenzie, Wayne Higby and Tony Hepburn. Artists who have participated in its Exhibition-Lecture-Workshop series include Peter Voulkos, Ron Nagle, Margaret Israel, Betty Woodman, Mary Frank and others.

Patricia Heesy Gallery 50 W. 57th St., New York, NY 10019 (212) 245-1420; owner/dir: Patricia Heesy
695

Concentration is on contemporary prints, both abstract and representational. The gallery also exhibits some painting and sculpture. Most artists exhibited have been active in the time since the last World War.

Among the artists are: Jim Dine, Sam Francis, Richard Diebenkorn, Helen Frankenthaler, Eric Fischl, David Hockney, Jasper Johns, Alex Katz, Michael Heizer, Ellsworth Kelly, Roy Lichtenstein, Robert Motherwell, Claes Oldenberg, Robert Rauschenberg, Edward Ruscha, Keith Haring, Frank Stella, Andy Warhol and others.

Also exhibited are realist panoramic landscapes and interiors of the West Coast by Larry Cohen, lyrical abstract prints by James Groff and wood relief prints by Charles Arnoldi.

Lillian Heidenberg Gallery 50 W. 57th St., New York, NY 10019 (212) 586-3808; Tue-Fri: 10-5:30 Sat: 11-5:30 Jun-Sep: Mon-Fri: 10-5:30 mid-Aug-Labor Day: closed; owner: Lillian Heidenberg dir: L. Heidenberg, Susan Borson
696

The gallery carries work in all media by late 19th and 20th century masters, as well as work by younger, less well-known artists.

The earliest works handled are by Impressionists and Post-Impressionists such as Camille Pissarro, Henri Toulouse-Lautrec, Edouard Vuillard, Pierre Bonnard, and Paul Signac. The gallery also shows works by contemporary masters Henry Moore, Joan Miro and sculptor Jean Arp, and other notable artists such as Fernando Botero, whose paintings ironically depict elephantine personages and objects, and Robert Natkin, a color field artist whose recent work appears imbued with the spirit of Paul Klee.

Younger contemporary artists and their work include Jeff Low, biomorphic forms in bronzes and monotypes; Gary Kahn, geometric sculpture; Yrjo Edelmann, trompe-l'oeil paintings and graphics; Lore Russ, Japanese kimono paintings; Michael Dillon, abstract paintings; J.L. Dulaar, Cubist constructions; and Elizabeth Blackladder, watercolors of still lifes and oriental objects.

Heller Gallery 965 Madison Ave., New York, NY 10021 (212) 988-7116; 71 Greene St., New York, NY 10012 (212) 966-5948; Tue-Sat: 11-6 Sun: 12-5 Aug: closed; dir: Doug Heller
697

Heller Gallery is dedicated to displaying contemporary glass sculpture by American and European artists.

The vast possibilities of the material used range from the massive layered sculpture of Harvey Littleton to the neon-charged forms of Paul Seide. Other artists, such as Tom Patti, Joel Philip Myers, Michael Glancy, Swedish artist Ann Warff, Steven Dee Edwards and Michael Pavlik, use glass-blowing techniques to produce forms which may subsequently be etched, sandblasted, cut, etc. Mark Peiser casts geometric forms which house suspended volumes of colored glass; Steven Weinberg and Swedish artist Bertil Vallien also use casting techniques. Sydney Cash presents flowing forms in stage-like glass constructions. Dana Zamecnikova from Czechoslovakia makes multi-layered paintings on glass. Margie Jervis, Susan Krasnican, Jay Musler, and Ulrica Hydman-Vallien also apply paint or enamel to their bowls and sculptures.

Other artists include William Carlson, multi-sectioned geometric sculpture; Jon Kuhn, chemically treated vessels and wall reliefs; David R. Huchthausen, laminated constructions; and Henry Halem, who makes abstract and graphic designs on vitriolite wall panels.

Gallery Henoch 80 Wooster St., New York, NY 10012 (212) 966-0303 Tue-Sat: 10:30-6 Sun:
698

Christopher Wilmarth, *Wyoming* (1972), 60 x 58 x 70, glass & steel, Hirschl & Adler Modern (New York, NY).

Raymon Elozua, *#11A Coal Unloader—detail* (1979), 25 x 48 x 23, painted ceramic, O. K. Harris (New York, NY).

Graham Nickson, *Lifeguard Chair with Bathers III* (1982), 70 x 140, charcoal on paper, Hirschl & Adler Modern (New York, NY).

1-6 Aug: closed; owner/dir: George Henoch Shechtman

Gallery Henoch specializes in contemporary American realism. Among the works displayed are architectural paintings by Robert Bidner, landscapes and still lifes by Joseph Riboli, city scenes by Max Ferguson, Southwestern landscapes by Ann Taylor, and figurative painting by Sharon Sprung. Ernesto Chorao paints interior still lifes. Anthony Southcombe and Lynn Curlee depend less on direct observation to paint "imaginary realism," and historic and mythological portraits,respectively. Other artists include landscape painters John Evans and Robert Neffson, suburban landscape painter Mel Leipzig, Photorealist Cesare Santander, and contemporary trompe-l'oeil painter Dana Loomis.

Henry Street Settlement/ Arts for Living Center 466
699 Grand St., New York, NY 10002 (212) 598-0400; Mon-Sat: 12-6 Aug: closed; dir: Susan Fleminger

The gallery shows mainly work by emerging, minority and women artists, presented in group or thematic exhibitions. Individual artists are not represented by the gallery, but there is an artist-in-residence program for six to eight artists who work in a communal studio space. A recent group included painters Juan Sanchez, Leslie Lowinger, and Susan Sauerbrun; printmaker Marina Gutierrez; and mixed-media artists William Jung and Willie Birch.

Recent exhibits have been: "Celebration", a selection of eight Afro-American artists by the well-known artist Romare Bearden; "Contemporary Photographs of the Lower East Side", 150 pictures by 18 emerging or established artists done in the last 10 years; "Funnybooks", humor in artists' books; and "Women Make Prints", selected work by 15 printmakers.

Hirschl & Adler Galleries 21 E. 70th St., New York,
700 NY 10021 (212) 535-8810 Tue-Fri: 9:30-5:30 Sat: 9:30-5 Jun-Sep: Mon-Fri: 9:30-5 Aug: by appt; dir: Stuart Feld

Located in a landmark building, the gallery houses an encyclopedic collection of American art from the mid-18th century to the second World War, as well as a significant stock of 20th century European paintings. The gallery's contemporary works are now exhibited at a separate location (see Hirschl & Adler Modern).

The collection of American art includes portraits by John Singleton Copley, still life paintings by William Harnett and figurative scenes by Eastman Johnson. Also featured are landscapes by Hudson River school painters, such as Albert Bierstadt and Jasper Cropsey. Luminist landscapes by Martin Johnson Heade and Fitz Hugh Lane may be seen, as well as cityscapes by the Eight, including Robert Henri, John Sloan, George Luks, Everett Shinn and William Glackens. Watercolors by Winslow Homer are also available. Works by great French and American Impressionists enhance the gallery's holdings.

Hirschl & Adler Modern 851 Madison Ave., New
701 York, NY 10021 (212) 744-6700; Tue-Fri: 9:30-5:30 Sat: 9-5 Aug: by appt; dir: Donald McKinney

Hirschl & Adler Modern carries works by important 20th century artists, including the work of William Baziotes, Franz Kline, Georgia O'Keeffe, Arthur Dove, Jackson Pollock, Mark Rothko and Cy Twombly, as well as the work of gallery artists.

Allied with the first generation of Abstract Expressionists in his focus on painting as an act of autobiographical improvisation, William Baziotes nevertheless tended to use biomorphic, surreal forms rather than gestural paint-handling. Mark Rothko's floating, diffuse rectangles of color were a point of departure for color field painting, while Franz Kline developed a concise gestural attack using unconventional techniques, such as painting with a broom, etc. Cy Twombly's contemporary gestural painting makes the canvas a complex place of encounter for cultural detritus, urban graffiti of all epochs and art historical references — including glosses on Abstract Expressionism, mythological and literary references.

Gallery artists include Elmer Bischoff, Rackstraw Downes, Charles Garabedian, Lloyd Goldsmith, Leon Kossoff, John Lees, Nancy Mitchnick, John Moore, Graham Nickson, Barbara Schwartz, Joan Snyder, Sarah Supplee, James Weeks, Christopher Wilmarth, Isaac Witkin and Paul Wonner.

The gallery also presents works from the estates of Edwin Dickinson, George L.K. Morris, and Fairfield Porter.

Nancy Hoffman Gallery 429 West Broadway, New
702 York, NY 10012 (212) 966-6676; Tue-Sat: 10-6. Summer, Mon-Fri: 10-5. owner/dir: Nancy Hoffman

The white-walled spaces of this street-level gallery contain large-scale paintings, three-dimensional objects, and drawings. The work shown tends to be representational and realist.

The artists shown range from Natalie Bieser, who first exhibited in the gallery's two-person inaugural show in 1972, to the noted abstract artist Jack Tworkov. The gallery's stable includes renowned Californians Joseph Raffael, Peter Plagens, and John Okulick. David Parrish, from Alabama, is a futurist-realist; Joe Nicastri, a Floridian, is a realist who paints portraits in fresco; and Carolyn Brady, from Maryland, is a watercolorist.

Other artists are realist painter Don Eddy, abstract painter Howard Buchwald, expressionist painters Jim Sullivan and Rafael Ferrer, trompe-l'oeil artist Paul Sarkisian, and realists Juan Gonzalez and Don Nice. Frank Owen and Philip Wofford are both energetic abstract painters; Bill Richards does finely detailed drawings of swamps and grasses; and sculptor Fumio Yoshimura recreates real-life objects in wood.

Horn Gallery, Inc. 503 6th Ave., New York, NY
703 10011 (212) 741-1450; Mon-Sat: 1-7:30; owner/dir: Lawrence A. Jeydel

The Horn Gallery specializes in contemporary prints by important living European and American printmakers. The gallery also carries watercolors and prints by young emerging artists. While the emphasis is on figurative works, abstract works are also carried in the inventory.

American printmakers whose works are available include Larry Rivers, a gestural realist

whose occasionally banal subject matter was an early point of departure for Pop Art; Alex Katz, known for his larger than lifesize portraits; Leonard Baskin, whose wood engravings of the human figure explore themes of death and spiritual decay; and landscape painter Robert Kipniss. European printmakers include Johnny Friedlander, Brigitte Coudrain, Jean-Michel Folon, Rene Carvan, Henry Moore, Marino Marini and Yozo Hamaguchi. The gallery also has works by Latin American artists such as Rufino Tamayo, Jose Luis Cuevas and Jorge Morales Zeno.

The gallery encourages presentation of young artists. Currently exhibiting their work through the Horn Gallery are Val Dubasky, Alexis Gorrodine, Al Doyle, J.M. Zeno, and many others.

Hudson Guild Art Gallery 441 W. 26th St., New
704 York, NY 10011 (212) 760-9814; Mon-Fri: 2-7 May-Aug: closed; owner: Hudson Guild dir: Haim Mendelson

Founded in 1948, Hudson Guild Art Gallery has brought art to the Chelsea community and provided an exhibition showcase for Chelsea artists. Many artists who have since risen to prominence in the art world got their start at the gallery. Originally limited to Chelsea artists, the Hudson Guild now concentrates on American art, with par-ticular attention to works by New York artists.

Ashcan School painter John Sloan, already a noted artist at the time, had his first one-person show at Hudson Guild soon after the gallery opened. Other early exhibitors were Federico Castellon, Theodore Fried, Philip Reisman and Houghton Cranford Smith. Harry Gottlieb and Harry Shoulberg pioneered the use of silk screen printing as a fine art medium in exhibits at the gallery.

Hudson Guild continues to exhibit the work of young artists of promise as well as seasoned professionals. A recent exhibition, "Aspects of Portrait Art," surveyed contemporary approaches to portraiture. In "Works on Paper" March Avery, Mary Carter, Arthur Cohen and Lynn Shaler showed robust, significant works. Haim Mendelson's composite intaglio printing was first shown in "Experimental Works".

Leonard Hutton Galleries 33 E. 74th St., New York,
705 NY 10021 (212) 249-9700; Mon-Fri: 11-5:30 Aug: by appt; dir: Ingrid Hutton

German Expressionist and Russian avant-garde works of art are the focus of exhibitions at the Hutton gallery. Paintings, watercolors, drawings, and lithographs of the artists of these periods are always on view.

German Expressionist artists whose works are shown include "The Blue Four'—Paul Klee, Lyonel Feininger, Alexej Jawlensky, and Wassily Kandinsky—as well as August Macke, Franz Marc, Gabriele Munter, Emil Nolde, Max Pechstein, and Georg Tappert. Among the Russian avant-garde artists are Vladimir Baranoff-Rossine, Ilya G. Chashnik, Alexandra Exter, Natalia Gontcharova, Mikhail Larionov, Lazar (El) Lissitzky, Kazimir Malevich, Ivan Puni, Alexandre Rodchenko, Olga Rozanova, and Nadeshda Udaltsova. The gallery holds occasional shows of costume and theater designs by artists such as Sonia Delaunay.

During major exhibitions the gallery is open Saturday, 11-5:30.

Ingber Gallery 460 W. Broadway, New York, NY
706 10012 (212) 674-0101 Tue-Sat: 10:30-5:30; owner/dir: Barbara Ingber

The gallery shows artists whose range of styles includes realism, abstraction and abstract realism.

Among the gallery artists Rosemarie Beck, Gretna Cambell and Louis Finkelstein paint representational landscapes, while Kermit Adler paints watercolor still lifes of food and flowers, reproducing their texture, weight and volume. In Rosemary Cove's sculptures, the female body becomes her source for exploring mass, volume and texture. Nicolas Marsicano is an abstract painter who deals mainly with the female figure. Other abstract painters are Joe Stefanelli, Perle Fine, Dina Gustin Baker, Fay Lansner and Ce Roser. Among the sculptors are Sidney Geist, Calvin Albert and Stanley Kearl. New to the gallery are representational painter Richard Hall and abstract painter Bill Barrel.

Edith Schloss works in oil, watercolor and silkscreen. Anne Tabachnick's compositions waver between abstract and representational. Also exhibited are Elise Asher's poetic paintings and Judith Godwin's gestural abstractions in the tradition of Franz Kline and Clyfford Still.

Other artists shown at Ingber include Natalie Edgar, Joanne Hartman, Bonnie Woit and Betty Klavun.

Iolas-Jackson Gallery 52 E. 57th St., New York, NY
707 10022 (212) 755-6778 Tue-Fri: 10-5:30 Sat: 11-5 Aug: closed; owner/dir: Brooks Jackson

Previously specialized in Surrealist painters such as Rene Magritte, Roberto Matta, Man Ray, Max Ernst and Victor Brauner, and contemporary European artists such as Niki de St. Phalle, Jean Tinguely, Yves Klein and Fernand Leger, the gallery now shows emerging New York artists as well.

Among the young artists, Harrison Burns shows drawings and paintings that look like still frames of video noise. Paul Thek's conceptual installations, small paintings and bronze sculpture, and Greek sculptor Takis's magnetically suspended disks and sound pieces reveal two forceful directions in contemporary art. Marina Karella's paintings involve drapery, to which her polystyrene resin sculpture adds the human form. Michael Vivo does graphite and color renderings of fabrics. Ed McGowin's "Inscapes" are public art proposals that use sculpture with interior narrative tableaux. Italian artist Mattiacci creates conceptual installations with interactive sound.

Jack Gallery 138 Prince St., New York, NY 10012
708 (212) 226-1989 Mon-Fri: 10-6 Sat: 11-6 Sun: 12-6; owner/dir: Jacquie Littlejohn

This is an experimental gallery, not restricted to any one style, which primarily handles contemporary abstract, realist, figurative and surrealist artists.

The gallery carries gouaches by Art Nouveau designer Erte; and drawings, as well as ceramics and jewelry by Surrealist poet, dramatist, and film-maker Jean Cocteau.

Contemporary realist Douglas Hofmann paints in a style reminiscent of Vermeer. Robert Anderson's realist paintings portray figures against a patterned background, where the plastic form of the figure contrasts with the flatness of the pictorial space, and acts as a compositional element to play against the design of foreground and background. Other artists shown include Bijan Bahar, Garth Benton, Eduardo Oliveira Cezar, Ralph Coxx, Elba Damast, Michael Knigin, Jochen Labriola, Norman Laliberte, Arnaldo Miccoli, Peter Mackie, Edward Pieters, Clayton Pond, Joseph Stabilito, and Robert Zeidman.

Bernard Jacobson, Ltd. 50 W. 57th St., New York, NY 10019 (212) 582-4695; Tue-Sat: 10-5:30; owner: Bernard Jacobson dir: E. Bissell

709

Bernard Jacobson, Ltd., are publishers and distributors of fine art prints, both editions and unique works. Most artists published are English, but some American artists are included as well. Some original works are available.

Works by English contemporary artists include prints and drawings of animals, figures and sculpture by Henry Moore; watercolors, paintings and prints by William Tillyer; prints and maquettes of sculpture by William Tucker; new editions and paper clip and folded paper series by Richard Smith; new editions by Leon Kossoff; and new editions of England, California and Paris by Michael Heindorff. One may also view works by Howard Hodgkin, Victor Willing, Ivor Abrahams, Frank Auerbach, Peter Blake, Stephen Buckley, Patrick Caulfield, Barry Flanagan, David Hockney, John Houland, Tom Holland, John Walker, Peter Stroud, Norman Stevens and others.

Among the contemporary American artists featured are Ed Ruscha, Robyn Denny, Anthony Gross and Joe Goode.

Sidney Janis Gallery 110 W. 57th St., New York, NY 10019 (212) 586-0110; Mon-Sat: 10-5:30 owner: Sidney Janis dir: Carroll Janis

710

The gallery has exhibited three generations of 20th century artists from a wide range of movements: Cubism, Futurism, Dada, Surrealism, Abstract Expressionism, Pop and Minimal Art. It now focuses on diverse currents of contemporary art, including New York graffiti artists.

Group shows and retrospectives have included works by Picasso, Fernand Leger, Piet Mondrian, Kurt Schwitters, Paul Klee, Alberto Giacometti, Constantin Brancusi, and Jean Arp. One-person shows have been devoted to American abstract painters Josef Albers, Willem de Kooning, Arshile Gorky, Adolph Gottlieb, Franz Kline, Robert Motherwell, Jackson Pollock and Mark Rothko. The gallery has also hung theme shows such as "New Realists", one of the first Pop Art shows, which included Jim Dine, Claes Oldenburg, Andy Warhol, Roy Lichtenstein, James Rosenquist, Tom Wesselmann, George Segal, Marisol, Arman, and Oyvind Fahlstrom. Other shows have featured Superrealists Duane Hanson, Richard Estes and Malcolm Morley; Op artists Bridget Riley and Victor Vasarely, Minimalists Robert Mangold and Robert Ryman, and hard-edge abstractionist Ellsworth Kelly.

Since the mid-1960s film and photography have become an important part of the gallery.

Photographers shown include Duane Michals, Gisele Freund, and Annie Leibovitz. The gallery also publishes prints and artist's editions.

The Jay Gallery 13 Jay Street, New York, NY 10013 (212) 925 9424 Tue-Sat: 11-6 Aug: closed; dir: Cheryl Pelavin

711

Concentration is on works on paper, mostly etchings and other prints, but including drawings and water colors. Small sculpture and wall hangings are also shown.

Works presented include etchings by Valentina Dubasky, color etchings by illustrator Robert Andrew Parker, and gouaches and watercolors by Chloe Fremantle. Prints by Charles Hewitt, Norman Akroyd, and Marjorie Mason are also featured by the gallery.

Other works seen at the gallery include satirical etchings by Chris Orr, aquatint interiors by Pat Shaverien, detailed line etchings by Evan Lindquist, and drawings by sculptor Richard Heinrich.

Jay Johnson 1044 Madison Ave., New York, NY 10021 (212) 628-7280; Tue-Fri: 10-6 Sat 12-6; owner/dir: Jay Johnson

712

The 34 gallery artists are primarily self-taught, naive folk artists who do wood carvings, paintings, and fabric work. They range from the very young to 84-year-old Thelma Graff. Exhibits change monthly, and since Fall 1984 the gallery has held double shows of two artists whose work has a common theme or approach. There is always a group show of gallery artists on display.

Among the gallery's stable are Michigan-born Kathy Jacobson, who paints New York landmarks as well as country scenes from Michigan. Janet Monroe does New England scenes in egg tempera on masonite, watercolor on paper, and oil on canvas. Painter Malcah Zeldis specializes in scenes of Jewish festivals, and also has been interested in Abraham Lincoln and Alexander Solzhenitsyn as subjects. Works by Barbara Bustetter Falk portray scenes from Arizona, especially mining towns and desert views. The gallery also shows the unique work of wood carver Ray Cusci, who builds brownstone miniatures from his carved wood bricks.

Jorice Art Glass 1057 Second Ave., New York, NY 10022 (212) 752-0129; Mon-Sat: 10:30-6 Jul-Aug: closed Sat; dir: Maurice Mogulescu, Joseph Mogulescu

713

The gallery specializes in hand made glass by contemporary American glass artists, both established and emerging. Work includes vases, paperweights, scent bottles, plates, lamps and sculpture.

Artists and works featured are: Charles Lotton, multi-colored, multi-layered floral vases; Donald Carlson, iridescent glass; John Nickerson, forms in clear glass; Paul Manners, colorful sculptural forms; Richard Jolley, fanciful drawings in glass vessels; Andrew Magdanz and Susan Shapiro, vessels in free-flowing color; Joe Clearman, unusual hand blown lamps; Leon Applebaum, varied scent bottles; and Josh Simpson, colorful floral designs. Rick Bernstein makes whimsically plays with color and form in his work. Thomas Buechner III and Matthew Buechner work independently in a Neo-Art Deco style,

Sharron Quasius, *Watson & the Shark by John Singleton Copley* (1981), 95 x 126 x 23, cotton & wood, O. K. Harris Works of Art (New York, NY).

John Marin, *Sea Fantasy No. 1* (1942), 16 x 22, watercolor, Kennedy Galleries (New York, NY).

while Michael David and Kit Karbler create multi-colored, faceted vessels and scent bottles.

Other artists include Stuart Abelman, Rick Gibbons, Randy Strong, Michael Nourot and Ann Corcoran, Keith Bowlby, John Gilvey, Connie Grant, and Jim Grant. In addition the gallery carries iridescent and cased glass vases, lamps, paperweights and scent bottles from Lundberg Studios; iridescent glass from Correia Studios; and paperweights and cased glass vessels from Orient & Flume.

A selection of ceramics is also shown, including work by Mark Foreman, Robin Katz, Vee Tuteur, Richard DiLaurentis, Washington Ledsma, Claire Desbecker and Jim Scenna.

Alexander Kahan Fine Arts, 25 E. 73rd St., New
714 York, NY 10021 (212) 737-4230; owner: Alexander Kahan

The gallery deals in 20th century graphics, as well as European and American painting.

The inventory includes works by Auguste Renoir, Camille Pissarro, Etienne Martin, Lebasque, Valtat, Picasso, Marc Chagall, Henry Moore, Georges Rouault, Joan Miro, Jean Dufy, Yaacov Agam, Fernand Leger, Roberto Matta, Marino Marini, Jean Dubuffet and David Hockney. Among the American artists are Milton Avery, a colorist influenced by Matisse and American Abstractionism whose *oeuvre* includes many New England landscapes , as well as Raphael Soyer, Alexander Calder, Frank Stella and Roy Lichtenstein.

Jane Kahan Gallery 922 Madison Ave., New York,
715 NY 10021 (212) 744-1490; owner: Jane Kahan
dir: Helga Jensen

The gallery specializes in late 19th to 20th century works on paper, master graphics, and contemporary prints. The ceramics of Picasso and some modern sculpture are handled as well.

Rare prints include works by Auguste Renoir, Henri Toulouse-Lautrec, Georges Rouault and Camille Pissarro, Picasso linocuts are available. The gallery also carries new editions by Marc Chagall, and has an extensive inventory of his lithographs. In addition, one may see Miro aquatints and work by sculptors Henry Moore and Marino Marini.

Contemporary American artists include Frank Stella, who has made many lithographic editions of his geometric abstract paintings; and Sam Francis, an Abstract Expressionist noted for his vibrant splashed color, whose monotype prints and paintings may be seen at the gallery.

Kennedy Galleries 40 W. 57th St., New York, NY
716 10019 (212) 541-9600; Tue-Sat: 9:30-5:30 Summer: Mon-Fri: 9:30-5:30 dir: Lawrence A. Fleischman

Kennedy Galleries specializes in 18th to 20th century American paintings, watercolors, sculpture and drawings.

The gallery features the work of Will Barnet, Leonard Baskin, Hyman Bloom, Allen Blagden, Colleen Browning, Ruth Gikow, Lorrie Goulet, Joseph Hirsch, Jack Levine, Carolyn Plochmann, Millard Sheets and Frank Wright, and works from the estates of Charles Burchfield, Marvin Cherney, John Steuart Curry, Abraham Rattner and John Marin.

The gallery specializes in works by 20th century American artists. They include Ivan Albright, Childe Hassam, Maurice Prendergast, Charles Sheeler, Charles Demuth, George Bellows, John Sloan, George Luks and Reginald Marsh. Artists of the Stieglitz group include Georgia O'Keeffe, whose portrayal of real objects and landscapes reveals their qualities as abstract forms; early abstractionist Arthur Dove; and Marsden Hartley, who developed a highly personal style influenced by German Expressionism, French Cubism, and a concern for the American landscape and culture. An artist endowed with acute powers of observation in the American tradition of Homer and Eakins, Edward Hopper portrayed the isolation of urban life. Architectural planes articulate Lyonel Feininger's seascapes and cityscapes. Stuart Davis's semi-abstract paintings employ flat and jangling billboard colors, while Walter Murch's muted still lifes endow banal objects with a mysterious presence.

The major 18th and 19th century American artists featured in the gallery include Albert Bierstadt, William Merritt Chase, Frederic E. Church, John Singleton Copley, Thomas Eakins, William Harnett, Martin Johnson Heade, Winslow Homer, John Frederick Kensett, the Peale family, John Singer Sargent, Gilbert Stuart and Worthington Whittredge among others.

Coe Kerr Gallery 49 E. 82nd St., New York, NY
717 10028 (212) 628-1340; Mon-Fri: 9-5 Sat during advertised exhibitions: 10-5 dir: Warren Adelson

Established in 1969, Coe Kerr Gallery specializes in 19th and 20th century American paintings and sculpture. The gallery occupies a townhouse between Park and Madison Avenues. The lower two floors contain semi-private viewing rooms where paintings from the gallery inventory can be individually displayed.

The gallery attempts to have available at any given time high quality examples of the Hudson River School artists, among them Thomas Cole, considered the founder of the school, as well as Frederic E. Church and Martin J. Heade; the American Impressionists, among them John Singer Sargent, Childe Hassam and Mary Cassatt; the Ash Can School, among them John Sloan, George Luks, and Everett Shinn; the Modernists, the Regionalists and the best-known Western artists.

In the contemporary field Coe Kerr is the primary dealer for Andrew Wyeth and his son Jamie. The elder Wyeth's scrupulously detailed watercolor, tempera and oil paintings have achieved a widespread popularity as portrayals of the American Scene. Other contemporary artists presented at the gallery are James Bama, Jonathan Kenworthy and Robert Cottingham, among others.

The Key Gallery 130 Greene St., New York, NY
718 10012 (212) 966-3597; Wed-Sat: 11-6 Aug: closed; owner/dir: Margaret Kilik

Key's exhibits focus on collages and drawings, and also present oils on wood, paper, and canvas.

Collages and drawings by Gerard Charriere reflect his dual career as a bookbinder and an artist. John Digby also shows collages, which

use animal motifs. Pen and ink drawings by Philip Sugden depict landscapes, people, and architectural details. Ellen McLaughlin uses carbon paper for her collage drawings. Using wood, Marcia G. Yerman carves and paints mysterious but humorous images.

Phyllis Kind Gallery 136 Greene St., New York, NY 10012 (212) 925-1200; Tue-Sat: 10-6 Jun-Aug: Tue-Fri: 10-6 owner/dir: Phyllis Kind
719

See listing for Chicago, Illinois.

The Kitchen 59 Wooster St., New York, NY 10012 (212) 925-3615; Tue-Sat: 1-6; dir: Stuart Hodes
720

The Kitchen began as an ad hoc video gallery in the kitchen of the old Mercer Arts Center. A nonprofit organization, it is a home for experimental work in the performing and visual arts. The Kitchen's programs include television, music, dance, and performance. There is a small gallery as well as a video viewing room for closed-circuit screenings.

Each year the Kitchen showcases approximately 150 video artists, 35 composers, 25 performance artists, and 10 choreographers, as well as mounting a dozen exhibitions and several major television productions. There also is an array of support services that enable artists to produce their work and present it to the public.

The Kitchen's Video Archive houses fiction, documentary, performance, image processing, and synthesis tapes. The archive also stores documents of early performance works. Tapes from the archive may be scheduled for viewing at the Kitchen. A video distribution catalogue listing all tapes in the archives is available.

Video equipment and screening facilities are provided to artists and the public. Other programs include a distribution service that presents videotape programs to museums, galleries, and community organizations; a touring program that presents work by young or emerging performers; and a media bureau that provides grants to media artists throughout New York State.

M. Knoedler & Co., Inc. 19 E. 70th St., New York, NY 10021 (212) 794-0550 Tue-Fri: 9:30-5:30 Sat: 10-5:30; dir: Lawrence Rubin
721

Founded in 1846, the gallery is one of the oldest exhibiting institutions in New York and also has well-established London and Zurich branches. Artists represented by the gallery are international in origin and reputation. Each has a show, generally of recent works, every two years.

The artists shown by the gallery include: Robert Motherwell, Frank Stella, Nancy Graves, Richard Diebenkorn, Howard Hodgkin, John Walker, Michael David, Friedel Dzubas, Joles Olitski and Walter Darby Bannard. The estates of several important artists are also represented by the gallery. They include the Esther and Adolph Gottlieb Foundation, and the estates of Ludwig Sander and David Smith.

Monique Knowlton Gallery 153 Mercer St., New York, NY 10012 (212) 431-8808; Tue-Fri: 10-6 Sat: 11-6; owner/dir: Monique Knowlton
722

The gallery favors work that is expressionistic and surrealistic, often dealing with personal narrative and decorative motifs. Exhibits change monthly, and works in multiple media are presented.

Among the gallery's artists are painters Phyllis Bramson, Robert Beauchamp, Christine Couture, Robert Donley, Cynthia Eardley, Frank Faulkner, Tommasi Ferroni, Peter Flaccus, Dale Frank, Gaylen Hansen, Robert Lostutter, James De Pasquale, Richard Seehausen, Richard Thompson, and Helen Miranda Wilson. The gallery also features works by artists who sculpt and create assemblages and constructions, including Jay Coogan, Thomas Cooney Crawford, Simone Gad, Ron Isaacs, Edward Larson, Helen Oji, Rod Rhodes, Alison Saar, Bettye Saar, and Shari Urquehart. Group shows are presented throughout the season, such as the recent "ecstasy show," curated by painter Nicholas Mouffarrege, which featured artists such as Linda Benglis, Louise Bourgeois, Yves Klein, Robin Winters, and Lucas Samaras.

Kornblee Gallery 20W. 57th St., New York, NY 10019 (212) 586-1178 Tue-Fri: 10-5:30 Sat: 11-5; owner/dir: Jill Kornblee
723

Showing a variety of contemporary art, the gallery tends to concentrate on American painters and a small number of Europeans. Some sculpture and works on paper are shown.

Most of the artists are relatively unknown and work in realist styles. Painter Billy Sullivan depicts New York night life. Patricia Tobacco Forester does large watercolor landscapes. Paul Linfante works in pastels to create realist still lifes. Hitch Lyman travels through Europe to paint his watercolor landscapes. Bruce Monteith makes sculpture of architectural environments in the form of box constructions. Donn Moulton uses molded fiberglass and lacquer in his wall sculpture. Steven Singer, an American residing in London, makes figurative sculpture in mild steel. Elga Heinzen paints cloths, clothing and flags in a trompe-l'oeil style. Randy Stevens shows a satirical vision of American glamour in his paintings and drawings.

Kouros Gallery 831 Madison Ave., New York, NY 10028 (212) 879-5454; Tue-Sat: 10-6 Aug: closed; owner/dir: A.E. Camillos
724

An ample selection of 20th century art is displayed at Kouros, ranging from historic to modern and post-modern tendencies in North and South America and in Europe, with particular attention to Expressionism.

Contemporary art exhibited at the gallery includes Michael Lekakis's biomorphic sculpture and drawings; Aristodemos Kaldis's expressionistic landscapes, and the non-objective painting of Jean Xceron. South American artists include Manabu Mabe (lyric expressionism), Nicholas Vlavianos (sculpture), Marcelo Bonevardi, Tomie Ohtake, and Omar Rayo, as well as Uruguayan master Joaquin Torres Garcia, whose paintings and theoretical writings were influential in the international avant-garde between the two world wars. Also included are works by Pop artist Richard Lindner, Larry Rivers and Cubist Albert Gleizes.

Younger artists, most of whom are figurative expressionists, include Despo Magoni, Alicia Creus, Agnese Udinotti, Jamie Mihaly, Cynthia Villet, Claude Carone, Charles Hewitt, Paul Weingarten, Hilary Johnston and Marcia Grostein.

Kraushaar Galleries 724 Fifth Ave., New York, NY
725 10019 (212) 307-5730; Tue-Sat: 9:30-5:30 Jun-
Sep: Mon-Fri: 10-5; owner: A.M. Kraushaar

American paintings, both contemporary and
from the early 20th century, may be viewed at at
this gallery.
Earlier works feature the social realists of the
Ashcan School, particularly John Sloan and Wil-
liam Glackens, as well as Jerome Myers, and
later realists such as Henry Schnakenberg, Louis
Bouche, and John Koch. One may also see se-
lected works of Alfred Maurer, Edwin Dickin-
son, William Kienbusch, Guy Pene du Bois and
others.
Contemporary artists include painters Karl
Schrag, John Heliker, John Hartell, James
Lechay, Jerome Witkin, and several others, as
well as sculptors Jerry Atkins, Jane Wasey, Leo-
nard DeLonga and others.

Navin Kumar Gallery 967 Madison Ave., New York,
726 NY 10021 (212) 734-4075; Mon-Sat: 10-6;
owner/dir: Navin Kumar

The main attraction of the gallery is its extensive
collection of antique Asian art from India, Nepal
and Tibet. The gallery also exhibits works by
some 20th century international artists.
The Asian collections range from the 2nd
century to the 19th century A.D., and embrace
many of the cultures from the region of the
Indian subcontinent. Islamic and Tantric Bud-
dhist works are displayed, as well as folk art.
The collections include paintings, miniatures,
sculptures, bronzes, woodcarvings and antique
jewelry.
Contemporary artists featured include Chilean
Surrealist Roberto Matta, Swiss illustrator Jean
Michel Folon, Dutch painter Karel Appel (a
founder of the COBRA group), and American
lyrical abstractionist Paul Jenkins.

La Boetie, Inc. 9 E. 82nd St., New York, NY 10028
727 (212) 535-4865 Tue-Sat: 10-5:30 Aug: closed;
dir: Helen Serger

The gallery concentrates on works in all media
by artists associated with major 20th century
movements: German and Austrian Expression-
ism, Dadaism, Surrealism, Futurism, the Bau-
haus, and the Russian avant-garde. The gallery
also handles work by such modern masters as
Balthus, Henry Moore, Fernando Botero, and
Kurt Schwitters.
Director Helen Serger mounts several exhibi-
tions every year. Herwarth Walden's "Der
Sturm" was highlighted with works from the
first ten years of exhibitions, mostly works on
paper, by Oskar Kokoschka, Wassily Kandin-
sky, Marc Chagall, Alexander Archipenko, Kurt
Schwitters, August Macke, and Laszlo Moholy-
Nagy. Other shows have included Dada works
on paper by Hannah Hoech, Johannes Baader
and Jean Arp; art of the Bauhaus; works by
German Expressionists; "Pioneering Women
Artists: 1900-1940"; and "Abstract and Con-
structivist Art 1910-1930". A recent one-person
show by Hannah Hoech included fine works of
her early period. A major exhibition of works by
Kurt Schwitters is scheduled for the fall of 1984.

Landfall Press Inc. 611 Broadway, 310A, New York,
728 NY 10012 (212) 420-9619; Mon-Fri: 9-5 Sat:

12-4; owner: Jack and Ethel Lemon dir: Molly
Rudder

See listing for Chicago, Illinois.

Ledel Gallery 168 Mercer St., New York, NY 10012
729 (212) 966-7659 Tue-Sat: 12-6 Sun: 1-5 Aug:
closed

Ledel Gallery features photography by 19th cen-
tury, 20th century and contemporary artists. The
gallery maintains extensive files of reserve prints
and portfolios, and a fine selection of gallery
posters.
Rare photographic work from 1900-1950 is a
specialty of the gallery. Ledel's opening exhibit
featured Edward S. Curtis's monumental work,
"The North American Indian", which included
gravures, platinum prints, orotones and portfo-
lios, all produced before 1920. Ledel also exhib-
its a large selection of photographs of New York
City by well-known photographers such as Ab-
bott, Stieglitz, Hine and Weegee, as well as the
rare works of post Photo-Secession pictorialists,
and contemporary photographers.
Recently featured photographers include P.
H. Polk, since 1920 the official photographer of
Tuskeegee Institute, Alabama, and British pho-
tographer Tony Ray-Jones. The landscape and
experimental photographs of Wynn Bullock, Al-
bert Renger-Patzsch's industrial landscapes and
Lotte Jacobi's German work from the 20's and
30's have recently been exhibited, as have the
handcolored Western landscapes of Gail Skoff,
the architectural work of Ezra Stoller and Judith
Turner, and the large urban panoramas of Mi-
chael Spano.

Lefebre Gallery 47 E.77th St., New York, NY 10021
730 (212) 744-3384; Tue-Sat: 10-5:30 Jun: Tue-Fri:
11-5 Jul & Aug: closed dir: John Lefebre

The gallery features work by European painters
and sculp-tors, among them several artists asso-
ciated with COBRA, a group of painters from
Copenhagen, Brussels and Amsterdam which in-
cludes Pierre Alechinsky, Corneille, Christian
Dotremont, Carl-Henning Pedersen and Asger
Jorn.
Others shown by the gallery are German
sculptors Horst Antes, Julius Bissier and Klaus
Fussmann; Belgian sculptors Pol Bury and Rein-
houd, and Belgian watercolorist and printmaker
Jean-Michel Folon. Also exhibited are Argentin-
ian painter Antonio Segui, Chinese painter Wal-
asse Ting and Spanish painter Juan Martinez.
The gallery has also exhibited work by Serge
Poliakoff and Hans Hartung.

Jon Leon Gallery 31 Desbrosses St., New York, NY
731 10012 (212) 219-3766 Sat: 12-6 & by appt; dir:
Jon Hutton

The Jon Leon Gallery shows contemporary
American painting, sculpture and graphics. Na-
than Slate Joseph creates paintings and sculpture
using oil paint, dry pigments and rust on steel.
Alf Young uses figural images on multiple layers
of semitransparent fabric in "veiled" paintings
and drawings. Aymon Roussy de Sales incorpo-
rates symbolic images from Central and South
American native traditions in semi-abstract, fan-
tastic painting. Graphics and paintings by Rich-
ard Mock are also on display. Other artists fea-

Kenneth Noland, *Across* (1964), 97 x 126, acrylic resin paint on canvas, Andre Emmerich Gallery (New York, NY).

Charles Burchfield, *Little Trees Dancing* (1967), 33 x 40, watercolor, Kennedy Galleries (New York, NY).

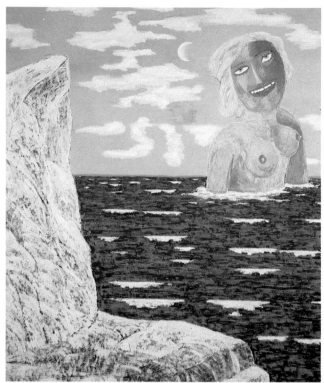

Carmen Cicero, *Provincetown Princess* (1984), 84 x 72, acrylic on canvas, Graham Modern Gallery (New York, NY).

Michael Gallagher, *UKIYO-E*, 60 x 48, acrylic on canvas, Louis K. Meisel (New York, NY).

Deborah Butterfield, *Freckles* (1983), 72 x 20 x 30, mixed media, O.K. Harris Works of Art (New York, NY).

Eric Fischl, *Master Bedroom* (1983), 84 x 108, oil on canvas, Mary Boone Gallery (New York, NY).

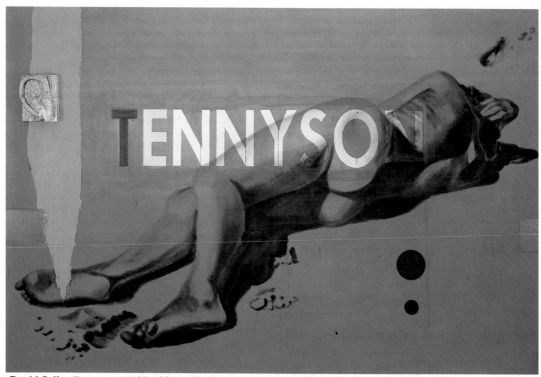

David Salle, *Tennyson* (1983), 78 x 117, oil on canvas, Mary Boone Gallery (New York, NY).

Fernando Botero, *Still Life with Bottle* (1982), 43 x 66, oil on canvas, Marlborough Gallery (New York, NY).

Richard Anuszkiewicz, *The Temple of Electric Tourquoise,* 60 x 48, acrylic on canvas, Graham Modern Gallery (New York, NY).

Lynda Benglis, *Vulpecula* (1983), 68 x 24 x 14, bronze wire, zinc, nickel, Paula Cooper Gallery, (New York, NY).

John Moore, *Industrial Pink* (1984), 90 x 50, oil on canvas, Hirschl and Adler Modern (New York, NY).

Susan Crile, *Wide Reach* (1983), 72 x 84, oil/gesso on canvas,
Graham Modern (New York, NY).

Richard Maury, *Claudia* (1935), 35 x 43, oil on canvas, Wunderlich & Company (New York, NY).

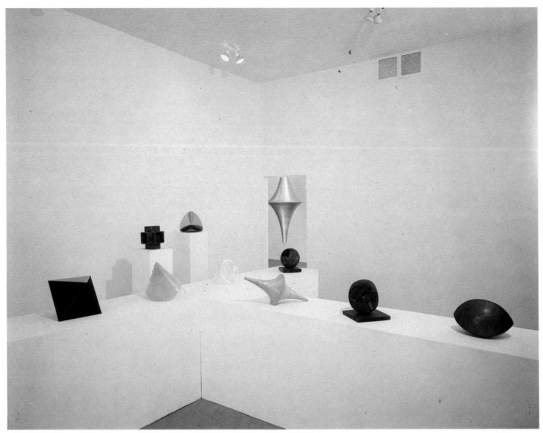

Ruth Vollmer, Installation, Jack Tilton Gallery (New York, NY).

Maurice B. Prendergast, *Monte Pincio, Rome,* watercolor, 15 x 19, Ira Spanierman, Inc. (New York, NY).

Jedd Garet, *Breathing Water* (1982), 73 x 57 x 3, acrylic on canvas, Robert Miller Gallery (New York, NY).

Ronnie Elliott, *Collage 374*, 21 x 14, mixed media.
Andre Zarre Gallery (New York, NY).

Peter Saari, untitled (1983), 78 x 46 x 9, casein gouache, plaster on canvas and wood, O.K.
Harris Works of Art (New York, NY).

Cecilia Beaux, *Mrs. Beauveau Borie and Her Son,
Adolphe,* 57 x 39, oil on canvas, Richard York Galleries
(New York, NY).

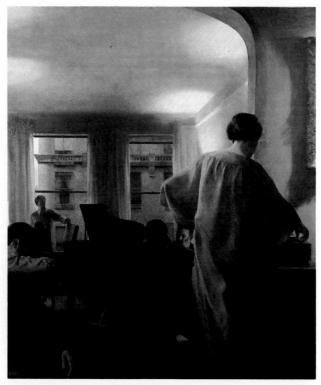

John Koch, *Music* (1968), 69 x 60, oil, Kraushaar
(New York, NY).

Irene Rice Pereira, *Radiant Source of Spring* (1952), 40 x 50, oil on canvas, Andre Zarre Gallery (New York, NY).

Charles Garabedian, *Green Man* (1983), 48 x 60, acrylic on panel, Hirschl & Adler Modern (New York, NY).

Cy Twombly, untitled (1969), 79 x 103, oil on canvas, Hirschl & Adler Modern (New York, NY).

Paul Resika, *Sleeping Gypsy*, 61 x 77, oil on canvas, Graham Modern (New York, NY).

Marilyn Levine, *Spot's Suitcase* (1981), 8 x 29 x 18, ceramic/mixed media, O.K. Harris Works of Art (New York, NY).

Michael Boyd, *Blue Mountain Lake* (1983), 78 x 144, acrylic on canvas, Andre Zarre Gallery (New York, NY).

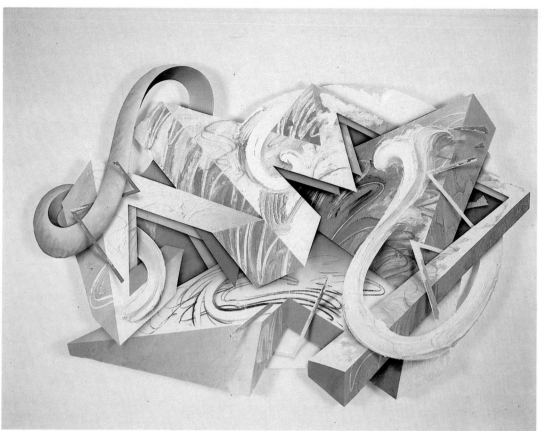

George Green, *Pacific Northwest,* 66 x 104, acrylic on canvas, Louis K. Meisel (New York, NY).

Jim Sullivan, *Cry For Home* (1984), 80 x 90, oil on canvas, Nancy Hoffman Gallery (New York, NY).

Donald Lipski, Installation, mixed media, Germans Van Eck Gallery (New York, NY).

Minoru Kawabata, Installation, Jack Tilton Gallery (New York, NY).

tured recently include David Novros, Gordon Hart, Yoji Shinagawa and Daniel Galliduani. The gallery also shows work on consignment from collectors.

Bernard & Dean Levy Gallery 981 Madison Ave.,
732 New York, NY 10021 (212) 628-7088; Tue-Sat: 10-5:30 Summer: Mon-Fri: 10-5:30 owner: Bernard & S. Dean Levy dir: Bernice K. Kimball

The gallery specializes exclusively in American paintings. Works by major artists from the 18th, 19th and 20th centuries are hung throughout the second floor gallery rooms, located in the Carlyle Hotel between 76th and 77th streets on Madison Avenue. American masters include Theodore Robinson, Willard Leroy Metcalf, William Lamb Picknell, William M. Harnett, J.F. Peto, James E. Butterworth, Thomas Birch, George Henry Hall, A.F. Tait, James Peale, Thomas Hovenden, Henry Inman, Severin Inman and other artists of stature. The Hudson River School is represented by Thomas Cole, Sanford R. Gifford, Homer D. Martin, George Harvey, Worthington Whittredge, Albert Bierstadt, and John Frederick Kensett. 18th century portraits by artists such as Joseph Blackburn and John Singleton Copley may be viewed as well. 20th century art schools are represented with works by Reginald Marsh, John Marin, Leon Kroll, Norman Rockwell and artists working in representational modes.

The full inventory of paintings by Cecil C. Bell (1906-1970) is handled in New York by the Levy Gallery, which gave this artist a retrospective exhibition "New York in Flying Colors", revealing Bell's energetic style that employed brilliant colors to express his *joie de vivre*.

Furthering interest in contemporary and post-1930 representational art, an exhibition of the works of Richard Pantell, titled "Urban Light", proposed the importance of exposing young, living artists.

Light Gallery 724 Fifth Ave., New York, NY 10019
733 (212) 582-6552 Tue-Fri: 10-6 Sat: 11-5; dir: Dale W. Stulz

Founded in 1971, this gallery specializes in contemporary photography, but also has a selection of work by 19th and 20th century masters.

Works by Robbert Flick, Susan Rankaitis and Blythe Bohnen have recently become part of the gallery's exhibition program. Light has a very complete range of prints by Aaron Siskind, from vintage work of the 1930s to the most recent work of the 1980s, as well as broad selections of prints by Ansel Adams, Harry Callahan, Eikoh Hosoe, W. Eugene Smith, Garry Winogrand and Louis Faurer, and color prints from the Farm Security Administration. Light is exhibiting the work of distinguished teacher and photographer Margaret Watkins for the first time in sixty years in the United States.

Among the younger artists exhibited at Light are Linda Connor, whose recent work in India and the Southwest is printed on gold-chloride paper; Will Larson, a versatile artist who most recently has done large Cibachromes with a pin-hole camera; Emmet Gowin, a portrait and landscape photographer; Grant Mudford, who investigates pattern and light in industrial structures; and Paul Berger, whose work deals with de-

tached shapes, tones and narrative elements reconstructed into ambiguous patterns.

Jean Lumbard Fine Arts 38 E. 57th St., New York,
734 NY 10022 (212) 421-3494; Tue-Fri: 10-5:30 Sat: 11-5; owner/dir: Jean Lumbard

The gallery shows contemporary American artists working on paper and canvas, with concentration in'':'Americana': landscapes, seascapes, regional art. Atrium, wall, plaza and small standing sculptures are shown, as well as tapestries and textile hangings. Some paintings of the Abstract Expressionist period are also shown.

Artists shown include John Grillo, hard edge abstractionist Nassos Daphnis, and abstract painter George Schucker. Tom De Jong works in a contemporary colorist vein, with stylized elements. Chuck Hinman exhibits his shaped canvas con-structions. Of the sculptors featured by the gallery, Tim Prentice makes kinetic works, Bob Longhurst constructs laminated sculpture which he bends into delicate shapes, and Vincenzo Leggiadro carves marble in a classical style.

The gallery also shows traditional painting by a group of young artists working in a detailed realistic style. The group includes Larry D'Amico, Anthony Butera, Derek Reist, Wilbur Streech, Robert Kipniss, Ross Barbera and Sharon Florin, who paint landscapes and urban scenes.

Galerie Maeght Le Long 9 W. 57th St., New York,
735 NY 10019 (212) 371-9077; Mon-Fri: 10-5:30; dir: Ms. Daryl Harnisch

With branches in Paris, Zurich and Barcelona and a museum collection in the Fondation Maeght, St. Paul de Vence, France, as well as an extensive fine art publishing venture, this is a leading gallery for contemporary art.

Artists presented by the gallery include: Valerio Adami, Pierre Alechinsky, Arakawa, Pol Bury, Alexander Calder, Marc Chagall, Eduardo Chillida, Jan Dibbets, Claude Garache, Gardy-Artigas, Alberto Giacometti, Edward Kienholz, Konrad Klapheck, Jiri Kolar, Fernand Leger, Richard Lindner, Joan Miro, Henry Moore, Isamu Noguchi, Pablo Palazuelo, Paul Rebeyrolle, Jean-Paul Riopelle, Paul Rotterdam, Saul Steinberg, Takis, Antoni Tapies, Gerard Titus-Carmel, Bram van Velde, Jim Dine, Francis Bacon, Nigel Hall and Ben Nicholson.

Formerly showing predominantly European artists, the gallery is starting a program of exhibitions of contemporary American artists. 1983-84 exhibitions included works by Louise Bourgeois, Robert Mangold, Willem de Kooning, Brice Marden, Philip Guston, Robert Ryman, George Segal, Cy Twombley and Joel Shapiro.

Marbella Gallery, Inc. 28 E. 72nd St., New York, Ny
736 10021 (212) 288-7809; Tue-Sat: 11-5:30; dir: Mildred Thaler Cohen

Concentration is on American artists of the late 19th and early 20th century, including the Hudson River artists and the American Impressionists.

Artists whose work may be viewed at the gallery include 19th century American landscape painters such as Frederic E. Church, George Inness, Albert Bierstadt and Jasper Cropsey, as well

as Ralph Blakelock, William Sonntag. A.T. Bricher and William Trost Richards. Others displayed are Edward Potthast, Willard Metcalf, J. Alden Weir, Impressionist John Twachtman, Chauncey Ryder, Theodore Robinson, Robert Hallowell, and members of the Ashcan School John Sloan, Everett Shinn and William Glackens.

Kathryn Markel Gallery 50 W. 57th St., New York,
737 NY 10019 (212) 581-1909 Tue-Sat: 10-5:30; owner: Kathryn Markel dir: Frank Rand

The gallery specializes contemporary painting and sculpture as well as artist's books. Most of the work is created by emerging artists in oil, acrylic, watercolor and collage. The gallery also handles paper constructions.

Artists featured by the gallery include Barbara Kassel, who paints intimate interior dreamscapes; Barton Lidice Benes, who makes collages from currency, and Elena Borstein, who paints light-drenched Grecian landscapes. Stephanie Brody Lederman combines objects, paint, crayon and words. Takako Yamaguchi paints large decorative Far Eastern images on paper. Pat Lasch creates life/death sculptures. Richard Tuschman models ominous wall sculptures and Ellen Frances Tuchman combines beads and paint on vellum.

In addition the gallery carries artist's books, unique and editions. The gallery handles the books of Bernard Maisner, Roz Chast, Ben Jasper and John Eric Broadus, among others.

The gallery also carries work on canvas and paper for corporations and businesses. The works range from figurative to abstract and are produced by relatively unknown artists.

Marlborough Gallery 40 W. 57th St., New York, NY
738 10019 (212) 541-4900 Mon-Fri: 10-5:30 Sat: 10-5 Summer: closed Sat; dir: Pierre Levai

With branches in London, New York and Tokyo, the gallery features major 19th and 20th century artists, as well as contemporary artists. Important works are available by Impressionists, 20th century European masters, German Expressionists, post-World War II American artists, as well as 19th and 20th century photographers.

Living artists featured include John Alexander, Mordecai Ardon, Avigdor Arikha, Frank Auerbach, Francis Bacon, Fernando Botero, Claudio Bravo, Frederick Brown, Lynn Chadwick, John Davies, Stephen Edlich, Rainer Fetting, Juan Genoves, Charles Ginnever, Ron Gorchov, Red Grooms, Dieter Hacker, Bill Jacklin, Alex Katz, R.B. Kitaj, Antonio Lopez-Garcia, Theodore Manolides, Raymond Mason, Henry Moore, Reuben Nakian, Victor Newsome, Sidney Nolan, Victor Pasmore, Irving Petlin, Jay Phillips, John Piper, Arnaldo Pomodoro, Daniel Quintero, Larry Rivers, James Rosati, Altoon Sultan, Rufino Tamayo, Neil Welliver and John Wonnacott. Also represented are the estates of Barbara Hepworth, Oskar Kokoschka, Jacques Lipchitz, Kurt Schwitters, Edward Seago and Graham Sutherland.

Photographic exhibitions, periodically held in the small gallery, feature well-known artists such as Berenice Abbott, Brassai, Herbert Matter, Irving Penn, and the estates of Eugene Atget and Bill Brandt. The graphics division offers numerous works by Adolph Gottlieb, Red Grooms,

Alex Katz, R.B. Kitaj, Robert Motherwell, Victor Pasmore, Larry Rivers, Rufino Tamayo and others.

One or more exhibitions, accompanied by an illustrated catalogue, are scheduled every month. A beautiful sculpture terrace is used to exhibit monumental works.

Barbara Mathes Gallery 851 Madison Ave., New
739 York, NY 10021 (212) 249-3600; Tue-Fri: 9:30-5:30 Sat: 10-5:30 Jun-Jul: Mon-Fri: 10-5 Aug: closed; owner/dir: Barbara Mathes

The gallery recently moved from its apartment-like space to a larger, more public space. The emphasis is on early 20th century American and European modern masters and important American contemporaries.

The gallery handles American works of the 20th century by artists such as Oscar Bluemner, Charles Burchfield, Andrew Dasburg, Stuart Davis, Charles Demuth, Arthur Dove, O. Louis Guglielmi, Marsden Hartley, John Marin, Georgia O'Keeffe, Charles Sheeler, Joseph Stella, and John Stoors. Among the European artists that may be seen are Picasso, Matisse, Archipenko, Henry Moore, and Fernand Leger. Contemporary artists featured by the gallery include Michael Maziur, Harry Roseman, and William Wilkins.

Matignon Gallery 897 Madison Ave., New York, NY
740 10021 (212) 628-6886 or 737 4563 Tue-Sat: 11-6 Jul & Aug: by appt; dir: Paul Kovesdy

The aim of the gallery is to provide a place for the recognition of the forgotten artists of the European avant-garde working between the two wars, especially those of the Bauhaus and Der Sturm-related periods.

The exhibition "The Avant-Garde in Eastern Europe" gave the public its first opportunity to see works by Lajos Kassak, Hugo Scheiber, Bela Kadar and others. The following exhibition in the year of the Bartok Centennial showed the composer's influence in the visual arts in works by Bela Kadar, Laszlo Moholy-Nagy, Zsigmond Kolos-Vary, Etienne Beothy, Sandor Bortnyik and Lajos Kassak.

Matignon's exhibits have continued to reveal the vigor and timeliness of Eastern European artists. Recent exhibi-tions have included a survey of Eastern European Construc-tivism from the 1920's to the present; the first retrospective in the U.S. of Constructivist leader Lajos Kassak; the sketchbook 1916-1922 of Ivan Kliun; and thematic exhibitions which included the work of Janos Mattis-Teutsch, Lajos Tihanyi, Wladyslaw Strzeminsky, Bela Kadar, Lajos Kassak and others.

Pierre Matisse Gallery 41 E. 57th St., New York, NY
741 10022 (212) 355-6269; Tue-Sat: 10-5 Jul-Aug: closed; owner: Pierre Matisse dir: Pierre Boudreau

Pierre Matisse, who is the younger son of artist Henri Matisse, established the gallery in 1931. The gallery is the principal representative of painters Miro and Chagall and sculptor Albert Giacometti. Other major artists represented include painters Jean Dubuffet, Loren McIver, Balthus, Marino Marini, and sculptor Reg Butler.

Some less-well-known international artists are

featured, among them Canadian painter Jean-Paul Riopelle, particularly known for dense, coruscating palette-knife textures filling the canvas; French painter Francois Rouan, and Japanese painter Zao Wou-ki, whose atmospheric abstractions recall Oriental brush painting. The gallery also shows members of "El Paso," a group founded in Madrid in 1957. They include the late Manolo Millares, an artist from the Canary Islands whose works in torn, stained, and sewn canvases evoke the tortured landscapes and mysterious petroglyphs of his birthplace; painter Antonio Saura, an expressionist with an intense, gestural style and a classical palette recalling the "Black Paintings" of Goya; and Manuel Rivera, whose layered, sometimes painted metallic screens reveal shifting moire patterns as the viewer moves.

Stephen Mazoh & Co., Inc. 13 E. 76th St., New York, NY 10021 (212) 737-2203; Tue-Sat: 10-6 Mon: by appt Aug: closed; owner/dir: Stephen Mazoh
742

The gallery specializes in late 19th and 20th century European and American artists, with a particular interest in post-World War II art.

Impressionist and Post-Impressionist works may be seen by such masters as Camille Pisarro, Paul Cezanne, Claude Monet, Edouard Manet and Auguste Renoir. New York School artists featured include painter Ad Reinhardt, whose black and monochrome geometric abstractions constitute a source of Minimalism; action painter Willem de Kooning; Mark Rothko, whose floating expanses of color were a source for Color Field painting; Jasper Johns, an artist associated with Pop, but who in many respects reformulated the lessons of Abstract Expressionism; and Hard Edge painter Ellsworth Kelly. One may also see work by Cy Twombly and David Hockney, as well as 20th century masters Picasso, Juan Gris and Matisse.

Some work by emerging artists is also displayed, for example, paintings by Italian New Imagists Sandro Chia and Mimmo Paladino, or German Neo-Expressionist Anselm Kiefer.

Jason McCoy, Inc. 19 E. 71st St., New York, NY 10021 (212) 570-2131; Tue-Sat: 10-6 Aug: closed; owner/dir: Jason McCoy
743

The gallery carries 20th century art by recognized masters, as well as by some younger contemporary artists.

The artists shown include Alexander Archipenko, a Cubist sculptor; sculptor Alexander Calder, known for his "mobiles" and earlier "stabiles"; Abstract Expressionists Willem de Kooning, Jackson Pollock and Lee Krasner; and contemporary artists Larry Rivers, Frank Stella, and Cy Twombly, whose work combines carefully modulated washes, smears and layering with painterly graffiti.

Among the other contemporary artists exhibited are Doug Kent, Gregoire Muller, Clark Murray and Michael Tetherow.

David McKee Gallery 41 E. 57th St., New York, NY 10022 (212) 688-5951 Tue-Sat: 10-5:30 Summer: closed Sat Aug: closed; owner: David McKee dir: Renee Conforte
744

The gallery represents established contemporary artists and has strong affinities with the postwar American school. Works by Franz Kline, David Smith and Clyfford Still are shown. The work of Philip Guston is handled by the gallery.

Among recent one-person exhibitions were the works of Vija Celmins, whose graphite drawings of seas, galaxies and deserts are shown with actual re-created objects, which might include stones, giant erasers or combs. The works of Katherine Porter employ circular forms, such as tornadoes, moons and spirals, in daring, strongly colored compositions. In Sean Scully's paintings bands of color exist on canvases joined together at varying depths.

Loren Madsden's gallery installations incorporate heavy materials suspended on wires. Paintings by Harvey Quaytman integrate color and light within a tightly controlled, sometimes eccentrically shaped canvas. Jake Berthot's paintings utilize earth tones and muted colors to evoke a mystical atmosphere.

Other artists shown are Stuart Diamond, three-dimensional painted constructions; David Humphrey, contemporary surreal paintings; and William Tucker, iron and bronze sculpture.

Louis K. Meisel Gallery 141 Prince St., New York, NY 10012 (212) 677-1340, Tue-Sat: 10-6; owner/dir: Louis K. Meisel
745

Noted for its group of Photorealist painters, this gallery exhibits several of the acknowledged masters of the style.

Charles Bell's spooky, larger-than-lifesize marbles, stones and toys, or Tom Blackwell's urban scenes reflected in storefronts display the precision and virtuosity that can be attained in this style. Other well-known Photorealists include Franz Gertsch, Audrey Flack and Tom "America" Kleeman, as well as Hilo Chen, Guy Johnson, Fran Bull, Mary Warner, C. J. Yao, and Joyce Stillman-Myers.

Combining the painterly concerns of Abstract Expressionism with trompe-l'oeil illusionism, painters James Havard, Michael Gallagher, George Green and Frank Roth have con-structed a powerful hybrid idiom. The gallery also shows several sculptors: Oded Halahmy, Steve Linn, Claudio Mar-zollo, Jud Nelson and Reeva Potoff.

Other artists shown include Murray Alcosser, Susan Pear Meisel, Alan Dworkowitz, Evelyn Ellwood, Mel Ramos, Jerry Williams, Alan Wolfson and Gahan Wilson.

55 Mercer Artists 55 Mercer St., New York, NY 10013 (212) 226- 8513 Tue-Sat: 11-6, Aug: closed; dir: Tom Nozkowski
746

The gallery is an artist-run cooperative operated by a core of permanent members, painters and sculptors. Two shows are hung at any given time, either one-person exhibitions by members or guest group shows.

The gallery specializes in avant-garde art. Current members include Domenic Capobianco, Joan Gardner, Gloria Nozkowski, Joyce Robins, Elfi Schuselka, Carol J. Steen, Grace Wapner, Marilyn Giersbach, Mike Metz, Betti Sue Hertz, and Ethelyn Honig. Among the past members are Alice Adams, Tom Doyle, Janet Fish and Mary Miss.

The gallery has always maintained an open

attitude to new work. Members look at slides and studios to find artists for guest shows.

Edward H. Merrin Gallery Inc. 724 Fifth Ave., New
747 York, NY 10019 (212) 757-2884; Tue-Sat: 10-5
Jun-$Sep: Tue-Fri: 10-5 owner/dir: Edward H. Merrin

The gallery specializes in ancient art of the Mediterranean Basin and South America. Included in the inventory are pieces of Greek, Roman, Etruscan, Egyptian, Cycladic, and Near Eastern (Parthian, Sassanian, Bactrian) origin, as well as Pre-Columbian and Peruvian textiles.

The gallery handles work from the collection of Pre-Columbian art from the estate of William Palmer III.

Metro Pictures 150 Greene St., New York, NY 10012
748 (212) 925 8335 Tue-Sat: 10-6 Aug: closed;
owner/dir: Janelle Reiring & Helene Winer

The gallery presents young contemporary artists who work in a wide variety of media, including painting, sculpture, drawing and photography. The artists are generally identified with postmodernist concerns.

Robert Longo, well-known for large scale black-and-white drawings of urban figures in animated postures and sculpted reliefs of buildings, now is working in multi-panel combine pieces using drawing, painting and sculptural elements. Understated but precise drawing with gestural passages and flat, abstract planes characterize Longo's style, which succeeds in evoking the anxiety of urban life without resorting to overt statement. Cindy Sherman works in the photographic medium as director, actress and photographer to create a wide variety of female roles. Jack Goldstein's current paintings are dramatic images of space, sky and landscape. Thomas Lawson's paintings are based on newspaper images or photographs of city and landscapes overlaid with brushwork which serves both to redefine and obscure the image.

In presenting new work, the gallery emphasizes images that comment on contemporary cultural concerns. Mike Kelly's paintings, drawings, objects and performances present a loose personal narrative around a theme. John Miller's small paintings and drawings catalogue public and private scenes of Americana. Other new work includes Walter Robinson's paintings of stereotypical magazine and novel illustrations, the near-abstract photographs of James Welling, the painted drawings of Michael Zwack, the drawing and sculptural tableaux of William Leavitt, photographs of Louise Lawler, Laurie Simmons and Richard Prince, and the paintings of Dutch artist Rene Daniels.

Elise Meyer, Inc. 477 Broome St., New York, NY
749 10013 (212) 925-3527 Mon-Fri: 10-6 or by appt,
Aug: closed; owner/dir: Elise Meyer

A gallery concerned with the the human aspect of investigation and inquiry, Elise Meyer, Inc., exhibits an international group of young artists whose work takes up the dynamic issues raised by human systems such as architecture, mathematics, politics and nature. Styles run the gamut from easel painting to video and installation.

Works indicative of the programs of the gallery include Agnes Denes's quest to make invisible processes such as probability theory visible, the manipulated natural elements of David Nash, the complex mythological language of Charles Luce, or the literary and historical collage work of Alfred DeCredico. Other projects of gallery include site-specific installation, such as the large-scale porcelain environments of Cathey Billian, the stone and found-wood sculpture of Boaz Vaadia and the primitive-inspired work of Mary Beth Edelson. A further interest of the gallery is color photography; on view are works by Sandi Fellman, Barnaby Evans, and Maureen Paley.

Ms. Meyer is currently involved with a survey exhibition of expressionistic works by women artists. Previous traveling exhibitions have included a survey of installation drawings, a show of sculpture designed for corner spaces, and color photography surveys from France and Great Britain.

Midtown Galleries, Inc. 11 E. 57th St., New York,
750 NY 10022 (212) 758-1900 Tue-Sat: 10-5:30
Summer: Mon-Fri: 10-5:30 owner/dir: Mrs. Alan D. Gruskin

The gallery specializes in contemporary American art. Among the artists featured are Edward Betts, Isabel Bishop, Julien Binford, Paul Cadmus, Ruth Cobb, Charles Coiner, Bruce Currie, Stephen Etnier, Emlen Etting, Maurice Freedman, Ethel Magafan, Richard Mayhew, Fred Meyer, Hans Moller, Fred Nagler, William Palmer, Gregorio Prestopino, Jason Schoener, Robert Sivard, William Thon, Bernarda Bryson Shahn, and the estates of Doris Rosenthal and Waldo Peirce.

Robert Miller Gallery 724 Fifth Ave., New York, NY
751 10019 (212) 246-1625; Tue-Sat: 10-5:30 Aug:
closed; owner: Robert Miller dir: John E. Cheim

Concentration is on 20th century American painting, but also includes sculpture and photography. Stylistically, this is an eclectic gallery which shows both realist and abstract work.

The artists featured include Louise Bourgeois, a highly influential 20th century artist whose idiosyncratic sculptural forms present organic and autobiographical references; Lee Krasner, a noted Abstract Expressionist painter; and Alice Neel, a painterly realist particularly known for her intimate portraits of friends. The painting of Al Held employs overlapping geometric forms in contradictory perspective. Jedd Garet's new figuration painting contains ironic references to classical form and space. Louisa Chase's paintings use iconic images, gestural markings and subtly spatial color to create a poetic yet timely idiom. The gallery also shows works by Cubist painter Jean Helion, Janet Fish, George Sugarman, Alex Katz, Roberto Juarez, William Brice, Juan Hamilton, Rodrigo Moynihan, Robert Graham and Robert S. Zakanitch, and represents the estates of Ralston Crawford.

Robert Miller Photography handles works by Diane Arbus, Brassai, Francis Bruguiere, Heinrich Kuhn, Clarence J. Laughlin, George Platt Lynes, Robert Mapplethorpe, Man Ray, Paul Outerbridge, Jr., and Bruce Weber.

Alexander F. Milliken, Inc. 98 Prince St., New York,
752 NY 10012 (212) 966-7800 Tue-Sat: 10-6 Aug:
closed; owner/dir: Alexander F. Milliken

James Peale, *Still Life with Vegetables* (1826), 20 x 26, oil on canvas, Bernard & S. Dean Levy Inc. (New York,NY).

Gifford Beal, *Spring Riders,* 31 x 48, Kraushaar Galleries (New York, NY).

The gallery presents master artists and craftsmen in many different media, with an emphasis on aesthetic quality and technical perfection.

American master craftsman Albert Paley, ironworker, and Wendell Castle, furniture maker, bring these neglected disciplines into the realm of fine art with designs of extraordinary beauty and skill.

A consummate draftsman, Arnold Bittleman explores a fantastic, changeful world in black and white images that border on the monumental. Common objects become a subject for contemplation in the pastels of Mary Ann Currier, encaustic panels by Steve Hawley, paintings by Stephen Lorber and Kazuma Oshita's sculpture in hammered steel. Recent exhibitions include works in handmade paper by Lois Polansky, abstract paintings by Richard Saba, and urban landscapes by Paul Rickert.

Modern Master Tapestries 11 E. 57th St., New York, NY 10022 (212) 838-0412 Tue-Sat: 9:30-5:30; dir: Dominique Mazeaud
753

Modern Master Tapestries is one of the few galleries in the country which exclusively exhibits tapestries. Opened in 1972 by noted art dealer Charles E. Slatkin, the gallery initially housed the European tapestry collection of Mme. Marie Cuttoli, which included works of Picasso, Miro and Calder.

Through this collection and by working with contemporary artists the gallery stimulated interest in this ancient art in the United States and enlarged its collection. The gallery features handwoven pile and Aubusson tapestries in limited editions by Karel Appel, Roy Lichtenstein, Robert Motherwell and Isamu Noguchi and others.

In response to the recent appearance of a fiber art movement the gallery now shows works by Lenore Tawney, Lia Cook, Nancy Guay, Sherri Smith and many others. The new fiber artists use such techniques as weaving, lashing, wrapping, knotting, pleating, painting and stitching.

The gallery has representatives in more than twenty cities in the United States.

Morningstar Gallery Ltd. 164 Mercer St., New York, NY 10012 (212) 334 9330 Wed-Fri: 3:30-6:00; Sat-Sun: 12-6; dir: Jack Krumholz
754

Morningstar Gallery specializes in original, signed and numbered limited edition graphics, with an emphasis on realism. Most of the artists shown are modern or contemporary American and European printmakers.

As well as always having on hand distinguished prints by Picasso, Miro, and Chagall, the gallery displays works by Will Barnet, revealing his mastery of design in a realist style, by pop artist Tom Wesselmann, by Kaiko Moti, by Judith Shahn, and by many young contemporary printmakers.

The gallery also provides a "search and find" service for works by many of the artists it handles.

Multiples/Marian Goodman Gallery 24 W. 57th St., New York, NY 10019 (212) 977-7160 Mon-Sat: 10-6; owner/dir: Marian Goodman
755

Although the gallery began dealing exclusively in prints, painting and sculpture of international artists are now exhibited. Recently photography has been added.

Painting shown at the gallery includes work by German Neo-Expressionists Anselm Kiefer and Sigmar Polke, sculptors Tony Cragg and Anselmo (part of the "Arte Povera" group of Italian conceptualists), Swiss Expressionist painter Martin Disler, and Dutch painter Ger Van Elk, who manipulates photographic images with paint on canvas. Kiefer's imagery appears as an affirmation of German culture with an emphasis on the material qualities of paint and collaged elements. Polke borrows images from pop culture and recent art history and juxtaposes these dislocated fragments in a patterned yet unresolved context. Younger artists include German Expressionist painter Walter Dahn and Dutch painter Emo Verkerk.

Multiples, Inc., publishes and exhibits limited edition prints by prominent American and European artists. The gallery's publications encompass photographs, books, objects or furniture as well as print media. Current publications include works by Alice Aycock, Jennifer Bartlett, Jan Dibbets, Helen Frankenthaler, Sol Lewitt, Claes Oldenburg, Dennis Oppenheim, Robert Rauschenberg, James Rosenquist, Susan Rothenberg, Andy Warhol and Tom Wesselmann. Also, there are in stock earlier works by Shusaku Arakawa, Joseph Beuys, Marcel Broodthaers, Richard Hamilton, Robert Indiana and Roy Lichtenstein.

Other artists either published or exhibited by Multiples include Richard Artschwager, John Baldessari, Georg Baselitz, John Chamberlain, Dan Flavin, Gus Foster, Donald Judd, Robert Morris, Bruce Nauman, A.R. Penck, Mimmo Paladino, Bruce Porter, Ed Ruscha, Robert Smithson, Richard Tuttle and Robert Wilson.

Galerie Naifs et Primitifs 172 Prince St., New York, NY 10012 (212) 325-0918; daily: 12-8; owner: Jacques Lehmann, Katou Fournier dir: Dominique Du Pont
756

As its name suggests, the Galerie Naifs et Primitifs handles works by artists with no formal training, who often gain in spontaneity what they lack in technique. The work exhibited includes paintings, lithography and reproductions by many European and American contemporary naive artists.

Most of the work is realistic in intention, although some naives work in "metaphysical" or abstract styles. There are the street scenes of Rudolphe Rousseau, landscapes of changing seasons by Cathe Waller, portraits by Magdalena Shummer, cats by Fanny Darnat, and scenes from Monet's house at Giverny by Monique Valdeneige. Bernard Partiot, however, paints in a surrealistic style.

Other artists whose work may be viewed at the gallery include Serge De Filippi, Christine Cipriano, Agnes Emanuelli, Marta Gaspar, Fanch, Annie Retivat, Gisele Pierlot and Suzan Tantlinger.

Eduard Nakhamkin Fine Arts, Inc. 1070 Madison Ave., New York, NY 10028 (212) 734-0271; Mon-Sat: 10-6 Sun: 12-5; owner: Eduard Nakhamkin dir: Nathan Berman
757

The work of contemporary Russian emigre artists finds a home in this gallery devoted to their particular vision. Frequently the object of official incomprehension and repression in their native land, which nevertheless was a center of the international avant-garde, their work may seem tame by woolier Western standards, yet it springs from an intensely personal way of seeing. Most are working in figurative styles, often with urgent social commentary and criticism in mind.

Yuri Krasny's paintings, pastels and small bronzes draw on folk and fine art traditions, with particular attention to the female figure. Oleg Tselkov's paintings are fiercely colored, surreal interpretations of the human figure. Shimon Okshteyn portrays Western city life with incisive irony. Mihail Chemiakin's muted still lifes, and works by E. Neizvestny, I. Tulipanov and E. Peker are also featured by the gallery.

Gallery Nature Morte 204 E. 10th St., New York, NY 10003 (212) 420-9544; Wed-Sun: 12-6:30 Aug: closed; owner: P. Nagy dir: P. Nagy, A. Belcher
758

Concentration of the gallery is on theoretical, critical and media-derived works.

Artists featured include Gretchen Bender, whose multi-media works explore technological power; Silvia Kolbowski, who re-contextualizes media images into feminist discourse; Steven Parrino and Julie Wachtel, who work in critical, mediated styles. Theoretical painters include Kevin Larmon, Peter Nadin and Richard Milani. Sculptors include Joel Otterson, Scott Richter and Not Vital. Guest curators have included Joseph Masheck, Tricia Collins and Richard Milazzo. Works are available by Ericka Beckman, Stephen Frailey, Sherrie Levin, Joseph Nechvatal, Kiki Smith and Michael Zwack.

The gallery functions as a forum for ideas and art. Well-known and unknown artists' works are exhibited in a schedule which mixes solos, groups, guest curators and project installations. Many prints, drawings and photographs by the artists represented are always available.

Neikrug Photographica Ltd. 224 E. 68th St., New York, NY 10021 (212) 288-7741 Wed-Sat: 1-6
759

One of the city's oldest photography galleries, this three-story space houses a wide selection of 19th and 20th century photography, an inventory of daguerrotypes and tintypes, an exhibit of antique cameras and a library of out-of-print photographic books.

The photographers exhibited include both major figures and younger, less well-known talents. Among the acclaimed artists are Eva Rubenstein, Bill Brandt, Cartier Bresson, Andre Kertesz, Irving Penn, Richard Avedon and Jay Jaffee.

Recent shows have featured Erika Stone, a documentary photographer who has developed a unique way of seeing. Martin Schwartz mounted his portfolio of twenty-five portraits of American artists. Patrizia della Porta creates abstract architectural studies in black and white. John Staszyn's black and white photographs show techniques of manipulation in front of the camera. Cibachrome color prints by Sandra Baker are multiple exposures of construction sites. Inge

Morath, Suzanne Szasz, Harvey Lloyd, Ellen Sandor and Barbara Norfleet also show their work.

Noortman & Brod, Ltd. 52 East 76th St., New York, NY 10021 (212) 772-3370; by appt only; owner/dir: R. Noortman, T. Brod, R. Merrington
760

The gallery specializes in old master paintings, particularly Dutch and Flemish works from the 16th through the 19th centuries. There is also an emphasis on English and French paintings, drawings, and watercolors from the 17th through the 19th centuries.

Among the artists available are Dutch painters Gerard Dou, Salomon Van Ruysdael, Jan van Gayens, and Manuel de Witte; British painters Joshua Reynolds, Richard Wilson, and Francis Towne, and famous American expatriate Benjamin West; French Impressionists Alfred Sisely, Renoir, Fantin-Latour, and Louis Valtat; and Flemish painters David Teniers and Jan Brueghel.

Annina Nosei Gallery 100 Prince St., New York, NY 10012 (212) 431 9253 Tue-Thu: 11-6; owner/dir: Annina Nosei
761

Now in its fourth year, the Annina Nosei Gallery shows works by the German Neo-expressionists and Italian New Image painters, as well as American painters.

Among the artists shown are New Image painter Mimmo Paladino, Neo-expressionist K. H. Hodicke, and American street artist Jean Michel Basquiat. Other artists include Francois Boisrond, David Bowes, David Deutsch, Barbara Kruger, Keith Milow, Sabina Mirri, Athos Ongaro, Stephen Mueller, Ira Richer, and Mario Schifano.

Novo Arts, Inc. 57 E. 11th St., New York, NY 10003 (212) 674-3093; Mon-Fri: 9-5 Sat-Sun: by appt; owner/dir: Lynda Deppe
762

Novo Arts acts as a consultant for architects, corporations and individual investors or collectors, providing indoor/outdoor commissions, curatorial design of exhibitions, and framing, installation and catalog services.

House inventory includes numerous well-known artists, such as Jim Dine, Arakawa, Joseph Beuys, Sandro Chia, Christo, Francesco Clemente, David Hockney, Jasper Johns, Roberto Longo, Dennis Oppenheim, James Rosenquist, Robert Rauschenberg, Claes Oldenburg, Susan Rothenberg, Frank Stella, Cy Twombley, Andy Warhol and others.

A large collection of younger artists working in all media is maintained on exhibition. The affiliated publishing operation, *Novo Press*, publishes fine art editions in etching and silkscreen.

Oil & Steel 157 Chambers, New York, NY 10007 (212) 964-1567; Tue-Fri: 11-5:30 Sat: 11-6; owner/dir: Richard Bellamy
763

Gallery founder Richard Bellamy is former director of the Hansa, a gallery founded by the pupils of Hans Hofmann, which played an historic role in the Abstract Expressionist movement. Bellamy opened Oil & Steel in 1980. The Tribeca gallery is on the 13th floor of a 1930s commercial building overlooking the Hudson

River. The art shown spans several decades and features established artists.

Bellamy favors group shows that usually feature works from the 1950s, 1960s, and 1970s. The four to six annual shows feature important works by major artists of the period. Among the frequent exhibitors is Mark di Suvero. Other sculptors shown include David Rabinowich, known for his massive steel planes; Richard Nonas, who recently has worked in wood as well as steel; Michael Heiser, an earth artist who favors work in block granite; and Crozier, who creates erotic sculptures.

The gallery also shows painters Myron Stout, Jan Mueller, Manny Farber, Gregoire Mueller, Alfred Leslie, and Stephen Ludlam.

Orion Editions 835 Madison Ave., New York, NY
764 10021 (212) 535-3006; Tue-Fri: 11-5:30; dir: Fred Deitzel

Orion Editions publishes original, limited edition prints and works on paper. Among the artists published are Jane Freilicher, Nancy Hagin, Harriet Shorr, Michael Goldberg, David Shapiro, Terence La Noue, Hugh Kepets, Richard Chiriani, Bill Sullivan, Harry Soviak, Elsie Manville and Paul Brach.

Pace Editions 32 E. 57th St., New York, NY 10022
765 (212) 421-3237 Tue-Sat: 9:30-5:30 Summer: closed Sat; owner: Richard Solomon dir: Kristin Heming

Initially established to publish and exhibit prints and multiples by artists represented by the Pace Gallery, Pace Editions has expanded as both a publisher and dealer in contemporary prints. An extensive selection of museum-quality prints from many contemporary print publishers is available and on display, in addition to those works published by Pace.

Artists whose prints and multiples are published by Pace Editions on an exclusive basis are Chuck Close, Jim Dine, Jean Dubuffet, Michael Mazur, Don Nice, Louise Nevelson, Lucas Samaras, Saul Steinberg, Ernest Trova, and Joe Zucker.

The Pace Gallery of New York, Inc. 32 E. 57th St.,
766 New York, NY 10022 (212) 421-3292; Tue-Fri: 9:30-5:30 Sat:10-6 Summer: closed Sat; owner: Arnold Glimcher dir: Renato Danese

The gallery exhibits paintings and sculpture by leading American and European contemporary artists.

The artists represented encompass a wide range of styles and media, working in painting, watercolor, drawing, collage, graphics, sculpture, and tapestry. Julian Schnabel's painting is arguably the strongest American contribution to the new Expressionism taking root on both sides of the Atlantic. At one time typically studded with broken plates, his paintings present an hermetic iconography charged with a painterly violence that does not conceal his considerable skill with the figure. At an opposite pole, the work of California artist Robert Irwin uses reduced yet sophisticated means to evoke the intangibles of space, time and consciousness in installations and sculptural wall pieces. Other artists featured include Chuck Close, Jim Dine, Jean Dubuffet, Barry Flanagan, Julio Gonzalez, Alfred Jensen,

Brice Marden, Agnes Martin, Louise Nevelson, Isamu Noguchi, Pablo Picasso, Ad Reinhardt, Mark Rothko, Lucas Samaras, Tony Smith, Saul Steinberg, Ernest Trova, and David von Schlegell. The gallery also represents the estate of Alexander Calder.

In addition to regular exhibitions of works by these artists, the gallery handles large-scale sculpture commissions by Dubuffet, Nevelson, Noguchi, Smith, Trova, and von Schlegell.

Illustrated catalogues with essays by major art critics and historians accompany most of the exhibitions.

Pace/MacGill Gallery 11 E. 57th St., New York, NY
767 10022 (212) 759-7999; Tue-Sat: 9:30-5:30 Summer: closed Sat; owner/dir: Peter MacGill

The emphasis of the Pace/MacGill Gallery is 20th century photography. Two shows are held each month during the season, and a large group show is presented each summer.

Recent exhibitions have featured photographs by Harry Callahan, Robert Frank, Jim Goldberg, Mark Klett, Joe Maloney, Nicholas Nixon, Lucas Samaras, Stephen Shore, and Joel-Peter Witkin. A show in Fall 1984 presented photography by four emerging artists: Eliot Schwartz, Lorne Greenberg, Hideji Nagura, and Gaylord Herron.

Pace Primitive 32 E. 57th St., New York, NY 10022
768 (212) 421-3688; Tue-Fri: 9:30-5:30 Sat: 10-6 Summer: closed Sat owner: Richard Solomon dir: Lisa Bradley

The gallery specializes in traditional sculptures from the art-producing areas of West and Central Africa. Most of the authentic, rare pieces date from the turn of the century, though some are ancient.

A permanent exhibition space open to the public displays a selection of African sculpture. The exhibitions change approximately every four weeks. Major exhibitions are held on the second floor. Among the recent major shows were works by the Yoruba tribe, selected masterpieces of African art, and a group show of African spirit images.

Painting Space Gallery 150 First Ave., New York,
769 NY 10009; (212) 533-4624; Thu-Sat: 12-6 mid-Jun-Labor Day: closed; dir: Arthur Natale

Painting Space is a not-for-profit gallery run by artists for artists who want to curate their own shows. Only group shows are hung. Some time is available for professional curators, as well. Shows have ranged from local to international work, and have focused on a wide range of concerns, from political art to formalism.

Shows have included the work of Keith Haring, whose images derived from graffiti and street art are becoming well-known, and Mark Tansey's paintings satirizing art and politics. Nancy Spero, whose work voices social concerns of feminism and world peace through juxtaposed texts and images, has also shown here. Critics John Perreault and Jeff Perrone have shown their works as well.

The gallery is particularly attentive to the work of younger, emerging artists and all artists whose work is perhaps more experimental than commercial, and consequently have not had wide exposure.

John Alexander, untitled (1982), 22 x 30, pastel on paper, Marlborough (New York, NY).

John George Brown, *The Stump Speech*, 28 x 44, oil on canvas, Ira Spanierman Inc. (New York, NY).

Payson-Weisberg Gallery 822 Madison Ave., New
770 York, NY 10021 (212) 249-1666; owner: Susan
Weisberg dir: Lisa Morgan The gallery specializes in late 19th and 20th century painting. Some contemporary artists are present, in particular artists working in the state of Maine.

American artists featured include 19th century landscape painter Thomas Moran, Ashcan School founder Robert Henri and many of his students such as George Bellows and William Glackens. Raphael Soyer continued in their line of social commentary in an Impressionist style. Works by Don Freeman, a social realist of the 30s are also available, as well as paintings by William Morris Hunt, Alfred Thomas Bricher, Bruce Crane, Ivan Olinsky, David Johnson, C.P. Ream and Chauncey Ryder. Contemporary artists include mixed-media artist Elaine Anthony, Neo-Expressionists Joan Banach and Gary Buch, sculptors Bernard Langlais and Celeste Roberge. Michael Dillon works in pastels. Beverly Hallam paints flowers, while John Laurent paints fish. Laurence Sisson paints Southwestern landscape.

Marilyn Pearl Gallery 38 E. 57th St., New York, NY
771 10022 (212) 838-6310; Tue-Sat: 10-5:30 Aug: closed; owner/dir: Marilyn Pearl

The gallery features both established and young, emerging artists. They include Stephen Greene, now working in an abstract and free-form manner, and Michael Loew, who continues to create abstractions. Matt Phillips's large monotypes reveal a subtle coloration and sense of place. Bernard Chaet's figurative works and Richard Lytle's abstract landscapes are also part of the gallery's offerings.

Among the other artists shown by the gallery are sculptors Winnifred Lutz and Lawrence Fane, and painters Anna Bialobroda, Clinton Hill, Henry Pearson, Pedro F. Perez, Leo Rabkin, Barbara Siegel and Charmion Von Wiegand.

Marie Pellicone 47 Bond St., New York, NY 10012
772 (212) 475-3899 Tue-Sat: 12-5:30 Jun-Aug: closed; owner/dir: M. Pellicone

The Marie Pellicone Gallery offers 20th century American contemporary art, including paintings, sculpture and works on paper.

Among the artists featured by the gallery, Ted Jeremenko is an American primitive who works in acrylics, depicting exactly rendered early American houses in stylized, atmospheric landscapes. Richard Toglia works in colored graphite and oils, creating symbolic landscapes with strips of color. Anna Jurinich's graphite and pen-and-ink drawings recall the 14th century masters in their handling of complex groups of figures. Mort Ostrer works in painting media which he merges with photographic collage to create surreal Southwestern landscapes. Rita Hill Torlen's epic paintings of masked Mexican wrestlers employ a scale as grand as her muscular subjects, yet she also creates gentle landscapes and psychological portraits. Joan Giordano makes her own paper which she uses in hanging sculptures and earth-toned reliefs.

Other artists shown include Charles Ames, assemblage boxes of found objects; Gary Arceri, pastoral scenes; Vincent Baldassano, high-key acrylic works on paper and canvas; Michael

Fedorov, detailed drawings of horses and landscapes; Tony Giliberto, formal designs in muted relief colors; Fry Karins, lyrical abstraction; Janet Kulesh, cloud and landscapes; Annabelle Meacham, surreal humor; Ken Nisson, vibrant impressionist landscapes; William Pellicone, landscapes and still lifes; Denise Regan, high-key, stark landscapes and houses; Jacqueline Wilentz, lush flower paintings; and Amy Zerner, tapestries.

Marie Pellicone operates a gallery in Southampton, New York, during the summer months.

Perls Galleries 1016 Madison Ave., New York, NY
773 10021 (212) 472-3200 Tue-Sat: 10-5 Summer: closed; owner: Klaus G. Perls

This elegant, fifty year old gallery has the appearance of a small museum. It has always specialized in School of Paris paintings, watercolors, drawings and sculpture. This group includes such artists as Georges Braque, Chagall, Dali, Raoul Dufy, Juan Gris, Fernand Leger, Henri Matisse, Miro, Modigliani, Jules Pascin, Picasso, Georges Roualt, Chaim Soutine, Maurice Utrillo, Kees van Dongen and Maurice de Vlaminck.

Also strongly represented are Camille Bombois, Andre Bauchant and Louis Vivin, who work in a primitive style. The sculpture of Alexander Archipenko, Aristide Maillol and Alexander Calder is shown, in addition to occasional pieces by Miro, Braque and Picasso.

American artist Darrel Austin, who paints fantasies of landscapes, animals, and people, recently had his first major show at the gallery.

Marcuse Pfeifer Gallery, Ltd. 568 Broadway, Suite
774 102, New York, NY 10012 (212) 226-2251; Sep-May: Tue-Sat: 10-5:30; Jun-Aug: Mon-Fri: by appt; owner/dir Cusie Pfeifer

In its new location across from the New Museum on the eastern edge of Soho the Marcuse Pfeifer continues to show photography. Most works are by lesser-known contemporary photographers, but there is a selection of vintage 19th century photographs as well. An ongoing project of the gallery is the exhibition of work by older photographers, especially women, who have been well-known but are now almost forgotten.

Many of the gallery artists were given their first show at the gallery. Lilo Raymond does interiors filled with light and simple objects. Olivia Parker composes still lifes with objects from her attic. Rosamund Purcell builds her pictures with collage and multiple images on Polaroid materials. Also on view are Timothy Greenfield-Sanders's portraits made with an ancient large format camera, David Hanson's one-of-a-kind books with tipped-in photographic images that are usually homages to pioneers in the field, and Lois Conner's platinum prints of landscapes. Frederick Cantor is a painter as well as a photographer. Hiromitsu Morimoto makes large prints of white subjects such as bathrooms, shirts and towels. Keiichi Tahara takes numerous photographs from the windows of his Paris apartment. Roberto D'Alessandro focuses on landscape in New Mexico and architecture in New York. Paul Cava makes mixed-media work, usually erotic, with old photos and found images.

"Forgotten" artists exhibited by the gallery

include Carlotta Corpron, whose abstract work had not been shown since the 50s; Clara Sipprell, a pictorialist not seen in New York since the 20s; Nell Dorr, who had been known only from her books, mostly about mothers and children; and Fred Korth, who worked for *Fortune* magazine in the 1930s and early 1940s. Most recently the gallery has shown the work of Trude Fleischmann, who had a distinguished career in pre-World War II Vienna as a portrait photographer, and continued to work in this country and Switzerland.

The gallery maintains an inventory of the works of Eugene Atget, George Platt Lynes and Weegee. Anonymous works and rare 19th century works by pioneers in the field can also be seen. Prints by the masters of photography are available on request.

A Clean Well-Lighted Place 363 Bleecker St., New
775 York, NY 10014 (212) 255-3656 Tue-Sat: 12-7 Sun: 1-5 Summer: closed Sun; dir: Thomas Martinelli

Concentration is on contemporary prints with a special interest in emerging artists who make their own prints.

Masaaki Noda's screenprints are flowing abstractions that portray his inner concepts with technical virtuosity. Mary Teichman's four-plate color etchings are full of personal symbols and universal themes. Thom DeJong's relief prints are well-known for combination of bright colors and subtle humor. Other artists include Lynn Shaler, Maria Henle, Charles Roy Purcell, Leni Fried, Wil Klaassen, Sarah Sears, Will Barnet and Raphael Soyer.

Theo Portnoy 162 W. 56th St., New York, NY 10019
776 (212) 757-1461 Tue-Sat: by appt Jul-Aug: closed; owner/dir: Theo Portnoy

Concentration is on 20th century sculpture, with special emphasis on clay, wood and forged metal. There are some abstract works, but most work shown is figurative.

Ceramic artists include Ralph Bacerra, Jack Earl, Martha Holt, Lucian Pompili, Victor Spinski and Bill Stewart. Mary Ann Toots Zynsky's work in glass is made in the U.S., Holland and Italy. Tommy Simpson's wood sculpture is in many well-known collections.

1984 marks the publication of a book by Lee Nordness on the work of Jack Earl, which will be celebrated with an exhibition of his ceramics at the Theo Portnoy Gallery.

P.P.O.W. 216 E. 10th St., New York, NY 10003
777 (212) 477-4084; Aug: closed; owner/dir: Penny Pilkington, Wendy Olsoff

P.P.O.W. is known for showing the work of emerging international artists who work in a variety of styles and media. The gallery has shown figurative political work as well as abstract paintings and sculpture. The gallery seeks artists who express continuity and strength in content and form.

Political artists are best represented by Sue Coe, Paul Marcus and Kathy Grove, who are concerned with revealing the political and social turmoil of our century. Paul Benney also reveals much turmoil in his paintings, executed on photosensitized canvas, but that of psychological unrest. Larry Silver, an abstract painter, tries to evoke a union between the primitive and the futuristic with his personal iconography. Tom Dillon paints beautiful detailed paintings of decay and disintegration.

P.P.O.W. also presents the work of Michele Zalopany, who executes monumental charcoal drawings of architectural sites and mysterious landscapes. Walter Martin, a sculptor, is concerned with history and its relation to the present. P.P.O.W. also has work by Jed Jackson, Richard Tuschman, Marc Travanti and Rande Barke.

Prakapas Gallery 19 E. 71st St., New York, NY
778 10021 (212) 737-6066; Tue: 12-9 Wed-Sat: 12-5; owner/dir: Eugene Prakapas

20th century art is the gallery's main concern, with special emphasis on its European manifestations. Particular attention is given to photography.

The gallery has a rich selection of work by Laszlo Moholy-Nagy, Man Ray, Florence Henri, Le Corbusier, J.J.P. Oud, Hans Bellmer, Piet Zwart, Ralph Steiner, Herbert Bayer, and various Bauhaus artists. It also has scattered examples of work by artists such as Russian Constructivist El Lissitzky, Victor Brauner, E. McKnight Kauffer, Cesar Domela, Sandor Bortnyik and Fernand Leger.

Galeria Joan Prats 29 W. 57th St., New York, NY
779 10019 (212) 486-6770; Tue-Sat: 10-5; owner: Juan de Muga dir: C. van der Voogt

First established in Barcelona, Spain, in 1975, the gallery generally presents works by major European contem-porary artists who have come into contact with the gallery through its publishing house, Ediciones Poligrafa. Since the establishment of a New York branch in 1981 this group has widened to include several American artists.

The group includes such European artists as Miro, Henry Moore, Christo, Hans Hartung, Julio Gonzalez, Antoni Tapies, Max Ernst, Zao Wou-ki, and a growing roster of American artists such as Kenneth Noland, Rufino Tamayo, Jose Luis Cuevas and Fritz Scholder. The gallery also presents contemporary Catalonian artists Albert Rafols Casamada and Hernandez Pijuan, informal abstract painters; Josep Guinovart, an abstract painter noted for his installations; and Frederic Amat, whose paintings often involve found objects and assemblage; as well as young American artists Jim Bird and Brian Nissen.

Pratt Manhattan Center Gallery 160 Lexington Ave.
780 at 30th St., New York, NY 10016 (212) 636-3517; Mon-Fri: 10-6 Sat: 10-5 Aug: closed; dir: Ellen Schwartz

The gallery focuses on contemporary art through thematic exhibitions of work in all media by established and emerging artists. Though owned by Pratt Institute, a school which has played an historic role in American art and design, the gallery mostly exhibits artists who are not affiliated with the school.

The format of exhibitions serves to sort out and interpret current trends in the arts, even if it means taking esthetic risks. For example, the 1983-84 season featured alternatives to the Inter-

national Style in Third World architecture; childhood and mature work by master printmakers; satirical prints, etc. About 200 artists are exhibited annually.

Exhibits are organized alternately with the Pratt Graphics Center, Andrew Stasik, director, and the Department of Exhibitions. Many exhibitions go on view subsequently at the Pratt Institute Gallery, Brooklyn campus, and other institutions nationally.

Ellen Price 26 W. 75th St., New York, NY 10023
781 (212) 580-9734 by appt; owner/dir: E. Price

The principal focus of the gallery is on German and Austrian Expressionists, and contemporary American abstract artists.

Works are available by some of the most influential artists of the 20th century, including Paul Klee, an artist of immense sophistication and simplicity whose theoretical work as a teacher at the Bauhaus brought techniques of musical composition to bear on pictorial composition. One may also view works by Kurt Schwitters, a pioneer of assemblage; George Grosz, an outspoken social critic; and American expatriate Lyonel Feininger, who exhibited with Klee in the Blaue Reiter group.

Contemporary American abstract artists exhibited include Michael Chandler, Louis Lieberman, Ross Neher, Claire Seidl and others.

Prince Street Gallery 121 Wooster St., New York,
782 NY 10012 (212) 226-9402 Tue-Sun: 12-6 Jul & Aug: closed

Prince Street Gallery is a cooperative, artist-run gallery, one of the first in the Soho area to promote repre-sentational art—including figurative art, landscape and still-life. All its artists are American contemporaries.

Prince Street has recently shown the work of Selina Trieff, known for her dramatic self-portraits and portraits of pigs; as well as Gina Werfel's Maine landscapes, Don Kines's paintings of Poppoldpen Creek, and Robert Braczyk's figurative sculpture.

Other artist members are landscape expressionists David Acker, Don Kimes and Sally Amster; perceptual painters Monica Bernier, Cynthia Costello, Gerald Marcus, Frances Siegel, David Lowe, Mary Salstrom, Sharyn Finnegan, Christopher Semergoeff, Janet Schneider, Alexander Wallace and Nancy Prusinowski; still life painters Marion Lerner Levine, Marie Annick Brown, Norma Shatan and Elizabeth Grubic. Arthur Levine paints surreal, expressionistic seascapes; Peter Martinez, heavily impastoed portraits and still lifes. Susan Grabel is a sculptor of socially conscious environments.

Recently the gallery has had invitational exhibits including the work of such well-known contemporary realists as Leland Bell, James Weeks, Lennart Anderson, Louisa Mattiasdotir, Herman Rose, Paul Resika and others.

Printed Matter, Inc. 7 Lispenard St., New York, NY
783 10013 (212) 925-0325 Tue-Sat: 10-6; dir: Nan Becker

A non-profit corporation for selling books, periodicals and audioworks made by contemporary artists, Printed Matter has a selection of 2,000 titles by over 1,000 artists. Editions number at least 150. Style and content cover a broad range: narrative, photo-narrative, figurative, minimalist, conceptualist, performance, feminist, political, etc. The selection is international, though most of the artists are American.

Some of the artists, such as Sol Lewitt, Ed Ruscha and Joseph Kosuth, are already major figures; many are young or unknown. Some work only in book format. A short list of artists might include Lawrence Weiner, Barbara Kruger, Richard Nonas, Jenny Holzer, Hans Haacke, Dan Graham, John Baldessari, Chris Burden, Carolee Schneemann, etc.

A complete catalog of artists and titles is available.

Max Protetch Gallery 37 W. 57th St., New York, NY
784 10019 (212) 838-7436; Tue-Sat: 10-6; owner: Max Protetch dir: Larry Shopmaker

The gallery deals in contemporary painting, sculpture, architectural drawing, and pottery. The gallery has pressed to see architecture be accepted as an art form, that of sculpture on a human scale. A primary interest of the gallery is in large-scale environmental sculpture. Several distinguished Post-Modernist architects, whose work has emphasized the gratuitous pleasures of form and space over pure functionality, are included among the gallery's regularly exhibited artists. Some of the other artists work with architectural imagery, as in earth art or documented temporary structures, or use of architectural perspectives and scale in painting and sculpture.

Artists featured by the gallery include Siah Armajani, Scott Burton, Farrell Brickhouse, Pinchas Cohen Gan, Jackie Ferrara, Richard Fleischner, Denise Green, Will Insley, Mary Miss, Philip Pavia, David Reed and Betty Woodman. Works are available by Minimalists Sol LeWitt and Robert Mangold.

Architects whose work is displayed at the gallery are Michael Graves, who is known for his murals as well as for his unconventional architecture; the firm of Venturi, Rauch, Scott Brown, who took an early leading role in the demise of glass-box architecture; and John Hedjuk, Rem Koolhaas, Leon Krier, and Aldo Rossi. Architectural photographer Ezra Stoller's work, and drawings from the estate of Frank Lloyd Wright may also be viewed.

Included in the gallery's inventory are sterling silver coffee and tea services designed by architects, and fabricated by Alessi, s.p.a., in Milan.

Raydon Gallery 1091 Madison Ave., New York, NY
785 10028 (212) 288-3555; Mon-Sat 11-6; dir: Alexander R. Raydon

The gallery carries works of art in all media from the Renaissance to the present, with emphasis on 19th-20th century American and European art, in addition to Old Master drawings and paintings.

American works come from a wide range of tendencies: Hudson River School, Tonalists, Impressionists, Regionalists, WPA artists, Naives, Abstract and Contemporary. The European works cover a similarly broad spectrum from Western Europe, Poland and Russia.

One may see work by the following artists: Johann Berthelsen, Albert Besnard, Norman Bluhm, Charles Burchfield, Marc Chagall, Gene

Robert Mapplethorpe, *Lisa Lyon—Paris* (1982), photograph, Robert Miller Gallery (New York, NY).

Frederick Brown, untitled, 24 x 36, oil on canvas, Marlborough Gallery (New York, NY).

Charlton, A.B. Davies, Eugene Higgins, Antonio Jacobsen, Henri Lebasque, DeWitt McClellan Lockman, Jane Peterson, Irene Rice-Pereira, Jean Riopelle, Florence Robinson, Roger Selchow, Rodulfo Tardo, Helene Trosky and Taro Yamamoto. Other artists shown include Gisela Hernandez, Oscar Thalinger and Victor Volodin.

Reinhold-Brown Gallery 26 E. 78th St., New York,
786 NY 10021 (212) 734-7999 Tue-Sat: 10:30-5; dir: Susan Reinhold & Robert Brown

This gallery specializes in graphic design from 1910 to 1940, with a particular emphasis on posters and design from the avant-garde of the 1910s and the 1920s. The gallery also exhibits and sells posters from 1950 to the present, as well as three-dimensional work by Japanese designers. The upstairs gallery is devoted to three or four yearly exhibitions, which focus on poster history or work by a notable graphic designer.

A large selection of rare typographic and photomontage posters is available. Among the artists likely to be found are major figures of such movements as the Vienna Secession, Bauhaus, Dada and Russian Constructivism, as well as important 20th century architect-designers. The gallery offers commercial posters (promoting products, travel, fashion and culture) by outstanding designers from 1900 to the present. These include Ludwig Hohlwein, A.M. Cassandre, Lucien Bernhard, Michael Graves and others.

A strong emphasis is also given to work being done by contemporary Japanese graphic designers: the "architectural alphabets" of Takenobu Igarashi, innovative package design by Katsu Kimura, the visual illusions and puns of Shizeo Fukuda, and the artist-robots of Keisuke Oki.

Sarah Y. Rentschler Gallery Penthouse 450 W. 24th
787 St., New York, NY 10011 (212) 929-0192; Tue-Sat: 12-5 and by appt Jun-Sep: closed; owner/dir: S.Y. Rentschler

This is not a gallery one can visit knowing beforehand the fame and style of the artists whose work is exhibited, but a space to discover new art. The gallery mostly shows work by emerging American artists. Media shown include painting, sculpture, works on paper and photography.

Works on display include the abstract oils of Susan Rowland, oil and mixed media works by David Geiser, aluminum sculpture by George Mittendorf, acrylic paintings on canvas and paper by Francine Tint, oil paintings on canvas and paper by Dinah Maxwell Smith, photographs by Jonathan Becker, gouaches by Peanna Sirlin, oil on canvas and oil stick and pastel on paper works by Billy Sullivan, and welded steel sculpture by Andrea Woodner.

Ricco-Johnson Gallery 475 Broome St., New York,
788 NY 10013 (212) 966-0541; Tue-Sat: 11-6; owner/dir: Roger R. Ricco

Set in New York's Cast Iron District, a former machine shop was transformed to showcase American folk art. The gallery carries pieces which span the centuries as well as a selection of contemporary work. A wide variety of work is shown in the constantly changing exhibits, but one may count on finding early New England Colonial furniture, including Pilgrim furniture,

whirligigs, old tools and promotional display objects. Works by early American and contemporary folk artists, typically unschooled craftspeople who work without the influence of contemporary art styles, are always on display. Figures, fanciful sculpture, furniture in twig, grain-painted wood and carved wood, Mennonite and Amish quilts and hand-hooked rugs, paintings and weathervanes are also regularly available.

The gallery is a work of art itself. Designer Lawrence Shapiro breathed new life into a landmark building where art may be seen on many levels with niches and private viewing areas that guide the visitor through several different environments.

Rizzoli Gallery 712 Fifth Ave., New York, NY 10022
789 (212) 397-3712 Mon-Sat: 10-10 Christmas Season: Sun: 12-5; dir: John Brancati

The gallery is located on the mezzanine level of the Rizzoli Bookstore, which carries books on literature, art, photography, design and architecture, as well as foreign periodicals and classical records.

The gallery has featured work by architects, designers, illustrators and photographers. Among important shows was an exhibit of architectural illustrations and models, with works by Robert A.M. Stern, Charles Moore and Rob Krier. Other shows have featured originals by prominent book illustrators such as John Collier, Paul David, Daniel Maffia, Bob Peak and Bernie Fuchs; decorative screens by architects Stanley Tigerman, Michael Graves, Richard Haas and Robert A.M. Stern; playful mechanical and sound pieces by inventor Christian Thee, and an installation by architects Jean-Pierre Heim and Christine Feuillette.

Photography exhibits have displayed images by contemporary photographers Ruth Orkin and Arthur Rothstein. Portfolios available by contemporary artists and photographers include works by Picasso, Chagall, Giorgio de Chirico, Moses Soyer and Alfred Stieglitz.

See also listing for Chicago, Illinois.

Margarete Roeder Fine Arts 545 Broadway, New
790 York, NY 10012 (212) 925 6098 by appt Jul-Aug: closed; owner/dir: Margarete Roeder

Two notable features of contrmporary art have been the fuzzing of the boundaries that formerly separated artforms and the ephemeral nature of many of its products. Musical scores and choreography may be seen as drawings, complete in themselves, while other works, dependent on time and place as music and dance are, survive only as documents, testimony of past events. This gallery specializes in such objects, and in contemporary drawings and prints, and also carries some painting and sculpture.

Both American and European composers, performers and artists are presented, including John Cage, Philip Corner, Merce Cunningham, Ruth Marten, and Gary Kuehn, from North America, and Arnulf Rainer, Guenter Brus, Peter Chevalier, Fernand Roda, and Elke Lixfeld, from Europe.

Rolly-Michaux 943 Madison Ave., New York, NY
791 10021 (212) 535-1460; Tue-Sat: 10:30-5:30; owner: Ronald Rolly & Ronald Michaux

The gallery carries modern master graphics by American and European contemporary artists, as well as paintings, drawings and sculpture.

Etchings and lithographs are available by painters Karel Appel, Marc Chagall and Pablo Picasso; sculptors Henry Moore and Marino Marini; and designer and fiber artist Sonia Delaunay. Aquatint etchings and early lithographs by Joan Miro are also available, as well as gouaches by Alexander Calder. The gallery handles the intricate puzzle sculpture of Spanish artist Miguel Berrocal.

One may also see paintings and silkscreens by Thomas McKnight, I-beam sculpture by Al Wilson, drawings and watercolors by George d'Alameida, and the work of Mexican artist Jose Garcia Ocejo.

Ronin Gallery 605 Madison Ave., New York, NY 10022 (212) 688-0188; Mon-Sat: 10-6; owner/dir: Roni Neuer
792

Designed in Japanese style with furniture by George Nakashimi, *shoji* screens and a rock garden, the gallery is a major source for Japanese fine art. fine art.

The gallery maintains a collection of over 10,000 woodblock prints from the earliest *ukiyo-e* masters to present day artists. Among the artists creating "pictures of the floating world", the transient world of *ukiyo-e*, are 17th century master Moronobu; 18th century masters Utamaro, Harunobu and Kiyonaga; and 19th century masters Hokusai, Hiroshige, Kuniyoshi, Toyokuni and Yoshitoshi.

The gallery also has a fine collection of *inro*, small lacquer boxes once used by Japanese men, and *netsuke*, small pendants of wood or ivory used to counterbalance the *inro* on a gentleman's sash. Most of these objects, as well as the gallery's collection of Japanese jewelry, are not on display, but may be viewed on request.

Major exhibitions have included the works of master Utamaro, and a series of landscapes by Hiroshige, *Fifty-three Stations of Tokaido*. Once a year the gallery hangs a major exhibition of contemporary woodblock prints.

A large selection of books on Japanese art is available, as well as gallery posters and a mail order catalog, *The Japan Collection,* enumerating the items for sale, which range from handmade paper to fine art.

Alex Rosenberg Gallery/Transworld Art 20 W. 57th St., New York, NY 10019 (212) 757-2700; Mon-Sat: 10-5 Jul & Aug: Mon-Fri: 10-5; owner/dir: Alex Rosenberg & Carole Rosenberg
793

The gallery specializes in paintings, sculpture, drawings and prints by American and European contemporary artists.

Among the works shown are realist paintings and pastels by Howard Kanovitz, abstract painting by James Coignard and Manoucher Yektai, abstract sculpture in combined metals by Lila Katzen, constructions and collages of found materials by Ilse Getz, and fan- and wing-like structures by Sven Lukin. One may also see the calligraphic abstractions of Mark Tobey, bronzes and drawings by Henry Moore, and the photographs of Gordon Parks and Michael Halsband.

Other artists are Stephen Woodburn, Ann Chernow, Diana Kurz, and Stephen Brown, who

work in representational styles and Giancarlo Impiglia, whose painting and sculpture reveal artistic resolution and acute social concern.

Transworld Art has published original graphics, multiples and art posters since 1969. Its collection includes work by noted contemporary masters Yaacov Agam, Romare Bearden, James Coignard, Dali, Paul Jenkins, Conrad Marca-Relli, Miro, Henry Moore, Rufino Tamayo, Mark Tobey, Esteban Vicente, Tom Wesselman, Jack Youngerman and others, as well as emerging printmakers such as Susan Elias, Claus Hoie, Harry Koursaros, Phyllis Sloane and Stan Taft.

Paul Rosenberg and Co. 20 E. 79th St., New York, NY 10021 (212) 472-1134 Mon-Fri: 10-5; dir: Alexandre P. Rosenberg
749

First established in Paris in 1878, the gallery originally showed noted French Impressionist and Post-Impressionist artists. For three generations the Rosenberg family has continued this tradition. The focus of the gallery is now on selected European masters, primarily French and Italian artists from the 1400s to the early 20th century.

Paintings, drawings and sculpture displayed are from the hand of such masters as 17th century artists J.B. Rude and Antoine Coypel, 18th century rococo artist Giambattista Tiepolo, and 18th century artist Pierre-Paul Prudhon. Also exhibited are 19th century French artists including Jean Auguste Dominique Ingres, and a multitude of Impressionists and Post-Impressionists featuring Auguste Renoir, Claude Monet, Edouard Manet, Edgar Degas, Paul Cezanne, Paul Gauguin, and Vincent van Gogh, as well as Fantin-Latour, Eva Gonzalez, Georges Seurat and Edouard Vuillard. Works by Matisse and Picasso are also available.

Rothschild Fine Arts, Inc. 205 West End Ave., New York, NY 10023 (212) 873-9142; by appt; owner: Carolyn & John Rothschild
795

This is a private gallery which both buys and sells late 19th and 20th century European and American paintings, drawings and sculpture. Areas of concentration include French Impressionism and Post-Impressionism, School of Paris, American Impressionism, the Ashcan School, and contemporary masters.

Currently available works include a 1908 painting by Georges Braque, a two-figure three foot high Auguste Rodin sculpture, an early Helen Frankenthaler stain painting and a Robert Motherwell paper work from the "Beside the Sea" series. Frequently shown artists include Claude Monet, Camille Pissarro, Andre Dunoyer de Segonzac, Reginald Marsh, Gifford Beal, Rene Magritte and Alexander Calder.

The gallery is always interested in purchasing work by Alfred Jensen. Contemporary artists available include Wolf Kahn and Hunt Slonem, as well as occasional avant-garde works by such artists as Ross Bleckner, Jonathan Borofsky, Ranier Fetting and Russ Warren.

Mary Ryan Gallery 452 Columbus Ave., New York, NY 10024 (212) 799-2304; Tue-Fri: 12-7 Sat: 12-6 Sun: 1-5; owner/dir: Mary Ryan
796

The gallery handles American prints and works on paper form 1900 to 1950 as well as contem-

porary prints, and also some British prints of the 30s.

American artists of the 30s and 40s whose prints are in the gallery's collection include many who were employed on the Fine Arts Project of the WPA, where members of both the midwest regionalist school and the international New York school first met. There are also some works by Ashcan School printmakers. The gallery carries contemporary printmakers (Realist, Super-Realist, Abstract, etc.) as well. One may find works by Will Barnet, Louis Lozowick, S.L. Margolies, Joseph Pennell, Fred Becker, Don Freeman, Martin Lewis, Edward Hopper, Reginald Marsh, Adolf Dehn, William Sharp, Harry Sternberg, Milton Avery, Stow Wengenroth, Raphael Soyer, James Allen, Fritz Eichenberg, Clare Leighton, John Sloan and Arthur B. Davies, as well as contemporary artists Philip Pearlstein, William Bailey, Jack Beal, Yvonne Jacquette, Craig McPherson, Altoon Sultan, Nona Hershey, David Bumbeck, Richard Harden, Sidney Hurwitz, Maureen Sullivan and Susan Cabral.

Other works available include Social Realist paintings by Philip Reisman; paintings and mural studies of the 30s by such artists as Stuyvesant van Veen and Fletcher Martin, early abstract prints from S.W. Hayter's Atelier 17, and realist pastels by Sigmund Abeles. Some prints by J.A.M. Whistler and Winslow Homer, and some regionalist prints by Thomas Hart Benton, Grant Wood and John Steuart Curry are available as well.

Serge Sabarsky Gallery 987 Madison Ave., New
797 York, NY 10021 (212) 628-6281 Tue-Sat: 12-6; owner/dir: Serge Sabarsky

The gallery is devoted exclusively to German and Austrian Expressionism. The owner is a recognized authority on the work of Egon Schiele.

One-person and group exhibitions have featured Max Beckmann, Otto Dix, Lyonel Feininger, George Grosz, Erich Heckel, Alexej Jawlensky, Ernst-Ludwig Kirchner, Otto Mueller, Paul Klee, Gustav Klimt, Oskar Kokoschka, Emil Nolde, Max Pechstein, Egon Schiele, Oskar Schlemmer, and Karl Schmidt-Rotluff.

In addition to staging exhibitions in New York, the gallery has organized numerous shows of German and Austrian Expressionism in the U.S., Europe and Japan.

A.M. Sachs Gallery 29 W. 57th St., New York, NY
798 10019 (212) 421-8686 Tue-Sat: 10-5:30 Jun & Jul: Mon-Fri: 10-5:30 Aug: closed; dir: Katharina Perlow

The gallery handles an eclectic selection he of contemporary American painters and sculptors.

Alice Dalton Brown paints interiors of Victorian houses, and Sally Vagliano paints landscape. Abstract sculptor Dorothy Dehner makes structures of carbonized steel that stand about eight feet tall, and small bronzes. Power Booth paints in an abstract style. Among the other artists regularly exhibited are Stephen Pace and Ben Norris. The gallery handles the estate of John Ferren, a 20th century abstract painter, and has planned a retrospective of his work from the 1930s, particularly 1933-34.

Among the artists recently presented by the gallery are Jon Schueler and Balcomb Greene, as well as Craig McPherson, painter of New York City scenes; Irish and English landscape painter Simon Harling; and English artist Alan Falk, who paints beach scenes.

Saidenberg Gallery 1018 Madison Ave., New York,
799 NY 10021 (212) 288-3387 Tue-Sat: 10-5 Aug: closed; owner/dir: Daniel Saidenberg, Eleanor Saidenberg

The gallery specializes in 20th century European masters. Since 1955, it has been the representative of the Galerie Louise Leiris, Paris, and has exhibited paintings and works on paper by Picasso, as well as graphics by Fernand Leger, Juan Gris, Georges Braque and Andre Masson. Also featured are Paul Klee and Wassily Kandinsky, and a few American artists.

Since it opened in 1950, the gallery has held many exhibitions, which include "An American Tribute to Picasso", and "An American Tribute to Braque". It organized the first one-person shows in New York of English sculptor Lynn Chadwick and Portuguese painter Viera da Silva. The gallery also held the American exhibitions of David Hare and Balcomb Green. Among the artists the gallery presently features are Herbert Bayer, sculptor Robert Braczyk, and painter and teacher Geoyrgy Kepes.

Galerie St. Etienne 24 W. 57th St., New York, NY
800 10019 (212) 245-6734; Tue-Sat: 11-5 Summer: closed Sat; dir: Hildegard Bachert, Jane Kallir

The gallery was founded by the late Dr. Otto Kallir (1894-1978) in 1939. Its field of specialization has been twofold: early 20th century Austrian and German Expressionism, and American and European naive art of the 19th and 20th century. Although a commercial gallery, it maintains extensive archives of interest to scholars, and about twice a year mounts museum-scope exhibitions accompanied by well researched and illustrated catalogs which explore a particular theme in depth.

Egon Schiele, Oskar Kokoschka, Gustav Klimt, Alfred Kubin, Lovis Corinth and Kathe Kollwitz are among the artists the gallery has introduced to the United States. The gallery also specializes in folk painting. It has shown the work of Anna Mary Robertson (Grandma) Moses since her first one-person show in 1940. The gallery recently began to show the work of John Kane, the first modern American folk painter to win recognition in his own lifetime. There is generally on view or available a large selection of work by these artists.

A selection of drawings, pastels and collages by Eugene Mihaesco, an illustrator best known through his *New Yorker* covers and contributions to other magazines, is always on view as well.

The gallery has a collection of oils, prints, drawings and watercolors by many lesser known Austrian Expressionists, such as Oscar Laske and L.H. Jungnickel; by the American Expressionists Martin Pajeck and Marvin Meisels; and oils by contemporary American folk artist Nan Phelps, as well as by other 19th and 20th century naive painters.

Salander-O'Reilly Galleries, Inc. 22 E. 80th St.,
801 New York, NY 879-6606; Mon-Sat: 10-5:30;

owner: Lawrence B. & Barbara J. Salander, William E. O'Reilly dir: Meg Moynihan

Concentration of the gallery is on 20th century American Modernist painters, including artists such as Arthur G. Dove, Morton Livingston Schamberg, Stuart Davis, Walt Kuhn, Charles Sheeler, Alfred Maurer, Marsden Hartley, John Marin and John Covert. Younger artists presented are mostly Color Field painters, including John Adams Griefen, Stanley Boxer, Dan Christensen, Darryl Hughto, Peter Reginato, Susan Roth, Kikuo Saito and Clifford Ross.

Sander Gallery 51 Greene St., New York, NY 10013
802 (212) 219-2200; Tue-Sat: 11-6 Aug: closed; dir: Eunmo Griebsch

Sander Gallery represents a variety of artists, painters from the 1930s and contemporary artists. The gallery shows works from the estates of photographers Lisette Model and August Sander as well as exhibiting photographic work such as that of David Buckland.

Sander Gallery is located in the heart of SoHo and is committed to showing thought-provoking work. Catalogs and books of gallery artists are available.

Schaeffer Gallery 500 E 77th St., New York, NY
803 10162 (212) 794-9712; by appt; owner/dir: Martha Schaeffer

The works of 20th century masters are the principal area of concentration of this gallery. Drawings, prints, and paintings from the first half of the century and earlier are available. The gallery also promotes emerging American and European artists, again with particular attention to drawings and paintings on paper, as well as prints, paintings on canvas and sculpture.

Modern masters include Miro, Matisse, Renoir, Picasso, Marie Cassat, Toulouse Lautrec, Leonor Fini, Edouard Vuillard and Camille Pissarro.

Contemporary artist Lisa Roggli exhibits marble and bronze sculpture. Printmakers Kay Mortensen and David Bumbeck work in lithographs and etchings/aquatints, respectively, while Pat Hammerman prints etchings on handmade paper. Painters are Jackie Battenfield, acrylic on paper and canvas; Rick Hallam, painting and mixed media on paper and canvas; and Bruce Brand, painting on paper.

Gallery Schlesinger-Boisante 822 Madison Ave.,
804 New York, NY 10021 (212) 734-3600; Tue-Sat: 10-6 Mon: By appt; owner: Stephen L. Schlesinger dir: Elise Libovicky

The gallery exhibits American and European contemporaries, as well as classical material. Concentration is on American abstract painting of the 20s, 30s and 40s.

The gallery presents work from the estate of abstract artist Byron Browne. Collages and box-assemblages by Hannelope Baron have been exhibited, as well as works by Dorothea Tanning, a contemporary Surrealist, and East German artist Werner Tubke, of the Leipzig School. of the Leipzig School.

Emerging artists are also frequently exhibited. Among their works are the primitive paintings of Victor Mira; Paula Tavins's canvases with accompanying sculptural elements; Roy Newell's hard edge geometric paintings; and the Surrealist prints, oils and drawings of Federico Castellon. Other artists include Michael Hafftka, Judy Levy, Dan Freeman, Ralph Rosenborg and Fred Schultz.

Robert Schoelkopf Gallery 50 W. 57th St., New
805 York, NY 10019 (212) 765-3540; Tue-Sat: 10-5; owner/dir: R. Schoelkopf

For over 25 years the gallery has been dealing in in 20th century American painting, mostly contemporary realist painting, and some small sculpture.

Paintings from the early part of the century are shown regularly. The work of painter Joseph Stella, unlike that of most of his contemporaries, who were influenced by the French avant-garde, reveals an affinity with the Italian Futurists. Sculptor Gaston Lachaise created a monumental image of woman as earth-mother. Others of this period are sculptor John Storrs, James Daugherty and Miklos Suba.

Contemporary painters take up the largest part of the gallery's changing exhibitions. Almost all of them are realists, many working in a figurative style. Best known of the gallery's contemporary painters are William Bailey, who executes metaphysical still lifes, colorist Leland Bell, Gabriel Laderman and Martha Mayer Erlebacher, who currently produces figurative, neo-Renaissance work. Others frequently shown are Milet Andrejevic, Bruno Civitico, Daniel Dallmann, Philip Grausman, Walter Hatke, Louisa Matthaisdottir and Paul Wiesenfeld. Other artists include Caren Canier, Barbara Cushing, Raymond Han, DeWitt Hardy, Keith Jacobshagen, Isabel McIlvain, Richard Piccolo, Edward Schmidt and Bonnie Sklarski.

Sculpture Center Gallery 167 E. 69th St., New York,
806 NY 10021 (212) 879-0430; Tue-Sat: 11-5 Jul-Aug: closed; owner: Sculpture Center, Inc. dir: Marian Griffiths

The Sculpture Center Gallery is a non-profit organization devoted to the art of sculpture, which it has consistently supported since its founding in 1927.

Several generations of American sculptors have exhibited here, from Gaston Lachaise, whose bronzes of bountiful female figures are rooted in classical tradition; to abstract sculptors such as David Smith, vigorous poet of industrial forms and techniques; Isamu Noguchi, whose understated elements in noble materials reveal a profound sense of space; and Louise Nevelson, creator of vast walls of monochromed found objects—to contemporary artists such as George Sugarman, Ibram Lassaw, Mary Frank, James Surls, Robert Cook, Mel Edwards and Mia Westerlund-Roosen.

Semaphore Gallery 462 W. Broadway, New York,
807 NY 10012 (212) 228-7990; Tue-Sat: 10-6; owner: Barry Blinderman & James Shapiro dir: B. Blinderman & Annie Herron

Semaphore Gallery shows work by contemporary American artists, most of them young, emerging artists. Many are involved in the current East Village art scene. Some are trained artists who

have taken to the city walls as an alternative space, while others are street artists who have found their work accepted in galleries.

Artists regularly shown include Ellen Berkenblit, Nancy Dwyer, graffiti artists Bobby G and Lady Pink, Duncan Hannah, Cara Perlman, Walter Robinson, Michael Ross, Mark Schwartz, Gregg Smith, Tseng Kwong Chi, Dan Witz and Martin Wong. Emerging painter Mark Kostabi's mannequin-like figures convey the frenzy of city life. California painter Robert Colescott, a satirist of American society and the Romantic image in American painting, wields bad taste with a surgeon's skill to lay bare the hidden content of stereotypes.

Serra di Felice 295 Lafayette St., New York, NY
808 10012 (212) 334-8192, Tue-Sat: 10-6; owner/dir: Attanasio di Felice & Paolo Serra Serra

Serra di Felice displays emerging American and European artists as well as Italian Modern painting and sculpture: Novocento, Futurism, and Italian Abstract of the 1930's.

Artists represented in major collections shown at the gallery include Domenico Paulon (born 1897), an Italian abstract painter of newly recognized historical importance, younger Italian artist Luigi Ontani, who works in watercolor and sculpture, influential American sculptor and conceptual artist Dennis Oppenheim , and American figurative painter Cuchk Connelly. Chuck Connelly.

Among the emerging artists shown, Italian artist Pietro Fortuna paints abstracted figuration. Hungarian-American artist Peter Grass paints in a surrealist style. Japanese-Swiss painter Leiko Ikemura produces elegant drawings and oils, and American Sy Ross paints and sculpts in the current Neo-Expressionist style.

724 Prints, Inc. 93 Mercer St., New York, NY 10012
809 (212) 431-1890; Tue-Fri: 10-5; owner: N. Meltzer, D. Pearlstein dir: Jamie Lustberg

724 Prints, Inc., publishes limited edition fine art prints, including etchings, lithography, woodcuts and cast paper relief multiples.

Among the contemporary artists whose work has been published are Philip Pearlstein, James Valerio, Janet Fish, Jane Freilicher, Susan Crile, Carolyn Brady, Cynthia Carlson, Terrence La Noue, Sylvia Plimack Mangold, Arlen Slavin, Frances Barth and Paul Narkiewicz.

Shepherd Gallery, Associates 21 E. 84th St., New
810 York, NY 10028 (212) 861-4050; Tue-Sat: 11-6; dir: Robert Kashey, Martin L.H. Reymert

The art of the 19th century presents a powerful surge of distinct currents in art, from Neo-Classic restraint to Academic kitsch, from Romantic *elan* to Symbolist decadence. The Shepherd Gallery presents a wide range of representative works of this epoch from France, Germany and other European countries.

Works are available by 18th century Rococo master Jean-Honore Fragonard, by Eugene Delacroix and Jean-Auguste-Dominique Ingres, as well as by the famous academic painter Bouguereau. Of special note are the works of the short-

lived painter Theodore Chasseriau, who successfully melded the precise line of Ingres with the intense color and Romantic atmosphere of Delacroix. Also on hand are works by Barye, Bastien-Lepage, Baudry, Bonheur, Bonvin, Cormon, Dedreux, Delaroche, Delaunay, Flendrin, Gavarni, Isabey, Lami, Lehmann, Regnault, Scheffer and Tassaert.

Works by German artists range from the Nazarenes, Christian artists who emulated the work of 15th century artists before Raphael, to Jugendstil. Artists represented in the inventory include Moritz von Schwind, Adolf Menzel, von Stuck, Schnorr von Karolsfeld, Max Klinger, Moser, Hoffman and Greiner.

Silberberg Gallery 16 E. 79th St., New York, NY
811 10021 (212) 861-6192; Mon-Sat: 10-5 Jul-Aug: closed; owner: N. Silberberg

The gallery carries contemporary European art. Its inventory includes paintings by Giorgio de Chirico, an Italian artist who anticipated the Surrealist movement in his enigmatic early paintings, but whose later work is fervently Neo-Classic. There are also works by the English sculptor Henry Moore, whose flowing monumental bronzes of the human figure can be seen throughout the world.

Other artists include Nadezda Nada Vitorovic, a Surrealist painter who depicts the mythical past; and Giulio Turcato, a contemporary Italian painter whose color recalls the tradition of the Venetian masters.

Sindin Galleries 1035 Madison Ave., New York, NY
812 10021 (212) 288-7902; Tue-Sat: 10-5:30; dir: Edward Sindin

A large number of European and Latin American artists are represented by the gallery, as well as a few American and Japanese artists.

Paintings and sculptures by Picasso, Miro, Chagall, Giacometti, and Henry Moore are shown at the gallery. Drawings and graphics by these artists also may be found.

Francisco Zuniga is among the Latin American artists shown. Zuniga's drawings and paintings depict rural life in his native Mexico. His figurative sculpture also is on display. Other Latin American artists shown include Giuliano Vangi, Luis Caballero, Guido Razzi, and Benjamin Canas.

Smith Gallery 1045 Madison Ave., New York, NY
813 10021 (212) 744-6171 Mon-Sat: 11-6 Jul, Mon-Fri: 10-6 Aug: closed; dir: Patricia Smith

This large gallery specializes in marine paintings of the 19th and early 20th century. Oil portraits of ships by expert artists James Butterworth, C.S. Raleigh, Antonio Jacobsen, Fred Pansing, James Bard, and James Gale Taylor are notable for their historical value.

Contemporary artists Albert Nemethy, Keith Miller and William G. Muller also paint carefully researched marine subjects. Miller's watercolors portray America's Cup Races prior to 1910 and contemporary New York port scenes. Muller and Nemethy depict the bustling steam period and 19th century scenery of the Hudson River.

The gallery also features contemporary West-

ern painters and sculptors. Don Troiani paints military and historical figures from the 1840's to the 1880's with painstaking historical accuracy. Gregory Sumida works in gouache, painting Indian encampments. French portraitist Antoine Tzapoff paints the American Indians in noteworthy detail. Harry Jackson is known for his fine standing figures and equestrian monuments.

Soho Center for Visual Arts 114 Prince St., New
814 York, NY 10012 (212) 226 1995 Tue-Sat: 12-6 Aug: closed; dir: Larry Aldrich

The gallery is a non-profit organization sponsored by the Aldrich Museum of Contemporary Art, with support from the Mobil Foundation. The gallery selects works for group shows of four artists each. The purpose of the exhibits is to give exposure to emerging New York artists who have not had a one-person show in a commercial New York gallery. All proceeds from the sale of art go to the artist. A reference library for is free to artists who register.

Solomon & Co. Fine Art 959 Madison Ave., New
815 York, NY 10021 (212) 737-8200; Mon-Sat: 10:30-5:30; owner/dir: Sally Solomon, Jerry Solomon

20th century American and European painting and sculpture are the field of interest of this gallery.
Works by contemporary masters are available, including Abstract Expressionists Willem de Kooning, a prolific painter whose disturbing series of images "Woman" now seems an anticipation of recent figurative painting; Franz Kline, known for his bold black and white calligraphy; Hans Hofmann, who worked in thick planes of color; and Jackson Pollock, whose drip paintings executed on the floor and cut to size are perhaps the best-known works to come out of Abstract Expressionism. European masters shown include Picasso, Marc Chagall, Joan Miro, Sculptor Henry Moore and others.

Holly Solomon Gallery 724 Fifth Ave., New York,
816 NY 10019 (212) 757-7777; Mon-Sat: 10-6 Summer: closed Sat; owner/dir: Holly Solomon

The gallery features avant-garde conceptual and performance artists, both American and international, as well as painters and sculptors who work in a decorative or symbolist tradition.
Performance artists Laurie Anderson and Alexis Smith have had photographic and audio installations of their performances at the gallery. Other artists regularly seen include conceptual artist William Wegman, New Image painters Joe Zucker and Lynton Wells and narrative. artists Donald Roller Wilson and Nicholas Africano.
Texas artist Melissa Miller, Mark Milloff, and Janis Provisor are among the gallery's group of younger artists working in a personal, subjective vein. Thomas Lanigan-Schmidt and Ned Smyth incorporate decorative and symbolic elements in their paintings. Several gallery artists work pictorially with sculpture, including Donna Dennis and Judy Pfaff. A new addition to the gallery's stable is Izhar Patkin, who does carpet-like works with oil crayons pressed through screens. Other artists shown include sculptor Gary Burnley and painters Jared Bark, Sam Cady, Christopher Knowles, and George Schneeman.

Several foreign artists were recently exhibited in major one-person shows at the gallery. These were French artists Michel Haas and Raoul Dufy, Austrian artists Neo-Expressionists Siegfried Anzinger and Hubert Schmalix, and German Neo-Expressionists Sigmar Polke, Michel Buthe, and Carl Otto Paefgen.
The gallery also handles a number of photographers: Kevin Boyle, Nancy Burson, Christine Osinski, Barbara Riley, Wolfgang Volz, and Dorothy Zeidman. Holly Solomon Editions publishes prints by many of the artists affiliated with the gallery.

Sonnabend Gallery 420 W. Broadway, New York,
817 NY 10012 (212) 966-6160 Tue-Sat: 10-6; owner: Ileana Sonnabend dir: Antonio Homem

First established in Paris in 1962 to introduce American artists such as Jasper Johns, Robert Rauschenberg and Robert Morris to Europe, the Sonnabend Gallery continues to show contemporary and avant-garde American and European painting, sculpture and photography in New York.
Besides Rauschenberg and Morris, the gallery shows John Baldessari, Mel Bochner, Bernd and Hilla Becher, Peter Bommels, James Casebere, Gilbert and George, Michael Goldberg, David Haxton, Jannis Kounellis, Barry Le Va, Anne and Patrick Poirier, Terry Winters and Gilberto Zorio.
Photographers Erica Lennard and Hiroshi Sugimoto are also shown. Works by Cy Twombly, and by German Neo-Expressionists Anselm Kiefer, Georg Baselitz, A. R. Penck and Jorg Immendorf are also available.

Soufer Gallery 1015 Madison Ave., New York, NY
818 10021; Tue-Sat: 10-5 Jul: closed; owner: Mrs. M. Soufer dir: M. Soufer

The gallery features late 19th and early 20th century European paintings and watercolors, with works by Post-Impressionists, Expressionists and contemporary artists.
European masters displayed include French landscape painter Maurice de Vlaminck, associated with the Fauves; and French painters Louis Valtat, Andre Lhote and Jean Dufy. Also available are works by George Grosz, whose scathing satirical drawings of Weimar Germany and the rise of Hitler are some of the most powerful political art of this century. His work after his emigration to the U.S. is calmer, even lyrical at times.
Contemporary artists Yves Brayer, a French Post-Impressionist, and David Azuz, an Israeli-born French painter, are also featured by the gallery.

Ira Spanierman, Inc. 50 E. 78th St., New York, NY
819 10021 (212) 879-7085 Mon-Fri: 9:30-5:30 Summer: Mon-Thu: 9-5:30 Fri: 9-3; owner: Ira Spanierman dir: Reagan Upshaw

This established gallery shows paintings and drawings by old masters to early 20th century artists. Some small sculpture is also available. Concentration is in 19th century European and American art.
Works include paintings by American Impressionists, such Maurice Prendergast, William

Merritt Chase, Theodore Robinson, John Singer Sargent, John Henry Twachtman, and Edward Potthast. Also available are works by Hudson River school artists, such as Jasper Cropsey and John Frederick Kensett, and seascapes by noted 19th century artists such as Alfred Thompson Bricher and William Trost Richards.

The gallery specializes in Western art of the 19th and early 20th centuries. A special exhibition was recently held of paintings of Indians by Henry Farny. The gallery also handles works by Frederic Remington and Charles Marion Russell, and the Taos school artists, such as Joseph H. Sharp, Ernest Blumenschein and others.

Ellen Sragow Gallery 80 Fifth Ave., New York, NY
820 10011 (212) 929-2734; Mon-Sat: by appt; owner/dir: Ellen Sragow

The gallery presents a group of emerging artists, mostly painters, from New York City. It also specializes in American paintings, prints and drawings from the 30s and 40s, including work by WPA artists.

Works are available by Joseph Delaney and Minna Citron, of the 14th Street School. One may also encounter prints and paintings by Social Realist Harry Gottlieb, and by Ernest Fiene. The gallery shows work from the estate of Konrad Cramer, of the Woodstock School.

Contemporary artists include Marc Eisenberg, who works in black and white imagery; George Mingo, an expressionist working in both figurative and abstract idioms; and Michael Robbins, who depicts people and places in New York City in his drawings, prints and paintings. Yolanda Shashaty's paintings build on landscape and animal imagery. George Singley executes painterly landscapes. James Zwadlo paints visionary landscape, while Herbert Wentscher portrays objects in space.

Staempfli Gallery 47 E. 77th St., New York, NY
821 10021 (212) 535-1919 Tue-Sat: 10-5:30 Jun-mid-Jul: Mon-Fri: 10-5:30 mid-Jul to Labor Day: closed; dir:G. Staempfli, P. Bruno

The gallery specializes in contemporary American, European and Japanese painting and sculpture.

Among the works shown are small scale collages with watercolor by American artist William Dole, paintings with figurative and biographical references by British artist Anthony Green, and romantic botanical watercolors by Rory McEwen, who is also British. Realistic painting has become an important part of the gallery's offerings, with works by Spanish painters Claudio Bravo and Cristobal Toral, drawings and paintings of pebbles and stones by Allen Magee, and precisionist still lifes by Akira Arita.

Sculpture on display includes monumental stone works by Japanese artist Masayuki Nagare, as well as "sounding sculptures" by American Harry Bertoia. The Bachet brothers from France exhibit kinetic steel works used in contemporary musical performance. The gallery also focuses on architectural sculpture, such as works by Michio Ihara.

The gallery has organized numerous exhibitions which have circulated throughout the United States.

Elaine Starkman Gallery 465 W. Broadway, New
822 York, NY 10012 (212) 228 3047; Wed-Sun: 12-5 & by appt Summer: by appt; owner/dir: Elaine Starkman

The gallery specializes in works by outstanding contemporary women artists. The artists represent a broad spectrum of styles, media, and techniques.

Among the artists working in contemporary realist styles, Carolyn Parker depicts Northeastern architectural scenes, Genevieve Reckling paints grand scale natural images of her Arizona environment, and bronze sculptor Lora Pennington casts images that range from classical portraits to photorealistic, satirical works. Jean Van Harlingen presents scaled-down versions of her grand scale works for corporate spaces.

Several papermakers show their work at the gallery. Ande Lau Chen works in a contemporary oriental style on large panels, Erika Kahn combines textures and printed embel-lishments, and Joan Needham creates cast paper works in a constructivist style. Other artists shown include Carlyn Fisher Abram, Janet Braun-Reinitz, Juliet Holland, Harriet Hurwitz, Ellen Levick, Vera Lightstone, Liz Whitney Quisgard and Joan Watts.

Bernice Steinbaum Gallery, Ltd. 903 Madison Ave.,
823 New York, NY 10021 (212) 734-3373; owner/dir: Bernice Steinbaum

The gallery handles American paintings, sculptures and wall-hangings.

Paul Brach comes from the school of Abstract Expressionism and Color Field painting. Currently he paints Western landscapes framed in Navajo borders. Jaune Quick-To-See Smith paints horizonless landscapes that weave together color paths and pictographic images. Fellow Native American George Longfish combines traditional signs of his culture with symbols of present day society. Wall hangings by Jane Kaufman are crocheted with silver and gold filaments into intricate patterns, studded with rhinestones, crystals, opals and bugle beads.

Portrait artists include Grace Graupe-Pillard, who creates super-realist figures in oils; and Doug Hilson, who works in erased graphite. Pattern artists include Phyllis Yes, who creates large lace paintings in raised line; and Renee Magnanti, who constructs grid-like metal wall-hangings. Sculptor Marjorie Strider works in welded metal; Hilda Steckel makes bulbous athletes and acrobats in glazed ceramic stoneware. James Pile's satirical paintings portray a modern day cowboy known as the "Arizona Kid". William C. Maxwell works in illuminated polymer emulsion glazes and acrylic pigment.

Allan Stone Gallery 48 E. 86th St., New York, NY
824 10028 (212) 988-6870 Mon-Fri: 10-6, Sat: 10-5; owner: Allan Stone dir: Joan Wolff

Contemporary American works in all styles are shown with an emphasis on Abstract Expressionism. Many mainline painters of the movement have had their works exhibited including Willem de Kooning and Franz Kline. Younger gallery artists often work in the same vein. Most noticeable among them are former Chicagoan Edvins Strautmanis whose work consists of

bold abstraction employing broad brush strokes and coloration.

Realists working with new ideas are a principal part of the offering. Their works relate to pioneers of the evolution from abstraction to realism including Gorky and Cornell. Wayne Thiebaud and Richard Estes are among the diverse examples. The list of artists is very large for the gallery space. The list is headed by John Anderson, Robert Bauer, David Beck, Rosamond Berg, Susan Goodrich, Richard Hickam, Edward Renouf and Phillip Sherrod.

A collection of Pre-Columbian, African, Early-American and Oceanic art is also available. Unique cabinet pieces are located throughout gallery including old apothecary chests, wooden desks, and other more recent antiquities.

Styria Studio 426 Broome St., New York, NY 10013
825 (212) 226-1373; Mon-Sat: 10-6 Summer: closed Sat; owner/dir: Adi Rischner

Styria Studios publishes limited edition graphics in all media. Artists who have published their work through Styria include major figures in post-World War II and contemporary art.

Editions are available by Will Barnet, Roger Brown, Marisol Escobar, Donald Judd, Alex Katz. Sylvia Plimack Mangold, Robert Natkin, Jerry Ott, Robert Petersen, Robert Rauschenberg, Larry Rivers, Ed Ruscha, David Shapiro, Paul Waldman, Susan Weil, C.J. Yao and Adja Yunkers.

Sutton Gallery 29 W. 57th St., New York, NY 10019
826 (212) 888-0638 Mon-Sat: 10-5:30; owner: Paul Kittay dir: Leslie Rankous

Sutton Gallery shows contemporary painting, sculpture and works on paper in figurative or representational styles.

Of the artists featured, sculptor Harriet Kittay makes figurative works in bronze, aluminum and stainless steel. The abstract imagery of Vassili Lambrinos's paintings is inspired in Greek marine life. Robert Cenedella's humorous and satirical paintings reflect social realities. Patricia Nix exhibits assemblages and figurative oils.

The gallery shows contemporary Latin American artists as well as a diverse selection of Europeans and Americans.

Leila Taghinia-Milani Gallery 1080 Madison Ave.,
827 New York, NY 10028 (212) 570-6173; owner/dir: Leila Taghinia-Milani

The gallery carries 20th century and contemporary inter-national painting, sculpture and photography.

Featured artists include Leopoldo Maler, Bill Barrette, Hossein Zenderoudi, Nickzad Nodjoum, Christopher Makos, Alessandro Durini di Monza, Judith Simonian, Milano Kazanjian, Benjamin Lira, Michael Falcone, Assurbanipal Babilla, Y.Z. Kami, Mahjoub Benbella, Marta Minujin, Elena Presser, Nasser Ahari, Tom McNulty and Dan Witz.

Amaury Taitinger Gallery 1089 Madison Ave., New
828 York, NY 10028 (212) 570-6767; Tue-Sat: 10-6 Aug: closed; owner/dir: Amaury Taitinger

Concentration is in European and American 19th and 20th century masters. Contemporary artists are shown several times a year.

Works by French painter Balthus move from an early poetic Naturalism to scenes depicting dreamy adolescent girls in interiors. Meticulously executed, the later works sustain an innocent, yet disturbing note. Works by Henri Toulouse-Lautrec, Fernand Leger, Pablo Picasso, Tamara de Lempicka and George Grosz are available, as well as works by American watercolorist Charles Burchfield, painter John Marin and contemporary sculptor Louise Nevelson, whose vast walls of monochromed found wood confront the viewer with enigmas of scale, space and articulation.

Other contemporary artists include painters Lydie Arickx, Sandorfi and Chambas, and sculptor Darnat.

Tatyana Gallery, Inc. 28 E. 72nd St., New York, NY
829 10021 (212) 249-3619; Tue-Sat: 12-5; dir: T. Gribanova

Russian realistic paintings from the 17th century to the beginning of the 20th century are the special field of interest of this gallery.

The gallery carries oils, watercolors, pastels and drawings. The following is a partial list of the artists in its inventory: I. Aivazovsky, V. Aralov, V. Bakscheev, K. Briullov, N. Bogdanov-Belsky, I. Brodsky, V. Byaliniztky-Birulya, V. Bychkov, M. Clodt, M. Guermachev, S. Kolesnikov, N. Krymov, A. Kuinji, I. Levitan, O. Kiprensky, I. Repin, A. Rylov, I. Shoultse, C. Westchiloff, M. Vorobyov and L. Turjansky.

Edward Thorp Gallery 103 Prince St., New York,
830 NY 10013 (212) 431-6880; Tue-Sat: 10-6 Summer: Tue-Fri: 11-5; dir: Edward Thorp

The gallery's primary focus is on emerging American artists, predominantly those working in the fields of painting and drawing.

Painter Gary Bower's narrative works mix the abstract and figurative, and employ mythological subjects. Anton Von Dalen is an illustrative artist who has worked closely with Saul Steinberg. He juxtaposes organic and mechanical imagery, often depicting his own neighborhood in Manhattan, the East Side.

The gallery's stable of painters includes Porfirio Di Donna, Doug Martin, Carole Alter, April Gornik, R. L. Kaplan, and Joseph Santore. The gallery handles the estate of John Altoon, known for his draftmanship and sense of color. The gallery's only sculptor, Edward Finnegan, works in marble or limestone in a minimalist style.

Jack Tilton Gallery 24 W. 57th St., New York, NY
831 10019 (212) 247-7480; Tue-Sat: 10-5:30; owner/dir: Jack Tilton

Concentration is on contemporary abstract artists, generally from the U.S. , working in nontraditional materials and methods. The gallery also represents some estates of artists whose work is non-representational.

Ruth Vollmer shows her bronze, wood and acrylic sculpture and drawings of geometric and primitive forms. Richard Tuttle makes Minimal drawings and wall constructions out of varying materials. One may also see Walter Murch's luminist paintings of still lifes, Kenzo Okada's softly colored oil paintings, Joseph Nechvatel's layered graphite drawings and sculptures, and

Betty Parsons's painted wood constructions, paintings and watercolors.

Other works displayed include Richard Nonas's minimal sculptures and environmental drawings, Richard Francisco's painted wood wall constructions, Bill Taggart's shaped canvases, Robert Yasuda's paintings and Minoru Kawabata's large abstract paintings, suggestive of origami. Finnish artist Carolus Enckell paints on canvas and slate, while painters Susan Frecon, Kiki Smith, Michael Kessler and Tod Wron work in various styles on wood and canvas.

Barbara Toll Fine Arts, Inc. 146 Greene St., New
832 York, NY 10013 (212) 431-1788, Tue-Sat: 10-6, Aug: closed; owner/dir: Barbara Toll

An eclectic gallery, Barbara Toll Fine Arts displays an ample array of painters, sculptors, and ceramicists.

Draftsman Richard Beckett is known for his abstract painting, as is Ellen Phelan, who works with shaped canvases. Figurative painters include Steven Cambell and Milo Reice. The latter specializes in allegorical themes. Curtis Ripley is a ceramic sculptor, while Jean-Luc Vilmouth creates sculpture in the style of the contemporary "British School".

Other artists include Kate Blacker, Joe Fyfe, Kathy Halbower, Jan Hashey, Dennis Kardon, Liliana Porter, Mark Saltz, Andy Spence and Robert Straight.

Tossan-Tossan Gallery Inc. 305 E. 50th St., New
833 York, NY 10022 (212) 688-1574; Wed-Fri: 2-7 Sat: 1-5 Jun-$Sep: by appt; owner/dir: Marta-Lourdes Santos

The gallery specializes in contemporary paintings, prints and drawings, mostly by Spanish and American artists. Some works by Picasso and Miro are available.

Contemporary painters include: Bella Baran, Pablo Sycet and Enrique Ortega, whose figures, interiors and landscape paintings can be seen either as abstract or figurative; Cesar Nicolau, known for his abstract repetition paint-ings; Rafael Arellano, who paints black, gray and white silhouettes in a minimalist style; Ibrahim Benoh, whose acrylic paintings suggest the curves of the female body; Simeon Saiz Ruiz and Julio Juste, abstract painters; James Ellis, Mehdi Qotbi and Samia Halaby, who work in non-fig-urative styles, and Marcos Irizarry, printmaker.

Touchstone Gallery 118 E. 64th St., New York, NY
834 10021 (212) 826-6111; Tue-Sat: 10-5:30 Jul: by appt Aug: closed; owner/dir: Barbara Hirschl

The gallery was founded to introduce the work of unknown contemporary American artists, as well as established foreign artists who had never exhibited in New York. Painting, sculpture, and mixed media are represented.

Among the gallery's artists are Peter Solow, who does figurative paintings and drawings; abstract painter Sydney Butckhes; sculptor Allan Sly, who works in cement and bronze; and painter Ryo Tokita, who concentrates on mystical geometric abstractions.

The gallery periodically organizes theme shows, and also presents an annual show of new talent. The gallery has presented a special exhibition of "Art for the Stage," comprised of stage and costume designs for ballet, opera, and theater.

David Tunick, Inc. 12 E. 81st St., New York, NY
835 10028 (212) 570-0090; Mon-Fri: 10-5; owner: David Tunick dir: Robert Conway

The gallery specializes in old master and modern prints, and old master drawings.

The inventory includes woodcuts and engravings by Albrecht Durer; etchings by Rembrandt and Goya, whose unorthodox techniques greatly expanded the expressive power of the medium; and etchings by Jacques Callot, careful observer of his epoch, whose style was influenced by the lines of the engraver's burin. Modern masters include Edouard Degas, Edouard Vuillard, Edvard Munch, Ernst Ludwig Kirchner, Picasso, Edward Hopper and others.

Drawings are limited to a selection of old masters, notably Bloemaert, DeGheyn and Rembrandt, from the Netherlands; and Italian artists Farinato, Cambiaso and Tiepolo.

Uptown Gallery 1194 Madison Ave., New York, NY
836 10128 (212) 722-3677; Mon-Sat: 10-6 Aug: closed; owner/dir: Philip M. Williams

This is an eclectic gallery showing contemporary graphics, paintings, sculpture and works on paper. Artists whose work is shown include Joan Miro, Henri Matisse, Marc Chagall, Pablo Picasso, Sonia Delaunay, Christo, Alexander Calder, Yaacov Agam, Victor Vasarely, Bruno Bruni, Harold Altman and many others.

Bertha Urdang 23 E. 74th St., New York, NY 10021
837 (212) 288-7004; Tue-Sat: 10-6 Aug: closed; owner/dir: B. Urdang

The gallery shows abstract works by American, European and Israeli contemporary artists. Part of the gallery is dedicated to photography.

Artists shown include Moshe Kupferman and Joshua Neustein. The gallery shows non-figurative paintings and drawings by emerging artists. Most of the work is non-celebratory in nature and has conceptual underpinnings.

Vanderwoude Tananbaum 24 E. 81st St., New York,
838 NY 10028 (212) 879-8200; Tue-Sat: 10-5:30 Summer: closed Sat Aug: by appt; owner/dir: Suzanne Vanderwoude, Dorothy Tananbaum

Rather than focusing on a particular trend or style, artists at Vanderwoude Tananbaum reflect a broad range of new ideas. Exploring new avenues of expression, they dissolve traditional distinctions between painting, sculpture, craft, design and drawing.

Heide Fasnacht's explosive, constructivist wood sculptures aggressively challenge staid concepts. Irvin Tepper's expressive ceramic cups and saucers have redefined sculpture. With paper, paint, sand and glitter Alvin Tada creates distinctive wall and table pieces. Augusta Talbot uses ceramic figures, canvas, paint and found objects to create unique environmental works.

Emblematic paintings from the estate of Bob Thompson draw on art history and personal trauma for their idiosyncratic imagery. Equally powerful are Michael Goldberg's Abstract Expressionist works of the 1950s. An underlying narrative binds Gina Gilmour's metaphysical paintings. Elena Sisto has developed a new pic-

Michael Kessler, *Waif* (1983), 23 x 27, oil on wood, Jack Tilton (New York, NY).

Richard Francisco, *California Dreaming,* 10 x 13 x 3, painted balsa wood, Jack Tilton Gallery (New York, NY).

torial vocabulary in her work based on remembered experiences and emotions.

The gallery's contemporary offerings also include Joe Neill's global, cosmic sculpture; David Shapiro's lyrical paintings; expressive figurative canvases from the estate of Maurice Sievan; and calligraphic sculptures in steel and wood by Will Horwitt.

The gallery offers a selection of 20th century masterworks as well, by such artists as Alfred Jensen, Willem de Kooning, Kenneth Noland, Tom Wesselmann, Alfred Maurer, Paul Kelpe, Joseph Stella and John Graham. Vanderwoude Tananbaum also handles works from the estate of American precisionist George Ault.

Verbena Galleries 16 W. 56th St., New York, NY
839 10019 (212) 586-3606; Tue-Fri: 10-5 Sat: 12-5 Aug: closed; owner: Orlow/Edelberg dir: Anita Edelberg

Contemporary works in fiber, clay, glass, metals, stone and wood are the specialty of the gallery. Styles range from abstract to representational and figurative, and often reflect highly innovative techniques.

The artists featured are mostly trained in the fine arts tradition. Many are pioneers in the development of modern, functional artforms, such as the carved furniture of Michael Coffey and the abstract quilts of Marie Combs. Kerry Tomlinson is well-known for her expressionistic portraiture. Sherry Schreiber creates large-scale, tranquil landscapes. Syndney K. Hamburger and Elspeth Meyer concentrate on figurative work, while Margaret Cusack, Angela Manno, Ferril Nawir, Pat Stumpf and Ann Welch work in realistic or impressionistic styles. Artists known for their abstract works include Arlene Absatz, Barbara Kirschner, John Knutila, Carol Kropnick, Kathleen Morrow and Aurelia Munoz.

Recent shows have featured the works of Jeffrey Biggs and Walter Horak, wood sculptors who work in a figurative style, and Randy Broderick, who makes representational works in glass.

Visual Arts Gallery 137 Wooster St., New York, NY
840 10012 (212) 598-0221; Tue-Sun: 11-6; dir: Pernel Berkeley

Affiliated with the School of Visual Arts, the gallery exhibits photography and fine arts by students at the school. Exhibitions are curated by artists on the faculty. Works include, on occasion, video, performance, installations, etc. All work shown is by emerging artists.

Vorpal Gallery 465 W.Broadway, New York, NY
841 10012 (212) 777-3939 Mon-Wed: 10-6; Thu-Sat: 10-6; Sun: 1-6; owner/dir: Muldoon Elder

First established in San Francisco in 1962, Vorpal Gallery primarily shows twentieth-century painting, prints and sculpture, although it also carries primitives, and prints by Paul Delvaux, Rene Magritte, Odilon Redon, Pierre Bonnard, and Pablo Picasso.

The fantastic geometry of master printmaker M. C. Escher has long been handled by the gallery, and is featured in a major show every few years. The mezzotints of Yozo Hamaguchi, and prints by Jesse Allen and Gary Smith are also notable presences in the gallery.

There are the bright, surrealistic figures of Yugoslavian artist Ivan Kustura, the pastel mindscapes of David Blackburn, and the lush gardens of Piet Bekaert. Among the other artists represented are Gio Biondi, Manfred Bockleman, Katherine Hagstrum, Jack Hooper, Jose Morales, Robert Singleton, and Toru Taki.

Ward-Nasse Gallery 178 Prince St., New York, NY
842 10012 (212) 925-6951; Tue-Sat: 11-5:30 Sun: 1-4; dir: Rina Goodman

The gallery was founded on the premise that many more artists deserve the right to exhibit in a Gallery situation than the current system permits. Through its growing membership, it seeks to understand and fulfill the needs of artists in general.

The gallery is an artist-run, nonprofit corporation, which is totally supported by its artist and public members. The gallery seeks to create an environment in which diverse aesthetic approaches coexist, contrast, complement and interact with each other, and thus accommodate a broad range of public interests.

There is a slide registry as well as biographical material representing the current gallery artists. The gallery issues a biannual catalogue, distributed free to museums, universities and institutions throughout the country.

The gallery also sponsors special events. Performance, music, dance, poetry and mixed-media events take place monthly and are often free to members.

The gallery features four artists in a three-week show, with members showing once every two years on the average. Gallery group shows are presented once a year.

Washburn Gallery 42 E. 57th St., New York, NY
843 10022 (212) 753-0546 & 113 Greene St., New York, NY 10012 (212) 966-3151 Tue-Sat: 10-5:30; owner/dir: Joan Washburn

The gallery specializes in 20th century American art, in particular the artists associated with Alfred Stieglitz: Arthur Dove, Marsden Hartley, and Georgia O'Keeffe, and contemporary American artists. Exhibits have also featured 19th century American landscape, furniture and objects designed by Gilbert Rohde, and works by Patrick Henry Bruce and Stuart Davis.

Featured artists are Bill Jensen, creator of abstract icons; Leon Polk Smith, a hard-edge constructivist; Jack Youngerman, who now makes carved and painted wall reliefs as well as paintings; and Richard Benson, a traditional photographer working in platinum and palladium prints. Also shown are Ilya Bolotowsky, whose biomorphic and geometric abstractions of the 1930s evolved into Neoplastic formations, and Alice Trumbull Mason, whose work shows the influences of the artistic movements of her lifetime, notably Surrealism and de Stijl. The gallery represents the estate of Charles Shaw. Selections from the photographs of James Abbe are also available.

Other artists shown include Mary Callery, John William Hill, John Henry Hill, Alan Cote and Rolph Scarlett.

John Weber Gallery 142 Greene St., New York, NY
844 10012 (212) 966 6115 Tue-Sat: 10-6; dir: John Weber & Joyce Nereaux

Michael Malpass, *Cubes in Transit,* 24 high, iron & steel, Andre Zarre Gallery (New York, NY).

Joseph Morviller, *Winter in Malden Mass* (1864), 16 x 26, oil on canvas, Richard York (New York, NY).

Established in 1971, the gallery has exhibited American and European art covering Abstract Expressionism, Pop Art, Minimalism and Conceptual Art. The latter two movements have been the focus of the gallery since the mid-1960s.

Works by internationally known artists such as Robert Mangold and Sol LeWitt as well as Daniel Buren, Roman Opalka, Victor Burgin and Hans Haacke form the core of the gallery's exhibitions. Alice Aycock's outdoor sculptural pieces, outdoor works by Nancy Holt and Charles Ross, and earth art from the estate of Robert Smithson are handled by the gallery. The gallery has emphasized what it feels to be the logical successor to minimal art, the work of abstract painters and sculptors such as Kes Zapkus, James Biederman, Mel Kendrick, Bruce Boice, Jeremy Gilbert-Rolfe and Lucio Pozzi. The gallery also shows the architectural photography of Hedrich-Blessing, as well as photographic work by Gwenn Thomas, Dennis Roth and Barbara Kasten.

Weintraub Gallery 992 Madison Ave., New York, NY 10021 (212) 879-1195; Tue-Sat: 10-5; owner/dir: Jacob B. Weintraub
845

The gallery's specialization is sculpture by 20th century modern masters. Art in all media by major 20th century artists may be found.

Among the sculptors featured are Alexander Archipenko, Hans (Jean) Arp, Alexander Calder, Joseph Cornell, Alberto Giacometti, Aristide Maillol, Marino Marini, and Henry Moore. The gallery recently held a large exhibition of Moore's sculptures and drawings.

Westbroadway Gallery/Alternate Space 431 W. Broadway, New York NY 10013 (212) 966-2520, Tue-Fri: 11-5, Sat: 11-6; dir: Robbie Ehrlich
846

Westbroadway Gallery and Alternate Space, respectively upstairs and downstairs at the same location, were among the first galleries to open in the Soho area. They have concertedly maintained what they consider to be the original Soho flavor. These artist-owned galleries are both co-operative and commercial.

Work exhibited at both spaces is eclectic; there is no focus or thrust toward collating works of a definable school of art. Artists from all over the world exhibit paintings, sculpture, photographs, conceptual art and mixed-media works. The older, regular artists exhibit upstairs, while the younger, more transient artists exhibit downstairs.

Weyhe Gallery 794 Lexington Ave., New York, NY 10021 (212) 838-5478 Oct-May: Tue-Sat: 9:30-5 Jun, Jul & Sep: Mon-Fri: 9:30-5 Aug: closed; dir: Gertrude Weyhe Dennis
847

Located since 1923 on the upper floor of a bookshop filled with rare and out-of-print books, this modest gallery specializes in graphic art of the 1920s and 1930s. One can find works by Peggy Bacon, Mabel Dwight and Wanda Gag, etchings by John Marin and drawings by Emil Ganso, Rockwell Kent's original drawings from *Moby Dick* and Louis Lozowick's lithographs of New York City, Antonio Frasconi's bold woodcuts, and watercolors by Sally Spofford. The gallery

continues to show the expressionist portraits and landscapes of Alfred Maurer, who had his first show at the gallery in 1924.

Graphics of European artists include works by Picasso, Max Beckmann and Kathe Kollwitz. Prints by Mexican muralists and painters Jose Clemente Orozco, Diego Rivera, David Siqueiros and Rufino Tamayo may be found. Drawings by Gaston Lachaise and George Grosz are also available. The gallery's small collection of sculpture includes works by Aristide Maillol and John B. Flannagan.

The founder, Erhard Weyhe, was the first to exhibit the photographs of Eugene Atget, chronicler of life on the streets of Paris. In 1930 he published a book of Atget's work, now out of print, a copy of which is available in the owner's private collection.

White Columns 325 Spring St., New York, NY 10013 (212) 924 4212 Tue-Fri: 11-7 Sat: 12-6 Jul-Aug: closed; dir: J.N. Fry & T.B. Solomon
848

White Columns Alternative Space is a non-profit organiza-tion funded by the general public, institutions and the art community, and devoted to showing emerging artists, as well as little known aspects of established artists' work. Formerly known as 112 Greene Street, the renovated gallery space sponsors biweekly one-person shows in all media, culminating in June with a month long group show with catalog. The space also houses theme exhibitions, video, dance, performance and music events organized either by the staff or guest curators.

Activities for 1983-1984 include a retrospective of Jack Goldstein's music and film; an art-band music festival, "Speed Trials"; theme exhibitions such as "Artist/Critic", "Science and Prophecy", and "House on the Borderline'; a one-person show of Japanese video artist Shigeko Kubota's video sculpture, and an exhibition featuring selected young regionalist work by artists from Minnesota.

Wildenstein & Company 19 E. 64th St., New York, NY 10021 (212) 879-0500 Mon-Fri: 9:30-5:30; dir: Harry A. Brooks
849

Founded in Paris in 1875, the gallery was established in New York in 1902. The structure in which it is presently located was designed in the style of Louis XVI and built in 1930 for the Wildenstein family as an art gallery.

The gallery's collection of art encompasses the Western tradition from the 12th to the early 20th century. Works by major artists of the Renaissance, the Enlightenment, the Romantic Age and the late 19th century are exhibited. The gallery specializes in old masters; 18th century French artists, such as Fragonard and Boucher; and the French Impressionists and Post-Impressionists, including Monet, Renoir, Mary Cassatt, Vuillard, and Bonnard. English sculptor Henry Moore is the only contemporary artist associated with the gallery.

The gallery has sponsored numerous philanthropic and educational exhibitions, drawing on its own resources and those of great American and foreign museums.

Willard Gallery 29 E. 72nd St., New York, NY 10021 (212) 744-2925 Tue-Fri: 10-6 Sat: 10-5 Aug: closed; dir: Miani Johnston
850

Since 1936 the gallery has exhibited contemporary painting and sculpture. Almost all the works are by American artists, most of whom live in New York City.

Since the early 40s the gallery has shown works by West Coast painters Mark Tobey and Morris Graves. Ralph Humphrey has progressed from Minimalist concerns to abstract, polychrome constructions. Sculptor Ken Price has shown his small-scale abstract sculpture in polychrome glazed or painted clay.

Most work shown is abstract, though figurative elements persist without becoming representational. Susan Rothenberg, first known for her flat paintings of horses, now paints images derived from figures and landscape. Lois Lane's work presents literal forms in an abstract way. Barry Ledoux uses lead and paint to make sculptures about the body. Robert Lobe hammers aluminum over trees and rocks to create a "rubbing" which is then removed from the site. Judith Shea's clothing derived images are recently being cast in metal. Harriet Korman's vivid abstract oils, Tod Wizon's highly colored imaginary landscapes, and Todd Watts's manipulated photographs may also be seen.

The Witkin Gallery, Inc. 41 E. 57th St., New York,
851 NY 10022 (212) 355-1461; Tue-Fri: 11-6 Sat: 12-5; owner/dir: Lee D. Witkin

Specializing in photography, the gallery has a selection of works by over 100 photographers from 1840 to the present. Also featured are American printmakers from the first half of the 20th century.

Major artists shown include: Berenice Abbott, Manuel Alvarez Bravo, Roy DeCarava, Robert Doisneau, Laura Gilpin, Christopher James, Russell Lee, Joel Meyerowitz, Wright Morris, Ruth Orkin, Doug Prince, W. Eugene Smith, George Tice, Jerry N. Uelsmann and Edward Weston as well as Gustave Baumann, Carol Brown, Howard Cook and Kyra Markham.

Of special interest are Doug Prince's "photosculptures', three-dimensional boxes in small format; Christopher James's watercolors of women swimmers, George Tice's platinum prints, and Jerry N. Uelsmann's multiple imagery.

Daniel Wolf, Inc. 30 W. 57th St., New York, NY
852 10019, (212) 586-8432; Mon-Sat: 10-6 Jun-Aug: closed Sat; owner: D. Wolf dir: Bonni Benrubi

The gallery features a wide range of photographers from the pioneer French photographers of the 19th century to the most important photographers of our time.

The extensive collection of 19th century American West photographers includes Carleton Watkins, William Henry Jackson, Timothy O'Sullivan and Adam Clarke Vroman. 19th century European photographers include Gustave Le Gray, Julia Margaret Cameron and Peter Henry Emerson; their 20th century inheritors include Martin Munkasci, Man Ray, and Moholy-Nagy. Contemporary photographers in the gallery's collection are Eliot Porter, Art Sinsabaugh, Tod Papageorge, Sheila Metzner, William Garnett, Helen Levitt, Harold Edgerton, Andreas Feininger, Joel Sternfeld, Jed Devine, Frank Gohlke, O. Winston Link, Arnold

Newman, Bettina Rheims, Helen Levitt, Barbara Morgan, Marcia Dalby and Michael Geiger. The gallery publishes portfolios by many of these artists.

In addition to photography the gallery exhibits 19th and 20th century European and American painting and sculpture.

Wunderlich & Co., Inc. 41E. 57th St., New York, NY
853 10022 (212) 838-2555; Mon-Fri: 9:30-5:30 Aug 15-31: closed; owner/dir: Gerald Wunderlich

Wunderlich and Company specializes in 19th and 20th century American realism, with particular attention to American historical and art prints. Art of the American West, the Hudson River School and Marine genre are well represented. The gallery prides itself on its knowledge of Frederic Remington and C.M. Russell bronzes.

American artists include Thomas Cole, Frederic Church, Martin J. Heade, Alfred T. Bricher, J. Battlesworth, A.F. Tait, C.M. Russell, F. Remington and Henry Farny. Masters in fine prints include Childe Hassam, Edward Hopper, John Marin, Charles Burchfield, Reginald Marsh, Thomas Hart Benton, Grant Wood, John Sloan and others.

Contemporary artists include Western artists Michael Coleman and Gordon Phillips, marine artist John Stobart, wildlife artist Jorge Mayel, and still life and genre painter Richard Maury, all of whom paint in traditional representational styles.

David & Constance Yates Box 580, Lenox Hill Station, New York, NY 10021 (212) 879-7758; by
854 appt; owner: D. & C. Yates dir: David Yates

This private gallery mostly handles European Master Drawings from 1825-1925.

Currently in the inventory are drawings by the great French Romantic painter and colorist Eugene Delacroix and a notable contemporary of his, Theodore Gericault. Other artists of the period include Henry Harpignies and Jean-Leon Gerome, an academic painter of scenes from Classical Antiquity. More recent works are by German Impressionist Max Liebermann, French Intimist Pierre Bonnard, and by Jacques Villon, whose luminous geometric style developed from Cubism. Other artists include Legrand, and Spanish sculptor Julio Gonzales, whose dramatic ironwork also reveals a Cubist influence.

The collection is particularly strong in works by the Nabis—the French Intimists Bonnard, Vuillard and others—and artists of the Symbolist Movement in France.

Richard York Gallery 21 E. 65th St., New York, NY
855 10021 (212) 772-9155 Tue-Sat: 10-5:30 Summer: Mon-Fri: 10-5:30 dir: Richard T. York

The gallery has an extensive collection of 19th and early 20th century American paintings ranging from Thomas Birch landscapes of the 1820's to Modernist paintings by Ralston Crawford from the 1960's.

The 19th century is well represented by such prominent Hudson River artists as Jasper Francis Cropsey, Albert Bierstadt, Sanford Gifford and Martin J. Heade. The gallery also has fine still lifes by John F. Peto, Levi Prentice, and George

Lambdin, and carries works by American Impressionists Childe Hassam and Theodore Robinson.

The gallery's collection includes works by members of the Stieglitz school Charles Demuth, Georgia O'Keeffe, and Arthur Dove; by members of the Eight Everett Shinn, George Luks, John Sloan, and Robert Henri; and by Modernists Oscar Bluemner, Charles Sheeler and Emil Bistram.

Another area of attention is art by women artists. The gallery has had exhibitions of paintings by Ellen Day Hale and Emma Fordyce MacRae, and carries works by Cecilia Beaux, Francesca Alexander and others.

Zabriskie Gallery 724 5th Ave., New York, NY
856 10019 (212) 307-7430; Mon-Sat: 10-5:30 Summer: closed Sat; owner/dir: Virginia M. Zabriskie

Established 30 years ago to exhibit paintings by contemporary artists, the gallery has emphasized sculpture and photography for the past several seasons. Zabriskie relocated to a new space in Fall 1982 that provides additional, more flexible room for exhibitions. In 1976 the gallery opened a Paris branch, which initially showed only photography. Now in larger quarters, the Paris gallery shows paintings and sculpture, as well.

The contemporary sculptors represented include Mary Frank, Lee Friedlander, Ibram Lassaw, Kenneth Snelson, and Timothy Woodman.

Contemporary painters Pat Adams and Lester Johnson are shown. Emphasis in photography focuses on the French, including 19th century artists Baldus and the Bisson brothers, and 20th century artists Eugene Atget, John Batho, Constantin Brancusi, Brassai, Pierre Boucher, Francois Kollar, and Man Ray. The gallery also represents the estates of A. Archipenko, Elie Nadelman, Richard Stankiewicz, Arnold Friedman, and Theodore Roszak.

Recent exhibitions featured surrealists Georges Hugnet and Man Ray and photographers Alfred Stieglitz and Atget.

Andre Zarre Gallery 41 E. 57th St., New York, NY
857 10022 (212) 752-0498; Tue-Sat: 10-5:30 Jul-Aug: closed; owner/dir: Andre Zarre

The Andre Zarre Gallery celebrated its tenth anniversary in the New York art community in 1984. Zarre, a poet as well as a gallery director, arrived in New York from his native Poland seventeen years ago, and was inspired to open a gallery by his literary and artistic friends.

The gallery mounts eight solo exhibitions and two thematic group shows each season. Most of the artists shown are Americans, with a sprinkling of Europeans, and include established, mid-career and emerging artists. Among the artists who were instrumental in inspiring the gallery is the late Irene Rice-Pereira, an abstractionist whose style developed in the period between the two World Wars. Her paintings are subtly orchestrated geometries of space, gesture and color. Other artists whose work is available include Michael Boyd, Dee Shapiro, Edgar Buonagurio, Michael Malpass, Doug Webb, Nassos Daphnis, Sonia Delaunay, Charles Olson, Constance Kheel, Jean Xceron, Joy Walker, Annette Oko, Ronnie Elliott and others.

NORTHPORT

Jeannot R. Barr, Inc. 39 Eatons Neck Rd., North-
858 port, NY 11768 (516) 261-7370; by appt only Aug: closed; owner/dir: Jeannot R. Barr

Jeannot R. Barr handles fine old and modern master prints, drawings and watercolors, with important examples of 19th century French drawings and watercolors, 17th century French drawings and prints, and American prints 1880-1945.

Old Master prints and drawings include works by Rembrandt, Durer, Goltzius, and Callot, as well as the French followers of Carravaggio. French 19th century drawings include works of the *petits maitres*. American masters include Arms, Edward Hopper, J.A.M. Whistler and Louis Lozowick.

The gallery also carries a limited but select inventory of American contemporary realists, including works by Dennis Blagg, Daniel Blagg, Karen Lind, and symbolist printmaker Gillian Pederson-Krag.

Northport Galleries 350-C Woodbine Ave., North-
859 port, NY 11768 (516) 754-9452; Tue-Sun: 12-5; dir: Elly Malamed, Lucy Taylor

An artist-run gallery with nearly 30 exhibiting artists, Northport Galleries features work by regional painters, printmakers, photographers, and sculptors whose work covers the gamut of contemporary art from realism to complete abstraction.

The following artists exhibit their work in the gallery: Ruth Buckman, Rita Calumet, Marie Cohen, Judith Davidson, Tom de Gruyl, David Jackier, Flo Kemp, Josette Lee, Leonard Leff, Evelyn Lucas, Kathleen Lundequist, Eleanor Malamed, Rhoda Mehlinger, Annette Merlis, Joyce B. Meyer, Ann Plesur, Abby Rust, Thomas Ryan, Mary Dean Sesti, Gerald Shak, Ann Simonsen, Chris Solbert, Lucy Taylor, Jeff Turner, Edith Tanner, Pearl Weiss and Geri Geremia.

NYACK

Belle Arts & Graphics, Inc. 11 S. Broadway, Nyack,
860 NY 10960 (914) 353-0883; call for hours; owner/dir: Carol Link, Carol Baretz

Belle Arts and Graphics specializes in original works on paper by contemporary artists.

Among the artists whose work is available are printmaker Will Barnet, whose sparely composed silkscreen prints recall Japanese woodblocks; realist Robert Kipniss; Julio Larraz; Carol Summers, known for his innovative woodblock technique; Masaaki Noda, and Charles Klabunde.

Trisdonn Gallery, Ltd. 4 Nyack Plaza, Main St.,
861 Nyack, NY 10960 (914) 358-6663; Wed-Sun: 11-5; owner/dir: Lynn S. Beman

The Trisdonn Gallery specializes in 19th and early 20th century American paintings, with a strong emphasis on works of the Hudson River School and American watercolors of the 19th century. The gallery also features several contemporary American artists who paint in a representational manner.

Doug Webb, *Urban Daydream* (1983), 40 x 50, oil on canvas, Andre Zarre (New York, NY).

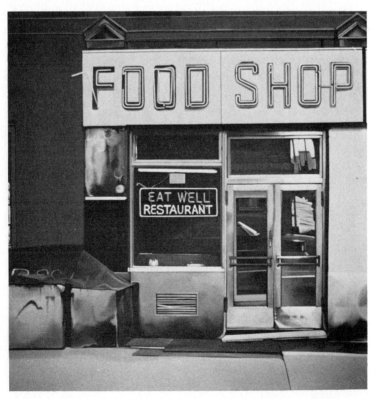

Annette Oko, *Food Shop*, 48 x 56, oil on canvas, Andre Zarre Gallery (New York, NY).

19th century paintings include landscapes, seascapes, still lifes and genre by George Smillie, Cornelius VerBryck, of the National Academy, Henry Bacon, Edward Moran, T.B. Griffin, Russell Smith, James Hamilton and C.P. Ream, among others.

Contemporary artists exhibited include Don Purdy, noted for his romantic Post-Impressionist style paintings; Barbara Stadtlander, who paints trompe-l'oeil still lifes; Frances Shapiro, watercolors; Frank M. Detrich, an emerging talent; and versatile artist Robert Meredith.

PORT WASHINGTON

Graphic Eye Gallery 301 Main St., Port Washington,
862 Long Island NY 11050 (516) 883-9668; Wed-Sun 12-5; cooperative dir: Viggo Holm Madsen

The Graphic Eye is a cooperative gallery with 23 artist members. One of the oldest printmakers cooperatives in the state, it is chartered as a nonprofit educational institution. The styles exhibited vary, but tend to the traditional rather than the experimental. Aside from original graphics, the gallery shows drawings, handmade papers and collages.

Artists include etcher Aida Whedon, founder of the gallery, a naive artist with local subjects; Viggo Holm Madsen, a Neo-Expressionist working in woodcut and lithography; and Olga Poloukhine, whose poetic aquatint landscapes have proved very popular.

Artists working in intaglio media include Jackie Friedman, views of women's world; Joan Johns, flowers; Florence Levine, embossings of geometric patterns and sports; Anna London, abstract designs; Rita Schwartz, bold geometric forms; Fred Pilkington, scenes of boats and sailors; Mary Lynn Conte Lawe, embossed landscapes; Helen Shalfi, designs; colorist Mary Ann De Carlo; Ann Pellaton, Mexican themes; Stelly Sterling, ironically humorous etchings; Bernice Harwood, a poetic colorist; Bernice Dauman, realistic trees and flowers; Diane Marxe, handmade papers and etchings; and Marion Klein, interiors.

Other artists are Diana Birnbaum, cityscapes and monoprints; Shellie Schneider, musical themes in silkscreen; George Wybenga, abstract silkscreen designs; and David Hecht, photo-silkscreens of strongly colored faces.

Isis Gallery, Ltd. 326 Main St., Port Washington, NY
863 11050 (516) 883-0009; Wed-Fri: 11-6 Sat-Sun: 12-5; owner: Diane Chichura, Thelma Stevens

The gallery paintings, drawings, and sculptures reflect a broad spectrum of contemporary style, media and technique including representational as well as abstract and non-objective approaches. Isis Gallery selects prizewinning contemporary artists who have exhibited nationally and internationally, and are represented in museum and corporate collections.

Realist and Superrealists include Rosemary D'Andrea, Nathan Katz, H.W. Kurlander and Joyce Stillman Meyers. Landscape artists include Marilyn Kaplan and Don Resnickl Abstract and non-objective artists include Mildred Herman, Katinka Mann, J. Okinoto, Pearl Rebhun, Dee Shapiro and Annette Weintraub. Sculptors include ceramic sculptor Lillian Dodson, wood

sculptor Caroline Kaplowitz, and float-glass sculptors Kurt and Marsha Runstatler.

Artists who work in unusual media are Arlene Absatz, who uses paper as the art material rather than the painting support; Charlotte Brown, who uses Xerography as an art material, creating exotic chine colle designs on handmade paper; and Jennifer Cecere, whose multi-media assemblage is representative of recent trends in Ornamental Art.

PURCHASE

Helene Trosky Yarmouth Rd., Purchase, NY 10577
864 (914) 946-2464 by appt only; owner/dir: Helene Trosky

Helene Trosky's inventory centers around 19th and 20th century American paintings, prints and sculpture, with some works by noted European artists.

These latter include Surrealist Max Ernst, Italian sculptor Gio Pomodoro, British Op artist Bridget Riley, Surrealist Hans Bellmer, cubist-influenced French abstractionist Jacques Villon, Marc Chagall, Italian sculptor Alberto Giacometti, as well as Kischka, Kremegne, Mary Golay, and South African born Hyperrealist James Fender, known for his scenes of southern Spain.

American masters include Hudson River School painter Jasper F. Cropsey, Jo Davidson, early abstractionist Irene Rice Pereira, regionalist Thomas Hart Benton, satirical social realist Jack Levine, David Burliuk, Zell, Maurice Sterne, Byron Brown, Alexander Calder, Leonard Baskin, Seong Moy, and Richard Merkin. In Merkin's paintings and prints American culture of the 30s is excavated with archaeological zeal, then displayed as an upbeat Cubist collage of quotes and oblique references. Helene Trosky's sculptures are made in hand cast and dyed paper pulp. The gallery also carries Haitian primitive paintings.

RIVERHEAD

East End Arts & Humanities Council 133 E. Main
865 St., Riverhead NY 11901 (516) 727-0900; Mon-Sat: 10-5; dir: Judith Weiner, Patricia Berman

Located in a charmingly restored residence, the gallery specializes in showing the work of well-known and developing artists who live on Long Island. The gallery consists of two main exhibition spaces, a foyer and a photo gallery. Exhibits change monthly; most gallery shows are accompanied by fine craft exhibits. The purpose of the gallery is to expose people in the community to high quality, and for the most part, contemporary art, and to provide them with an appropriate forum for display.

ROCHESTER

Artist Showcase 2070 Five Mile Line Rd., Penfield,
866 NY 14526 (716) 385-3220; Tue-Sat: 11-4; owner/dir: Bev McInerny

Specializing in works on paper by American watercolorists and printmakers, the Artist Showcase presents national and regional artists.

Leading American watercolorists featured by

the gallery include Edward Betts, Ruth Cobb, Katherine Lui and Frank Webb, all members of the American Watercolor Society of of the National Watercolor Society.

Artists who have gained regional recognition for their excellent portrayal of upstate New York's verdant countryside are Bernard Gerstner, Clifford Spangenberg, Thomas Geddis and Thomas H. Miller.

Other artists featured by the gallery include Beverly McInerny, large floral watercolors; Doug Grant McDaniel, torn paper collage with watercolor; Raymond Edgcomb, realist watercolors; Grace Dibble, abstract serigraphs; Paul Merideth Falk, New England landscapes.

Artworks at Sibley's 228 E. Main St., Rochester, NY
867 14604 (716) 423-6289; Mon-Sat: 10-6 Thu: 10-9; owner: Sibley Lindsay dir: Roz Goldman

Concentration of the gallery is on contemporary prints, American, Canadian and European. A search service is available for 19th century American paintings and special requests. In addition, the gallery carries some contempo-rary watercolors, drawings, paintings and crafts.

Mezzotints by Hwang, Yokoi and Honda are available, as well as by Canadian printmaker Brian Kelley. One may also encounter watercolor florals by Wendy Gwirtzman, pastel drawings by Yakov Brusin, hand-colored etchings and lithographs by Jan Hunt and Susan Hunt-Wulkowicz, and landscape paintings by Helen Strasenburgh.

The gallery also features American and European landscape paintings by Peter Kahn and John Loftus, lithography and 3-D constructions by James Rizzi, and pewter ware by Nutmeg.

Craft Company No. 6 785 University Ave., Ro-
868 chester, NY 14607 (716) 473-3413; Mon-Sat: 10:30-5:30 Thu: 10:30-9 summer: Thu: 10:30-5:30; owner/dir: Lynn Allinger

Located in a renovated Victorian firehouse—formerly Engine Company No. 6—the gallery features contemporary American crafts by more than 200 artisans. The spacious two-story building combines shop and gallery, displaying functional works and art forms by established artists as well as those newly emerging.

Among the multitude of craft artisans featured are glass artists Michael David, Kit Karbler, Josh Simpson, John and Jan Gilmer, Andrew Magdanz and Susan Shapiro; clay artists Mary Roehm, Jeff Zigulus and Curtis Scott; wood artists Gary Stam, John Dodd and Doug Sigler; metal artist Tom Markusen; and jewelry artists Pat Garrett, Karen Bilgrai and artisans of the Vincent Street Studio. New gallery artists include ceramists Dick Lang and Karen Tretiak, and weaver Margaret Barry. Handmade furniture is a specialty of the gallery.

The gallery offer various services, including gifts, commissioned works, shipping and consultation.

Dawson Gallery 100 Alexander St., Rochester, NY
869 14620 (716) 454-6609; Tue-Sat: 11-5 Aug 25-31: closed; owner/dir: Shirley Dawson

Choosing as its criterion the belief that function in craft media is less important than complete artistic expression, the Dawson Gallery looks for and exhibits the work of fine American craft artists in both traditional and non-traditional forms. Clay, fiber, metal, glass and wood crafts are displayed, with an annual invitational exhibit illustrating the scope of one chosen field. Work by mature artists is stressed; however, because of the proximity of the School of American Craftsmen, the gallery mounts an annual student show as well.

Vessel interpretation and clay sculpture are highly regarded at Dawson. Clay artists include Frank Boyden, Jenny Lind, Nancy Meeker and Molly Cowgill. Metal artists include David Bacharach, Charles Cowley and Diane Hildebran.

Invitational shows in 1984 included a national iron show and a national clay survey exhibition.

Oxford Gallery 267 Oxford St., Rochester, NY 14607
870 (716) 271-5885; Tue-Sat: 12-4 Jul-Aug: closed; owner: Edythe Shedden & Glorya Mueller

Painting and sculpture by New York State artists, and graphics from all over the U.S. and Europe are the principal areas of concentration of the Oxford Gallery, which also deals in tribal art from West Africa and New Guinea, and Pre-Columbian artifacts.

Artists whose work is featured by the gallery include Ann Taylor, a landscape painter of skies, seas, plains and mountains; Cathy Calderwood, who creates surrealist images in a meticulous technique; and trompe-l'oeil painter Catherine Koenig. Many of the artists exhibited are active as university professors in art, such as printmakers David Burnbeck and Jack Coughlin, painters Ainslie Burke and Frank Goodnow, painter and sculptor Fred Miller, and ceramist and sculptor Bill Stewart.

The gallery exhibits collage and assemblages by Leo Kaplan; paintings, sculpture, and collages by Jim Ridlon; paintings by Mary Orwen; abstract paintings by Jack Wolsky; surreal paintings by Catherine Romaine; naive painting and sculpture by Edith Lunt Small; and prints by Lois Olian Rheingold.

Shahin Requicha Gallery 273 Alexander St.,
871 Rochester, NY 14607 (716) 232-4389; Wed-Sat: 12-4 Aug: closed; owner/dir: Shahin Requicha

The Shahin Requicha Gallery exhibits contemporary American and European painting and sculpture.

American Expressionist painting is a feature of the gallery, which shows works by New York artists Peter Dean, Bill Barrell, Jay Milder, Nicolas Sperakis and David Cummings. Expressionist sculptors are Alicia Penalba from France, Gigi Guadagnucci from Italy, and William Crovello and Judith Brown from the U.S.A.

Other contemporary sculptors include James Thomas, known for his light sculptures, Archie Miller, James Marshall and Armanda Balduzzi. Other painters featured are Lanna Pejovic and Mary Lou Dooley.

Shoestring Gallery 2180 Monroe Ave., Rochester,
872 NY 14618 (716) 271-3886; Mon-Sat: 10-4; owner/dir: Ellen Brown & Nancy Esmay

Since 1969 the Shoestring Gallery has been exhibiting original paintings, graphics, sculpture

and ceramics by regional artists. Soapstone carvings by Canadian Inuit artists are a further attraction of the gallery.

Contemporary watercolorists include Harriet "Bing" Thayer, Lisa Forster, Richard Beale and Doug Forsythe. Graphic artists include Lee Ann Fanning and Sabra Richards, silkscreens; Elizabeth King Durand, Eric Bellmann, Audrey Freedman and David Dickinson, etchings; and Sandra Bowden, collagraphs. Metal sculpture by Achille Forgione, and porcelain by Nina Goby are also exhibited.

Visual Studies Workshop Galleries 31 Prince St.,
873 Rochester, NY 14607 (716) 442-8676; Tue-Sat: 12-5 Mon-Tue: 5-9; gallery dir: Glenn Knudsen workshop dir: Nathan Lyons

Workshop Gallery and Annex, for contemporary photographers and printmakers; the two Loft Galleries for major traveling exhibitions and group shows; the Research Center Gallery, for material from the permanent collection; and the newly established Video Theater, for the work of independent video artists.

The Workshop Gallery features the following contemporary photographers and photo-print-makers: Michael Bishop, Linda Connor, John Divola, Carol Drobek, Marion Faller, Robbert Flick, Hollis Frampton, Bonnie Gordon, Gary Hallman, Wanda Hammerbeck, Eikoh Hosoe, Joseph Jachna, Susan Jahoda, Kenneth Josephson, Joan Lyons, Nathan Lyons, Lawrence McFarland, Roger Mertin, Bart Parker, John Pfahl, Jeff Silverthorne, Murray Riss, Ann Rosen, Keith Smith, Charles Traub and John Wood.

The Workshop's exhibition program is dedicated to displaying the work of today's most important established and emerging photographic artists, and to providing unique interpretations of historical material. Recent exhibitions include: *Video Installations 1983, New Family Album* by Barbara Jo Revelle and Alex Sweetman, *Seattle Subtext* by Paul Berger, and *The Landscape Starts Here.*

ROCKVILLE

ROCKVILLE CENTER

Galerie Cote 302 Sunrise Hwy., Rockville Center, NY
874 11570 (516) 678-2659; Tue-Sat: 12-6; owner: victor Rosado dir: Marjorie Rosado

The Galerie Cote specializes in the work of contemporary American and European masters, with emphasis on American realists. The gallery carries a wide selection of original prints, as well as many unique pieces.

American social realists Raphael Soyer and Moses Soyer are among the artists whose work is available. Other American realists are Isabel Bishop and Will Barnet. European Surrealists Salvador Dali and Joan MIro are represented in the gallery inventory, which also includes Surrealist David Mann.

The gallery holds at least one exhibition a year of its featured artists, and two or three of work by emerging painters such as realist Doug Auld, geometric abstractionist Sonny Zohack, and impressionist Richard Zodda.

ROSLYN

Robley Gallery 1356 Old Northern Blvd., Roslyn, NY
875 11576 (516) 484-5960; Mon-Sat: 10-5; owner: Roberta Frank dir: Shirley Janowitz

Concentration is on contemporary American and European graphics and paintings by well-known and new artists.

Paintings and graphics are available by Benny Andrews, Judith Silver, Charles Dryer, Peter Freudenthal and Albert Snayhoover. The gallery carries an inventory of collector graphics by Robert Rauschenberg, Louise Nevelson, Ed Baynard, Adolf Dehn, Leonard Baskin, and others. Photographs by prizewinning photojournalist Lawrence Frank are also exhibited.

The gallery has always carried the work of younger painters, many of whom have since become well-known. Currently shown are abstract pastels and oils by Bruce Busko, hyperrealist oils by John Pate, hand-colored collagraphs by Sidney Schatzky, which recall Art Deco, and handmade paper collages by Bunny Kline.

SCARSDALE

The Craftsman's Gallery 16 Chase Rd., Scarsdale,
876 NY 10583 (914) 725-4644; Tue-Sat: 10:30-5:30; dir: Sybil Robins

Now in its second decade, The Craftsman's Gallery presents contemporary American craft in changing exhibitions throughout the year. Media exhibited include clay, wood, metal, glass and fiber.

Craftspeople include noted metalsmiths Robert Ebendorf, Sharon Church and David Bacharach; ceramists Bennett Bean, Chris Richard, Val Cushing, Ban Kajitani, David Shaner and Harvey Sadow; and contemporary glass sculptors Stephen Dee Edwards, Michael Pavlik, Dale Chihuly, John Nygren and Robert Palusky.

SETAUKET

Gallery North 90 N. Country Rd., Setauket, NY
877 11733 (516) 751-2676; Tue-Sat: 10-5 Sun: 1-5; dir: Elizabeth Goldberg

A nonprofit gallery dedicated to contemporary works by Long Island artists and artisans, Gallery North exhibits paintings, prints, sculpture, and crafts. Styles range from realist to abstract. The gallery represents both established and emerging artists.

Among the many artists featured are realist painters Joseph Reboli and Marjorie Bishop, and abstract painter Stan Brodsky; printmakers Clayton Pond, Eleanor Rappe and Joan Rogers; photographers Vinnie Fish, Michael Edelson and Michael Petroske; and craft artists Jon and Jan Gilmor (glass), George William Peterson (ceramics), and Patricia Allebrand (silver smith).

SOUTHHAMPTON

Gayle Willson Gallery 42-B Job's Lane, Southhampton,
878 NY 11968 (516) 283-7430; daily: 11-5:30 Wed: closed; Jan-Mar: closed; owner: Paul Willson dir: Gayle Willson

Concentration of the gallery is on contemporary fiber art, including wall pieces, sculptural forms, and art to wear. The principal emphasis of the

gallery is one-of-a-kind wearable art from American artists who work in silk, wool and cotton, woven or dyed.

Works II Gallery 28 Job's Lane, Southhampton, NY
879 11968 (516) 283-8546; Thu-Sun: 12-5 winter: closed; owner: Roberta Von Schlossberg & F. Pereira

Concentration is on contemporary art and sculpture, both abstract and representational.

American contemporary artists whose work is exhibited include Giancarlo Impiglia, Art Deco paintings; Hector Leonardi, collage paintings; Daniel Maffia, "romantic" school paintings; Frank McCulloch, Southwestern landscape paintings and monotypes; and Richard Mizdal, photorealist paintings. The gallery also shows works by younger artists such as Michael Haykin, who paints Key West landscapes and makes fantasy constructions; and Jeanne van Gemert, who welds and paints steel sculptures.

SYRACUSE

The Studio Gallery 133 S. Salina St., Syracuse, NY
880 13202 (315) 472-0805; Tue-Sat: 10:30-5:30; owner: Allan Sustare dir: Gail B. Willshire

The Studio Gallery specializes in contemporary crafts by American artists. The gallery carries a wide range of blown glass, prints, and porcelain, and handmakes and designs jewelry. Custom work in scrimshaw, ivory, gold, silver and precious stones is available as well.

The gallery represents well over one hundred American craft artists. Glassblowers in the gallery collection include Stephen Dellerman, Donald Carlson, Bob Eickholt, the Nourot Studio, Nancy Freeman, Rick Strini, Rich Miller and Mary More. Also available are *raku* by Deborah Monaghan, Kerry Gonzales and Scott Lindberg, porcelain by Beth Changstrom, Heyward Cutting and Sally Ann Endleman.

Signed and numbered prints are available by Peter Max, Salvador Dali, G.H. Rothe, Rita Raymond, Polly Chax and many others.

The gallery attempts to showcase local talent of national stature. Sculpture by Arlene Abend, weaving and tapestries by Judy McNelly-Warner, and stone sculpture by Sylvia Jayes add dimension to the gallery.

UTICA

Rutger Gallery 402 Rutger St., Utica, NY 13501,
881 (315) 797-1415 Sun: 1-4 Mon: 7-9 and by appt Jul-Aug: closed; owner: Wilma Sinnott

The Rutger Gallery specializes in work by contemporary photographers.

While the gallery does not represent any artist exclusively, recent shows included work by Stephen Brigidi, Lorna Lentini, Dave Read, Susan Hacker and Robert Dawson.

NORTH CAROLINA

CHARLOTTE

Jerald Melberg Gallery 119 E7th St., Charlotte, NC
882 28202 (704) 333-8601; Tue-Sat: 10-5:30; owner: Jerald Melberg dir: Jane McKinnon

The gallery represents established and emerging living American artists with a variety of styles. It also carries individually important works by both American and European artists from the entire 20th century.

Artists of national reputation featured by the gallery include landscape painter Wolf Kahn, master collagist Romare Bearden, sculptor Seymour Lipton and abstract painter Ida Kohlmeyer.

Other artists who border on national recognition include Russ Warren, Alice Ballard Munn, Edgar Buonagurio, Toby Buonagurio, Herb Jackson, Clara Couch, Rod MacKillop and Jesus Bautista Moroles, all of whom have attained recognition for significant contributions in various media.

DURHAM

Somerhill Gallery 5504 Chapel Hill Blvd., Durham,
883 NC 27707 (919) 493-3574; Mon-Fri: 10-5:30 Sat: 10-4; owner/dir: Joseph Roand

Concentration is unique pieces and original multiples generally by contemporary artists of the Southeast or artists who have lived, worked or have some experience in this geographical region.

Work exhibited includes lithographs and etchings by Harold Altman, tapestry by Silvia Heydon, and sculpture by Jane Armstrong, Dorothy Gillespie and Mary Lou Higgins. MacDonald Bane exhibits large color field oil paintings on canvas; Robert Broderson, figurative, abstract and surreal painting; S. Tucker Cooke, fantastical acrylics and drawings of dream imagery executed with classical draftsmanship; Maud Gatewood, large scale, flat realism; and Claude Howell, large scale figurative paintings.

Other artists shown are photographers Melinda Blauvelt and James Crable, and ceramists Dino Reed, Elaine Reed and Scott Bridge. Painters include Susan Durfee, Richard Fennel, Vic Higgins, Stephen White, Jane Sorrell Walden, Geoffrey Lardiere, Thomas Link, Edith London and Vernon Pratt. Nancy Tuttle May and Missie Dickens work in watercolor. Sculptors are Richard Fennel and Dean Levy. Kent Ipsen works in glass. Artists working in graphic media include Tony Bradley, mixed media; Yale Epstein, pastels and lithographs; Shirley Koller, paper assemblages; Swietlan Kraczynn, etchings and drawings; Susan Durfee and Edith London, collages; and Stephen White, linocuts.

GRAHAM

Firehouse Galleries 135 W. Elm St., Graham, NC
884 27253 (919) 226-4495; Mon-Fri: 9-5 Sun: 3-5 Jul-Aug: closed; dir: Alex Hutchins

The three galleries that comprise the Firehouse Galleries feature monthly exhibits of local, state and regional artists. Concentration is on contemporary art.

GREENSBORO

Green Hill Center for North Carolina Art 200 N.
885 Davie St., Greensboro, NC 27401 (919) 373-4515; Tue-Fri: 10-5 Sat-Sun: 2-5 Jun-Aug: closed Sat; dir: Cynthia K. Ference

The Green Hill Center is a nonprofit exhibition

gallery and educational facility featuring the contemporary visual arts of North Carolina through changing exhibitions and a wide variety of education programs for children, adults, students and special populations.

Artists whose work has been displayed in the gallery include, among many others, internationally known studio glass artist Harvey Littleton, representational painter Maud Gatewood, and abstract painter and printmaker Herb Jackson.

HILLSBOROUGH

Priestley Fine Art Cheyenne Dr., Rte. 5, Box 180,
886 Hillsborough, NC 27278 (919) 968-1736; by appt; owner/dir: Mary Ellen Priestley

Concentration is on 19th and 20th century British watercolors, etchings, serigraphs, lithographs and woodcuts, including work by contemporary artists.

The oldest watercolors in the gallery are those by the great Baroque painter Sir Anthony van Dyck, who left Holland to serve the court of Charles I of England in the mid-17th century. There are also works by 18th century artist John Singleton Copley, whose dramatic realism inspired the Romantics. 19th century watercolorists include Fielding, Henry Bright, Edward West, Sir Aston Webb, William Whymper, Charles Whymper and Thomas Miles Richardson, jr.

Contemporary British printmakers include Graham Clarke, whose arched-top hard-colored etchings of village life are exhibited at the Royal Academy; Robert Greenhalf, whose etchings and woodcuts portray nature; Graham Evernden, etchings; and Kenneth Hildrew, serigraphs and mixed media paintings. The gallery also carries drawings, watercolors and pastels by American artist Arthur B. Davies.

NORTH WILKESBORO

Wilkes Art Gallery 800 Elizabeth St., North Wilkes-
887 boro, NC 28659 (919) 667-2841; Mon-Fri 10-5 Sat: 3-5 Wed: closed July: closed; dir: Martha Baker

Concentration is on 20th century American painting by living artists, mostly from the North Carolina region.

Artists whose work is exhibited include Ric Chin, Ward Nichols and Raymond Williams.

RALEIGH

Ruth Green's Little Art Gallery North Hills Mall,
888 Raleigh, NC 27609 (919) 787-6317; Mon-Sat: 10-9; owner/dir: R. Green

Abstracted realism is the area of concentration of this gallery, which shows over 100 artists working mostly in watercolor and graphic media. The majority of the artists are from the Southeast, but the gallery also has one-person shows of nationally known artists.

Out-of-state artists include Bob Kane (New York), represented in the MOMA, who paints wildly imaginative florals and sea scenes; Paul Landry (Connecticut), whose oils on paper are of last-century romantic imagery; and Arthur Weeks (Alabama), oils of Southern gardens.

Gallery regulars are shown during featured shows. They include Nancy Tuttle May, Nancy Taylor, Holly Simons, Paul Minnis, David Martin, all well-known North Carolinians. Original graphics from all parts of the United States are continually on display.

SALISBURY

Waterworks Gallery 1 Water St., Salisbury, NC
889 28144 (704) 636-1882; Mon-Fri: 10-5 Sun: 2-5; dir: Robert E. Heywood

Waterworks Gallery specializes in contemporary and 20th century American art.

The gallery features photographs by Clarence Laughlin and master photographer Edward Weston. Bamboo and rope constructions by Tom Grubb are also featured, as well as paintings by California artist Peter Plagens, who works in a Minimalist style. Sculpture by noted studio glass artist Harvey Littleton, fiber pieces by Louise Todd Cope and clay sculpture by Steve Howell are also on display.

NORTH DAKOTA

GRAND FORKS

Browning Arts 22 N. 4th St., Grand Forks, ND 58201
890 (701) 746-5090; Tue-Sat: 9-6; owner/dir: Mark Browning

Browning Arts presents works by contemporary regional artists in all media, including painting, drawing, watercolor, prints and sculpture.

Among the artists presented in solo exhibitions in the 1984 season are Margot Behsman, Ernest Cialone, Don Miller and Frances Karlson.

MINOT

Artmain 13 S. Main St., Minot, ND 58701 (701)
891 838-4747; Mon-Sat: 10-5:30 Thu: 10-7; owner/dir: Beth Kjelson & Becky Piehl

Artmain carries work by regional artists and Native American beadwork, baskets and star quilts.

Works displayed at the gallery include the primitive prints of Emily Lunde, and watercolors and *sumi* ink paintings of North Dakota by Frosty Paris. One may also view watercolors by Leon Basler, silkscreen prints of nostalgic subjects by Dale Twingley, and oil paintings by Timothy Green. Richard Gruchalla makes *raku* pottery, while Bob Briscoe and Paul Anderson make functional ware. (Given its high porosity, *raku* is not always adequate as functional pottery, although the Japanese traditionally use *raku* pieces in the tea ceremony.) The gallery also displays work by jewelers Phillip Hall and Cheryl Ingberg.

Minot Art Gallery P.O. Box 325, Minot, ND 58702
892 (701) 838-4445 Tue-Sun: 1-5 Jan: closed; dir: Connie Rosecrans

A nonprofit gallery, the Minot Art Gallery has two distinct areas of specialization: realistic American scenes and contemporary trends in American art. In both areas two and three dimensional works are displayed. The gallery also displays functional and decorative crafts.

Sandi Dahl perhaps best reflects the "Spirit of North Dakota" in her acrylics and waterco-

lors, as does Don Miller in his ceramics. Other realtstic painters include Judy Bell, Betsy Jones, Sarita Huber and Jack Ross.

Other artists showing in the gallery include Tom and Linda Willis, pottery; Ardis MaCaulay, drawings; Beverly Velure, oil paintings; Rikki Barnes, weavings; Randy McClain and Kerry Loveridge, pottery; Michael N. Westergard, bronze sculpture; and William Reynolds, watercolors and needlepoint.

OHIO

AKRON

John Davis Gallery 161 S. Main St., Akron, OH
893 44308 (216) 434-1124; Tue-Fri: 11-6 Sat: 12-5 Aug: closed; owner/dir: John Davis

The John Davis Gallery shows contemporary American painting, photography and sculpture by New York and Ohio artists. Among the artists whose work is shown are Andrea Belag, Daisy Craddock, Jean Feinberg, Joseph Haske, Robert K. Hower, Ron Janowich, Catherine Lee, Janice Lessman-Moss, Craig Lucas, Chuck Magistro, Nicholas Maffei, John Parcher, David Reed, Herbert Reichert, Claire Seidl, John Sokol, D. Jack Solomon, Tom Turner, Janet Vicario, La Wilson, Dona Nelson and Louise Fishman.

CINCINNATI

Toni Birckhead Gallery, 342 W. Fourth St., Cincin-
894 nati, OH 45202 (513) 241-0212; Mon-Fri: 10-4 Sat: 12-4; owner/dir: Toni Birckhead

With an emphasis on artists living and working in the Midwest, the Toni Birckhead Gallery shows painting, works on paper and sculpture. A select group of artists working in New York is also exhibited.

Artists represented from the Midwest include abstract painters Denny Griffith, Dennis Harrington, Susan Sensemann and McCrystle Wood; landscape artists Dan Boldman, Corson Hirschfeld, Leslie Horlander, Dennis Puhalla, Joseph O'Sickey and Brinsly Tyrrell; and artists whose work is based on the human figure Stephanie Cooper, Stuart Fink, Jan Harrison, Stewart Goldman, Peter Huttinger, Lisa Jameson, Kathie Johnson, Brent Riley, Sandy Rosen and David Sheldon. Artists working in New York featured by the gallery are Tom Bachler, Scott Davis, Tom Levin, Linda Levit, George Rickey, Ted Stamm and Robert Swain.

C.A.G.E. (Cincinnati Artists' Group Effort) 344 W.
895 Fourth St., Cincinnati, OH 45202 (513) 381-2437; Thu-Sat: 12-4

C.A.G.E. is a nonprofit alternative arts organization founded by and for artists in May 1978. C.A.G.E. seeks visual, performance and audio works and special projects. Artists are selected by a programming committee which reviews proposals and makes recommendations to the board of directors. Proposal forms are available by SASE from : C.A.G.E. P.O. Box 1362, Cincinnati, OH 45201.

C.A.G.E. is supported by grants from the Ohio Arts Council, the National Endowment for the Arts, and contributions from members and friends. C.A.G.E. is a member of the National Association of Artists Organizations, an arts advocacy organization.

Artists currently associated with C.A.G.E. are Charles Krider, photography; William Radawec, paintings; R.S. Beckman, xerography; Erin K. Weseli, sculpture; Jack Gron, sculpture; Ed Andrews, video-installation; David Ettinger, sculpture; Rob Fronk, paintings; and Kate Gallion, performance-installation. Artists who specialize in performance are Brendan de Vallance, Andy Somma, Hudson, Ellen Glantz and Sandra Binion.

Ludeke Gallery 7781 Cooper Rd., Cincinnati, OH
896 45242 (513) 984-4721; Tue-Sat: 10-5; owner/ dir: Carol Ludeke

The Ludeke Gallery specializes in signed and numbered original prints by nationally and internationally known artists. The gallery also handles original oil, watercolor and acrylic paintings, and sculpture. Works by local artists are exhibited as well.

One of the most important artists shown at the gallery is sculptor Alvar, known for his figurative works in bronze. The gallery also carries works by Lebadang, Picasso, Miro, Dali, Max Papart, Alexander Calder, Victor Vasarely, Graciela Rodo Boulanger, Michel Delacroix, Erte and many others.

The gallery features realistic landscapes by Shirly Zwisler, abstract watercolor landscapes by Judy Tummino, and decorative sculptures by Paul Braslow. Braslow's sculptures are known for their gold plating and hand-applied patinas of burgundy, green and blue, and gold and silver leaf. Braslow is noted for his Entebbe Rescue Memorial, commissioned by the Israeli government and permanently installed at Ben-Gurion Airport.

Malton Gallery 2709 Observatory Ave., Cincinnati,
897 OH 45208 (513) 321-8614; Tue-Sat: 10-5; owner/dir: Donald F. Malton

Located in the Hyde Park neighborhood of Cincinnati, the Malton Gallery specializes in contemporary American artists working in all media and styles. The gallery features emerging and established local, regional and national artists.

The gallery handles work by noted woodcut artists Carol Summers, Gordon Mortenson, and Joseph Domjan, and by master lithographer Garo Z. Antreasian. Summers's innovations in the medium include the use of an inked roller on paper placed on the uninked block, resulting in diffused tones similar to a rubbing. Antreasian focuses on latent or disused possibilities of lithography in his geometric compositions.

Miller Gallery 2715 Erie Ave, Cincinnati, OH 45208
898 (513) 871-4420; Mon-Sat: 10-5; owner/dir: Mr. & Mrs. Norman J. Miller

Established in 1960, this large gallery houses an extensive and diverse collection, from 19th and 20th century paintings and original prints by American and European artists, to contemporary sculpture, art glass, ceramics, handmade paper compositions and fiber art. Not given to echoing the *dernier cri* of the art market, Miller Gallery

stresses quality over notoriety, while showing a wide range of realist and non-objective styles.

The graphics collection features original lithographs by Thomas Hart Benton; original etchings by Gunter Grass, David Bumbeck and Jos. Demarais; and original screenprints by Seong Moy, Pang Jen, Judith Shahn and Julian Stanczak. The gallery specializes in etchings and lithographs by Marino Marini. Works by American and European masters such as Chagall, Picasso, Miro, Motherwell, Natkin and others form the rest of the collection.

Paintings shown include works by Ann Taylor, James O'Neil, Ron Romano, Anne Shreve, Thomas Hilty, Frederick MacNeill and many others. Sculpture is available by Bob Longhurst, Arthur Schneider, Mike Barkin, Allen Dwight, Lucille Driskell, John Pappas, Campbell Paxton, Robert Sanabria and Joseph Burlini; blown art glass by Dominick Labino, Charles Lotton, Marc Peiser, Christopher Ries, Kathleen Mulcahy and Desmett, and E. Baker O'Brien. Handmade paper works are available by Mildred Fischer, Stephen Watson and Tom Balbo.

Greta Peterson Galerie 7696 Camargo Rd., Madeira,
899 Cincinnati, OH 45243 (513) 561-6785; Mon-Sat: 10-5; owner/dir: Greta Peterson

Concentration of the gallery is on abstract art from North America, and also on primitive Scandinavian art.

Paintings by Swedish artist Erik Rohman, active at the beginning of the 20th century, are a distinctive feature of the gallery. Greta Peterson also presents emerging painters, such as Helle Martin, Mona Starfelt, Susan Head Riggs and Hope Meek.

Carl Solway Gallery 314 W. Fourth St., Cincinnati,
900 OH 45202 (513) 621-0069; Mon-Sat: 10-5:30; owner/dir: Carl Solway

A gallery with a notable presence of avant garde figures, the Carl Solway Gallery exhibits 20th century American and European painting, sculpture, and graphics.

The legendary figure of French-American painter and sculptor Marcel Duchamp, influential as much for his person as for his work, presides (counter to his intentions) over such diverse currents as Dada, Conceptualism, optical and kinetic art. Embattled against the mystique of taste and aesthetic beauty, his singular contributions revolutionized the concept of art in the 20th century. His close friend, the American composer John Cage did for 20th century ears what Duchamp did for 20th century eyes, using found sounds where Duchamp used found objects. As Cage wrote in "26 Statements Re Duchamp": "Every object... plus the process of looking at it—is a Duchamp." Cage has also applied his aleatoric compositional methods to visual artworks. Buckminster Fuller's design science takes a holistic view of human and world resources, a philosophy at one with his inventions and his social criticism. Fuller's re-union of humanistic and scientific concerns has influenced American art, particularly in sculpture and architecture, while his drawings and installations have revealed him as an artist. Nam June Paik, an artist associated with the international Neo-Dada group

Fluxus, is best known as a pioneer video artist and inventor of an early video synthesizer. Originally a composer, Paik has created works for cello and interactive video, as well as graphics based on video imagery.

Carl Solway exhibits works by other well-known artists, including Jay Bolotin, Jack Chevalier, Rocio Rodriguez, Joan Snyder, John Torreano, Hap Tivey, Sam Gilliam, Alan Sonfist, Richard George, Gregory Thorp, Russ Maddick, Julian Stanczak, Ray Parker and Jim Pernotto.

TOLEDO

J. Barrett Galleries 3154 Markway Dr., Toledo, OH
901 43606 (419) 531-0623; Mon-Sat: 10-5; owner/dir: Jim Barrett, Jr.

The J. Barrett Galleries specializes in American and European paintings, sculptures, works on paper, and studio art glass. The gallery also handles the location of major works by Mexican artists and arranges their entry into the U.S. for both galleries and individuals. Through contacts with major galleries and artists in Mexico, Jim Barrett also locates major works of any artist for clients on an individual basis.

The gallery features such artists as Thomas Hilty, Felipe Castenada, Hugo Victor Castenada, Pat Denton, and others. Graphic artist and painter Thomas Hilty works in pastels, conte and graphite in medium-scale figurative drawings in a multiple image technique. Felipe and Victor Hugo Castenada are Mexican sculptors working in stone and bronze, whose imagery is of Mexican Indian women. Painter Pat Denton works in watercolor and egg tempera, generally portraying traditional subject matter.

Images Gallery 4324 W. Central Ave., Toledo, OH
902 43615 (419) 537-1400; Mon-Fri: 10-5 Sat: 11-3 Jun-Sep: closed Sat; owner/dir: Frederick D. Cohn Established in 1970, the gallery handles American artists from the 19th century to the present, with an emphasis on contemporary art. Gallery exhibitions often complement Toledo Museum of Art exhibitions.

There is always an inventory of John James Audubon engravings from the Havell Elephant Folio, as well as Bowen editions of the Octavo editions, *Quadrupeds,* etc.

Artists whose work has been exhibited at the Toledo Museum and consequently may be found in depth in the gallery collection are Walter Darby Bannard, Jon Carsman, Robert Motherwell, Philip Pearlstein, Joseph Raffael, Deborah Remington, Carol Summers and Jack Beal. Other well-known artists whose work is shown are Gary Bukovnik, Robert Goodnough, Charles Hinman, David Hockney, Lowell Nesbitt, Don Nice, Emilio Sanchez, Julian Stanczak and Larry Zox.

The gallery shows work by emerging artists who are just beginning their careers in New York and California. They include Gary Bukovnik (San Francisco), Hugh Kepets (NY), Po Kim (NY) and Zarko Stefancic, a Yugoslavian artist living in New York. Stefancic's trompe-l'oeil drawings in acrylic, watercolor and colored pencil constitute a diary of his visit to the U.S. using found objects. Ralph Woehrman, teaching at the Cleveland Institute of Art, depicts horses in polo matches or racing events, grand scale in acrylic

and colored pencil. Po Kim's realistic studies of fruit and vegetables are also done in colored pencil.

OKLAHOMA

OKLAHOMA CITY

Shorney Gallery of Fine Art 6616 N. Olie, Oklahoma
903 City, OK 73116 (405) 842-6175; Mon-Fri: 1:30-5:30 Sat: by appt; owner/dir: Margo Kay Shorney

The Shorney Gallery features Oklahoma residents or native artists working in all media. Representational and abstract sculpture in bronze, stone and terra cotta are displayed, as well as abstract, realist and impressionist painting and graphics, and stoneware pottery.

The gallery represents over 50 living artists. Jo Saylors sculpts in bronze and terra cotta, working in wildlife, Western and contemporary themes, as well as portraits. John Learned produces Indian and Western bronzes, including commissioned outdoor pieces and portraits. Sculptor James A. Pitt works in stone, and makes wood and aluminum portrait plaques. Don Webster portrays wildlife in wood, bronze and stone. Ben Hofstetter dwells on themes from Greek mythology in his bronzes, or makes small animals and whimsical pieces.

Painter Gary Goree works in as wide range of media and styles, including realist and abstract work in silverpoint, oils and acrylics. Emerging artist Jim Cassel similarly works in all media and diverse styles. Artists working in watercolor include Bill Thompson, landscapes and figurative paintings; Carolyn Schaefer, wildlife paintings; and Connie Segal, figurative painting. Other artists include Janet Triplett, oils and graphics, Southwestern landscape; Michael Hurd, impressionistic oil landscapes and Western scenes; Mary Virginia Lee, a well-known artist working in all media; Angelo Marelli, an Italian artist working in mosaic, pyrographics, enamels of architectural subjects; and Roger Maddox, a realist working in all media.

TULSA

Daphne Art and Frame Gallery 8162 S. Harvard,
904 Tulsa, OK 74137 & 1506 E. 15th St., Tulsa, OK 74120 (918) 481-1232; Tue-Fri: 10-5 Sat: 10-3; owner: Daphne Loyd dir: Bill Loyd

The gallery carries original works in oil, watercolor, pastel and scratchboard. Limited edition prints by well-known artists from throughout the United States are also available. While there are works by Norman Rockwell, Pablo Picasso, Joan Miro and Salvador Dali, the gallery is most active in promoting and selling work by artists form Tulsa and the Oklahoma region.

OREGON

ASHLAND

Hanson Howard Gallery 505 Siskiyou Ave., Ashland,
905 OR 97520 (503) 488-2562; Tue-Sat: 10-5; owner/dir: Judy Hansen

The Hanson Howard Gallery mostly exhibits

West Coast contemporary artists. Innovative use of watercolor and printmaking media distinguishes the work of many of the artists shown.

Artists working in watercolor include Judy Howard, K. Wengi O'Connor and Carol Riley. Among the printmakers whose work may be seen are Lyle Matoush, Betty LaDuke, Valerie Willson and Gwen Stone. Paintings are exhibited by Douglas Campbell Stone and Phyllis Yes. Painter Robert DeVoe works in a photorealist style.

EUGENE

Zone Gallery 411 High St., Eugene, OR 97401 (503)
906 485-2278; Mon-Sat: 11-5; owner: nonprofit dir: board

Formerly known as Project Space and Artists Union, Zone Gallery is devoted to showing works by artists residing in the Northwestern United States and working in contemporary art modes.

Contemporary artists whose work is exhibited at the gallery include: Mike E. Walsh, mixed media sculpture and installation; Carol Westlake, mixed media collage and photography; David Joyce, mixed media photography installations; Richard Beckman, sculpture; Linda Walrod-Frith, silkscreen prints; Harold Hoy, mixed media painting and sculpture; Bob Devine, painting; Frank Fox, light installation; Robert Gibney mixed media sculpture; Mike Leckie, sculpture; Mike Bukowski, installation; Mike Kelly, painting; Andy Johnston, painting; Richard Pickering, sculpture; K.C. Joyce, printmaking; Glen Diseth, painting; Nancy Prowell, painting; and Byard Pidgeon, mixed media photography.

PORTLAND

Attic Gallery 206 SW First Ave., Portland, OR
907 97204 (503) 228-7830; Mon-Sat: 11-5:30, owner: Diana Faville & Jan Smith

Located in the heart of the old town renovation district of Portland, the Attic Gallery features a large selection of original paintings, prints, sculpture, pencil drawings and ceramics by contemporary Northwest artists.

The paintings exhibited include representational and impressionistic watercolors and acrylics. There is also and emphasis on abstract oils and mixed media paintings. A print room features original drypoints, etchings, woodcuts, silkscreen prints, monoprints and mezzotints by regional artists. Bronze, wood and stone contemporary sculpture can always be found, as well as a changing exhibit of ceramics. In addition, the gallery provides consulting and framing services.

Blackfish Gallery 325 N.W. 6th Ave., Portland, OR
908 97209 (503) 224-2634; Tue-Sat: 11-5; owner: coop dir: Marc Tetreault

The Blackfish Gallery exhibits contemporary West Coast artists working in a wide variety of styles and media. The gallery specializes in showing work by artists living in the Northwest, providing those who are just emerging into the art market the opportunity to exhibit and the support of their fellow artists.

Nationally known artists whose work may be seen include Roy DeForest, Leonard Riley, Diane

Katsiaficas and Neda Al Hilali. Diane Katsiaficas's work currently involves the use of natural and geometric, architectural elements in site-specific installations. The natural and man-made castoffs she uses are often laminated with recycled paper, while the architectural space contains classical allusions. The disparate elements combine to evoke contemporary contradictions.

Prominent emerging artists from the Northwest featured are Kim Hoffman, Paul Missal, Jim Hibbard, Ester Podemski, Michihiro Kosuge, Ron Mills, Ann Hughes, Dennis Cunningham, Lynn Woods-Turner, Robert Hanson, Barbara Black, Sheryl Funkhouser, Christy Wyckoff, Andrea Joseph, Margret Shirley, David Pearson, Harold Hoy, Richard Rezac, Judy Cooke, William Moore, Susan Hereford, Vern Luce, Julia Fish, Kathy Caprario and Steve Soihl.

Fountain Gallery of Art 117 NW 21st Ave., Portland,
909 OR 97209 (503) 228-8476; Mon-Sat: 11-5; owner/dir: Arlene Schnitzer

Featuring some of the most highly regarded artwork in the Northwest, Fountain Gallery displays paintings, sculpture, watercolors, prints and drawings both by established artists and by young, emerging artists.

Major artists shown include Louis Bunce, Kenneth Calahan, Carl Morris, Hilda Morris, Robert Colescott, Tom Fawkes, Sally Haley, Henk Pander and LaVerne Krause. Michele Russo's painting makes use of a flat, incisively drawn and stylized figuration to convey the ethical conflicts of contemporary society. Lucinda Parker paints in a free gestural style, employing simple signs such as stars, spirals or triangles over an underlying visual structure. George Johansen also works with the figure, in phantasmagoric color and surreal situations. Alden Mason's patterned paintings suggest folk textiles or ceramics. Painter Francis Celentano creates complex visual effects with simple means in his airbrush paintings, which are executed on non-conventional supports. Sculptors shown at the gallery include Mel Katz, who began his career as a painter and is currently working in wood; Manuel Izquierdo, whose welded and painted steel pieces combine geometric and organic elements; and Lee Kelly, whose welded steel sculpture plays with architecture.

Nationally known artists such as Robert Arneson, James McGarrell, Roy DeForest and Joan Brown have also had shows of their work at the gallery.

Exciting work is also shown by young contemporary artists such as Jack Chevalier, Gregory Grenon, Jack Portland, Suzanne Duryea, Mary Heebner, Karen Guzak, Scott Sonniksen, Rene Rickabaugh, Orleonok Pitkin and Joan Ross Bloedel along with many others.

Northwest Artists Workshop 511 NW 12th St., Port-
910 land, OR 97209 (503) 220-0435; Tue-Sat: 12-5; nonprofit dir: Julie Yoho

Northwest Artists Workshop exhibits new and experimental work mostly by Northwest area artists. The gallery space is used for visual exhibitions, site-specific installations and performance events. The gallery generally shows regional or emerging artists who are not known outside the

Portland area. No particular school or style is emphasized; rather, the gallery tries to remain open to new developments.

NWAW is the only alternative gallery of its kind in the Portland area. It is funded by the NEA, the Oregon Arts Commission, and the Portland Metropolitan Arts Commission.

Occupied Space 410 SW 13th St., Portland, OR 97205
911 (503) 223-8086; hours by coincidence and appointment; dir: Ragnars Veilands

A cooperative gallery, Occupied Space features contemporary works and events by artists from the Portland area and beyond. Painting, photography, sculpture, and music and performance events are presented with a concern for today's idioms and an evident will to defend art from gravity with humor.

A "What's Happening" body of artists congregates here, including Jenny. Jenny apart, one may find Occupied Space's spaces occupied by Ragnars Veilands, Jim Wittkopf, Bennett Steen, Steve Steckley, Anton Kimball and the Usual Suspects (performance), all of whom are avant-garde (no small accomplishment in this day and age), some of whom are neo-primitivists, and a few of whom are photographers.

PENNSYLVANIA

BRYN MAWR

Newman Galleries 850 Lancaster Ave., Bryn Mawr,
912 PA 10910 (215) 525-0625; Mon-Fri: 9:30-5:30 Sat: 10-5; owner: Walter Newman dir: Teresa DeFazlo

Concentration is on 20th century art, including work by many Pennsylvania artists. Recent exhibits include works by Howard Watson, Wayne Morrell, Karl Kuerner, and the gallery's annual 19th century show.

See listing for Philadelphia, PA.

CONSHOHOCKEN

Hallowell Gallery 151 10th Ave. East, Conshohocken,
913 PA 19428 (215) 828-8666; Mon-Fri: 10-5 Sat: 11-5 Sun: 12-5; owner: Jack A. Rounick dir: Janet Mano

The Hallowell Gallery specializes in contemporary graphics by New York and West Coast artists, as well as contemporary European artists and printmakers.

Works by the following artists are available: Agam, Appel, Barnet, Bragg, Binder, Carruthers, Dali, Ginzburg, R.C. Gorman, Luongo, Masson, Max, Papart, Rothe, Vasarely, Takara, Yamagata and others.

ELKINS PARK

Gallery 500 Yorktown Courtyard Church & Old York
914 Rds., Elkins Park, PA 19117 (215) 572-1203; Mon-Sat: 10-5 Wed: 10-9; owner: Rita Greenfield, Harriet Friedberg dir: Gary Pelkey

The Gallery 500 handles contemporary American art, including painting, drawing and graphics; and contemporary American crafts, with fine work in glass, wood, clay, fiber and metals.

The gallery features a wide range of artists, styles and media. Dorothy Gillespie makes

brightly painted aluminum mobiles and sculptures; Stefan Martin, incised collages; Paul Garland, abstract watercolors; Frank McCullough, large airbrushed acrylics; Connie Slack, stained acrylic canvases; and Gregorio Prestopino, figurative watercolors and serigraphs. Susan and Steven Kemenyffy create large *raku* wall pieces and sculptures.

Other artists featured include Elizabeth Rickert, pastel drawings of flowers; Mark Lavatelli, acrylics; Helene Stephenson, acrylics and mixed media; Wally Mason, ceramic wall plates; David Crane, sculptural ceramic vessels; Robert Palusky, glass globes and sculpture; Henry Summa, glass plates and sculpture; and Penelope Fleming, *raku* wall sculptures and standing pieces.

KING OF PRUSSIA

W. Graham Arader III 1000 Boxwood Court, King
915 of Prussia, PA 19406 (215) 825-6570; owner/
dir: W. Graham Arader

From his main offices here in King of Prussia, W. Graham Arader conducts a respected art and antiquary business with branches in Atlanta, Houston, Philadelphia, Chicago, and San Francisco.

W. Graham Arader concentrates on American prints, including prints by American naturalist John James Audubon and English naturalist Mark Catesby, who worked in the United States. Audubon's well-known *Birds of America,* engraved by the Englishman Robert Havell, Jr., are tribute to his precise observation and unending devotion. His later work, *Viviparous Quadrupeds of North America* was finished with the assistance of his two sons, Victor and John, Jr. Also available are Indian portraits and scenes of Indian life by George Catlin, Karl Bodmer; as well as works by Bartram, Alexander Wilson, Albert Bierstadt, Will James and others. The gallery also carries a wide selection of Currier and Ives and other genre prints, landscapes and scenes of city life, oil paintings and watercolors of the West, and antique maps of all regions.

PHILADELPHIA

Paul Cava Gallery 1715 Spruce St., Philadelphia, PA
916 19103 (215) 732-5188; by appt Jul-Aug: closed;
owner/dir: Paul Cava

The Paul Cava Gallery specializes in contemporary art in all media, including 19th and 20th century photographs.

Painters whose work is exhibited include Abstract Expressionist Robert Motherwell, Italian New Image painters Gino Longobardi and Francesco Clemente, and American painters Louisa Chase and Susan Rothenberg. Photographers include Joel-Peter Witkin, Aaron Siskind, and Wilhelm von Gloeden. The gallery also has a selection of works by 19th century Japanese photographers.

David David Gallery Art Gallery/David David
917 **Graphics** 260 S. 18th St., Philadelphia, PA
19103 (215) 735-2922; Mon-Fri: 10-5 Sat: by
appt; owner/dir: Alan David, Carl David

The David David Gallery specializes in American paintings, watercolors and drawings from colonial times to the 20th century; and in European paintings, watercolors and drawings from Old Masters to the 20th century. David David Graphics publishes continuous tone lithographs of each segment of the world renowned mural (owned by the gallery) by Frederick Carl Frieseke, from the Shelbourne Hotel in Atlantic City, New Jersey. Plans are for 10 to 12 pieces in the series.

American masters whose work is available through the gallery include Mary Cassatt, Martha Walter, Frederick Frieseke, Jasper Cropsey, John Peto, Thomas Eakins, William Harnett, Frederic Church, Albert Bierstadt, Frederic Remington, Thomas Cole, Winslow Homer, John Singer Sargent, Thomas Moran, George Inness, Charles Willson Peale, John Copley, William Sidney Mount, George Caleb Bingham, George Bellows, Childe Hassam, James McNeil Whistler, John Sloan, John Twachtman and Andrew Wyeth.

European masters include Impressionists and Post-Impressionists Monet, Renoir, Sisley, Pissarro, Degas, Maxmilien Luce, Henri Le Sidaner and Pierre Bonnard; French painters of the Barbizon School Camille Corot, Charles Daubigny and Henri Joseph Harpignies; and French *plein air* artists Eugene Boudin and Leon Lhermitte. Works by Honore Daumier and Picasso are also available, as well as works by Spanish masters Francisco Goya and Joaquin Sorolla; English painter William Hogarth; Dutch painters Hobbema, Van Goyen, Jacob van Ruisdael, and Jacob van Es.

Contemporary American artists exhibited are Alice Kent Stoddard, Frank Reed Whiteside, Fred Wagner and Nancy Ferguson. The work of European artist Harold Speed is also featured by the gallery.

Dolan/Maxwell 1701 Walnut St., Philadelphia, PA
918 19103 (215) 665-1701; Tue-Fri: 10-6 Sat: 10-5;
owner: Dolan/Maxwell dir: Margo Dolan

The Dolan/Maxwell Gallery specializes in works of art on paper. Fine original prints from Old Masters through contemporary works are available for viewing. Unique works, such as monotypes, drawings and watercolors are also exhibited. Emphasis is on works from the 19th and 20th centuries by American, British and European masters.

The gallery's inaugural show in 1984 featured works by painter and innovative printmaker Steven Sorman. Sorman's graphics present a startling variety of techniques within an supple abstract idiom. Lithography, silkscreen, intaglio printing, collage and metal leaf are used on Japanese handmade *shibugami,* Nepalese and other rare papers. Printmaker Ken Tyler, who prints works for Frank Stella, will also be exhibiting. Other featured artists include Frank Stella, Robert Motherwell, Jim Dine, Jasper Johns, Susan Rothenberg, and other contemporary American masters, as well as Mimmo Paladino, Sandro Chia, Francesco Clemente, and David Hockney.

The gallery will also exhibit emerging artists such as Anthony Gorny, Dean Dass, Martha Zelt and Ed O'Brien. Gorny's delicately drawn figurative lithographs, Zelt's colorful and sensual collages, Dass's ephemeral unique works and O'Brien's clear and precise etchings make this a strong contemporary group.

Janet Fleisher Gallery 211 S. 17th St., Philadelphia,
919 PA 19103 (215) 545-7562; Mon-Fri: 10-5 Sat:
11:30-5; owner: Janet Fleisher dir: John Ollman

The gallery's focus is 20th century American art.
Within this category it exhibits 20th century
American folk art, American Impressionists, and
important modern and contemporary work. In
addition the gallery has mounted major shows of
Pre-Columbian and Native American artifacts.

Some of the important folk artists presented
are Martin Ramirez, Howard Finster and Bill
Taylor. Impressionists in the gallery collection in-
clude Daniel Garber, Clarence Johnson and Theo-
dore E. Butler. Other Impressionists and Modern-
ists are featured, including Arthur B. Carles.

Contemporary artists include Marcy Herman-
sader, whose detailed, symbolic drawings reflect
the mysterious nature of the world. John Ferris's
drawings and paintings evoke intense dreamlike
imagery, as do Lynda Schmid's large-scale
works on paper. Recent additions to the gallery
are the works of Tom Judd and Susan Chrysler
White. One-person shows in the 1983-84 season
included the archaeologically derived drawings
of Stephen Talasnik and large wooden sculptures
by Brian Meunier.

Jeffrey Fuller Fine Art 2108 Spruce St., Philadelphia,
920 PA 19103 (215) 545-8154; Tue-Sat: 11-5;
owner/dir: Jeffrey Fuller

Founded in 1979, the gallery primarily shows
emerging American art. The gallery's 35 artists
show painting, sculpture, drawings, prints, and
photographs.

The gallery's selection includes paintings and
prints by Richard Diebenkorn, paintings by Em-
len Etting and Susanne Slavick, sculpture and
prints by Buckminster Fuller, paintings and
sculpture by Maurie Kerrigan, photographs by
Willie Larson and Martha Madigan, and sculp-
ture by Bruce Pollock.

In addition to the monthly one-person exhibi-
tions, there are occasional thematic shows. Re-
cently the gallery mounted "Platinum and Gold/
Image and Process," which presented platinum-
or gold-toned photographic prints by over 40
artists.

Suzanne Gross Gallery 1726 Sansom St., Philadel-
921 phia, PA 19103 (617) 563-4753; Tue, Thu, Fri:
10:30-6 Wed:11-6 Sat: 11-5; owner/dir: Suzanne
Gross

The Suzanne Gross Gallery features contempo-
rary masters and area artists. Original works han-
dled by the gallery include paintings, works on
paper and sculpture.

Among the contemporary masters whose
work is available are Andy Warhol, Louise Ne-
velson, George Grosz, Jonathan Borofsky,
Christo, Jean Dubuffet, and Gunter Grass.

Area artists exhibited include Barbara Minch,
who paints photorealist cityscapes; Charles Du-
Back, impressionist landscapes; Rita Barnett,
impressionist paintings of daily life; and Joshua
Garfield, photorealist figure paintings. Artists
working in abstract modes include Jill Disque,
Judith Heep, Timothy Sheesley, and many
others.

The Hahn Gallery 8439 Germantown Ave., Philadel-
922 phia, PA 19118 (215) 247-8439; Mon-Sat:

10-5:30 Wed: 10-9; dir: Roslyn S. Hahn & Mau-
rice W. Hahn

The Hahn Gallery exhibits contemporary works
of art. The gallery takes particular interest in
American prints of the first half of the 20th
century. The estates of Earl Horter and Benton
Spruance, two noted regional artists, are repre-
sented by the gallery.

Jaipaul Galleries, Inc. 1610 Locust St., Philadelphia,
923 PA 19103 (215) 735-7303; Mon-Fri: 10:30-5:30
Sat: 11-4 Jul 15-Aug 14: closed; dir: Dr. Jaipaul

The Jaipaul Galleries specialize in antique art in
all media from India, Nepal and Tibet.

The 1984 program included several special
shows. One exhibition featured bronze masks
and plaques from the 8th through 19th centuries
A.D.; in another fifty-one chests and boxes of
wood, bronze and marble from the 18th and 19th
century were displayed, including Colonial Of-
ficers' office chests used as lap desks, jewelry
and tobacco boxes, and dowry chests. Temple
art in wood formed the substance of another
show, which included sixty intricately carved
panels, some in polychrome depicting Hindu
deities and mythology. Indian folk art through
the centuries, and Hindu mythical sculptures,
called *valayas,* in bronze and wood from the
16th through 19th centuries were also shown.
Most special exhibitions are accompanied with a
published catalog.

The Kling Gallery 2301 Chestnut St., Philadelphia,
924 PA 19103 (215) 569-2900; Mon-Sat: 9-5; owner:
Kling Partnership dir: George Young

The Kling Gallery is a nonprofit organization of
an architectural/engineering firm, The Kling
Partnership. The space is provided as a service to
the art community to provide public exposure to
diversified contemporary artwork, primarily by
local emerging artists without gallery affiliation,
as well as artists with a more wide-spread reputa-
tion. All media are exhibited, including site-spe-
cific installation and performance.

While the gallery does not represent artists,
it welcomes proposals from emerging artists and
others. Proposals are reviewed by appointment,
and should be accompanied by 15 to 20 slides
or originals and a resume. Exhibitions run one
month and are planned 12 to 18 months in
advance.

The gallery's primary concerns while review-
ing work are "Quality of execution regarding
exploration of characteristics, unique to the me-
dium or crossing media boundaries, through un-
conventional techniques."

Rodger La Pelle Gallery 2002 Rittenhouse Square,
925 Philadelphia, PA 19125 (215) 546-0220; Tue-
Sat: 11-7 Sun: 12-5; owner: Rodger La Pelle dir:
Peter Grimord

Concentration of the gallery is on 20th century
American painting, sculpture, graphics and
photography.

The gallery specializes in fantasy paintings
and graphics by Christine McGinnis; realist
paintings by Fred Danziger and Allan Grow; and
"stickman" lamps by Harry Anderson. Also
available are graphics by Austrian artist Frie-
densreich Hundertwasser and noted Afro-Ameri-
can artist Romare Bearden.

Rodger La Pelle Gallery shows painting and sculpture by established and emerging Philadelphia artists. The works exhibited include self-portraits by Isaiah Zagar; egg tempera paintings by Louise Grassie; crayon drawings by Jack Gerber; pastels by Frieda Fehrenbacher; tension and compression sculptures by Peter Grimord; folk-inspired sculpture by Joan Gallup; antique assemblages by Tim Dixon; and humorous figurative sculptures by Holly Smith. Other artists featured are Linda Brenner, James Farrah, Ted Kliman and Marlene Summers, among others. The gallery also shows a selection of fiber artists.

Marian Locks Gallery 1524 Walnut St., Philadelphia,
926 PA 19102 (215) 546-0322; Mon-Sat: 10-6; owner/dir: Marian Locks

The gallery features contemporary and regional art of the greater Delaware Valley, specializing in Philadelphia artists. An additional warehouse-like space at 122 Arch St. is a non-profit space for emerging artists, offering opportunities for the presentation of large-scale works and installations.

Painters shown in recent exhibitions include Ronald Bateman, Diane Burko, Robert Keyser, David Ferdig, James Havard, Ed Mandrotti, Edith Neff, Elizabeth Osborne, and Jody Pinto. The gallery also features works by sculptor Charles Fahlen. Recent exhibitions included drawings by Jim Turrell of his Crater Project, a show of contemporary Chinese artists, and the gallery's annual New Talent show.

Works seen at the Arch Street space have included large tents by Lucio Pozzi, a simulation of mine stripping by Harriet Feigenbaum, and an installation of cinder blocks and hay by Jody Pinto.

Gilbert Luber Gallery 1220 Walnut St., Philadelphia,
927 PA 19107 (215) 732-2996; Mon-Sat: 11:30-5:30 Wed: 11:30-6; owner/dir: Shirley and Gilbert Luber

Specializing in antique and contemporary Japanese graphic art, the Gilbert Luber Gallery exhibits woodblock prints, etchings, silkscreen prints, and mixed media works.

Japanese master artists whose work may be seen are Hokusai, a student of both Chinese and European art in whose work figures, animals and landscape are marvelously fused, and Hiroshige, whose greatest fame is as a landscape artist, as well as masters such as Toyokuni III, Yoshitoshi, Gekko, Chikanobu, Kuniyoshi and others.

Contemporary artists exhibited include Shigeki Kuroda, Shin Taga, Toshi Yoshida, S. Watanabe, T. Tokuriki, Tanaka Ryohei and Kosuke Kimura. Shigeki Kuroda is known for his etchings and mezzotints of bicycles and umbrellas depicting movement in urban life. Shin Taga's etchings and aquatints meticulously portray esoteric subjects.

Makler Gallery 1716 Locust St., Philadelphia, PA
928 19103 (215) 735-2540; Mon-Fri: 11-5; owner/dir: Paul & Hope Makler

The Makler Gallery specializes in contemporary painting and sculpture.

Artists whose work is available include sculptors Louise Nevelson, George Rickey, Justin McCarthy, George Segal, and David Smith, and

painter Milton Avery. Avery's paintings reveal, more than those of any other American painter, the influence of Henri Matisse in their luminous color and exaltation of decorative composition. Avery achieved a highly personal palette and formal simplicity whose resonance may still be felt in American art. David Smith's sculpture holds a similarly influential position in American art, both in its pragmatic approach to materials—industrial steel and found materials such as old machine parts—and in its freely structured objectivity, presenting such materials undisguised.

Benjamin Mangel Gallery 1714 Rittenhouse Square,
929 Philadelphia, PA 19103 (215) 545-4343; Mon-Sat: 10-5 Summer: closed Sat; owner/dir: Benjamin Mangel

The gallery presents high-quality contemporary work, with a heavy concentration in sculpture. Local sculptors and painters are well represented. The gallery also shows New York and international artists, with the work ranging from abstraction to realism.

Monumental works by gallery sculptor Joe Brown can be seen outside Philadelphia's Vet Stadium and throughout the city. The gallery also represents the estate of Harry Bertoia. The gallery shows works by John Boyle, Red Grooms, Jacques Lipchitz, Robert Rousch, and German sculptor Klaus Ihlenfeld.

Other work shown by local artists includes cityscapes by painter Benjamin Eisenstat, painted nudes on ceramics by Francis McCarthy, illusionary painting by Paul Kane, architectural subjects by painter Allen Koss, soft realistic images by Tom Gaines, and surrealistic paintings by John Dawson. The gallery exclusively represents New York artist Ann Youkeles, known for her abstract three-dimensional prints and paintings.

Susan Montezinos Gallery 1628 Pine St., Philadel-
930 phia, PA 19103 (215) 735-3235; Tue-Sat: 10-6; owner/dir: S. Montezinos

Opened in October of 1983, the Susan Montezinos Gallery focuses on contemporary art in all media.

The inaugural exhibition of the gallery presented the work of artist and filmmaker Paul de Lussanet, from the Netherlands, whose paintings in gouache and oils render the figure in an Expressionistic style. To date the gallery has shown works ranging from drawings on paper by Ted Katz to whimsical and elegant paintings by Bill Schafer. Also shown are works by recognized artists such as Jackie Ferrara, David Reed, Richard Merkin and Pat Steir.

The More Gallery, Inc. 1630 Walnut St., Philadel-
931 phia, PA 19103 (215) 735-1827; Mon-Sat: 10-5:30 Wed: 10-7; owner/dir: Charles N. More

Concentration of the gallery is on 20th century American painting in figurative, narrative and allegorical modes. There is a strong interest in displaying regional talent. The gallery hangs continuous one-person shows throughout the season.

Artists whose work is available through the gallery include Frank Galuszka, Philip Geiger, Scott Noel, Christopher Cairns and James DeWoody.

Muse Gallery 1915 Walnut St., Philadelphia, PA
932 19103 (215) 963-0959; Tue-Sat: 11-5 Jul-Aug: closed; cooperative dir: E. Sherman-Hayman, Carol Clamer

Muse Gallery is a cooperative gallery for professional women artists in the greater Philadelphia area. Membership includes 14 artists of varying styles and media. Many are young, emerging artists.

Newman Galleries 1625 Walnut St., Philadelphia, PA
933 19103 (215) 563-1779; Mon-Fri: 9-5:30 Sat: 10-4:30 Jul-Aug: closed Sat; owner/dir: Walter Newman

The focus of the Newman Gallery is on 19th and 20th century American and European oil paintings, watercolors and graphics. The gallery takes special interest in presenting the work of American illustrators and 20th century artists, including a group of Philadelphia artists.

Pennsylvania artists whose work is displayed include members of the New Hope colony, notably Daniel Garber, Edward W. Redfield, Kenneth R. Nunamaker and Fern Coopedge. Other artists exhibited include those from the Chester County group, and American illustrators N.C. Wyeth and Norman Rockwell.

Works by contemporary artists such as A.J. Rudisill, Philip Jamison, Ranulph Bye, Ben Eisenstat and Frank Nofer are also exhibited.

Painted Bride Art Center 230 Vine St., Philadelphia,
934 PA 19106 (215) 925-9914; Tue-Fri: 12-6 Sat: 2-5; dir: Gerard Givnisch & Julie Courtney

This noncommercial exhibition gallery, founded in 1969, presents new work by local artists. The gallery space is located in the Painted Bride Art Center, which also features performances. The curated shows include installations, photography, sculpture, and installations for performances that combine the visual and performing arts.

The one-person and group shows change monthly. Among the artists seen recently are painter James Brantley, printmaker Cindy Ettinger, sculptors Abe Rothblatt and Eiko Fan, and performance artist Woofy Bubbles. The space has been the site of installations by Uta Fellechner and Elaine Crivelli.

Philadelphia Art Alliance 251 S. 18th St., Philadel-
935 phia, PA 19103 (215) 545-4302; Mon-Sat: 10:30-5; dir: Dr. Marilyn J.S. Goodman

The Philadelphia Art Alliance is a nonprofit cultural institution with two floors of gallery exhibition space. Housed in the elegantly restored Wetherill Mansion on Rittenhouse Square, the Art Alliance concentrates on contemporary works of art by well-known artists as well as artists in the Philadelphia region.

Shows have included works by Pop artist Andy Warhol. Conceptualist Dennis Oppenheim, sculptor Isamu Noguchi, and Philadelphia folk artist Howard Finster.

Portico Gallery 902 Spruce St., Philadelphia, PA
936 19107 (215) 627-8089; Tue-Fri: 10-5 Sat: 12-5 Aug: closed; dir: Stephen P. Lowy

Portico Gallery specializes in art consultation to the corporate and private client. The gallery handles painting, sculpture and photography by young contemporary artists who seem to be on the verge of success in New York and internationally. Portico Editions publishes graphics for the gallery. Portico also handles some vintage photography, and 19th century woodblock prints.

Works by Gary Stephan, Ross Bleckner, Carl Apfelschnitt and Richard Hambleton are available in Philadelphia through the gallery, which also has access to works by Mimmo Paladino, Jorg Immendorf, Alice Aycock, Sandro Chia and others. Vintage photographs are available by George Platt Lynes, Edward Curtis and Nell Dorr; and woodblock prints by Gustave Dore, Winslow Homer and Timothy Cole.

Artists featured by Portico Gallery include Mark Ed, drawings, paintings and prints; Michael Tingley, mobiles, sculpture and drawings; Yasuji "Paul" Hamanaka, paintings, drawings and prints; Laurinda Stockwell, mixed media photoworks with color Xerox, B & W and color photos; Stephan Spera, photography, painting, and artist's books (including the ever-popular *Museum of Modern Rat*); Michael Burns, painting and installation concerned with technology and mysticism; and Connie Coleman/Alan Powell, video installation and computer-altered stills. Other Philadelphia artists are Michael Rasmussen, Lee Lippman, Arlene Love and Natalie Dymnicki.

The Print Club 1614 Latimer St., Philadelphia, PA
937 19103 (215) 735-6090; Tue-Sat: 10-5:30 mid-Summer: closed; dir: Ofelia Garcia

The Print Club has been operating continuously since 1915; its purpose is to encourage contemporary printmaking. A nonprofit corporation, the Print Club sponsors educational and service programs to inform and support printmakers, print collectors, and general public. Some of its activities include: an annual international competition of prints and photography, which draws over 1600 entries, lectures and workshops, artists' referral service, occasional print publications, and a gallery space in downtown Philadelphia.

The Print Club's permanent collection is housed in the Philadelphia Museum of Art, and is generally not exhibited in its gallery. The gallery shows and stocks primarily contemporary works, though occasionally works are borrowed for exhibition from other dealers and collectors.

Exhibitions are generally one month long, and special attention is paid to new and notable changes in technique or image. The purpose of the gallery is primarily educational, though usually all works are available for sale to the public.

Route 66 2026 Locust St., Philadelphia, PA 19103
938 (215) 985-1061 Tue-Sat: 10-5:30 Aug-early Sep: closed; owner/dir Harriet Polite

A relatively new gallery in process of expanding its stable of artists, Route 66 shows internationally and nationally recognized contemporary painters and sculptors. There is also an inventory of paintings, drawings and prints by many modern masters, including artists associated with Pop Art.

Realist Tom Palmore is well-known for his gorillas and other skillfully rendered animals, which are often inserted as incongruous tropes

into art historical settings, such as scenes of the Hudson River School. California painter Mel Ramos, who first came to public attention as a Pop artist, juxtaposes iconic images—typically those of consumer goods and "girlie pics." Though apparently delivered in a precise realist style, Ramos's imagery dissolves to an interrogation of the act of painting in which content poses ironic questions. Abstract Illusionist Joe Doyle combines his geometric compositions with *trompe-l'oeil* impasto. John Fincher paints in a unique representational style. Robert Cottingham paints photorealist works. Painter Charles Fuhrman creates rhythmic geometric compositions. Artist/architect Matteo Thun, who lives in Milan, Italy, creates ceramic sculptures, as well as furniture and ceramics for "Memphis." Stuart Lehrman is known for his brightly painted and textured sculptures, in both very large and small scale.

Frank S. Schwarz & Son 1806 Chestnut St., Philadelphia, PA 19103 (215) 563-4887; Mon-Sat: 10-5 Jul-Aug: closed Sat; dir: Robert Schwarz
939

The gallery specializes in 19th century American and European paintings. Although the majority of the paintings and oils, the gallery also handles watercolors and other works on paper.

Works by artists of the Philadelphia marine tradition are an area of particular interest in the gallery. One may find paintings by artists such as Hudson River School artist Thomas Birch, who with his brother William also published prints of topographical views of Philadelphia, as well as James Hamilton, Franklin Dullin Briscoe and William Trost Richards. Landscape and still life painters handled by the gallery on a regular basis are Herman Herzog, Edmund Darch Lewis, Carl Weber, Mary Smith, Xanthus Russell Smith, William Thompson Russell Smith and William Van de Velde Bonfield.

The gallery also carries portraits, full-size as well as miniature, by James Peale, a noted miniaturist of the Federal period; by his contemporary Jacob Eichholtz, an unsophisticated but charming portraitist; by Philadelphia artist and teacher Thomas Sully, an acclaimed and prolific portraitist; by Cecilia Beaux; and by Philadelphia artist Thomas Eakins, one of America's most accomplished painters, whose uncompromising realism epitomizes the scientific tradition in American art.

Charles Sessler, Inc. 1308 Walnut St., Philadelphia, PA 19107 (215) 735-8811; dir: Holly Powers
940

See listing for W. Graham Arader, King of Prussia, PA.

Jane Steinsnyder 1608 Pine St., Philadelphia, PA 19103 (215) 732-9685; Tue-Sat: 12-5 Aug: closed; owner/dir: Jane Steinsnyder
941

The specialty of the gallery is antique ethnic crafts, mainly tribal African and Oceanic sculpture. The gallery also handles textiles and exotic jewelry from Indonesia, India and Tibet, including original costumes and contemporary incorporating ethnic fragments. From time to time one may find Oriental rugs as well. The gallery does not exhibit contemporary ethnic crafts.

Swan Gallery 132 S. 18th St., Rittenhouse Square, Philadelphia, PA 19103 (215) 568-9898; Mon-Sat: 10-6; dir: Jane Korman 8433 Germantown Ave., Chestnut Hill, Philadelphia, PA 19118 (215) 242-5300; Mon-Sat: 10-5:30; dir: Ann Sklar
942

The Swan Gallery specializes in contemporary American crafts, featuring metal, clay, fiber, glass and wood. Corporate services are available at the 18th Street location, art to wear at the Chestnut Hill gallery.

Among the artists whose work is available at the gallery are Sharon Church, Wayne Bates, Rick Bernstein, David Ebner and Susan Neal, who makes handwoven clothing.

20th Century Gallery 259 S. 20th St., Philadelphia, PA 19103 (215) 735-1466; Tue-Fri: 12-6 Sat: 12-5; owner/dir: Frank Giannetta
943

The Twentieth Century Gallery specializes in contemporary art with a focus on the figure, with particular to the power of the figure to convey emotion.

Works exhibited include the paintings of Michael Shanoski, who portrays human figures in varying degrees of abstraction, at times realistically, most often in an expressionistic style. The pleasing formal qualities of his work are counterpointed by its intellectual and emotional appeal. Alfred Ortega reveals the influence of Matisse and Soutine in the vitality of his color and expressionistic temperament. Robert Andriulli paints impressionistic landscapes.

Other artists whose work expresses the mood and concentration of the gallery include Vivian Wolovitz, Barbro Jernberg and Grace Bishko.

Sande Webster Gallery 2018 Locust St., Philadelphia, PA 19103 (215) 732-8850; Mon-Fri: 10-6 Sat: 11-4; owner: Sande Webster dir: Bob Reinhardt
944

The gallery represents current 20th century artists and deals in paintings, graphics, watercolors, sculpture and fine art crafts. Although considered a "discovery" gallery, Sande Webster exhibits many nationally and internationally recognized artists. The stylistic thrust of the gallery is non-representational. The gallery mounts traveling exhibitions and serves the corporate community as well as the general public.

The gallery represents a number of significant Black American artists, whose work is described in a catalog available from the gallery.

Artists exhibited at the gallery whose work is included in museum or important private collections are Hubert Taylor, Bob Reinhardt, Richard Jordan, Charles Searles, James Dupree, Syd Carpenter, Mike Cunningham, Carolynn Hayward Jackson, Marc Forman, Joe Stabilito, Andrew Turner, Weyman Lew and Ryo Watanabe. Many of the artists work large-scale, and many are available for commissions, including Andrew Turner, who does portrait commissions.

Other artists exhibited are John Seitz, glass constructions; Barbara Canin, floral watercolors; W.A.S. Hatch, representational watercolors; Harold Altman, representational graphics; Sica, metallic constructions; Honda, aquatints; Margery Applebaum and Debra Von Damm, handmade paper constructions; and Alan Willoughby, ceramic plates and urns.

PITTSBURGH

Concept Art Gallery 1031 S. Braddock Ave., Pittsburgh, PA 15218 (412) 242-9200; Mon-Sat: 10-5:30 Thu: 10-9; owner: Sam Berkowitz dir: Mel Berkowitz
945

Concept Art Gallery specializes in contemporary American art in all media, including painting, watercolors, graphics, glass, ceramics, posters, etc. Both established and emerging artists are represented. The Gallery also handles master graphics.

Artists who have exhibited recently include Daniel Joshua Goldstein, who makes rainbow-hued rolled paper cutouts; Gary Bukovnik, watercolors and monotypes; Gordon Mortensen, woodcut reduction prints; Henry Koerner, a magic realist who produces paintings, watercolors, and drawings; as well as Romare Bearden, Harold Altman and Robert Kipniss. The gallery has also exhibited the sculpture and prints of British sculptor Henry Moore.

The gallery has also hung two important survey exhibitions during the past two years. "Fine Contemporary Quilts" featured the work of innovative quilters such as Pamela Studstill, Rise Nagin and Louise Silk. "Glass State of the Art" featured contemporary art glass artisans Harvey Littleton, Dale Chihuly and J.P. Meyers.

The gallery also shows leading Southwestern Pennsylvania artists Robert Qualters, Charles Pitcher and Anna Schnur. Craft artists Concetta Mason and Edward Nesteruk work in glass, while Marak Cecula works in porcelain. Emerging artists shown at the gallery include Mark Symczak, Richard Channon, Sandra Brett and George Morris.

Wiebe & Bonwell Galleries 705 Liberty Ave., Pittsburgh, PA 15222 (412) 765-3444; Mon-Fri: 10-5 Sat: 11-2; owner: Charles Wiebe dir: M. Hahalyak
946

The Wiebe Collection is made up of three areas: early Japanese woodblock prints, Old Master prints, and contemporary paintings and prints. The Bonwell Collection is made up of American 18th and 19th century paintings, and European 18th and 19th century paintings.

Japanese masters of the *Ukiyo-e* School include Utamaro, Shunsen, Hokusai, Hiroshige, Eisen, Kuniyoshi, Kunisada and Hirosada. Old Masters include Piranesi, Jacques Callot, Francisco Goya and William Hogarth. American 19th and 20th century painters include American Impressionists Joseph Boston, George W. Picknell, C. Emerson Brown and A. Brian Wall, as well as Aaron Gorson, George Hetzel, Edward Moran, Ross Braught, Henry McCarter and others. European painters include the Barbizon A.R. Veron and Antonio of the Spanish School.

Contemporary artists include Leonard Baskin, known for his forceful woodcuts and wood engravings, George Nama, Henry Koerner, and British sculptor Joe Tilson, associated with the first generation of British Pop artists.

Among the contemporary regional artists shown by the gallery are realists Jim Heintz, Gregory Smith and Elizabeth Daniels; abstract painters Douglas Salveson, Karen Scofield, Lewis Kesling and James Koerner. Also included

are sculptors Bob La Bobgah, Lee Richardson and Philip Mendlow, and video artist Philip Rostek, the most experimental of the group.

RHODE ISLAND

PROVIDENCE

Jeb Gallery 305 S. Main St., Providence, RI 02901 (401) 272-3312; Mon-Thu: 4-6 & by appt; owner/dir: Ronald Caplain
947

The gallery shows works by 20th century living photographers. A selection of photography books is also available.

Artists whose work is exhibited include Kelly Wise, William Clift, Lee Friedlander, Jerry Uelsmann, Canadian portraitist Yousuf Karsh, Max Kozloff, Oliver Gagliani, and Joel Meyerowitz.

Woods-Gerry Gallery 62 Prospect St., Providence, RI 02906 (401) 331-3511 ext 147; Mon-Fri: 10-4 Sat: 11-4 Sun: 2-5; dir: Kristine Diekman
948

Set high on a hill among historic houses, the Woods-Gerry Gallery overlooks the city of Providence. This former mansion was converted to provide additional exhibition space for the Rhode Island School of Design. Its spacious garden permits outdoor sculptural installations and performance, while the interior rooms host a variety of changing exhibitions of painting, sculpture, ceramics, glass and furniture by artists from throughout the U.S. as well as students, faculty and alumni of the School.

At this teaching gallery directed to the community, experimentation is encouraged. Many of its thematic shows, such as a recent one on mathematics in the arts, involve people from outside the School of Design. Depending on the current session of the School, the gallery may show student work (Winter), graduate thesis and exchange faculty exhibitions (Fall), or architectural degree projects and exhibitions of outside artists (Spring and Summer).

SOUTH CAROLINA

CHARLESTON

Gibbes Art Gallery 135 Meeting St., Charleston, SC 29401 (803) 722-2706; Tue-Sat: 10-5 Sun, Mon: 1-5; dir: Charles L. Wyrick, Jr.
949

The Gibbes Art Gallery carries a wide variety of artworks, including American painting, graphics and photography. Included in the painting collection are American portraits and miniatures from colonial times through the 19th century. The gallery also has collections of Oriental art, and devotes part of its space to the works of contemporary American artists as well.

Among the contemporary artists whose work is exhibited at the gallery are Sandra Baker, Robert Courtright, Sam Doyle, Charles Fraser, Andre Harvey, Elena Karina, Louise Nevelson, Alice Ravenal Huger Smith and Elizabeth O'Neill Verner. Photographs by Edward Weston are also available.

HILTON HEAD ISLAND

Artistic Sass/Primary Art 14 Greenwood Dr. #6, Hilton Head Island, SC 29928 (803) 785-8442;
950

Mon-Fri: 10-9 Sat: 10-6; owner: R.L. Tarchinski
dir: P.J. Tarchinski

The gallery features contemporary art by American artists in clay, fiber, glass, metal, oil, acrylic and wood.

Works available include abstract illusionist paintings by Mark Elliot Flowers, contemporary wood sculpture and furniture by Peter Adams, glass sculpture by Kate Voge, and John Littleton, glass sculpture by Yaffa Sikorsky, and fiber works by Louise Todd-Cope.

Red Piano Art Gallery 220 Cordillo Pkwy., Hilton
951 Head Island, SC 29928 (803) 785-2318; Tue-Sat: 11-5 Sun: 1-5; owner/dir: Louanne C. LaRoche

Red Piano Art Gallery handles American art, including illustration, folk art, contemporary representational art and jewelry, as well as African and Nepalese art and textiles.

On view at the gallery one may find illustrations from 1940-60 by Coby Whitemore, plus recent paintings by this artist, as well as paintings by Bernard D'Andrea in a style combining elements of impressionism and expressionism. There are watercolors of coastal waterways by Ray G. Ellis, and the paintings of black folk artist Sam Doyle. The unusual portrait jewels of Jean Stark are also on display, along with her classical jewelry.

SOUTH DAKOTA

RAPID CITY

Anakota Arts, Ltd. 516 7th St., Suite 213, Rapid
952 City, SD 57701 (605) 348-1890; Mon-Fri: 9:30-5:30 Sat: 9:30-5; dir: Anna Marie Thatcher

An active gallery with a program including exhibitions, a corporate leasing service, consultation and commission services, as well as educational events and art publications, Anakota Arts handles Western art, contemporary prints, watercolors, sculpture, weavings and photography by local, regional and national artists. Jewelry, crafts and wearable art are also displayed.

The gallery has the last prints of the "Buffalo Dance" by Oscar Howe, the last remaining original works of his on the market. Educated at the Santa Fe Indian School, Howe is a significant contributor to Native American art history, both as an artist and as an educator.

The gallery features work by Dale Lamphere, who works in bronze, creating bas relief landscapes, poetic images of the pioneer women of the plains, and contemporary images. South Dakota painter Roger Broer presents multi-media paintings and stone lithographs in a unique style reflecting his Oglala Sioux roots. Jacqueline Rochester's oil paintings and serigraphs depict contemporary Southwest family scenes and images. Martin Green's monotypes are colorful florals and landscapes with an Oriental touch. Jane B. Scott's painterly oil and pastel portraits and still lifes recall the Impressionist masters.

A recent exhibition featured the work of Priscilla Hoback, a ceramist from Santa Fe, New Mexico, who is best known for her stoneware pottery. Hoback's one-of-a-kind platters, bowls and jars are the color of the Southwest landscape, with blue-grays from pinion ashes and russets from scrapings off rusty stock tanks.

The gallery is also a source for Native American art from the region.

SIOUX FALLS

Jim Savage's Western Art Gallery 713 S. Cleveland,
953 Sioux Falls, SD 57103 (605) 332-7551; daily: 9-6; owner/dir: Jim & Shirley Savage

The gallery presents bronzes and paintings by contemporary Western artists from all over the United States. In addition to Western art, the gallery offers Indian baskets, pottery, peace pipes and sand paintings.

Many of the artists featured have participated in national exhibitions of Western art. Jim Savage is known for his wood sculpture, and also works in watercolor and graphics, offering limited edition prints for the collector. Gerry Metz's watercolors, oil paintings by Harry Brunk, oil paintings and bronzes by Ted Long, and bronze sculpture by Pam Harr and Harvey Rattey round out the selection of Western art at the gallery.

TENNESSEE

MEMPHIS

Oates Gallery 97 N. Tillman St., Memphis, TN 38111
954 (901) 323-5659; Mon-Sat: 10-4; owner/dir: Rena Dewey

The gallery concentrates in several different areas of specialization: 19th and 20th century American art, contemporary and modern European and Balkan art, and works by local and mid-South artists working primarily in primitive and representational styles. Works are available in all media.

Among the artists featured are Jay H. Connaway, a member of the National Academy active in this country in the late 19th and early 20th century; Dorothy Sturm, who works in enamels, watercolor and gouache; and contemporary artist Lynda Ireland, from Memphis.

Regional artists include Janis Albertine, Robert Blum, Richard Knowles, William Knowland Van Powell, John Stoakley and Gerald Sweatt. The gallery also carries works by Arkansan Josephine Graham and Texan Donald S. Vogel. European artists are Kurt Craemer, Lajos Dobroszlav, Joseph Dobroszlav, Tanasis Fappas, Rudolf Fischer, Emil Gador, George Ionescu, Walter Krause, Siegfried Kratchowil, Eszter Mattioni, Meta Mettig, Pohm Poldi, Fritz Seeman, Stefan Stirbu, Szallaug Svalastoga and Anke Wiesmer.

NASHVILLE

Cumberland Gallery 2213 Bandywood Dr., Nash-
955 ville, TN 37215 (615) 297-0296; Mon-Sat: 10-5 & by appt; owner/dir: Carol Stein & Caroline Stevens

The gallery focuses on contemporary art, mostly abstract. All media are represented—painting, graphics, sculpture, etc. The gallery features Southwestern artists and nationally known emerging artists.

Works displayed include prints and watercolors by John Baeder, a photorealist whose ima-

gery revolves around roadside diners; prints and paintings by Minimalist David Shapiro, who employs literary symbolism; paintings by Ida Kohlmeyer, a painterly abstractionist working with personal hieroglyphs; and painted constructions based on landscapes by Robert Quijada.

Other artists are Bryan Harrington, textural collages with mixed media and handmade paper; Marilyn Murphy, photorealist drawings on paper; Peter Laytin, infrared photography; and Carole Sue Lebbin, graphics and paintings of architectural details.

The gallery also has a collection of contemporary master graphics by Joan Miro, Pablo Picasso, Marc Chagall, Max Ernst, Robert Motherwell, James Rosenquist and others.

TEXAS

AMARILLO

The James M. Haney Gallery 4500 I-40 West, Suite
956 D, Amarillo, TX 79106 (806) 356-3653; Mon-Sat: 10-5; owner/dir: J.M. Haney

The gallery offers an overall resume of different styles of art, with concentration on contemporary Southwestern paintings and sculpture. The paintings shown range from representational English and American antique paintings, contemporary European paintings, traditional still life and landscape, energy-related landscape, bronze and wood sculpture, to Southwestern painting and sculpture. There is also a selection of signed and numbered limited edition prints, as well as serigraphs and some lithographs.

The James M. Haney Gallery exhibits work by Del Parson, a Western artist known for his landscapes of the Grand Tetons and figurative Indian subject matter. There are also acrylic paintings by James M. Haney of Southwestern subjects, including North American Indian artifacts such as pottery and basketry. One may also find pastels by Penni Anne Cross, a leading Southwestern artist.

Oil canvases by French artists Gaston, Blanchard and Cortez, and Spanish artist De Sosa are available, as well as a large portfolio of collagraphs by English artist Basil Ede depicting waterfowl and upland game birds.

AUSTIN

El Taller 725 E. 6th St., Austin, TX 78701 (512)
957 473-8693; Mon-Sat: 10-6; dir: Marilyn Scott

Contemporary Southwestern artist Amado Maurilio Pena opened the gallery and studio in 1979. Since then it has expanded into a studio, frame shop, and two galleries. The main exhibit shows work by Pena and Liese Jean Scott on a permanent basis. The gallery also features works by other Southwestern artists.

Pena's mixed media paintings use oil, acrylic, pencil, ink, pastel and watercolor. He is also proficient in graphic media. His images reflect the life styles of Indian and Mestizo cultures. Scott's work comprises a statement of a young woman in these cultures, reflecting the struggles of Indian women as well as their beauty.

Also on display are weavings of the Zapotec Indians of Mexico, and clay works by Shirley Thompson Smith. The studio where Pena and Scott work is open to the public.

Native American Images 2104 Nueces, Box 746,
958 Austin, TX 78767 natl: (800) 531-5008 TX: (800) 252 3332; Mon-Fri: 9-6 Sat: 10-5; owner: Ted Pearsall dir: Brooks Bannett

Located in the same space formerly occupied by Ni-Wo-Di-Hi Galleries, Native American Images publishes Native American Indian art, providing artwork to individual collectors as well as to galleries and dealers nationwide.

The art publishing company presents many award-winning, traditional and contemporary Indian artists such as Donald Vann, Paladine Roye and Steve Forbis.

Other artists whose work has been published include Katalin Ehling, Charles Lovato, Virginia Stroud and Antowine Warrior. The newest artists, who have already gained a measure of public recognition, are David Dawangyumptewa, whose work deals with Hopi symbolism, and Roger Broer, who depicts wildlife in mixed media.

Patrick Gallery 721 E. 6th St., Austin, TX 78701
959 (512) 472-4741 Tue-Sat: 1-6 and by appt; owner/dir: Mary Lou Patrick

The focus of the gallery is on new. contemporary work with concentration on emerging Texas artists. Many of the artists exhibited have received significant recognition. The works shown are both representational and non-representational, and include paintings, sculpture, drawings and prints.

Among the artists whose work is displayed at the gallery are Austin artists Robert Levers and Robert Yarber, whose work will be included in the 1984 Venice Biennale. Other Austin artists working in a variety of media are Vicki Teague-Cooper, Helena de la Fontaine, David Deming, James Janknegt, Keith S. Ferris, Gibbs Milliken, Connie Morrison, Gary Nowlin, Carol Rabel, Hills Snyder, Steve Swagerle and Bill Wiman.

Other Texas artists include John Chatmas, Jerry Dodd, Berry Klingman, David Peacock, Karl Umlauf and Stephen Daly. Emerging artists from outside Texas are Sandy Brooke, Elen Feinberg and Marilyn Duke.

Galerie Ravel 1210 W. Fifth, Austin, TX 78703 (512)
960 474-2628 Tue-Sat: 11-5

Galerie Ravel, which opened in 1976, carries an extensive collection of contemporary original prints by European, American and Latin American artists. The major focus at this time is on Latin American artists.

The Latin American collection contains both painting and prints in surrealist and figurative styles. There are works by major artists such as Armando Morales, prints and oil paintings; Rufino Tamayo, prints and mixographic prints; and prints by Carlos Merida and Francisco Zuniga. Also included are European prints by Karel Appel, Antoni Clave, Victor Vasarely, Horst Antes, and Coignard; and American prints by Robert Rauschenberg, Jim Dine, Alexander Calder, Richard Lindner, and Claes Oldenburg.

The gallery has five to six shows a year of work by established as well as promising young artists such as Kenneth Hale, printmaker and

painter; Pauline van Bavel-Kearney; ceramist; and Teodulo Romulo, painter and printmaker. The gallery also has an excellent reference library, in addition to its two exhibition spaces.

DALLAS

Adams-Middleton Gallery 3000 Maple Ave., Dallas, *961* TX 75201 (214) 742-3682; Tue-Fri: 10-6 Sat: 11-5; owner/dir: Anita Middleton, Terry Adams

The Adams-Middleton Gallery opened in 1980. It is housed in a converted mansion and is made up of one large gallery and three smaller ones on the ground floor. The gallery exhibits contemporary European and American artists of international, national and regional interest.

Current one-person shows include Jorge Castillo, a Spanish figurative artist whose work reflects his concern with drawing and a metaphorical use of space as a stage for human experience; and Norman Lundin, a California artist known for his carefully rendered studies of interior light effects in charcoal and dry pigment; as well as Xavier Corbero and Paul Rotterdam. The gallery also hangs group shows, such as "America Seen", American representational artists including Neil Welliver, Alex Katz, Don Eddy, Richard McLean, Ron Kleeman, and many others.

Adams-Middleton Gallery also features many artists living and working in Texas, the South and the Southwest, including Marcia Myers from Virginia, Veloy Vigil and Gary Mauro from New Mexico, and Pamela Studstill and C. James Frazier from Texas.

Adelle M Gallery and Art Services 3317 McKinney *962* Ave., Dallas, TX 75204 (214) 526-0800; Mon-Fri: 10-5 and by appt; owner/dir: Adelle M. Taylor

The gallery shows contemporary paintings, claywork and sculpture, as well as fiber art.

Works featured at the gallery include the representational oils and pastels of Charles Basham, and an installation of architectural fiber occupying both floors of the gallery by fiber artist Gerhardt Knodel.

Other artists whose work may be seen are sculptors Leonard Cave, William Keen, Geoffrey Naylor, Charles Umlauf, and Joseph McDonnell; ceramists Les Mitchell, Dennis Smith, Evelyn Baldwin, Martha Hendrix Denman and Nancy Pawel; watercolorist Charles McGough; and painters Thelma Appel and Albert Millar.

The Afterimage No. 151, The Quadrangle, 2800 *963* Routh St., Dallas, TX 75201 (214) 748-2521; Mon-Sat: 10-5:30; owner/dir: Ben Breard

When the gallery first opened in 1971, it was one of the only photographic galleries between New York and San Francisco. And it remains Dallas's only gallery devoted exclusively to photography.

The photographs displayed include well-crafted images by some of America's most highly acclaimed master photographers, such as Ansel Adams, Edward Weston and Harry Callahan, as well as occasional works by distinguished European masters such as Henri Cartier-Bresson and Brassai. The visitor is likely to find works by many other important 20th century photographers on the walls, such as Walker Evans, George Tice, Robert Frank, Yousuf Karsh, Eva Rubinstein and Ruth Orkin.

The gallery offers a schedule of regularly changing exhibits. Typical shows have included the unusual architectural photographs of Harry Wilks, eerie long-exposure nighttime color photographs by Eric Staller, Elliot McDowell's humorous photographs, and Texas landscapes by Jim Bones, a former printer for Eliot Porter. The gallery has also handled vintage photographs, such as the collection of prints and collatypes by L.A. Huffman, a photographer in turn-of-the-century Montana.

One of the pleasant aspects of the gallery is the bins of photographs by talented but lesser-known artists. The gallery also stocks an exceptionally fine selection of in-print photographic books.

Altermann Art Gallery 2504 Cedar Springs Rd., Dal-*946* las 75201 (214) 745-1266; Mon-Fri: 9-5 Sat: by appt; owner/dir: Tony Altermann

The gallery is concerned with the acquisition and sale of fine Western, wildlife, and American art, and carries both paintings and bronzes by significant contemporary and deceased artists.

Included are Western bronzes by Harry Jackson, Truman Bolinger, Joe Beeler, Peter Fillerup and Ken Ottinger; wildlife bronzes by Bob Wolf and Clark Bronson; and Western and American oils, watercolors and gouaches by J.H. Sharp, James Boren, Nick Eggenhofer, G. Harvey, Frank McCarthy, Chuck Ren, Don Ricks, Douglas Ricks, Gordon Snidow, Robert Summers, Mark Swanson, Loretta Taylor, Olaf Wieghorst, David Wright, P. Salinas, O.C. Seltzer and Robert Wood.

The gallery, small but attractive, presents only a small part of the works available. Those interested in a more complete notion of the gallery's inventory will want to request Altermann's annual, extensive catalogue .

Arthello's Gallery 1922 S. Beckley Ave., Dallas, TX *965* 75224 (214) 941-2276; Mon-Fri: 10-5:30 Sat-Sun: by appt; owner/dir: Arthello Beck, Jr.

Occupying both floors of a converted apartment building about 20 minutes from downtown Dallas, Arthello's is the only gallery in the Dallas area devoted exclusively to work by black artists.

The paintings, drawings and prints that crowd the walls are invariably representational, stressing such themes as family and children and scenes of everyday life of black people, and village scenes in Africa. The gallery regularly exhibits the meticulously detailed pencil drawings of Nathen Jones; oils, watercolors and prints by Arthello Beck, Jr., who, together with his wife, founded the gallery in 1980; and two-dimensional work by James Dunn, Burl Washington, Taylor Gurley and Carl Sidle, who are all from the Dallas area.

Arthello's also has a selection of inexpensive prints and reproductions by gallery artists. A few sculptures and photographs are also displayed. If planning a visit, it is well to call ahead. Arthello's is a one-man operation, and occasionally that one man is out painting.

Clifford Gallery 6610 Snider Plaza, Dallas, TX 75205
966 (214) 363-8223; Tue-Sat: 10-5:30; owner: Jutta
Clifford dir: Kim Herbst

Clifford Gallery shows mostly works by contemporary Texas artists, among them printmakers, painters, and sculptors, from the local arts community.

Jutta Clifford opened her gallery in 1974. A highly-considered print appraiser and lecturer, she is a member of the Dallas Print and Drawing Society.

The printmakers presented at Clifford are Jane E. Goldman, Dan Allison, Jeffrey L. Vaughn, Gary S. Bush and William B. Montgomery. Other works on paper include watercolors by Jane E. Goldman and Victoria A. Henderson, print and drawing collages by Betsy Muller, and paper constructions by Carol Wilder.

Some of the painters exhibited at Clifford are Carol Wilder, Wayne Toepp and Leah Goren. Sculptors are Pamela Nelson and Ann Chamberlain.

Contemporary Gallery 5100 Belt Line Rd., Dallas,
967 TX 75240 (214) 934-2323; Mon-Sat: 10:30-5 &
by appt; owner/dir: R.H. Kahn

The major concentration of the gallery is in 20th century prints, paintings and sculpture, in both abstract and modern realist styles.

Major 20th century artists whose work may be found in the gallery include Chagall, Miro, Picasso, Georges Rouault, Jim Dine, Frank Stella, Robert Motherwell, Paul Jenkins and others.

The gallery presents many local artists as well as some contemporary European artists. Local artists include J. Koch, abstract paintings; R. Koch, conceptual constructions; Cobie Russell, semi-realistic landscapes; John Axton, contemporary Southwestern painting; B. Skynear, symbolist works; and Ali Baudoin, abstract stainless steel sculpture. European artists featured are Peter Foeller, a contemporary surrealist, and Michael Eisemann, Modern impressionism and multiple images.

D-Art Visual Art Center 2917 Swiss Ave., Dallas,
968 TX 75204 (214) 821-2522; Mon-Sat: 9-5; pres:
Patricia B. Meadows

D-Art Visual Art Center is the only umbrella arts organization spotlighting the visual arts and artists in the metroplex area. The Center is located in a renovated warehouse, with areas for classes, workshops, demonstrations, meetings and exhibitions.

Exhibitions are booked by individual artists, groups of artists, and art organizations. There are several nationally touring shows in D-Art in addition to the exhibition of local artists' work. The quality and style of the work shown varies greatly because D-Art is committed to allowing artists to show work without being juried. D-Art does not sell work, being a nonprofit organization, but it does attempt to bring the audience and the artists together for mutual support.

Delahunty Gallery 2701 Canton St., Dallas, TX
969 78226 (214) 744-1346; Tue-Sat: 11-5; dir: Hiram
Butler

One of Dallas's oldest and most important galleries, Delahunty occupies a newly refurbished two-story warehouse on the edge of downtown Dallas. The gallery regularly exhibits paintings, prints, ceramics, sculpture and photography, mostly by Texas artists, a number of whom have received national recognition.

James Surls's spiky, rough-hewn wood sculptures and Vernon Fisher's narrative works combining imagery with a written text, which have been widely exhibited and favorably reviewed, are regularly seen at Delahunty. Also exhibiting at the gallery are sculptors Clyde Connell and Italo Scanga, collagist-painter Dan Rizzie, assemblagist David McManaway, and Danny Williams. Photographers include Nico Nicosia, Mark McFadden, Wanda Hammerback, Steve Dennie and Gail Skoff.

The Delahunty also has a print section featuring the works of such significant American artists as Jim Dine, Frank Stella and Robert Rauschenberg. The gallery has a photography department with its own curator, and has also opened a New York branch.

DW Gallery 3200 Main St., Dallas, TX 75226 (214)
970 939-0045; Tue-Sat: 11-5; owner/dir: Diana
Block

DW started in 1975 as a cooperative gallery, organized by a group of women artists for the exhibition of works by women artists. No longer a co-op, DW now shows interesting and important work by North Texas artists of both sexes. In 1983 the gallery relocated to a new space in the "Deep Ellum" warehouse district of Dallas, a developing area that is attracting both new and established galleries.

Work by the gallery's artists includes large-scale constructions by Linnea Glatt, large nude drawings by Ellen Soderquist, haunting paintings by Lee Smith III, folk art paintings by Martin Delabanco, collages by Gail Norfleet, constructed paintings by Rick Maxwell, wooden boats by Dalton Maroney. watercolors by Barbara Bell, paintings and drawings by Bill Komodore, glass sculpture and wood-box constructions by Linda Ridgeway Taylor, and collages by Rebecca Best.

The gallery's focus is on one-person and group shows, though there is an occasional curated drawing show. In Spring 1984, the gallery held its first juried exhibition, which it hopes to make an annual event.

A special feature of the new space is the expanded bookstore, which has artist's books, catalogues, and one-of-a-kind objects.

500X Gallery 500 Exposition Ave., Dallas, TX 75226
971 (214) 828-1111; Wed: 6-9 Thu-Sat: 1-5; pres:
Susan Kae Grant

Blessed with one of the largest and most flexible exposition spaces in Dallas, 500X has endeared itself to art lovers by making its walls available to serious but struggling local artists. Sharing a two-story warehouse with several artists' studios, 500X emphasizes work by young Texas artists, with occasional looks at what artists are doing in other parts of the country. All media are represented in the regularly changing shows, and works on view range from photography and abstract painting to experimental multi-media installations and video.

Amado M. Pena Jr., *Dos Amores,* 36 x 2, serigraph, El Taller (Austin, TX).

Emily Guthrie Smith, *Loing at Nemours,* 34 x 39, pastel, Carlin Galleries (Fort Worth, TX).

The gallery is managed by the artists, who select gallery shows. Among the artists exhibited are Susan Kae Grant, Susan Harrington, Joe Havel, Pauline Hudel, Manuel Mauricio, Steven J. Miller, Kathleen Mitchell, Tom Moody III, Dennis Sharnberg, Barbra Simcoe, David Smith, Mark Smith, John Snygg and P.M. Summers.

Every so often the gallery walls are opened to all comers, and 500X mounts some of the most uneven, but liveliest shows in town.

Florence Art Gallery 2500 Cedar Springs, Dallas, TX *972* 75201 (214) 748-6463; Mon-Fri: 10-4 and by appt; dir: Ms. E. Shwiff

Gallery concentration is centered on European artists of the 19th and 20th century. There is also a selection of bronze sculpture for individual as well as corporate collectors. The gallery is diversified in its selection of artists and their works.

Among the artists whose work is presented by the gallery are Nicola Simbari, a contemporary Italian painter and printmaker who uses brilliant colors in depicting scenes of the Riviera; Wladimir Terlikowski, a 19th century Polish Impressionist; Pierre Laurent Brenot, a contemporary French artist, who as the official artist of the Lido in Paris usually paints women; Robert Russin, a contemporary sculptor of abstract bronze figures; Panos Petros, a Greek Impressionist who paints garden scenes the border on abstraction; and Harry Marinsky, a contemporary of figurative bronzes.

Other gallery artists include Italian painter De Panis, author of minutely detailed landscapes; Denis Paul Noyer, a French contemporary painter of scenes of European life in flat oils; and Florence Arven, an Italian landscape painter who uses a vivid palette.

Foster Goldstrom, Inc. 2722 Fairmount, Dallas, TX *973* 75201 (214) 744-0711; Tue-Sat: 10:30-5:30; owner/dir: Foster Goldstrom

Contemporary American art with an emphasis on sculpture is shown at the Foster Goldstrom Gallery. In addition to works by nationallly recognized artists, the gallery shows and promotes the works of young regional artists from Texas and California.

Contemporary masters include abstract painters Kenneth Noland, whose Hard Edge, shaped canvas paintings have recently given way to more textural works, including embossed prints; and the late Morris Louis, whose poured acrylic paintings were immensely influential in the development of Color Field painting. The gallery also shows works by architect Frank Lloyd Wright, by painterly realist Wayne Thiebaud, and by hyperrealist sculptor John DeAndrea and photorealist painter Richard Estes. The gallery carries graphics by Thiebaud, Estes, David Hockney and F. Hundertwasser, among others.

Younger, emerging artists include Bill Kane, Stuart Lehrman, Joe Doyle, Ben Kaiser and David Maxim, all Bay Area artists whose work bridges painting and sculpture. Sandy Steni and David Merkel are two of the young Texas artists featured.

Frontroom Gallery 6617 Snider Plaza, Dallas, TX *974* 75205 (214) 369-8338; Mon-Sat: 10-5; owner/ dir: John Hancock & Bill Bloom

The gallery specializes in fine American crafts, including ceramics, glass, weaving, wood and leather. Foreign crafts are sometimes exhibited, along with occasional shows of painting and lithography.

The gallery shows lithographs by Catalonian master Joan Miro, and by leading English potter David Leach. Works on on canvas and paper by contemporary American painter John Strawn are also featured.

Hadler/Rodriguez Galleries 2320 Portsmouth, Hous- *975* ton, TX 77098 (713) 520-6329; Tue-Fri: 10-5 Sat: 11-5 Aug 15-31: closed; owner/dir: Warren Hadler

The gallery specializes in contemporary American painting and sculpture, and also handles contemporary American ceramics.

American artists featured include Michael Tracy, Laura Russell, Jimmy Kellough, Phillip Maberry, Howard Ben Tre, Gordon Hart, Walter Dusenberry, Edgar Buonagurio, Jack Clift and Robin Bruch.

Michele Herling Galleries 3200 Main St., Dallas, TX *976* 75226 (214) 748-2924; Tue-Sat: 12-5:30; owner/ dir: Michele Herling

For 18 years, Michele Herling has dealt in pre-Columbian, African, and Oceanic art to collectors. She moved to her present location in 1982, and now occupies a very large space in a six-story building containing several other galleries.

Statuettes, masks, fetish objects, vases, figurines, pots, and carvings are featured in the collectioes. In addition to primitive art, the gallery shows jewelry from Afghanistan and India and rugs from Afghanistan, Russia, and Iran. Occasionally there are Roman and Egyptian antiquities on view.

Once a year Mrs. Herling travels to San Blas Island off the coast of Panama to acquire colorful applique blouses, or "molas," made by Cuna Indians. The gallery has a selection of books on primitive and ethnic art and a reference library.

Houshang's Gallery 9820 N. Central #514; Dallas, *977* TX 75231 (214) 363-5300; Mon-Sat: 10-6; owner: Houshang Youdim dir: Bonny Youdim

Established in 1970, Houshang's exhibits works from several different contemporary schools of art, including impressionist and abstract works, as well as many contemporary Southwestern paintings.

John Nieto, Kevin Red Star, Tavlos and Amado Pena are among the Southwestern artists. John Nieto's work carries Indian imagery with a strong contemporary coloration and composition. Kevin Red Star's satirical paintings and prints take a poke at romantic Western imagery. Amado Pena's work is not so charged with irony, rather it reveals his heritage with warmth and a candorous attention to form. Other artists are impressionists Sotiris Corzo and Anton Sipos, and abstractionist Gregory Deanz.

The gallery also carries drawings and lithographs by Mexican sculptor Francisco Zuniga, and silkscreen print by French fashion designer Erte.

HumanArts Suite 150, The Quadrangle, 2800 Routh *978* St., Dallas, TX 75201 (214)748-3948; Mon-Sat: 10-5:30; dir: Marise Riddell

HumanArts offers fine contemporary crafts in glass, pottery, jewelry and wood. Both established and emerging artists are exhibited. The gallery tends to emphasize "art in crafts" over strict functionality.

Leading artists whose work is displayed at the gallery include Harvey Sadow in pottery, William Bernstein and John Nygren in glass, and Charlene Biesele in jewelry.

Important also are the emerging artists who may not yet have attracted national attention, such as Jeff Smith of Dallas, who works with fused glass; Wendy Barrie, who makes handbuilt pottery; and Idelle Hammond, who fashions elegant gold and silver jewelry.

In wood there are the works of such artists as Bob McKeown of California, who does acrylic resin inlay into hardwoods; and fellow Californians Bill and Nan Bolstad who make one-of-a-kind and limited-edition boxes.

Mattingly-Baker Gallery 3000 McKinney Ave., Dallas, TX 75204 (214) 526-0031; Tue-Fri: 10-6 Sat: 11-5; dir: Kathleen Sterritt

979

This spacious gallery specializes in living, established, and lesser known artists from New York and the Southwest who work in a contemporary vein.

The gallery shows figurative painters Marcia King and Bob Yarber, color field painter Mark Lavatelli, expressionistic painter Vincent Falsetta, and minimalist painter Joy Jacobs.

Works in a variety of media are exhibited. Among these are large-scale, figurative clay pieces by Claudia Reece, glass works by Susan Stinsmuhler, ceramic wall reliefs and vessels by Jane Aebersold, mixed media constructions and ceramics by Mary McCleary, minimal sculptures and prints by Philip Van Keuren, and tapestries by Jana Vander Lee.

Nimbus Gallery 1135 Dragon St., Dallas, TX 75207 (214) 742-1348 Mon-Fri: 10-5 Sat: 10-4; dir: James Chumley

980

Showing works by a sizable group of contemporary artists, Nimbus Gallery offers large abstract paintings, sculpture in a variety of media, prints and other original works on paper, and art in fiber media.

Eight regularly changing shows are scheduled each year, both group and one-person, in the gallery's main space; two smaller rooms are devoted to a permanent exhibition of works by gallery regulars. These include paintings and paper works in pastel and gouache by internationally recognized artist Joy Laville; serigraphs of Navajo weavings by Southwest artist Jack Silverman; water-media paintings by Judy Rhymes; and stainless steel works by renowned Swiss sculptor Joseph Staub. One can also find watercolors by Peter Kitchell and Karen Guzak as well as sculpture in paper by Anne Flaten Pixley. Usually on hand, too, are works in fiber and cast paper.

Paige Gallery 1519 Hi Line Dr., Dallas, TX 75207 (214) 742-8483 Mon-Fri: 9:30-4:30; owner: Howard Crow dir: Bobette Bird

981

Established in 1980, Paige Gallery occupies a vast warehouse space where anything seems possible. Paige is an eclectic gallery which shows both contemporary realism and abstract work, including painting, sculpture, ceramics, fiber art, works on paper and graphics. Paige also exhibits in the San Jacinto Tower lobby and in a new gallery space in the LTV Tower in downtown Dallas.

Paige has introduced many outstanding artists to the Southwest. Alfredo Arreguin is famous in the Northwest for his patterned paintings using tropical images from his native Mexico. New York artist Mary Francis Judge paints enigmatic figurative works. Oriental artist Li Shan creates traditional brush paintings, and Ng Tri Minh is known for his impressionistic work.

Landscape painters exhibiting at Paige are Ken Holder, Daniel Lang, Artyce Colen and Hans Schiebold. Edith Stull makes color drawings of cacti and wildflowers. Mozelle Brown paints harmonious abstracts. Tapestries and fiber art are exhibited by Hester Bender, Ann Connolly, Stephanie Grubbs and Winston Herbert.

The graphics collection is extensive and features Northwest artists Max Hayslette and Michael Cobb, a group from Oregon, and many others. Scott Sandell's large paper collages, Nola Zirin's dramatic pastel-colored etchings and Daga Ramsey's colorful floats are only a few of the unusual works on paper to be found in the gallery.

Major sculptors are presented, with figurative works by Carol Miller and Victor Salmones. Joe Orlando, David Burt, Jerry Sanders and Jean Woodham provide abstract work in various materials.

Phillips Galleries 2517 Fairmount, Dallas, TX 75201 (214) 748-7888; Mon-Sat: 10-5; owner: Ray Phillips

982

Founded in 1970 and still housed in the same location, a magnificent mansion, Phillips Galleries specializes in the "school of Paris" and art by naive painters, mainly French. The gallery offers a continuous group show of works, with special exhibits once or twice a year focusing on one or two artists.

Impressionistic landscapes by such artists as Monique Journoi, Ginette Rapp, Jacques Bouyssou and Paul Jean Anderbouhr fill the two-floor exhibition area. A special room is set aside for the works of naive painters. Among these are Maurice Ghiglion-Green, a former casino croupier who now paints romantic landscapes; Raphael Toussaint, another painter of romantic landscapes with punctuates his scenes with humorous vignettes of village life; Fernand Boilauges, a onetime sign painter and portrait photographer whose works depict groups of people posed formally in front of quaint Paris shops; and Cora Lou Robinson, whose work recalls memories of childhood in and around Minden, Louisiana.

PS Galleries 2525 Fairmount, Dallas, TX 75201 (214) 741-5576; Tue-Sat: 10-5 Summer: closed; owner/dir: Michael A. Palmer, Peter E. Spear dir, Summer: Barbara Hilty

983

Established recently as a companion gallery to a summer gallery in Ogunquit, Maine, PS specializes in contemporary American representational art.

Among the artists regularly shown are David Shaw, painter of rural interiors and genre scenes; Stephen Etnier, a seascape painter; Edward Betts, also a painter of rural scenes; David Bumbeck, a printmaker whose aquatints of nudes have a photographic look; and Ralph Hurst, who carves animals and birds in alabaster.

Exhibits change every month. Once or twice a year the gallery shows work of historical significance, such as lithographs of George Bellows, or the sun-drenched paintings of Robert Vickrey, or works from the estate of Rudolph Dirks, who drew the comic strip Katzenjammer Kids, but also produced vividly colored paintings.

Simons-Lucet Art Gallery 2707 Fairmount, Dallas, *984* TX 75201 (214) 761-9912; Mon-Fri: 10-5; owner: Sharon Simons dir: Francois Lucet

Simons-Lucet Gallery specializes in paintings of the 19th century Barbizon French landscape school, French Impressionists, Dadaists and contemporary artists.

The most distinguished works in the gallery are those of the French Impressionists, including Pierre Auguste Renoir, Claude Monet, Paul Cezanne, and Paul Gauguin. There are also works of the Italian artist Amadeo Modigliani, whose work represents an outstanding and highly personal synthesis of classical line with the expressionistic qualities of primitive art, particularly European Romanesque and African sculpture. One may also see work by Kees van Dongen, a Dutch Expressionist who became one of the leading Fauves, and ended up as a chronicler of the *beau monde*.

Other artists exhibited include French artists Jean Allemand, Serge Manceau, F.M. Lucet, O. Debre, G. Cheyssial and R. Einbeck; Italian artist Guarducci; and American artists Richard Childers, Larry Von Heren and Carole Greer.

Texas Art Gallery 1400 Main St., Dallas, TX 75202 *985* (214) 747-8158; Mon-Fri: 9-5; mgr: Sherrie Schork

Though mostly devoted to exhibiting Western art, the Texas Art Gallery also shows 19th century English and French works, as well as cor temporary American Impressionism.

The gallery carries a wide range of Western art by some of the best-known artists of the genre: James Boren, Penni Anne Cross, Tim Cox, Michael Coleman, Robert Pummill, James Reynolds, Olaf Wieghorst and sculptor Grant Speed. They also carry the work of Joe Abbrescia, James Asher, Bill Atkins, Wayne Baize, Joe Beeler, Tracy Beeler Brinkman, Dan Bodelson, Nancy Boren, Michael Desatnick, Bruce Dines, Barbara East, Tony Eubanks, Gerald Farm, Martin Grelle, George Hallmark, Lad Odell, Donald "Putt" Putman, Robert Wagoner and Martin Weekly.

The gallery also handles paintings and bronzes by well-known past masters such as W.H.D. Koerner, Henry Farny, Charles Schreyvogel, Olaf Seltzer, C.M. Russell and Frederick Remington. There are also paintings by Grandma Moses, America's most well-known naive painter, and by famous illustrator Norman Rockwell.

The gallery has several art shows a year, but are best known for their auctions of paintings

and bronzes. There are also sections of the gallery dedicated to books and limited edition prints.

Valley House Gallery, Inc. 6616 Spring Valley Rd., *986* Dallas, TX 75240 (214) 239-2441; Mon-Fri: 10-5 Sat: 10-3; owner/dir: Donald S. Vogel, Kevin E. Vogel

Founded in 1953, Valley House was one of the first galleries to exhibit contemporary art in this region, and now specializes in 19th and early 20th century European and American paintings, drawings and prints.

The estates of Hugh Breckenridge and Synchromist painter Morgan Russell have been represented at the gallery, with an important catalog published on Breckenridge. Valley House is currently representing the estate of Fred Nagler.

The contemporary artists featured are working in many different media and styles, including abstract, figurative and surrealistic. Carl Stroh and Gottfried Honegger work in abstraction. Donald Vogel, Loren Mozley and Robert Peterson work in figurative styles, with elements of Impressionism and Cubism. Hub Miller and Valton Tyler work in a surrealistic figurative manner.

A unique aspect of the gallery is the garden which is ideally suited to sculpture exhibitions. Works by Henry Moore, Sorel Etrog, Charles Umlauf and Mike Cunningham have been displayed here.

There has been a recent emphasis on prints. Exhibitions of master prints and drawings are periodically arranged, as well as thematic group shows.

FORT WORTH

Carlin Galleries 710 Montgomery, Fort Worth, TX *987* 76107, (817) 733-6921; Mon-Fri: 10-5; owner/dir: Electra Carlin

Opened in 1959, the Carlin Galleries features contemporary American painters, printmakers and craftsmen, and Eskimo prints and sculpture.

mong the painters presented are landscape artists Peter Hurd, John McCoy, John Chumley, George Harkins and Emily Guthrie Smith. Works by Henriette Wyeth, the well-known still life and portrait painter, and by John Guerin, whose landscapes tend to an abstract style, are also available. James R. Blake, Bill Bomar and Luis Eades defy a descriptive category; their work is highly individual.

The Canadian Eskimo sculpture complements the contemporary painters and printmakers in an interesting and unusual way, displayed in the same gallery space. The Eskimo prints with their strong and singular images are shown together in a separate room. The gallery devotes an annual show to Eskimo art.

Among the craftsmen shown are potters Richard M. Lincoln and Elmer Taylor, who have shown in national and international crafts exhibitions.

Perry Coldwell 4727 Camp Bowie Blvd., Fort Worth, *988* TX 76107 (817) 731-1801; Wed-Sat: 2-7; owner/dir: Perry Coldwell

At one time devoted exclusively to photography, particularly work by local talent, the gallery has

Kenojuak Ashevak, *Goddess of The Sky*, 24 x 30, stonecut & stencil, Carlin Galleries (Fort Worth, TX).

A. T. Bricher, *Cushing Island—Maine*, 25 x 50, oil on canvas, Hall Galleries (Fort Worth, TX).

recently expanded to include other art forms. As the gallery continues searching out new artists, exhibitions will be mounted of sculpture, abstract tapestry, and works in silver. The gallery also has a collection of old academicians of the 17th to early 19th century from Morocco, Italy and France.

Artists currently featured are Glen Clark, D. Hedges Miller, Delbert Miller and Kathy Palmer, to mention only a few who are currently on exhibit at the gallery.

Shaindy Fenton 1420 Shady Oaks Lane, Fort Worth, TX 76107 (817) 429-0161; by appt; pres: Luanne McKinnon
989

Shaindy Fenton is particularly noted for its large inventory of contemporary limited edition prints. The gallery also carries 20th century American paintings since the 1960s, with a special interest in works by Andy Warhol, Frank Stella, Jasper Johns, Robert Rauschenberg and Roy Lichtenstein.

Hall Galleries, Inc. 312 Main St., Fort Worth, TX 76102 (817) 332-3773; Mon-Sat: 10-5:30; owner/dir: Ron Hall
990

Located in a turn-of-the-century brownstone in downtown Fort Worth's historic Sundance Square, Hall Galleries handles high-quality American and French paintings of the 19th and 20th century, including works by American and French Impressionists, the Hudson River School, the Luminist movement, and Western landscape genre.

19th century American artists whose work has been exhibited include landscape painter Thomas Moran, known for his flamboyant panoramas of Western scenery; still life painter Martin Heade; the American master Winslow Homer; and William Merritt Chase, whose later style sheds academicism for a luminous Impressionism. The early 20th century is represented by works of American Impressionists Childe Hassam and Theodore Robinson, as well as Mary Cassatt, who was associated with the French Impressionists, and Modernists John Marin and Georgia O'Keeffe.

French Impressionists exhibited include Claude Monet and Camille Pissarro. One may also see work of Maximilien Luce, a Post-Impressionist who adopted the technique of pointillism used by Signac and Seurat.

Hall Galleries stages four contemporary exhibitions annually and presents such artists as Julio Larraz, David Ligare, Richard Bunhill and Don Vogel, who all paint representational images, and Jennie Haddad, a contemporary abstract expressionist.

Gallery One, Inc. 4935 Byers, Fort Worth, TX 76107 (817) 737-9566; Tue-Fri: 10-5 Sat: 10-2 and by appt; owner/dir: Bill Campbell
991

Gallery One exhibits contemporary art including painting, sculpture, drawing , original prints and ceramics. Artists with national and international reputations are handled as well as regional artists. Both abstract and figurative work is represented.

Sandra Leveson-Meares from Australia and

David McCullough do abstract paintings, while a more figurative image is employed by Michel Demanche, Gary Komarin, Len Agrella, Joe Johnson and Dan Allison. Artists working in sculpture are Lyman Kipp, Dorothy Gillespie and Salvatore Pecoraro. Many of these artists work in mixed media, combining photography with painting (Demanche), or painting and sculpture (Gillespie and Pecoraro). Another important painter is Joe Goode, from California.

The gallery carries prints by many acclaimed artists, such as Minimalist Sol LeWitt, Pop artist Jim Dine, Richard Smith, James Groff, Gene Davis, Laddie John Dill, Joe Goode, Frank Stella and Ellsworth Kelly. There are both prints and paintings by Karl Umlauf, Lamar Briggs, Stefanie Lea Job, James Kuiper and Jack Boynton, and ceramics by Dennis Gabbard, Jeffrey Zigulis, Curt Brill and Muffin Williams.

Reminisce Gallery 3322 Camp Bowie, Fort Worth, TX 76107 (817) 335-4295; Mon-Fri: 9:30-5:30 Sat-Sun: by appt; owner/dir: Barbara Bowden & Ken Johnson
992

Specializing in art of the West and Southwest, the gallery carries oil paintings, watercolors, bronzes, Indian pottery, and hand-woven wall tapestries.

Melvin C. Warren, a member of the Cowboy Artists of America, paints the American West of the past and present. Other leading members of the Cowboy Artists of America are also represented, among them Gordon Snidow, George Marks, Fritz White, James Boren, and Gary Niblett.

Patricia Warren, daughter of Melvin C. Warren, depicts women of the Southwest in her bronze sculpture. Walt Gonske impressionistically interprets the Southwest landscape. Gallery exhibits also feature the works of Ramon Froman, Roy Lee Ward, Tony Eubanks, and Donald Teague.

Sundance Gallery 310 Main St., Fort Worth, TX 76102 (817) 870-1001; Mon-Sat: 10-5:30
993

Sundance is Fort Worth's first folk art gallery, displaying 19th and early 20th century Americana. One may find domestic objects, such as quilts and bowls, ornamentation from homes, barns, shops and boats, and art objects such as folk sculpture and ceramics.

As in most folk art, the majority of the artists are un-known, leaving the works to be judged on their own evident merits of creative design, craftsmanship and visual interest. Sweetie Ladd, current painter of Texas historical scenes, is featured at the gallery, as are folk sculptors David Alvarez and Felipe Archuleta of New Mexico.

Most of the folk art originated in the Northeast or in the Southwest, especially Texas and New Mexico, and reflects regional habits. From the Northeast are whirligigs, chests, carved signs and symbols, and weathervanes; from the Southwest come quilts, pottery, carved animals, belts and jewelry.

The gallery is located in a historic building in a restoration area of downtown Fort Worth. The exhibition design employs Southwestern antiques, such as pharmacy cases and a 19th century buggy.

HOUSTON

Archway Gallery 2517 University Blvd., Houston, TX
994 77005 (713) 522-2409; Mon-Sat: 10-5:30; dir:
Mary Jean Fowler

Archway is a partnership of professional artists
with regional and national recognition. A wide
variety of original abstract and representational
art is available: painting, drawing, sculpture,
pottery, fiber and collage. The gallery is also a
source for Eskimo stone carvings.

Painter Dick Barlow's watercolors reflect a
musical approach to people and landscapes. Au-
drey Dygert works in diverse styles. Ben Howatt
explores vast realms of spaces, meticulously de-
veloping depth. Parting from natural forms,
Stephanie Nadolski expands and abstracts.
Nighat O'Brian paints oils that reflect the dyn-
amism of life.

Fiber artists at Archway work in woven and
felted media. Mary Jean Fowler creates serene
landscapes tapestries. Marleah MacDougal's
felted compositions vibrate with subtle variations
of color. Carol Stoddard weaves brocade tapes-
tries of abstract landscapes.

Sculptors include Stanley Alberts, who
works in strong, simple forms; Ann Armstrong,
figures and portraits; and Rose Van Vranken,
who works in a variety of media. Using raku
pottery forms, Jo Zider creates a personal vision
of landscape.

The gallery is one of the few sources in
Houston for Eskimo stone carving.

Atelier 1513 2520 Time Blvd., Houston, TX 77005
995 (713) 522-7988 Sat: 11-5 and by appt to the
trade

Atelier 1513 aims to be a working studio as well
as a sophisticated print gallery featuring works of
contemporary artists from Europe, South Amer-
ica, Japan, and China as well as from the United
States. The unique combination of gallery and
workshop enables the visitor to learn firsthand
about original editions.

Special exhibits are organized to show the
work of visiting artists who are not necessarily
printmakers themselves, although on such occa-
sions artists are given the opportunity to produce
one or more series of etchings.

Etchings are printed upstairs, and press time
is available for lease to artists who do not have
the equipment to produce their own editions.

Intaglio editions are printed here for many
artists from Texas and other states.

James Atkinson Galleries 12230 Westheimer Rd.,
996 Houston, TX 77077 (713) 870-8744; Tue-Sat:
10-6; owner/dir: Paul Atkinson

The gallery relocated in Fall 1984, tripling the
size of its exhibition area. The new, expanded
space shows paintings, prints, watercolors, and
graphics, with the focus on important works
from American and European schools of
Impressionism.

Most of the work is representational, with an
emphasis on American, British, and French
painters from the turn of the century. British
Impressionism from the Victorian period is well
represented with works by John D. Ferguson and
Ethel Walker. Works by French Impressionists
Charles Agard, Henri Martin, Achilles Lauge,

and Paul Signac also may be found. Among the
gallery's American Impressionists are Thomas
Dewing, Ernest Lawson, Robert Henri, and
Theodore Robinson. As the official Houston rep-
resentative of Newman & Cooling in London,
the gallery offers a selection of British landscape
painters of the 19th century.

Some contemporary painters and sculptors are
shown, including Robert Vickrey, Gage Taylor,
Megan Bowman, and Margaret Fisher.

Benteler Galleries, Inc. 2409 Rice Blvd., Houston,
997 TX 77005 (713) 522-8228; Tue-Sat: 11-5 July-
Aug: call for hours owner/dir: Petra Benteler

Benteler deals exclusively in European photogra-
phy. All shows consist of European photogra-
phy, with occasional exceptions. American pho-
tography can be acquired upon request.

Artists whose work is displayed include: Pi-
erre Cordier, Belgium, an experimentalist, in-
ventor of the "chimigramme"; Andre Gelpke,
Germany, contemporary visualism photography;
Robert Hausser, Germany, a classicist of modern
photography; Fritze Henle, Germany, one of the
first photographers for *"Life"* magazine, still
active; Marta Hoepffner, Germany, whose artis-
tic domain is the field between photography and
painting; Floris M. Neususs, Germany, concep-
tual photography, including life-size photograms;
Karin Szekessy, Germany, whose work alludes
to famous paintings, known for her "sisterly"
nudes; Albert Renger Patzsch, Germany, master
photographer of the 1920s-60s, leading figure of
the Neue Sachlichkeit, "New Objectivity"
Movement of Weimar Germany; Reinhart Wolf,
known for his huge documentary photographs
about cities and architecture around the world;
and Philipp Scholz Rittermann, a contemporary
photographer, one of the few who restricts his
work to night-time photography.

Other artists who work is available are: Jaro-
mir Funke, Karl Haag, Werner Hannappel, Ed-
ward Hartwig, Milan Horacek, Peter Keetman,
Fritz Kempe, Heinrich Kuhn, Karl Ludwig
Lange, Adolf Lazi, Rudolf Lichsteiner, Victor
Macarol, Gerald Minkoff, Andreas Muller-Pohle,
Raphael Navarro, Nils Udo, Detlef Orlopp, Alex-
ander Rodchenko, Michael Ruetz, Fee Schlapper,
Adolf Schneeberger, Toni Schneiders, Friederich
Seidenstucker, and Josef Sudek.

Lowell Collins Gallery 2903 Saint St., Houston, TX
998 77027 (713) 622-6962; Tue-Sat: 11-5; owner/
dir: Lowell Collins

Located in a yellow steel building on a leafy side
street off the 3600 block of Westheimer Road,
Lowell Collins Gallery is a fascinating place to
visit for anyone interested in antique ethnic art
and classical antiquities from every corner of the
world. Owner Lowell Collins and his son preside
over a three-part enterprise that trades in ethnic
art, provides appraisals for insurance and various
estate purposes, and has an attached art school.

While the gallery is particularly strong in pre-
Columbian and Mesoamerican art and artifacts,
there are many fascinating items of South Ameri-
can, Korean, West African, Chinese, Tibetan,
Oceanic and Sepik River, New Guinea prove-
nance. In the European area there are classical
items from Greece and Rome, Byzantine icons,
and even some early Renaissance items.

The school offers classes for adults and children in life drawing, painting and design. In addition, there are lectures in pre-Columbian history taught by Mr. Collins, who has traveled extensively in Mexico and Central America.

Connally & Altermann 3461 W. Alabama, Houston,
999 TX 77027 (713) 840-1922; Tue-Sat: 10-6; owner: John B. Connally, Tony Altermann, Jack Morris dir: Jack Morris.

This Houston gallery was founded in March 1984 in association with the Altermann Art Gallery in Dallas, TX. In late 1984 the two galleries merged with the Trailside Galleries, which have branches in Jackson Hole, WY; Scottsdale, AZ; and Phoenix, AZ.

Connally and Altermann specializes in 19th and 20th century American painting and sculpture. Several important schools are represented, including the Hudson River, Ashcan, and Taos Founders. There is a special emphasis on Western and wildlife art.

Painters Frederick Remington, Charles Marion Russell, Joseph Henry Sharpe, E. I. Couse, Oscar Berninghaus, Albert Bierstadt, and Thomas Moran are among the deceased artists represented. The gallery features many contemporary Western artists, including painters Howard Terpning, G. Harvey, William Acheff, Paul Calle, James Boren, Michael Gnatek, Wilson Hurley, Grant Mac Donald, Don Powers, Henry Cassell, Roy Swanson, William Whitaker, and Kenneth Riley. The gallery also shows bronze sculpture by Peter Fillerup, Harry Jackson, Clark Bronson, Glenna Goodacre, Ken Ottinger, Veryl Goodnight, Grant Speed, and Fritz White.

There are special group and theme shows in addition to the monthly one-person exhibitions. Connally and Altermann also sponsors a Western Collectors Sale and Auction every June in Dallas.

Rachel W. Davis Gallery 2402 Addison St., Houston,
1000 TX 77030 (713) 664-4130; by appt Aug: closed; owner/dir: R.W. Davis

Situated in a unique courtyard building near Rice University, Rachel W. Davis gallery specializes in American art of the 20th century, with particular emphasis on figurative work.

American realists of the period between WWI and WWII are a special interest of the gallery, which features work by artists such as Sloan, Bacon, Lewis, Landeck, Leighton and Albee. Several estates of this period are handled, such as that of Walter Inglis Anderson.

Local and national artists featured in seasonal exhibition include Jefferson Smith, Ann Royer, Louis D'Avila, Candace Knapp, Virginia Bradley and Gayle de Gregori. Other figurative artists exhibited are Bernard Chaet, Joseph Ablow, Cheng-Khee-Chee and Bill Heise. The Rachel W. Davis Gallery is a member of the Houston Art Dealers Association.

Davis/McClain Galleries 2818 Kirby Dr., Houston,
1001 TX 77098 (713) 520-9200; Mon-Fri: 10-5:30 Sat: 11-4; owner/dir: Barbara Davis and Bob McClain

The gallery is committed to introducing emerging regional and national artists. The emphasis is on contemporary work in painting, sculpture, and photography.

Artists recently shown include New York artists Frank Faulkner and Tony Robbin, both non-representational painters; granite sculptor Jesus Bautista Moroles; photographer Gary Faye; kinetic sculptor Edward Lee Hendricks; painter Aaron Karp; and ceramicist Ron Fondaw. The gallery also regularly exhibits works by three Houston painters who are becoming nationally known: Joanne Brigham, Jim Poag, and Perry House.

Dubose Galleries 1700 Bissonnet, Houston, TX 77005
1002 (713) 526-4916; Tue-Fri: 10-5:30 Sat: 11-5; dir: Ellen Penner

Dubose Galleries, one of Houston's most established galleries, has been operating for 18 years. A variety of contemporary paintings, graphics and sculptures is shown.

The work ranges from abstract canvases to realistic landscapes, to surrealistic collages. Charles Schorre, Herb Mears and Robert Weimerskirch have shown at the gallery since its inception and continue to represent some of Houston's finest artists. The gallery also exhibits work by newer contemporary artists in Houston including Ken Luce, Sheila Zeve and papermaker Yvonne Parker.

Of the more realistic styles, Dubose continues to feature Kermit Oliver's iconographical paintings and Michel Bezman's fantasy collages along with more traditional landscapes by Bill Hoey, Tallie Lipscomb and James Busby.

Work by several sculptors is displayed, ranging from whimsical bird sculptures by John Olsen to Daniel Sellers's architectural pieces in Corten steel.

Graham Gallery 1431 W. Alabama, Houston, TX
1003 77098 (713) 528-4957 Tue-Sat: 10-6; dir: William A. Graham

Having directed a gallery in New York and founded his own in Paris in 1970, William A. Graham recently opened his new gallery in Houston. Although the gallery exhibits contemporary painting from both Europe and America, it concentrates on Southwest and Texas artists, both figurative and abstract.

Abstract Expressionist and gestural figurative painters such as Jeff DeLude, Lynn Randolph and Ron Hoover are exhibited, as well as assemblagist-sculptors Stephen Daly, Dalton Maroney and Vicky Barnett; and photographer Alain Clement. There are also abstract oils and mixed media works by Terrell James, figurative watercolors by Hitch Lyman, and narrative expressionist painting by Patricia Gonzalez. Video art is shown by Andy Mann, who also works in graphic arts.

Modern European masters such as Man Ray, an influential American expatriate in Paris, who worked as an innovative photographer and painter associated with the Surrealists, have also been presented at the gallery. Young European artists Charles Lapicque, Aleco Fassianos and Rene Laubies have been introduced to Houston through the gallery.

Original limited edition lithographs and engravings by modern European masters are also available.

Harris Gallery 1100 Bissonnet, Houston, TX 77005,
1004 (713) 522-9116 Tue-Sat: 10-6; dir: Harrison Itz

John Chumley, *Skating Party*, 19 x 32, oil, Carlin Galleries (Fort Worth, TX).

Charles Agard, *Still Life*, 15 x 22, oil, James-Atkinson Gallery (Houston, TX).

J. H. Sharp, *Rabbit Hunt-Taos Valley,* 18 x 24, oil, Altermann Art Gallery (Dallas, TX).

Mary Cassatt, *Bare Back,* 29 x 22, pastel, Hall Galleries
(Fort Worth, TX).

James R. Blake, *Carnations and Lilies,* 30 x 30, oil, Carlin Galleries (Fort Worth, TX).

Amado M. Pena, Jr., *El,* 36 x 22, serigraph, El Taller Gallery (Austin, TX).

Dan Allison, *Gato Blanco,* 18 x 24, etching, Gallery One (Fort Worth, TX).

Howard Terpning, *Scouting for Crow Sign,* 24 x 34, oil, Connally & Altermann Art Gallery (Houston, TX).

Located in a 4,000 square foot house adjacent to the Contemporary Arts Museum, the Harris Gallery offers a diverse selection of art that ranges from Old Master prints to contemporary masters and talented regional artists.

The gallery has exhibited prints by Rembrandt and Whistler, drawings and prints by Gene Davis, an artist associated with "Op Art" whose paintings consist of vertical stripes of interactive color, as well as prints by other leading contemporary artists such as Robert Motherwell, Frank Stella, Helen Frankenthaler, Robert Rauschenberg and Roy Lichtenstein.

Texas artists include Pauline Howard, Linda Obermoeller, Chris Burkholder, Susan Smith, Al Smith and Linda Graetz. Figurative artist Pauline Howard creates complex studies of light and motion in her pastels and watercolors of ballet dancers, beach scenes and other energetic human activities. Linda Obermoeller works in watercolor, generally focusing on her subjects with a portraiture attitude. Chris Burkholder explores the contrasts of light and atmosphere peculiar to the landscape of West Texas. Susan Smith's figurative compositions are dramatic tableaux that employ the imagery of high-fashion mannequins in store windows as a comment on modern society.

Linda Graetz and Al Smith work in abstract modes. Graetz concentrates on space and landscape in her rich gouache paintings on paper. Al Smith's abstracts use a wealth of color and texture relations.

Harris has also been compiling a major inventory of contemporary landscape by artists from all over the country. Among the works available are Southwestern canyons and valleys by Ed Mell, Death Valley scenes by Willard Dixon, and rolling hill scenery of central California by Don Irwin. In addition, Harris shows photographs by George Krause, Geoff Winningham and Peter Brown.

Hooks-Epstein Galleries, Inc. 1200 Bissonnet, Houston, TX 77005 (713) 522-0718; Tue-Sat: 10-5:30
1005 & by appt; dir: Charles V. Hooks

The gallery exhibits late 19th and 20th century representational American, European and Latin American paintings, sculpture and works on paper.

The following artists are presented by Hooks-Epstein in this area: Elaine Aptekar, Michael Collins, Jane Egan, Jacqueline Fogel, Helen O. Gross, Judith Ingram, Jay Lef-kowitz, Otis Lumpkin, William Ludwig, Marcia Marx, Peter Paone, Hib Sabin, J.M. Sorg, Mary Sims, Sherry Sullivan, Douglas Schneider, Hannah Stewart, Bob Seabeck and Thea Tiwi. Peter Paone is presented internationally by the gallery.

The gallery hangs at least nine shows a year, changing every six weeks, and participates in presenting new talent in the July "Introductions" series of the Houston Art Dealers Association, of which it is a charter member.

Toni Jones, Inc. 1200 Bissonnet, Houston, TX 77005
1006 (713) 528-7998; Mon-Sat: 10-5; owner/dir: Toni Jones

Concentration is on 20th century American painting, with work by many contemporaries who paint in abstract and representational

modes. All media are handled, most especially watercolor and prints. An eclectic approach prevails, with particular interest in sculptural form, including furniture and other three dimensional objects. Other dimensional travels are recorded in magic realist and surreal works. Photographic works of great diversity are also handled.

The gallery regularly exhibits paintings, drawings and prints by Fernando Casas and Steve Adams; watercolors and prints by Kersti Anderson; sculpture by Tom Allen and Pam Nelson; and watercolors by Mary Benedick, Barbara Gerry, Ann Pace and Pauline Bloch. Imaginative paintings by Joanne Copeland are shown, as well as drawings by Marilyn Thompson. European artists featured are Ugo Dossi, Andreas Nottebohm, Adi, Suzac and Francesco Costanzo.

Recently the gallery has begun showing paintings and drawings by Darryl Halbrooks, Chinese brush paintings by Duc Hein Nguyen, pastels and computer graphics by Audene, naif paintings by Gregory Horndesky, and expressionist works by Katherine Dunlauy-Hayes, Corinne Jones, Charles Jones and Mark Todd.

Kauffman Galleries 2702 W. Alabama, Houston, TX
1007 77098 (713) 528-4229; Mon-Sat: 10-6; owner: Marjorie Kauffman dir: John Sandor

Kauffman Galleries emphasizes works on paper in all media by over a hundred living artists, from well-known to unknown, from the U.S. and abroad. Paintings, sculpture and fiber works are also accorded an important place in the gallery's inventory.

Among the artists featured are Louise Nevelson, prints and handmade paper works; Jim Dine, recent aquatints and etchings; Carol Summers, woodblock prints; Fritz Scholder, lithographs; and R.C. Gorman, lithographs and ceramics.

One may also see paintings and prints by John Axton; paintings by Igor Galanin; trompe-l'oeil paintings and prints by Yrjo Edelmann; raku ceramic vessels and non-functional objects by Piero Fenci; and handmade paper and bamboo constructions by Nance O'Banion.

Contemporary Japanese printmakers are a strong area of specialization, with works by Saito, Hoshi, Tanaka, Mori and others.

Contemporary fiber works include woven, braided, and hand-constructed works by Karen Chapnick, Barbara Nelson and Alexandra Hart.

Marjorie Kauffman Graphics 5011 Westheimer Rd.,
1008 Suite 3220, The Galleria, Houston, TX 77056 (713) 622-6001; Mon-Fri: 10-9 Sat: 10-6; owner: Marjorie Kauffman dir: Ilene Haney

A small, brightly-lit space on the third level of the Galleria Mall, Marjorie Kauffman Graphics is a branch office of the Kauffman Gallery. The collection of the gallery contains an extensive body of work by contemporary artists as well as quality posters and reproductions of work by artists from Houston poster artist Jack Boynton to Impressionist master Henri Toulouse-Lautrec. A framing service is available on the premises.

McIntosh/Drysdale Gallery 2008 Peden, Houston,
1009 TX 77019 (713) 520-1888; Tue-Sat: 10-5:30; owner/dir: Nancy Drysdale

Formerly in Washington, D.C., this gallery relocated in 1982. Nancy McIntosh Drysdale continues to represent a varied group of painters, sculptors, occasionally photographers, most of whom are working in the more advanced modes of contemporary art, and have national reputations.

Most of the artists presented are in mid-career, with identifiable personal styles which they are developing to plenitude. Sculptors include Alice Aycock, Scott Burton, Jene Highstein, Martin Puryear, Ned Smyth and Patsy Norvell. Painters exhibiting at the gallery are Tom Wesselman, Pat Steir, Sam Gilliam, Robert Zakanitch, Basilios Poulos, Brad Davis, Janis Provisor, Robert Kushner and Richard Haas.

The gallery also shows works by emerging Texas artists, and organizes important group shows from time to time: Small Bronzes, Architectural Fantasies, Post Graffiti Artists, etc.

Jack Meier Gallery 2310 Bissonnet, Houston, TX
1010 77005 (713) 526-2983; Mon-Fri: 10-5:30 Sat: 10-2; owner: Jack Meier dir: Martha Meier

The gallery presents American contemporary painters and sculptors, with emphasis on regional artists. The artists' work ranges from realism, satirical realism and impressionism to non-objective styles. Watercolors form a substantial part of the inventory.

Among the artists featured are Rosemary Mahoney, whose portrait of Charles Lindbergh is on display at the Smithsonian Institution; Virginia Cobb, an Associate member of the National Academy; Al Brouillette, of the American Watercolor Society; Harold Phenix, whose book ''Paintings of the Texas Coast'' has been published by A & M Press; and Peter Hsu, a Chinese-American watercolorist.

Other artists include Herb Rather, watercolor realism; Jose S. Perez, satirical paintings; Ann Hunt, Texas realism; Jane Bazinet, watercolors and paintings on silk; and landscape painter Tim Zolan.

Meinhard Galleries, Inc. 1502 Augusta Dr., Houston,
1011 TX 77057 (713) 977-6200; Tue-Fri: 9-5:30 Sat: 10-4:30; dir: Julie A. Cain ¼ 1011½

Meinhard Galleries is one of the oldest galleries in Houston. Since 1940 the gallery has specialized in 19th and 20th century traditional and impressionistic art by European and American artists. The American Western theme in landscape, figure painting and bronze sculpture, as well as School of Paris and the American Sporting and Wildlife scene are on view for the public.

present-day American Impressionists, notably Fremont Ellis, Dane Clark, Rod Goebel and Robert Sarsony. The American West is reflected in the works of David Halbach, Shannon Stirnweis, Ramon Kelley, Bob Wygant and Jim Robinson. Sculpture ranges from figure bronzes by Glenna Goodacre and George Lundeen to wildlife works by Les Perhacs, Clark Bronson and Dan Ostermiller.

Contemporary European artists include contemporary English landscape painter Ian Houston and French Impressionists Jean Rigaud, Jean Venetien, Paul Anderbouhr and Bernardino

Toppi. 19th century English masters are on view as well, including William Shayer, Sr., Joseph Thors, Frederick Richard Lee and Frederick William Hulme.

M.E.'s Gallery 1408 Michigan, Houston, TX 77006
1012 (713) 527-8862 Fall and Spring: 10-4; owner/dir: Mary Ellen Whitwork

M.E.'s Gallery specializes in contemporary American crafts. Single or group exhibitions have included ceramics, jewelry, leatherworks, hand-blown glass, wearable arts, woodworking, paper and soft sculpture. Many native Texans as well as out-of-state artists have been exhibited. The gallery shows ceramics extensively.

Bob Karloff and Julie Kent of Morningside Pottery execute large sculptural pieces in stoneware, often employing metallic glazes. Marie Blazch of Bastrop, Texas produces fine functional wares in porcelain and stoneware.

Naida Seibel of Fort Collins, Colorado, specializes in sculpture and weavings. Her work features women in clay, with cast-bronze faces, wrapped in earth-toned sisal twines that Seibel dyes herself. The wrapped bodies are symbolic of women bound to tradition, an expression of the artist's past.

During the spring and the fall, delicate silk prints designed by Barbara Hewitt of California can be viewed.

Special exhibits also include watercolors, photography, drawings, etchings and fine jewelry.

Moody Gallery 2015-J West Gray, Houston, TX
1013 77019 (713) 526-9911 Tue-Sat: 10-5:30; dir: Betty Moody

Moody Gallery opened in 1975 and represents contemporary artists who work in various media—painting, sculpture, works on paper, and photography.

Dick Wray, for example, does large, geometric abstract oil paintings in chromatic colors. Lucas Johnson's paintings, drawings, and monotypes are representational works with surreal imagery in an ambiguous space. Donald Roller Wilson paints highly realistic animals, people and everyday objects in fantastical situations, in the spirit of the arbitrary juxtapositions of the Surrealists. Other artists exhibited are: Arthur Turner, abstract drawings and watercolors; Lamar Briggs, large abstract paintings, acrylic on canvas and monotypes; Don Shaw, steel sculpture and works on paper; Ida Kohlmeyer, large abstract paintings on canvas and silkscreens; Bill Steffy, sculpture and jewelry; Charles Pebworth, sculpture and metal relief; and Jack Boynton, works on paper and mixed-media assemblages.

The following artists are also featured at the gallery: Terry Allen, Ed Blackburn, Suzanne Bocanegra, William Christenberry, Bill Dennard, Roy Fridge, Douglas Kent Hall, John Hernandez, Anstis Lundy, MANUAL (Ed Hill and Suzanne Bloom), Madeline O'Connor, Jim Roche, Al Souza, and Jim Woodson.

Off the Wall Graphics 7437 Southwest Freeway,
1014 Houston, TX 77036 (713) 988-7500; Mon-Sat: 10-5:30 Galleria I, Level I, Houston, TX 77056 (713) 871-0940; Mon-Thu: 10-9 Fri-Sat: 10-10 Sun: 11:30-5:30

W. K. F. Arnesen, *Dutch Fishing Vessels,* 25 x 36, James Atkinson Galleries (Houston, TX).

Jeff Delude, *The Visitor* (1983), 81 x 95, oil on canvas, Graham Gallery (Houston, TX).

Off the Wall Graphics opened in September 1978. Graphics— primarily etchings, silk-screens, lithographs and posters— are the main fare here. Contemporary prints by international artists such as Alvar, Azoulay and Charlotte Reine, as well as works by many Southwestern artists are the specialty.

A particular feature of the inventory are graphics relating to the oil industry. Artists who have employed their skills in prints on this topic include Delmar, Collette, Ewebank, Willis, and Bart Forbes, while others such as Steven Kenny, Charles Bragg, Michael Delacroix, and Boulanger have made posters.

Plaza Gallery 5020 Montrose (in the Plaza Hotel),
1015 Houston, TX 77006 (713) 627-7024; Mon-Fri: 10-5 & by appt; owner/dir: Adrian Shapiro

Plaza specializes in limited edition prints by prominent 20th century artists. Each is produced by hand in small quantities, and the majority range in price between $200-$600. Artists include COBRA group members Karel Appel and Corneille, Abstract Expressionist Conrad Marca-Relli, stripe painter Gene Davis, impressionistic social realist Raphael Soyer, noted collage artist Romare Bearden, abstract painter Larry Zox, as well as John Baeder, Tom Blackwell, Fran Bull, Moshe Castel, Conrad Schwiering, Walasse Ting, Ivan Theimer and C.J. Yao.

Plaza also presents outstanding artists working in other media, including Werner Pfeiffer, sculpture and dimensional works; Gary San Pietro, photography; James Hendricks, Carol Parlato and Margaret Walasse, acrylics. Plaza serves the trade as well as the public, and produces a color catalog available at a nominal cost.

C.G. Rein Galleries 4380 Westheimer at Midlane,
1016 Houston, TX 77027 (713) 871-9701; Mon-Sat: 10-5:30; owner: C.G.Rein dir: Jeanne Parker

See listing for Scottsdale, Arizona.

Robinson Galleries 1200 Bissonnet, Houston, TX
1017 77005 (713) 521-9221; Tue-Sat: 10-5:30 Aug: closed; dir: Thomas V. Robinson

Established in 1969, Robinson Galleries features the work of 19th and 20th century American artists working in painting, sculpture, drawing, printmaking, mixed-media, conceptual and performance art, and video. The Hudson River School, American Impressionism, the Ashcan School, American Social Realists, 20th century Mexican art, and regional contemporary art are all exhibited here.

Robinson Galleries publishes and distributes original graphics and multiples, and has organized traveling exhibitions here and abroad.

Artists whose work has been featured include Ben Shahn, George Bellows, Abraham Rattner, Leonard Baskin, Charles Burchfield and figurative artists Gregory Palmer, John Dawson and Paul Suttman.

The gallery has also shown the work of artists working in abstraction based on the figure or natural forms: Arthur G. Dove, Don Foster, Reginald Rowe and Vera Simons.

Watson/de Nagy & Company 1106 Berthea, Hous-
1018 ton, TX 77006 (713) 526-9883; Tue-Sat: 10-6; owner: Marvin Watson, Jr. dir: Clint Willour

The gallery presents work by contemporary American artists including painting, metal sculpture, and collage. Works tend toward painterly realism, color field painting, and abstract sculpture, but the gallery's criterion remains open to all art of interest and quality.

Houston-area artists include Roberta Harris, who does brightly painted totemic sculpture and three-dimensional, autobiographical paintings; Jane Allensworth, who produces multi-layered poured paint canvases; Robin Utterback, who has gone from Abstract Expressionist canvases to subtle, lightly impastoed color field painting; Earl Staley, a figure painter who uses images reminiscent of children's art; and Tom Sayre, a sculptor producing small, precise abstract pieces in metal painted in various neutral shades, as well as large-scale welded steel sculpture.

A number of collage artists show here as well. Stephanie Cole works with stamps and cloth. Mary McCleary creates large collages and constructions of brightly painted geometric forms. Dallas artist Dan Rizzie's collages are usually small format, bright, geometric works. Dee Wolf uses gold leaf and layers of gouache over a black background to produce works between collage and painting.

Additional artists include abstract painters Walter Darby Bannard, whose work is Minimalist in spirit; Robert Goodnough, an Abstract Expressionist whose work retained hidden references to traditional subject matter; Merrill Wagner and steel sculptor Peter Reginato. Representational painters include Jane Freilicher, who works in the tradition of Fairfield Porter; Santa Fe landscape impressionist Forrest Moses; and Hal Reddcliff, a Columbus, Ohio, artist who creates precise, painterly still lifes.

Gerhard Wurzer Gallery 5085 Westheimer Rd., Suite
1019 3707, The Galleria, Houston, TX 77056 (713) 961-9888; Mon-Sat: 10-9 owner/dir: Gerhard Wurzer

Located on the third level of the Galleria shopping mall, the gallery shows a good selection of 19th and 20th century prints by over fifty deceased artists and eight living artists.

The emphasis is on prints of the late 19th century by French and English artists. Works are available by distinguished masters such as Henri Toulouse-Lautrec, Pierre Auguste Renoir, James Whistler, Alphonse Mucha, John Martin, Pierre Bonnard and Camille Pissarro. The 20th century is represented by masters such as Picasso, Miro and Chagall. the gallery also carries works by Buhot, Chahine and Cheret, and has an inventory of prints by artists from Albers to Zorn.

The eight living artists include two photographers, one Mexican artist, and five Americans. Michael Rubin and Ronald Wohlauer, the photographers, work in the tradition of California's "f-64" group, so-called because the f-64 aperture setting of the view cameras used before the 35 mm. format came into use resulted in photographs sharply in focus over the whole field of the image. This clarity asserted the independence of the photographic medium from the fuzzy tones of drawing and painting, which it had been constrained to imitate. The Mexican artist is Gustavo Arias-Muruetta. Of the con-

temporary artists, Robert Kipniss and Thom Kapheim are especially well represented. Kapheim is known for his large, playfully erotic drawings, reminiscent of Chagall in their use of line and color.

SAN ANTONIO

Charlton Art Gallery 308 N. Presa, San Antonio, TX
1020 78205 (512) 223-2181; Mon-Sat: 10-5:30; dir: Anne Alexander

Contemporary regional artists are featured here, displaying works in various media—painting, sculpture, photography, prints, drawings and ceramics.

David McCullough executes abstract paintings in acrylics mixed with sand to give body and texture. Gilberto Tarin paints figurative fantasies in acrylic. Printmaker Dan Allison makes vibrantly colored aquatints.

Panoramic photographs are available by E.O. Goldbeck, and ceramics by William Wilhelmi.

Objects Gallery 4010 Broadway, San Antonio, TX
1021 78209 (512) 826-8996; Mon-Sat: 10-5; owner/dir: Caroline Lee

Objects Gallery handles contemporary art by artists from throughout the United States. There is an interest in sculptural ceramics and paper works, as well as painting.

Among the artists represented are paper artists Ann Flaten Pexley, Charles Hilger, Ann Page and Zarima Harshimi; ceramic artists Carl Culbreth, Dorothy Hafner, Claudia Reese and Robert Cueva Keer. Laurie Meller, painter, and William Maxwell, sculptor, are two Texas artists featured by the gallery.

Artists who have exhibited recently in one-person shows include Paul Saldner, Joe Guy, Betty Woodman, Michel Amateau and Diane Itter.

UTAH

MOAB

Jailhouse Gallery 103 N. Main St., Moab, UT 84532
1022 (801) 259-7523; Mon-Fri: 2-6 Sat: 12-4 Jan-Mar: open Mon, Fri, Sat; owner/dir: Arlene Ruggeri

Concentration is on contemporary Intermountain Western painting, prints and crafts. Work exhibited includes abstract, realist and historical Western painting; ceramics such as decorative and functional stoneware, porcelain, salt glaze, etc. Some fine art prints by national and international artists are available.

Western American painters include Robert Barrett, Evelyn Henderson, Esther Keyser, Fred Hunger, Gaell Lindstrom, Arleen Ruggeri, June Wagoner and William Wagoner. Western ceramic artists are Liz Enyeart, Dennis Haberkorn, and Wolyson-Duty. Printmakers are Kurt Meyer-Eberhart, C. Bragg and Kaiko Moti. Books and signed reproductions by Chen Chi are also available.

SALT LAKE CITY

Artist in Action/Crossroads 50 S. Main #286, Salt
1023 Lake City, UT 84144 (801) 521-8436; Mon-Fri: 10-9 Sat: 10-6 Sun: 12-5; owner/dir: Pat Williams

The gallery presents a broad cross-section of art, including juried works by regional and national artists working in both contemporary and traditional modes in painting, sculpture, photography, ceramics, limited edition prints, batik and stained glass.

Artists exhibited include Bill Granizo, Cecil Scarborough, Linda Roberts, Jacqueline Rochester, Tony Sanna, Bill Alexander and Al Aspenwall. Well-known regional artists include Renae Taylor, Trevor Southey, Norma Forsberg and Ralph Crawford.

Gallery 56 56 West 400 South, Salt Lake City, UT
1024 84101 (801) 533-8245; daily: 10-5; owner/dir: David Ericson

Gallery 56 specializes in contemporary realism by Utah artists, as well as carrying all forms of early Utah art.

Utah landscape painters shown are Al Rounds, Randall Lake, Earl Jones, Ken Baxter, Kimbal Warren, Gary Smith, Frank Huff, and Dan Baxter. Representational sculpture is exhibited by Peter M. Fillerup, Dennis Smith and Avard Fairbanks.

The gallery also handles works by historical American masters, including members of the Ashcan School, American Impressionists, Western masters, and Hudson River School. Among the artists whose works may be available are anecdo-tal impressionist Julian Alden Weir, Salt Lake City sculptor Mahonri Young and California painter Maynard Dixon.

Phillips Gallery 444 East 200 South, Salt Lake City,
1025 UT 84111 (801) 364-8284; Tue-Fri: 10-5:30 Sat: 10-2 Jul 24-Aug: closed; owner/dir: Bonnie & Denis Phillips

Established in 1966. the gallery exhibits artists from the Utah and Intermountain area. Emphasis is on contemporary works, with a fine selection of representational art. The gallery has changing monthly shows in the main exhibition space, and a changing group exhibit, which often includes emerging regional artists, in a second space.

Contemporary Utah artists exhibited at the gallery include the double weaver Sharon Alderman, whose skillful use and play of add to the illusory quality of her work. Larry Elsner, teacher of ceramics and sculptor, is equally at home with metal and clay. Ed Maryon's colorful watercolors evoke typical Utah scenes of buildings and landscape. Working from life, Silvia Davis adeptly carves wood into realistic objects: a sewing machine, a cat on a windowsill or a 1930s lawnmower. Denis Phillips paints abstracts in oil and acrylic suggestive of the diversity and moods of Utah. The paintings of the late Don Olsen, bold in form and vibrant in color, are also exhibited.

Other artists shown are Allen Bishop, Richard Burton, Angelo Caravaglia, Larry Christensen, Sharlene Christensen, Ann Day, George Dibble, Cynthia Fehr, Bart Morse, Tom Mulder, Greg Perri, F. Anthony Smith, V. Douglas Snow, Kate Woolstenhulme and Francis Zimbeaux.

Tivoli Gallery 255 S. State St., Salt Lake City, UT
1026 84111 (801) 521-6288; Mon-Sat: 10-5:30; owner: Dan Olsen dir: Mary Ann Olsen

A large sales gallery which concentrates on all

regional and local artists as well as 19th and 20th century Americana, Tivoli Gallery features works by over forty-five artists in its two-story space.

Important local artists shown include Ken Baxter, Gary Smith, Nancy Lund, Valoy Eaton, Paul Forster and Grant Speed. Examples of work by early Utah artists and members of the Taos School are also on hand.

VERMONT

FERRISBURGH

Four Winds Gallery and Teahouse Ferrisburgh, VT
1027 05456 (802) 425-2101; May-Oct: daily: 11-5 Winter: by appt; owner: Madeleine C. Borden & Barry Borden dir: M.C. Borden

Out in the country fifteen miles south of Burlington, the Four Winds Gallery and Teahouse blends the pleasures of art, nature and gourmet cooking. The extensive gallery space occupies various levels in vintage houses linked together with gardens, a fish pond, an artificial waterfall and a greenhouse.

The four large galleries display works by Vermont and New England artists as well as international artists. In addition there are displays of 19th and 20th century American painting and graphics, European antiques, Canadian Eskimo graphics and stone carvings, and art from the Far East, Canada, Europe and the United States—from all points of the compass.

Works by Vermont's foremost artists are always available. A recent exhibition included works by Fred Swan, Jean Lehrbaum, Joseph Bolger and Arthur Healy. Contemporary European and American masters are represented in the gallery's graphics collection. The gallery handles the work of international European artist Pierre Baziere.

Visitors who wish to partake of the gourmet luncheon offered by the teahouse should call for reservations.

WOODSTOCK

Charles Fenton Gallery Woodstock East, Woodstock,
1028 VT 05091 (802) 457-1900; Mon-Fri: 9-5 Sat: 11-5; owner: C. Fenton dir: Jon G. Fox

The Charles Fenton Gallery specializes in regional contemporary artists, also offering a wide selection of 19th century American painting and prints. Artists are featured in monthly changing exhibitions.

Painters include Diane Sophrin, John Bott and Susan Dowley; sculptors are Judith Brown and Ronny Solbert. Children's book illustrators Tomie de Paola, Trina Schart Hyman and Lucy Doane are featured, along with photographers Dorothea Kehaya, Geoffrey Clifford and Rosamund Orford. Mary Modeen's abstract prints and Vicki Junk-Wright's embossed etchings share space with limited edition prints by such popular artists as Robert Bateman, David Mass and Jablonsky.

The gallery also carries collector's prints by Winslow Homer, Salvador Dali, Joseph Pennell and Roland Clark.

Recent shows have highlighted vintage photographic works in platinum and silver by Laura Gilpin, displayed handmade paper works by Sarah Warren, and juxtaposed David Ellsworth's wooden Vessels with those in porcelain by Sylvia Bower.

The gallery presented the first showing of the photographs that later were published as the book *El Salvador,* edited by Susan Meiselas and Harry Mattison.

VIRGINIA

ALEXANDRIA

The Athenaum, Northern Virginia Fine Arts Asso-
1029 **ciation** 201 Prince St., Alexandria, VA 22314 (703) 548-0035; Tue-Sat: 10-4 Sun: 1-4 Jul-Aug 15: closed; dir: Betsy Mansmann

The Athenaum presents a well-rounded variety of changing exhibits in all media and styles, both contemporary and historical. The majority of the artists live or work in the greater Washington, D.C., area.

The Athenaum is a nonprofit arts center, and as such represents no artists. Many different American artists and craftsmen are regularly featured in its temporary exhibits and sculpture garden.

Gallery 4 115 S. Columbus St., Alexandria, VA 22314
1030 (703) 548-4600; Tue-Sat: 10-5 Aug: closed; dir: Mary Kay Ryan

Concentration is on contemporary artists, usually from the Washington, D.C., area. The gallery initiated sections specializing in 19th and early 20th century art in September of 1984.

Among the artists whose work is featured are William Dunlap, Deborah Ellis, and Gordon Mortensen.

Old Warsaw Galleries, Inc. 319 Cameron St., Alex-
1031 andria, VA 22314 (703) 548-9188; Tue-Sat: 10-6 Sun: 11-5; owner/dir: Barbara Witulska Lazo

Located since 1975 in Alexandria's historic Old Town, the Old Warsaw Galleries, Inc., is devoted exclusively to Polish artists both here and abroad. Perhaps as a tribute to the Polish glass blowers who plied their trade among the original Jamestown settlers, Director Barbara Witulska Lazo, a native of Krakow, Poland, carries a wide range of crafts in her gallery while striving to promote contemporary Polish painters, sculptors and printmakers, who frequently have not been recognized in their own country.

Among the artists are John De Rosen, whose mosaics are included in the Vatican and major cathedrals throughout the world. Contemporary Polish graphic artists represented are Andrezej Pietsch, Jacek Gaj, Marta Kremer, Lesznek Rozga, Lucian Mianowski and Krystyna Marek-Swiecicka, an area artist and a Corcoran Gallery of Art faculty member.

Andrezej Urbanowicz's oil paintings concern the existential while Henryk Fantazo's are surrealistic. Impressionistic painters include Ludwik Wiechecki in watercolors and Magdalena Spasowicz in oils. Sculptors include Andrzej Pitynski and Marion Owczarski.

Torpedo Factory Art Center 105 N. Union St., Alexandria, VA 22314 (704) 838-4565; Mon-Sun: 10-5
1032

This gigantic art center, located on the Potomac River at the foot of KIng Street, was opened in 1974 in an old torpedo factory, as a Bicentennial project. The center provides studio space for more than 175 artists and craftspeople. Visitors are welcome to prowl and buy directly from the artists.

There are four nonprofit coop galleries in the building. The Art League, a 700 member group of artists, runs the biggest gallery for paintings, drawings, sculpture, prints and photography. Works are exhibited in monthly shows juried by different area teachers and critics.

Potomac Craftsmen shows the work of 200 artists who work in fiber, and includes everything from woven shawls and skirts to baskets and batik.

Scope Gallery features, in alternating monthly shows, ceramic work by the Ceramic Guild of Bethesda and The Washington Kiln Club.

Enamelists Gallery shows jewelry, wallpieces, boxes and other objects by 30 artists who do copper enameling and cloisonne. In addition there are seventeen workshops in the Torpedo Factory where other groups exhibit.

BLACKSBURG

Block Prints Gallery 143 Jackson St., Blacksburg, VA 24060 (703) 552-6969; Tue-Fri: 10-5 Sat: 12-5; owner: Robert A. Miller dir: Amy T. Miller
1033

The Block Prints Gallery specializes in contemporary original work, mostly prints and paintings, with some sculpture. About half the work is by local artists, with the rest acquired through shows and other galleries.

Artists whose work is displayed include local artists Joni Pienkowski, an abstract painter and portrait artist who has exhibited nationally, and Harold Little, a printmaker known for his etchings. Other artists are Marcel, silkscreen; Jan Bos, tapestries; Terence Roberts, photographs; Diane Gofl; Carole Davis, watercolors; Martha Dillard, acrylic paintings in staining technique; Patrick McKelvy, oils; Bill Cox, etchings; Carol Burch-Brown, drawings; and Marie Livermore, watercolors.

The gallery also exhibits Pat West, oils; Catherine Hunt, batik drawings; Tena Kelsey, oils; Gil Roberts, jewelry; Lana Roberts, stained glass; Liz Kregloe, handmade paper; and Carol Hoge, watercolors.

RICHMOND

Cudahy's Gallery 1314 E. Cary St., Richmond, VA 23219 (804) 782-1776; Mon-Thu: 10:30-5:30 Fri-Sat: 10:30-10 Sun: 12-5; owner: Peter Stearns dir: Helen G. Levinson
1034

The gallery features original contemporary art embracing all media and styles by more than fifty artists, mostly from the Southeast region.

Monthly individual shows, a continuing show of gallery artists, and a selection of wildlife paintings and sculpture occupy the three levels of the gallery.

Artists include Stephen Fox, an emerging artist in the realist tradition specializing in urban nocturnes; Eldridge Bagley, a naive painter who depicts rural country scenes drawn from childhood memories; and David Cochran, whose acrylic figurative paintings of interior settings evoke hidden narratives.

The gallery group includes Carlton Abbott, pastels in an abstract, architectural style; David Gill, urban landscapes; and realists Ed Myers and Paul Germain. A wide array of original graphics are also available, including the woodcuts of James Kirby, silkscreens by Jane Aman, and wood engravings by Dave Bruner.

ROANOKE

The Art Affair Gallery Tanglewood Mall, Roanoke, VA 24014 (703) 774-0400; Mon-Sat: 10-7; owner: Ed Smith dir: Bruce Cody
1035

The gallery focuses on regional artists with an emphasis on work in contemporary styles, and also carries functional and decorative craft items.

Regional painters include Joni Pienkowski, Vera Dickerson and Beth Shively. Printmakers include Marlia McDade, Stephen White and Harold Little. Among the craftspeople are David Crane, Glen Appleman and Vernon Reed.

Watercolors by Katherine C. Liu and drawings by Stephen T. Endres are also exhibited. The gallery has four to six shows a year, and works with clients when commissions are sought.

WASHINGTON

SEATTLE

Davidson Galleries 87 Yesler Way, Seattle, WA 98104 (602) 624-7684; Mon-Sat: 12-5; owner/dir: Sam Davidson
1036

Davidson Galleries specializes in original woodcuts, etchings, engravings and lithographs from 1500 to the present. The gallery features many contemporary artists, mostly from the Northwest, and shows contemporary work in all media except sculpture and photography.

Works by most of the historically important artists of the period mentioned are available, including Albrecht Durer, Rembrandt, Francisco Goya, Jacques Callot, William Hogarth, Thomas Rowlandson, Honore Daumier and others. Recently the gallery has shown painting by 19th century American masters such as A.T. Bricher, William Merritt Chase, J. Hart, W.M. Paxton, G.C. Wiggins and J. Sessions.

Contemporary prints by Wayne Thiebaud, Carol Summers, Peter Milton and many others also are available. There are paintings and drawings by Liza von Rosenstiel; paintings and lithographs by Kate Wade, Doug Somivan, and Scott Smith; lithograph collages by Diane Katsiaficas; etchings by Norman Elder; lithographs by Lockwood Dennis; and etchings and lithographs by Karen Guzak.

Equivalents Gallery 115 S. Jackson St., Seattle, WA
1037 98104 (206) 467-8864; Tue-Sat: 11:30-5:30 Sun: 1-5; owner/dir: Charles E. Rynd

Taking its name from a famous series of photographs by Edward Stieglitz—cloudscapes which sought to create an image equivalent to music in their formal design—Equivalents Gallery exhibits 20th century fine art photography. Emphasis is on contemporary photographers from the U.S. and Europe, with a firm commitment to showing work by Northwest photographers.

Internationally recognized artists exhibited at the gallery include Barbara Morgan, Andre Kertesz, Lucien Clergue, Jan Saudek, Jack Welpott, Ruth Orkin, Danny Lyon, Larry Clark, Annie Leibovitz and Marion Post Walcott.

Also exhibited are younger "mid-career" photographers who have gained national recognition, including Christopher James, Michael Kenna, Paul Berger, Jim Goldberg, Christopher Rauschenberg, Denny Moers and Joan Myers.

Linda Farris Gallery 322 2nd Ave. S., Seattle, WA
1038 98104 (206) 623-1110; Mon-Sat: 11:30-5 Sun: 1-5; owner/dir: Linda Farris

The focus is on contemporary art by artists from the Northwest, West, and West Coast. The works shown include paintings, sculpture, ceramics, and works on paper.

The majority of the gallery's artists are from Seattle. They include sculptors Sherry Markovitz, Dennis Evans, and Nancy Mee, and painters Randy Hayes, Andrew Keating, Mary Ann Peters, and Jeffrey Bishop. The gallery also shows work by New York and West Coast artists Michael Lucero, Laddie John Dill, Tom Holland, and Billy Al Bengston. A recent group show, "Self Portraits," featured works by 54 American artists and traveled to the Los Angeles Municipal Art Gallery.

Foster/White Gallery 311 1/2 Occidental Ave.,
1039 Seattle, WA 98104 (206) 622-2833; Mon-Sat: 10-5:30 Sun: 12-5; owner: Don Foster dir: Johanna Nitzke

The gallery exhibits Northwest contemporary art including fiber, ceramics, painting and sculpture. Glass works from the Pilchuck Glass Center are a special feature of the gallery.

Northwest masters shown include Mark Tobey, Kenneth Callahan and Morris Graves. A student of Chinese and Japanese Zen calligraphy, Mark Tobey is known for his "white writing" all-over calligraphic designs, abstractions which anticipated the decentralized compositions of Jackson Pollock and the Abstract Expressionists. As distinct from works of the New York School, Tobey's paintings stressed meditation over action, but had in common with them the quality of being performances, works which focussed on the process of painting rather than on the end product. Morris Grave's lyrical paintings of birds and small animals breathe a poetry akin to Chinese or Korean painting. Kenneth Callahan also uses calligraphic gesture in his paintings, but has retained figurative and even narrative elements united by the broad visual sweep of his rhythmic compositions.

Among the contemporary artists exhibited by the gallery are Joan Ross Bloedel, Parks Anderson, Joseph Goldberg, Lois Graham, Thomas William Hones and Tony Angell.

Kirsten Gallery 5320 Roosevelt Way NE, Seattle, WA
1040 98105 (206) 522-2011; daily: 11-5; owner/dir: R.J. Kirsten

While offering a broad selection of fine art works, the Kirsten Gallery specializes in marine art. The Annual Marine Exhibition is held each year in July and draws artists from all over the U.S.A. as well as from abroad. The number and quality of the works exhibited make this one of the leading marine art exhibitions in the U.S.A.

Among the artists who exhibit work at the gallery are Alaskan watercolorist Byron Birdsall, and Mark Myers of Cornwall, England, a leading young marine artist who has a bi-annual show at the gallery.

Gallery Mack NW 123 S. Jackson St., Seattle, WA
1041 98104 (206) 623-1414; Mon-Sat: 10-6 Sun: 12-5; owner: Barbara Mack dir: Mike Peterson

This well-appointed gallery shows works by regional, national and international artists in all media.

Among the artists featured are R. C. Gorman, the noted Navajo Indian artist; Leroy Nieman, an internationally known painterly realist whose portrayal of sports has achieved widespread popularity; and Erwin Bender, an internationally known sculptor.

Two regional artists presented at the gallery are Duane Pasco and William E. Ryan. Pasco creates exacting works in the Northwest Coast Native American tradition—ceremonial masks, totems, and bent wood boxes. Ryan is known for his local scenery; his marine paintings have been exhibited in many parts of the United States.

Manolides Gallery 89 Yesler Way, Seattle, WA 98104
1042 (206) 622-3204; Tue-Fri: 11-4; owner/dir: Jim Manolides

Manolides Gallery exhibits contemporary works by artists from California and Washington state. Most of the work displayed is figurative with a touch of humor.

Among the artists whose work is shown are Roy DeForest, T. Michael Gardiner and Gaylen Hansen, as well as many others. Roy DeForest's work, where brightly colored and decorated figures slide through the picture space, appears to be a further, more cerebral development of the "funk art" of his native California. Gaylen Hansen plays with some of the the same artfully artless imagery as DeForest, but usually employs country rather than city or art historical images.

Sacred Circle Gallery of American Indian Art 2223
1043 Fourth Ave., Seattle, WA 98121 (206) 223 0072; Mon-Fri: 10-5 Sat-Sun: 12-5; owner: U.I.A.T.F. dir: Jim Halliday

Owned by the United Indians of All Tribes Foundation, the Sacred Circle Gallery exhibits traditional and contemporary Indian and Eskimo art, focusing on artists whose work is a combination of their heritage and modern experience.

The gallery is one of the leading centers for contem-porary Native American art. Artists exhibiting in 1984 include: abstract painter Joe

Feddersen (Colville), Dorothea Romero (Tlingit), Theodore Villa (Apache), James Lavadour (Walla Walla), Victor Curran (Quechan), sculptor Lawrence J. Beck (Eskimo), Darrell Norman (Blackfeet), David Boxley (Tsimshian), Lillian Pitt (Warm Springs/ Yakima), Ted Garner (Sioux), Conrad House (Navajo), Eunice Carney (Athabascan), bronze sculptor Lawney Reyes (Colville), Edna Jackson (Tlingit), Ric Danay (Mohawk) and David Jones (Navajo).

Francine Seders Gallery 6701 Greenwood Ave. N.,
1044 Seattle, WA 98103 (206) 782-0355; Tue-Sat: 10-5 Sun: 1-5; owner/dir: Francine Seders

Director Francine Seders bought the Otto Seligman Gallery in 1967, retaining a number of his artists. The gallery features a variety of contemporary art, including abstract, representational, and figurative work.

Most of the artists are from the Northwest. They include painters Guy Anderson, Fay Jones, Norman Lundin, Michael Spafford, Ben Frank, K. C. Maxwell, Robert C. Jones, Linda Okasuki, Rob Herlitz, Boyer Gonzales, Julian A. Heyne, and sculptors Elizabeth Sandvig and John Keppelman. California painters Carl Benjamin and Rene Groch also are shown. Recent shows included an exhibit of the paintings of German artist Andreas Grunert; "Myth in Primitive and Contemporary Art," featuring works by Guy Anderson, Reuben Nakian, and Michael Spafford, along with African, New Guinea, and North American Indian artifacts; and an invitational show of figurative painting.

Traver-Sutton Gallery 2219 Fourth Ave., Seattle,
1045 WA 98121 (206) 622-4234; Tue-Fri: 10-5 Sat: 12-5; owner/dir: Bill Traver & Iris Sutton

The Traver-Sutton Gallery exhibits contemporary art in all media, including painting, sculpture, glass, photography, fiber, clay and wood. Two to three one-person shows are mounted monthly, with occasional group exhibitions in particular media, such as clay, fiber and glass.

Among the artists whose work is exhibited is Paul Heald, an abstract painter who also has worked in film animation and performance art. Abstract painter Judy Cooke employs gestural line poised against flat expanses of color, and has worked with collage extensively. Other artists shown include Diane Katsiaficas, Esther Podemski, Bob Hansen, Scott Somiksen, William Turner, David Nechak, Gregory Grenon, Dorit Brand, Amy Roberts, Geoffrey Pagen, George Chacona, Linda Beaumont, Bill Whipple, Debra Sherwood, Sonja Blomdahl, Benjamin Moore, Dick Weiss, Bertil Vallien, Ulrica Hydman Vallien and Peter Shire.

Gordon Woodside/John Braseth Galleries 1101
1046 Howell St. at Boren Ave., Seattle, WA 98101 (206) 622-7243; daily: 11-6; owner/dir: G. Woodside & J. Braseth

For over 25 years the Woodside/Braseth Galleries has specialized in contemporary painting, sculpture and prints by artists of the Pacific Northwest.

Among the Northwest masters exhibited are William Ivey, whose abstract paintings show a certain influence of Clyfford Still and of Impressionist all-over texturing; abstract painter Frank

Sumio Okada, whose recent work moves away from pure color field painting to strongly defined structures and colors; abstract painter Carl Morris and abstract sculptor Hilda Morris, who first arrived in the Northwest on a WPA project; Paul Horiuchi, painter of harmonious geometrical abstracts; as well as Kathleen G. Adkinson and Paul Havas.

Other artists include Lorraine Ledbetter, Tom Brennan, Robert Sperry, Sally Haley, Michael Sweeney, Allen Lobb, Phyllis Emmert, Robert McKnown, Steven Cramer and James Martin, as well as many others.

WEST VIRGINIA

CHARLESTON

West Virginia Guild Gallery, Inc. 32 1/2 Capitol
1047 St., Charleston, WV 25301 (304) 345-0289; Mon-Sat: 10-9 Sun: 12:30-5:30; dir: Ene Purre

Owned and operated by the West Virginia Artists and Craftsmens Guild, the gallery shows traditional and contemporary crafts and fine art prints produced by members of the Guild. Only members' works which have been selected by a demanding jury review are exhibited.

HARPERS FERRY

Stowell Galleries 769 Washington St., Harpers Ferry,
1048 WV 25425 (304) 535-6693; Sat-Sun: 10-6; owner/dir: Walton D. Stowell

Concentration of the gallery is 20th century paintings and sculpture.

Stowell Galleries presents the work of Thor Carlson of Westminster, Massachusetts. Carlson work in various media, including painting, sculpture and weaving.

The gallery also shows emerging artists from West Virginia, Virginia, Maryland and the District of Columbia.

WISCONSIN

ELLISON BAY

Tria Gallery Hwy. 42, Ellison Bay, WI 54210 (414)
1049 854-2298; daily: 10:30-6; owner/dir: Ruth & Philip Philipon

The Tria Gallery exhibits contemporary paintings, original graphics, handmade paper works, indoor and outdoor sculpture, fiber works and some pottery. The paintings shown are mostly non-representational or organic abstractions. Of particular interest is the gallery's selection of outdoor sculpture.

Abstract painter Ruth Philipon also prints limited edition etchings; Philip Philipon paints in poured acrylics; and Keith Davis paints in acrylics. Micheale Tugel works in handmade paper. Pat Diacca Topp's cloisonne enamels and Robert Hodgell's ceramic sculpture are also featured. Other sculptors include Charles Kraus, indoor and outdoor bronzes; Thomas Brings, who creates indoor and outdoor pieces; and Susan Falkman, who work in marble. In addition, the gallery shows work by well known English printmaker Graham Clark.

The gallery also features the organic wood sculpture of Jerry Deasy, organic wall reliefs by Ann Waisbrot, sculpture by Kevin Strandberg, ceramic sculpture by Robert Von Neuman, and outdoor sculpture by Bill Little. Fiber artists are Ilena Grayson, Alexa Williamson and Ray Azcuy. Prints by Bill Renc, Arthur Skinner and Lois Mogensen, calligraphy by Kathy Fenner, and works in clay by John Eckert are also available.

MADISON

Seuferer Chosy Gallery 218 N. Henry St., Madison,
1050 WI 53703 (608) 255-1211; Mon-Fri: 10-5 Sat: 11-5; owner/dir: Ellen Seuferer & Grace Chosy

Concentration of the gallery is on artists presently living and working in Wisconsin and surrounding states. Media exhibited include oil, acrylic, watercolor, original print editions, monotypes and ceramics.

Artists whose work is exhibited include Keith Achepohl, lithographs and watercolors; Wendell Arneson, watercolors; Susan Bailey, serigraphs; Andrew Balkin, etchings and monotypes; Sylvia Beckman, paintings and sculpture; John Colt, pastels and watercolors; Jack Damer, constructions and serigraphs; Willem DeLooper, acrylic paintings; John Earnest, oil paintings and monotypes; Ruth Grotenrath, casein paintings; Skip Johnson, works in wood; Ruth Kjaer, watercolors and acrylics; Schomer Lichtner, acrylics and prints; John Mominee, monotypes; Paula Nees, pastels and oil paintings; JoAnna Poehlmann, watercolors and prints; Robert Schultz, graphite drawings; Jan Serr, oil paintings and monotypes; Marko Spalatin, serigraphs and oil paintings; Leslie Vansen, acrylics; William Weege, handmade paper; and Santos Zingale, oil paintings and ink drawings. Artists working in ceramics are Kerry Chaplin, Dick Evans, Rick Foris, Karen Gunderman and Marjorie Mau.

MILWAUKEE

David Barnett Gallery 2101 W. Wisconsin Ave., Mil-
1051 waukee, WI 53233 (414) 344-6070; Mon-Sat: 10-5 summer: closed Sat; owner/dir: David J. Barnett

The David Barnett Gallery specializes in 19th and 20th century European and American masters working in painting, sculpture, ceramics, watercolor, drawing, fiber, and graphics. In addition to a small selection of old master prints and paintings, the gallery handles original posters and exhibits work by established and emerging regional and Wisconsin artists.

Works are available by Picasso, Marc Chagall, Maurice Vlaminck, Henri Toulouse Lautrec, Jacques Villon, Alexander Calder, Victor Vasarely, Alphonse Mucha, Wolf Kahn, Warren Brandt, Ilya Bolotowsky, and many others. The gallery also carries Currier & Ives lithographs.

Other artists whose work may be seen include contemporary French artist Claude Weisbuch, who works in a classical drawing style; contemporary Peruvian figure painter Ernesto Gutierrez; and Alicia Czechowski, whose paintings and pastels in a classical realist style center on the human figure. There are also works by Peggy Farrel, Mark Mille, Todd Boppel, Pam Bachman

and Barbara Kohl.

Bradley Galleries 2565 N. Downer Ave., Milwaukee,
1052 WI 53211 (414) 332-9500; Tue-Sat: 11-5 Sun: 1-5; owner/dir: Dorothy M. Bradley

Established in 1960, the gallery specializes in work by Wisconsin artists, many of whom are of national stature, with occasional shows of Haitian artists' works.

Artists featured by the gallery include Robert Burkert, John Colt, Ruth Grotenrath, Schomer Lichtner, JoAnne Poehlmann, Beverly Harrington, Anne E. Miothe, Ida Ozonoff, John Sayers, Laurence Rathsach, Joann Toman, Gibson Byrd, Danny Pierce, John Earnest, Aaron Bohrod, Joseph Friebert, John Wilde, Wayne Fischer, Ruth Kjaer and Tom Uttech. All these artists are contributing to giving Wisconsin a forceful art.

Other artists, who have contributed to recognized juried shows, are Christel-Anthony Tuchalke, Arthur Thrall, Karen Gunderman, Susan Bachmann, Flora Langlois, Helen Olney, Susan Hoover, Keiko Hara and Harold Altman.

Lenz Gallery 7733 W. Burleigh St., Milwaukee, WI
1053 53222 (414) 444-5375; Tue-Sat: 10-5; owner/dir: Thomas E. Lenz

In business in Milwaukee since 1919, the Lenz Gallery specializes in early 20th century American and European paintings.

Michael H. Lord Gallery 700 N. Milwaukee St.,
1054 Milwaukee, WI 53202 (414) 272-1007; Mon-Sat: 10-5; owner: Michael H. Lord dir: Annette Robertson

Concentration is on contemporary American art and post-World War II photography, with emphasis on the New York School and contemporary master photographers.

Among the contemporary American painters whose work is shown are Jasper Johns, Frank Stella, Alex Katz, Robert Zakanitch, Jedd Garet, Alexander &ZY,591 Cleve Gray, Chuck Close, Farid Haddad and Nancy Graves.

Master photographers include Henri Cartier-Bresson, Bill Brandt, Irving Penn, Joel Meyerowitz and Brassai.

Posner Gallery 7641 N. Port Washington Rd., Mil-
1055 waukee, WI 53217 (414) 352-3097; Mon-Fri: 10-5 Sat: 10-3; owner/dir: Judith L. Posner

Posner Gallery specializes in 19th and 20th century paintings, sculpture and works on paper. Judith L. Posner and Associates also publishes limited edition prints and posters, and maintains a collection of over 5000 prints, including works by Jasper Johns, Jim Dine, Karel Appel, Joan Miro, and Marc Chagall, among many others.

The gallery is international in its scope and selection of artwork. Paintings and sculpture by Jean Dubuffet, Miro, Henry Moore and Yaacov Agam are available, as well as works by younger American and European artists.

A recent exhibit of the paintings by Jean Crane was exhibited nationally. Her most recent watercolors are realistic in style, with loose backgrounds in dark hues. The paintings, wood reliefs and tapestries of Spanish painter Gustavo, currently a resident of Berlin, in the German Federal Republic, were also highly acclaimed. In boldly colored, flat organic shapes reminiscent

of the surrealist epochs of Miro and Picasso, Gustavo presents a language of symbols at once apparent and secret.

WYOMING

JACKSON

Main Trail Galleries 92 N. Center St., Jackson, WY
1056 83007 (307) 733-4355; Mon-Sat: 9-5; owner/dir: Richard Flood III

See listing for Scottsdale, AZ.

Trailside Galleries 105 N. Center St., Jackson, WY
1057 83001 (307) 733-3186; Mon-Sat: 9:30-6; owner/dir: Ted & Christine Mollring

See listing for Scottsdale, AZ.

Peacock Galleries, Ltd. Box 20315, Jackson, WY
1058 83001 (307) 733-9211; summer: Mon-Sat: 10-6 winter: Tue-Sat: 10-5 dir: Ann Morrow

See listing for Scottsdale, AZ.

CROSS REFERENCES BY SPECIALIZATIONS

The list which follows represents concentrations of art styles and not necessarily the individual focus of the gallery. Galleries not named below show primarily contemporary American painting and sculpture. The Index to Gallery Specializations has the following listings:

GALLERY SPECIALIZATIONS

CRAFTS; GRAPHICS, Contemporary and Historical Periods; PAINTING, Historical Periods, Europe: Contemporary and Historical Periods; PHOTOGRAPHY; VIDEO, FILM AND PERFORMANCE

SPECIALIZATIONS IN CULTURAL AREAS

Afro-American Art, Ancient Art and Antiquities, Asian Art, Ethnic Art, Folk Art, Native American Art, South American and Hispano-American Art, Western Art, Women's Art

ALTERNATE SPACES AND COOPERATIVE GALLERIES

CRAFT

ALASKA: *Anchorage:* Stephan, *Ketchikan:* The Gathering **ARIZONA:** *Phoenix:* Gallery Three, *Scottsdale:* Bishop, Suzanne Brown, Joan Cawley, Hand & Spirit, Mammen, Lovena Ohl, Gallery 10, Trailside, *Sedona:* Mundo Magico **CALIFORNIA:** *La Jolla:* Eight, Knowles, *Los Angeles:* ARCO, Janus, Kurland/Summers, L.A. Municipal, Shinno, *San Diego:* A.R.T./Beasley, Orr's, *San Francisco:* Allrich, Editions Ltd. West, Gump's, Images of the North, Miller/Brown, Potter, Dorothy Weiss, *San Jose:* Young, *Stinson Beach:* Gardner **COLORADO:** *Allenspark:* Bishop, *Georgetown:* Saxon Mtn. **CONNECTICUT:** *Avon:* Farmington Valley Ctr., *Farmington:* Tribeca **DELAWARE:** *Greenville''* Gallery at Greenville **DISTRICT OF COLUMBIA:** *Washington:* Capitol East Graphics, Fendrick, Spectrum, Touchstone, Zenith **FLORIDA:** *Bay Harbor Islands::* Habatat, *Miami:* Lanvin, *Palm Beach:* Holsten, *Sarasota''* Hodgell, Image, *South Miami:* Netsky **GEORGIA:** *Atlanta:* Artists Associates, Gillette-Fruchtey, Portofolio **HAWAII:** *Holualoa:* Hale O Kula, Studio 7, *Kailua-Kona''* Kona-Mini, *Kailua-Kona''* Showcase, *Lihue Kauai:* Stones **ILLINOIS:** *Chicago:* American West, Baruch, Bell, Exhibit A, Hokin/Kaufman, B.C. Holland, Horwich, Mindscape, Randolph St., Rizzoli, Rosenfield, Yolanda, *Evanston:* Mindscape, *Winnetka:* Yolanda **INDIANA:** *Fort Wayne:* Artlink, *Indianapolis:* Editions Limited **KANSAS:** *Kansas City:* Drake, *Louisville:* Contemporary Crafts, Park **MARYLAND:** *Baltimore:* Meredith, *Bethesda:* Glass, *Kensington:* Plum **MASSACHUSETTTS:** *Boston:* Alianza, Bernstein, Signature, Westminster, *Cambridge:* Mobilia, Ten Arrow, *Chestnut Hill:* Quadrum, *Hyannis:* Signature, *Lincoln:* Clark, *Rockport:* Wenniger, *Stockbridge:* Holsten **MICHIGAN:** *Birmingham:* GMB, Hooberman, Jacobs, *Detroit:* Artists' Market, *Lathrup Village:* Habatat **MISSOURI:** *St. Louis:* Wagman **MONTANA:** *Billings:* Castle, *Bozeman:* Artifacts, *Great Falls:* Gallery 16, *Kalispell:* Cottonwood **NEVADA:** *Reno:* Artist Co-op **NEW HAMPSHIRE:** *Manchester:* Manchester Institute **NEW JERSEY:** *Fair Lawn:* Kornbluth, *Freehold:* Jentra, *Montclair:* Double Tree, *New Brunswick:* Dumont-Landis, *Tenafly:* America House **NEW MEXICO:** *Albuquerque:* Adobe, Mariposa, *Santa Fe:* Contemporary Craftsman, Christof's, New Trends, Running Ridge, Santa Fe East, *Taos:* Clay & Fiber, El Taller Taos, Fennell, Gallery G, Grycner, Ledoux, Magic Mtn., Return, Southwestern Arts **NEW YORK:** *Bridgehampton:* Benson, *Buffalo:* Freudenheim, *Endicott:* Spectrum 15, *New York:* Jayne Baum, Convergence, Barry F.+591 Hartsook, Heller, Jorice, Jane Kahan, Milliken, Modern Master, Multiples, Protetch, Barbara Toll, Verbena, *Riverhead:* East End Council, *Rochester:* Craft Co. #6, Dawson, *Scarsdale:* Craftsman's, *Setauket:* Gallery North, *Southhampton:* Gayle Willson, *Syracuse:* The Studio **NORTH CAROLINA:** *Durham:* Somerhill, *Greensboro:* Green Hill Ctr., *Salisbury:* Waterworks **NORTH DAKOTA:** *Minot:* Artmain, Minot **OHIO:** *Cincinnati:* Miller, *Toledo:* J. Barrett **OKLAHOMA:** *Oklahoma City:* Shorney **OREGON:** *Portland:* Attic **PENNSYLVANIA:** *Elkins Park:* Gallery 500, *Philadelphia:* Route 66, Swan, Sande Webster, *Pittsburgh:* Concept **RHODE ISLAND:** *Providence:* Woods-Gerry **SOUTH CAROLINA:** *Hilton Head Island:* Artistic Sass, Red Piano **SOUTH DAKOTA:** *Rapid City:* Anakota **TEXAS:** *Dallas:* Adelle M, Delahunty, Frontroom, Hadler/Rodriguez, Humanarts, Mattingly-Baker, Nimbus, Paige, *Fort Worth:* Carlin, Perry Coldwell, Gallery One, *Houston:* Archway, Toni Jones, Kauffman, M.E.'s, *San Antonio:* Charlton, Objects **UTAH:** *Moab:* Jailhouse, *Salt Lake City:* Artist in Action, Phillips **VIRGINIA:** *Alexandria:* Athenaum, Old Warsaw, Torpedo Factory, *Roanoke:* Art Affair **WASHINGTON:** *Seattle:* Linda Farris, Foster/White, Traver-Sutton **WEST VIRGINIA:** *Charleston:* W.V. Guild **WISCONSIN:** *Ellison Bay:* Tria, *Madison:* Seuferer Chosy **WYOMING:** *Jackson:* Trailside

GRAPHICS

Contemporary

ALABAMA: *Mobile:* Boland-Bethea **ALASKA:** *Anchorage:* Stephan, *Ketchikan:* The Gathering **ARIZONA:** *Phoenix:* Ianuzzi, Thompson, Gallery Three, West Side, *Scottsdale:* Bishop, Joan Cawley, Fagen-Petersen, Elaine Horwitch, Martin, Missal, Peacock, *Sedona:* Elaine

Horwitch, Masters, Mundo Magico **ARKANSAS:** *Little Rock:* Arkansas Arts Ctr. **CALIFORNIA:** *Berkeley:* Ames, *Beverly Hills:* Louis Newman, *Carmel:* Iannetti, *Laguna Beach:* Haggenmaker, *San Rafael:* R.E. Lewis, *Los Angeles:* Ankrum, Cirrus, DeVorzon, Gemini G.E.L., Heritage, *Los Angeles:* Koplin, Lawrence, Leavin, L.A. Municipal, Mekler, Tobey C. Moss, Pink/Master Prints, Shinno, Space L.A., *Newport Beach:* Lawrence, *Oakland:* Crown Point, *Palo Alto:* Anderson, *Riverside:* Robertson, *San Diego:* Riggs, Wenger, *San Francisco:* Hank Baum, Bluxome, de Soto, Eaton/Shoen, Editions Ltd. West, Graystone, Gump's, Harcourts Contemporary, Iannetti, Postcard Palace, Soker-Kaseman, Soma, Vorpal, Walton-Gilbert, *San Jose:* Young, Tortue, *Sherman Oaks:* Lawrence **COLORADO:** *Allenspark:* Bishop, *Denver:* Art Resources, Inkfish, *Telluride:* 21st Century **CONNECTICUT:** *Danbury:* Print Cabinet, *Farmington:* Tribeca, *Guilford:* Greene, *Stamford:* Smith-Girard, *Westport:* Connecticut Fine Arts **DELAWARE:** *Wilmington:* Carspecken-Scott **DISTRICT OF COLUMBIA:** *Washington:* David Adamson, Art Barn, Atlantic, Franz Bader, Robert Brown, Capitol East Graphics, Fendrick, Haslem, Hom, Kornblatt, Mickelson, Rosen, Shogun, Spectrum, Touchstone, Venable-Neslage, Washington Project, Women's Art Ctr. **FLORIDA:** *Bay Harbor Islands:* Luria, *Coconut Grove:* Greene, *Miami:* Gillman, *Naples:* Valand, *Palm Beach:* Holsten, *Sarasota:* Adley, Hodgell, *Surfside:* Medici-Berenson **GEORGIA:** *Atlanta:* Artists Associates, Beckerton, Fox, Gillette-Fruchtey, Greggie, Jacob, Kraskin/Mitchell, Nexus **HAWAII:** *Holualoa:* Studio 7, *Honolulu:* Queen Emma, *Kailua-Kona''* Kona-Mini, *Lahaina:* Casay, Village, *Lihue Kauai:* Stones **IDAHO:** *Boise:* Ochi **ILLINOIS:** *Chicago:* Aiko's, Artemisia, Baruch, Bell, Benjamin-Beattie, Chase, Cicero, Circle, Contemporary Art Workshop, Frumkin & Struve, Goldman-Kraft, Hokin/Kaufman, Billy Hork, Klein, Landfall, Michael's Edition, Perimeter, Rizzoli, SAIC, SAIC Superior St., Stein, Van Straaten, Worthington, Walton St. , *Evanston:* Billy Hork, Neville-Sargent, *Highland Park:* Eva Cohon, *Northbrook:* Circle-North, *Peoria Heights:* Tower Park, *Skokie:* Prestige **INDIANA:** *Fort Wayne:* Thomas Smith, *Indianapolis:* Editions Limited **IOWA:** *Des Moines:* Percival, *Marshaltown:* Fernette's **KANSAS:** *Kansas City:* Drake, *Manhattan:* Strecker, *Topeka:* Weiner **KENTUCKY:** *Frankfort:* Capital, *Louisville:* Byck, Park, Swearingen, White **LOUISIANA:** *New Orleans:* Beall, Casell, Hanson, Arthur Roger, Tahir **MAINE:** *Ogunquit:* PS, *Portland:* Hobe Sound **MASSACHUSETTS:** *Boston:* Graphics I & II, Harcus, Krakow, Rolly-Michaux, Segal, Wenniger, *Chestnut Hill:* Quadrum, *Lincoln:* Clark, *Stockbridge:* Holsten **MICHIGAN:** *Ann Arbor:* Clare Spitler, Alice Simsar, *Birmingham:* Cantor/Lemberg, GMB, *Detroit:* London Arts, C.A.De., *Lakeside:* Lakeside, *Okemos:* Bel Esprit, *Royal Oak:* Arnold Klein, *Southfield:* Park West, *Troy:* Troy **MINNESOTA:** *Minneapolis:* Peter M. David, Fiterman, Stoller **MISSISSIPPI:** *Jackson:* Whittington **MISSOURI:** *Kansas City:* Art Research Ctr., Batz/Lawrence, New Structures, *St. Louis:* Shapiro, Singer **MONTANA:** *Great Falls:* Gallery 16, *Kalispell:* Cottonwood **NEBRASKA:** *Lincoln:* Haymarket, *Omaha:* Gallery 72 **NEVADA:** *Incline Village:* Lake, *Las Vegas:* Minotaur **NEW JERSEY:** *Chatham:* Gallery 9, *Fair Lawn:* Kornbluth, *Freehold:* Jentra, *Newark:* City Without Walls, *New Brunswick:* Old Queens, *Princeton:* Princeton, *Short Hills:* Petan, *Sparta:* Sparta, *Watchung:* Only Originals **NEW MEXICO:** *Albuquerque:* Adobe, Tamarind, *Santa Fe:* Enthios, 21st Century, Gondeck, Graphics House, Hand Graphics, Horwitch, Keats, Little Plaza, Munson, *Taos:* Gallery A, Ledoux, Magic Mtn., Tally Richards, Sigala, Total Arts, Gallery West **NEW YORK:** *Buffalo:* Freudenheim, *Cedarhurst:* Loring, *East Hampton:* Gallery East, *East Meadow:* Now & Then, *Great Neck:* V & R, *Hartsdale:* Alan Brown, *Ithaca:* Upstairs, *Jericho:* Gillary, *New York:* A.I.R., Alexander, A.S.A.G.E., Anderson, Art Spectrum, Art Students League, AAA, Jayne Baum, Bellman, Brandt, Leo Castelli, Cayman, Christie's, City, Crispo Graphics, Crown Point, Ettinger, Feldman, First St., 49th Parallel, Franklin Furnace, Gerst, Getler/Pall/Saper, Gladstone, Glass, Goldberg, Goodman, Hammer, Heesy, Henry St., Hirschl & Adler Modern, Horn, Hudson Guild, Jacobson, Janis, Jay, Alexander Kahan, Jane Kahan, Key, Landfall, Leon, Maeght, Markel, Marlborough, Morningstar, Multiples, Nature Morte, Novo, Orion Editions, Pace Editions, Clean Well-lighted Place, Joan Prats, Pratt, Printed Matter, Reinhold-Brown, Rizzoli, Roeder, Rolly-Michaux, Rosenberg/Transworld, Mary Ryan, Schaeffer, 724 Prints, Styria, Uptown, Visual Arts, Vorpal, *Northport:* Northport, *Nyack:* Belle Arts, *Port Washington:* Graphic Eye, *Penfield:* Artist Showcase, *Rochester:* Sibley's, Oxford, Shoestring, Visual Studies, *Roslyn:* Robley, *Setauket:* Gallery North, *Syracuse:* The Studio **NORTH CAROLINA:** *Durham:* Somerhill, *Greensboro:* Green Hill Ctr., *Hillsborough:* Priestley, *Raleigh:* Ruth Green's **NORTH DAKOTA:** *Grand Forks:* Browning, *Minot:* Artmain **OHIO:** *Cincinnati:* Toni Birckhead, Ludeke, Malton, Miller, Solway **OKLAHOMA:** *Oklahoma City:* Shorney, *Tulsa:* Daphne **OREGON:** *Ashland:* Hanson Howard, *Eugene:* Zone, *Portland:* Attic, *Portland:* Fountain **PENNSYLVANIA:** *Conshohocken:* Hallowell, *Elkins Parkk:* Gallery 500, Dolan/Maxwell, Jeffrey Fuller, Suzanne Gross, La Pelle, Luber, Montezinos, Painted Bride, Portico, Print Club, Sande Webster, *Pittsburgh:* Concept, Wiebe & Bonwell **RHODE ISLAND:** *Providence:* Woods-Gerry **SOUTH CAROLINA:** *Charleston:* Gibbes **SOUTH DAKOTA:** *Rapid City:* Anakota **TENNESSEE:** *Nashville:* Cumberland **TEXAS:** *Amarillo:* James M. Haney, *Austin:* Native American Images, Parrish, Ravel, *Dallas:* Clifford, Contemporary, D-Art, Delahunty, DW, Foster Goldstrom, Frontroom, Nimbus, Paige, PS, Texas Art, Valley House, *Fort Worth:* Carlin, Shaindy Fenton, Gallery One, *Houston:* Atelier

280

1513, Dubose, Graham, Harris, Toni Jones, Kauffman, Kauffman Graphics, M.E.'s, Off the Wall, Plaza, Robinson, Wurzer, *San Antonio:* Charlton, Objects **UTAH:** *Moab:* Jailhouse, *Salt Lake City:* Artist in Action **VERMONT:** *Ferrisburgh:* Four Winds, *Woodstock:* Charles Fenton **VIRGINIA:** *Alexandria:* Old Warsaw, Torpedo Factory, *Blacksburg:* Block Prints, *Richmond:* Cudahy's **WASHINGTON:** *Seattle:* Davidson, Linda Farris, Woodside/Braseth **WEST VIRGINIA:** *Charleston:* W.V. Guild **WISCONSIN:** *Ellison Bay:* Tria, *Madison:* Seuferer Chosy, *Milwaukee:* Posner **WYOMING:** *Jackson:* Peacock

Historical Periods

ARIZONA: *Scottsdale:* Missal **ARKANSAS:** *Little Rock:* Arkanasas Arts Ctr. **CALIFORNIA:** *Carmel:* Iannetti, *San Rafael:* R.E. Lewis, *Los Angeles:* Dailey, Heritage, Tobey C. Moss, Pink/Master Prints, Zeitlin & ver Brugge, *San Francisco:* Iannetti, Thackrey & Robinson, Walton-Gilbert, Wylie Wong **CONNECTICUT:** *Danbury:* Print Cabinet **DISTRICT OF COLUMBIA:** *Washington:* Atlantic, Haslem, Hom, Hull, Mickelson, Old Print, Shogun **GEORGIA:** *Atlanta:* Greggie **ILLINOIS:** *Chicago:* Chase, R.S. Johnson, Kamp, Kenyon, Mongerson, Stein **LOUISIANA:** *New Orleans:* Galleria 539, Tahir **MARYLAND:** *Bethesda:* Bethesda **MASSACHUSETTS:** *Boston:* Alpha, Childs, Nielsen, Wenniger **MICHIGAN:** *Birmingham:* Ross, *Detroit:* London Arts, *Lakeside:* Lakeside, *Okemos:* Bel Esprit, *Royal Oak:* Arnold Klein, *Southfield:* Park West, *Troy:* Troy **MISSOURI:** *Kansas City:* Batz/Lawrence **NEW JERSEY:** *East Hanover:* Bradley's **NEW YORK:** *New York:* Arader, AAA, Bellman, Aldis Browne, Christie's, Gerst, Glass, Goldberg, Goldschmidt, Hammer, Hutton, Jane Kahan, Morningstar, Reinhold-Brown, Ronin, Mary Ryan, Schaeffer, Ellen Sragow, Tunick, Vorpal, Weyhe, *Northport:* Jeannot R. Barr **NORTH CAROLINA:** *Hillsborough:* Priestley **OHIO:** *Toledo:* Images **PENNSYLVANIA:** *King of Prussia:* Arader, *Philadelphia:* Dolan/Maxwell, Hahn, Luber, Charles Sessler, *Pittsburgh:* Wiebe & Bonwell **TEXAS:** *Dallas:* Valley House, *Houston:* James Atkinson, Harris, Wurzer **VERMONT:** *Woodstock:* Charles Fenton **WASHINGTON:** *Seattle:* Davidson **WISCONSIN:** *Milwaukee:* David Barnett

PAINTING

Historical Periods (before 1950): U.S. & Canada:

ARIZONA: *Phoenix:* Thompson, *Scottsdale:* Golden West, Main Trail, Missal, C.G. Rein, *Tucson:* Presidio **CALIFORNIA:** *Beverly Hills:* Peterson, *La Jolla:* Jones, *Los Angeles:* De Ville, Goldfield, Heritage, Tobey C. Moss, Newspace, Paideia, Zeitlin & ver Brugge, *San Diego:* Orr's, *San Francisco:* Atelier Dore, Harcourts, Hunter, Maxwell, North Point, Stewart, *Santa Ana:* Bolen **COLORADO:** *Denver:* C.G. Rein, Rosenstock **CONNECTICUT:** *Ridgefield:* Branchville Soho **DISTRICT OF COLUMBIA:** *Washington:* Adams Davidson, Atlantic, Guarisco, Haslem, Hull, Pensler, Tolley **FLORIDA:** *Sarasota:* Foster Harmon **GEORGIA:** *Atlanta:* Ramus, *Marietta:* Knoke **HAWAII:** *Lahaina:* Lahaina **ILLINOIS:** *Chicago:* Benjamin-Beattie, Campanile, B.C. Holland, Kamp, Kenyon, R.H. Love, Mongerson, Sternberg, *Skokie:* Prestige **KENTUCKY:** *Louisville:* Merida **MASSACHUSETTS:** *Boston:* Childs, Vose, *Lexington:* Gallery on the Green **MICHIGAN:** *Birmingham:* Morris, Ross **MINNESOTA:** *Minneapolis:* C.G. Rein **MISSOURI:** *Kansas City:* Batz/Lawrence, *St. Louis:* Masters **NEVADA:** *Las Vegas:* Minotaur **NEW HAMPSHIRE:** *Ashland:* Artist Express Depot, *Manchester:* Currier **NEW JERSEY:** *Basking Ridge:* Whistler's Daughter, *New Brunswick:* Old Queens **NEW MEXICO:** *Santa Fe:* Fenn, C.G. Rein, Santa Fe East, Wadle, Webb, Woodrow Wilson **NEW YORK:** *New York:* ACA, Jeffrey Alan, Babcock, Beadleston, Bellman, Berman, Castelli Feigen Corcoran, Crispo, Maxwell Davidson, Davis & Langdale, Deutsch, Diamond, Dintenfass, Einstein, David Findlay, Forum, Fourcade, Goffman, Graham, Grand Central, Grossman, Hammer, Hirschl & Adler, Alexander Kahan, Kennedy, Coe Kerr, Kraushaar, Levy, Marbella, Marlborough, Mathes, Payson-Weisberg, Raydon, Rothschild, Salander-O'Reilly, Sander, Schlesinger-Boisante, Schoelkopf, Smith, Solomon & Co., Spanierman, Ellen Sragow, Taitinger, Washburn, Wunderlich, York, *Nyack:* Trisdonn, *Purchase:* Helene Trosky **OHIO:** *Cincinnati:* Miller, *Toledo:* Images **PENNSYLVANIA:** *Bryn Mawr:* Newman, *Philadelphia:* David David, Newman, Frank S. Schwarz, *Pittsburgh:* Wiebe & Bonwell **SOUTH CAROLINA** *Charleston:* Gibbes **TENNESSEE:** *Memphis:* Oates **TEXAS:** *Amarillo:* James M. Haney, *Dallas:* Valley House, *Fort Worth:* Hall, *Houston:* James Atkinson, Connally & Altermann, R.W. Davis, Hooks-Epstein, Meinhard, C.G. Rein, Robinson **UTAH:** *Salt Lake City:* Gallery 56, Tivoli **VERMONT:** *Ferrisburgh:* Four Winds, *Woodstock:* Charles Fenton **VIRGINIA:** *Alexandria:* Gallery 4 **WISCONSIN:** *Milwaukee:* David Barnett, Posner **WYOMING:** *Jackson:* Main Trail

Contemporary (after 1950): Europe:

ARIZONA: *Phoenix:* Ianuzzi, *Scottsdale:* Missal, Yares, *Sedona:* Masters **CALIFORNIA:** *Los Angeles:* Susan Gersh, Newspace, *San Francisco:* Bergruen, Eaton/Shoen, Modernism, Wirt, *Venice:* L.A. Louver **CONNECTICUT:** *Guilford:* Greene, *Westport:* Connecticut Fine Arts **DISTRICT OF COLUMBIA:** *Washington:* Franz Bader, Baumgartner, Robert Brown, Gallery K, Venable-Neslage **FLORIDA:** *Bay Harbor Islands:* Sklar, *Boca Raton:* Berenson, Patricia Judith, *Miami:* M. Ross Friedman, *Naples:* Naples, Valand, *Palm Beach:* Gemini, Irving, *Sarasota'':* Oehlschlager **GEORGIA:** *Atlanta:* Fox,

Gold, Jacob **ILLINOIS:** *Chicago:* Baruch, Wally Findlay, Galleries d'Art, Hoffman, Worthington, Young, *Highland Park:* Eva Cohon **KENTUCKY:** *Lexington:* Cross Gate **MICHIGAN:** *Ann Arbor:* Alice Simsar, *Birmingham:* Hilberry, Morris, Schweyer-Galdo, *Southfield:* Park West **MINNESOTA:** *Minneapolis:* Fiterman **MISSOURI:** *Kansas City:* Art Research Ctr., Batz/Lawrence, New Structures **NEW JERSEY:** *New Brunswick:* Dumont-Landis **NEW YORK:** *Buffalo:* Freudenheim, *Jericho:* Gillary, *Locust Valley:* Country, *New York:* Anderson, Beadleston, Bellman, Berman, Boone, Bonnier, Borgenicht, Brewster, Bromm, Leo Castelli, C D S, Davis & Langdale, Dorsky, Van Eck, Elkon, Emmerich, Wally Findlay, Fourcade, Gerst, Gimpel & Weitzenhoffer, Nohra Haime, Iolas-Jackson, Janis, Kornblee, Kouros, Kumar, Lefebre, Maeght, Marlborough, Matisse, Mazoh, Multiples, Nakhamkin, Nosei, Novo, Pace, Joan Prats, Raydon, Rosenberg/Transworld, Rothschild, Saidenberg, Schaeffer, Schlesinger-Boisante, Serra de Felice, Silberberg, Solomon & Co., Holly Solomon, Sonnabend, Soufer, Staempfli, Taghinia-Milani, Tossan-Tossan, Urdang, Weber, Zarre, *Purchase:* Helene Trosky, *Rochester:* Shahin Requicha, *Rockville Ctr.:* Cote **OHIO:** *Cincinnati:* Ludeke, Miller, *Toledo:* J. Barrett **PENNSYLVANIA:** *Philadelphia:* Cava, Newman **TENNESSEE:** *Memphis:* Oates **TEXAS:** *Amarillo:* James M. Haney, *Dallas:* Adams-Middleton, Florence, Phillips, Simons-Lucet, *Houston:* Graham, Hooks-Epstein, Toni Jones, Meinhard **VERMONT:** *Ferrisburgh:* Four Winds **VIRGINIA:** *Alexandria:* Old Warsaw **WISCONSIN:** *Milwaukee:* David Barnett, Lenz, Posner

Historical Periods (before 1950): Europe

ARIZONA: *Scottsdale:* Missal, Montgomery-Taylor **CALIFORNIA:** *Los Angeles:* De Ville, Feingarten, Paideia, Zeitlin & ver Brugge, *San Diego:* Orr's, *San Francisco:* Atelier Dore, Harcourts, Hoover **DISTRICT OF COLUMBIA:** *Washington:* Atlantic, Baumgartner, Guarisco, Pensler **GEORGIA:** *Atlanta:* Ramus **ILLINOIS:** *Chicago:* Campanile, Wally Findlay, Gray, B.C. Holland, R.S. Johnson, Kamp, Sternberg, Worthington **KENTUCKY:** *Lexington:* Cross Gate, *Louisville;* Merida **MASSACHUSETTS:** *Boston:* Childs, Vose **MICHIGAN:** *Birmingham:* Morris **MISSOURI:** *Kansas City:* Batz/Lawrence **NEVADA:** *Las Vegas:* Minotaur **NEW YORK:** *New York:* Acquavella, Rachel Adler, Beadleston, Bellman, Berman, Castelli Feigen Corcoran, Maxwell Davidson, Davis & Langdale, Dorsky, Elkon, Peter Findlay, Wally Findlay, Fourcade, Barry Friedman, NY: *New york:* Gerst, Grossman, Hammer, Heidenberg, Hirschl & Adler, Hutton, Iolas-Jackson, Janis, Alexander Kahan, La Boetie, Lefebre, Maeght, Marlborough, Mathes, Matignon, Matisse, Mazoh, Noortman & Brod, Perls, Prakapas, Joan Prats, Price, Raydon, Rosenberg, Rothschild, Sabarsky, Saidenberg, St. Etienne, Schaeffer, Serra de Felice, Shepherd, Silberberg, Sindin, Solomon & Co., Soufer, Taitinger, Tatyana, Weintraub, Wildenstein, Yates **PENNSYLVANIA:** *Philadelphia:* David David, Newman, Frank S. Schwarz, *Pittsburgh:* Wiebe & Bonwell **TEXAS:** *Dallas:* Florence, Simons-Lucet, Texas Art, Valley House, *Fort Worth:* Perry Coldwell, Hall, *Houston:* James Atkinson, Hooks-Epstein, Meinhard **VERMONT:** *Ferrisburgh:* Four Winds **WISCONSIN:** *Milwaukee:* David Barnett, Posner

PHOTOGRAPHY

ARIZONA: *Phoenix:* Gallery Three **CALIFORNIA:** *Carmel:* Friends of Photography, Weston, *La Jolla:* Photography Gallery, *Los Angeles:* Ankrum, Hawkins, Koplin, Kuhlenschmidt, L.A. Municipal, *Newport Beach:* Spiritus, *San Francisco:* Eaton/Shoen, Editions Ltd. West, Fraenkel, Grapestake, Hobs, Postcard Palace, Thackrey & Robinson, Vision, Wirtz, *Santa Barbara:* SBCAF **COLORADO:** *Denver:* Camera Obscura **CONNECTICUT:** *Danbury:* Print Cabinet **DISTRICT OF COLUMBIA:** *Washington:* Kathleen Ewing, Touchstone, Women's Art Ctr. **FLORIDA:** *Coral Gables:* Artspace, *Palm Beach:* Helander/Rubenstein **GEORGIA:** *Atlanta:* Gillette-Fruchtey, Gold, Nexus, Two Nine One **HAWAII:** *Honolulu:* Queen Emma, *Kailua-Kona:* Kona-Mini **ILLINOIS:** *Chicago:* Artemisia, Baruch, Deson, Allan Frumkin, Houk, Kamp, Pallas, Randolph St., Rizzoli, SAIC, SAIC Superior St., WPA **KANSAS:** *Kansas City:* Drake **LOUISIANA:** *New Orleans:* Fine Photography, Arthur Roger, Villa **MAINE:** *Rockport:* Maine Photographic **MARYLAND:** *Baltimore:* Dalsheimer **MASSACHUSETTS:** *Boston:* Harcus, Kingston, Klein, Segal **MICHIGAN:** *Birmingham:* Halsted, Pierce St. **MINNESOTA:** *Minneapolis:* Peter M. David, **MISSISSIPPI:** *Jackson:* Whittington **MISSOURI:** *Kansas City:* Art Research Ctr., New Structures **NEW HAMPSHIRE:** *Manchester:* Manchester Institute **NEW JERSEY:** *Montclair:* Simon **NEW MEXICO:** *Santa Fe:* Ctr. for Photography, Scheinbaum & Russek, *Taos:* Gallery G **NEW YORK:** *Buffalo:* CEPA, Freudenheim, *Endicott:* Spectrum 15, *Ithaca:* Upstairs, *New York:* Baskerville + Watson, Bromm, Leo Castelli, City, Clock Tower, Gallery 84, Einstein, Amos Eno, Feldman, Greene Space, Susan Harder, O.K. Harris, Henry St., Janis, Ledel, Light, Marlborough, Metro Pictures, Robert Miller, Multiples, Nature Morte, Neikrug, Pace/McGill, Pfeifer, Prakapas, Rentschler, Rizzoli, Sander, Holly Solomon, Sonnabend, Taghinia-Milani, Urdang, Visual Arts, Westbroadway, White Columns, Witkin, Wolf, Zabriskie, *Northport:* Northport, *Riverhead:* East End Council, *Rochester:* Visual Studies, *Utica:* Rutger **NORTH CAROLINA:** *Salisbury:* Waterworks **OHIO:** *Akron:* John Davis, *Cincinnati:* C.A.G.E. **OREGON:** *Eugene:* Zone, *Portland:* Occupied Space **PENNSYLVANIA:** *Philadelphia:* Cava, Jeffrey Fuller, Kling, La Pelle, Painted Bride, Portico **RHODE ISLAND:** *Providence:* Jeb, Woods-Gerry **SOUTH CAROLINA:** *Charleston:* Gibbes **TEXAS:** *Dallas:* Afterimage, Delahunty, 500X, Fort

Worth: Perry Coldwell, *Houston:* Benteler, Davis/McClain, McIntosh/ Drysdale, Moody, Wurzer, *San Antonio:* Charlton **UTAH:** *Salt Lake City:* Artist in Action **VERMONT:** *Woodstock:* Charles Fenton **VIRGINIA:** *Alexandria:* Torpedo Factory **WASHINGTON:** *Seattle:* Equivalents, Traver-Sutton **WISCONSIN:** *Milwaukee:* Michael H. Lord

VIDEO, FILM & PERFORMANCE

CALIFORNIA: *Los Angeles:* LACE, *San Francisco:* La Mamelle, *Santa Barbara:* SBCAF, *Sherman Oaks:* Orlando **DISTRICT OF COLUMBIA:** *Washington:* Fondo Del Sol, Washington Project **IDAHO:** *Sun Valley:* Sun Valley Ctr. **ILLINOIS:** *Chicago:* ARC, Artemisia, Gilman, Landfall, N.A.M.E., Randolph St., SAIC, SAIC Superior St. **MASSACHUSETTS:** *Boston:* Stux **MISSOURI:** *Kansas City:* Art Research Ctr., New Structures **NEW YORK:** *New York:* A.I.R., Artists Space, Leo Castelli, Clock Tower, Diaz, Amos Eno, Feldman, Franklin Furnace, Greene Space, Janis, The Kitchen, Landfall, Metro Pictures, Printed Matter, Holly Solomon, Visual Arts, Ward-Nasse, White Columns, *Rochester:* Visual Studies **OHIO:** *Cincinnati:* C.A.G.E., Solway **OREGON:** *Portland:* Northwest Artists, Occupied Space **PENNSYLVANIA:** *Philadelphia:* Kling, Painted Bride **RHODE ISLAND:** *Providence:* Woods-Gerry **TEXAS:** *Dallas:* 500X, *Houston:* Robinson

SPECIALIZATIONS IN CULTURAL AREAS

Afro-American Art

DISTRICT OF COLUMBIA: *Washington:* Capitol East Graphics, Fondo Del Sol **MACHUSETTS:** *Cambridge:* 17 Wendell St. **NEW YORK:** *New York:* Henry St. **PENNSYLVANIA:** *Philadelphia:* Sande Webster **TEXAS:** *Dallas:* Arthello's

Ancient Art & Antiquities

ARIZONA: *Scottsdale:* Bishop **COLORADO:** *Allenspark:* Bishop **ILLINOIS:** *Chicago:* B.C. Holland, Wyman **MICHIGAN:** *Birmingham:* Jacobs **NEW YORK:** *New York:* Arader, Emmerich, Kumar, Merrin **PENNSYLVANIA:** *King of Prussia:* Arader, *Philadelphia:* Jaipaul, Charles Sessler **TEXAS:** *Dallas:* Michele Herling, *Houston:* Lowell Collins

Asian Art

CALIFORNIA: *Carmel:* New World, *Los Angeles:* L.A. Artcore, Shinno, *San Francisco:* Soker-Kaseman, Triangle, Wylie Wong **DISTRICT OF COLUMBIA:** *Washington:* Shogun **ILLINOIS:** *Chicago:* Aiko's **LOUISIANA:** *New Orleans:* Galleria 539 **MICHIGAN:** *Troy:* Troy **NEW JERSEY:** *East Hanover:* Bradley's **NEW YORK:** *New York:* Caro, Glass, Kumar, Ronin **PENNSYLVANIA:** *Philadelphia:* Jaipaul, Luber, *Pittsburgh:* Wiebe & Bonwell **SOUTH CAROLINA:** *Charleston:* Gibbes **VERMONT:** *Ferrisburgh:* Four Winds

Ethnic Art (outside Europe & North America)

CALIFORNIA: *Beverly Hills:* Franklin, *Los Angeles:* Jan Baum, Feingarten, Gallery K, *San Francisco:* Willis, *Sherman Oaks:* Orlando **CONNECTICUT:** *Westport:* Connecticut Fine Arts **DISTRICT OF COLUMBIA:** *Washington:* Volta Place **HAWAII:** *Hilo:* Wailoa Ctr. **ILLINOIS:** *Chicago:* Gray, B.C. Holland, Wyman **MASSACHUSETTS:** *Boston:* Loupkhine **MICHIGAN:** *Birmingham:* Jacobs, Ross **MISSISSIPPI:** *Jackson:* Bryant **NEW YORK:** *Bridgehampton:* Benson, *New York:* David Bernstein, Emmerich, Kumar, Pace Primitive, Allan Stone, *Purchase:* Helene Trosky, *Rochester:* Oxford **PENNSYLVANIA:** *Philadelphia:* Janet Fleisher, Steinsnyder **SOUTH CAROLINA:** *Hilton Head Island:* Red Piano **TEXAS:** *Dallas:* Michele Herling, *Houston:* Lowell Collins **WASHINGTON:** *Seattle:* Francine Seders **WISCONSIN:** *Milwaukee:* Bradley

Folk Art (Europe & North America)

CALIFORNIA: *Berkeley:* Ames **ILLINOIS:** *Chicago:* Hammer, Horwich, Kind, R.H. Love, Mongerson, Yolanda, *Winnetka:* Yolanda **NEW MEXICO:** *Taos:* Gallery West **NEW YORK:** *Locust Valley:* Country, *New York:* Brewster, Jay Johnson, Kind, Naifs et Primitifs, Perls, Ricco-Johnson, St. Etienne **OHIO:** *Cincinnati:* Peterson **PENNSYLVANIA:** *Philadelphia:* Janet Fleisher **SOUTH CAROLINA:** *Hilton Head Island:* Red Piano **TENNESSEE:** *Memphis:* Oates **TEXAS:** *Dallas:* Phillips, *Fort Worth:* Sundance

Native American Art (North America)

ALASKA: *Anchorage:* Artique, Stephan, *Ketchikan:* The Gathering **ARIZONA:** *Scottsdale:* Suzanne Brown, Marilyn Butler, Joan Cawley, Main Trail, Mammen, Lovena Ohl, C.G. Rein, Gallery 10, Trailside, Wall **CALIFORNIA:** *Palm Springs:* Adagio, *San Francisco:* Images of the North **COLORADO:** *Denver:* C.G. Rein, *Telluride:* 21st Century **DISTRICT OF COLUMBIA:** *Washington:* Franz Bader, Fondo Del Sol, Via Gambaro **ILLINOIS:** *Chicago:* American West, Mongerson **KANSAS:** *Kansas City:* In the Spirit **MINNESOTA:** *Minneapolis:* Avanyu, C.G. Rein **MONTANA:** *Billings:* Art in the Atrium **NEW JERSEY:** *New Brunswick:* Old Queens **NEW MEXICO:** *Albuquerque:* Adobe, *Santa Fe:* Christof's, Enthios, Fenn, 21st Century, Little Plaza, Mayans, Mudd Carr, C.G. Rein, Santa Fe East, Taylor's, Wadle, Webb, *Taos:* El Taller Taos, Fennell, Magic Mtn., Southwestern Arts, Gallery West **NEW YORK:** *East Meadow:* Now & Then, *New York:* Deutsch **NORTH DAKOTA:** *Minot:* Art-

main **PENNSYLVANIA:** *Philadelphia:* Janet Fleisher **SOUTH DAKOTA:** *Rapid City:* Anakota **TEXAS:** *Austin:* El Taller, *Austin:* Native American Images, *Dallas:* Michele Herling, Houshang's, *Fort Worth:* Carlin, *Houston:* Archway, C.G. Rein **VERMONT:** *Ferrisburgh:* Four Winds **WASHINGTON:** *Seattle:* Mack, Sacred Circle **WYOMING:** *Jackson:* Main Trail, Trailside

South American & Hispano-American Art

ARIZONA: *Phoenix:* Ianuzzi, *Scottsdale:* Joan Cawley, Fagen-Petersen, C.G. Rein **CALIFORNIA:** *Beverly Hills:* B. Lewin, *Los Angeles:* Factory Place, *Palm Springs:* B. Lewin, *San Francisco:* Belcher, de Soto, Harcourts, Moss **COLORADO:** *Denver:* C.G. Rein **DISTRICT OF COLUMBIA:** *Washington:* Fondo Del Sol, Osuna **FLORIDA:** *Bay Harbor Island:* Sklar, *Coral Gables:* Artspace **MICHIGAN:** *Birmingham:* Schweyer-Galdo **MINNESOTA:** *Minneapolis:* C.G. Rein **NEW MEXICO:** *Santa Fe:* Mudd Carr, C.G. Rein **NEW YORK:** *New York:* Rachel Adler, Brewster, Cayman, C D S, Nohra Haime, Henry St., Horn, Kouros, Sindin, Sutton, Tossan-Tossan **OHIO** *Toledo:* J. Barrett **TEXAS:** *Austin:* Ravel, *Houston:* Hooks-Epstein, C.G. Rein

Western Art

ARIZONA: *Phoenix:* Thompson, West Side, *Scottsdale:* Suzanne Brown, Joan Cawley, Fagen-Petersen, Golden West, Elaine Horwitch, Main Trail, Mammen, Martin, May, O'Briens, Bob Parks, C.G. Rein, Savage, Trailside, *Sedona:* El Prado, Elaine Horwitch, Husberg, Mundo Magico, *Tucson:* Presidio, *Tucson:* Sanders, *Tucson:* Settlers West **CALIFORNIA:** *Beverly Hills:* Peterson, *La Jolla:* Knowles, *Los Angeles:* Goldfield, *San Francisco:* Hunter **COLORADO:** *Breckenridge:* Breckenridge, *Denver:* C.G. Rein, Rosenstock, *Grand Junction:* Frame Works, *Vail:* Driscol **ILLINOIS:** *Chicago:* American West, Mongerson, Sternberg **KANSAS:** *Kansas City:* In the Spirit, *Wichita:* Wichita **MACHUSETTS:** *Boston:* Vose **MINNESOTA:** *Minneapolis:* C.G. Rein **MISSOURI:** *St. Louis:* Masters **MONTANA:** *Billings:* Gallery '85, *Kalispell:* Glacier **NEVADA:** *Boulder City:* Burk **NEW JERSEY:** *Freehold:* Jentra **NEW MEXICO:** *Albuquerque:* Del Sol, Weems, *Santa Fe:* Fenn, Horwitch, Jamison, Marcus, MacAdoo, Gerald Peters, C.G. Rein, Taylor's, Wadle, Webb, Woodrow Wilson, *Taos:* Gallery A, El Taller Taos, Fennell, Southwest, Merrill's, Shriver, Taos, Total Arts, Variant, Gallery West **NEW YORK:** *East Meadow:* Now & Then, Hammer, Coe Kerr, Smith, Spanierman, Wunderlich **OKLAHOMA:** *Oklahoma City:* Shorney **SOUTH DAKOTA:** *Rapid City:* Anakota, *Sioux Falls:* Jim Savage's **TEXAS:** *Amarillo:* James M. Haney, *Dallas:* Altermann, Houshang's, *Dallas:* Texas Art, *Fort Worth:* Hall, Reminisce, *Houston:* Connally & Altermann, Meinhard, C.G. Rein **UTAH:** *Moab:* Jailhouse, *Salt Lake City:* Gallery 56, Tivoli **WYOMING:** *Jackson:* Main Trail, Trailside

Women's Art

DISTRICT OF COLUMBIA: *Washington:* Women's Art Ctr. **ILLINOIS:** *Chicago:* ARC, Artemisia **MONTANA:** *Great Falls:* Gallery 16 **NEW YORK:** *New York:* A.I.R., Henry St., Starkman **PENNSYLVANIA:** *Philadelphia:* Muse **TEXAS:** *Dallas:* DW

ALTERNATE SPACES & COOPERATIVE GALLERIES

ARKANSAS: *Van Buren:* Art Gallery & Studio **CALIFORNIA:** *Carmel:* Friends of Photography, *Los Angeles:* ARCO, LACE, L.A. Municipal, S. Cal Contemporary, *San Francisco:* La Mamelle, Mus. of Mod. Art Rental, Postcard Palace, *Santa Barbara:* SBCAF **CONNECTICUT:** *Avon:* Farmington Valley Ctr. **DELAWARE:** *Wilmington:* Downtown **DISTRICT OF COLUMBIA:** *Washington:* Art Barn, Fondo Del Sol, Spectrum, Touchstone, Washington Project for the Arts, Women's Art Ctr., Zenith **GEORGIA:** *Atlanta:* Artists Associates, Nexus **HAWAII:** *Hilo:* Wailoa Ctr., *Honolulu:* Queen Emma **IDAHO:** *Sun Valley:* Sun Valley Ctr. **ILLINOIS:** *Chicago:* ARC, Artemisia, Contemporary Art Workshop, IAC, N.A.M.E., Randolph St., SAIC, SAIC Superior St., WPA **MASSACHUSETTS:** *Provincetown:* Long Point **MICHIGAN:** *Detroit:* C.A.De., Artists' Market **MISSISSIPPI:** *Jackson:* Arts Alliance **MISSOURI:** *Kansas City:* Art Research Ctr. **MONTANA:** *Great Falls:* Gallery 16 **NEBRASKA:** *Lincoln:* Haymarket **NEVADA:** *Reno:* Artist Co-op **NEW HAMPSHIRE:** *Manchester:* Currier, Manchester Institute **NEW JERSEY:** *Montclair:* Double Tree, *Newark:* City Without Walls, *Plainfield:* Tweed **NEW MEXICO:** *Albuquerque:* Tamarind, *Santa Fe:* Ctr. for Photography, *Taos:* Return **NEW YORK:** *Buffalo:* CEPA, *Endicott:* Spectrum 15, *Ithaca:* Upstairs, *New York:* A.I.R., Artists' Space, Art Students League, Atlantic, Blue Mtn., City, Clock Tower, Gallery 84, Amos Eno, 49th Parallel, 14 Sculptors, Franklin Furnace, Greene Space, Henry St., Hudson Guild, The Kitchen, 55 Mercer, Painting Space, Pratt, Prince St., Printed Matter, Sculpture Ctr., Soho Ctr., Visual Arts, Ward-Nasse, Westbroadway, White Columns, *Northport:* Northport, *Port Washington:* Graphic Eye, *Riverhead:* East End Council, *Rochester:* Visual Studies, *Setauket:* Gallery North **NORTH CAROLINA:** *Greensboro:* Green Hill Ctr. **NORTH DAKOTA:** *Minot:* Minot **OHIO:** *Cincinnati:* C.A.G.E. **OREGON:** *Eugene:* Zone, *Portland:* Blackfish, Northwest Artists, Occupied Space **PHILADELPHIA:** *Philadelphia:* Kling, Muse, Painted Bride, Phila. Art Alliance, Print Club **RHODE ISLAND:** *Providence:* Woods-Gerry **TEXAS:** *Dallas:* D-Art, 500X, *Houston:* Archway **VIRGINIA:** *Alexandria:* Athenaum, Torpedo Factory **WASHINGTON:** *Seattle:* Sacred Circle **WEST VIRGINIA:** *Charleston:* W.V. Guild

HOW TO USE THIS INDEX: Each gallery is found below with a separate listing for the names of their key personell. The corresponding number indicates the *entry* number, not the page number. Approximately 10,000 artists are indexed. An artist's name in boldface, indicates a photo appears. The photo location, however refers to a *page number* (the only exception to entry numbers). The picture page is always the first number after a boldface artist's name and this page number is always preceeded by **PP** as a reminder it refers to a "Picture Page." More detailed information about some artists are indicated by the entry number which is shown in boldface.

Bagosian, Eric 92
Bahanek, Branko 621
Bahar, Bijan 708
Bailey, Andrew 1050
Bailey, Barry 407
Bailey, Clayton 132
Bailey, Lee 380
Bailey, William 227, 475, 796, 805
Bain, Esta 524
Bainton, Kenneth 584
Baird, J.A., Jr. 157
Baird, John 481
Baize, Wayne 985
Bakas, Jozef 538
Baker, Chet Michael 599
Baker, Dina Gustin 706
Baker, George 96
Baker, Joe 501
Baker, Martha 887
Baker, Richard 70
Baker, Sandra 759, 949
Baker, Sarah 222
Bakscheev, V. 829
Bakst, Leon 101
Balbo, Tom 329, 898
Balcar, Jiri 313
Balclair, Gerald 26, 203
Baldassano, Vincent 772
Baldessari, John 70, 134, 281, 322, 386, 580, 755, 783, 817
Baldus 856
Balduzzi, Armanda 871
Baldwin, Evelyn 962
Baldyga-Stagg, Stephanie 396
Balentine, Anna 37
Bales, Jean 534
Balink, Henry 538
Balkin, Andrew 1050
Ball, Bradly 47
Ball, Thomas 218
Balla, Giacomo 595
Ballowe, Marcia 492
Balthus 335, 727, 741, **828**
Baltz, Lewis 139
Bama, James 29, 717
Banach, Joan 770
Bane, MacDonald 883
Banger, Raymond 274
Bangert, Charles 480
Bangert, Colette 389, 480
Banks, Ellen 428
Banks, Fred 142
Banks, Ian 129
Bannard, Walter Darby 514, 645, 721, 902, 1018
Bannett, Brooks 958
Bar-Dor, Yasmin 122
Baran, Bella 833
Baranoff-Rossine, Vladimir 705
Barazani, Morris 329
Barbara, Ross 734
Barber, Bill 568
Barber, Phan 301
Barber, Sam 663
Barbero, David 543
Barbier, Ed 409
Barchers, Nelda 151
Bard, James 813
Baretz, Carol 860
Barham, Doran 390
Baribeau, Robert 168
Bark, Jared 816
Barke, Rande 777
Barkin, Mike 898
Barkins, Michael 265
Barlach, Ernst 459
Barletta, Joel 171
Barlow, Dick 994
Barnbaum, Bruce 226
Barnes, Michael 131
Barnes, Rikki 892
Barnes, Rita 91
Barnes, Robert 327
Barnes Gallery, Molly 67
Barnet, Will 230, 274, 315, 320, 378, 382, 399, 437, 470, 509, 582, 605, 716, 754, 775, 790
754, 775, 825, **860**, 874, 913
Barnett, R. 622
Barnett, Rita 921
Barnett, Vicky 1003
Barnett Gallery, David 1051
Baron, Hannelope 804
Barr, Jeannot R. 858
Barr, Roger 112
Barr, Inc., Jeannot R. 858
Barrel, Bill 706, 871
Barrett, Robert 1022
Barrett Galleries, J. 901
Barrette, Bill 827
Barrie, Wendy 978
Barrish, A.J. 449
Barros, Augusto 328
Barrows, Allan 633
Barry, D.H. 194
Barry, Margaret 868
Barry, Robert 111

Barry-Wilson, Coleen 529
Barsano, Ron PP 145, 390, 575
Bartek, Tom 495
Barth, Frances 319, 809
Barth, Jack 617
Bartlett, Jennifer 94, 252, 475, **486, 637**, 755
Bartlett, Robert 421
Bartnick, Harry 432
Bartol, Teri 614
Bartram 915
Baruch Gallery, Jacques 313
Barye 810
Barzaghi, Gabrielle 434
Baschet, Bernard 821
Baschet, Francois 821
Baselitz, Georg 190, 281, 284, 333, **616**, 668, 755, 817
Basham, Charles 962
Baskerville½Watson 608
Baskin, Leonard 230, 274, **703**, 716, 864, 875, 946, 1017
Basler, Leon 891
Basquiat, Jean Michel PP 165, 284, **616**
Bass, Jim 480
Bass, Kim 58
Bassler, Lynn 91
Bastell, Christine 151
Bastien, Chris 173
Bastien-Lepage 810
Batchelor, Carolyn Prince 117
Bateman, Robert 4, 29, 1028
Bateman, Ronald 926
Bates, Dan 43
Bates, David 639
Bates, Pearce 515
Bates, Wayne 399, 942
Batho, John 856
Batson, Blanche 477
Battenberg, John 132
Battenfield, Jackie 803
Battlesworth, J. 853
Batz/Lawrence Gallery 480
Bauchant, Andre 773
Baudoin, Ali 967
Baudoin Suarez, Susie 522
Baudry 810
Bauer, Dorothy 417
Bauer, Richard 64, 137
Bauer, Robert 385, 824
Baum, Don **357**
Baum Gallery, Hank 126
Baum Gallery, Jan 68
Baum Gallery, Jayne H. 609
Bauman, Jane 633
Baumann, Gustave 558, 851
Baumgarten, Lothar 678
Baumgartner Galleries 223
Baus, Stephanie 405
Bavetta, Ruth 187
Baxter, Bonnie 480
Baxter, Don 1024
Baxter, Ian 234, 111
Baxter, Ken 1024
Bayalis, John, Jr. 19, 592
Bayer, Herbert 65, 778, 799
Baynard, Ed 381, 415, 486, 594, 875
Bayuzick, Dennis 337
Bazan, Ernesto 61
Baziere, Pierre 1027
Bazinet, Jane 1010
Baziotes, William 615, 643, 701, **701**
Beadleston, Inc., William 610
Beal, Gifford PP 213, 795
Beal, Jack 327, **673**, 796, 902
Beale, Richard 872
Beall Fine Arts, Monte 401
Beallor, Fran 671
Bean, Bennett 17, 448, 876
Bear, Josh 47
Bearden, Romare **289, 440**, 459, 462, 638, 640, 699, 793, 882, 925, 945, 1015
Beardsley, Connie 477
Beasley, Dorothy 117
Beaton, Cecil 206
Beattie, Drew 124
Beattie, Paul 172
Beatty, Francis F.L. 626
Beauchamp, Robert 269, 722
Beaumont, Linda 1045
Beaumont, Nanette 477
Beaux, Cecilia PP 203, 855
Bechtle, Robert 111, 140, **693**
Beck, Arthello 2
Beck, B. 423
Beck, Bernard 329
Beck, Clifford 12, 471
Beck, David 824
Beck, Joel 465
Beck, Lawrence 1043
Beck, Margit 592
Beck, Michael 112
Beck, Rosemarie 706
Becker, David 222

Becker, Fred 796
Becker, Hilla 817
Becker, Jonathan 787
Becker, Nan 783
Becker, Pamela 382, 609, 609
Beckerton Fine Art 281
Beckesh, Anthony 194
Beckett, Richard 832
Beckman, Ericka 758
Beckman, R.S. 895
Beckman, Richard 906
Beckman, Sylvia 1050
Beckman, William 673
Beckmann, Max 340, 420, 459, 618, 797, 847
Beckwith, J. Carroll 125
Beecham, Gary 421
Beecham, Greg 201
Beecham, Tom 201
Beeler, Joe 22, 33, 37, 350, 572, 964, 985
Begay, Harvey 27
Begay, Mita 574
Behnke, Leigh 665
Behrman, David 634
Behsman, Margot 890
Bekaert, Piet 174, 841
Bel Esprit Fine Arts 467
Belag, Andrea 893
Belcher, A. 758
Belcher Gallery, George 127
Belfield, Brenda 245
Bell, Barbara 970
Bell, Cecil C. 732
Bell, Charles **745**
Bell, Don 31
Bell, Judy 892
Bell, Larry 65, **571**
Bell, Leland 782, 805
Bell, Marty 57
Bell, Scott 124
Bell, Sylvia 47
Bell, Trevor 259
Bell Galleries, Mary 314
Bellamak, Lu 352
Bellamy, Richard 763
Bellany, John 658
Belle Arts & Graphics 860
Bellegarde, Claude 328
Bellman, Galleri 611
Bellmann, Eric 872
Bellmer, Hans 778, 864
Bellows, George 72, 233, 236, 315, 408, 461, 605, 667, 716, 770, 917, 983, 1017
Belnick, Julie 91
Belshe, Morella 245
Beman, Lynn S. 861
Bemis, Ray 365
Ben Tre, Howard 444
Benbella, Mahjoub 827
Bencomo 460
Bendell, Marilyn 556
Bender, Erwin 1041
Bender, Gretchen 758
Bender, Hester 981
Bender, Shellie 389
Benedick, Mary 1006
Benes, Barton Lidice **525**, 737
Benglis, Lynda PP 198, 94, 138, 345, 454, **637**, 722
Bengston, Billy Al 67, **527**, 593, 1038
Bengstonson, William H. 343
Benjamin, Karl 97, 126, 166, 1044
Benjamin-Beattie Ltd. 315
Benn, Ben 212, 612
Bennet, Philomene 480
Bennett, Carol 306
Bennett, Garry 17
Bennett, Jamie 418
Bennett, Philomene 389
Bennion, D. Pendleton 567
Bennion, Douglas P. 10
Benny, Paul 777
Benoh, Ibrahim 833
Benow, Sheila 126
Benrubi, Bonni 852
Benson, Ben 331
Benson, Frank 146, 422, 661
Benson, Richard 843
Benson Gallery, Elaine 579
Benteler Galleries, Inc. 997
Benton, Fletcher 36, 128, 424
Benton, Garth 708
Benton, Salley 664
Benton, Thomas Hart PP 53, 82, 101, 125, 175, 182, 233, 315, 408, 416, 422, 483, 592, 605, 796, 853, 864, 898
Benvenuri, Ricardo 256
Benvenuri, Sergio 256
Benzle, Curtis 58, 395, 485
Benzle, Susan 58, 395
Beothy, Etienne 740
Berens, Marith 283, 609
Berenson, Inc., Galleria 256
Berg, Rosamond 824
Bergen, Sidney L. 592

Berger, Marian 300
Berger, Paul 733, 873, 1037
Berger, Richard 132
Berger, Sylvia J. 396
Berggruen Gallery, John 128
Bergsetin, Gerry 435
Bergt, Michael 158
Berkeley, Perrel 840
Berkenblit, Ellen 807
Berkowitz, Leon 220, 237
Berkowitz, Mel 945
Berkowitz, Sam 945
Berlant, Tony 190, 668
Berlet, Marc 264
Berman, Eugene 277
Berman, Judith 444
Berman, Nathan 757
Berman, Patricia 865
Berman, Wallace 190
Berman Gallery, Aaron 612
Bermudez, Jose 117
Berne-Bellecoueur, Etienne 240
Bernhard, Lucien 786
Bernier, Monica 782
Berninghaus, Charles 564, 999
Berninghaus, Oscar 16, 82, 146, 198, 362, 483, 538, 548, 558
Bernsen, Bill 502
Bernstein, Gerda Meyer 596
Bernstein, Rick 90, 278, 421, 433, 713, 942
Bernstein, Saralinda 624
Bernstein, Theresa 213
Bernstein, William 421, 978
Bernstein Fine Art, David 613
Bernstein Gallery, David 421
Berringer, Jennifer 444
Berrocal, Miguel 791
Berry, Roger 129
Berry, Scott 300
Bersani, Claire 456
Bershad, Helen 107, 279
Berthelsen, Johann 785
Berthold, Joachim 677
Berthot, Jake 322, 429, 744
Bertoia, Harry 7, 195, **324**, 821, 929
Bertulli, Catherine 427
Besnard, Albert 785
Bessega, Martin 663
Besser, Arne 462
Best, Diane 159
Best, Rebecca 970
Bethesda Art Gallery 416
Betts, Edward 374, 750, 866, 983
Betzenderfer, Mary 29
Beuys, Joseph **660**, 755, 762
Bexter, Ken 1026
Beylik, Melodie 417
Beynon, Aggie 389
Bezalel, Aharon 330
Bezman, Michel 1002
Bhavsar, Natvar 514
Bialobroda, Anna 771
Bianchi, Tom 73
Biasi, Alberto 481
Bibby, Richard 544
Bidner, Robert 698
Biederman, Charles 618
Biederman, James 844
Biegel, Peter 392
Bielat, Robert 463
Bierstadt, Albert 16, 30, 82, 100, 146, 198, 218, 557, 597, 644, 700, 716, 732, 736, 855, 915, 917, 999
Biesele, Charlene 978
Bieser, Natalie 702
Bigger, Michael 231
Biggers, John 536
Biggs, H.A. 380
Biggs, Jeffrey 839
Biji, Guillaume 670
Bilan, Peter 526
Bilane, Ruth 519
Bilgrai, Karen 868
Billian, Cathey 749
Billings Gazette 488
Billups, Betty 40
Binder, Erwin 175, 913
Binford, Julian 750
Bingham, George Caleb 917
Bingham, Ray 75
Binion, Sandra 895
Bins, Polly 438
Biondi, Gio 841
Birch, Thomas 732, 855, 939
Birch, Willie 699
Birckhead Gallery, Toni 894
Bird, Bobette 981
Bird, Jim 779
Birdsall, Byron 4, 1040
Birke, Judy 210
Birmelin, Robert 671
Birnbaum, Diana 862
Birnbaum, Robert 283, 609
Bischoff, Elmer 128, 701
Bischoff, Franz 52, 157

Bishko, Grace 943
Bishop, Allen 1025
Bishop Gallery 191
Bishop, Isabel 274, 416, 605, 750, 874
Bishop, Jeffrey 183, 1038
Bishop, Marjorie 877
Bishop, Michael 132, 873
Bishop, W.P. 11, 191
Bishop Gallery 11
Bissell, E. 709
Bissier, Julius 730
Bisson 56, 856
Bisttram, Emil PP 141, 548, 647, 855
Bittleman, Arnold 752
Bjorkland, George 507
Bjorkland, Lee 472
Bjurland, Jack 586
Bjurlin, Marvin 636
Black, Barbara 908
Black, Ken 565
Black, Laverne Nelson 30
Black, Richard 465
Blackburn, A.K. 516
Blackburn, David 174, 841
Blackburn, Ed 1013
Blackburn, Joseph 732
Blackburn, Julia 382
Blacker, Kate 832
Blackfish Gallery 908
Blackladder, Elizabeth 696
Blackwell, Tom 462, **745**, 1015
Blades, Barbara 319
Bladgen, Jr., Tom 283
Blagden, Allen 274, 716
Blagg, Daniel 858
Blagg, Dennis 858
Blaine, Nell 522, 665
Blair, Robert 490
Blair, Sandra 409
Blake, James R. PP 267, 987
Blake, Peter 709
Blake, Philip 277
Blake, William 169, 605
Blakelock, Ralph 736
Blakely, James 238
Blakely, Judy 238
Blancard 956
Blanco, Beatriz 251
Blau, Dorothy 254
Blauvelt, Melinda 883
Blazaje, Zbigniew 481
Blazeje, Zbigniew 479
Bleach, Bruce 609
Bleckner, Ross 616, 795, 936
Bleifeld, Stanely 59
Blell, Dianne 580
Blendowski, Steven 425
Blick, Irving 64
Blinderman, Barry 807
Bliss, Earl 536
Bliss, Mary Beth 526
Bliss, Steve 412
Bloch, Pauline 1006
Block, Amanda 382
Block, Diana 970
Block Prints Gallery 1033
Blockman, Karen 409
Blocksma, Dewey 461
Bloedel, Joan Ross 183, 909, 1039
Bloemaert 835
Blomdahl, Sonja 487, 1045
Bloom, Bill 974
Bloom, Hyman 716
Bloom, Martha 599
Bloom, Suzanne 1013
Blount, Brian 18
Blovits, Larry 468
Blue, Patt 580
Blue Corn 27, 567
Blue Mountain Gallery 614
Bluemner, Oscar 233, 612, 640, 739, 855
Bluhm, Norman 600, 785
Blum Helman Gallery 615
Blum, Robert 954
Blumanfield, R. 653
Blumberg, Ron 103
Blume, Patricia 491
Blume, Peter 649
Blumenschein, Ernest 198, 350, 538, 548, 558, 819
Blumenschein, Oscar 16
Blunk, J.B. 112
Bluxome Gallery 129
Boardman, S. 612
Boatright, Alice 47
Bobbs, Howard 555
Bocanegra, Suzanne 1013
Bochner, Mel 258, 817
Bock-Tobotski, Marilyn 380
Bockleman, Manfred 841
Bodelson, Dan 387, 985
Bodily, Sheryl 493
Bodine, A. Aubrey 226

Ference, Cynthia K. 885
Ferentz, Nicole 312
Ferguson, Cathy 460
Ferguson, John D. 996
Ferguson, Ken 484
Ferguson, Max 698
Ferguson, Nancy 917
Ferguson, Toni 290
Fernandes, Joyce 359, 360
Fernandez, Rudy 18
Ferra, Lucille 40
Ferrandini, Bob 434
Ferrara, Jackie 322, 784, 930
Ferreia, Donna 425
Ferren, John 798
Ferrer, Rafael 228, 327, 702
Ferris, John 919
Ferris, Keith S. 959
Ferris, Walter 269
Ferroni, Tommasi 722
Ferrugia, Joe 237
Fetting, Rainer 190, 738, 795
Feuerman, Carole Jean 587
Feuerstein, Roberta 107
Feuillette, Christine 789
Fey, Gary 117
Fieffer, Jules 230
Fielding, M.
Fieldings, Marta 406
Fields, Paul 394
Fiene, Alicia 480
Fiene, Ernest 480, 592, 820
Fife, Lin 395
Figari, 629
Filios, Jan 425
Fillerup, Peter 964, 999, 1024
Filmus, Michael 661
Fima, Solomon 347
Finachel, Lilly 569
Finch, Helen 261
Fincher, John 18, 197, 938
Findlay Galleries, Wally 325, 663
Findlay Gallery, Peter 662
Findlay, Jr., Fine Art, David 661
Fine, Joan 669
Fine, Jud 94, 660
Fine, Perle 706
Finer, Judy H. 312
Fini, Leonor 320, 347, 518, 541, 803
Fink, Aaron 420, 514
Fink, Alan 420
Fink, Ray 321
Fink, Stuart 894
Finkelstein, Louis 706
Finley, Donny 476
Finn, Margaret 279
Finnegan, Edward 830
Finnegan, Sharyn 782
Finster, Howard 284, 343, 919, 935
Fiorini, Chiara 328
Fire, Michelle 312
Firefires, Nicholas 556
Firehouse Galleries, 884
Firestone, Susan 234
Firmin-Girard, 362
First Street Gallery, 664
Fisch, Arline 418
Fischbach Gallery, 665
Fischel, David 40
Fischer, George 572
Fischer, Mildred 898
Fischer, R.M. 608
Fischer, Rudolf 954
Fischer, Wayne 1052
Fischer Galleries, Victor 112
Fischinger, Oskar 97
Fischl, Eric PP 195, 134, 235, 616, 695
Fish, Janet 269, 527, 612, 746, 751, 809
Fish, Julia 908
Fish, Vinnie 877
Fisher, Joel 111, 620, 623
Fisher, Margaret 996
Fisher, Vernon 345, 678, 969
Fishko, Bella 667
Fishman, Louise 608, 893
Fiske, Frank 194
Fiskin, Judy 98
Fiterman Gallery, Dolly 473
Fitzgerald, Astrid 609
Fitzgerald, Diane 656
Fitzgerald, f-stop 159
Flaccus, Peter 722
Flack, Audrey 745
Flagg, James Montgomery 507
Flanagan, Barry 709, 766
Flanagan, Michael 638
Flannagan, John B. 847
Flattman, Alan 476
Flavin, Dan 79, 111, 627, 755
Fleischman, Lawrence A. 716
Fleischmann, Trude 774
Fleischner, Richard 784
Fleisher, Janet 919
Fleisher, Mata 183

Fleisher Gallery, Janet 919
Fleming, Frank 259, 448
Fleming, John 278
Fleming, Penelope 914
Fleming, Rod 47
Fleminger, Susan 699
Flendrin, 810
Fletus, Alan 667
Flick, Michael 293
Flick, Robert 185, 733, 873
Fligny, P. 378
Flint, Gavin 159
Flint, William Russell 118
Flitner, Dave 21
Flood, Daro 20
Flood, Edward 344
Flood, Richard 20, 678, 1056
Florence, Arlene 258
Florence Art Gallery, 972
Florin, Sharon 734
Florio, R.A. 604
Florsheim, Lilliam 324
Florsheim, Richard 277, 315
Flow Ace Galleries, 189
Flow Ace Gallery, 79
Flowers, Mark Elliot 950
Floyd, Dixie 568
Floyd, Otis 568
Flynn, B. 358
Flynn, Pat 520
Flynn-Miller, Karen 417
Foeller, Peter 967
Fogel, Jacqueline 1005
Fogel, Seymour PP 177, 686
Folberg, Neil 173
Folk-Williams, Cathy 543
Folon, Jean-Michel 147, 314, 336, 703, 726, 730
Folsom, Fred 234
Fondaw, Ron 1001
Fondo del Sol, 228
Fong, Chung Ray 102
Fong, Freddie 630
Fong-Yu, Wang 625
Fonseca, Harry 18, 310
Foolery, Tom 172
Foos, David 513
Foosaner, Judith 168, 121
Foose, Robert Jones 397
Forbes, Bart 352, 1014
Forbes, Robert 482
Forbis, Steve 958
Forcade, Tim 479, 481
Ford, Betty Davenport 59
Fordyce, Ike 554
Foreman, Mark 713
Forgione, Achille 872
Foris, Rick 1050
Forman, Marc 944
Forrester, Patricia Tobacco 227
Forsberg, Norma 1023
Forsman, Chuck 645
Forster, Lisa 872
Forster, Paul 1026
Forsythe, Doug 872
Fortuna, Pietro 808
Fortune, James 502
Fortune, Tim 269
Forty-Ninth Parallel, 666
Forum Gallery, 667
Fossum, Leighton 42
Foster, Carole 34
Foster, Don 1017, 1039
Foster, Gus 755
Foster/White Gallery, 1039
Foulkes, Lyn 67
Fountain Gallery of Art, 909
Four Winds Gallery, 1027
Fourcade, Inc., Xavier 668
Fournier, Katou 756
Foust, John 3
Fouts, Linda 288
Fowell, Jody 32
Fowler, Mary Jean 994
Fox, Bernadine 488
Fox, Frank 906
Fox, Jon G. 1028
Fox, Stephen 533, 1034
Fox, Terry 111, 660
Fox Galleries, Shirley 282
Foy, Fran 679
Frace, Charles 22
Fraenkel Gallery, 136
Fragonard, Jean-Honore 810, 849
Fragua, Cliff 524, 556
Frailey, Stephen 758
Frakes, Bill 264
Frame, John 86
Frame Works and Gallery, 200
Frampton, Hollis 580, 873
Francheschi, Edgar 619
Francis, John F. 597
Francis, Ke 126
Francis, Sam 66, 67, 71, 79, 80, 81, 115, 128, 143, 162, 270, 315, 375, 451, 473, 486, 588, 593, 598, 600, 643, 654, 655, 683, 695, 715
Francisco, Richard PP 231,

831
Franck, Jean 40
Frangella, Luis 622, 633
Frank, Audrey 358
Frank, Ben 1044
Frank, Dale 722
Frank, Douglas 453
Frank, Helen 507, 515
Frank, Lawrence 875
Frank, Marian 531
Frank, Mary 694, 806, 856
Frank, Robert 83, 139, 767, 963
Frank, Roberta 875
Frank, Ruth O. 276
Franke, Herbert W. 481
Frankenthaler, Helen 79, 128, 162, 227, 235, 272, 363, 381, 383, 386, 394, 400, 424, 431, 475, 486, 593, 599, 645, 655, 681, 695, 755, 795, 1004
Franklin, B.J. 60
Franklin Furnace Archive, 670
Franklin Gallery, Harry A. 49
Franzheim, Elizabeth 328
Frasca, Liliana 57
Frasconi, Antonio 230, 649, 847
Fraser, Charles 949
Fratt, Dorothy 36
Frazier, C. James 961
Frecon, Susan 831
Fred, Jim 523
Frederick, Helen 413, 418
Frederick-Fiolic, Lillian 260
Fredericks, Steve 663
Frederickson, Laurel 311
Free, John 390, 557
Freed, David 222
Freed, Douglas 480
Freedman, Audrey 872
Freedman, Louise A. 679
Freedman, Maurice 750
Freedman, Robert 251
Freeland, Betty Hay 305
Freeman, Dan 804
Freeman, Don 770, 796
Freeman, Mallory 185
Freeman, Nan 428
Freeman, Nancy 880
Freeman, Peter 615
Freeman, Robert 440, 444
Freese, Gary 192
Freilich, Ann 679
Freilicher, Jane 579, 665, 764, 809, 1018
Fremantle, Chloe 711
French, Daniel Chester 218
French, Frank 503
French Gallery, Sherry 671
Frere, Theodore 689
Frets, Barbara 337, 386, 389, 485
Freud, Lucian 190, 644
Freudenheim Gallery, Nina 581
Freudenthal, Peter 875
Freund, Gisele 88, 710
Freund, Marjorie 397
Frey, Viola 161, 484
Freyman, Marcia 393
Friberg, Arnold 39
Fricano, Tom 51
Fridge, Roy 1013
Friebert, Joseph 1052
Fried, Leni 775
Fried, Lenore 418
Fried, Theodore 704
Friedberg, Harriet 914
Friedeberg, Pedro 77
Friedensohn, Elias 649
Friedlander, Harold 511
Friedlander, Johnny 147, 467, 703
Friedlander, Lee 136, 856, 947
Friedlander, Nancy 511
Friedman, Arnold 856
Friedman, Betty 204
Friedman, Dan 674
Friedman, Henry 365
Friedman, Jackie 862
Friedman & Co., Marvin Ross 262
Friedman, Ltd., Barry 672
Friedmann, Benno 173
Friend, Patricia 418
Friend-Jones, Gretchen 245
Friends of Photography, The 53
Frieseke, Frederick Carl 82, 152, 483, 689, 917
Frigerios, Ismael 628
Frischli, Meyer 515
Frischli, Sally 515
Frith, Francis 552
Fritz, Donald 172
Fritzler, Gerald 572
Frizell, Deborah 208
Frizzell, Charles 22
Froman, Ramon 992
Fromboluti, Sideo 446

Fronk, Rob 895
Frontroom Gallery, 974
Frost, Jack 159
Froth, Joan 480
Fruchiger, Fritz A. 65
Fruhauf, Aline 416
Frumkin & Struve Gallery, 327
Frumkin Gallery, Allan 326, 673
Frutchey, Jere 283
Fry, J.N. 848
Frye-Weaver, Greg 529
Fryer, Janet 175
Fuchs, Bernie 352, 789
Fuchs, Tippy 387
Fuente, Larry 228
Fuertsch, Marie 528
Fugate, Joe 463, 463
Fuhrman, Charles 154, 938
Fujita, Kyohei 487
Fukuda, Shizeo 786
Fuller, Buckminster 7, 660, 900, 920
Fuller, George 597
Fuller, Nancy 42
Fuller Fine Art, Jeffrey 920
Fuller Goldeen Gallery, 138
Fullerton, Stan 172
Fulton, Chris 471
Fulton, Hamish 111, 169
Fumagalli, Luigi 298
Fun Gallery, 674
Funke, Jaromir 997
Funkhouser, Sheryl 908
Fussiner, Howard 210
Fussmann, Klaus 730
Futura, 674
Fydryck, Walter 329
Fyfe, Joe 832
G., Bobby 807
Gabbard, Dennis 991
Gable, John 505
Gablik, Suzi 649
Gabotto, Luis 64
Gabriel, Dan 603
Gabrielli, Phillip 444
Gad, Simone 722
Gadamus, Jerry 41
Gador, Emil 954
Gag, Wanda 847
Gagliani, Oliver 947
Gainan, Karolyn 490
Gaines, Ann Farley 311
Gaines, Charles 94, 345
Gaines, Tom 929
Gainsborough, Thomas 644
Gaiter, Marcia 42
Gaj, Jacek 1031
Galanin, Igor 1007
Galas, Diamanda 180
Gale, Denise 86
Gale, Nessa 15
Galeria Del Sol 524
Galeria Sigala 573
Galerie Cote 874
Galeries d'Art Internatial 328
Gall, Susan 293
Gall, Ted 349
Gallagher, Barbara 3
Gallagher, Dennis 161
Gallagher, Michael PP 194, 270, 745
Gallagos, David 143
Gallegos, Joyce Sisneros 556
Galleria 539 403
Galleries BKM, The 209
Galleries, Moulton 45
Gallery '85 490
Gallery 1 211
Gallery 16 492
Gallery 4 1030
Gallery 500 914
Gallery 56 1024
Gallery 72 496
Gallery 84 652
Gallery 9 507
Gallery A 559
Gallery At Greenville 215
Gallery East 584
Gallery for Fine Photo 404
Gallery G 563
Gallery Gemini 268
Gallery K 234
Gallery Mack NW 1041
Gallery North 877
Gallery of Art, Fernette's 384
Gallery of the 21st Century 533
Gallery of the Masters 483
Gallery of the Southwest 564
Gallery on the Green 445
Gallery One 991
Galles, Arie 371
Galliano, Jack 112
Galliduani, Daniel 731
Gallion, Kate 895
Gallo, Frank 286, 329, 384
Gallup, Joan 925
Galston, Beth 425
Galuszka, Frank 931
Galvan, John 572

Gambaro, Rita Walden 247
Gambaro, Stephen 247
Gan, Pinchas Cohen 784
Gandolfi, Diana Gonzalez 423
Ganek, P. David 519
Ganis, John 463
Gann, Jane Kent 529
Gann, Kyle 351
Ganso, Emil 847
Ganson, Arthur 439
Garabedian, Charles PP 204, 190, 701
Garache, Claude 735
Garber, Barbara 596
Garber, Daniel 919, 933
Garcia, Bob 113
Garcia, Effie 567
Garcia, Fernando 258, 264, 599
Garcia, Ofelia 937
Garcia, Robert 567
Gardaire, Christian 234
Gardiner, T. Michael 1042
Gardner, Byron 547
Gardner, Christopher 237
Gardner Gallery, Anna 188
Gardy-Artigas, 375, 735
Garet, Jedd PP 201, 178, 357, 751, 1054
Garfield, Hushi 277
Garfield, Joshua 921
Garland, Paul 630, 914
Garman, Ed 647
Garnder, Joan 746
Garner, Ted 1043
Garnet, Eldon 580
Garnett, William 173, 413, 852
Garnick, Marilyn 514
Garnick, Philip 514
Garns, Allen 19
Garrett, John 58, 278
Garrett, Pat 868
Garrett, Sidney 409
Garrison, Sid 278
Gascard, Cilly 368
Gaspar, Marta 756
Gaspard, Leon 16, 350, 532, 538, 553
Gaston 956
Gatewood, Maud 885
Gatewood, Maude 883
Gatewood, William 149, 183
Gathering, The 6
Gathman, Tom 314
Gaudin 591
Gauguin, Paul 147, 232, 610, 794, 984
Gaul, Gilbert 362, 597
Gause, Charles 5
Gavarni 810
Gavigan, James 248
Gavigan, Mona 248
Gay, Jane Watkins 300
Geary, Geoffrey 201
Geddes-Woodward, Alice 663
Geddis, Thomas 866
Gehm, Charlie 201
Gehry, Frank 80
Geiger, Michael 852
Geiger, Philip 931
Geis, Bill 132
Geiser, David 787
Geist, Sidney 706
Gekko 927
Gelfman, Lynn Golob 252
Geller, Harold 576
Gelman, Nancy 614
Gelpke, Andre 997
Gemini G.E.L. 80
Gemmill, Gloria 21
Generalic, Ivan 621
Genn, Nancy 149, 581
Genoves, Juan 738
Gentry, Herbert 225
George, Bessie 475
George, Jean Morgan 539
George, Richard 900
George, Thomas 517
George, William 59
Georgesco, Christopher 98
Gerard, John 463
Gerber, Deborah 122
Gerber, Jack 925
Geremia, Geri 859
Gericault, Theodore 72, 624, 854
Germain, Paul 1034
Germans Van Eck Gallery 651
Gerome, Jean-Leon 854
Gerry, Barbara 1006
Gersh Galleries, Susan 81
Gerst Gallery, Hilde 675
Gerstner, Bernard 866
Gerszo, Gunther 127
Gertjensansen, Doyle 407
Gertsch, Franz 745
Gertz, Sue 311
Gestson, Gary 242
Getler/Pall/Saper 676
Getz, Ilse 793

295

Meyerowitz, Joel 139, 453, 851, 947, 1054
Meyerowitz, William 213
Meyers, J.P. 945
Meyers, Jan 283, 349
Meyers, Joyce Stillman 863
Meyers, Mabel Burnside 574
Mianowski, Lucian 1031
Micale, Al 43
Miccoli, Arnaldo 708
Michael's Edition Inc. 347
Michaelson, Philip 269
Michals, Duane 710
Michas, Tjelda 518
Michaux, Ronald 430, 791
Michelson, Philip 442
Michod, Susan PP 98, 319
Mickelson Gallery 236
Micossi, Mario 246
Middendorf Gallery 237
Middlebrook, David 344
Middleman, Raoul 414
Middleton, Anita 961
Middleton, Kathleen 391
Midner, Peggy 463
Midtown Galleries, Inc. 750
Mignon, Roger 606
Mihaesco, Eugene 800
Mihuly, Jamie 724
Mikeska, Riko 650
Mikiver, Jurg 591
Mikolas, Karel 417
Milan, Richard 620
Milani, Richard 587, 758
Milazzo, Richard 758
Milder, Jay 612, 871
Miles, Don 497
Miles, Melinda 120
Miley, Doug 568
Millais, Raoul 591
Millant, Jean 70
Millar, Albert 962
Millares, Manolo **741**
Mille, Mark 1051
Millei, John 187
Miller, Alfred Jacob 483, 548, 557
Miller, Amy T. 1033
Miller, Archie 871
Miller, Carol 380, 981
Miller, Delbert 988
Miller, Don 890, 892
Miller, Earl 225
Miller, Elizabeth 383
Miller, Frank 383
Miller, Fred 870
Miller, Genell 482
Miller, Grant 283
Miller, Hub 986
Miller, Jan 337
Miller, John 748
Miller, Keith 813
Miller, Martin 154
Miller, Melissa 816
Miller, Mike 497
Miller, Mirian 612
Miller, Paton 690
Miller, Peg 511
Miller, Randy 503
Miller, Richard 612
Miller, Rick 880
Miller, Robert 496, 751
Miller, Robert A. 1033
Miller, Steven J. 971
Miller, Thomas H. 866
Miller, Virginia 259
Miller Gallery 898
Miller Gallery, Peter 348
Miller Gallery, Robert 751
Miller/Brown Gallery 153
Millet, Francois 63
Millevolte, Rose 584
Milligan, Bob 380
Milliken, Gibbs 959
Milliken, Inc., Alexander F. 752
Million, Chris 365
Milloff, Mark 816
Mills, James A. 669
Mills, John W. 450
Mills, Ron 908
Milnes, Robert 415
Milow, Keith 761
Milton 437
Milton, Peter PP 21, 55, 51, 135, 140, 222, 420, 1036
Min, Mary 311
Minch, Barbara 921
Mindel, Marilyn 129
Mindscape Collection 349
Mindscape Gallery 373
Mingo, George 820
Minh, Ng Tri 981
Minkkinen, Arno 426
Minkoff, Gerald 997
Minnis, Paul 888
Minoh, Tetsumi 166
Minor, Robert C. 294
Minor, Thomas 258
Minot Art Gallery 892

Minotaur Fine Arts 499
Minujim, Marta 827
Miothe, Anne E. 1052
Mira, Victor 628, 804
Miripolsky, Andre 107
Miro, Joan PP 47, 24, 40, 84, 96, 121, 142, 147, 175, 186, 214, 268, 285, 314, 318, 330, 336, 347, 375, 384, 394, 402, 405, 423, 457, 460, 467, 469, 480, 518, 624, 631, 650, 675, 681, 683, 691, 696, 714, 715, 735, 741, 753, 754, 773, 779, 791, 793, 803, 812, 8
Mirri, Sabina 761
Misrach, Richard 139
Miss, Mary 746, 784
Missal, Paul 908
Missal, Stephen 24, 40
Missal Gallery 24
Mitchell, Alfred A. 118
Mitchell, Annette 502
Mitchell, Carol 287
Mitchell, Dennis 323
Mitchell, Joan 381, 600, 668
Mitchell, Kathleen 971
Mitchell, Les 962
Mitchell, Peter 630
Mitchell, Sandra 196
Mitchnick, Nancy 454, 701
Mitropoulos, Clayton 657, 671
Mittendorf, George 787
Mitty, Lizbeth 658
Miura, Shigeo 91
Miyasaki, George 178
Miyzaki, Hiroshi 117
Mizdal, Richard 879
Mizuma, Mineo 86
Mobilia 439
Mocenini, Gualtiero 328
Mochary, Roland 513
Mock, Richard 598, 731
Modeen, Mary 1028
Model, Lisette 802
Modern Master Tapestries 753
Modernism 154
Modigliani, Amadeo 683, 773, 984
Moeller, Hans 274
Moers, Denny 226, 413, 431, **458**, 693, 1037
Mogensen, Lois 1049
Mogulescu, Joseph 713
Mogulescu, Maurice 713
Moholy-Nagy, Laszlo **326**, 653, 727, 740, 778, 852
Mohr, Manfred 481, 479
Mohr, Wendell 383
Moje, Klaus 421, 487
Mojica, Luis 526, 553
Moller, Hans 750
Mollring, Christine 33, 1057
Mollring, Ted 33, 1057
Moment, Joan 121
Mominee, John 1050
Monaghan, Deborah 880
Monaghan, Eileen 59
Monamy, Peter 229
Moncrief, Loy 477
Monczewski, Duane 554
Mondrian, Piet 710
Monet, Claude 98, 285, 325, 593, 610, 662, 663, 742, 794, 795, 849, 917, 984, 990
Mongerson Gallery 350
Mongiello, Ginger 560, 569
Monongya, Von 32
Monreal, Andres 155
Monroe, Janet 712
Monte, John 618
Monteith, Bruce 431, 723
Montezin, Pierre Eugene 663
Montezinos Gallery, Susan 930
Montgomery, Karen 220
Montgomery, Nan 414
Montgomery, William B. 966
Montgomery-Taylor 25
Montoya, Gustavo 50
Montoya, Tommy Edward 523
Moochnek, Cecile 556
Moody, Richard 425
Moody Gallery 1013
Moody III, Tom 991
Moon, Robert 166
Moor, Beverly 487
Moore, Andrew 581
Moore, Benjamin 1045
Moore, Charles 71, 789
Moore, Claire 599
Moore, Henry PP 38, 62, 78, 98, 128, 142, 256, 262, 268, 270, 287, 330, 400, 467, 473, 610, 631, 650, 668, 683, 696, 703, 709, 714, 715, 727, 735, 738, 739, 779, 791, 793, 793, **811**, 812, 815, 845, 849, 945, 986, 1055
Moore, Ina Mae 8

Moore, John PP 198, 701
Moore, Rosaline 233
Moore, Susan 482
Moore, Todd 269
Moore, Wayland 282
Moore, William 908
Moorhouse, Robert 258
Morales, Armando 155, 960
Morales, Jose 841
Moran, Edward 861
Moran, Judy 151
Moran, Thomas PP 148, 16, 52, 198, 483, 532, 548, 557, 661, 770, 917, **990**, 999
Morang, Alfred PP 150, 538, 578
Morath, Inge 759
More Gallery, Inc.,The 931
More, Mary 880
Moreau, Gustave 672
Morehead, Gerry 678
Morellet, Francois 479
Morency, Ann 231
Morency-Lay, Mireille 453
Moreton, Russell 57
Moretti, Henry 261
Morgan, Barbara 173, 852, 1037
Morgan, Bill 506
Morgan, Clyde 556
Morgan, Elemore 407
Morgan, Lisa 770
Morgan, Maud 445
Morgan, Norma 225
Morgan, Sister Gertrude 368
Mori 1007
Mori, Yoshitoshi 242, 309
Morimoto, Hiromitsu 774
Morin, France 666
Morinoue, Hiroki 297
Moriaot, Berthe 691
Morita, Yuji 140, 143
Morley, Malcolm 381, 454, 617, 668, 710
Morley-Price, Ursula 438
Morlock, James 582
Morningstar, William 283
Morningstar Gallery 754
Moroles, Jesus Bautista 197, 539, 882, 1001
Moronobu 63, 792
Morper, Daniel 461, 653
Morphesis, Jim 185
Morreale, Frank 334
Morrell, Wayne 912
Morris, Carl 171, 909, 1046
Morris, Florence 457
Morris, George 945
Morris, George L. K. 701
Morris, Hilda 909, 1046
Morris, Jack 999
Morris, Jim 89
Morris, Mark 457
Morris, Richard Allen 119
Morris, Robert 627, 755, 817
Morris, Robin 582
Morris, Steven 457
Morris, William 357, 551
Morris, Wright 851
Morris Gallery, Inc., Donald 457
Morris-Back, Carolyn 278
Morrison, Boone 306
Morrison, Connie 959
Morrison, Fritzi 117
Morrison, Jim 492
Morrow, Anne 29, 1058
Morrow, Bell Cain 47
Morrow, Kathleen 839
Morse, Bart 1025
Morse Gallery, Inc. Mitch 603
Mortensen, Gordon 391, 945, 1030
Mortensen, Kay 803
Mortensen, William 453
Mortenson, Gordon 897
Morton, Geer 131
Morviller, Joseph PP 233
Moscowitz, Robert 94
Moser 672, 810
Moser, Charles 661
Moser, Lee 92
Moses, Anna Mary Robert 691, 800, 985
Moses, Ed 67, 70, 86, 115, 190
Moses, Forrest 645, 1018
Moses, Grandma 691, 985
Moses, Meredyth Hyatt 444
Mosher, Robert 62
Moskowitz, Molly 656
Moskowitz, Robert 615
Moss, Kay 47
Moss, P. Buckley 215
Moss Gallery 155
Moss Gallery, Tobey C. 97
Motherwell, Robert PP 43, 94, 128, 141, 143, 162, 190, 234, 235, 270, 272, 284, 315, 363, 381, 386, 394, 415, 423, 424, 446, 472,

473, 475, 484, 486, 598, 640, 654, 695, 710, 721, 738, 753, 795, 898, 902, 916, 918, 955, 967, 1004
Mothner, Carol 535
Moti, Kaiko 22, 40, 236, 754, 1022
Motoush, Lyle 905
Mottishaw, John 88
Moty, Eleanor 354, 418
Mouffarrege, Nicholas 722
Moulthrop, Ed PP 15, 17
Moulthrop, Philip 278
Moulton, Bettye 45
Moulton, Donn 723
Moulton, Jeff 215
Mount, William Sidney 917
Movelli, Mary 520
Mower-Connor, Pam 187
Mowery, Jeff 37
Moxley, Star 307
Moy, Jeff 425
Moy, Seong 864, 898
Moyano, Sergio 536
Moyens, H. Marc 234
Moyer, Gisella 283
Moyers, Charles 524
Moyers, John 575
Moyers, Terri Kelly 575
Moyers, William 524, 575
Moynihan, Meg 801
Moynihan, Rodrigo 751
Mozley, Loren 986
Mucha, Alphonse 147, 1019, 1051
Muchmore, Maggie 546
Mudd, Harvey 166
Mudd Carr Gallery 545
Mudford, Grant 733
Mueller, Glorya 870
Mueller, Greg 763
Mueller, Jan 658, 763
Mueller, Otto 797
Mueller, Stephen 645, 761
Muench, John 411
Muenter, Gabriel 612
Muir, J.N. 39, 201
Mulcahy, Kathleen 898
Mulder, Tom 1025
Mull, Martin 67
Mullen, Philip 389, 661, 671
Muller, Betsy 966
Muller, Gregoire 743
Muller, William G. 813
Muller, Yvonne 645
Muller-Pohle, Andreas 997
Mullican, Lee **95**, 569
Mullican, Matt 616
Multiples/Marian Goodman 755
Munch, Edvard 232, **611**, 624, 835
Mundo Magico Gallery, El 41
Munkacsi, Martin 852
Munnings, Sir Alfred 392
Munoz, Aurelia 839
Munoz, Ramon 498
Munoz, Rie 4
Munson Gallery 210, 546
Munter, Gabriele 705
Munzer, Aribert 473
Munn, Alice Ballard 882
Murch, Walter **716**, 831
Murphy, Catherine 506, 668
Murphy, Hermann Dudley 685
Murphy, Karen 77
Murphy, Marilyn 955
Murphy-Reed, Margaret 252
Murray, Allan 57
Murray, Clark 743
Murray, Elizabeth 454, 598, 637
Murray, Shirley 8
Murrill, Gwynn 66
Murtic, Edo 328
Muse Gallery, 932
Museum of Modern Art, Rental Gallery 156
Museum's Downtown, Deleware Art 217
Musler, Jay 176, 697
Mussoff, Jody 234
Muth, Marcia 368
Muti, Kaiko 590
Muyatt, Greely 293
Myer, Jo 2
Myers, Ed 1034
Myers, Forest 334
Myers, Jerome 82, 725
Myers, Jo 383
Myers, Joan 110, 1037
Myers, Joel Philip 283, 357, 448, 487, 697
Myers, Malcolm 473
Myers, Marcia 961
Myers, Mark 1040
Myers, Martin 154
Myford, Jim 315
N.A.M.E. Gallery 351

Nadeau, Ellen 321
Nadel, Ann 129
Nadelman, Elie 667, 856
Nadin, Peter 758
Nadolski, Stephanie 994
Naegele, Rosemary 614
Nagano, Shoz 505
Nagaoka, Kunito 102, 165
Nagatani, Patrick 110
Nagin, Rise 945
Nagle, Rod 357
Nagle, Ron 161, 639, 694
Nagler, Fred 750, 986
Nagler, Jack 663
Nagler, Monte 356
Nagura, Hideji 767
Nagy, P. 758
Naifs et Primitifs, Galerie 756
Naimark, Michael 172
Naito, Rakuko 224
Nakane, Aiko 309
Nakashima, George 17
Nakashima, Tom 231
Nakayama, Hiroshi 520
Nakayama, Judy 520
Nakhamkin Fine Arts, Eduard 757
Nakian, Reuben 205, 212, 239, 738, 1044
Nama, George 946
Namiki, Mitsuko 91
Namingha, Dan PP 33, 35
Namuth, Hans 154
Nanao, Kenji 165
Nangoldin 608
Naples Art Gallery 265
Napolitano, Mary 664
Naponic, Tony 345, 386
Naranjo, Geri 540
Nardi, Dan 316
Narin, John 828
Narkiewicz, Paul 809
Nash, David 749
Nason, Thomas 437
Natale, Arthur 769
Natapoff, Flora 427
Nathan, Harold 91
Nathaniel-Walker, Inez 332
Native American Images 958
Natkin, Robert PP 42, 96, 149, 185, 252, 268, 269, 375, 386, 452, 677, 696, 825, 898
Nature Morte, Gallery 758
Natzler, Otto PP 77, 222
Natzler, Gertrude 222
Nauman, Bruce 70, 79, 106, 322, 369, 627, 755
Nava, John 88, 154
Navarro, Raphael 997
Navone, Edward 389
Nawir, Ferril 839
Naylor, Geoffrey 962
Nazler, Otto 51
Neal, Frank 477
Neal, Susan 17, 942
Nebeker, Bill 33
Nechak, David 1045
Nechvatal, Joseph 758, 831
Neckvatal, Dennis 371
Needham, Joan 822
Neel, Alice 414, 454, 659, **751**
Neff, Edith 926
Neff, John 208, 211
Neffson, Robert 698
Negroponte, George 598
Neher, Ross 781
Neijna, Barbara 252
Neikrug Photographica 759
Neil, Bill 28
Neill, Christine 414
Neill, Joe 838
Neizvestny, E. 757
Nelson, Albert 396
Nelson, Alex 321
Nelson, Andy 64
Nelson, Barbara 1007
Nelson, C. 265
Nelson, Dona 893
Nelson, Dyan 40
Nelson, Jud 745
Nelson, Karen 96
Nelson, Pam 1006
Nelson, Pamela 966
Nelson, Peter 105
Nelson, Robert 298
Nelson, Robert Lyn PP 88, 302, 304
Nelson, Roger Laux 217, 235
Nelson, S. 265
Nelson, Tess 40
Nelson, Tom 489
Nelson, Van Kirke 494
Nelson, Walter 554
Nemethy, Albert 813
Nereaux, Joyce 844
Neri, Manuel 128, **237**, 639
Nery, Eduardo 121
Nesbit, P.A. 538
Nesbitt, Lowell 274, 275, 462,

Swiggett, Jean 64
Swindell, Geoffrey 438
Sycet, Pablo 833
Symczak, Mark 945
Symons, Gardner 362
Sypulski, Michael 633
Syrop, Mitchell 89
Szabo, Steven 226
Szabo, Zoltan 10, 573
Szasz, Suzanne 759
Szekessy, Karin 997
Szeto, Keung 693
Szp, Paul 580
Ta-Chien, Chang 179
Tabachnick, Anne 706
Tabak, Chaim 650
Tablot, Tom 201
Tacla, Jorge 690
Tada, Alvin 838
Tadini, Emili 178
Tafoya, Margaret 32
Tafoya, Roy 567
Taft, Stan 793
Taga, Shin 927
Tagami, Hiroshi 298
Taggart, Bill 831
Taghinia-Milani Gallery, Leila 827
Tahara, Keiichi 774
Tahir Gallery Inc. 408
Taira, Masa Morioka 299
Tait, A.F. 732, 853
Taitinger Gallery, Amaury 828
Tajima 242
Takaezu, Toshiko 514, 579
Takako 3
Takara 913
Takara, S. 186
Takayama, Michio 569, 576
Takeshita, Lydia 91
Taki, Toru 841
Takigushi, Barbara 609
Takis 707, 735
Talasnik, Stephen 919
Talbot 56
Talbot, Augusta 838
Talbot, Tom 559
Talbot, William H.F. 169
Tamarind Institute 527
Tamayo, Rufino 14, 15, 30, 50, 127, 133, 142, 155, 285, 320, 384, 405, 460, 498, 541, 595, 621, 650, 690, 703, 738, 738, 779, 793, 847, 960
Tanaka 1007
Tanaka, Masaaki 102
Tanaka, Min 92
Tanakaare, Masaaki 309
Tananbaum, Dorothy 838
Tanenbaum, Zelda 609
Tanguy, Yves 654
Tania 60
Taniguchi, Yoshi 234
Tanner, Edith 859
Tanning, Dorothea 804
Tansey, Mark 618, 769
Tantlinger, Suzan 756
Taos Art Gallery 575
Tapia, Belen 567
Tapies, Antoni 96, 178, **255**, 375, 460, 600, 735, 779
Tappert, Georg 705
Tarallo, Jorge 557
Tarbell, Edmund 82, 422
Tarchinski, P. 950
Tardo, Rudolfo 785
Tarin, Gilberto 1020
Tarlow, Philip 665
Tarr, William 585
Tasch, Linda PP 152, 569
Tasende Gallery 62
Tassaert 810
Tassananchalee, Kamol 107
Tatafiore, Ernesto 322, 655
Tatyana Gallery 829
Taugher, Lawrence 107
Tavarelli, Andrew 424
Tavernier, Jules 125, 167
Tavin, Paula 804
Tawney, Lenore 579, 753
Taylor, Adelle M. 962
Taylor, Ann 30, 117, 698, 870, 898
Taylor, Bill 332, 919
Taylor, Brian 110
Taylor, Elmer 987
Taylor, Gage 996
Taylor, Gwen 40
Taylor, Hubert 944
Taylor, James Gale 813
Taylor, Janet 17
Taylor, Linda Ridgeway 970
Taylor, Loretta 964
Taylor, Lucy 859, 859
Taylor, Marshall 117
Taylor, Michele 305
Taylor, Nancy 888
Taylor, Prentis 222
Taylor, Renae 1023

Taylor, Yoshio 176
Taylor's Gallery 555
Tchalenko, Janice 438
Teabo, Andrew 587
Teague, Donald 146, 992
Teague-Cooper, Vicki 959
Teihman, Mary 775
Templeton, Lois Main 380
Ten Arrow 441
Ten, Gallery 32
Tenier, David 760
Tennant, Donna 671
Tepper, Irvin **838**
Teraoka, Masami 95, 104
Terlikowski, Wladimir 972
Terna, Fred 213
Terpning, Howard PP 268, 44, 999
Terry, Jane 151
Teske, Edmund 173
Tesler, Diane 391
Tessem, Susan 584
Tetherow, Michael 587, 743
Tetkowski, Neil 278, 283, 581
Tetreault, Marc 908
Texas Art Gallery 985
Thackrey & Robinson 169
Thalinger, Oscar 785
Thatcher, Anna Marie 952
Thavonsuk, Thep 117
Thaw, Avie 499
Thayer, Abbott 240
Thayer, Alix 40
Thayer, Barbara 576
Thayer, Bruce 449
Thayer, Harriet 'Bing' 872
Thayer, Nancy 315
Thee, Christian 789
Theimer, Ivan 1015
Thek, Paul **678**, 707
Thelin, Valfred 277
Theobald, Gillian 70
Theroux, Carol 21
Therrien, Norman 409
Therrien, Robert 79, 525
Thiebaud, Wayne PP 48, 111, 128, 131, 140, 162, 175, 180, 234, 235, 424, 451, 514, 824, 973, 1036
Thieme, Anthony 294
Thienes, Rachelle 636
Thiewes, George 421, 520
Thom, James 378
Thomas, Alma 222
Thomas, Barbara 609
Thomas, Dan 636
Thomas, Gwenn 844
Thomas, James 871
Thomas, Jinni 21, 573
Thomas, John 301
Thomas, Joyce 492
Thomas, Kathleen 678
Thomas, Kurtis 2
Thomas, Larry 129
Thomas, Lew 136
Thomas, Lynne 497
Thomas, Reynolds 591
Thomas, Richard D. 192, 542
Thomas, Steffen 282
Thompson, Bill 903
Thompson, Bob 838
Thompson, Elizabeth 640
Thompson, George 389
Thompson, J.B. 207
Thompson, Marilyn 1006
Thompson, Mark S. 203
Thompson, Richard PP 66, 29, 104, 170, 722
Thompson, Tom 151
Thompson Gallery 8
Thompson Gallery, Richard 170
Thon, William 750
Thorn, Bruce 329
Thorne, Joan 252, 581
Thornley, Bob 542
Thornton, Colleen 513
Thorp, Gregory 900
Thorp Gallery, Edward 830
Thorpe, Gordon 73
Thors, Joseph 1011
Thorsten, Lloyd 568
Thrall, Arthur 1052
Threadgill, Henry 688
Three, Gallery 9
Thun, Matteo 938
Thurmond, George 476
Thurston, Jacqueline 110
Tice, George 110, 412, 512, 851, 963
Tichansky, Michael 389
Tidd, Leona 41
Tidd, Ray 41
Tiepolo, Giambattista 63, 794, 835
Tietz, Gladys 512
Tiffany, Lee Wilson 276
Tiger, Jr., Johnny 247
Tigerman, Stanley 479, 789
Tihanyi, Lajos 740

Tillyer, William 709
Tilson, Joe 184, 473, 946
Tilton Gallery, Jack 831
Timberlake, Bob 691
Timlin, Hugh 463
Timock, George 323
Timpson, Michael 432
Ting, Walasse 451, 462, 730, 1015
Tingley, Michael 936
Tinguely, Jean 36, 707
Tinlot, Elizabeth 441
Tinsley, Barry 316
Tint, Francine 787
Tisdale, David 58, 636
Tissot, James 72, 84
Title, Christian 74
Titolo, Carl Nicholas 649
Titus-Carmel, Gerard 735
Tivey, Hap 94, 615, 900
Tivoli Gallery 1026
Tobey, Mark 121, 230, 260, 324, 330, 467, 793, 793, 850, 1039
Tobias, Willi 257
Tobiasse, Theo **257**, 347
Tobin, Steve 421
Todd, Mark 1006
Todd, Michael 124, 185, 235, **344**, 639
Todd-Cope, Louise 950
Toepp, Wayne 966
Tofthagen, Yvonne 314
Toglia, Richard 772
Tokita, Ryo 834
Tokuriki, T. 927
Tolbert, Margaret 291
Toledo, Francisco 127, 142, 621, 629
Toll Fine Arts, Inc., Barbara 832
Tolley Galleries 244
Tolliver, William 406
Tolson, Edgar 332
Toman, Joann 1052
Tomasso, Raymond 283, 565
Tomioka, Soichiro 171
Tomlin, Bradley Walker 475
Tomlinson, Kerry 839
Tompkins, Betty 630
Toney, Anthony 592
Tooker, George PP 67, 175, 320
Topolski, Andrew 581
Topp, Pat Diacca 1049
Toppi, Bernardino 1011
Toral, Cristobal 821
Torlen, Rita Hill 772
Tornero, Sergio Gonzales 628
Torpeo Factory Art Center 1032
Torr, Helen 685
Torreano, John 454, 608, 900
Torres, Francesc 620
Torres, Horatio 645
Torres Garcia, Joaquin **724**
Tortue Gallery 185
Toscano, Dee 572
Toshikoba 679
Toso, Giani 90
Tossan-Tossan Gallery 833
Total Arts Gallery 576
Touchstone Gallery 245, 834
Toulouse-Lautrec, Henri PP 41, 55, 24, 147, 175, 232, 285, 340, 420, 469, 624, 682, 696, 715, 803, 828, 1008, 1019, 1051
Tourau, Maria 245
Toussaint, Raphael 982
Tovish, Harold **420**, 649
Tower Park Gallery 377
Towne, Francis 760
Toya, Mary E. 574
Toyokuni 508, 679, 927
Toyokuni III 470
Tracy, Michael 975
Trailside Galleries 33, 1057
Traub, Charles 873
Travanti, Marc 777
Traver-Sutton Gallery 1045
Traverman, Marge 664
Trawoger, Ernst 620
Tre, Howard Ben 975
Treiman, Joyce 185, 324
Tress, Arthur 83, 692
Tretiak, Karen 868
Tria Gallery 1049
Triangle Gallery 171
Tribecia Gallery 207
Trieff, Selina 782
Triggs, Jim 201
Triplett, Janet 903
Trisdonn Gallery, Ltd. 861
Troiani, Don 201, 813
Trosky, Helene 588, 785, **864**, 864, 864
Trotman, Bob 334, 636
Trouillebert, Paul Desire 689

Trova, Ernest 270, 394, 765, 766
Trowbridge, David 180
Troy Art Gallery 470
Trudeau, Gary 230
Truitt, Anne 655
Tse'Pe 562
Tselkov, Oleg 757
Tseng, Mon-Sien 265
TsePe, Dora 567
Tsiaras, Philip 619
Tsoodle, Jay 528
Tu, Chien 179
Tubke, Werner 804
Tuchalke, Christel-Anthony 1052
Tucker, Allan 604
Tucker, William 620, 654, 709, 744
Tuegel, Michele 278
Tufts, Gayle 648
Tugel, Micheale 1049
Tuggle, Catherine S. 396
Tulipanov, I. 757
Tumarkin, I. 612
Tummino, Judy 896
Tunick, Inc., David 835
Tunison, Ron 201
Turbeville, Deborah 634
Turcato, Giulio 811
Turim, Judith 245
Turino, Betty 520
Turjansky, L. 829
Turk, Rudy 34
Turnbull, Bruce 302, 304
Turnbull, Murray 299
Turner, Andrew 944, 944
Turner, Arthur 1013
Turner, J.M.W. 72
Turner, Jeff 859
Turner, Judith 729
Turner, Richard 172
Turner, Ross 422
Turner, Tom 893
Turner, William 1045
Turrell, James 65, 79, 926
Turrell, Jim 926
Tuschman, Ellen Frances 737
Tuschman, Richard 737, 777
Tuteur, Vee 713
Tuttle, Richard 106, 615, 755, **831**
Twachtman, John 82, 292, 346, 436, 736, 819, 917
Tweddle, John 615
Tweed Gallery 516
Twingley, Dale 891
Two Nine One, Gallery 293
Twombly, Cy PP 205, 71, 79, 190, 262, 593, 617, 627, 651, 701, **701**, 735, 742, **743**, 762, 817
Tworkov, Jack 345, 527, 702
Tyler, Ken 918
Tyler, Valton 986
Tyrrell, Brinsly 894
Tyson, Carroll 553
Tzapoff, Antoine 813
Uchima, Ansei 309
Udaltsova, Nadeshda 705
Udinotti, Agnese 34, 724
Udinotti Gallery 34
Udo, Niles 997
Uecker, Gunther 36
Uelsmann, Jerry 56, 110, 139, 259, 413, 851, 947
Ufer, Walter 16, 198, 548, 558
Uffelman 241
Uffhen, Rosemary 582
Uhlencott, Michael 92
Ullberg, Kent 33, 59
Ulman, Doris 552
Ulman, Jane 91
Ulrich, Charles 42
Umbo 83
Umeda, Kenji 36
Umen, Harry 487
Umlauf, Charles 962, 946
Umlauf, Karl 959, 991
Unwin, Nora 503
Upstairs Gallery, The 589
Upshaw, Reagan 819
Uptown Gallery 244
Urbanowicz, Andrzej 1031
Urdang, Bertha 837
Urquehart, Shari 722
Us, Valta 424
Useem, S. 498
Ushenko, Audrey 329
Usner, Art 542
Usual Suspects, The 911
Utamaro 242, 792, 946
Utrillo, Maurice 662, 663, 675, 691, 773
Uttech, Tom 1052
Utterback, Robin 1018
Uzilevsky, Marcus 163, 266, 336
V & R Fine Arts 587
Vaadia, Boaz 749

Vaccaro, Anne 283
Vadala, Angelo 256
Vagliano, Sally 798
Vahlkamp, Nicholas 341
Vail, Clover 596
Valand Art Gallery 266
Valdeneige, Monique 756
Valdex, Alice 528
Valdez, Patti 15
Valencias, Irene 428
Valentine, DeWain 67, 252, 486
Valerio, James PP 105, 327, 673, 809
Valesco, Frances 126
Vallance, Jeffrey 92
Valle, Cynda PP 27, 187
Valledor, Leo 154, 166
Valley House Gallery 986
Vallien, Bertil 90, 697, 1045
Vallien, Ultica Hydman 1045
Vallotton, Felix 340, 605
Valtat, Louis 663, 714, 760, 818
Van Allsburg, Chris 269
Van Alstine, John 231, 239, 414, 623
van Bavel-Kearney, Pauline 960
Van Campen, Susan 122
Van Darzen, James 265
Van de Bovenkamp, Hans 509
Van Der Zee, James 632
van Dongen, Kees 773, 984
van Dyck, Sir Anthony 886
Van Dyke, Willard 178, 194, 554
Van Elk, Ger 383, 755
Van Elten, Kruesmann PP 47
van Es, Jacob 917
Van Fleet, Daniel 547
van Gayens, Jan 760
Van Gemert, Jeanne 879
Van Gogh, Vincent 610, 714
Van Goyen 917
Van Harlingen, Jean 480, 822
Van Hasselt, Tony 45
Van Hiele, Jack 171
Van Hoesen, Beth 486
Van Housten, Skip 231
Van Kearen, Phillip 979
Van Powell, William Knowland 954
Van Riet, Jan 121
Van Riper, Frank 245
Van Riper, Zinnia 245
van Ruisdael, Jacob 917
Van Ruysdael, Salomon 760
Van Selm, Arie 2
Van Straaten Gallery 363
Van Suchtelen, Adrian 465, 467
van Tongeren, Herk 638
van Veen, Stuyvesant 796
van Velde, Bram 668, 735
Van Vranken, Rose 994
Van Wert, Gordon 43, 544
Van Wieck, Nigel 651
Van Winkle, Lester 231
Van Zyle, Jon 4
VanDerlans, Rudy 159
Vanderlean, Peter 526
Vanderwoude Tananbaum 838
Vangi, Giuliano 812
Vann, Donald 471, 958
Vansen, Leslie 1050
Variant Gallery, The 557
Vasa 67, 75, 107, 121, 315, 375
Vasarely, Victor 24, 266, 282, 336, 347, 378, 384, 467, 469, 518, 710, 836, 896, 913, 960, 1051
Vaske, Barbara 384
Vasquez 553
Vasquez, Isabel 628
Vaughn, Jeffrey L. 966
Vebell, Ed 201
Vega, Alan 678
Veilands, Ragnars 911
Velardi, Ernest 187
Velasco, Jose Maria 127
Velazquez, Joe 201
Velazquez, Juan Ramon 255
Velick Gallery, Bruce 172
Velure, Beverly 892
Venable-Neslage Gallerie 246
Venditti, Jerry 572
Venet, Bernar 345
Venetien, Jean 1011
Venn, Sam 11
Venner Shee, Mary 69
ver der Vooget, C. 779
Verbena Galleries 839
Verboeckhorn 274
VerBryck, Cornelius 861
Verdugo, James 59
Vered Gallery 585
Verkerk, Emo 755
Verner, Elizabeth O. 949